ARKITEKTURANG FILIPINO

A HISTORY OF ARCHITECTURE AND URBANISM
IN THE PHILIPPINES

ARKITEKTURANG FILIPINO

A HISTORY OF ARCHITECTURE AND URBANISM
IN THE PHILIPPINES

GERARD LICO

The University of the Philippines Press
Diliman, Quezon City

THE UNIVERSITY OF THE PHILIPPINES PRESS
E. de los Santos St., UP Campus, Diliman, Quezon City 1101
Tel. Nos.: 9253243 / Telefax No.: 9282558
E-mail: press@up.edu.ph

The National Library of the Philippines CIP Data

Recommended entry:

Lico, Gerard.
 Arkitekturang Filipino: a history of architecture
and urbanism in the Philippines / Gerard Lico.—
Quezon City: The University of the Philippines
Press, c2008.
 p. ; cm.

 1. Architecture—Philippines—History. 2. Architecture,
Domestic—Philippines. 3. Vernacular architecture—
Philippines. I. Title.

NA1527 720.9599 2009 P091000058
ISBN 978-971-542-579-7

Book Design: Gerard Lico

Printed in the Philippines by Econofast Press

Table of Contents

4 Spectacle of Power
Hispanic Structuring of the Colonial Space (1565–1898)

5 Imperial Imaginings
Architecture and Urban Design in the New Tropical Colony of the United States (1898–1946)

8 Architecture of Pluralism
and the Postmodern Urban Scenography

Foreword

Rodrigo D. Perez, III

The title of this book—*Arkitekturang Filipino*—may resurrect an old question: Is there such a thing as Filipino architecture? Can one speak of it as one speaks of Filipino music, Filipino dance, Filipino painting, Filipino sculpture, Filipino literature, Filipino theater, and Filipino cinema; that is to say, as something recognizably Filipino, something that reflects the culture and spirit of the Filipino people?

It shouldn't be surprising to hear vehement denials of the existence of Filipino architecture even from academics and architects. The various buildings of the Spanish colonial, American colonial, and postcolonial periods are dismissed as mere imitations of Western architecture. The indigenous dwellings, which developed from precolonial traditions, are not considered architecture at all since they are not monumental. Such judgments arise from plain ignorance, a colonial mentality, and the national propensity for self-bashing. Anyone who has diligently examined the various types of buildings in this country and has bothered to look into their history will realize that there is such a thing as Filipino architecture.

The author, Gerard Lico, has chosen a Filipino title for a book that is entirely in English. Translated into English, the title would be either *Filipino Architecture* or *Philippine Architecture.* Is there any difference? In an article published in 1958, writer Danny Villanueva made a distinction. "Philippine architecture" is "only a generic term we use to denote geography or the place where the buildings are located." Filipino architecture, on the other hand, would be the term for that which is the appropriate response to the environment and to the Filipino's individual and social needs. It could be understood as the reflection and expression of culture, which arises from human beings' interaction with their environment, with their history, and among themselves.

In the brief description of the book's content, the author uses the term "Philippine architecture." Being "geographical," it is comprehensive, and would therefore include both what is truly Filipino architecture and what is not.

Histories of Filipino architecture—the term I prefer—which are contained in a number of books and essays, usually focus on the evolution of building forms in the light of political, economic, social, and cultural developments, and on the synthesis of native and foreign elements. Lico's history is not only an account of an evolution but also a critique of the succession of regimes. He shows how architecture has been an instrument of domination and even injustice. The subject is not only Art in all its splendor but also Power and its hidden ugliness: the power of colonial masters, the power of a dictator, and the power of global business. But, fortunately, power does not destroy the genius of the Filipino architect, whether unschooled or formally trained. To develop his thesis, Lico has assembled a vast amount of information and commentary that is both enlightening and indicting.

The saga begins with the early people settling in found shelters—trees and caves. Nature herself is the architect of these dwellings.

Indigenous houses are recognized as architecture, although qualified by the term "vernacular." Lico enables the reader to appreciate such buildings not only in the Southeast Asian context but also in the wider Austronesian context. Here, shelter is built and formed by the interaction of human beings with their environment.

Islamic architecture in the Philippines represents a period characterized by organized religion as symbolized by the mosque, and a power structure as symbolized by the *torogan.*

The chapter on the Spanish colonial period—entitled "Spectacle of Power"— recounts the transformation of the country through the establishment of towns in compliance with Philip II's *Ordenanzas* for effective control of the natives. The colonizer's accommodation to the environment and native culture gave birth to what was christened *arquitectura mestiza.* This developed into the *bahay na bato.*

"Imperial Imaginings," which covers the American colonial period, focuses on Daniel Burnham's plans for Manila and Baguio and their implementation by William Parsons. Baguio was to be developed for the comfort of the colonizers. Filipino architects of the period—Juan Arellano, Arcadio Arellano, Antonio Toledo, Tomas Mapua, Tomas Arguelles, Andres Luna de San Pedro, Juan Nakpil, Femando Ocampo, and Pablo Antonio—are highlighted in this chapter. The section on Art Deco shows how European style was "Filipinized."

The chapter "Postcolonial Modernity" includes the period of reconstruction following World War II, the plan for the Capital City, the architecture of government buildings, low-cost housing, and the architectural styles and outstanding architects of the late 1940s to the early 1970s.

"Vernacular Renaissance" begins with the buildings commissioned during the Conjugal Dictatorship and, later, examines the various trends: Romantic Regionalism. Pragmatic Tropicalism, and Neovernacularism, represented respectively by Leandro Locsin, Felipe Mendoza, and Francisco Mañosa. Paradoxically, an era of repression spawned a Romantic movement.

The last chapter, "Architecture of Pluralism," examines Postmodernism in the Philippines, the phenomenon of the malls, and the global cities of Manila: Fort Bonifacio Global City, Rockwell Center, and Eastwood City Cyberpark.

With globalization, more and more foreign architects have been engaged to design major projects in the Philippines in collaboration with Filipino architects who are designated "architects of record." The reasons for this are many and apparently convincing. One fears, however, that the period of Postmodern architecture in the Philippines might well become the period of Post-Filipino architecture.

But perhaps, one way or another, as in the past, the Filipino will prevail.

Preface

Architecture possesses the capability to reflect the essence of a time and a place like no other artifact. It not only embodies the collective cultural values of the society that made it possible, but also palpably manifests the society's creative responses to environmental imperatives, the ecological milieu, power structures, and even material deprivation.

The Philippines has long been a locus of exchange and a crucible of cultural cross-breeding because of its geographic location and archipelagic openness, which has resulted in a wealth of architectural expressions. This book presents a wide range of built forms, from the crudest modes of human habitation, such as primeval caves, to the most sophisticated artificial environments, such as postmodern megastructures. Architecture in the Philippines is extremely multifaceted, mirroring the rich diversity of cultural, historical, and geographic influences that have forged the Filipino nation as a whole.

As the title *Arkitekturang Filipino: A History of Architecture and Urbanism in the Philippines* suggests, this book tells the story of architecture that is rooted in geography. At the same time, the book expresses a nation's aspiration to an entitlement. The term "Arkitekturang Filipino" is heavily charged with the quest for national identity. To avert homogenizing this into a singular construct, the geo-political setting is established in subtitle to substantiate the variety of geographic conditions and the plurality of Filipino cultures that have shaped these built forms. Filipino architecture is therefore overwhelmingly diverse, generated by a myriad of architectural practices, building processes, regional expressions, cultures, the divergent experiences of class, gender, religion, ethnicity, and the idiosyncrasies of the building auteur. What this history does is to explore the pluralism that has enriched the complexity of Filipino architectural expressions—the energy, vitality, and intricacies this pluralism has inevitably brought.

In this volume, I employed the term "architecture" to refer to a more encompassing category: the "built environment." This implicates an entire cultural landscape, including the so-called designed landscapes, urban spaces, and human modifications of natural spaces. In so doing, the long-standing canonic dichotomy between vernacular and monumental and the taxonomic distinction between "low architecture" and "high architecture" are dismantled, as both these polar sets, although materially disparate, essentially share common architectural strategies where their respective builders and designers employ the same tactics to create habitable spaces. Architectural history, therefore, is narrated democratically in this book, incorporating both vernacular and monumental structures, executed by professional and novice builders, in all scales and materiality.

This book emanates from a multidisciplinary springboard, as a result of a decade of teaching and research in Philippine architecture. Architecture, possessing multiple meanings, has necessitated a multipronged approach to investigation, often looking through the lens of other disciplines. Thus, in addition to the traditional formal survey of architectural and urban history, discursive routes by way of social and economic history, sociology, anthropology, feminism, colonial and postcolonial

studies, material culture, cultural landscape studies, and literary theory were also undertaken. This approach aimed to reveal new perspectives on architecture and to unravel intersecting forces that shaped the style, conceptual imagery, building technology, and planning theory within a particular historical time frame, as these were all formerly silenced or hidden within the text. There are layers to this effort: the survey of built forms arranged through time and across settings; the identification of supposed tangents that surprisingly intersect with architecture, such as electricity, cinema, and even the rivers where architectural stones are sourced; the detection of issues that complicate the diachronic framework and the seemingly innocent passage of history. For instance, the Austronesian pedigree of Southeast Asian architecture, the mythology of building edifices in nation-states, hygiene and the ideology of sanitation, and the problem-fraught issue of modernity become intrinsic to the production of architectural forms, not just contexts from which they spring up. It is therefore prudent to cast a wide conceptual net in order to capture the sprawl of a mutating discipline, from its emergence in prehistoric times to its recent development in urban districts.

It is also interesting to note that prior to publication, the book's manuscript was condensed to form the script of a four-part documentary released on DVD in 2007 as the *Audio-Visual Textbook of Philippine Architecture*. The video series was produced by the National Committee on Architecture and Allied Arts (NCAAA) of the National Commission for Culture and the Arts (NCCA) through the Council of Deans and Heads of Architectural Schools of the Philippines (CODHASP) to supplement the teaching of Philippine architecture, which is now part of a newly mandated five-year ladder curriculum leading to the degree of Bachelor of Science in Architecture. The DVD is an imperative companion to this book when teaching Philippine architecture.

As a student, professor, and practitioner of architecture, I look to mentor-friends whose commitment to the field and whose generosity of spirit I truly cherish: Arch. Maria Cristina V. Turalba, Fr. Rodrigo D. Perez III, and the late Dr. Honrado R. Fernandez. I would like to thank those who supported the gestation of this project with valuable advice, expertise, encouragement, and inspiration: Dr. Patrick D. Flores, Arch. Edson Roy Cabalfin, Prof. Ruben D.F. Defeo, Arch. Prosperidad C. Luis, Dr. Geronimo V. Manahan, Arch. Danilo Silvestre, Arch. Paulo G. Alcazaren, Arch. Nicolo del Castillo, Dr. Elena R. Mirano, Jason P. Jacobo and Susan Calo-Medina. For the additional illustrations, I am grateful to Jeffrey Cobilla. I also thank Jojo Mata, Nonoy Ozaeta, Randi Reyes, Delia Tomacruz, Ning Tan, Maureen Anne Araneta, Zeny Galingan, Grace Gregorio, Melanie Casul, Marty Paz, Merlyn Sornorza, Wilma Azarcon, Rod Tarlit, Marlo Basco, and Michael Ang for their friendship and support.

The task would have been too much of a burden without the support of the faculty and staff of the University of the Philippines College of Architecture as well as its University Librarian, Salvacion Arlante. I wish to acknowledge the professional support of the staff of the University of the Philippines Press and its Director, Dr. Ma. Luisa T. Camagay. Lastly, this book would not have been possible without the generous financial support from the University of the Philippines System Textbook Writing Grant.

As always, Bernadette Lico and our children, Jarred, Gerdette, and Grei, provide me with moral support and a life apart from work. My gratitude is the very least that they deserve.

Introduction

Maria Cristina V. Turalba

Architecture is a conveyance of the past to the future. It embodies the cultural pluralism of countries that have weathered the dominance of various cultures at certain milestones in its past. The culture of architecture is intricate, multifarious, paradoxical, and elusive, even in seemingly monocultural countries. Because of the Philippines' strategic location at the crossroads of major global trade routes, its typhoon and earthquake-prone environment that is not exactly kind to building structures, and its being a victim of a severely destructive war, the *arkitekturang Filipino* that emerged over a period of time is a product of multicultural creativity and inventive cultures.

Arkitekturang Filipino is a continuing passion for the author, Dr. Gerard Lico. His early years were marked by an unrelenting pursuit in search of Filipino architecture. His insight is impeccable, language kaleidoscopic. For the past fifty years of its existence, the University of the Philippines College of Architecture has always espoused scholarly works in Philippine architecture. This exhaustive treatise bespeaks years of laborious pursuit of creating a legitimate textbook which will dispel myths regarding Filipino architecture.

The Philippine archipelago, located at the crossroads of the Pacific Ocean and South China Sea, had been the site of brisk commerce. For a thousand years, the Chinese junk traders and the Muslim traders visited the islands using the very same sea currents that transported the early humans who traveled from China to the Batanes islands to "percolate" as the Austronesian race. They eventually populated Southeast Asia and the Oceania. This scholarly work of Gerard Lico exhaustively discusses the unrevealed impact of the Austronesians on the Philippines and the rest of the region.

Our early ancestors left explicit traces of the manner in which they lived with the harshness of the sky and the generous bounty of the earth. They used the Tabon caves as their shelter; they carved out of the Cordilleras the terraces from which they sourced their rice supply; and they formed the *Idjang* from the mountains of Batanes as a means of defense and as a vantage point to sight the migration of fish.

Vernacular architecture is classified into various categories in terms of structural form, function, historical period, and geographic location. These ethnocultural groups have constructed structures in response to the ever-changing sociocultural needs. From the northernmost islands to the southernmost point of the Philippines, the ethnocultural groups include the Ivatans of Batanes; the Tingguians, Ifugao, Kalinga, Bontoc, Isneg, Kankanay, Ibaloy, and other peoples of the Cordilleras; the various Aeta groups like the Agta, Pinatubo Aeta, and Dumagat; the various Mangyan groups in Mindoro, notably the Hanunoo and Alangan; the Tagbanua, Batak, and Palawan peoples of the Palawan islands; the Maranao, Maguindanao, T'boli, Tasaday, Yakan, Tausug, Sama, Badjao, Tagbanua, Bagobo, Manobo, Mandaya, and Bukidnon who inhabit the Mindanao-South China Sea area.

There are as much archetypal forms of vernacular architecture as there are ethnolinguistic groups in the Philippines. Due to this cultural diversity, interesting forms and ornamentation have emerged. The mountain people have developed architectural forms different from those who live along the coastline or on flat lands. Although, there is a strong commonality in the disposition of spaces, "communal memory," social organization, lifestyle, belief system, exposure to foreign culture, natural environment, building technology, and available construction materials create the variations across the different ethnocultural communities.

Philippine Muslim architecture has never been given singular focus as a subject of empirical research until Lico did in this landmark textbook. The wealth of information that he has amassed confirms the Muslims' rightful place in Philippine architecture. As early as the thirteenth century, the indigenous population in western Mindanao had already embraced Islam. Muslims design spaces in the light of the Koran but retain the multifunctional mode of Filipino spaces.

Our ancestors had to grapple not only with the raging typhoons, violent earthquakes, and searing sun, but also with foreign intruders who tried to subjugate them, the easiest way by totally erasing their culture. But our resilient ancestors have deluded those who wanted to subjugate them by their seeming meekness. The Filipino individuality is manifested by the architecture that our ancestors have created: overflowing in light and air, generously embellished, and welcoming.

In the sixteenth century the Spanish conquistadores vanquished resistance in the archipelago through "the cross and the sword." New forms of structures were introduced which were not essential in the early Filipinos' traditional existence. The new Roman Catholic belief system built splendid churches, conventos, and bell towers. Fortifications, codification of town planning, civic structures, lighthouses, bridges, and *portos* honed our ancestors' construction vocabulary to articulate Filipino architecture. The lifestyle of the new colonial masters of working and relaxing indoors was so contrary to the Filipinos' preferred outdoor existence. So even the new multiroomed *bahay na bato*, ceramic roof tiles, "stone and mortar" construction techniques, which created what was called *arquitectura mestiza*, emerged as Filipino architecture.

The naming of the colony as *Filipinas* after the King of Spain Felipe II dealt a stronger blow than the establishment of the *reduccion*, the *encomienda*, and the *cuadricula* planning in altering the socioeconomic and cultural environment in the Philippine archipelago. Three hundred years of continuous interaction with Spain and Mexico have left an indelible imprint on Filipino architecture, and yet the Spanish colonial period churches are local architectural improvisations embellished with neoclassic or baroque Philippine flowers, fruits, and crocodiles.

This book, a landmark achievement in the quest for Filipino architecture, exhaustively details town planning milestones, achievements in domestic architecture, civic architecture typologies, and Filipino interpretations of classical European typologies and architectural styles. The Filipino institutions: the *sabungan*, *sari-sari* store, and *turo-turo* or *carinderia*, are architecturally dissected as well as commercial and recreational structures that sustained the livelihood

and social life of that period. By then the population was a blend of Eastern and Western cultures: *Indio, mestizo Indio, Insulares, Peninsulares, Sangley, mestizo Sangley.*

Before the dawn of the twentieth century, triggered by land tenure problems, the Filipino nationalists finally clamored for reforms from the Spanish government. The martyrdom of patriot Dr. Jose Rizal provoked the revolution against Spain and in 1898, the Philippine revolutionary forces declared independence of the country from Spain. By a "quirk of an international accident," the Spanish-American War was resolved with the purchase of the Philippines from Spain by the United States. In the race for supremacy among the colonial powers, the addition of the Philippines to the colonial coffers of the United States was an opportunity to assert dominance in the region.

A societal transformation and architectural uniformity were about to happen with the United States imposing the American Neoclassic style and Daniel H. Burnham's built-environment prescription. Plans for new cities and architecture were formally crafted. The Filipino *ilustrados*, some of whom were sent to study abroad as *pensionados*, worked with American architects. There were tremendous opportunities to launch projects in education, resource development, public works, sanitation and public health, communication, transportation, and conservation. The *ilustrados* and the *hacenderos* were able to consolidate their resources to continue their influence as well as their political power.

Eventually, the enlightened Filipino nationalists, realizing the disparity created by colonialism, clamored for balance in national interests. The strong petition for independence was addressed with the US Congress passage of the Philippine Independence Act of 1934. The Commonwealth period was marked with the governance of the country by Filipinos and a period of stability fondly remembered by our ancestors as "peace time." For the extensive built-environment accomplished during that period, Manila gained the accolade of "Paris of the Far East." This section of the book, "Imperial Imaginings," is a comprehensive monograph of this period.

While the early twentieth century was an era of dramatic urban redefinition and architectural realization, wartime was an era of inexpressible destruction at a rate unimagined in human history. By the end of World War II, Manila was the second most devastated city in the world after Warsaw. Irreplaceable Intramuros was almost obliterated from the map as well as other areas of the country. Yet, Filipino resilience again came into the forefront: "The atrocities of war were followed by the atrocities of reconstruction," noted Fr. Rodrigo Perez III.

The practice of architecture was institutionalized by Republic Act 545 in 1950. In anticipation of an imminent reconstruction and building boom, a new crop of young Filipinos studied architecture and prepared themselves for the built-environment profession. On the other hand, established architects expanded their practice. They were the predecessors of the Modern Movement, which extracted romanticism from the soul of Filipino architects. Some architects never pursued academic training abroad, but their credentials were on par with the best of foreign architects.

Contemporary architecture incorporated folk art details and local architectural expressions. The Marcos era brought about the most extensive opportunities for Filipino architects, and the massive building projects of the First Lady Imelda R. Marcos have outlasted that era. Multistorey tenements and mass-housing typologies were alternative responses to solve the housing needs of an increasing population. Gifted with the ability to discern the creative strength of cultures that have arrived in the country, the Filipino assimilated them into the local fabric, oftentimes improving on them. This scholarly work exhaustively explores each significant period in the history of the Filipinos in the context of the built-environment.

In the wholesale reconfiguration of the urban centers that has occurred nationwide for the past ten years or so, age-old values, philosophy, economics, politics, technology, and aesthetics of architecture are likewise undergoing an equally radical transformation. The architecture in the Philippines is a product of a spontaneous process of cross-cultural alliance and adaptation of form. However, that is no longer the norm. Used to harnessing multicultural inventiveness, it has now been transformed into the creation of generic structures with no memories of the past nor the promise of delivering a gift to the future.

Lico culminates his book with an extraneous dissertation, "Architecture of Pluralism," on the recent state of architecture in the country. This could serve as an examination of conscience for Filipino architects to rethink their role in the preservation of the "specialness of place" of our urban centers.

ARKITEKTURANG FILIPINO

A HISTORY OF ARCHITECTURE AND URBANISM
IN THE PHILIPPINES

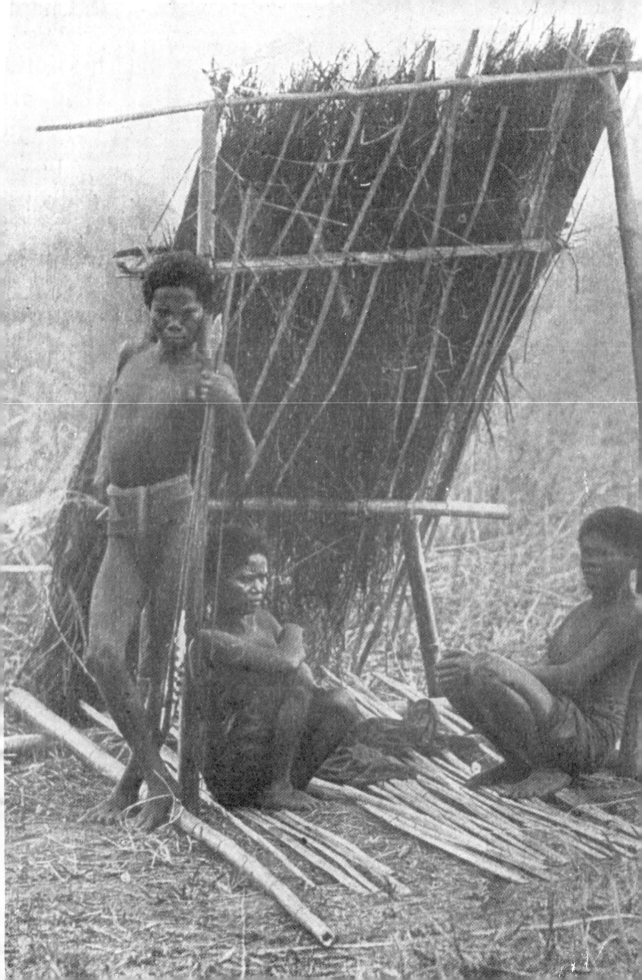

1 Between the Earth and Sky
Early Philippine Shelters

Architecture began as a response to nature. For the primitive who was defenseless before the violence of wind and rain, the cave was a refuge, a serendipitous place of dwelling. For the most part, the said shelter had always been there, ready for use, but it needed to be reclaimed and made safe from predators. Fire, the chief human invention, proved to be a significant element not only in driving savage animals away from cave habitats but also in carving out space. The burning fire marked the new human territory and served as a site for rituals and other gatherings.

Coming out from the caves, man initiated the first architectural revolution with the invention of stone tools for cutting fibrous materials, plant stems, and wood. This fibroconstructive technology helped develop the temporary, tent-like shelters made of wooden skeleton, vegetative fiber, or animal skin and constructed through binding, weaving, and lashing. These shelters embraced the life of the hunter-gatherer. Such structures also nurtured a new figure that would take the place of the wanderer—homo faber, "man the maker," architect, and builder.

Cave Dwellings as the Early Human Shelter
Prehistoric cave shelters were the earliest form of human habitation. The use of natural caves predated the emergence of Homo sapiens. Constructing cave dwellings only required minimal site-work and modification as the shelters conformed to the structural properties of rock or earth in situ. The shelters were made via excavation rather than construction. Cave spaces were hollowed out either by extending caves or burrowing into the recesses of the cliffs, yielding for its occupants a living space protected from heat, rain, and wind.

In the Philippines, the earliest dwellers of caves were the Pleistocene people, offsprings of the Ice Age. They had come on foot by way of land bridges that emerged when the sea subsided because of the formation of glaciers and the polar ice caps some two to half a million years ago.

The most antiquated, and perhaps the largest, cave periodically dwelt in by prehistoric families for thirty thousand years is the Tabon Cave complex, situated on Lipuun Point, southwest of Palawan. It covers 138 hectares of rugged cliffs and

1.1 An Aeta lean-to windscreen

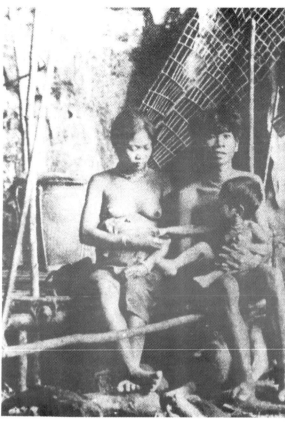

deep slopes. A human bone fossil tentatively dated from 22,000 to 24,000 years ago was discovered in Tabon Cave in the 1960s by a team of National Museum archeologists headed by the late Dr. Robert B. Fox. The cave's portal is about sixteen meters in width and eight meters in height and extends to an interior depth of forty-one meters. Verified through findings from archeological excavations and carbon-14 datings, the cave was found to have been suitable for human habitation. In fact, the cliffs and slopes around the area are punctured with more than 200 caverns. Twenty-nine of these caves were fully explored and found to have been ideal for habitation or burial by ancient Filipinos. The cave was named "tabon" after the large-footed bird that lays eggs in huge holes it digs into cave floors, many of which have been found in the cave.

To this date, Tau't Batu people occupying the southern part of Palawan continues the primeval practice of living in caves. During the monsoon season, members of this cultural group can spend months living in the caves of the Mantalingajan mountain overlooking the valley of Singnapan. But, occasionally, they move to wooden houses and shelters near the fields they cultivate. A Tau't Batu cave may shelter more than one family.

A basic sleeping platform, known as a *datag*, is made from tree branches and dried leaves and is built inside the cave, raised slightly above ground, with a fireplace in close proximity to provide warmth during the night. A more complex datag is made depending on the environmental conditions. If the place is windy, a wall is

1.2 Tabon Cave in Palawan (left)

1.3 A Tau't Batu family seated on a datag, Ugpay Cave in Palawan (right)

erected in the direction of the wind; or all three sides are walled in, leaving open only the side where the fireplace is located. A roof is provided to protect the datag from rain. A cave may accommodate several family units that form a kin group, with the place of each family unit defined by the individual datag.

The Tau't Batu also make covered huts using light materials within larger caves. Their fear of thunder is one of the main reasons why they retreat into caves, and why peals of thunder figure in Tau't Batu folklore as a warning against mocking or laughing at animals. The Tau't Batu believe that their world is inhabited by a vast population of forest, rock, and water spirits, with deities responsible for the different aspects of nature.

There are other examples of caves and rock shelters in the Philippines that were once inhabited by early Filipinos. The petroglyphs (prehistoric drawings of human figures engraved on the cave walls) in a rock shelter in Angono, Rizal, provide evidence of the ancient Filipino's attempt to embellish his space and domain with symbolic values. The mountaintop citadels of Savidug, Batanes, known as *idjang*, is a testimony to the sophisticated defensive engineering of the early Ivatan settlers, who carved the hard limestone formation to create planes of vertical walls. The presence of clay shards from cooking utensils attests to the existence of settlements on top of these structures. These settlements could have been used as lookout points to monitor marine life for food and to warn against invading forces.

Nomadism and Ephemeral Portable Architecture

Ephemeral architecture was one of the first artifacts created by humans. The primitive lifestyle was essentially nomadic, needing a form of temporary shelter that utilized readily available materials with limited investment in time and energy. As nomadism entailed constant movement, materials that were portable and demountable were requisites in design and construction.

1.4 Idjang rock-hewn fortress in the island of Batanes

1.5 Petroglyphs of Angono, Rizal

In the Philippines, the fundamental act of building was practiced by nomads in the form of the windbreak (lean-to), windscreen, or windshield. It was set up for shelter before commencing a hunting or food-gathering journey. Early Filipinos constructed a wind-sun-and-rain screen anchored by a pole or stick at an angle on the ground.

The lean-to is the early dwelling of the Aeta. This transient architecture is an inalienable aspect of their nomadic lifestyle. It is still very popular among Aeta groups, although the acculturated Aeta of Pampanga and Zambales, not as nomadic as their ancestors, have chosen to settle in more permanent abodes, like their stilt houses—structures raised above the ground on wooden posts with thatched roofs and walls.

The lean-to or *pinanahang* of the Agta of Palanan is a botanic shield against wind, sun, and rain, built with strong but light branches and palm fronds. Yet, in spite of its apparent flimsy character and fragile structure, the pinanahang, constructed along the principle of a tripod, can solidly withstand storms and strong winds. The lean-to of the Palanan Agta is a transient shelter built close to streams, coastlines, or riverbanks during the dry months. This shelter is readily moved to higher areas and the floor elevated to knee-high level during the rainy season as a protection against wetness and humidity and for better air circulation.

The Casiguran Dumagat live temporarily in low, unwalled sheds, which have floor spaces of more than 4.5 square meters, while the Ebuked Agta of northeastern Luzon build more spacious and complex lean-tos than the downriver Agta. Areas for sleeping are prepared by removing protruding rocks, compacting the earth to level the ground, and making use of leaves placed under mats as cushion.

1.6 Aetas and their lean-to depicted in the 1885 book *Bosquejo geografico e historico-natural del archipiélago Filipino* (left)

1.7 An Aeta family and their lean-to in an early twentieth century photograph.

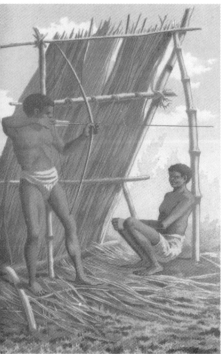

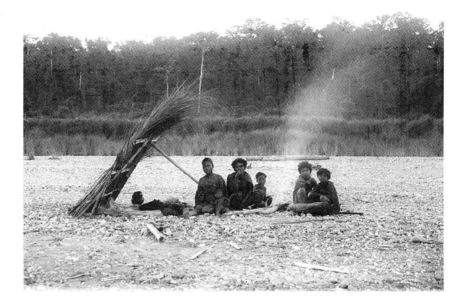

The *dait-dait* is the simple windscreen used by the Mamanua of northeastern Mindanao when hunting. It is made from the leaves of wild banana, coconut fronds, or grass and usually lashed together with rattan. When they stay longer in a place, they modify the basic structure and build a platform. This same type of windscreen is also built by the Pinatubo and Panay Aeta.

A typical *hawong* of the Pinatubo Aeta has no living platform and is usually constructed with a ridgepole supported by forked stakes or limbs. It forms two sloping sides with one or both ends left open.

Arboreal Shelter: Dwelling High on Trees

While the first to be inhabited by people were the caves, the first shelters to be constructed were made of interlocking branches. L'Abbe Laugier (1713-1769) provides an account of man's search for shelter in his *Essai sur l'Architecture* of 1753:

> Some [branches] broken off in the forest are materials for his purposes. He chooses four of the strongest and raises them perpendicular to the ground, to form a square. On these four he supports four others laid across them.

The illustration, which accompanied this account, showed that these latter branches laid across the fork of trees were still rooted to the ground.

In the nineteenth century, arboreal shelters reinforced the racial stereotypes of post-Darwinian evolutionary concepts as "climbing down from trees," representing the transition of man from ape to sentient human being. Frenchman Paul de la Gironiere, also in 1854, provides the earliest written description of the tree house in the Philippines. Investigating the houses and settlement configuration of the Tinguian of Palan, northwest of Abra, he observed that the Tinguian had a separate daytime and nocturnal abode. The day abode was a small hut of bamboo and thatch built on the ground, while the night abode, the *alligang*, was even smaller

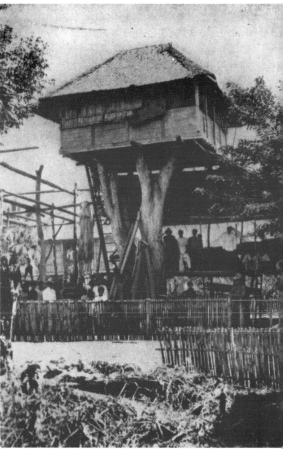

and rested on a tree top, some eighteen to twenty-four meters from the ground, as a safeguard from nighttime ambushes perpetuated by Guinana, their tribal nemesis.

Arboreal shelters still persist to this date. The greatest concentration of tree houses exists in the regions of New Guinea, Borneo, and the Philippines. In the Philippines, the tree house is an old institution, built and used by the Gaddang and Kalinga of Luzon, the Manobo and Mandaya of Mindanao, and by the Maranao of Lake Lanao, according to Alfred Louis Kroeber (1928). Tree houses are usually found in areas where violent intertribal conflicts and nocturnal raids are frequent. These houses are perched on the forked branches of trees, six, twelve, or even eighteen meters above the ground. Kroeber stressed that tree houses are highly elevated to protect families living in isolated communities from the attack of animals and human enemies.

The tree houses of the Manobo of Southern Mindanao are made with a rectangular frame, hipped roof, and paneled walls. The floors are built with strong joists to form a platform. A large tree with many thick branches is lopped off approximately 7.5 meters from the ground, and the whole house constructed on the stumps. The Mandaya of the Davao Gulf region of southeast Mindanao construct two types of arboreal architecture: one simply rests on the limbs of trees, its shape and size adapting to the features of the supporting branches; the other, which is more predominant and sturdily built, is constructed on the stump of a large tree which

1.9 Tinguian tree house (opposite)

1.10 L'Abbe Laugier's illustration of a primordial tree house (above left)

1.11 Manobo tree house (above right)

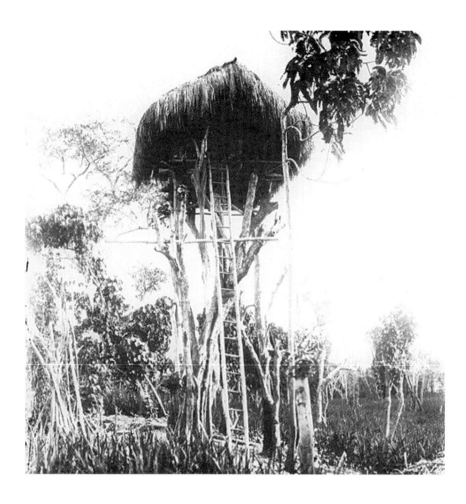

has been cut off some 4.5-6 meters above ground. A tree with buttress roots is chosen whenever possible and a framework is assembled on top of the stump, further supported by slender poles; these may rise to form the corner and intermediate post of the house. Lashed to the poles with rattan are floor crossbeams, overlaid with beaten bark, and above the flooring are the supporting poles that form the framework for attaching woven nipa palm wall panels. A king post system supports the roof ridge, from which pole rafters are laid so as to extend over the walls, leaving space for ventilation; the roof is thatched with nipa palm. A ladder with lashed crosspieces and a handrail placed at one corner renders the house accessible from the ground. The entire tree house is so firmly lashed together by rattan that it could withstand violent storms, though it may still shake with the wind. To minimize vibration, the house is further secured by anchoring it with rattan lines to nearby trees.

The Negritos, perhaps the first inhabitants of the Philippines, according to anthropologists, also built tree houses. They first lived in the tropical forests of the Zambales province, near Mt. Pinatubo. They built their houses on trees that have little or no lower branches, such as the eucalyptus, some six to ten meters above the ground.

Kenneth Mcleish (1972) reported that in the latter part of 1970, some 500 members of the Higaonon tribe were found to still be living in tropical tree houses of lashed

saplings in the virgin rain forest of their habitat. Precarious catwalks, passing a high-rise dormitory, led to a centrally located communal area.

Rice Terraces—The Prehistoric Megastructure

Throughout the Asia-Pacific region, mountainous terrain, over the centuries, has been shaped into landscapes of terraced pond fields for the cultivation of rice and other crops. These landscapes exist both as archeological sites and as living landscapes, and continue to be used and maintained by the people who created them.

The technique of pond-field agriculture, which characterizes the rice culture of the entire Asia-Pacific region, transforms and shapes the landscape. The application of the technique to mountainous terrain has created a terraced landscape. These terraces provide habitats modified by humankind. Archaeological evidence indicates that the earliest terraces may have been used for the cultivation of taro and other root crops which continue to be an important staple for a part of the region.

The network of rice terraces in the Cordilleras is a testament to Philippine premodern engineering. Included in the UNESCO's World Heritage List, it is living proof of man's genius at turning a rugged and forbidding terrain into a continuing source of sustenance. Originally covered with woodland and perpetually visited by tremors, the landscape had been altered by human hands. The rice terraces may be found in high altitudes of anywhere from 500–1,600 meters, spanning the provinces of Cordillera's mountain range, including Ifugao, Mountain Province, Benguet,

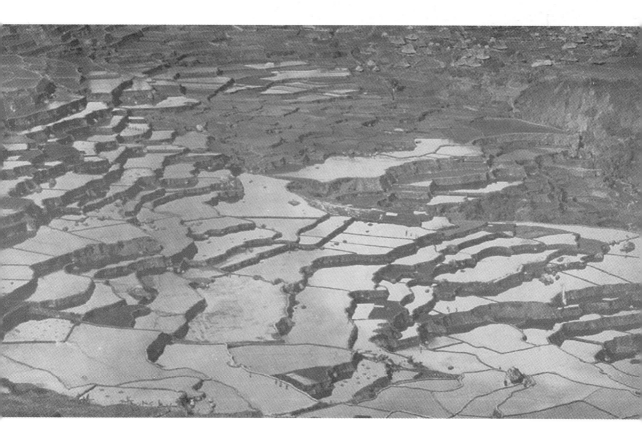

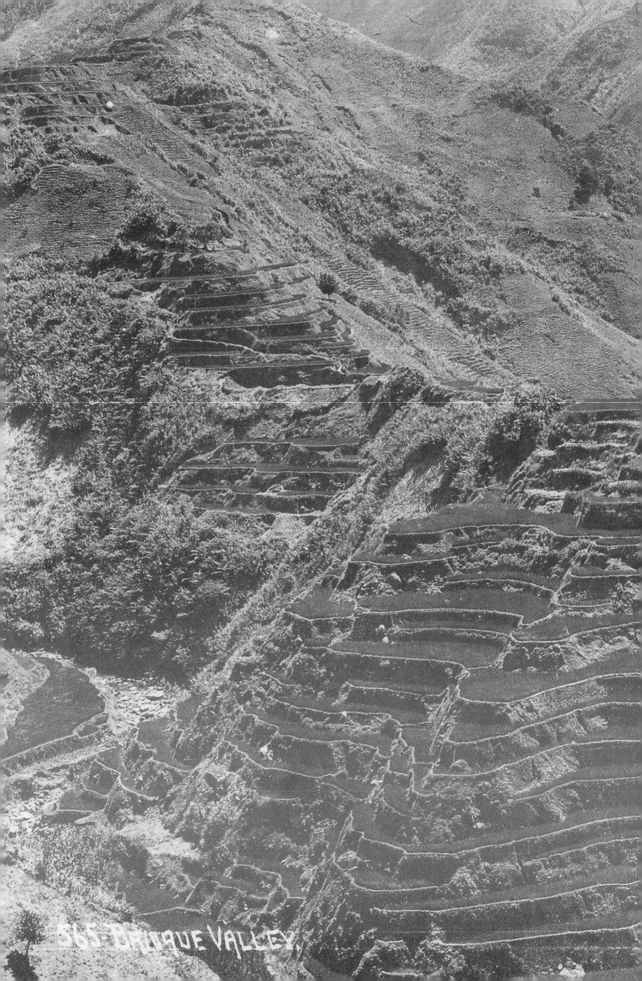

565 BANQUE VALLEY,

1.14 Rice Terraces of Baloque Valley in the Cordilleras (opposite)

1.15 Cross-sectional components of a typical rice terrace in Banaue

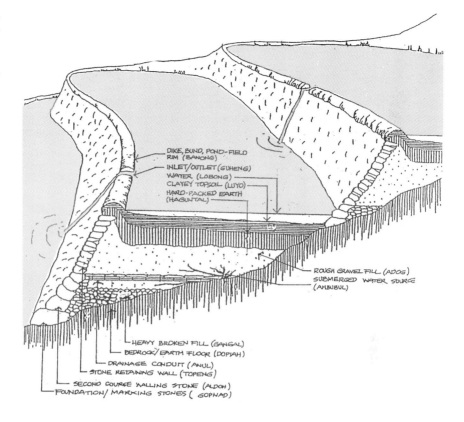

DIKE, BUND, POND-FIELD RIM (BANONG)
INLET/OUTLET (GUHENG)
WATER (LOBONG)
CLAYEY TOPSOIL (LUYO)
HARD-PACKED EARTH (HAGUNTAL)

ROUGH GRAVEL FILL (ADOG)
SUBMERGED WATER SOURCE (AHBUBUL)

HEAVY BROKEN FILL (GANGAL)
BEDROCK/EARTH FLOOR (DOPIAH)
DRAINAGE CONDUIT (ANUL)
STONE RETAINING WALL (TOPENG)
SECOND COURSE WALLING STONE (ALDOH)
FOUNDATION/MARKING STONES (GOPNAD)

Apayao, Kalinga, and areas of Abra. The walls reach up to a height of six meters, and in some cases sixteen meters, configured in a range of shape and gradient. Every terrace construction in the Cordillera Highlands contains three basic elements: the terrace base, the embankment, and the soil body.

Although the historical genesis and age of the terraces are subject to debate, modern dating tends to support archeologist Henry O. Beyer's contention that the terraces had existed at least by 1000 BC. From 1964 to 1967, Robert Mahler, chairman of the Department of Anthropology, West Michigan University, collected charcoal specimens of rice chaff from a house terrace in Banaue, which revealed the date 2950 BP or roughly 1000 BC. The findings readily refuted the Keesing-Lambrecht theory. But Mahler made it clear that "there was no age determination of the rice-terrace site itself" and that the age of the house terrace cannot be held coincident with that of the field terrace sites.

The stone walls, canals, dams, and reservoirs of the Cordillera can also be considered as types of megalithic architecture, or, at least, of stone engineering. The amount of stones used by the Ifugao in their hydraulic engineering works is estimated to far exceed in bulk those used in building the Pyramids or the Great Wall of China. Many of these walls and canals are thousands of years old and have withstood countless typhoons and the effects of sun, wind, and time.

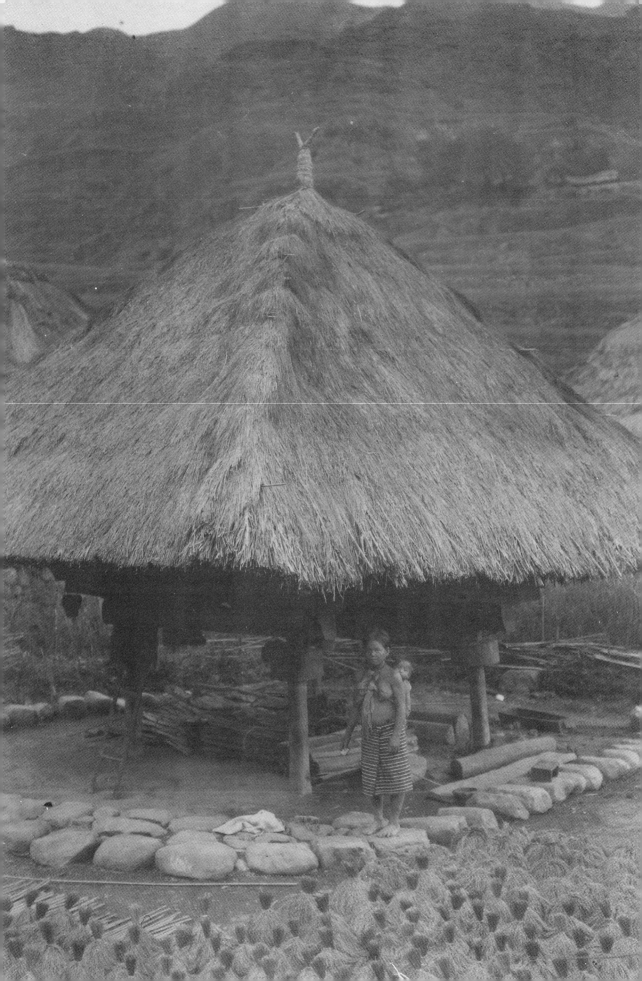

Philippine Vernacular Architecture
and its Austronesian Ancestry

Defining the Vernacular

Vernacular architecture is a term now broadly applied to denote indigenous, folk, tribal, ethnic, or traditional architecture found among the different ethnolinguistic communities in the Philippines. Majority of vernacular built forms are dwellings, whether permanent or makeshift, constructed by their owners or by communities, which assemble the building resources, or by local specialized builders or craftsmen. Granaries, fortifications, places of worship, ephemeral and demountable structures, and contemporary urban shanties belong to the vernacular lineage.

The pervasive phrase "primitive architecture" in the 1980s has unwittingly disseminated a pejorative implication emphasizing the dualistic distinction between "primal" and "cultivated," "barbarism" and "civilization," and "nonwestern" and "western." Similarly, the category "indigenous architecture," used by other writers seemed to bracket off the nonformal architecture introduced and built by immigrant and colonialist population in order to privilege those building forms constructed by the indigenes. The category "anonymous architecture" reflects the bias towards buildings designed by named and canonic architects, while "folk architecture" is tinged with issues of class differentiation. The same privileging is offered by "ethnic architecture," a term that reflects an exoticization of the residual ethnolinguistic Other by the dominant cosmopolitan culture.

Vernacular, from the Latin "vernaculus," means native. Vernacular architecture refers to the grammar, syntax, and diction in expressing buildings in a locale, while signifying the diverse range of building traditions in a region.

There are five principal features of vernacular architecture. These are: (1) the builders, whether artisans or those planning to live in the buildings, are nonprofessional architects or engineers; (2) there is consonant adaptation, using natural materials, to the geographical environment; (3) the actual process of construction involves intuitive thinking, done without the use of blueprints, and is open to later modifications; (4) there is balance between social/economic functionality and aesthetic features; and, (5) architectural patterns and styles are subject to a protracted evolution of traditional styles specific to an ethnic domain.

2.1 An Ifugao *fale*

A section in the book *Balai Vernacular* (1992), entitled "The Ethnic Balai: Living in Harmony with Nature" by Ma. Corazon A. Hila, refers to the vernacular *balai* as the "pure, Southeast Asian type of domestic architecture found in the non-Hispanized, non-Anglo-Saxon communities around the country" (Hila 1992, 13). From this definition, the balai is viewed as the origin of Philippine traditional architecture. Its Austronesian ancestry is manifested in its archetypal tropical characteristics: an elevated living floor, buoyant rectangular volume, raised pile foundation, and voluminous thatched roof. The house lifts its inhabitants to expose them to the breeze, away from the moist earth with its insects and reptiles. Its large roof provides maximum shade for the elevated living platform and the high ridge permits warm air in the interior to rise above the inhabitants then vent to the roof's upturned ends. The roof's high and steep profile provides the highest protection against heavy monsoon downpours.

All forms of vernacular architecture are built to meet specific needs, primary of which is the accommodation of values, economies, and ways of living of the culture that produced them. The construction of vernacular buildings also demonstrates the achievements and limitations of early technology. Related to their environmental context, they are handcrafted by the owner or by members of the community, requiring no assistance from design professionals, such as architects and engineers, utilizing technologies learned only through tradition. Indubitably, this tradition, dictating the overall form and tessellation of structural components, has been perfected through an evolutionary process involving trial and error. Once the dwellings are built, minor adjustments to compensate for the changing environmental conditions can easily be made. Modifications to their form or materials can effectively be executed as long as the changing social requirements or seasonal climatic variation of their respective regional settings are not too great or sudden. Beyond the basic requirements of shelter, they stand as paradigms of man-made order constructed in response to a tangible and immediate world of nature.

2.2 and 2.3 A lowland famer's hut, the *bahay kubo*

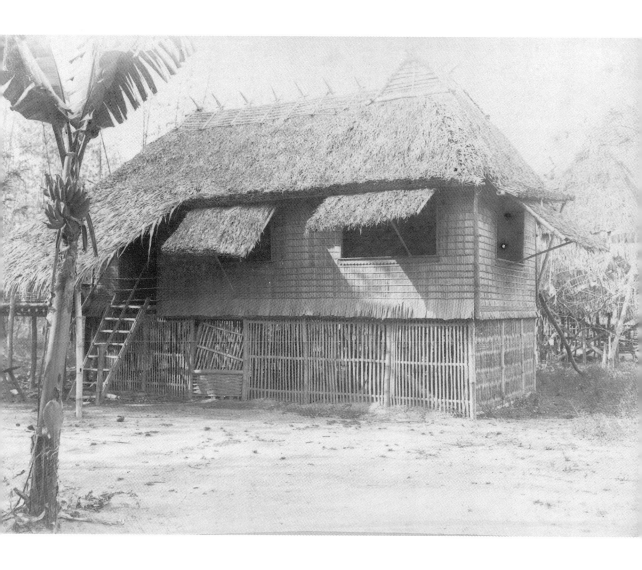

It is interesting to mention that the structural logic and architectonic paradigm of Philippine vernacular architecture inspired the invention of a new structural system which made possible the soaring skyscrapers of Chicago in the last decade of the nineteenth century. Yet this fact was never even mentioned in the annals of modern architecture as modernism denies historicity in its search for new architectural forms. The inventor of the new structural technique, William Le Baron Jenny, a prominent figure in the Chicago school, formulated and developed the steel-frame skyscraper from a building tradition originating from a Philippine source—the wooden framed construction of the *bahay kubo*. According to a written account, Jenny was so "impressed by the possibilities of framed construction when he spent three months in Manila, in the Philippines, following a voyage on one of his father's whaling ships"(Condit 1964, 81). Snatching the structural principle he singled out from the vernacular source, he then appropriated and transcoded the tectonic principle in steel and iron to replace timber and bamboo. The invention made possible the first all-steel skeleton framed skyscraper in the world, which was first applied to the Home Insurance Building (1884), the first tall building in America to use steel.

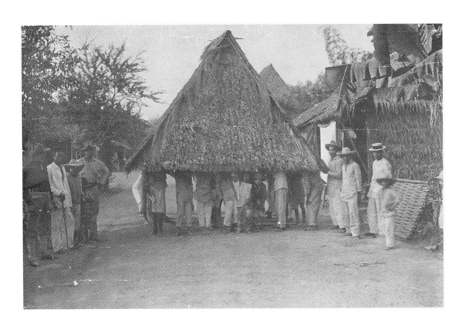

2.4 Moving the bahay kubo's thatch roof through communal cooperation called *bayanihan*

The building technology developed by the vernacular tradition is sustained through independent evolution and the accumulation of local wisdom. Vernacular architecture embodies the communal, symbolizes the cultural, and concretizes the abstract. As a product of a material culture, the balai is where the values and beliefs of its builders and users culminate.

All buildings exist in an environmental context, which is conditioned by the ability of the land to sustain a given populace. Inevitably, the economy of the culture affects the choice of the site for a vernacular structure. All vernacular dwellings make use of readily available materials and those obtained locally from the natural resource of the region. Climate and the local environment (together with its macro and microclimate) conjure an environmentally sound and responsive structure. By addressing the imperatives of nature, vernacular architecture shows great resilience against physical constraints. In other words, vernacular architecture can address the most common of structural problems with its simplicity and logical arrangement of elements.

Communities still employ vernacular building methods even today. Mass urban migration to the city has led to the crafting of informal urban dwellings, or the act of "squatting" on other people's lands, which in turn allows a different form of vernacular building practice to proliferate in a metropolitan context. As the vernacular domicile draws its materials from its immediate site, teeming with botanic resources, so does the urban shanty, drawing from an environment brimming with recyclable garbage materials, surplus, and salvaged building materials. Here, the urban environment provides the squatters with materials that require their improvisation skills to cunningly transform and reuse cheap, discarded building materials into a domestic space in the shortest possible time. An omnipresent building practice in the country, the vernacular tradition in architecture remains an accessible architectural idiom to the majority of Filipinos.

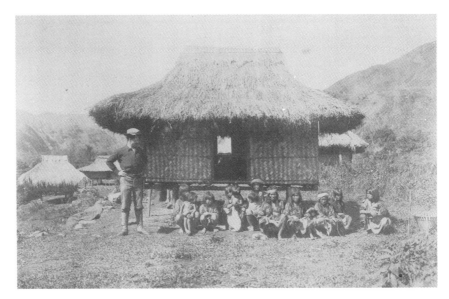

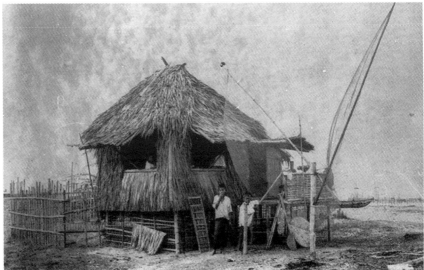

The range of construction forms, array of methods and materials, multiplicity of uses, layers of meaning, and complexity of the cultural milieu of vernacular architecture is indeed diverse. To seek a singular definition and appoint rigid stylistic essentials of vernacular architecture is, perhaps, imprudent and futile, for the project traps the richness of Philippine architectural traditions in constricting vessels of national identity.

Austronesian Building Heritage and the Aquatic Cultural Network of Asia-Pacific

Notwithstanding regional variations in form, style, and construction technologies, a shared architectural theme and common design principle can be discerned in vernacular architecture in the Philippines. These correspondences can be traced to the ancient Austronesian building tradition, which can be found throughout most of the islands in Southeast Asia and the shorelines of Asia Pacific.

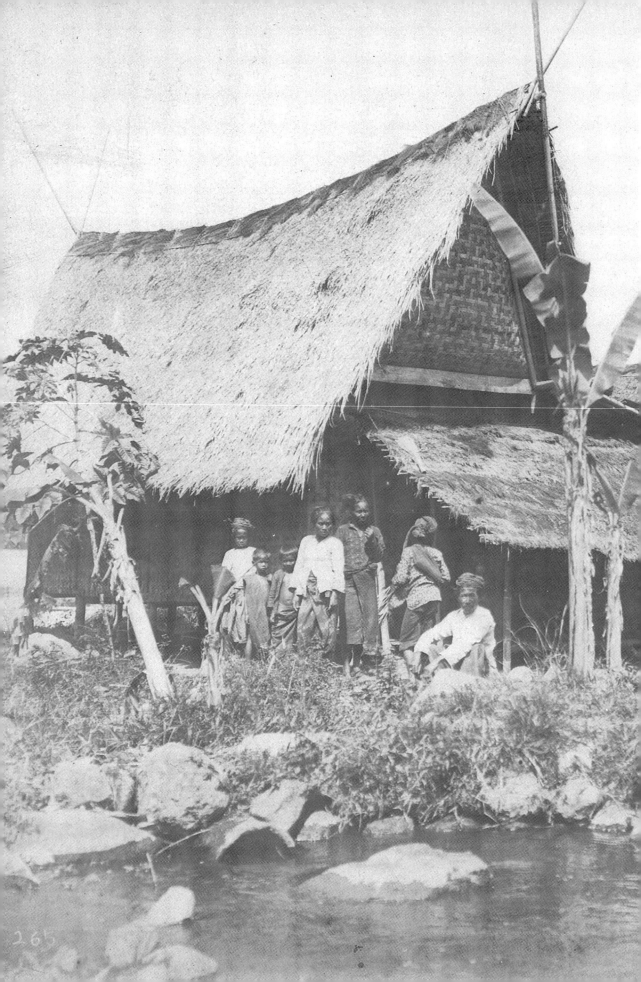

The archetypal Austronesian house consists of pile construction on stilts, a raised living floor, and a pitch roof with extended ridges. Variants on these general architectural themes occur throughout the archipelago, attesting to the gradual diffusion of this ancient architectural tradition from a common point of cultural origin.

These common architectural features evolved as a result of the monsoonal and aquatic-based way of life since settlement patterns have a direct connection to bodies of water. Communities were usually situated along sheltered bays, coastal areas, and mouths of rivers. Interior settlements were established at the headwaters and banks of rivers and their tributaries. In the Philippines, this type of settlement can be found in Cebu, Leyte, Bohol, Panay, Cagayan, Agusan, Lanao, Manila, and others. The bodies of water provided food, such as fish, shrimp, and shellfish, which were easily harvested around the communities. Transportation on and along the rivers and streams was also practical. Much more, rice cultures in these places where wetlands prevailed also conditioned the house types to be raised on stilts.

The term Austronesian refers to a family of languages, believed to have originated in Taiwan some 6,000 years ago, numbering some 1,000 to 1,200 languages spoken in the vast geographical area between Madagascar, Taiwan, Hawaii, Easter Island, and New Zealand. Although many peoples constitute this widely scattered language group, their common cultural background can still be perceived. In addition to linguistic affiliation, distinctive attributes, defined by a world-view linked to an aquatic-based view of life, and translated into architectural terms, are found throughout the Austronesian region.

2.7 and **2.8** Variations of a coastal Tausug house. Both feature a slightly saddle-back roof outline and a plain cross-gable finial.

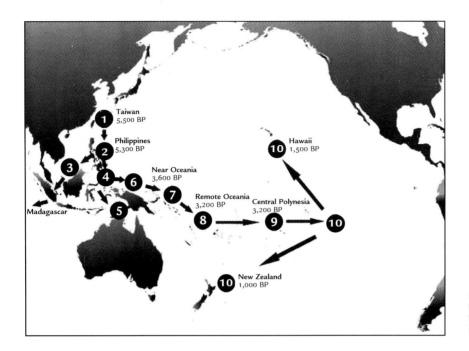

2.9 Paths of Austronesian transoceanic migration redrawn from Gray, R. D., & Jordan F.M. (2000)

The Great Austronesian Expansion

The great migration of Austronesian peoples from riverine areas of southern China commenced some 6,000 years ago and culminated in the eventual dispersal of Austronesian speakers half way around the globe by about 500 AD. This movement can be reconstructed chronologically from archaeological and linguistic sources. These sources suggest that Taiwan was settled around 4000 BC. From Taiwan the Austronesians seem to have spread south into the Philippines via Batanes about 3000 BC and Borneo, Sulawesi, and eastern Indonesia a thousand years later. The colonization of Oceania to the east did not begin until after 2000 BC and the Malay Peninsula and Vietnam were colonized by the Austronesians sometime after 1000 BC. Madagascar was not reached until about 400 AD. At roughly the same time New Zealand was colonized by other Austronesian-speaking peoples traveling from Tahiti.

The Austronesian expansion required a sophisticated system of open sea navigation, which differed greatly from sailing along the coastline or to visible landmarks. Not only were sturdy oceanic vessels needed, but a system of orientation, dead reckoning, position-fixing, and detection of landfall and weather prediction had been developed.

Buckminster Fuller (1981), developer of "Synergism" and theorist on the development of technology, believed that a combination of population pressures and the submergence of the Southeast Asian landmass caused the rise of nautical and other technologies in Austronesia. He gave examples of the circular weaves used in Southeast Asia and the Pacific, comparing them to the unstable grid pattern weaves used in most of the rest of the world, as examples of how the need to build stable blue-water ship designs indirectly influence other areas of life. Thai architect Sumet Jumsai (1988), extending Fuller's work, compared Southeast

Asian architectural designs with ship architecture, showing the same relationship of concept.

The logistics of aquatic living was developed as a result of water-borne migration, leading to the conception of a set of symbols, rituals, nautical technology, and architectural and urban models which are specific to the region.

Historical linguistics, as much as archaeology, provides crucial evidence in the search for the origins of Austronesians and their architecture. Tentative reconstructions of Proto-Malayo-Polynesian include terms for the house post and notched ladder, pointing to the ancient origins of this construction technique. A range of similarities exists in Austronesian cultural tradition which draws attention to terms that are associated with the house. These similarities may be ascribed to cultural borrowings, especially among neighboring populations.

Linguist Robert Blust (1987), has extensively studied the Austronesian house and the principal elements of its design to map out the Austronesian cultural history. He collated a list of principal terms that denote or relate to the "house" among the different linguistic subgroups of Austronesians and subjected these terms to detailed scrutiny. The lexically reconstructed forms of these various house terms are: (1) *rumaq*; (2) *balay*; (3) *lepaw*; (4) *kamalir*; and (5) *banua*.

The term "rumaq" is the most widely distributed term for "house," which is included in the Iban, Gerai, and Minangkabau (*rumah*) and Rotinese (*uma*) vocabulary. The similar form is used to designate the Badjao stilt house (*luma*) that is located in the waters of the sea near the shoreline and elevated from the water by a number of major and minor posts, poles, and stilts.

"Balay" takes a variety of form in the Malayo-Polynesian and Oceanic languages. In the Philippines, reflexes of this term (Isneg, baláy; Cebuano, baláy) refer to a "house," while in Malay languages, the term balai signifies a "public meeting house." In the Pacific, the reflexes of balay denote the same meaning as they do in the Philippines (Fijian, *vale*; Samoan, *fale*; Hawaiian, *hale*).

The third term, "lepaw," also refers to a house but assumes a variety of meanings: a "storehouse for grain" (Ngaju, *lepau*); a "hut other than the longhouse" (Uma Juman, *lêpo*); and a "back verandah or kitchen verandah of a Malay house, booth, or shop" (Malay, lepau). In the Philippines, the Badjao word *lepa* denotes a "long, slow-moving houseboat with no outrigger"; the structure of which is loose and detachable, with long poles attached in all directions as a framework over which a nipa roof may be unrolled.

The house term "kamalir" is adapted in the Philippines as *kamalig* or *kamarin* that generally refers to a "granary, storehouse, or barn," whereas in Oceanic language, it denotes a special "men's house."

Finally, the term "banua" occurs in the Malayo-Polynesian vocabulary in reference to the "house" (Toraja, banua; Banggai, *bonua*; Wolio, banua; Molima, *vanua*; Wosi-Mana, *wanua*). Far more often, reflexes of banua denote a territorial domain, such as "land, country, place, settlement, inhabited territory, village."

Naga, an Austronesian Water Symbol

The *naga*, Sanskrit for serpent, represents the cosmological model's waveform as well as the universality of water in the daily life of Southeast Asia. The said creature is aquatic in character, but also appears in hybrids. The Thai *sang* is a cross between a snake and a lion, and the Chinese and Japanese dragon is a flying amphibian. However, the basic forms are primarily wave-like in nature, as seen in architectural ornamentation and building motifs where the naga is best exhibited in its water element.

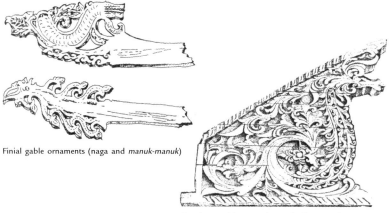

Finial gable ornaments (naga and *manuk-manuk*)

Panolong, a Maranao decorative beam end

In the Pacific region, the serpentine coil has been used in house carving and in boat motifs since prehistoric times. In these cultural representations, the coils turn in both directions reminding one of the Coriolis effect whereby winds and ocean currents tend to whirl clockwise and counter-clockwise north and south of the Equator, respectively (Jumsai1988, 20). This phenomenon stimulated on the Asian waterfronts a host of interpretations in terms of urban planning and architecture and in almost every art form and ritual, both sacred and profane.

The naga motif predominates artifacts such as Islamic carvings in boats, musical instruments, grave markers, protruding beam ends, and design patterns found in woven textiles and wall ornaments produced by Maranao, Samal, Tausug, and other Philippine Islamic groups. The *magoyada* is a Maranao okir motif featuring the naga or serpent figure combined with other leaf or plant motifs.

Stilt Houses—An Austronesian Legacy

The architectural system that predominates the Austronesian region is that of a raised wooden structure typically consisting of a rectangular volume elevated on posts with a thatched roof and decorative gable-finials shaped like carabao horns. Buildings with pile or stilt foundations are a pervasive feature not only in mainland and island Southeast Asia but also in parts of Micronesia and Melanesia. The occurrence of this type of structure, along with other characteristically Austronesian features, in parts of Madagascar and in the ancient Japanese shrines at Ise and Izumo, bears witness to the far-flung influence of Austronesian seafarers.

Significantly, for many Austronesian peoples, the house is much more than simply a dwelling place. Rather, it is a symbolically ordered structure in which a number

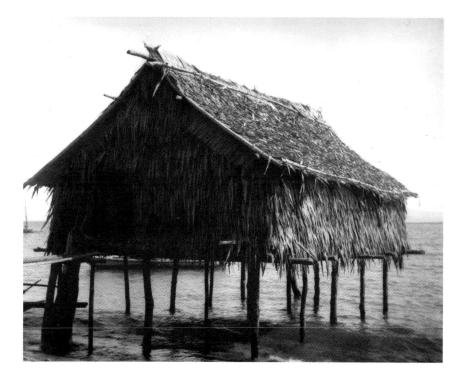

2.10 A Tausug dwelling whose rectangular living space is suspended by a pile foundation anchored to the seafloor

of key ideas and cultural concerns may be represented. Thus, the Austronesian house may variously be seen as a sacred representation of the ancestors, a physical embodiment of group identities, a cosmological model of the universe, and an expression of rank and social status.

This basic stilt architecture has undergone elaborate refinements in many parts of the Austronesian region and is immediately linked to a culture nourished by a tropical aquatic environment. Excluding the stylistic variation, houses on stilts can generally be found in the Western Pacific, in a region of more than 6,000 kilometers across the Equator from Melanesia and Indonesia to Japan.

Morphologically, the house is constructed using wooden structural components configured in the post-and-lintel framework, which supports a steeply pitched thatched roof. The dwelling is distinguished by a living floor raised on sturdy stilt foundations with a voluminous, well-ventilated roof cavity above, providing a straightforward solution to the environmental problems imposed by the humid tropical climate coupled with seasonal monsoon rains.

Until recently, these houses were constructed entirely of botanic building materials—timber, bamboo, thatch, and fibers—assembled without the use of nails. A quintessential method of construction is exemplified by vertical house posts and horizontal tie beams that provide a load bearing structure to which floors, walls and, a roof are later attached. The main framework is fabricated using sophisticated jointing techniques, while the walls, roof, and other non-load bearing elements are typically secured by wooden pegs and vegetative fiber lashing.

The Raised Pile Foundation

Building on piles is an almost universal, and undoubtedly ancient, feature of Philippine vernacular architecture, both among lowland communities and ethnic groups. Its history in mainland Southeast Asia can be traced back to Neolithic times, and its wide distribution in Southeast Asia and the Pacific islands suggests that the technique was used by the early Austronesian settlers of the archipelago.

The prototypical bahay kubo is usually built with wooden posts as its framework. The four posts of the Ifugao house, which is both granary and home, is distinctive for circular rat guards, while the Maranao torogan (sleeping place) stands on stout log posts resting on round stones. Houses built on the sea, like the Samal houses, are raised on slim posts or stilts.

Pile foundations have several advantages in a tropical climate, especially when settlement patterns are mainly concentrated in coastal, riverine, and lakeshore areas. Piles raise the living floor above the mud and flood waters, which occur during seasonal monsoon rains, while providing excellent under-floor ventilation in hot weather—warm air within the house rises and escapes through openings in the roof, drawing a current of cooler air from beneath the house through gaps in the floor. Furthermore, a small fire, lit under the house, drives away mosquitoes, while the smoke, as it escapes through the thatch, effectively fumigates the house. Housework is also quick and easy as dust and rubbish can be swept through these same gaps in the floor.

The underfloor space is often used as a pen for stabling domestic animals and as a place for storing utensils. It can also provide a shaded daytime work space for tasks such as weaving and basketry.

In many areas, house posts simply rest on top of foundation stones rather than driven into the ground. This ensures that the building has enough flexibility to survive earthquakes in this seismically active region. At the same time, should one wish to move house, the entire structure can literally be picked up and carried to a new site.

2.11 The Ifugao fale is elevated from the ground by a structural system of unprocessed tree trunks. The organic form of the trunk's base, including the large roots, is utilized for maximum spread and anchorage to the ground. From the ground the trunk tapers and is capped by wooden cylinders or disc-shaped rat guards called halipan. (opposite)

2.12 The bamboo box frame of a bahay kubo

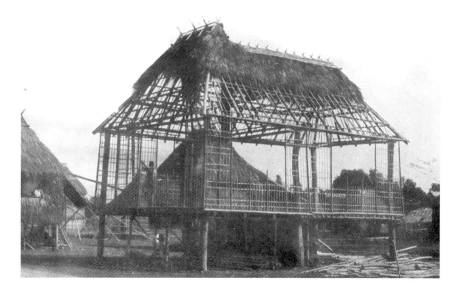

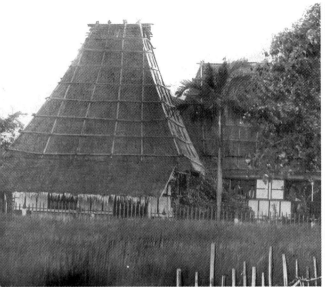 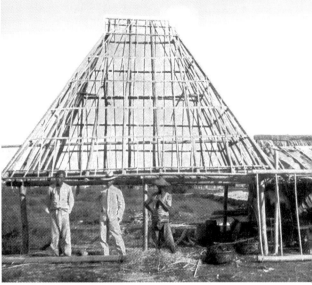

Piles built of hardwoods may endure for over a hundred years, while some palm trunks also make excellent, long-lasting piles. An easily available and replaceable pile material, bamboo is widely used for ordinary houses of temporary structures.

The Voluminous Thatch Roof

The most distinctive feature of the Austronesian vernacular architectural form is the extended line of the roof, often with outward sloping gables forming elegant saddleback curves. Although Philippine vernacular houses generally lack the graceful curve characteristic of saddleback roofs of the architecture of the Minangkabau in Sumatra or the noble houses at Lemo, Tana Toraja, Sulawesi, their hip roofs are closely related to the saddleback type. As in most of Southeast Asia, the roof is the dominant architectural feature of most dwellings. In some cases, the house is mostly a roof, as seen in the pyramidal roof of an Ifugao dwelling and an older bahay kubo where the roofs are pitched more steeply than its contemporary version.

Vernacular dwellings are thatched. Thatch is a generic name for any roof covering made of dead plant material other than wood. Grasses and palm leaves are the most widely used traditional materials. Despite its combustibility, thatch is watertight and may last for a hundred years if properly constructed. For thatch to be durable, it must be effectively laid out so that water runs off the entire surface consistently and quickly, allowing itself to dry out soon after a downpour.

Cross gable finials, which hold the rafters together at the ridge, are an ever-present feature of Southeast Asian roofs. The ornamented ones are made by crossed poles that meet at the apex of the roof, although the Tausug *sungan* roof is decorated at either end of the house by a horn or crescent-shaped *tadjuk pasung*, which is usually a stylized manuk-manuk (bird) or naga (dragon) design with swirling fern-like *ukkil* (carving).

2.13 In Southeast Asia, the roof is the dominant architectural feature of most dwellings. In some cases, the house is mostly a roof of thatch, pitched steeply to repel rain outside and allow the circulation of air within.

2.14 The bamboo roof framing of a bahay kubo before it is covered by layers of thatch

Traditional Materials and Construction Techniques

The vernacular architecture of the Philippines is characterized by its use of organic materials—wood, bamboo, palm leaves, grass thatch, and plant fibres—which are deployed in a variety of ingenious ways to provide protection against sun and rain.

Philippine vernacular architecture employs a post-and-beam method of construction, which is largely a matter of shaping and jointing wooden members with a range of specialized tools, which include axes, adzes, and chisels. The wooden framework is assembled without nails, using complex techniques of jointing. The roof rafters are typically supported by wall plates, with additional support often provided by a ridge piece and purlins—elements that variously transmit the load to other structural members. Walls and floors do not constitute a part of the main load-bearing elements but may brace the structure as a whole.

Pile structures, with posts buried in the ground, have been mostly superseded by stilt structures where the house posts rest on top of foundation stones. Stability is achieved by horizontal rails running through apertures cut into the posts. Often, the post-and-beam framework is loosely assembled on the ground before it is placed on the foundation stones. The joints are then secured by wedging or pegging. Full stability is achieved only when the floors and the walls are added.

Sometimes a box frame is used for the upper portion of a building. Sitting like a bird cage on top of the main posts, a box frame consists of vertical studs slotted into horizontal sills and held together at the top by wall plates. A variety of joints may be utilized, including mortise, tenon, lapped, and notched joints. The frame is usually first put together on the ground and then taken apart to be reassembled in place on top of the posts.

Box frames are often further stabilized by wooden panels fitted to the main framework using tongue-and-groove or mortise-and-tenon joints. The walls of vernacular structures are made of light windscreens, which provide protection from the elements and secure privacy for the residents. The said walls may consist of matting, palm leaves folded round a lath and stitched together with a strip of

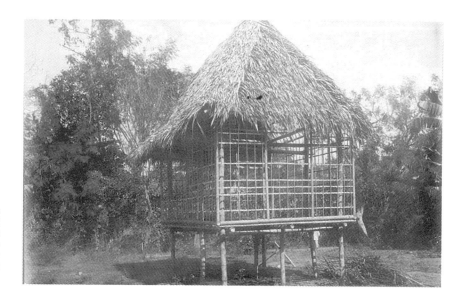

2.15 The wall sidings of the bahay kubo are fabricated independently from the stucture, usually woven from plaited or flattened bamboo or folded plam leaves, and stitched round a lath.

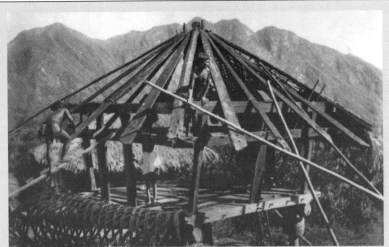

The building of an Ifugao house utilizes sophisticated methods of jointing without the use of nails

Structures without Nails

Indigenous Philippine houses are held entirely together without nails, relying instead on a variety of jointing techniques, which are sometimes reinforced by pegging, wedging, or binding. Not surprisingly, similar construction methods are employed in local boat building traditions, a proof of the Austronesian (seafaring) ancestry of vernacular architecture. In the case of foundation posts, these may either be buried in the ground or else placed on top of flat stones. The space under the house may then be used as a stall for fowl or pigs, though this is no longer common today.

Most of Philippine vernacular-built forms represent variations of a post-and-beam construction technique where walls (if they exist at all; interior partions) are seldom load-bearing and, proportionally, the roof dominates.

rattan, flattened or plaited bamboo panels as well as wooden boards and panels, depending on the use and status of the building. These nonstructural walls are sometimes fixed in an outward sloping position, a familiar feature of traditional Ifugao architecture.

The House as a Ritually Ordered Space

The construction of a house necessitates the performance of symbolic rituals in some areas because the house is considered a physical and spiritual body, not just an assemblage of building materials in a chosen site. The ritual commences with the selection of building materials and the season during which they are cut. A bloodletting ritual or *padugo* is performed, wherein the blood of a sacrificial white chicken is wiped on the tree to be cut to appease spirits believed to be residing in the forest.

The construction of the Tausug house recreates the creation of the human according to their genesis myth. The task entails erecting nine posts, the sequence representing the order of how the human body was supposedly created: the first/center post signifies the navel; the second/southeast post, the hip; the third/

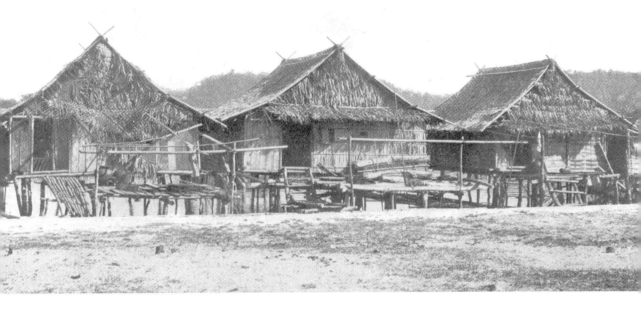

2.16 Tausug houses lined the coastal areas of the Sulu archipelago in Mindanao.

northwest post, the shoulder; the fourth/southwest post, the second hip; the fifth/northwest post, the second shoulder; the sixth/west and the seventh/east posts, the ribs; the eighth/north post, the neck; and the ninth/south post, the groin.

According to Panay house-building beliefs, a mythical dragon, the *bakunawa*, signifies the forces of evil. The erection of the post is sequenced to systematically slay the cosmic serpent. The dragon's head and body can be located according to positions prescribed in a local almanac. In January, February, and March, the dragon faces north with its tail pointing south. Toward the second quarter, its head is positioned toward the west, with its tail pointing east. From July to September, the dragon faces south with its tail pointing north. Finally, during the last quarter of the year, its head is positioned in the east with its tail pointing west.

Armed with this information, the Panay housebuilder must kill the dragon by driving the first post into the ground in the position of the dragon's head. The next two posts beat the dragon to death, while the fourth post, driven diagonally across from the first, pierces its tail. In destroying the bakunawa, the builder ensures that the dwelling shall be safe and its inhabitants protected from harm.

The house entrance and the kitchen face the rising sun; coins are embedded into the base of house posts to invite prosperity. Water is brought into the house to soothe hot tempers, and a comb to straighten out disagreements. When the house is finished, the family enters first, bearing offerings of salt, a lantern with sufficient fuel to burn for three days, unhusked rice, and the image of a saint. Salt is believed to ward off evil, light to cast away darkness, the unhusked rice to invite abundance, and the holy image to invoke divine guidance and protection. The ritual of purification exorcises malevolent forces and prepares the house to take its place in society, transforming it into a sanctified dwelling place.

2.17 Map of the Philippine
archipelago and the geographic
distribution of ethnolinguistic
groups

Ivatan

Isneg

South

China

Sea

Kalinga
Bontoc Sagada
Kankanay Ifugao
Luzon

Pacific Ocean

Aeta

Tagalog
• Manila

Mindoro

Samar

Panay Visayan

Leyte

Palawan

• Cebu

Tau't Bato

Negros

Samal

PHILIPPINES

Sulu Sea

Maranao *Mindanao*

Davao
•
Maguindanao

Badjao

Yakan Tausug

Badjao
Samal

Samal

Tausug

Celebes Sea

Regional House Types

Having probed the Austronesian heritage of Philippine architecture as a stilt habitation with buoyant volumetric properties, we now survey specific examples of Philippine vernacular house types through a regional appraisal. The inventory shall take into account the modes of construction, the forms and materials, associated building beliefs, and various site contexts which affect the production of architectural forms in order to point out regional differences and the degree of fidelity to the Austronesian architectural archetype.

Upland and lowland houses have acquired distinct architectural features because of the difference in environmental conditions and site contexts. For instance, lowland dwellings tend to have a more open, airy interior, while highland types are tightly sealed off with solid planks, having few or no windows as a defense against the cold upland climate.

2.18 The Ivatan stone houses may be classified according to roof configuration: the *maytuab* (hip roof) and *sinadumparan* (gable roof).

Monsoon Frontiers: Ivatan Houses

The Ivatan resides in four of the ten islands of Batanes situated off the northern tip of Luzon. The aboriginal Ivatan lived in low houses of wood, bamboo, and thatch which stood in rows on the steep terrain of mountain and hill slopes, forming hamlet settlements. As described by the English traveler William Dampier in 1687, the early Ivatan houses were built small and low, their sides made of small posts not more than 1.4 meters high. These houses had ridgepoles, which were about 2.1 or 2.4 meters long. A fireplace was built at one end of the house. The occupants had simple wooden boards placed on the ground to lie on.

The houses were built close together in small villages located on the slopes or peaks of hills. They appeared to be stacked one on top of the other since they occupied varying levels of steep rock faces. There were wooden ladders reaching from the lowest to the highest level, which was the only way the occupants could get to their houses on the upper slopes or peaks of hills.

The huts were low, partly because high structures would have been easily toppled by very strong winds with nine months of rain and a constant onslaught of cyclones and partly because Batanes did not possess enough timber resources nor appropriate tools for larger construction. Cogon grass (*Imperata cylindrica*) was the main roofing material. To close the sides of the hut, cogon and sticks were used. Occasionally, the walls were made of stones held together by *fango*, a kind of mortar formed by mixing mud with bits and pieces of cogon.

The more familiar Ivatan traditional house of stone and mortar (known as *cal y canto*) made their first appearance in the late eighteenth or early nineteenth century when the Spanish government and the missions were founded, and public architecture like churches and *tribunales* (town halls), fortifications, and bridges necessitated a much sturdier material. Lime was used as a building material when the Spanish authorities brought in stonecutters and masons from Luzon. Through the guidance of missionaries and Spanish officials, these artisans taught the native

2.19 A *maytuab* Ivatan stone house. The Ivatan house is designed not only to withstand the battering of the most severe of storms, but also built to withstand intense earthquakes. Wooden reinforcements are embedded inside the walls, running all the way to the eaves, where they are joined to the beams and frames of the roof.

population to supplant the traditional and weak stone-and-mud or cogon-and-sticks walls with thick stone-and-lime, which provided superior defense against frequent cyclones. The natives adopted and made these methods and skills their own, developing a hybrid architecture typified by an austere, white, box-like stone-and-lime edifice covered with a thatch roof having a four-sided slope to the ridge.

With the knowledge of processing lime for building, the Ivatan was able to construct a main house, known as the *rakuh*, whose 4 x 8 meter-space can be used as a living and sleeping area. The structure has higher and thicker walls now made of mixed material. Wooden post-and-lintel frameworks are implanted in the walls. The 1–1.2 meter-thick cogon thatch, *vuchid*, precipitously slopes down and is heavily fastened onto a ceiling with many layers of small, polished reeds and rattan to support the rafters and beam. The structure is much more open than before because of the inclusion of long windows and two taller doors. The fourth windowless wall confronts the direction of the strongest typhoon winds as the house is oriented north-south. As further protection against these violent winds and strong rains, a big roof net called *panpet,* made of strong ropes fastened securely to the ground via strong pegs or large stone anchors, is thrown over the entire roof during typhoons.

The Ivatan house is designed and built not only to withstand the battering of the most severe of storms, sea sprays, gusts, and rains but also to withstand high-intensity earthquakes. This is why wooden reinforcements are embedded inside the walls, running all the way to the eaves, where they are joined to the beams and frames of the roof.

Galvanized iron was introduced in the 1890s. The use of such material eliminated the need to gather tons upon tons of cogon to roof the structure. However, galvanized iron was extremely vulnerable to stormy weather unless coated thickly with paint and the large amount of sea spray could only rust the sheets.

The first concrete buildings were constructed in 1910-1920. In the succeeding decades, steel reinforcements were used. However, since these new materials, usually shipped from the neighboring island of Luzon, were costly and scarce, the production of native lime in kilns continued, and the Ivatan chose cogon over the rust-prone galvanized iron sheets. The use of cogon minimized the use of nails in the woodwork because the latter proved to be less durable because of eventual corrosion.

Cordillera Houses

William Henry Scott (1966) classified houses in the mountain ranges of the Cordilleras in Luzon into the northern strain and the southern strain. According to Scott, the northern strain consists of houses made by the Isneg and Kalinga. The southern strain, on the other hand, are those constructed by the Ifugao, Bontoc, Ibaloi, and Kankanay.

The northern strain is characterized by houses with a rectangular plan covered by a high gable roof. The roof framing is independent of the floor framework so that the floor and all of its legs can be removed, leaving the roof still upright, or vice versa. An example is the Isneg house, with its floor and roof supported by completely different sets of posts. The squarish house elongates into a rectangle with a roof that is bowed into the shape of a Gothic arch or a boat turned upside down. The Kalinga construct octagonal houses having three divided floorings, the center being the lowest.

The houses of the southern strain have square plans with either a pyramidal or conical roof resting on top of the walls of the house. The house is a box supported by posts, reaching no higher than the floor joists. An example is the windowless Ifugao house, with its low walls and roofs, which keep the inhabitants warm. The floors are, however, raised 0.9 m above the ground.

Although houses in the Cordilleras vary in size and shape, they all have common functions. Primary is the provision of shelter from the cold. Houses also give enough protection from dampness and humidity, which may destroy the grains stored inside the house or *alang* (granary). The structures must also offer defense against hostile tribesmen, wild animals, and vermin. To avoid landslides, these homes must be designed in relation to the terrain of the mountains.

Isneg

Inhabiting the wide mountains of Apayao at the northern tip of the Cordillera ranges, the Isnegs build their houses in close proximity to one another, forming a hamlet or clusters of hamlet mainly for protection. A hamlet consists of four to

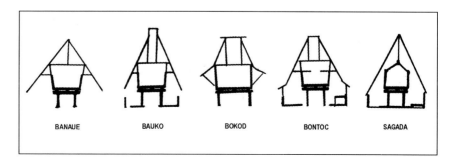

2.20 William Henry Scott's classification of Cordillera houses and their typical cross-sections and representative silhouettes

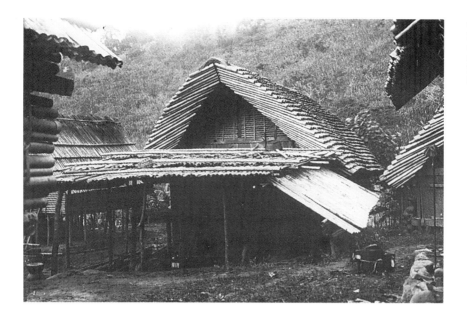

2.21 The Isneg binuron is a one-room abode with a large concave-shaped roof made up of heavy layers of bamboo formed to resemble an inverted boat.

eight houses, granaries, and an enclosing bamboo fence where residents cultivate coconut, betel nut, and other crops in a grove or orchard covered with weeds and bushes.

The Isneg house distinguishes itself from the typical Cordillera house by its boat-like appearance. The Isneg one-room abode, the *binuron,* with its large concave-shaped roof resembles an inverted traditional Isneg boat. The adoption of boat architecture to the design of the house may be attributed to the fact that Apayao is the only region in the Cordillera with a navigable river, and among the mountain people of the north, only the Isnegs possess a boat-building tradition. The boat, known as *barana'y* or *bank'l,* is made up of three planks: a bottom plank, which gets thinner at both ends, and two planks on both sides, carved and shaped to fit alongside the bottom plank.

Regarded as the largest and among the most substantially constructed houses in the Cordilleras, the typical Isneg binuron stands 4.6 x 7.9 meters, rectangular in form, with several post systems and a prominent Gothic-like roof that assumes the silhouette of an upturned boat. Fifteen wooden piles carry different parts of the house: eight support the 1.2–1.5–meter elevated floor; six support the roof frame; and a slim one supports one end of the 6.4 meter ridge-pole.

The walls of the binuron slant and taper downward. It has a gable roof, unlike most Cordillera dwellings, which have pyramidal or conical roofs. A *tarakip,* an extension structure, is built at one end of the house. It is as wide as the house itself, with a slightly higher floor, but a lower roof. Some houses feature a tarakip at both ends. The Isnegs use wood for the posts, girders, joists, and walls, and thatch or bamboo for the roof.

Interesting is the way the Isneg roof is constructed. Lengths of bamboo tubes are split in two, and these are laid in an alternating face-down-face-up arrangement, their sides interlocking together. Several rows are laid on top of one another like shingles, forming a continuous wave-like link that effectively keeps out rainwater.

Sometimes, a layer of thatch is laid on top of this bamboo arrangement for added protection. Scott classifies the Isneg binuron as an example of the northern style of Cordillera architecture, because it is gabled, elevated, and elongated. Its floor and roof are entirely supported by two completely independent sets of posts. The floor itself has slightly raised platforms along the sides (Scott 1966, 187). This is the opposite of the southern house, the roof of which rests on the walls of the square cage constituting the house proper that is supported by posts higher than the floor joists.

Although the Isneg house may seem small, there is ample space inside because it has no ceiling. One looks up to see the interior of the bamboo roof. Because the walls slant towards the roof, the space inside expands. A practical feature of the binuron is its roll-up floor made from long reeds strung or woven together. These are laid on top of a floor frame made up of lateral and longitudinal supports. Once in a while, the reed floor is rolled up for washing in the nearby river. The walls of the house are but planks fitted together, all of which can be removed, so that the binuron can be converted into a platform (or stage) with a roof, to be used for rituals, ceremonies, and meetings. Windows are not structured frames cut out of the walls, but are part of the walls themselves. A number of wall planks are removed to provide the needed openings.

Another important architectural work in Isneg society is the rice granary. Building big granaries remains a salient part of Isneg material culture. The granary shelters not only the annual harvest of grains, but is also believed to house the benign spirits invoked to guard the treasure of food they contain. These granaries are provided adequate protection, mainly with rat guards, which are found on the upper part of posts, and may be disc-shaped or rounded-plate, knob- or potshaped, or cylindrical.

Kalinga

The Kalinga settlements are situated along the Chico river in the north central region of northern Luzon. These communities are strategically located on steep mountain slopes where villagers can easily be alerted against interlopers.

There are three kinds of settlements: one with three to four houses, a hamlet of twenty or more, and villages of fifty. In the early decades of the twentieth century, there were arboreal shelters built twelve to sixteen meters above the ground. These tree houses have long vanished since the demise of the headhunting practice and the establishment of peace agreements among warring tribes.

Despite the fact that present-day houses have been influenced by nearby lowland communities—that is, the house being made of concrete, galvanized iron, and lumber—two types of traditional Kalinga houses remain extant: one is the famed octagonal house (*binayon* or *finaryon*), which assumes a curvilinear form rather than polygonal at first glance; the other is the square-shaped Kalinga house known as *foruy* in Bangad, *buloy* in Mabaca, *fuloy* in Bugnay, *phoyoy* in Balbalasang, or *biloy* in Lubuagan.

Wealthy families in the past lived in octagonally shaped houses. At the core of the eight-sided house, a four-post-, two-girder- and three-floor-joist system forms the foundation of the house supporting the 1.2 meter-high central floor, which in turn

is flanked by raised floors on either side. This is made possible by two beams resting on the end of the floor joist. The side floors reach to the outer walls, which have eight sides.

William Henry Scott (1966) provides a lengthy description of the octagonal house of the Kalinga in Bongod:

> the three floor joists, two girders, and four posts, which form the foundation of the house are called *fat-ang*, *oling*, and *tuod*, respectively, and riding on top of the joists are two beams or stringers that run from front to back called *anisil* or *fuchis*. Just beyond each end of these stringers, but not mortised into them, is another post set in the ground, and at equivalent distance from the center of the house four more off to each side of the central four, giving a total of eight for the support of the wall. Across the tops of these outer (and lighter posts), and connecting them, are eight short sills (*pisipis*) grooved to receive the wall-boards (*okong*), the front and back ones being parallel, the two side ones being parallel, and the four-corner ones joining them at 45degree angle—producing that eight-sided plan for which the house is famous. The logs outside below the level of the floor are backed up against a sawali matting (*dingding*), which encloses the area beneath the house.
>
> The reed-mat floor (*tatagon*) is laid down in the center section on laths (*chosar*) set into the top of the three joists parallel to the stringers, and in the two side sections on laths, which run transversely from the outer edges of the stringers to the inner edges of the sills. Mortised into the upper faces of the stringers are four sturdy posts (*paratok*), two of which carry a crossbeam (*fatangan*), which, in turn, carries two light queenposts (*ta'ray*) supporting four crossbeams or purlins (*ati-atig*) in the form of a square. The rafters (*pongo*), fastened below the upper pisipis-beam of the outside wall, are bowed over these purlins and drawn together over three small ridgepoles, which carry little actual weight but form the ridging (*panabfongan*). Despite the central square foundations and the octagonal floor plan, however, the roof with its ridgepole presents a different profile from the side ... the bowed pongo rafters are not duplicated on the front or back of the house; instead, straight rafters (*pakantod*) run up only as far as the ati-atig crossbeams (196–97).

Upon entering the binayon, one perceives the protective aura of the dome and the warmth emitted from the fire pit, a square box filled with sand located a little off center toward the rear of the house. Above this fireplace is a storage rack. Shelves flaunting heirloom artifacts like precious China and pottery pieces extol the status of the owner in the community.

The common Kalinga residence is the square or rectangular single room dwelling elevated above ground on post, with a split-bamboo flooring that can be rolled up or removed for washing. In the past, the space underneath the house is enclosed by bamboo walling for protection against invaders. Some houses also use pinewood for flooring, which, oftentimes, has three subdivisions: the *kansauwan* is the middle section with two sides called *sipi*, which are platformed areas for sleeping. At one end of the kansauwan is the cooking area consisting of a box of sand and ashes with three large stones to hold pots. Above this cooking area is a drying and

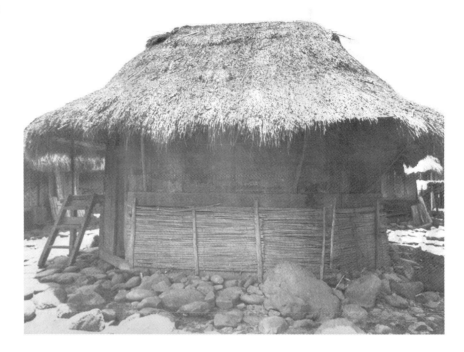

smoking rack. The only opening is opposite the cooking area, a small sliding door
leading to a *kalanga* or small veranda. A house shrine stands in a corner of the
house, with racks that display a porcelain plate for offerings, a sacred spear, and
a symbolic décor of coconut leaves. Walls are made of pinewood. *Otop* or roofs
are made of cogon and bamboo.

Bontoc

The Bontoc *ili* or village has three basic residential structures which differentiates
it from the neighboring *poblacion*, where immigrants settle: the *ato*, the council
house and dormitory of the young and old unmarried males; the *ulog/olog*, the
female dormitory; and the *afong*, the family residence.

The Bontoc term for house, in general, is afong. The rich and the poor classes have
different kinds of afong. A rich family resides in the *fayu*, which is open and
relatively large (3.6 x 4.5 meters). A poor family lives in the *katyufong*, which is
smaller, enclosed, and stone-walled. The residence of widows or unmarried old
women is the *kol-lob,* also called katyufong.

Although the common usage of the word afong more often refers to a hut, the
Bontoc house in its formal sense is a fayu. A fayu has a huge and sloping roof that
configures a pyramidal form at the front and rear but trapezoidal at the side and
rests on the outward-leaning frame of the first storey. Enveloping the entire roof
are grasses bunched into shingles on fine stems tied to the rafters and thatched
with layers of cogon and runo.

Sloping downward from the ridgepole for around two-thirds of the height, the fayu
roof inclines outward from the walls of the house at a distance of approximately
1.2 meters from the ground. The roof defines a space for an upper room along an
attic that doubles as a granary.

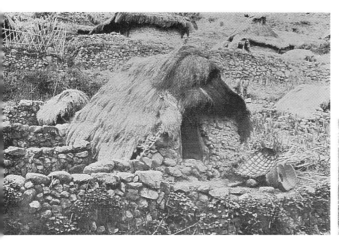

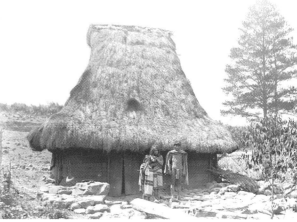

To prevent the roof from falling, the walls of the entire first storey slant outward as they are raised from the floor toward the upper horizontal beams. The square floor of the attic is made by means of four upper horizontal beams supporting the upper rafters as they descend down the ridgepole. Approximately 1.6 meters in length, the ridgepole is laid on two queen–posts, which in turn, rest on a central upper horizontal beam. Small smoke exhausts are found at both ends of the ridgepole.

The fayu is windowless, but a gap between the walls of the ground level and the eaves facilitate ventilation. Access to the Bontoc house is through a front wall doorway about 0.4 meters wide and opens into a passage that extends to the rear inner post of the first storey. To the left of this entrance is a room, about 1.7 square meters, dug one foot into the ground, and is used for threshing rice.

Other Bontoc structures are the *al-lang*, a repository of food supplies, jewelry, and wine jars; the *akhamang*, the rice granaries; and the *falinto-og*, the pigpens. Acts of theft are prevented, not by locking devices, but through the *pachipad*, twigs and leaves entangled together, symbolic of the owner's curse on potential trespassers.

An ato consists of fifteen to thirty afong, pigsties, and rice granaries. It has a low stone wall and footpaths connecting the various houses to one another. A typical ili has about 600 to 3,000 residents living in different ato. Community spirit in the ili is based on kindred ties, ato loyalties, communal rituals, and a shared history of defending themselves against common enemies.

Besides being the term for the social institution, the ato is also a physical structure consisting of a large hut, called the *pabafunan*, and an open court where people gather to perform their rituals. The pabafunan can accommodate about six to eighteen males. With a thatched roof and stone walls mortared together by mud, the rectangular pabafunan has only one small opening, 0.75 meters high and 0.25 meters wide, through which one enters sideways.

Adjacent to the pabafunan is the open court, a stone platform with a fireplace in the center, around which the men congregate when ceremonies are performed. The seats consist of flat, elevated stones, worn smooth by the generations of Bontoc who have sat on them. The court is sheltered by a tree; there are posts,

2.23 A Bontoc katyufong

2.24 A Bontoc fayu has a huge and sloping roof that assumes a pyramidal form at the front and rear, but a trapezoidal one at the side.

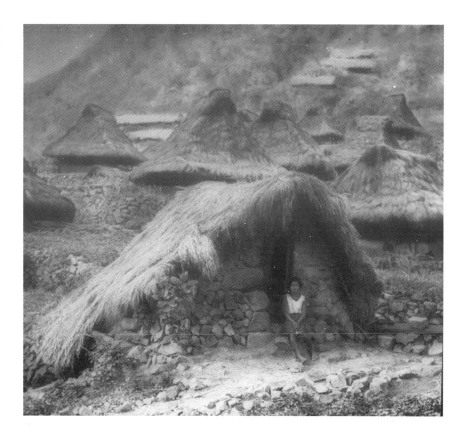

2.25 A poor Bontoc family lives in the katyufong, which is small, enclosed, and walled by stone.

either carved to represent human skulls or holding stones atop them that resemble skulls. In the headhunting past, these posts held the enemies' heads, which were brought home by warriors.

The olog is a public structure where young women of marriageable age go to sleep at night. Similar to the ato, it is a stone structure with a thatched roof. The single doorway is about 0.75 meters high and 0.25 meters wide. Inside, boards are placed side by side for the girls to sleep on. These are usually built over the pigpen. Unlike the ato, the olog is not an institution; hence, there is no ceremonial stone platform or open court. It is in the olog where courtship commences and ends with engagement. A few days before the final ceremonies of marriage are performed, couples are allowed to sleep together in the olog.

Ifugao

An Ifugao settlement is composed of twelve to thirty houses, situated amid rice terraces and, often, near springs and groves. A village is accessible through footpaths on the terrace walls. Village terraces are classified as center, border (lower, near the pond fields), or upper (near the mountain slopes). Wealthier inhabitants prefer the central terraces. Houses may be clustered, as in Banaue, or scattered asymmetrically, like those in the Mayaoyao area. The arrangement of the house conforms to the contour of the terrace where the latter is located. On narrow terraces, houses may stand in rows, while on wider ones, they may be spread out or grouped around an open space. As with rice terraces, the house lot is paved with megalithic stones and has entrances generally facing away from the rise of the slope.

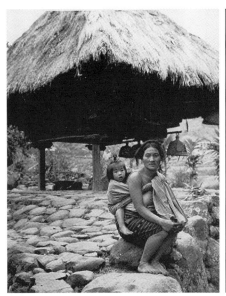

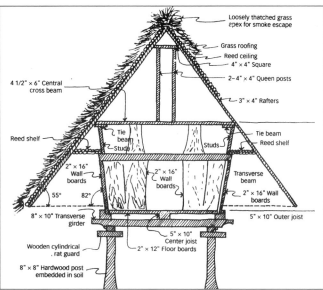

2.26 An Ifugao fale

2.27 Cross-section of an Ifugao fale

Houses are classified according to the social standing of residents: the fale or bale for the affluent; the *abong* for the poor; and the communal, segregated dormitory for unmarried boys, girls, and the elderly. While the traditional house has a specific shape and form, the Ifugao dormitory is a hut that does not have uniform dimensions. It is located in the middle of rice fields. The rice granary, though smaller in scale, possesses the same basic design and structure of the fale, and is also indicative of the high status of the owner in the community.

The Ifugao house is a three-level structure. The first level consists of the stone pavement, whose perimeter coincides with the edge of the eaves, posts, and girders. A wooden cylindrical disk, the halipan or rat guard, is fitted on each of the four posts. The second level of the Ifugao structure is the house cage, consisting of the room frame, walls, and floor. The pyramidal hipped roof comprises the third level. Ifugao houses rise to about shoulder height from the ground to the girder, but the posts do not frame the house cage nor directly support the roof. The house cage rests on the posts, and the roof rests on the house cage. The upper frame of the house cage is above head level. The wallboard rises from the floor to reach the chest or waist height. The roof slopes down and goes beyond the upper frame of the cage to floor level. The *patie* or shelf extends outwards from the top of the wallboards to the underside of the roof and forms a recess that supports the roof.

The fale is a small house with a floor area of about twelve to fifteen square meters. It is elevated by four posts 1.2 to 1.8 meters above ground. The roof is a steeply pitched hut, made of hand-hewn timber and without windows to protect the residents from the chilly mountain weather. The house is constructed without the use of nails so that it can be dismantled and relocated to another area easily.

The interior walls of the Ifugao house incline to give a spherical dimension inside. The interior, with no windows and with only a front door and a back door for ventilation, is blackened with soot owing to the absence of a chimney.

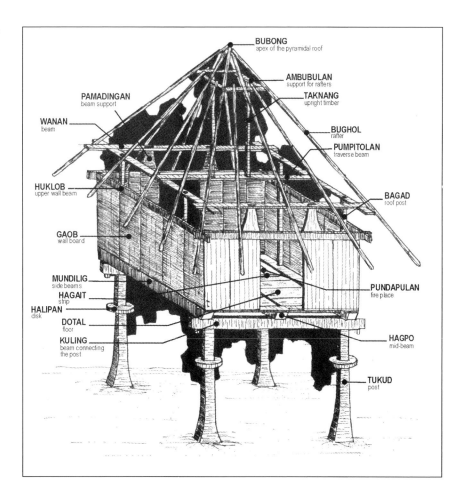

A hearth is built on a lower plane at the right-hand corner of the house to protect the house from the humid climate. A layer of soil is spread over the area where three huge stones are positioned to form a stove tripod. The heat and smoke serve to dry the roof as well as the grain stored in the upper part of the house. Near the fireplace, jawbones of sacrificial animals are on display as a sign of status or to keep peace with the gods. Unthreshed rice is also stored on a platform on the tie beams. Jars and plates are kept in the patie shelf.

The Ifugao house presents some remarkable features. First is the pyramidal roof that is protected with layers of thatch. The thatch roofing insulates the interior from the heat of the sun as it repels rainwater. Lately, thatch, being prone to organic decay and of combustible quality, has been giving way to galvanized iron roofs, which have been found to be more durable, and more symbolic of prestige and wealth among the Ifugao.

Ifugao housebuilding techniques are precise and accurate; each piece of timber is carved such that it interlocks with others perfectly without the aid of nails or hardware. In housebuilding, an Ifugao may choose four trees to form a square, chopping off their crowns and leaving the roots and trunks intact to serve as strong house posts. Otherwise, four posts of strong *amugawan* wood are sunk into the ground about half a meter deep, with stones placed around them to keep them

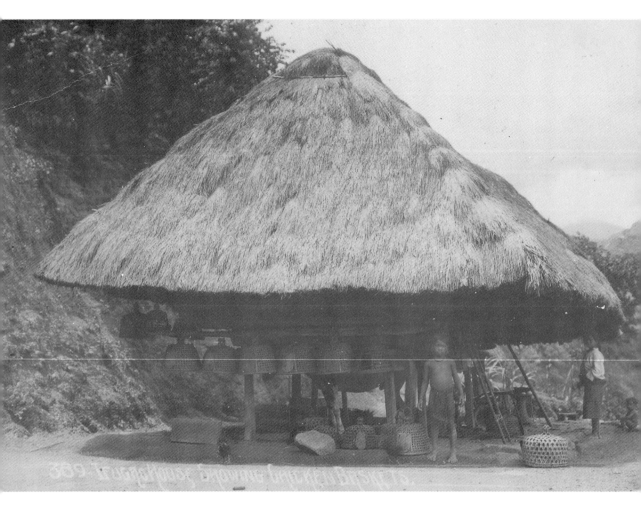

vertical and prevent them from sinking into the ground. These posts are bigger at the bottom than at the top for added stability. Rat guards are fitted 0.25 x 0.25 meters in width and 1.52 meters in height and sharpened to form a large tenon into which the transverse girders are driven.

2.29 Ifugao traditional house with chicken baskets suspended from one of the floor beams

Though housebuilding may take as long as two years, the house, mostly of hand-hewn wood, may be assembled and dismantled within a day. The house may last from five to six generations, with only the post being replaced every two decades as the dampness of the earth slowly deteriorates it.

Outside the house, animal skulls (and, previously, human skulls from the headhunting past) are displayed below the eaves and on the walls. Postharvest implements of mortar and pestle and weaving loom are placed on the open ground of the underfloor space. In the same space, wealthy residents flaunt a *hagabi* (long wooden bench) with carved animal heads on both sides as a sign of prosperity.

Only the couple and perhaps their youngest child reside in the house. Older siblings sleep away from their parents in communal dormitories. Interior furnishings in the house are rare. An occasional bench made of a square piece of wood and a flat slab with the low guard on one side, serving as the bed, are the only notable pieces of furniture.

Although Ifugao houses vary little from this basic configuration, houses of the nobility are often differentiated through distinctive architectural refinements, such as massive hagabi lounging benches, decorated attic beams, kingposts, and doorjambs carved with human (*bul-ul*) effigies, and ornate exterior friezes portraying pigs, carabaos, and other animals.

Kankanay

Traditionally, the Kankanay village was situated on the bulge of a hill, whose height afforded a natural defensive advantage against rival tribes. Contemporary Kankanay villages, however, are located near the source of a stream or river, which provides irrigation water for the rice terraces. A typical village of the northern Kankanay or Lepanto Igorot would have at least 700 inhabitants residing in a cluster of some 150 houses. Slopes of hills or mountains are flattened so that houses can be built. Lying near this village is a consecrated grove of trees, which serve as the setting for sacrificial rituals.

There are three main types of Kankanay dwellings: the *binangiyan*, the *apa* or *inapa,* and the *allao*. The binangiyan is a Kankanay family abode that has a basic resemblance to the Ifugao house (fale), having a high hipped roof with the ridge parallel to the front. The key feature of the binangiyan is the box-like compartment— a single-room dwelling with a spacious attic (*baeg*)—that functions as a granary.

The roof of the binangiyan is pyramidal in form with overhanging eaves extending downward about 1.2 meters from the ground. The eaves are supported by four walls that slant outwards toward the upper part where the roof is mortised to the four corners. The four walls are rabbeted into the transverse beam below at chest height. Usually, four wooden posts secure two transverse girders, which likewise support three floor joists onto which floor boards are attached.

Close to the ground, there is a wooden platform stretching out to the eaves. The platform is formed by several broad planks laid together above the ground instead of stone blocks set on the earth. This space is used for weaving and cooking. Stone is used as pavement around the house. The interior consists of a sleeping area, a kitchen (with a hearth in one corner), and a storage space for utensils.

2.30 A Kankanay traditional house called binangiyan

2.31 Cross-section of the binangiyan

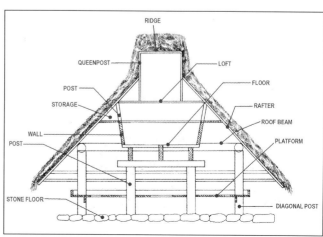

The floor, about 1.5 meters above ground, is unenclosed, allowing occupants to perform chores, such as basket and cloth weaving, making utensils, and splitting firewood. There is an opening on one side, leading to a narrow passageway protected by a sliding door. A pigpen may be found in one of the end corners. The living room is upstairs, which also serves as the sleeping and dining area. The attic space formed by the high roof is used to store rice. There are no windows except a small exhaust opening in the roof for the smoke coming from the hearth. The low eaves afford protection against heavy rains. The house has only one entrance, the front door, the access to which is a slender, removable ladder. The door panels are lavished with vertical flutings and the beams and joists with horizontal, wave-like ornamental furrows. The provision of disc-shaped rat guards under the girders ensures the protection of the house granary against rodents.

The *apa* and the *allao*, the dwellings for poorer families, are built more modestly than the binangiyan. Regarded as a temporary abode, the apa (also called *inapa*) has walls which are perpendicular to the ground, with the four main posts standing directly in the corners. The materials used for the floor are split bamboo and lengths of runo. Even if the roof is conical, as in the binangiyan, it is built lower and closer to the ground.

Regarded as even more temporary that the apa is the allao. It has a rectangular floor plan and a gable-shaped roof that slopes down beyond the floor towards the ground. The four-corner posts reach up to the roof. The floor is lashed to these posts and supported by wooden piles underneath. Since construction does not require walls, the allao allows no space for an attic for storage. The structure has no stairs for the floor height is only 0.6 meters.

Lowland Vernacular Dwellings: The Bahay Kubo

The word "bahay" evolved from the word "balai," a vernacular word for house. On the other hand, for the longest time, architectural historians mistakenly took the word "kubo" as the translation of the Spanish word "cubo" which pertains to the cube because of the obvious overall cubic geometry—the height of the walls equals its width. On the contrary, the word "kubo" already appears among early versions of Tagalog (Fr. Pedro De San Buenaventura's *Vocabulario de Lengua Tagalog*) and Kapampangan dictionaries (Fr. Diego Bergaño's *Vocabulario dela Lengua Pampanga en Romance*) in the seventeenth century. The Tagalog "kobo" refers to mountain houses. The Kapampangan "kúbu," on the other hand, is synonymous to *balungbung* (Kapampangan word for hut, cabin or lodge), "cuala," "saung," and "dangpa" (Kapampangan word for shepherd's hut or hovel, *dampa* of the Tagalogs). Usually owned by peasant families and other low income groups, the bahay kubo has been described as an idyll of peace and bucolic prosperity in the middle of the fields, as portrayed in the popular Tagalog folk song of the same name.

Depending on the ecology of the vicinity, the bahay kubo may be constructed from various kinds of botanical materials, such as wood, rattan, cane, bamboo, anahaw, nipa, bark, or cogon. Nipa (*Nipa fruticans*) is the widely used material; thus, the bahay kubo is also referred to as the nipa hut. Bamboo (*Schizostachyum lumampao*) is also used as a major material for the construction of the house because of its availability and flexibility. The inherent toughness of bamboo can

2.32 A Tagalog bahay kubo in Antipolo circa 1900

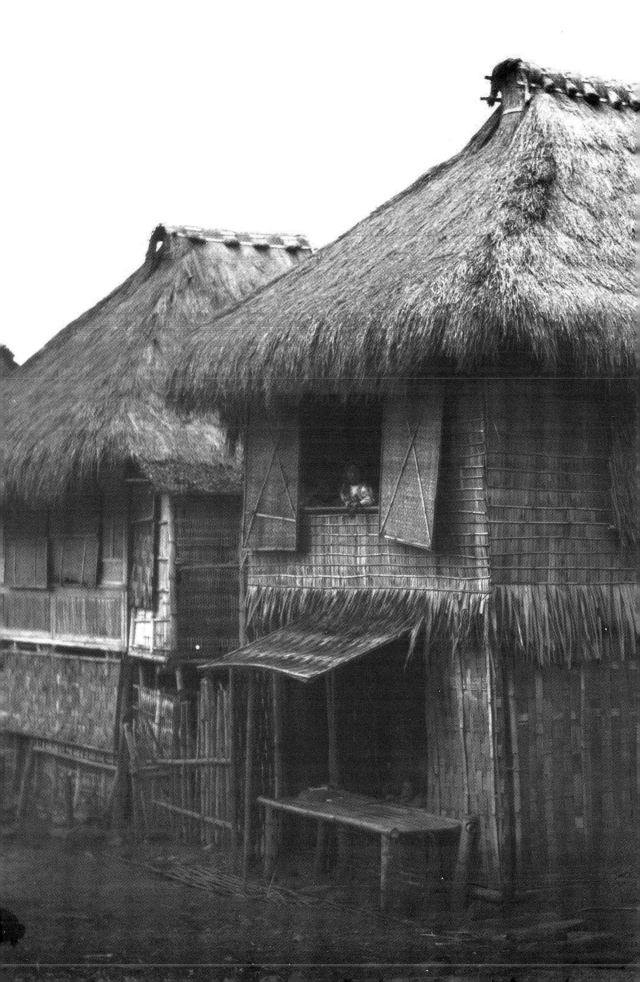

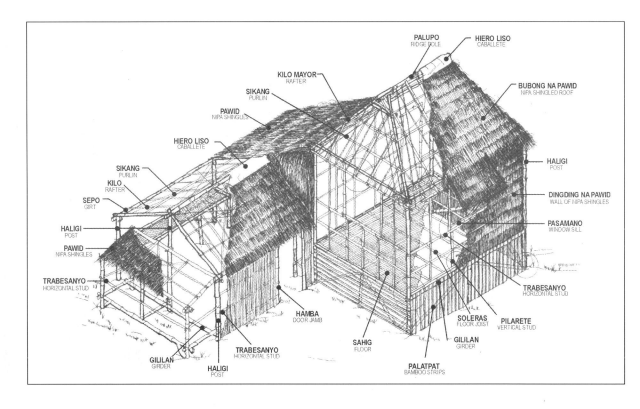

Labels on the diagram:

PALUPO
RIDGE POLE

HIERO LISO
CABALLETE

BUBONG NA PAWID
NIPA SHINGLED ROOF

KILO MAYOR
RAFTER

SIKANG
PURLIN

PAWID
NIPA SHINGLES

HIERO LISO
CABALLETE

HALIGI
POST

SIKANG
PURLIN

KILO
RAFTER

DINGDING NA PAWID
WALL OF NIPA SHINGLES

SEPO
GIRT

PASAMANO
WINDOW SILL

HALIGI
POST

PAWID
NIPA SHINGLES

TRABESANYO
HORIZONTAL STUD

TRABESANYO
HORIZONTAL STUD

HAMBA
DOOR JAMB

SOLERAS
FLOOR JOIST

PILARETE
VERTICAL STUD

GILILAN
GIRDER

SAHIG
FLOOR

GILILAN
GIRDER

TRABESANYO
HORIZONTAL STUD

PALATPAT
BAMBOO STRIPS

HALIGI
POST

2.33 Parts of a bahay kubo

only yield to a sharp blade. Its extensive use may be connected to the coming of iron and tools in the Philippine cultural history, which dates around 200 BC.

The posts of the nipa hut mark out a 3 meter x 2.5 meter-area and carries a hipped roof. Hardwood, particularly molave (*Vitex geniculata*), is the favored material for the post, but bamboo is more prevalent. The tiebeams ascend some two meters above the room floor. Forming the roof are four-corner rafters and two rows of minor rafters that together carry a ridgepole. Four poles delineate the roof's perimeter. The roof frame and the many slats lining across the rafters are made of bamboo. Structural segments are tied together with strips of rattan (*Calamus*). Onto the bamboo skeleton, shingles of nipa (*Nipa fruticans*) or cogon (*Imperata cylindrica*) are bound in dense rows. Other materials alternatively used for roof shingles are anahaw palm (*Livistona rotundifolia*) and sugar palm (*Arenga pinnata*).

Beams perpendicularly traversing each other and lashed to the post one to two meters above the ground, support the bamboo joist, which, in turn, holds up a bamboo slatted floor. This type of floor allows the circulation of air and light and facilitates cleaning as dirt and dust fall directly to the space underneath. A floor sill supports the bamboo frames of the exterior walls. The bamboo frames are then fastened at the corners rather than directly to the house post. Wall sidings may be of nipa or sawali; the latter uses bamboo that has been split, flattened, and cut into strips, then woven together in a herringbone design. The sawali virtually makes the house a penetrable basket propped up by poles. Windows of the awning-type have a nipa or palm window lid that can either slide from side to side or be pushed out by a pole that also serves as support when not in use. There are usually no ceilings or room divisions. However, if required, room partitions are quite low and

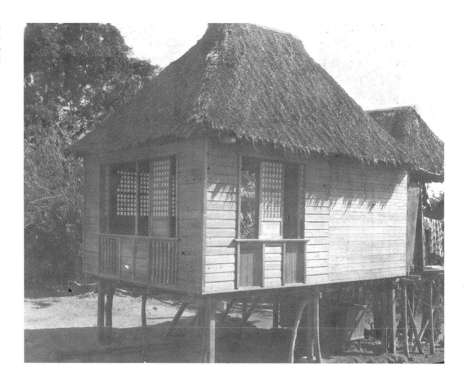

2.34 A Hispanized bahay kubo (circa 1900) with wood board sidings, sliding capiz window panes, and balustered *ventanillas*

Folk Building Beliefs

Houses are artifacts conditioned by the forces of culture and sprituality; architectural forms, designs, and layouts are influenced by a number of cultural factors, like religious beliefs and the supernatural world.

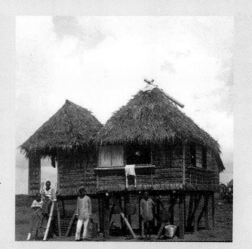

Selecting a site for a new house in the lowlands, the Christianized builder first lodges a wooden cross at the center of the site and then leaves it for several days. If the cross remains undisturbed for a time, resident spirits approve of the construction. Afterwards, the site is blessed with prayers to drive evil spirits away.

Certain rituals are performed before, during, and after construction. The appropriate orientation of the house is strictly observed to ensure an auspicious beginning for the structure and its occupants. For instance, the foundation of the post should be bathed with the blood of a pig or pure white chicken to appease the spirit of the site. Before moving to a new house, each post must be stained with blood from the aforementioned animals. Coins are placed between the stone footings and wood post to bring good fortune to the owner.

Generally, the doors of houses must be oriented to the east in the belief that the rising sun stands for happiness and prosperity. Doors must also not face each other. The "oro-plata-mata" method of counting determines the number of steps of the stairs. It must not be divisible by three, for ending in "mata," is believed to bring bad luck. For a comprehensive inventory of Filipino building beliefs, the volume *Oro, Plata, Mata* (2000), authored by Ernesto Zarate, provides ready reference for understanding the correlation between architecture and folklore.

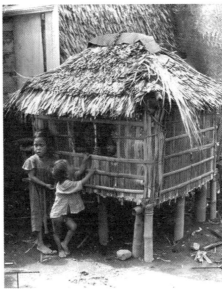
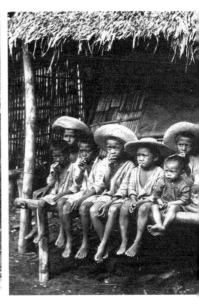

do not reach the underside of the roof, or the ceiling if there is any, to allow for free circulation of air within the house. Sawali walls may divide the interior space into rooms with open doorways.

The lower part of the house, called *silong*, is used as an enclosure for keeping domestic animals, such as swine and fowl, and as a storage for household implements, goods, crops, and, in some cases, as burial ground for the dead. The upper floor, where the inhabitants live, consists of the most essential compartments—an all-purpose single area, or a two-to-three unit quarter consisting of a living-and-sleeping area, a kitchen or storage room, and an open gallery at the front or rear of the house, called *balkon* or *batalan*, respectively. When found at the front, the gallery serves as an anteroom or lounging area. When located at the rear, it is used for keeping the *banga* (water jar) or for bathing. As the household expands, or as its occupant becomes wealthier, extensions (a bigger batalan) are added to the basic form of the house. Behind the house, near the batalan, is a kitchen, which has a separate roof and window with *bangguera*, a hanging slatted rack for drying dishes and kitchen utensils.

The nipa hut has evolved, but its basic elements have been retained. However, the dwelling forms and residential patterns have been expanded and outwardly modified. At present, the idea of a bahay kubo still connotes a one-room but multifunctional abode. The open space in the one-room structure can be transformed into different spaces at different times of the day: living area, dining area, bedroom, and kitchen. It is also common to see an altar of religious icons and photos of deceased family members, adorned by some candles, flowers, and, in a few instances, filled with fruits and other offerings.

In most bi-level houses, the living area, kitchen, and dining room are defined on the ground level, while the bedroom is located on the second level. These low levels may be connected by a door without a swing board and may be provided with four-step stairs, at the top of which is a *sagang*, a barrier to prevent children from falling. Some houses have no furnishings except a few functional devices, such as

2.35 The ladder-type stair in front of the bahay kubo serves as congregational space for carefree seating.

2.36 A bahay kubo playhouse in the early 1900s. Inside this play space, the children simulate the routines of domesticity in a game called *bahay-bahayan*.

2.37 A bangko, a long bench made of either bamboo or wood planks, is a built-in furniture piece in the bahay kubo to accommodate guests and informal gatherings.

Organic Materials for Indigenous Constructions

Traditional vernacular houses are almost wholly made of organic materials—wood, bamboo, palm leaves, grass, and plant fibers—which are utilized in a number of ingenious techniques to ensure that the residences are protected against sun and rain.

Bamboo

Bamboo is found in large quantities nearly everywhere in the archipelago. There are around thirty-two species of bamboo in the Philippines. The commercially important bamboo species in the country are *kauayan tinik* or spiny bamboo (*Bambusa lumeana*); *kauayan kiling* (*Bambusa vulgaris*); *Bayog* (*Dendrocalamus merrillianus*); *Bolo* (*Gigantochloa levis*); and *buho* (*Schizostachyum lumampao*). Among the five species, spiny bamboo and kauayan kiling are the preferred species for building, furniture making, and making boat outriggers. Bayog is used for tying and making ropes.

Bamboos are tall, tree-like grasses. Mature bamboos are cut during dry season, or when the sap flow is sluggish and sugar content is low—a condition where powder-post beetles, (*Lyctus brunneus*), locally called *bukbok*, are no longer drawn to its cane. To eliminate all insects, bamboo canes are soaked in river or lake water or buried in the sand for some six months prior to application.

Bamboos can be used as full canes or split longitudinally into halved or quartered strips or segments. The bamboo is spliced in this way to maintain its structural properties. In the construction of the bahay kubo, the bamboo performs as a structural element in the form of canes (for post, beams, and rails) or stiffening frames (lattice), and as cladding material (for floors, walls, and fences) in the form of planks and lattice panels. The components can be easily prefabricated, assembled, and replaced.

Depending on the age and species, the bamboo can have variable diameters. Bamboos having diameters of five to twelve centimeters are commonly utilized for building. Aside from being cheap, readily available, and easily manipulated with basic tools, a variable cross-sectional diameter and an ability to grow fast make bamboo a popular building material.

Cogon (*Imperata cylindrica*)

Cogon is a perennial that grows in dense clusters to a height of 1.8-2 meters with narrow, rigid leaf-blades. Although inferior to nipa, it is efficient for thatching and is widely used wherever nipa is unavailable. Notwithstanding its architectural application, cogon is used for soil erosion control, mulch in coffee plantations, fodder, papermaking, packaging, fuel, and ornamental purposes. The rhizomes and root extracts are used medicinally.

To make a thatched roof, the cogon is first made to dry. Bundling the dried grass follows after a few days. Then the butts are cut into squares with a thatching needle forty to forty-five centimeters long. The bundled grass is fixed firmly to the purlins with the butt downward for the first row and alternately thereafter until the ridge of the roof is reached. For every three or four bundles, a stitch is firmly tied to prevent slippage. The cogon thatch should be at least fifteen centimeters thick. A pair of smoke vents can be placed in the roof fifty centimeters below the ridge. Smoke coming from the firewood stove in the kitchen adds to the durability of cogon thatch as the smoke makes its way through the beams and goes outside through a hole on top of the roof. Thus, the beams and thatch are continuously smoked and are protected from vermin and decay through the smoke's stabilizing and drying effects.

Nipa (*Nipa fruticans*)

The leaves of nipa, a non-timber species that thrives well along tidal flats and brackish swamps, are made into thatching materials, bags, baskets, hats, and raincoats. From the nipa's stalk, sap is extracted and made into alcohol, vinegar, wine, and sugar. Kernels of young nuts of nipa are made into sweets and preserves.

The nipa palm is believed to be one of the oldest and most extensive palms of the world. Found in India, Sri Lanka, the Philippines, and in some other Pacific islands, nipa is adapted to muddy soils along rivers and estuaries. In the Philippines, nipa is planted in the months of May and August, at the height of the rainy season, when the soil is saturated with moisture. When mature, this plant grows to about 3–3.5 meters in height and its long pinnate leaves acquire a rich green color. Nipa as thatching material is generally regarded as superior to coconut or cogon thatch because it performs better in repelling rainwater and offers higher resistance to rotting.

Coconut Palm (*Cocos nucifera*)

The coconut palm may have originated in South America or Oceania, but it is widespread throughout the Philippines, Malaysia, and India. They can grow at high altitudes, and flourish at sea level, lining island coasts and bays. The trunks may grow to as much as thirty meters high and forty-five centimeters or more in diameter. Its huge leaves bunched at the crest of the tree are used in its entirety with layers placed from ridge to eaves, or the leaflet stripped from the ribs, relaid and interwoven to make a more permanent roof cladding. Coco lumber is also extensively used for house posts, roof frames, and scaffolding.

Rattan (*Calamus*)

The rattan is a climbing palm that provides raw material for vernacular buildings and the cane-furniture industry. It is the most important forest product in the country after timber. In the Philippines, rattan is represented by sixty-two species, of which twelve are of commercial value.

Rattan has long and very flexible stems that need support. It is harvested every fifteen years when the stems have grown to an average length of twenty-five meters and a diameter of 1.5–3.5 centimeters. Afterwards, selective cutting of mature canes is done at a three- to four-year-gap.

Rattan gatherers need to pull the canes down from the forest canopy and remove the spiny sheaths, leaves, and whips, leaving a bare cane. Rattan harvesting is, thus, a rather dangerous undertaking—dead branches can be dislodged as the rattan is pulled and ants and wasps can often be disturbed in the process. The bare canes are carried out of the forest and partially processed; small-diameter canes are dried in the sun and often smoked, while large canes are boiled in oil (often a mixture of diesel and palm oil) to remove excess moisture and natural gums and to prevent attack by wood-boring beetles.

Rattan is the widely used material for lashing, binding, and knotting where structural materials, such as bamboo are to be joined. Slender, peeled rattan may be dried of their residual sap and then coiled, ready for use as a binding material, while thicker rattan, whose stems are solid, are used to make household items and furniture.

a *papag* or built-in bed, a *dulang* or low table, a *bangko* or bench, bamboo grilles, and *sala-sala* or bamboo latticework.

The typical Filipino house or the bahay kubo is the consequence of centuries of evolution. Some Hispanic influences are evident, such as the altar niche for the villager's *santos*. Originally, the empty floor space and a low table, called the dulang, were used for sitting and dining; later, a built-in long bench of split bamboo, called the *papag*, was introduced, along with tables and other furnishings required by Hispanized domestic practices.

Although commonly claimed to be of Hispanic influence, the *silid* or *kuwarto* (room) where the women of the house could change clothes in private seems to have been present prior to Hispanization, as evidenced by early chroniclers like Fray Juan Francisco de San Antonio, who in 1738 provided a detailed description of a nipa hut with interior partitions.

Iskwater: Vernacular Architecture for the Urban Margins

Even though canons of architecture have marginalized the study of vernacular architecture, residues of the latter form persist in the metropolitan context. The prospect of building a house with one's own hands—which is in fact the essence of the vernacular mode—will always remain trivial in a highly industrialized setting. Massive migrations from the provincial areas to the big cities have produced significant vernacular renaissance: skillful and resourceful people living in a rationalist architectural culture are instead forced to use vernacular modes of building. Although these migrants would have preferred to live in dwellings of a more modern type, the pressure of poverty has forced them to reinvent a degraded vernacular architectural structure—the shanty. Like traditional dwellings, shanties are built by their own inhabitants, with no blueprints, using materials available in the immediate environment; however, because of difficult and particular circumstances, no attention is paid to social and economic function or to planned aesthetic values.

With little skills and resources—financial or otherwise—or access to them, these migrants, whose presence in the urban landscape is fiercely challenged, resort to the only available option of illegally occupying a vacant piece of land to build a rudimentary shelter. These makeshift structures form a shanty town, which is negatively viewed by various state agencies and urban upper crust as an invasion of urban areas by the poor and its proliferation as both a social evil that needs to be exorcised from the urban terrain. Their visibility is consistently being erased via institutional efforts to relocate them elsewhere, away from the urban core.

Technically, informal settlements or squatters' areas can be defined as improvised residential communities in the urban fringes, inhabited by the very poor, usually migrants from the countryside, who have no access to legally tenured land of their own and, hence, illegally occupying a vacant land, either private or public. The key characteristic that delineates a squatter is his lack of ownership of the land parcel on which he has built his house. It could be vacant government or public land, or marginal land parcels such as a railway setback, or undesirable marshy land—sites which are unsuitable to other land use. Thus, when land is not put to productive use by the owner, it is appropriated by a squatter for building a house. For instance, along the many steep banks of the Pasig River and its tributaries are rows of fragile

houses precariously erected on slender timber stilts and projecting platforms. The similar structural system can also be found in low-lying marsh lands where matrices of raised timber catwalks interconnect the houses.

Aside from being prone to flood and fire, a squatter settlement, due to its inherent nonlegal status, lacks even the basic services and infrastructure facilities. Such services include both network and social infrastructure like water supply, sanitation, electricity, roads and drainage, schools, health centers, marketplaces. Water supply to individual households is usually absent, or there may be a few public or communal pipes provided. As a result, informal networks for the supply of water is resorted to. Similar improvised arrangements are also made for electricity, drainage, toilet facilities etc., with little dependence on public authorities or formal channels.

Most squatter settlement households belong to the lower income group, either working as wage laborers or in various informal sector enterprises. On an average, most earn wages at or near the minimum wage level. Squatters are predominantly migrants, either rural-urban or urban-urban. But many are also second or third generation squatters.

The informal architecture of the slum uses an endless array of building materials, and may be broadly categorized in terms of materials used, such as: a) temporary

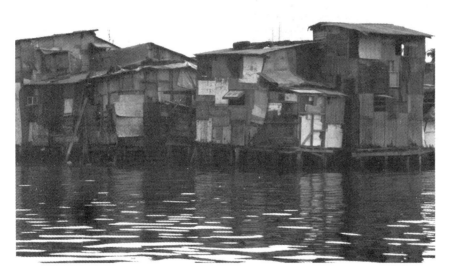

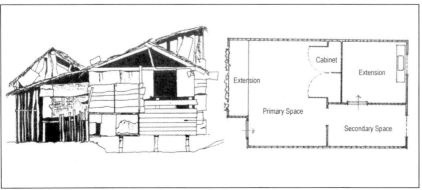

2.38 The urban shanty is a descendant of the provincial bahay kubo. Like traditional dwellings, shanties are built by their own inhabitants, with no blueprints, using materials available in the immediate environment.

2.39 A typical elevation and plan of an urban shanty. The temporary shanty or *barong-barong* is a typical one-room dwelling, a spatial concept derived from the well-established vernacular building knowledge learned from the bahay kubo.

Slumming the Screen

Philippine cinema and television have provided architectural images of blight and dereliction to visually prop asymmetric social relations among characters. Such imagery aims to simplistically retell the gaping social polarity that glorifies the values of destitution, while mapping the starting point of the poor man's difficult route from rags to riches.

This polarity of characterization (rich-poor/evil-good dualism) fosters a kind of realism that makes possible stark contrast in the architectural backdrop of respective social stations. In the daily *telenovela* or soap opera, when the clan is portrayed as rich, the house is an ostentatious Mediterranean mansion or a well-furnished condominium unit emulated from interior design magazines. Characters converse under the light of crystal chandeliers. They conduct their carefree lives in a conspicuous environment garnished with fixtures like European furniture, curtain swags, paintings, carpets, enormous vases, a grandfather's clock, and a swimming pool—all of which are elements of the *nouveau riche* domicile projecting itself as a locus of power.

On the other hand, the counter-imagery for this surplus of wealth is the slum. Easily dismissed as an unplanned and spontaneous agglomeration of migrant population, the high-density slum settlement is seen as a community of the impoverished constituted by tightly packed shanty units that share walls and are forced to expand upwards due to scarcity of land. Such a neighborhood is preconceived as the vortex of all society's ills and marginalization.

Through cinema and television, the squatter architecture and its locale is more than what meets the eye. It is an arena that grips the audience in a potential spell—the promise of a better tomorrow—conjuring a consciousness of hope in a world that triumphs over material poverty and rises above the limited destinies posed by the deprived space.

The obtrusive disparity in the depiction of the rich and the poor in architectural terms is necessary to sustain the drama of the great class divide. The squatter shanty is presented as a site of sordid domesticity defined by daily struggles and oppression (with an exception from television sitcom portrayals like *John en Marsha* or *Home Along the Riles* where human misery is absent). From a vantage point of social realist directors, the slum is a product of a huge wave of internal migration, spawning chaos in the city that is unprepared to accommodate so many new arrivals and continuous provincial exodus. The lure of the city life and urban modernity and the unfulfilled promise of a better life in the city have fueled the plot of Lino Brocka's films.

The cinematic slum takes a variety of morphologies and locations. Along the railroad easements (*Malvarosa, Home Along the Riles, Biyaheng Langit*); in vacant private or

idle government properties (*Insiang, Jaguar, Bona, Mga Batang Yagit, Demolisyon, Pila Balde*); inside cemeteries (*Babae sa Bubungang Lata*); along riverbanks and esteros (*Home Along the River, Batang Quiapo, Geron Busabos*); in reclaimed foreshore areas (*Lucia, Hubog, Bulaklak ng Maynila*); in garbage heaps and dumpsites (*Pasan Ko ang Daigdig, Maynila sa Kuko ng Liwanag*); in shells of ruined and dilapidated buildings (*Anak Dalita, Scorpio Nights, Macho Dancer*); along sidewalks, public streets, and in homeless carts (*Mila*), shanty communities proliferate like barnacles, superimposing with an image of urban neglect an image of modernity and urban celebration. They disrupt planned urban coherence and resist state-initiated cosmetological urban erasure as their dissonant architecture and makeshift condition challenge urban eviction and dislocation imposed on them by homelessness. Squalor and violence, dirt and criminality, prostitution and gambling are trademarks of these informal settlements. The trauma and violence of demolition as a way to exorcise the unsightly informal communities is captured in films like *Demolisyon* (1997) and *Hubog* (2001).

In the late 1940s and 1950s, the cinematic representation of the squatter zeroes in on the terrain of *komiks*-mode melodrama and comedy, which failed to deliver audiences from the romanticized realm of poverty. *Victory Joe* (1946), *Backpay* (1948), *Lupang Pangako* (1949) *48 Oras* (1950), *Roberta* (1951), *Basahang Ginto* (1952), *Batas ng Daigdig* (1952), *Iskwater* (1953), and *Palasyong Pawid* (1955) locate the urban saga amidst postwar reconstruction and destitution.

Few studios dared to lift the veil of the squatter ghetto as a site of social formation and strife. Eddie Romero's *Buhay Alamang* (1952) derives its significance from the use of a neorealist style to depict the interwoven lives of the urban poor in the rundown part of Manila in a comedic mode.

Postwar slummification is best captured in Lamberto Avellana's classic *Anak Dalita* (1956). The story revolves around a Korean war veteran and a prostitute trying to survive poverty in the war-ravaged slum of Manila. Using a style derived from Italian neorealism, Avellana's film takes us to the world of the walled slum of Intramuros, in the bombed-out shell of the church where each shanty attaches itself to the brick wall of the church ruins for structural support.

Malvarosa (1958), directed by Gregorio Fernandez, underscores a visual motif of the railroad tracks that run, not just through the community, but also through the lives of its characters. *Geron Busabos: Ang Batang Quiapo* (1964) successfully snatches moments of visual poetry from the film's grimy and derelict setting as its characters try to survive in the bowels of the big city.

The New Wave Cinema of the 1970s gave graphic depictions of the Manila slum area. The new wave film aesthetics sought to advocate the rights of the disenfranchised and the urban poor. It attempted to expose the Third World's social contradictions by focusing on the problems of the urban and rural lower classes who were confronted each day by starvation, violence, urban alienation, and economic exploitation. Nowhere is this tendency evident than in the films attributed to Lino Brocka, a trenchant critic of the Marcos government.

Brocka's films plot the physical and human geography of the squatters to expose the contradictions, desires, fears, and convulsive energy lurking among its inhabitants. Here, the camera is witness to hard-edged realism and social misery, portraying the said habitations as spaces cut off from the prosperity pledged by Marcosian modernity. The pathological architecture ridicules the very essence of Imeldific urban cosmetics of the "the true, the good, and the beautiful." These communities are discarded ghettoes whitewashed to obscurity through extensive spans of sterile wall and cordoned off through lush vegetative screens in the guise of an urban "Green Revolution."

Urban decay and the shattering indictment of the city is the subject of *Maynila sa Kuko ng Liwanag* (1975). It tells the story of a naive *probinsiyano* engulfed in the big city's web of exploitation and poverty that devours him as he sojourns in the asphalt jungle in search of a better life and of a lost love. *Insiang* (1976) shows how the slums nip innocence in the bud. Set against the infamous Smokey Mountain, the garbage heap that became the symbol of the country's economic downturn, the film examines the hierarchies of street-corner mafias and slum dwellers. The drama unfolds within the space of the shanty where spatial permeability tolerates voyeuristic gaze and sexual assaults. *Jaguar* (1979) revolves around a social climbing security guard who becomes the fall guy of a criminal syndicate. A police chase towards the end of the film portrays the hell of a tragedy that befalls the most desperate and helpless of characters in Philippine film history.

The slum as the governing trope of the anti-Marcos, social realist cinema of the 1970s has resurfaced in Jeffrey Jeturian's *Pila Balde* (1999). The story configures a milieu that links a slum community with an urban mass-housing program conceived by Imelda Marcos, the BLISS human settlement project. The failure of *Bagong Lipunan* modernity is underscored by the absence of water supply in the middle-class architectural artifact and the unresolved problems of homelessness in its vicinity. The slum, with its environs, tight, labyrinthine alleys, and plywood shanties, is a source of cheap and ready labor to sustain the daily operation of the nearby BLISS. Pushed by the logistics of survival, the informal urban dwellers fetch water, peddle sex, and offer other services to the BLISS tenants—a telling image of class encounters. In a turning point, arson reduces the community into ashes, but the end shows the slum resurrecting from its own sorry remains.

shelters (mostly made of salvaged or recycled materials); b) semipermanent (made of a combination of secondhand but durable material); and, c) permanent shelters (made of entirely durable construction material, such as reinforced concrete, concrete hollow blocks, and galvanized iron sheets). The latter type is synonymous to "professional squatters,"—individuals or groups who occupy lands without the owner's consent but have sufficient income for legitimate housing.

The building of the shanty must be accomplished with a degree of speed and adaptability unmatched by legitimate homebuilders. The speed of construction is crucial to evade the vigilance of the authorities monitoring the illegal structures.

The temporary shanty, or "barong-barong" in local parlance, is a typical one-room dwelling, a spatial concept derived from the well-established vernacular building knowledge (learned from the rustic bahay kubo). As the bahay kubo draws its materials from its immediate site that teems with botanical building

components, so does the urban shanty but from an environment brimming with garbage and discarded building materials, such as scrap wood, cardboard, or plastic materials.

Generally, the shanty has a lean-to roof (with a single slope) constructed of corrugated sheets, flattened biscuit cans, metal sheets, tarpaulin from billboards, or transparent plastic sheets, among others. Since these roofing materials cannot be nailed, they are kept in place by improvised weights, such as stones, concrete hollow blocks, discarded car battery casings, rubber tires, metal meshes, or even plastic drums. The internal walls are of scrap plywood usually lined with cardboard carton fastened to the walls with strips of bamboo studs. Plastic sheets line the wall inside or outside the wall sidings as waterproofing measure. Most often the entire family stays in one room, which has no ventilation. The residents do not have access to any traditional building material, such as thatch, in an urban setting. As a result the very basic nature of its building materials is not conducive to any kind of passive cooling. However, on a broader level, the utilization of whatever building materials found shows a very high level of recycling and salvaging that is extremely sustainable. Nothing is wasted for everything is precious in a design language ruled by juxtaposition of incongruent materials found in the immediate environment. Although its architecture is a revealing narrative of social deprivation brought about by indigence, it is nonetheless expressive of its builder's (who is also its inhabitant) ability to creatively transform and improvise scrap and found materials into a temporary space and makeshift settlement. In this context, garbage as construction material has become an important input in the evolution of the contemporary vernacular structure in the Third World milieu.

Moreover, the diversity of building patterns depends on a random availability of a great variety of building materials. The architecture of squatter settlements is an interesting case of a genuinely adaptive application of the vernacular mode in an urban environment. Residents are preoccupied with basic survival and have no wish to copy elements of a theoretical form language. They definitely apply an

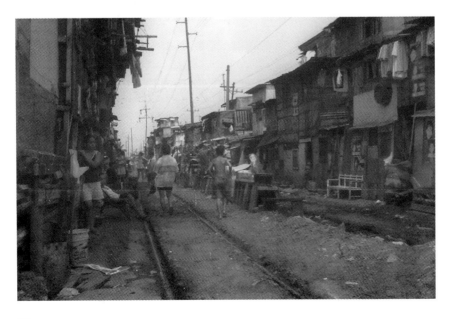

2.40 The riverine settlement pattern of traditional villages is resonated in the configuration of squatter communities along railroad tracks, creeks, and estuaries.

aesthetic language, albeit, unwittingly executed in a "bahala na" philosophy, because they want their dwellings to be as beautiful and as comfortable as possible.

The space inside the shanty unit shows a very high level of flexibility and accommodates different activities at different times of the day. Similar to the traditional house's concept of domesticity, the barong-barong provides a multifunctional, single-room space in which life's daily routines are performed. Pressed by the logistics of survival, the inhabitants creatively transform the meager interior space, about six square meters (or 3 x 2 meters), into a home with its shifting activity patterns of sleeping, cooking, eating, and recreation.

In slum housing, there exists a complex hierarchy of extensional spaces that are a part of the public realm but have acquired a private character through their physical modifications and use. The house extensions range from a simple enlarged step made out of packed raw earth to larger extensions, such as a makeshift porch. The porch is a feature of rural housing that the residents understand and integrate into everyday life. Its public nature allows greater contact with streetlife and also makes a very distinct climatic statement, again derived from its vernacular precedent.

The riverine settlement pattern of traditional villages is resonated in the configuration of squatter communities along railroads tracks, creeks, and estuaries. The penchant for siting the dwellings near rivers and lakes insists on the primeval tradition of locating villages close to bodies of water not only for sourcing water supply but also for transportation. If space is unavailable on dry land, the house is built directly over water and is suspended by stilts above water to a height ruled by the tide. While easements parallel to the railroad tracks are likewise densely populated by informal settlers, residents in such an area have developed tolerance to noise and safety measures to the potential dangers of living by the tracks. With dwellings flanking both sides, the length of the railroad track itself is rearticulated as a communal space suited for passage, promenade, playing, gardening, and work area, and as a temporary marketplace and ephemeral plaza. The railway lines are fitted with specially designed wooden pushcarts for local transit. Generally, amid the unruly arrangements and densely crammed houses, these settlements are characterized by a strong sense of community resulting from provincial allegiances and common rural origin.

The shanty community, as a reflection of the appalling specter of a social demand for housing, indubitably possesses its own aesthetic and anthropological values. This is not to say that we favor its maintenance in the city because of its aesthetic merits; rather, we admire, without social and economic prejudice, its capacity to provide immediate shelter for the poor and its reiteration of improvised beauty processed through the aesthetics of poverty.

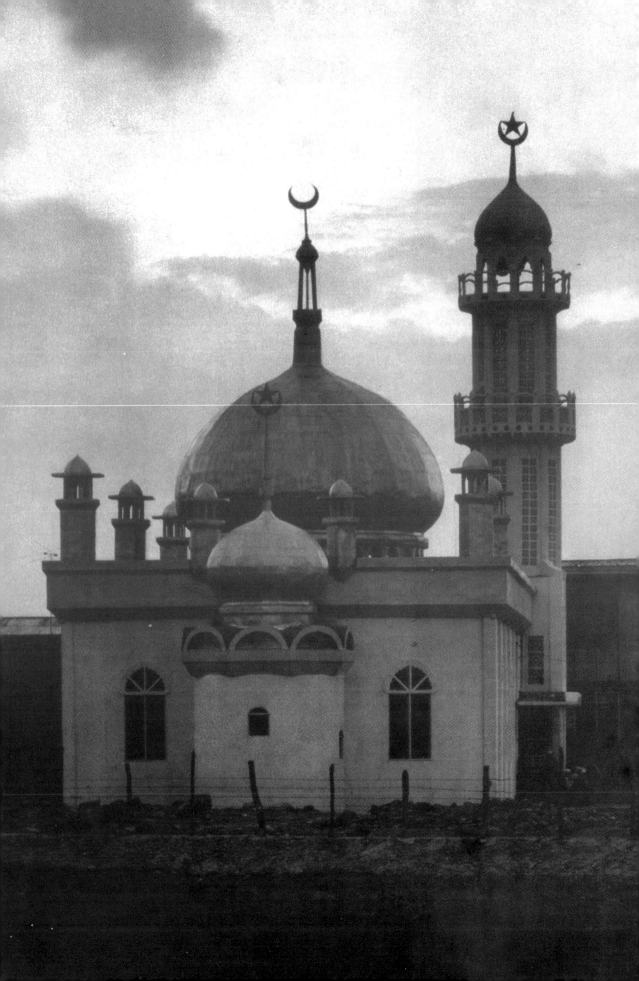

Muslim Space
and the Philippine Islamic Architecture

Islam in the Philippines

Islam was brought to the Philippines by means of two cultural routes: Southeast Asia and the Iberian Peninsula. When Muslim traders and missionaries came via the nearest Southeast Asian outpost, they eventually settled and systematically introduced a new culture to our ancestors in the Southern Philippines. The earliest evidence of Muslim presence in Sulu, and possibly of a Muslim settlement that can be found is the tomb of Tahun Maqbalu (Muqbalu) who died in 710 AD or 1310. Spain, being under very strong Arabic influence from 732 to 1492 AD, the Spanish colonization of the Philippines added another dimension to the propagation of Muslim influence in Philippine culture, allowing aspects of Ibero-Islamic culture to graft itself to the Christianized colonial culture.

The Islamization of Southeast Asia commenced between the eighth and nineth century, a period when Arabs were extensively trading with the Chinese. These traders established trading centers in Southeast Asia as their regular commercial stopovers on their way to China. But with the political upheaval in South China during the later period of the T'ang dynasty, foreign merchants, including the Arabs, were expelled from China. They sought asylum in various areas of Southeast Asia, principally in Malaysia, awaiting the restoration of order in China and the resumption of normal commercial ties with the Chinese.

In the interim, these traders established new economic routes in the adjacent islands of Insular Southeast Asia. As trade became firmly entrenched, the stations of commerce developed into ports and business hubs. Soon after, the Arab traders forged economic relations among the wealthy native population. Marriage with the rich natives and local headmen guaranteed the permanent consolidation of their business partnership, often taking the daughter of the local chief who himself converted to Islam.

3.1 Persian influence is evident in the onion domes and elaborate minarets of one of the first mosques built after the Second World War in Mindanao.

In these trade centers, the need for Muslim education was soon felt. Muslim teachers and missionaries were also among the first transmitters of Islamic religion. They came from the Arab region, such as Baghdad.

During the last quarter of the thirteenth century, if not earlier, a Muslim community in Sulu already existed. Historically, the introduction and diffusion of Islam in the Philippines is attributed to Tuan Masha'ika and later to Karim ul-Mahkdum, the leading figures in the Islamization of Sulu, who came to mentor the children of the rich merchants of Sulu and assimilate all the people in the area to the message of Allah. In fact, the first to convert to Islam were the trading partners of the Muslim merchants. With the arrival of more Islamic teachers, the faith spread rapidly and reached as far as Luzon. There is no historical evidence that the native people resisted the coming of a new religion.

Through the support of the affluent and newly converted business partners, the spread of the new religion gained an unprecedented mileage throughout the area. One explanation for the rapid Islamic expansion in the Philippines may be the conversion of community leaders. This was crucial in the spread of the religion as the local leadership compelled the population to embrace Muslim beliefs.

Some scholars argued, however, that the indigenous population themselves were simply and spontaneously attracted to Islam because of the beautiful rituals, stories, and art. Moreover, the feeling of belonging to a larger community, to a group of equal people, the brotherhood of Islam, convinced the natives to the path of conversion. Many native practices survived, and people found ways to combine Islamic religion with their local beliefs, tradition, and practices that led to the development of folk-Islamic traditions. Islam contributed to the consolidation of communities ruled by an independent datuship, and restructured these communities within the centralized framework of politico-religious sultanates. Through the sultanate, the leadership was bestowed upon the sultan who exercised paramount authority over the people. These Islamic communities were founded in many coastal parts of the Philippines during this period, since it was largely in these areas where Islam was first introduced by visiting foreign traders and from where it systematically spread. Three sultanates were thereby established after the

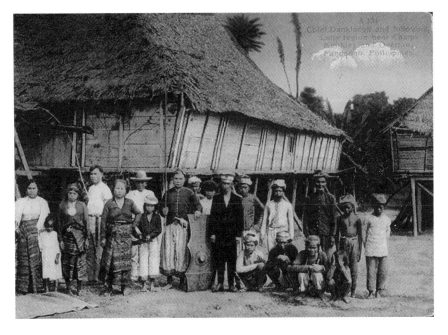

3.2 A Maranao tribe and their chieftain in front of their communal abode

arrival and diffusion of the new religion. The Sultanate of Sulu was the first to be formally established in 1450, with Abu Bakr as its first sultan. The second consolidation occured within Maguindanao; and the third was within Lanao.

Communities which responded favorably to the ways of Islam were gathered together under the mosque, the locus of communal spirituality. Islam acculturated the people to a novel way of life. With it came the alliance of economic and social influences into political power and authority. In Sulu, the oldest mosque is in Tubig, Indangan, Simunul islands. The original mosque, built in the fourteenth century, is attributed to Karim ul-Mahkdum. It has been reconstructed many times.

In Maguindanao, most of the Maguindano *tarsilas*—written genealogical accounts interwoven with oral traditions or folklore—impart an impression that the work of conversion was mainly the singular work of Sharif Muhammad Kabungsuwan around 1515. It is asserted that the process of religious conversion in these areas was a result of the institution of a system of political alliances and plural marriages on the part of Kabungsuwan after he had been able to install himself as the ruler of Maguindanao.

Maranao traditions cite the arrival of Sharif Alawi to what is now known as Misamis Oriental. Written and oral lore also tell of the spread of Alawi's teachings in Lanao and Bukidnon. By all accounts, Islam was brought to Lake Lanao by the datus who were converted to the faith by means of marriage alliances with Muslim Iranuns and Maguindanao datus, predominantly with the former.

The Islamic tradition found favorable reception from the natives of the Sulu archipelago, Basilan, Palawan, and Mindanao—predominantly the Samal, Badjao, Tausug, Jama Mapun, Yakan, Maranao, Iranon, and Maguindanao. They wholeheartedly embraced the new culture and integrated it into their own traditional

3.3 Moro women posing in front of their communal house. The underfloor space of the house is shielded by split bamboo screens. The living area is raised by log piles rising more than a meter above ground

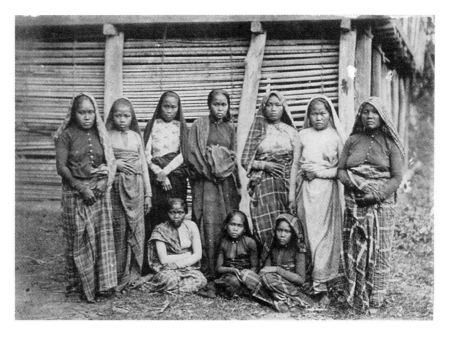

way of life. The wisdom derived from the Koran became the vortex of their belief system.

With the colonization of the Philippines by Spain beginning in the sixteenth century came the influx of Mudejar culture to the archipelago. Before the ascendancy of Ferdinand and Isabella to the Spanish throne, parts of Spain were under Islamic reign. Islamic influence is predominant in the Southern regions of Spain where Moorish leaders once built their palace. The Alhambra, for example, stands as an architectural testament to the strong Islamic legacy in Spain. Through the Spanish Inquisition, many conquered Muslims converted to Christianity, often through brute force. These Christianized Moors were called "mudejar" and were allowed to stay in Spain, bringing their own traditions to Spanish architecture, evolving a style of architecture that resulted from their interaction with the Iberian culture that was named after them. The Mudejar influence is manifested in the design of some colonial churches, industrial, and commercial buildings in the Philippines built during the Spanish colonial era.

Philippine Muslim Concept of Space

As one religio-cultural group bound together by Islam and common historical experience, the Philippine Muslims belong to a larger Islamic and Southeast Asian grouping. In the Southern Philippines there is no boundary that separates Mindanao and Sulu from the Celebes and Borneo, and from the rest of the Islamic cosmos for they are all affiliated under the universal *ummah* and incorporated into the global religious community called *darul Islam*. The ummah, therefore, transcends long–established tribal boundaries to create a degree of political unity among the Muslim faithfuls.

Philippine Muslims constitute some thirteen ethnolinguistic communities. The major groups include the Tausug of Sulu, Samal of Tawi-tawi, Yakan of Basilan, Maranao of Lanao Provinces, and the Maguindanao of the Cotabato region. With such plurality of ethnolinguistic roots from which Islamic tradition was grafted upon, Filipino Muslims over history have varied widely in their cultural lives though they share certain practices dependent on space.

Islamic theology affects all aspects of Muslim life. Muslims' submission of their will to Allah ideally reappropriates space and reorganizes temporality. *Salat* (formal prayer) requires space both physically and mentally. Fasting makes demands of mental and spiritual space, while altering temporality. The *hajj* demands its space and time. In salat, for instance, boundaries are formed when the prayer space is isolated even in a plain prayer rug. The calling of the *adhan* (the summon for an obligatory prayer) and the *iqamah* (to stand up for a prayer) signals movement from one reality to another as the Muslims stand before Allah. In salat, the individual merges with the global ummah in a time for God that is distinct and boundless. Both the practical needs of ritual and the profound juncture of the coterminous nature of the time and space of salat with the time and space of the world have a fundamental influence on space.

Muslim scholar Abraham Sakili maintains that Islamic architecture is entangled with Islamic space, and the understanding of the Muslim concept and use of such space should be probed in relation to the fundamental Islamic doctrine of *Tawhid*. The Tawhid is further elaborated through the articulation of Islamic Cosmology

and view of Man as *Khalifa* or Vice-regent of God in this world. The correlation of these three principles, he substantiates, has a profound and direct bearing on the Islamic concept and use of space on Muslim architecture.

The Tawhid means "Unity of Allah." It is the single most important doctrine of Islam, which at the basic semantic level means monotheism. The Islamic Tawhid, as an all-governing concept, considers everything in relation and in unity with God. Muslim aesthetics and architectural ornamentation have always been the pursuit of geometrization and denaturalization of form to divert one's imagination away from human nature and direct the thoughts toward the contemplation of the Divine. Islam instructs its believers that no material things should be considered sacred. Thus, there is a widespread use of calligraphic inscription, lifted from the verse of Koran, as ornament on Muslim structures in order to shift human consciousness from the material world to the realm of spirituality.

A Muslim believes that the Koran is the precise and literal words of Allah; thus, inscriptions must be inscribed in Arabic, the language of divine revelation. The choice of Koranic verses may be dictated by a building's function. For instance, the following verse is most commonly inscribed on mosque doorways:

إِنَّمَا يَعْمُرُ مَسَـٰجِدَ ٱللَّهِ مَنْ ءَامَنَ بِٱللَّهِ
وَٱلْيَـوْمِ ٱلْأَخِـرِ وَأَقَـامَ ٱلصَّلَوٰةَ وَءَاتَـى
ٱلزَّكَـوٰةَ وَلَـمْ يَخْـشَ إِلَّا ٱللَّـهَ فَعَسَـىٰ
أُوْلَـٰئِكَ أَن يَكُونُواْ مِنَ ٱلْمُهْتَدِينَ ﴿١٨﴾

"The mosques of Allah shall be visited and maintained by such as those who believe in Allah and the Last Day, establish regular prayers, and practice regular charity, and fear none (at all) except Allah. It is they who are expected to be on true guidance."
(Koran 9:18)

A designer, therefore, who applies Islamic calligraphy, vegetal reliefs, or geometric patterns in intertwining and continuous patterns to architecture yearn for, above all, the creation of a visual pattern that will deliver the viewer to an instinctive perception of divine transcendence. The basic structural components of the mosque are concealed through an elaborate but infinitely repeating geometric pattern, for the architecture of the mosque encloses a space considered sacred by believers. Muslim architects attempt to craft an environment in which the transient and temporal characters of material things are emphasized and within which the sparseness and vacuity of the architectural container is bestowed with prominence. Surface decoration, therefore, reduces the importance of structural elements by redirecting the attention away from natural materials to the abstract denaturalized ornamentation of buildings. The percipience of space leads one to reflect on the divine.

Intertwined with Tawhid is the Muslim view of the universe. The Islamic cosmos is based on the emphasis upon God as the Unique Origin of all things or beings on the hierarchy of existence who are all dependent upon Him. The Muslim views the cosmos or the whole of nature in all its dimensions not as a phenomenon divorced from the real world, but as signs of God. Islamic cosmology ranks God at the top and, at the same time, recognizes His encompassing presence in every dimension in the Muslim "hierarchy" of creation.

The diversity of space in the Islamic universe is aligned and polarized by means of a focal point in Mecca, which is the *Ka'aba*, a square building inside the great mosque in Mecca containing a holy Black Stone said to have been given by God to man. The Ka'aba is the most sacred architecture of Islam. It is the liturgical axis with which the *mihrab* of every mosque is aligned. Every Muslim turns toward its direction to pray. Muslims pay high reverence to the *Ka'aba* not as an object of worship but as a point of convergence where the spiritual and material life of the Muslims comes into contact.

The spot on which the Ka'aba is constructed is believed to be the first part of the world to be created. It is the *axis mundi* of the Muslim cosmos, being the location at which communication between celestial and terrestrial realms is possible. The harmony, dimension, stability, and symmetry of the Ka'aba are design principles that inspire and guide Muslim designers and builders all over the Islamic world.

The Mosque and the Axis of Prayer

At the core of Islamic law stand the Five Pillars (in Arabic, it literally means "corners"). This does not equate to an architecture of faith that is pentagonal, for the Pillars are configured in a pattern of a quincunx (an arrangement of five objects in a square, with four at the corners and one in the center). The First Pillar, the *shahada* (the profession of faith that begins with the verse "There is no God but Allah and Muhammad is the prophet of Allah") is at the center to which the

3.4 and 3.5 The Muslim settlement pattern is dominated by a spatial locus established by the mosque or masjid. Protected areas called *harams*, meaning "inviolate zones," are sanctuaries or places where contending parties could settle disputes peacefully. Towns are usually built near a river, which provides drinking and domestic water (upstream) and carries waste and sewage away (downstream). The harams are typically positioned to ensure access to parkland and nature, restrict urban sprawl, and protect water courses and watersheds.

remaining four are peripheral: salat (prayer); *siyam* (fasting); *zakat* (charity tax), and hajj (pilgrimage). The Pillars which have an architectural implication are the salat and the hajj.

Through worship, the congregation of the faithful becomes one with God in a sublime state of humility and reverence, best attained in the mosque, which in its Arabic equivalent, *masjid*, literally translates to a "place of prostration." The function is clearly established in Sura 24, Aya 36:

> In houses which Allah has permitted to be exalted and that His name may be remembered in them, there glorify Him therein in the mornings and the evenings (Koran 24:36).

Architecturally, the mosque's basic shape is derived from early Christian churches, with their important entry courtyards, and from Middle Eastern courtyard houses, possibly because the Prophet Muhammad, Arab founder of the Islamic faith, addressed his first followers in the courtyard of his house.

At the outset of its inception, the mosque structure consisted only of a courtyard bordered by a wall, patterned after Muhammad's house in Medina, Saudi Arabia, which consisted of a courtyard surrounded by a brick wall of living rooms and a latrine. This courtyard was the place where the early Muslims congregated for their daily prayers. This first embryonic mosque, characterized by an open quadrangular court, soon developed into a building complex equipped with a number of functional and decorative elements and incorporating spatial arrangements unique from components and buildings of earlier religions.

The Ka'aba

The Ka'aba is believed to have been constructed at God's command by Abraham and his sons, Hagar and Ishmael. It is located on the site which many believe to have been a sanctuary founded by Adam, the first man. In the pre-Islamic era it functioned as a shrine to 360 Arabian divinities, and it was not until 630 (Christian Era) that Muhammad overthrew these divinities and rededicated the shrine to one true God. Every year, two million pilgrims visit Mecca to perform the hajj or pilgrimage. The hajj can only be performed in the 12th lunar month of the Islamic calendar.

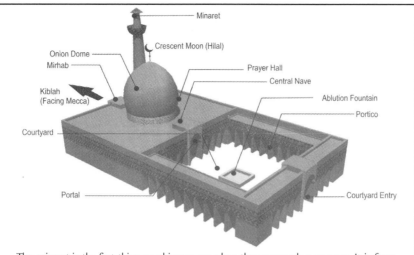

Onion Dome	Minaret
Mirhab	Crescent Moon (Hilal)
Kiblah (Facing Mecca)	Prayer Hall
	Central Nave
Courtyard	Ablution Fountain
	Portico
Portal	Courtyard Entry

The *minaret* is the first thing worshippers see when they approach a mosque. It is from here that callings to the mosque are made. The *ablution fountain* is where worshippers wash their hands, face, and feet before entering the prayer hall in order to ensure that they are pure. The wall of the mosque that faces the direction of Mecca is called the *kiblah*. In the center of the kiblah wall is the mihrab or prayer niche which is a very sacred area of the mosque. It is also important acoustically as it allows the voice to resonate during prayer. The *mimbar* is a pulpit from which the Friday sermon is preached.

The mosque can be defined as a building erected over an invisible axis. This axis is the principal determinant of the mosque design. The Muslim universe is distributed like a centrifugal wheel with Mecca as the hub, with lines drawn from all mosques in the world forming the spindle. These lines converge on the city of Mecca and the centerpoint is the Ka'aba. Mecca, the birthplace of Muhammad, is Islam's sacred city and the goal of the pilgrimage. The Ka'aba, a hollow cube of stone, many times rebuilt, is the axis mundi of the Islamic cosmology. It is diagonally oriented, with its corners facing the cardinal points. During the hajj ceremony, the pilgrims circumambulate the Ka'aba seven times, resembling an immense whirlpool when seen from the minaret.

Prayer, the Second Pillar, can be construed as the use of the horizontal axis by which one relates to the vertical axis as represented by the Ka'aba. The mosque becomes grounded around a single horizontal axis, the *kibla*, which traverses invisibly down the middle of the floor and, issuing from the far wall, terminates eventually in Mecca. The orientation of the edifice along the kibla is in compliance with the regulation provided by Sura 2 Ayah 145, which states that:

> And now We will turn you indeed towards a Qibla which shall please you. So turn your face [in prayer] toward the Sanctified Mosque, and ye [o Muslims] wheresoever ye find yourselves, turn your faces [likewise] toward it. (Koran 2:145).

Trimmed to its essentials, the mosque, therefore, is no more than a wall at right angles to the kibla axis. At the point where the kibla axis intersects with the wall an indentation is produced, a directional niche called the mihrab, which is a liturgical axis made visible. The mihrab is the visual and liturgical climax of the mosque. It

3.6 The mihrab or directional niche of the Golden Mosque of Quiapo. To the right of the mihrab is a raised pulpit called mimbar, where the imam delivers his sermons.

is in relation to the kibla axis that the principal liturgical furniture is distributed and arranged. The imam, as the leader of mosque prayer, stands just within the niche. To the right of the mihrab stands the mimbar, a raised pulpit where the imam delivers his sermons.

The minaret, the dome, and the ablution area comprise the external features of the mosque. The *muezzin*, a mosque official, summons Muslims to prayer from a minaret five times a day. The minaret requirement for height is directly proportional to its ability to reach a wider acoustic coverage. The higher its elevation, the greater is the area over which the sound can be distributed. However, with the advent of electronic sound amplification, the minaret is fitted with loudspeakers, rendering the muezzin's balcony obsolete.

The dome is a cosmic symbol in almost every religious tradition. In Islam, it represents the vault of heaven in the same way that a garden prefigures Paradise. Since the dome stands for heaven, the Paradisal Tree provides an appropriate motif to decorate its interior surface.

In the Philippines, the ablution area or the *wudu* is the nearby river or lake where the mosque is strategically sited. In the absence of natural bodies of water, a tank that is built near the mosque suffices. The ablution area emphasizes water as an Islamic symbol of initiation. Similar to Christianity, water, in Islam, is a vehicle of purification and assumes a sacramental status. Ablution may be total or partial depending on the state of ritual impurity in which the worshipper finds himself.

The entrance to the mosque stands as another barrier for the purpose of demarcating pure and impure areas. It is at this threshold that worshippers remove their footwear before entering the mosque. This is to preclude the possibility of ritually impure substances adhering to the soles and being deposited on the mosque

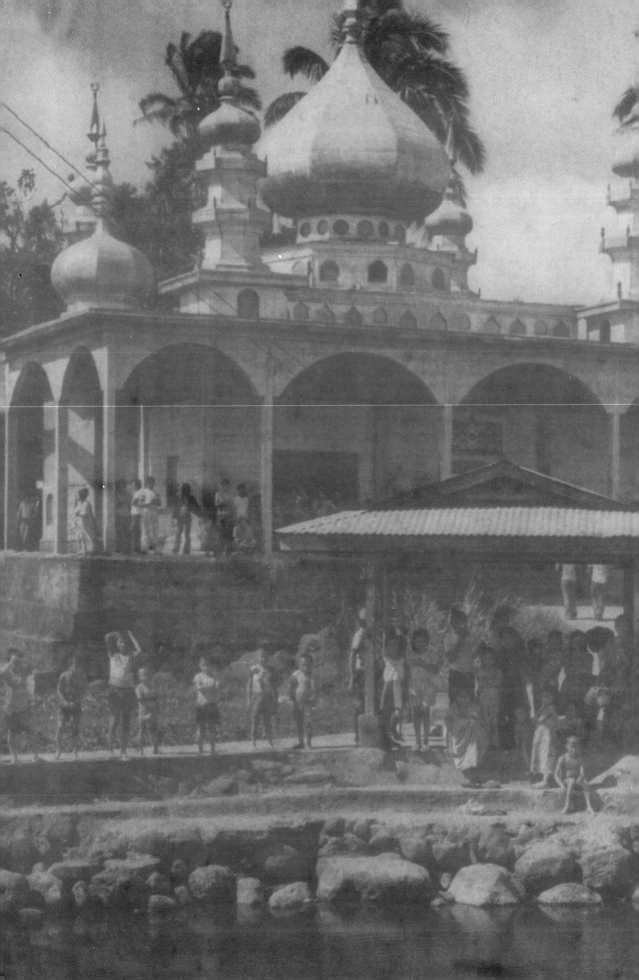

floor. Shoes are left in racks at the entrance or set against the walls. In addition to the removal of footwear, the congregants should properly cover their heads as a sign of respect for the Divinity.

Formal prayer in Islam consists of repeated sequences of standing, bowing, prostration, and genuflection. Islamic prayer is not only a mental and verbal act but also a physical one involving the entire being.

Prayer is established at four levels: the individual, the congregation, the total population of a town, and the entire Muslim world. Distinct liturgical structures correspond to three of these levels. The first is the masjid, the mosque used for daily prayer by individuals or small groups but not for Friday worship. A Muslim can pray in any place that is clean; a prayer rug also corresponds to this level. Prayer is held at five liturgical hours: dawn, noon, afternoon, sunset, and evening. The second is the *jami*, the congregational Friday prayer held at the mosque, which is obligatory for all male Muslims who have reached the age of reason. The third, although not a mosque but an open space, is the *idgah* or *musalla* (place of prayer), which serves as a site of communal worship on special occasions, including the two chief Muslim festivals, the Eid al-Fitr and the Eid al-Adha. In the end, the mosque represents the place where a concerted submission of all Muslims to a monotheistic God is publicly performed. Compliant with the religious belief in egalitarianism, there is no formal hierarchy in the simple rituals. Usually the only religious dignitaries involved in the organization of religious practices are the *khatib*, or teacher, and the *imam*, or the prayer leader.

The Architecture of the Philippine Mosque

The Koran contains no special or specific instruction for the architectural form of its worship space. Filipino Muslim architects are free to interpret these basic requirements in accordance with their own preexisting ideas. They have no exact indigenous equivalent from which to pattern the mosque. The mosque is a totally new building type. The physical features of early Philippine mosques have been ascertained through the amalgamation of Islamic and indigenous notions about the form which sacred architecture should assume.

There is a dearth of knowledge regarding the evolution of mosque typology in the Philippines, including the history of its architectural design. This fact may be explained by the following reasons: 1) much of the earliest types of mosques built by early missionaries of Islam were made of materials prone to deterioration and defiant to permanence, such as wood, bamboo, and cogon; 2) the extant earlier types of mosques were either demolished, destroyed during earthquakes, or were reconstructed and remodeled to conform to modern architectural types sourced from Middle Eastern designs; 3) the annual pilgrimage to Mecca radically transformed all early mosques, as these pilgrims were acquainted with Islamic buildings and sought to replicate their sacred experience derived from these idealized Islamic monuments in their own locales.

There are two types of traditional structures used by Philippine Muslims for worship: the *langgal* (Tausug and Yakan) or *ranggar* (Maranao), and the masjid or *maskid*. The terms all denote a "mosque." Langgal, which literally means "to meet," refers

3.7 The absence of an ablution fountain or wudu as an architectural element in most of Philippine mosques is compensated by siting the mosque near a natural body of water. The ablution area emphasizes water as an Islamic symbol of initiation. Similar to Christianity, water, in Islam, is a vehicle of purification and assumes a sacramental status.

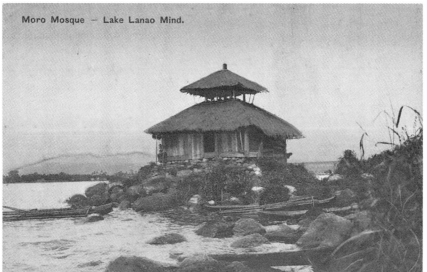

Moro Mosque — Lake Lanao Mind.

3.8 A postcard of a masjid in Lake Lanao in the early 1900s. Prior to the Second World War, masjids were multitiered bamboo or wooden structures reminiscent of Chinese pagodas or Javanese temples. This mosque archetype is predominant in the Indonesian archipelago and the Malay Peninsula.

3.9 A mosque in Lanao, built in the 1950s, combined the multitiered roof with an onion-shaped dome. Air travel allowed many Muslim Filipinos to perform the hajj in Mecca, exposing them to the Middle Eastern mosque that had a bulbous dome on squinches. The bulbous dome was an architectural element favored by the Mugals who spread the style in Persia, the Indian sub-continent, and Asia.

to a mosque that can accommodate a small group of worshippers who assemble every Friday in such a spiritual space. Commonly built in rural areas, its design is no different from Southeast Asian prayer houses. The masjid, on the other hand, is commonly associated with any building that includes a dome and a minaret as an integral part of the design regardless of period styles.

Among the older generations of Muslims, the word masjid is used interchangeably with the langgal to signify a place of worship of whatever dimension or stylistic persuasion. The masjid is differentiated from the langgal by its larger and more permanent structure, stone foundations, and its location near a river or body of water. It is only in the masjid where the Friday noon assembly prayers (with sermon) and two important Muslim festivals may be held. The ranggar or langgal, on the other hand, is somewhat synonymous to a small chapel made of semipermanent materials built for the convenience of the worshippers who live far from the masjid.

In the Philippines, up until the end of the Pacific war, the mosques were mainly constructed of wood. They were all roofed over a space big enough for at least forty (or forty-four in Sulu) worshippers, the number required to render a Friday congregational prayer legitimate in accordance with the parameters of the Shafi'I school of jurisprudence. While the general features of Philippine mosques approximate the traditional Islamic type of mosque, some of their characteristics are peculiar to the country. For one, the *sahn* or wide enclosed courtyard furnished with an ablution fountain is generally absent; instead, a seating area with benches is provided outside the mosque where worshippers may sit and talk while waiting for the next prayer. Similarly, the mimbar (elevated pulpit) is not high unlike those of Africa and Western Asia. An elevated platform, a chair or any similar furniture can replace and function as a mimbar in some mosques. Here, the preacher delivers a sermon during Friday congregational prayers. Furthermore, the call to prayer is usually done not on tall minarets, but inside the mosques. Hanging drums, variously called *tabo*, *jabu-jabu*, or *dabu-dabu*, are beaten to summon the worshipper from afar to the mosque. Among the Yakan, a bamboo drum is used for calling people to worship. But this practice is discouraged by the *Ulama*, a body of religious scholars and leaders who have jurisdiction over legal and social matters for the people of Islam, because of its Jewish origin.

While minarets may be present in most Philippine mosques, they are not functional unlike those in the Middle East and India. With the advent of electronic sound amplifiers, minarets are instead reduced to mere decorative vertical appendages, but they remain an essential iconic element of the mosque. Some minarets are installed with loudspeakers to preserve its traditional architectural function. Nowadays, a microphone is placed right beside the mosque where the imam stands. This is the place where the *azan* is called.

Aside from the minarets, another ever-present iconic element of Philippine mosques is the crescent and star ornament that surmount the bulbous domes. The use of *okir* carving and the *burak* (centaur)—a mythical winged creature, half-human, half-horse—and other motifs in highly colorful designs is also a local introduction. The mosques of Lanao are unique for the presence of an inverted jar (perhaps originating from the Sung or Ming dynasty) placed at the apex of the dome (known locally as *obor-obor*). This Chinese jar is considered as a *posaka* (heirloom) among the Maranaos. This jar and the pagoda-like silhouette of the early mosque in Lanao provide evidence of a strong Chinese influence among the Maranaos.

Some mosques have separate entrances for male and female worshippers, while others have common entrances for both sexes. Inside the mosque is a white cloth

hung to segregate the males from the female congregants. Other mosques have a mezzanine-like structure in its interior devoted for female prayer. Women usually stay at the back of the men during worship.

The masjid was formerly a multitiered bamboo or wooden structure reminiscent of a Chinese pagoda or Javanese temple, a mosque prototype predominantly found in the Indonesian archipelago and the Malay Peninsula. The regionally characteristic roof consists of three ascending layers of flared pyramidal roofs separated by gaps to allow direct air and light into the building. These tiers are held aloft by four great columns in the center extending to outer columns for the lower, wider roofs. The centralized, vertical hierarchy lends the structure to a square plan only disrupted by a small section of the porch area of the *iwan*, which juts from the front of the mosque. Locally, the roof layers may assume a three-tiered, five-tiered, or seven-tiered superstructure, decorated with pottery finials at its pinnacle. Scholars of Southeast Asian architecture agree that the Javanese mosque, which is characterized by its multilayered roof capped by an ornamental pinnacle, is actually a design pattern that had its origin in China where the pyramidal roof and rooftop ornament have been known for centuries. This architectural cross-wiring may be attributed to close diplomatic ties established by the Chinese Ming dynasty with many Muslim states in the Southeast Asian archipelago. In fact, the Ming dynasty (1368–1644 AD) brought Islam to China under the aegis of Emperor Chu Yuan-chang (better known as Hung Wu), who traced his Muslim roots to Medina and commanded the building of a mosque in Nanjing after he ascended to the throne.

The multilayered roof of the pagoda-style mosque is exemplified by the oldest standing mosque in the Philippines found in Tubig, Indangan, Simunul islands, Tawi-tawi. This mosque, built in 1380, is attributed to Sheikh Karimul Makhdum, one of the first Arab missionaries who brought Islam to the Philippines. The mosque is square in plan, with a huge post at its corner. It has a main enclosure of a gabled

3.12 A 1931 photograph of the Sheikh Karimul Makhdum Mosque, the oldest standing mosque in the Philippines, found in Tubig, Indangan, Simunul islands, Tawi-tawi. The mosque was built in 1380.

roof made of palm leaves with the lower roof supported by smaller posts enriched with okir carving. Scholars claimed that the Simunul mosque had undergone modification and reconstruction in several instances in the past; specifically, its roofing of palm leaves may have been replaced over time and its floor area may have been extended at various times. But its four, huge wooden posts of ipil, whose surfaces are fully elaborated with okir reliefs, are believed to be authentic to the original mosque.

Two photographs of the Simunul mosque, one shot in 1923 and another in 1975, reveal the degree of modification that the structure had undergone in less than a hundred-year period. In the first shot, the mosque appears as a slightly elevated, box-like wooden structure with a gabled roof of palm, while in the second photo, the palm roof had been replaced by a two-tiered, pyramidal roof of iron sheets over which a slender minaret-like tower is capped by a bullet-shaped dome.

To commemorate the 600 years of Islam in the Philippines, the Simunul Mosque was again renovated in 1982. With a political pretext, the Marcos government funded the project as a means to portray the regime's deference to Muslim culture and to appease the Filipino Muslims who were, at the time, up in rebellion against the state. The contemporary Simunul Mosque now has a central dome and a detached minaret, which recalls the stepped contours of the minaret of Samarra Mosque in Iraq. Parts of the interior wall are lavished with okir and Koranic calligraphic inscriptions. With all the architectural interventions, what remained from the original mosque are the four hardwood posts. In 2006, the mosque, officially known as the Sheikh Karimul Makhdum Mosque, was declared by the Philippine government as a national shrine through a bill approved by the Senate.

In mainland Mindanao, the first mosque to be constructed was approximately in 1515. Its construction was credited to Sharief Kabungsuwan, who founded the Sultanate of Maguindanao. From Maguindanao, Islam proliferated in the areas

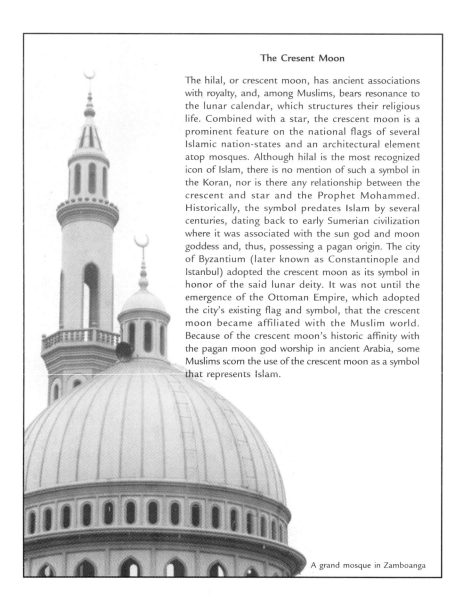

The Cresent Moon

The hilal, or crescent moon, has ancient associations with royalty, and, among Muslims, bears resonance to the lunar calendar, which structures their religious life. Combined with a star, the crescent moon is a prominent feature on the national flags of several Islamic nation-states and an architectural element atop mosques. Although hilal is the most recognized icon of Islam, there is no mention of such a symbol in the Koran, nor is there any relationship between the crescent and star and the Prophet Mohammed. Historically, the symbol predates Islam by several centuries, dating back to early Sumerian civilization where it was associated with the sun god and moon goddess and, thus, possessing a pagan origin. The city of Byzantium (later known as Constantinople and Istanbul) adopted the crescent moon as its symbol in honor of the said lunar deity. It was not until the emergence of the Ottoman Empire, which adopted the city's existing flag and symbol, that the crescent moon became affiliated with the Muslim world. Because of the crescent moon's historic affinity with the pagan moon god worship in ancient Arabia, some Muslims scorn the use of the crescent moon as a symbol that represents Islam.

A grand mosque in Zamboanga

of the Maranao through marriage alliances. Adherence to Islamic faith consequently led to the construction of mosques.

The genesis of the first mosque in Lanao can be inferred through oral traditions. Two conflicting oral accounts claim the existence of the oldest mosque in the area. Common to both oral traditions is the claim that the first mosque built for the Maranaos was in Ditsaan, but they differ only as to the architectural sponsorship. As asserted by the Taraka people, who settled at the eastern side of Lake Lanao, the Babo-Rahman Mosque, constructed by Apo Balindog, is the oldest. *Babo* comes from the Arabic word *baab*, which means door, and *Rahma* symbolically signifies the "door of mercy." In a sense it is the first mosque erected symbolizing the conversion of the people to a new faith. However, other sources mention the mosque built in Bundi Alao in the *inged* (township) of Ditsaan (presently a part of the Ditsaan-Ramain municipality) as the pioneering mosque in the area.

3.13 Mosque in Maibung, Sulu. This mosque with an onion dome was one of the first to be built after the Second World War, manifesting a strong Persian decorative influence combined with the use of modern materials, such as reinforced concrete and mass-fabricated ornamental pierced blocks.

3.14 The Blue Mosque in Maharlika Village in Taguig City. The mosque was designed by Gabriel Formoso in the late 1970s as part of the residential complex built by then First Lady Imelda Marcos to address the housing needs of migrant Muslims in Manila.

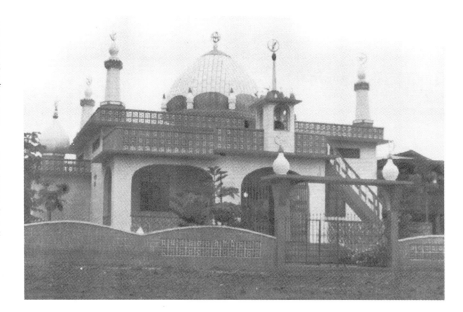

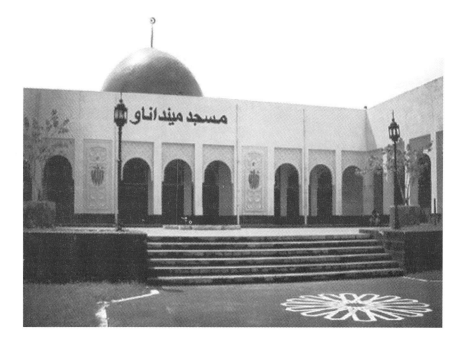

Another mosque style, whose prominent feature is the bulbous dome (also called the onion-shaped dome) on squinches, emerged as a result of exposure to mosques in the Middle East in the course of visiting Mecca for the hajj. The bulbous dome was favored particularly by the Mugals who spread it in Persia, the Indian subcontinent, and Asia. As this form of high-style Islamic architecture was allowed to interface with indigenous mosque styles, changes were introduced to localize the Middle Eastern style in terms of materials and methods of construction. For instance, the dome was modified from circular to octagonal because it is more convenient to construct a polygonal dome than a rounded one using wood.

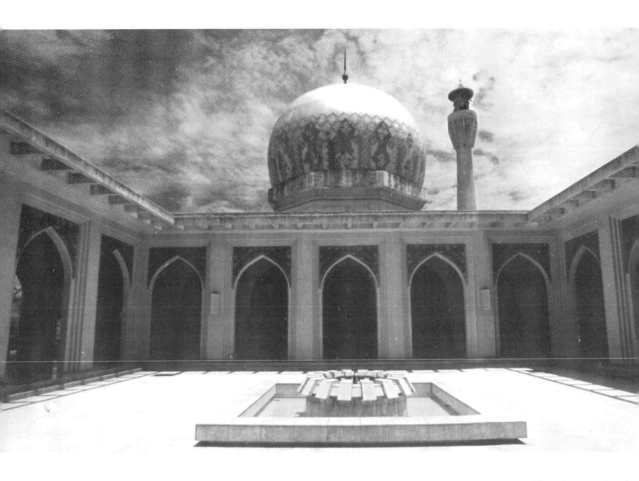

The post-Second World War resurgence of Islam worldwide brought about an increase in the number of mosques in Mindanao and in the Sulu Archipelago. Before the war, it was estimated that there were only fifty-four mosques all over Mindanao. These mosques, built mostly of austere and temporary materials (wood, palm, grass, etc.) in tiered style, were generally plain and unadorned. They provided a palm-leaf roofing to cover a rectilinear internal volume having enough room for at least forty congregants. Some were built with a small roof covering raised slightly to form a clerestory, providing natural light and ventilation in a way that approximates the numinous effect of the dome.

Today, there are hundreds of mosques in many Muslim communities around the Philippines, a large percentage of which are built of permanent materials (reinforced concrete, marble, glazed tiles, prefabricated components, etc.) and heavily inspired by the domed mosque styles from West Asia and North Africa. One of these is the Golden Mosque, a part of the Islamic Center in Quiapo, Manila. Designed by Jorge Ramos, with stained glass panels by Antonio Dumlao, it is called such because of its gilded dome, glimmering on Globo de Oro Street. It was designed to symbolize the nation's Islamic heritage through a modernist interpretation of Maranao design motifs in geometrized form. The project was sponsored by the then First Lady Imelda R. Marcos in 1976 in anticipation of the state visit of Libya's strongman, Muammar Khadafy. The state visit was cancelled, but the mosque remained to become the biggest mosque in Metro Manila, with a maximum capacity of 3,000 worshippers.

3.15 The sahn or enclosed courtyard of the Golden Mosque of Quiapo designed by Jorge Ramos in 1976. The courtyard is furnished with an ablution fountain placed at the center of the courtyard.

Aside from the Quiapo Mosque, other outstanding mosques of this style are the King Faisal Mosque at the campus of the Mindanao State University and the Blue Mosque in Maharlika Village in Taguig. Both of these mosques maintain the traditional elements but incorporate modern ones in design and planning. The mosque complex may also contain a *madrasa* (school), a library, a conference hall, and other function rooms around an open courtyard behind the main prayer hall or the mosque proper. Arabic geometric designs as well as large Koranic inscriptions have become more common in the ornamentation of modern mosques and have supplanted in many localities the traditional okir designs, such as those in the Al Foqara Mosque in Manila Bay and the Jama Masjid in Manila.

In the Philippines, the mosque is constructed with funds derived from annual contributions and other religious and financial obligations collected from its followers. It is designed and built for them and symbolic of their acceptance of the Islamic faith. The mosque as an architectural form has undergone numerous changes both in surface and in form, but its main features have remained. Most importantly, the symbolic value of the structure has been strengthened and renewed in every new mosque. This place of worship has continued up to our time not only as a religious edifice but also as a political, social, and cultural center for our Muslim brothers.

The Center of Islamic Instruction

At first, mosques were not meant to be important visual symbols. Their function was primarily the provision of a place for public worship. Yet mosques also possessed a secondary educational function—to strengthen the bind between Islamic religious and secular thought. Since literacy in Arabic was imperative for Islamic cohesion and expansion, the complexes that Muslims built to accommodate the activities of their faith in all parts of the Islamic world also included schools. Later, communities in the pursuit of intellectual enrichment established private academies of Islamic jurisprudence. The buildings they erected solely for teaching Koranic, philosophical, and administrative laws are known as madrasas, originating from the Arabic *darasa*, which means "to read" or "to learn." Madrasas are separate from, but adjacent to, the mosque; the complex includes classrooms and lodgings for students and teachers.

3.16 An early twentieth century mosque and madrasa in Jolo, Sulu

The origin of the madrasa has been traced to the tenth-century domestic courtyards in the Iranian province of Khurasan, where believers maintained their allegiance to the orthodox Islamic faith despite contemporary political questioning and emergence of new doctrines. The Serljuk rulers of Khurasan, who made education a strategy to return to basic Islamic ideology, patterned their mosques from the Khurasanian cruciform house plan: a central courtyard with four arched openings forming an axis-cross-axis design. As the Seljuk Empire expanded, it brought the classic madrasa–type of mosque to other parts of the Islamic world.

In the Philippines, the madrasa was introduced at the outset of the Islamization process and continued to be a vital force in the dissemination of Islamic doctrine, especially among the Muslim youth. However, the Philippine madrasa has failed to evolve beyond its basic functional requirements.

Muslim Secular Architecture

Forts and Royal Residences

In Mindanao and Sulu as well as in Manila and Mindoro, the early Filipinos constructed forts or *kota*. In a broader sense, the said structure denotes any fortified site, which may include a well-protected residential compound. The efficient design of the kota in Islamic settlements repelled many Spanish and American assaults.

Spanish chroniclers describe Raja Sulayman's fort in Manila as one constructed from palm tree logs dominating a narrow knoll. Wide gaps in the walls allowed ten to twelve mid-sized artillery pieces to project through. Sulayman's house was also big enough to accommodate ammunitions and other weapons.

Other notable kota during the Spanish regime include Sultan Kudarat's kota in Ilihan Heights near his capital in Lamitan, which had trenches planned by the

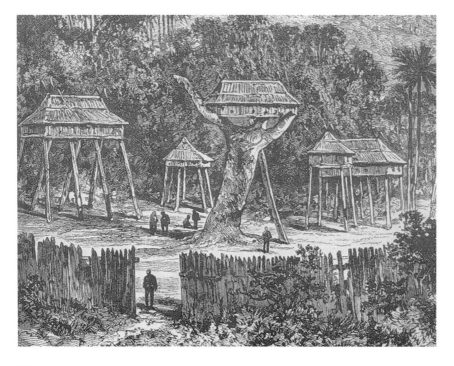

3.17 A kota was a fortified settlement bordered by a palisade, which is a series of long strong timber stakes pointed at the top and set close to each other to form a defensive wall.

Dutch; the Maguindanao and Buayan kota chain built on hills, swamps, and plains along the Pulangi River, and which featured long-range cannons manufactured by the Portuguese and Dutch; the Maranao kota in Lanao, which greatly harassed the Spaniards; the Sama kota, in Sipak, Balangigi, Sungap, and Bukotingul—the most impressive being the Sipak kota which had 5.4 to 6 meter-high walls of thick tree trunks filled with coral, rock, soil, and earth.

Antonio Morga (1609) provides a description of indigenous fortifications, which was made up of "walls of palm trees and stout arigue (wooden posts) filled with earth." *Lantaka*, the native culverins, were mounted at strategic points on these walls. Houses were usually located inside the fort to insure the safety of their inhabitants.

Spain's failure to subjugate Mindanao, except for limited areas like Zamboanga, left much of Mindanao to its original inhabitants, most of whom were Muslims. Here the early kotas or forts have remained, unlike those captured by the Spaniards, which were then converted into Spanish forts.

The kota was significant because inside it was the torogan, the Maranao chief's residence. Although "torogan" implies a place for sleeping, it serves many other purpose. Aside from being the house of the royal family, the torogan can also be the warriors' den, a storage house, an ammunition area, as well as an assembly place for ceremonies.

The houses of the chiefs were the most prominent within a kota and were said to be impressive:

> They are built upon trees and thick arigues, with many rooms and comforts. They are well constructed of timber and planks, and are strong and large. They are furnished and supplied with all that is necessary, and are much finer and more substantial than the others (Blair and Robertson, vol.xvi, 84).

The interior of the house was usually divided into several rooms, separated based on the activity or function in the house, or settled according to the location of the household implements. The area below the house was enclosed to keep domesticated animals and fowls.

The Maranao residential palace has a ceremonial umbrella design for its roof, soaring as if to proclaim the exalted status of its occupants. The huge posts signifying established power may be plain and massive or they may be carved to look like clay pots or huge chess pieces. These posts rest on stones to allow the house the flexibility to sway with earthquake tremors. The torogan is best known for its row of carved panolong in ornate motifs, which flare out from the façade in high-spirited, wave-like patterns of okil design sculpted to look like the prow of a boat. This feature gives the torogan the appearance of a floating royal vessel, reminding one of an Austronesian seafaring past.

Mindanao and Sulu Vernacular Houses

The archipelagic features of the Philippines have encouraged both terrestrial and naval architecture. Filipinos living in maritime regions have, for centuries, constructed houses on stilts. Sea nomads, such as the Samal, the Tausug, the

Yakan, and the Badjao, inhabit these amphibious houses. Although descending from the Austronesian architectural tradition, the houses found dominant among the different Muslim communities in the South are categorized into: land-based stilted dwellings situated along the shoreline, oceanic dwellings built completely over the sea and entirely detached from the shoreline, and houseboats, which serve as both home and fishing boat to the Badjao.

Sulu houses are supported by piles driven deep enough for structural anchorage into the reef floor. The houses are connected to the shore and linked to one another by a network of above-sea-level catwalks and bridges of timber and split bamboo. The elevation of the house must be higher than the maximum high-tide level in order to allow the storage of the outrigger boat underneath the house when not in use. With this arrangement, the Samal could easily get inside the house from their boats after fishing or shell gathering, and they can easily get out to their fishing grounds as well.

Ancestral houses are quite large with dimensions reaching up to twenty-four by twelve meters and nine meters high at the gable. These traditional houses are two-

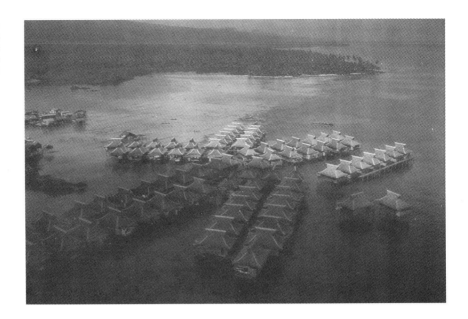

storeyed, with balconies, and elaborate carvings. The large space is intended to accommodate the members of the extended family, such as in the case of the T'boli's. In fact, it is not surprising to find an average of two or three, to as big as fifteen, nuclear families living together under one roof. However, the more recent houses have a smaller dimension of about four by six meters and are three meters high. A typical house is simply designed to have only a single level for sleeping, living, cooking, and eating. The silong or space underneath the house serves both as a shed for the boat and as an area for bathing. The open porch or terrace called *pantan* is important to the Samal tribe because it is here where they work, accept visitors, hold rituals, and allow the children to play. The interior is plainly provisioned, except for a baby's cradle. It has no partitions or ornamentations.

The Badjaos are frequently spotted in the channels of Tawi-tawi province or where fishes and corals abound for their livelihood. They use their shelters as a means of travel, which they usually do in groups. Their mobile shelter allows them to flee to safer grounds in the event of a typhoon or pirate attack. Their house has a native bench and a detachable A-frame roof. It is structurally supported by a *katig*, which allows the boat to float steadily. Likewise, the katig is anchored to the main structure by a bow-like wooden frame called *batangan*. The floor is made of unnailed loose implements and fishing tools. The interior of the houseboat is divided into three major zones: for sleeping, cooking, and storing fishing tools. Sleeping and dining are done in a particular area that gets used only during the night and during rest time.

The most interesting feature of the Badjao houseboat is the elaborate carving employing okir design on the walls and prows, stems, shafts, and gunnel of the boat. It is usually designed and carved by the owner himself.

Maranao

The Maranao, the "people of the lake," is the largest Islamic ethnolinguistic group. The four settlement principalities, known as *pangampong*, around Lake Lanao in the province of Lanao del Sur are the traditional population centers of the Maranaos.

A 108 · On the Rio Grande, Mindanao, Philippines.

These settlements are organized like a hamlet, consisting of three to thirty multifamily dwellings. In areas where wet-rice agriculture is practiced, the houses are generally organized in rows following the length of a river, road, or lakeshore. In dry-rice land areas, communities are smaller and the houses may aggregate irregularly near a water source.

Maranao houses are of three types: *lawig* (small house); *mala-a-walai* (large house); and the torogan, the ornately decorated ancestral residence of the datu and his extended family.

Lawigs vary in size from field huts, which are raised above ground on stilts with lean-to roofing and an outdoor cooking area. These structures are mainly used for sleeping. In the population centers, lawigs are common household structures which have an interior hearth. Usually occupied by a single family unit, the lawig is not normally adorned, except for an occasional wooden adornment that may embellish the window sill or door portal.

The mala-a-walai, a single-room and partitionless structure, is the house of a well-to-do family. Although architectural ornaments are present in the stucture, the house does not have the panolong, an elaborately carved beam extension identified with the royal torogan. The okir decorations are generally to be found on the baseboards, windowsills, and doorjambs. The mala-a-walai stands 0.3–2.2 meters above the ground and rests on nine to twelve bamboo or wooden poles. The *kinansad*, a bamboo-fenced porch, marks the facade of the house; the kitchen, which is 0.50 meters lower than the structure, is located at the back. The main body houses the sleeping area, which doubles as a living and working area at daytime. Storage space can be found underneath the main house and the kitchen.

Chests, headboards, mosquito screens, or *sapiyay* (woven split rattan) are used to partition the interior into sleeping and non-sleeping zones. Covered with a *riyara* woven mat, bundles of rice stalks function as bed mattresses, the head and foot of which are laid out with pillows. Over and beside the bed are the *taritib* canopy and the curtains respectively. The roof of the mala-a-walai is made of thick cogon thatch secured on bamboo frames by rattan chords or occasionally, of bamboo

3.21 Tausug fishing village in Jolo, Sulu

3.22 Badjao houseboat

**84** ARKITEKTURANG FILIPINO

spliced into two halves (*rangeb*). Notched bamboo poles are placed at the front and back of the house to serve as ladders.

Although both houses are large and raised on stilts two meters above ground, the torogan is distinguished from the mala-a-walai by features that signify royalty and

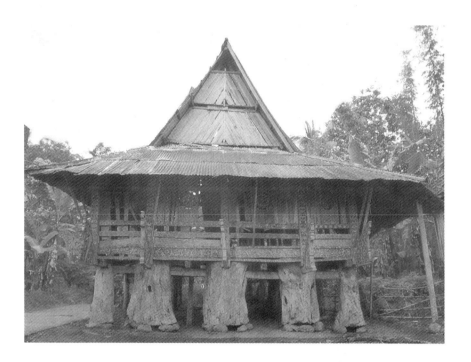

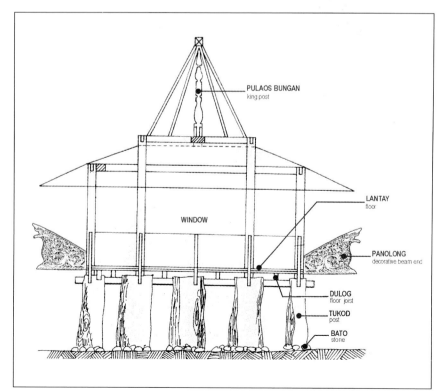

3.23 Maranao torogan. The torogan, which literally means "a place for sleeping," is the ornately decorated ancestral residence of the datu or chief and his extended family

3.24 Cross-section of a torogan

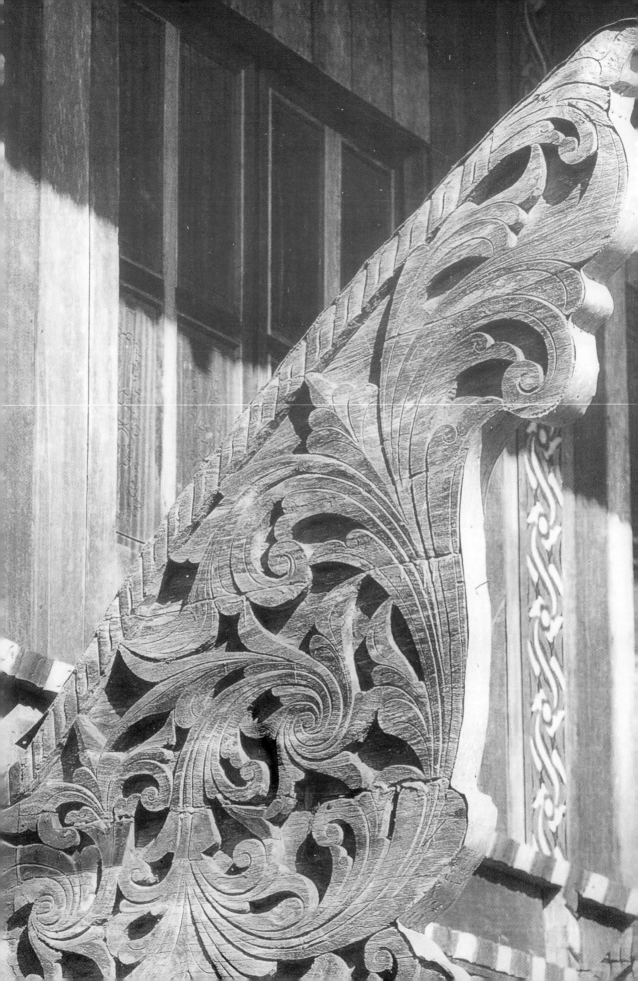

prestige. The torogan has more posts, numbering to as many as twenty-five, some of which are non-loadbearing. At the facade, huge tree trunks are used as posts. Since the land is tectonically volatile, timber posts are not buried into the ground; rather they stand on rounded boulders, which act as rollers that allow the structure to sway with earthquake movements (thus averting the possibility of the structure to collapse). Furthermore, these boulders prevent direct contact of the post with the ground, thus inhibiting termite attack and wood decay. The posts on the frontage are usually carved and decorated with okir motifs and may occasionally assume a chesspiece-like contour.

The most noticeable feature of the torogan is the panolong, a wing-like house beam with a *pako rabong* (fern) or naga (serpent) motif. The panalong are ends of the floor beams that project and splay out like triangular butterfly wings on the facade and side elevations. The motifs are chiseled in high relief and painted with bright hues. The side strips, facade panels, and window frames are lavished in the same fashion.

The interior of the house is a cavernous hall with no permanent wall partitions. Supporting the kingpost of the high-ridged roof is the *rampatan* or *tinai a walai*, central beams considered as the intestines of the house. What serves as the ceiling is a cloth suspended from the rafters to absorb the heat from the roof.

The torogan is provided with a high and steep roof comparable to that of the Malacca house or the Minangkabau houses of Sumatra. A carabao horn ornament at the roof apex of the *rumah adat* house in Batak, Indonesia is indistinguishable from the Maranao *dongal* (*jungal* to the Badjao).

To assess the torogan's strength and resilience, it is traditional to have two carabaos fight inside the structure; if the structure collapsed, the house was dismissed as unworthy to be inhabited.

As a multifamily dwelling, each family is given a designated sleeping space provided with mats and sleeping mattresses (*lapa*) and demarcated from one another by a cloth divider. This sleeping area also functions as the all-purpose space—a living room, working space, and dining room. Guests are not permitted into the *gibon* or *paga*, the room for the datu's daughter, and the *bilik*, a hiding place at the back of the sultan's headboard. The torogan may also have the *lamin*, a tower-like structure serving as a dormitory and hideaway for the sultan's daughter and her ladies-in-waiting. The lamin is constructed atop the torogan and its entrance is always located near the datu's bed.

Maguindanao

The town of Cotabato represents a multiethnic amalgam of Chinese, Christian, and Muslims, with the latter no longer the predominant group. The earliest Christian settlers, the Zamboangueños, were concentrated on the riverfront along the west side of the town. But in recent times, Christian settlers are found scattered throughout the better residential areas, while the Chinese occupy apartments above their stores in the business district. A great number of Maguindanaos live in close proximity to the river in villages and towns on the outskirts.

3.25 Exquisitely carved panolong, the wing-like beam end, flares out at the façade and side elevations of the torogan. The surface is chiseled in high relief with pako rabong (fern) or naga (serpent) designs and usually polychromed in bright hues.

Traditional Maguindanao houses, which have close resemblance to traditional Maranao dwellings, maintain the features of a one-room house without ceilings and room partitions. Mats, wooden coffers, or woven cloth are interior elements that are used as provisional spatial markers. The following materials make up the Maguindanao house: nipa (for the roof), bamboo (for walls and floors), and rattan and hardwood (for structural and cladding requirements).

A Maguindanao house is typically built on nine posts and is provided with a porch serving as a transitional space connecting the house proper to the kitchen, whose floor level is slightly lower than that of the main floor. The space underneath the house is fenced, serving multiple functions, such as a place for weaving, a space for pounding and threshing rice, and an area for storing agricultural implements and rice produce.

Interesting features of the traditional Maguindanao house include the okir decorations, the steep and graceful roofs, the solid construction, the handcrafted ornaments, the concern for ventilation, and the concept of space. Contemporary houses incorporate all these features but may be rendered in modern materials, such as galvanized steel, aluminum sheets, concrete, and glass.

Tausug

The Tausug, whose name means "people of the current," are the second largest group of Muslim Filipinos. They are a dominant group in Sulu; more than half of their population live in the island of Jolo, while the rest are scattered in the Sulu archipelago, including the island of Tapul and Siasi, the coastal areas of Basilan, and the eastern coast of Borneo, Malaysia. Their traditional occupations include farming, fishing, and trade. The Tausug are renowned in the manufacture of traditional maritime vessels, weapons, and woven textiles.

The Tausug communities are located both inland (*tau gimba*) and along the shoreline (*tau higad*). Inland homesteads are dispersed, while concentrated fishing communities can be found along the coast. A Tausug community may have twenty to a hundred or more houses.

The Tausug house is a one-room structure supported by 1.8 to 2.5 meter-high stilts and surmounted by a pitched roof that may be gabled, hipped, or pyramidal. The preferred materials for its construction are wood, bamboo, and thatch. In some instances, a porch of light construction, an open deck, and a kitchen may be connected to this structure.

The traditional Tausug house or the *bay sinug* is a single-room partitionless structure. It has nine poles arranged in three rows of three, each representing the human anatomy. The post at the center, representing the navel (*pipul*), is the first to be erected. This is followed by the post on the southeast corner, which represents the hip (*pigi*); then the post on the northwest corner, the shoulder (*agaba*); that on the southwestern corner, the other hip; that on the northeastern corner, the other shoulder; that on the west of the navel, the rib (*gusuk*); that on the east, the

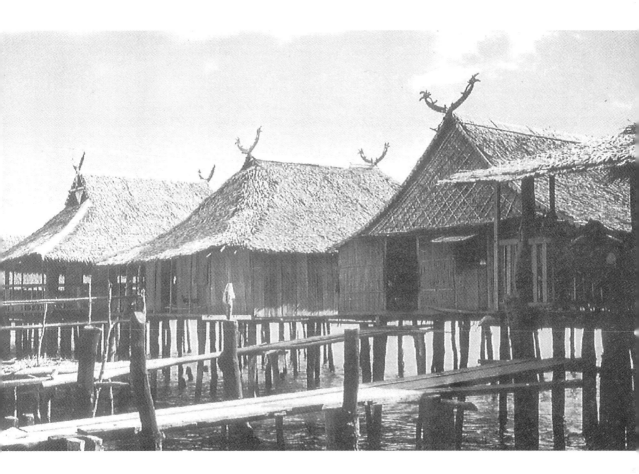

3.26 The Tausug house is distinguished by carved wooden finials, the tadjuk pasung, placed on one or both ends of the ridge of the gable or hipped roof

other rib; that on the north of the navel, the neck (*liug*); and that on the south of the navel, the groin (*hita*). Adherence to this sequence of post erection will guarantee the durability of the house and the safety of its inhabitants.

The eight noncenter perimeter posts rise to the roof level. The central navel post rises only to floor level. Connected to the post are floor and roof beams. Wooden floor beams are mortised to the side and corner posts, and also to the navel post. When the beams are made of bamboo, they are placed on brackets nailed or bolted to the wooden post. Bamboo beams are held to the post by lashing. Bamboo or wood joists set on the beams support the floor made of bamboo strips.

The roof is given form by the ridge beam and is made from *sari*, nipa, *sago* palm, or *niug* (coconut palms). Aside from a gable roof, roof forms include: the hipped roof with triangular vents (*sungan*), which is well ventilated by a hole formed by having only two (out of four) slopes meeting at the apex; and the pyramidal roof (*libut*), whose tip is cut off to provide a vent, which is protected by a pyramidal cap placed high enough to allow the unhindered discharge of rising warm air.

Carved wooden finials, the *tadjuk pasung*, shaped like a bird (manuk-manuk), swirling leaves (pako rabong), or a dragon (naga), are placed at one or both ends of the ridge of the gable or hipped roof. Instead of ceilings, the Tausugs decorate

the bilik (room) with a large *luhul* or rectangular cloth to catch leaves, dust, and insects. Depending on their economic disposition, the Tausugs use plywood, split bamboo, woven bamboo strips, or coconut palm as cladding for walls, which may rise up to about forty centimeters below the roof beams, thereby providing continuous openings for ventilation. This can only be achieved by piercing *jalajala* panels between the walls and the roof. Except for woven coconut palms, the walling usually has a window of various forms attached to it. In the past, the Tausug only had wall slits as windows to conceal their unmarried women inside. The flooring is usually of bamboo.

Yakan

The Yakans live in the mountainous interior of Basilan Island. Traditionally, the houses of the Yakan are either scattered among the fields or clustered around the *langgal*, a mosque made of the same material as the dwellings. The houses are individually owned, occupied by one family.

The Yakan house, called *lumah*, is a rectangular, ridge-roofed, single-room, pile structure of varying size and elevation from the ground. It has a floor area ranging from fifty to a hundred square meters. The steep pitch roof (*sapiaw*) is concave and is thatched with either cogon or nipa. Lately, the more durable galvanized iron sheets have been used, although they have proven to be visually and functionally incongruent, since the traditional Yakan house has no ceiling and few or no windows because of a belief that bad spirits could easily come in through these openings. Thus, there is often only one *tandiwan* or window, located at the front side of the house; beside this is a long bench for guests. Another tandiwan, however, may be appended on the end wall opposite the kitchen or cooking shed.

The Yakan dwelling is largely made of bamboo, thatched, with some parts woven, fitted, or tied together the way a basket is made. While posts, beams, and joints are assembled, the roof is put together separately and later fitted on top like the lid of a basket. The *pugaan* (bamboo floor slates) are set slightly apart, similar to the bottom of a basket, for better ventilation.

3.27 Group of Yakans

3.28 The Yakan house, called lumah, is a rectangular, ridge-roofed, single-room pile structure raised several meters.

3.29 The steep pitch roof or sapiaw of a Yakan lumah is concave and thatched with either cogon or nipa. A Yakan house has no ceiling. Windows are limited for there is a belief among the Yakans that bad spirits could easily enter the house through these openings.

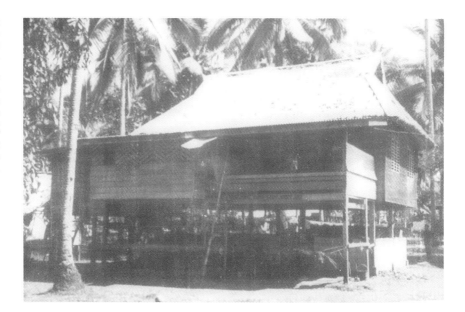

Walls are made of either the horizontally positioned wooden planks or the air-penetrable sawali (plaited bamboo or reeds). For the floor, the material of choice is either split bamboo poles (with the convex sides upwards) or timber for the main room. For the kitchen, the floor is usually made of bamboo, used for practical reasons since waste can easily be thrown through its gaps. Even the kitchen walls are plaited so that smoke can easily escape. If a wooden floor is used for the main house, a small piece of bamboo is inserted, or a hole is punctured onto the floor for spitting chewed betel nut.

The lumah has three parts: the *kokan* or *tindakan* (main house), the *kosina* (kitchen), and the *pantan* or *simpey* (porch). Territorial spaces in the structures are achieved by placing a 0.25 m x 0.25 m *patung* (wooden flitch) at the middle of the one-room structure. The patung separates the kokan (sleeping area) from the

tindakan (multipurpose living room), which serves as a place for entertaining intimate guests, weaving, dining as well as for the holding of a *magtimbang* (ritual). The tindakan is also the setting for weddings, wakes, death anniversaries, and other commemorations. Access to the main house is through a *harren* (a retractable bamboo/timber ladder), then through the simpey/pantan (the porch where clothes are hung and dried, long bamboo water containers are stored, and where most visitors are entertained); and finally through the *gawang,* a sliding main door.

If the need arises and if the occasion demands, the kokan can be converted into an expanded portion of the tindakan. During the day, the kokan is the entertainment area where one can find all the sleeping paraphernalia neatly rolled, folded, and kept on the side of the wall over and under open shelves. Oftentimes, above the sleeping area is the *angkap,* a mezzanine for girls, which can be accessed through the harren. The kokan is also used to hide a family fugitive. In the absence of furniture, the occupants squat to eat in the living room area near the main door opening. The slatted pugaan/nibong flooring does not only provide good ventilation but also serves as a drain for leftover food and water used in washing hands before and after meals. Cats, dogs, and chickens consume whatever food residues fall underneath.

There are basically two doors in a Yakan house: a main sliding door and a service sliding door that leads to the bridged kitchen. Small slit openings or a window, *tendewan,* at eye-level height serve as lookout holes. The kosina, which is set apart from the house, is accessible through a pantan, or bridge, to avoid fire in the main house, which is made of light and combustible material. A typical early Yakan house has no toilet.

A house for the Yakan has a lifespan of ten to fifteen years, after which, a new house will have to be built. Even then, usable materials from the demolished house will often be used for the construction of a new one, which is usually erected near the previous house.

Samal

The Samals are dispersed all over the southern island of Mindanao, southern Palawan, Basilan, Davao, Zamboanga, the Sulu archipelago, and as far as North Borneo. A Samal kinship group of 100 to 500 members lives in a cluster of houses usually standing on wooden piles on the foreshore areas or directly over tidal mud flats of reefs. Each group is affiliated with the nearest mosque. This Samal community may be located within a larger non-Samal town.

The traditional sources of livelihood of the Samal include fishing, farming, logging, hunting, boat-building, pearl diving, mat-weaving, and pottery. They are also renowned in the manufacture of *boras,* large rattan mats distinctive for their multihued painted decorations.

Samals who are engaged in farming reside in houses built on solid ground. In western Sulu, the dwellings are entirely built over tidal mud flats or reefs, while, in eastern Sulu and Basilan, Samal houses are built on stilts on the fringes of the seashore so that the ground under the house is flooded and washed clean during

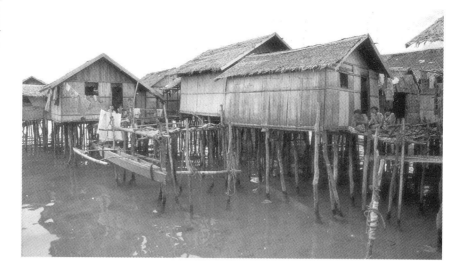

high tides. Most of the Samals who occupy the smaller coral islands of Sulu and Tawi-Tawi build their houses on piles driven into the reef floor yet they are linked to the shore and to one another by a maze of catwalks and bridges. These houses may be built close together or loosely arranged. The height of the dwelling is based on the maximum elevation tide level in the area: a height sufficient enough to provide enough space for their outrigger fishing boats, which are moored underneath the house when not in use. At the façade of some houses are racks where boats are sometimes laid to keep them above water.

Traditional Samal houses may be as large as twenty-four by twelve meters, with the roof ridge nine meters above the floor, some of which have two stories with balconies and elaborate carvings. In the past, these houses tended to be large because a typical household was an extended family ranging from two to fifteen nuclear families. However, this type of house and familial setup has become rare, for many Samals have migrated to Sabah, Malaysia as refugees.

Nowadays, Samals build houses of a more modest scale, about six by four meters with a maximum interior height of three meters. The house consists of a single space for lounging, sleeping, and dining. The interior of the house is unwalled and depending on the economic status of the owner, it may be sparsely furnished or richly decorated with boras. A Samal dwelling also has the pantan (open porch or terrace) as a prominent house feature. Customarily, the pantan faces the east and provides space for drying fish, woodworking, and preparing cassava. It is also the children's playground, a gathering area for families, or a place where rituals are conducted. Normally, a shed is built right along the porch to serve as the kitchen. The space underneath the house does not only accommodate boat and fishing equipment exclusively but also functions as the bathroom and laundry area.

Samal houses are constructed from bamboo and nipa, coconut lumber, and mangrove; nipa or sawali for the roof and walls; bamboo for the stairs and flooring; coconut wood, mangrove, or other tree trunks for the posts and other structural bracing. Structural members are held through lashing. The gable roof is of simple

construction, the ridgepole being supported by the kingpost. Rather than trusses, horizontal beams supporting the weight of the roof are positioned outside the structure, not in its interior, since the roof is low. Rainwater from the roof is collected as there are no other sources of potable water in many of the smaller and isolated islands. The wall sidings may be of thatch, woven bamboo strips, or palm fronds woven together. The front and back doors are utilized for both access and ventilation. There are no stairs or ladders since bridges and catwalks already connect the house with one another and to the coastline. Although it has retained its basic architectural form, the Samal house has also accommodated industrialized building materials such as corrugated iron, plywood, and processed lumber.

Badjao

Traditionally, the Badjaos use boats as their houses, although there are Badjaos, particularly in Sibutu and Semporna, Malaysia, who have settled on land and use their boats only for fishing. Badjaos are found around the islands of Tawi-tawi, with all settlements having a common feature; that is, an area protected from the open sea by reefs in close proximity to the sandy beach where children can play and boats can be repaired.

The largest Badjao community used to be in Tungkalang, Sangga-sangga, Tawi-tawi, where a variety of houseboats were moored. The structures of these buoyant abodes protect the Badjao from heat and rain. Because of the limited space aboard the houseboats, the Badjaos live as nuclear families, mostly separated from others. Life in the houseboat has altered the natural postures of its Badjao boat dwellers; they have adapted a curved body posture, which makes them stand or walk with protruding buttocks.

3.31 Badjao houseboats in Tawi-tawi

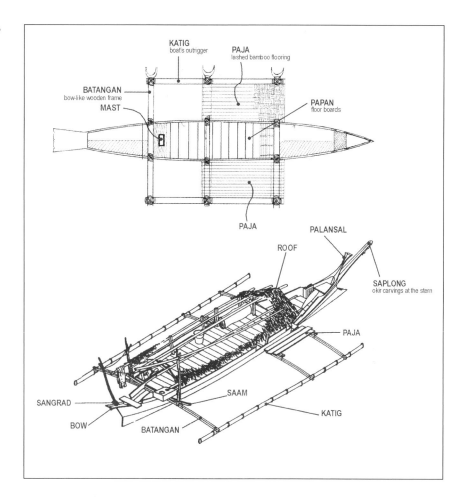

A boat may last for ten to fifteen years. A single beam forms the bottom and the boards of wood form the body. To the rear of the structure is a fireplace and a storage area for household items. The covered part is divided into a living area and a sleeping place, and the front is used for fishing and storing fishing paraphernalia. Between the front outriggers there is a small platform for harpooning large fish and catching smaller ones through nets. The boats vary in length and, depending on the economic status of the owner, may be lavishly carved, front and back. At shallow water the boat can be moved by a stick, while for longer navigation a small sail is used. When all the children have left, the old man of the house is expected to marry again or attempt to join another boat; adoption is also widely practiced to keep the boat functional. The death of the family head transforms the boat into a coffin, making it a symbolic mortuary piece to transport the dead into another plane of existence.

The Badjaos have two kinds of boats, the structure of which is made of single tree trunks: the *dapang* or *vinta*, used for short fishing trips, and the *palaw*, which may either be a permanent dwelling place or temporary lodging during fishing trips. The vinta is a swift and smooth-sailing boat with bamboo outriggers and a sail attached to a bamboo mast arranged in a tripod. The palaw is of two types: the lighter and

speedier *lepa*, and the bigger and heavier *jengning*. Not having outriggers, the lepa differs strikingly from the other two boats. The hull of the lepa is a log that is hollowed out, about twenty meters long with a beam two meters tall. Planks are laid across the hull to serve as the foundation on which the palaw (nipa hut) can be constructed. These planks are not securely fastened so that they can be raised to allow storage of household effects in the hull. Sticking out above the roof may be the owner's fishing spears and harpoon gun. The lepa house structure is loose and has detachable long poles attached to it and over which a thatched nipa roof called kadjang, opens out to form a curved gable.

Unlike the lepa, the jengning has outriggers. Its hull measures thirteen to seventeen meters long and two meters wide. Its house structure is walled on all sides by wooden boards fastened with nails and is provided with window and door openings for light and ventilation. This wooden cabin is roofed by sheets of galvanized iron. The roof can reach up to one meter at its peak, allowing the Badjao to squat inside the house. The patchwork character of the jengning has prompted scholars to describe it as "a floating shanty of the southern sea." A poor family who can afford only a small boat uses nipa, sackcloth, corroded galvanized sheets, matted coconut leaves, and a hodgepodge of cardboards as construction material.

Since they dwell permanently on boats most Badjaos come to land only to exchange their catch with land produce, and to bury their dead. But some Badjao build landhouses, which are technically not on dry land but along the shore on shallow water adequate for navigation. Landhouses, called luma, rest on log or wooden stilts driven into the sand. Tree trunks that can withstand seawater are made into posts. The floor is about 1.5 meters above the normal sea level, high enough to be safe at high tide. The *harun* (ladder) is a log into which notches are carved to serve as steps. One end is buried in the sand and rises about three notches above the water; the other end leans on the footbridge, which serves as a landing leading to an open doorway. The house has a long frame, about four meters wide. The roof is of tin sheets, nipa, or coconut leaves. The walls and floor are made of wooden boards sawn from logs found floating on the sea, lying on the seashore, or felled in

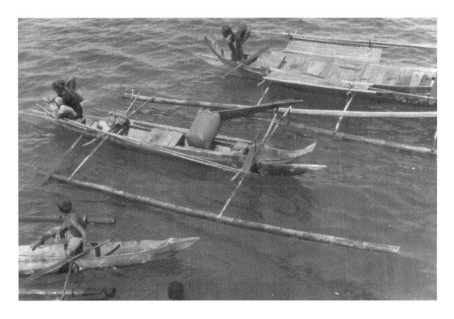

3.33 Badjao vinta

the inland forests. Two window openings are punctured out of the front wall, and a third window out of another wall.

The lone room, about three by three meters, serves as the sleeping area, toilet, and storage space. On the inner walls are mirrors hung slanting, the number of which depends on the number of children in the family. Mirrors are believed to drive away evil spirits. A roof beam holds the fishnets. A second doorway leads to the kitchen, which is a separate structure from the main house and connected to a footbridge. The footbridge that connects the kitchen to the next house forms part of the flooring of that house. A pantan is an extension where fish is dried. Laundry and dishwashing are done with the person sitting on the ladder's last step above the water and utilizing the sea as the huge wash basin. Clothes are hung to dry from poles stretched across the landing.

The Badjao, whether nomadic or settled, consider their hometown the *kawman* in which they were reared. A kawman is made up of several related nuclear families, with a male elder as the *panglima*. A larger moorage consists of several clans, with the panglima of the original kin group serving as the overall head. The biggest house in the kawman is the property of the panglima. On the rooftop, a white banner, measuring seventy centimeters by one meter, proclaims his exalted status. Stilt houses are linked together though a labyrinth of footbridges or catwalks made of loosely nailed boards. Relatives live near one another in the same neighborhood. Sitangkai is said to be the Badjao's main settlement, constituted exclusively of stilt houses.

Islamic Domestic Environment in Urban Settlements

Islam, both as a religion and as a way of life, frames the character of the city. Islamic town planning and urbanism hardly conform to the geometric symmetry of urban planning conceived by cultures whose settlement pattern strictly adheres to an image of an ordered cosmos, a cosmological diagram. Islamic urban organization is the physical manifestation of the equilibrium between social homogeneity and heterogeneity in a social system that requires the separation of domestic life and the involvement in the economic and religious life of the community. Nevertheless, Muslim urban order is neither fortuitous nor unstructured for it reveals a consistent underlying arrangement of hierarchical sequences of access and enclosure responding to the social relations specific to Muslim society.

Muslims communities in Mindanao and migrant Muslims communities in large cities, such as those living in the Muslim quarters of Quiapo in Manila and Maharlika Village in Taguig, have continually attempted to replicate the earliest Muslim communities by locating themselves in a settlement pattern that is in close proximity to the masjid.

Muslim urban organization is the physical realization of a social system that requires spatial division between domestic and public lives. The city is characterized by a triumvirate system of public, semi-public, and private spaces manifested in various intensities of access and restriction.

The public area is the domain of men, with emphasis on accessibility and unrestricted contact. Muslim privacy, together with domestic life, on the other

3.34 Aerial view of a Muslim urban settlement in the heart of the Quiapo district in Manila

hand, is centered inside the house. In Islamic culture it is both the explicit and the implicit Koranic prohibitions that are principal to the design of a domestic unit, for these regulate the spatial practices that are deemed socially acceptable. The programming of interior spaces in a Muslim house emphasizes domestic privacy and the protection, seclusion, and segregation of women. Women segregation is physically manifested in various forms of spatial barriers, through which women can see but not be seen. Veiling is integrated with women's sartorial practices to function as a device of seclusion and introversion. In house architecture, a screened balcony enables the female occupant to have a vision of the outside world without being seen. The Islamic house is therefore introverted, conceptualized from the inside outwards. Exterior windows are rare to prevent passersby from looking into the house.

While rooms in non-Muslim houses are compartmentalized and designated to a specific activity, the significant demarcator of space in Muslim houses is social accessibility, the divide between public and private realms. Rooms can be used interchangeably for eating, sleeping, recreation, and performance of domestic tasks. This flexibility of living space is indicated by the absence of obtrusive furniture that reiterates the rigidly defined interior patterns of spatial use.

The symbolic importance of the house entrance—the vulnerable threshold between the domestic and the public—is often accentuated by a highly decorated doorway, frequently utilizing symbols and calligraphic designs of an auspicious nature. The prohibition of figurative representation, though not closely observed, has encouraged the development of geometric and vegetal decorative motifs.

Through the door, Muslims often mark their homes as a space to indicate their difference, privacy, and separation. Throughout the Muslim world, the doorway or the door is the expressive and symbolic boundary signalling both a warning and a welcome. Entrance to the door implies refuge, especially for those living outside the Muslim enclave. Inside the Muslim house, the external, hostile environment of racism, religious intolerance, and discrimination are locked out; prayer space and hospitality are guaranteed.

Muslims self-consciously and deliberately organize the use of domestic space in the light of the teachings found in the Koran and Al-Hadith (source of Islamic doctrine and law second only to the Koran) as well as through the example of homes in the Muslim world. These Islamic norms thus inform the basic daily needs characteristic of domestic space—shelter, food storage and use, ritual activities, and social interaction. For Muslims, the home becomes a space for learning and practicing Muslim behavior and for being separate from the larger society.

One of the classical divisions known in Islam, between Darul Islam (the House of Islam) and Darul Harb (the House of War), translates into non-Muslim division of the domestic space (private) and the outside community (public). Domestic space is consciously separated from the space of the House of War, which is viewed as a space of religious intolerance and racism. The use of domestic space creates, moreover, a sense of shared spirituality with Muslims elsewhere in the Muslim world, while fostering a sense of security in an environment perceived as hostile.

Stories of the Prophet Muhammad's life yield a central paradigm for living within the house. Prophet Muhammad lived in a one-room dwelling furnished with the bare necessities for living, but with unimpeded access to prayer space. Thus, the house should be austere and near the masjid. The Al-Hadith regulates the accumulation of wealth and delineates the responsibilities attached to its use. Accordingly Filipino Muslims austerely furnish their homes within these constraints.

3.35 The gilded dome of the modern Golden Mosque of Quiapo is the *axis mundi* of the Islamic community in the district.

Within their homes, Muslims live a distinctive life. Even their concept of time differs from those of non-Muslims. The Muslim community is seen as a dot on a continuum that begins with creation and does not end but shifts focus in the afterlife. Ritual practices define Muslim schedules, beginning with the pre-dawn prayer while most non-Muslim neighbors are still sleeping.

There is a single requirement for Muslim domestic space—a place for prayer. The Muslim not only retreats internally for experiencing *taqwa* (piety) for salat, but also requires a physical place to orient oneself to the direction of the Ka'aba and to perform the prayer undisturbed. This space should above all be free from contamination. Muslims have contingently developed some creative strategies to surmount the physical limitation of their homes. One enters the house by first removing the footwear, leaving them in baskets, shoe racks, crates, or just a designated space near the front door, since most houses do not have foyers. Women, who typically carry an extra pair of socks to wear inside, are escorted to one part of the house, while the men are escorted to another. The members of the household also divide themselves along gender lines at this time.

The house is usually adorned with Islamic texts and calligraphy, framed as well as unframed, and bronze plates engraved with various Koranic *suras* (a chapter from the Koran). Koranic recitations are the only music generally played in the public rooms of the home. The *kibla* (direction toward the Ka'ba in Mecca) may also be indicated by a wall plaque or by some other piece of furnishing, such as the carved screen.

Basic to Muslim interior space are decorative elements like Arabic calligraphy, "oriental" rugs, brassware, latticed screens, and so on. Living room furniture is kept to a minimum in order to be able to turn the living room into a prayer space without difficulty. Dining rooms are often meagerly furnished so that, along with the living room, they too can become a prayer area.

Window shades, curtains, and drapes are always drawn to block the view of neighbors in adjoining houses. When there are no visitors, women are free to unveil and wear any appropriate clothing. When visitors are present, if there is even one adult male in the house, all the women should remain in the kitchen, leaving it only to serve food or to pray.

The kitchen may accommodate a small dinette set, which doubles as a space for food preparation. Halal meat (meat from animals that have been raised and then slaughtered in the ritual way prescribed by Islamic law) is purchased at great expense and all members of the community strictly adhere to dietary restrictions.

Muslims do not hang around in the *hamam* (bathroom) where the *jinn* (a spirit in Islamic mythology that takes on various human and animal forms, makes mischievous use of its supernatural powers, and is thought in general to be evil) is believed to be present. Bathroom doors are kept closed for this reason. Those entering a bathroom wear special shoes or slippers. The bathroom is a space both of pollution and purification. The believer enters with the left foot, acknowledges the dangers of the space with a *du'a*, performs the necessary rituals, and leaves with the right foot, reentering prayer space. Some people place pictures or other

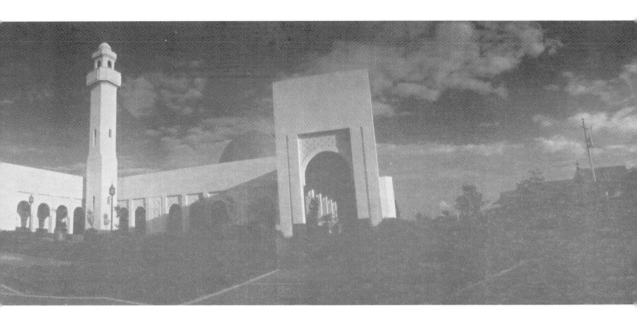

3.36 The mosque is the *axis mundi* of an Islamic community. The housing units in Maharlika Village in Taguig are so arranged to replicate the earliest Muslim community pattern by locating the dwelling units in close proximity to the masjid, the Blue Mosque.

decorative items in bathrooms that could not be placed in spaces for prayer. There may also be signs with instructions on ablution.

Full participation in the Muslim community requires certain responses in the domestic space. Homes must reflect Islamic injunctions on prayer space and diet. They must also reflect Muslim prohibitions of certain kinds of art, social entertainment, and association of men and women.

4 Spectacle of Power
Hispanic Structuring of the Colonial Space
(1565–1898)

Spaces of Colonial Encounter

Colonialism may be defined as a set of interactions between the colonizer and the colonized in a complex relationship based on the imposition of political control of powerful states over weaker ones. At a basic level, colonialism implies a condition of domination that expansionist foreign powers instantiate, engendering hegemonic relations between them and the resisting peoples who defend their indisputable interest over a contested space. Moreover, the process of colonialism presupposes what anthropologists would refer to as "directed change," insofar as it involves one people establishing dominance over the other through military conquest, political domination, or some other means of control. This type of acculturation often predicates the need to change, to some degree, the way of life of the dominated group, usually in conformity with that of the dominant culture. Colonization does not only manifest itself as a mere political and economic strategy, it also doles out its myriad consequences on life and culture, which are exercised spatially.

Reading the said asymmetrical power relations in the architectural space reveals the complex imperatives that subjugated peoples must perform to endure the colonial authorities' techniques to control the space in eliciting absolute obedience from its subjects. The centuries of colonial encounter in the Philippines expedited the rigorous processes of colonial place-making, empowering the colonizer to define/defend territory and set its boundaries, demarcate loci of domination and marginalization, appropriate spatial zones for designated function, and organize them in accordance to certain urbanizing programs. Through the instruments of urbanism, the Spaniards, therefore, cemented their territorial and spiritual takeover in the archipelago. Thus, under a colonial framework, a systemic metamorphosis of the physical space of the colony is initiated to mechanize civilizing and urbanizing procedures, conflating colonial pledge and intimidation through the alliance of secular and religious hegemony.

The notion of imposing power through subtle and almost undetectable means was inscribed spatially on the designed environment sponsored by the colonialist—a premise that the author owes to Foucault's concept of panoptic mechanism of

4.1 Binondo Church in the late nineteenth century

disciplinary power, one that makes possible the fixing of people in precise places and the reduction of bodies to a certain number of gestures and habits (Foucault 1988).

The colony as place is constituted by the modes by which land and its populace are collected as a particular geography and mapped through the technology of cartography to establish possession and rule. The "enframing" of space mediates the power of the colonial authorities through the occidental rationality of space that combines Foucault's theory of "microphysical" or panoptic disciplinary power with an effect of structured visual representation, whose techniques—dividing, containing, simulating—are inscribed in space and geometrical units of containment (Mitchell 1988). As projects of improvement and mileage in public works proclaim colonial progress, these practices also facilitate a method of control that may be said to effect lesser harshness compared to military enforcements, but, in the end, the order sought is still similar to that aimed by more "repressive" acts. Nonetheless, disciplinary power is invisible, residing in the seemingly neutral arena of ordinary space.

The laying out of towns and cities, the erection of infrastructure, and the design of settlements gave colonialism a certain order and organization. But colonial space could only be configured in terms of racial and social differentiation. This was rigidly practiced in Manila's prime city of *Intramuros* (within the walls) and spawned the exclusionary spatial category *Extramuros*, referring to non-Western people living outside the walls (Reed 1978). Extramuros included the residential and occupational quarters for Asians: *Dilao*, a Japanese district, the *Parian* for the Chinese, and the Filipino *arrabales*. Methods that guarantee the security of Spanish colonial elites were enforced. The colonial government issued a series of decrees that restricted the number of non-Europeans who could work and reside within Intramuros.

Intramuros was Manila's self-contained colonial city built exclusively for the habitation of Western elites. Buildings and street patterns were laid out within the intramural premises to imprint the urban order with a sense of awe for Ibero-American culture and civilization. It was an apt articulation of the expansionist Iberian imperial power that sought to replicate European grandeur in the colonial domain. The suspicion of revolt marshalled the deployment of the *cuadricula* street pattern, walls, and *garitas* (watch towers) under a panoptical maneuver that subjected the colonized body to constant surveillance. Protecting the exclusivity of the site and interiors of Intramuros was meant to maintain cultural superiority and to cultivate a system of "othering" as Indios, Chinese, and Japanese were relegated outside the vicinity of the walls to preserve the colonialist ideology of *pureza de sangre* or hygienic purity of the Iberian blood.

Moreover, the prominence of Spanish colonial churches in colonial town-planning should not just be seen as mere monuments to God's greater glory or as architectural inheritance from our civilizing colonial masters. Church architecture must be framed within the canvas of power and political strategies associated with the colonial discourse, such as forced labor, religious tolerance, genocide, and obscurantism.

Instituting the Program for Colonial Urbanism

The story of architecture in the Philippines under Spain begins with the permanent occupation of the island in 1565. The arrival of Miguel Lopez de Legaspi's expedition in Cebu in that year ushered in an important phase in the development of architecture and urbanism in the Philippines with the establishment of colonial settlements, the building of a chapel, and the erection of a fort. Before Legaspi's death in 1572, he had already conquered the greater portions of the archipelago to spread Christianity and to colonize the islands.

It was not long before the Spaniards gained a foothold in Manila in 1571. After launching a military assault against Rajah Sulayman, the settlement's ruler, Legaspi occupied the strategic site at the mouth of the Pasig River. Here he was to institute an urban prototype of a colonial settelemt, following the recommendations of the decree issued by King Philip II in 1573, from which future colonial towns and cities of Imperial Spain would be modeled after.

In a broad historical stroke, Spanish colonialism had changed the face of the built environment in the Philippines as much as it had altered the social and economic conditions. The Spanish conquistadores succeeded in developing the archipelago's town according to their colonial urban prescription. The main ingredients in the urban transformation of the Philippine colonial landscape included the following:

> *The establishment of reduccion, or forced urbanization and resettlement.* The formerly scattered barangays were brought together and reduced in number and made into compact and larger communities to facilitate religious conversion and cultural change.

> *The creation of a land-use pattern through the encomienda system.* The concept of land as private property and capital was introduced. Communal and individual lands were confiscated, and thus circulated through the *encomienda* system of landownership, by which the colony

was divided into parcels, each assigned to a pioneering Spanish colonist who was mandated "to allocate, allot, or distribute" the resources of the domain. Conniving members of the *principalia* (former datus, their families, and descendants, who later assumed office in the colonial bureaucracy) sold or donated lands which they formerly governed and privately owned.

The institution of a hierarchical settlement system. With the reduccion came a hierarchy of settlements. The core of the municipality was called cabecera (head) or poblacion and the adjacent barangays became known as barrios. The poblacion became the center, not necessarily because it was the geographical center but because it was where the elite resided, where the church was located, and where folk paid tribute. Estancias or large ranches were the first haciendas or large land estates for both local consumption and for Manila.

The creation and structuring of towns according to the cuadrícula model of planning. The cuadrícula, a system of streets and blocks laid out with uniform precision, was introduced through a varied typology, and was usually structured in a hierarchical fashion, with the central plaza as its focal point since the space symbolized the seat of power. The cuadrícula method was efficient in maximizing space and in the supervision of colonial subjects.

The introduction of building typologies and construction technology through colonial infrastructures. New activities jump-started urban life, one which required particular building types. The urbanization of the colonial landscape necessitated the creation of new institutions represented by buildings that carried functional and formal analogies (i.e., church for worship, school for learning, prison for incarceration). Moreover, colonial infrastructures were constructed of sturdier and more permanent building materials using novel methods of construction to express material superiority and to distinguish itself from the flimsy indigenous architecture.

At the very outset of imperial expansion in Southeast Asia, the tactics of the conquistadores for colonization varied greatly from the imperial system implemented by other European colonizers in other parts of the region. The Portuguese, Dutch, and British before the nineteenth century steadily limited their activities in the region to matters of trade, while avoiding direct interference in the internal affairs of the indigenous states and participation in prolonged wars, in order to maximize commercial profits. The Spaniards stood out among these other colonizers for they were dedicated to the implementation of a thorough colonial schema that fused together territorial expansion, economic exploitation, Christian conversion, and cultural transformation (Reed 1978, 11). To achieve these radical agenda, a consolidated effort was exacted from soldiers, missionaries, bureaucrats, and merchants, in which participants could gain both material and spiritual remuneration.

As cities and towns formed the nucleus of colonial control, the absence of indigenous urban centers from which the colonizers were to graft their Western version of an urban institution presented a formidable challenge to the Spaniards, who equated civilization with urbanism. The Philippine archipelagic domain was without a tradition of urbanism unlike other indigenous states of Southeast Asia

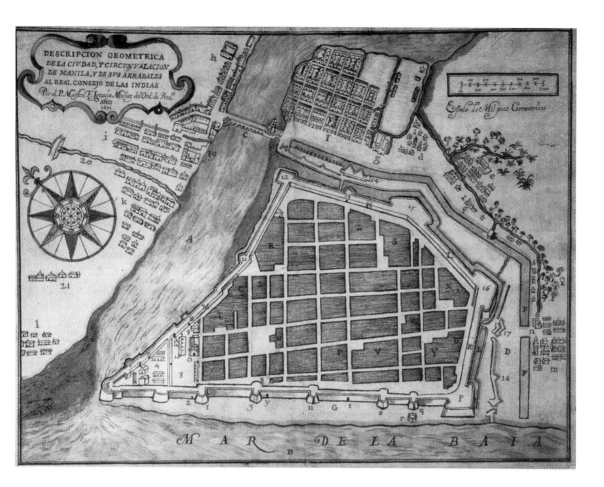

4.3 A map of Manila and its suburbs drawn by Fray Ignacio Muñoz in 1671 for the *Council of the Indies* (Consejo de Indias), the most important administrative organ of the Spanish Empire.

with complex kingdoms such as those Hinduized or Theravada Buddhist-influenced kingdoms in mainland Southeast Asia and on the island of Java in Indonesia. The pre-Hispanic communities were rather characterized by a decentralized pattern of low-density settlements with substantial sociopolitical fragmentation and independence from one another.

Given this condition, it was physically and logistically impossible for a small deputation of missionaries to convert the native population to the Christian faith and indoctrinate them to the ways of Western civilization. Thus, late in the sixteenth century, the Hispanic authority launched an urbanizing program, known as the "reducción," which was designed to systematically resettle the indigenous lowland population in larger urban communities so as to accelerate the processes of politico-religious transformation. This policy essentially meant a forced relocation of small, scattered settlements into one larger town. The Filipinos must be "congregated" or "reduced" into compact villages varying in size from 2,400 to 5,000 people, where they could be easily reached by missionaries, tribute collectors, and the military. It was programmed for the administration of the Spanish colony's population, an ingenious method to enable a small number of armed Spanish constabulary to control more easily the movements and actions of a large number of Filipinos. The reducción policy also made it easier for a single Spanish Catholic friar to train Filipinos in the basic principles of Christianity. In reality, the policy was successful

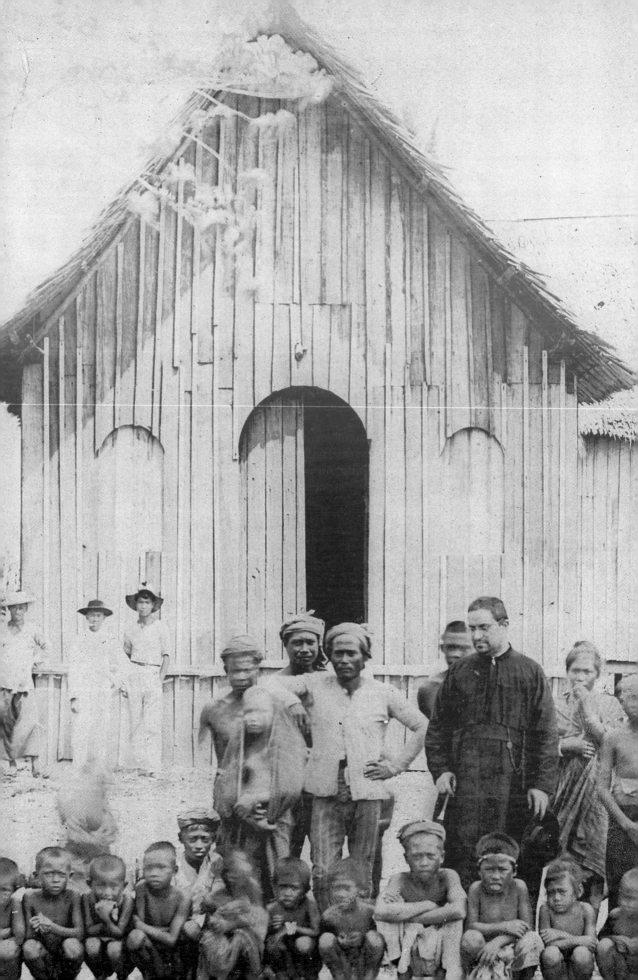

in some areas but impossible to enforce in most. In retrospect, not all reducción were successful or passively accepted by the natives. The onslaught of epidemics like cholera and smallpox had erased even the stable reducción from the colonial map. Some reducción were simply dissolved with the exodus of the resettled natives, who tenaciously resisted resettlements and continued to maintain sentimental close ties to their agricultural plots, clinging to a semi-migratory mode of existence. In fact, the Spanish archives are brimming with accounts of frustrated colonial officials complaining about how such settlements were all but abandoned in many cases after only a few weeks.

Military coercion was rarely used to overcome resistance to relocation except in cases of extreme provocation. Since most Filipinos could not be forced to form new villages, they had to be enticed via the spectacle of religion. And the natives, seduced to the revelry, did flock to the churches. However, many of the new Catholic communities were sporadic rather than constant, coalescing to perform certain rituals set by the Church, only to disband after an event. The cabecera was the capital of the parish and was designed to be the site of a compact village. Since the natives were hesitant to move into these villages in large numbers, every parish had a whole series of *visita* chapels. The cabecera-visita slowly became the prevailing pattern of rural settlement in the Philippines (Phelan 1959, 47). Concisely, the reduccion policy paved the way for the emergence of the present system of politico-territorial organization of villages, towns, and provinces.

The villages were literally "under the bells," which sanctioned the control of natives' everyday life by allowing the clergy to wake the villagers up each day, summon them to mass, and subject them to religious indoctrination or cathechismal instruction.

The massive and sweeping spatial reorganization of the lowland Filipinos resulted in the establishment of more than 1,000 towns and cities during the entire duration of the Hispanic colonial tenure in the Philippines. But the Spanish were unsuccessful in converting Muslim sultanates to Christianity, and, in fact, warred with the Muslim Filipinos throughout their years of colonial rule. Nor did they successfully conquer certain highland areas, such as the Luzon highlands, where a diverse array of ethno-linguistic groups took advantage of their remote, difficult, and mountainous terrain to successfully avoid colonization.

Codification of Conquest and City Planning

The Spaniards regarded the city as an indispensable factor in the organization of its colonial territories in Latin America and the Philippines. Cities were considered focal points of the decision-making process. Instituting social control in the metropole was the first step in establishing economic and political continuity for those in power. The use of a grid-pattern for the urban fabric, together with the adherence to other architectural rules, was a consequence of the ideal Greco-Roman city concept, when medieval, organic urban planning methods had already been abandoned.

The Church and the State endeavored to replicate their American program of resettlement and urban interventions in the Philippines. From their experience in the Americas, they had become renowned founders and proficient developers of towns and cities in the world. The resultant urban blueprint featured a small

4.4 A mission church in Mindanao in the late nineteenth century—the chapel was made of wood plank sidings and thatched gable roof and no different from the natives' houses. It was simple in plan and structure, with a rectangular nave and high pitched roof.

Leyes de Indias
Prescriptions for the Foundation of Hispanic Colonial Towns
Philip II, July 3, 1573, San Lorenzo, Spain*

110. Upon arrival at the locality where the new settlement is to be founded (which according to our will and ordinance must be one which is vacant and can be occupied without doing harm to the Indians and natives or with their free consent), the plan of the place, with its squares, streets, and building lots is to be outlined by means of measuring by cord and ruler, beginning with the main square from which streets are to run to the gates and principal roads and leaving sufficient open space so that even if the town grows it can always spread in a symmetrical manner. Having thus laid out the chosen site the settlement is to be founded in the following form.

111. The chosen site shall be on an elevation; healthful; with means of fortification; fertile and with plenty of land for farming and pasturage; fuel and timber; fresh water, a native population, commodiousness; resources and with convenient access and egress. It shall be open to the north wind. If on the coast care is to be taken that the sea does not lie to the south or west of the harbor. If possible the port is not to be near lagoons or marshes in which poisonous animals and corruption of air and water breed.

112. In the case of a seacoast town, the main plaza, which is to be the starting point for the building of the town, is to be situated near the landing place of the port. In inland towns the main plaza should be in the center of the town and of an oblong shape, its length being equal to at least one and a half times its width, as this proportion is the best for festivals in which horses are used and any other celebrations, which have to be held.

113. The size of the plaza shall be in proportion to the number of residents, heed being given to the fact that towns of Indians, being new, are bound to grow and it is intended that they shall do so. Therefore, the plaza is to be planned with reference to the possible growth of the town. It shall not be smaller than two hundred feet wide and three hundred feet long nor larger than eight hundred feet long and three hundred feet wide. A well-proportioned, medium-sized plaza is one that is six hundred feet long and four hundred feet wide.

114. From the plaza, the four principal streets are to diverge, one from the middle of each of its sides and two streets are to meet at each of its corners. The four corners of the plaza are to face the four points of the compass, because, thus, the streets diverging from the plaza will not be directly exposed to the four principal winds, which would cause much inconvenience.

115. The whole plaza and the four main streets diverging from it shall have arcades, for these are a great convenience for those who resort thither for trade. The eight streets which run into the plaza at its four corners are to do so freely without being obstructed by the arcades of the plaza. These arcades are to end at the corners in such a way that the sidewalks of the streets can evenly join those of the plaza.

116. In cold climates the streets shall be wide; in hot climates narrow, however, for purposes of defense and where horses are kept, the streets had better be wide.

117. The other streets laid out consecutively around the plaza are to be so planned that even if the town should increase considerably in size it would meet with no obstruction which might disfigure what had already been built or be a detriment to the defense or convenience of the town.

118. At certain distances from the town, smaller, well proportioned plazas are to be laid out on which the main church, the parish church, or monastery shall be built so that the teaching of religious doctrine may be evenly distributed.

119. If the town lies on the coast its main church shall be so situated that it may be visible from the landing place and so built that its structure may serve as a means of defense for the port itself.

120. After the plaza and streets have been laid out building lots are to be designated, in the first place, for the erection of the main church, the parish church, or monastery and these are to occupy, respectively, an entire block so that no other structure can be built next to them except those which contribute to their commodiousness or beauty.

121. Immediately afterwards, the place and site for the Royal and Town Council House, Custom House, and Arsenal are to be assigned, which are to be close to the church and port so that in case of necessity, one can protect the other. The hospital for the poor and sick of noncontagious diseases shall be built next to the church, forming its cloister.

122. The lots and sites for slaughter houses, fisheries, tanneries, and the like, which produce garbage, shall be so situated that the latter can be easily disposed of.

123. It would be of great advantage if inland towns at a distance from ports were built on the banks of a navigable river, in which case an endeavor should be made to build on the northern riverbank. All occupations producing garbage shall be relegated to the riverbank or sea situated below the town.

124. In inland towns, the church is not to be on the plaza but at a distance from it, in a location where it can stand by itself, separate from other buildings, so that it can be seen from all sides. It can thus be made more beautiful and it will command more respect. It would be built on high ground so that, in order to reach its entrance, people will have to ascend a flight of steps. Nearby and between it and the main plaza, the Royal Council and Town House and the Custom House are to be erected in order to increase its impressiveness but without obstructing it in any way. The hospital of the poor who are ill with noncontagious diseases shall be built facing the north and so planned that it will enjoy a southern exposure.

125. The same plan shall be carried out in any inland settlement where there are no rivers, with much care being taken so that they enjoy other requisite and necessary conveniences.

126. No building lots surrounding the main plaza are to be given to private individuals, for these are to be reserved for the church, Royal and Town House, and also the shops and dwellings for merchants, which are to be the first erected. For the erection of public buildings the settlers shall contribute and, for this purpose, a moderate tax shall be imposed on all merchandise.

127. The remaining building lots shall be distributed by lottery to those settlers who are entitled to build around the main plaza. The rest are to be held for us to grant to settlers who may come later or to dispose of at our pleasure. In order that entries of these assignments be better made, a plan of the town is always to be made in advance.

128. After the plan of the town and the distribution of the lots have been made, each settler is to set up his tent on his lot if he has one, for which purpose the captains shall persuade them to carry tents with them. Those who own none are to build huts of such materials as are available wherever they can be collected. All settlers, with greatest possible haste, are to jointly erect some kind of palisade or dig a ditch around the main plaza so that the Indians cannot do them harm.

129. A common shall be assigned to each town, of adequate size so that even though the town expands in the future there would always be sufficient space for its inhabitants to find recreation and for cattle to pasture without encroaching upon private property.

130. Adjoining the common, there shall be assigned pastures for team oxen, for horses, for cattle destined for slaughter, and for the regular number of cattle, which according to law, the settlers are obliged to have, so that they can be employed for public purposes by the council. The remainder of land is to be subdivided into as many plots for cultivation as there are town lots, and the settlers are to draw lots for these. Should there be any land which can be irrigated it is to be distributed to the first settlers in the same proportion and drawn for by lottery. Whatever remains is to be reserved for us so that we can make grants to those who may settle later.

131. As soon as the plots for cultivation have been distributed, the settlers shall immediately plant all the seeds that they have brought or are obtainable, for which reason it is advisable that all go well provided. All cattle transported thither by the settlers or collected are to be taken to the pasture lands so that they can begin at once to breed and multiply.

132. Having sown their seeds and provided accommodation for their cattle in such quantities and with such diligence that they can reasonably hope for an abundance of food, the settlers, with great care and activity, are to erect their houses, with solid foundations and walls for which purpose they shall go provided with moulds or planks for making adobes and all other tools for building quickly and at little cost.

133. The building lots and the structures erected thereon are to be so situated that in the living rooms one can enjoy air from the south and from the north, which are the best. All town homes are to be so planned that they can serve as a defense or fortress against those who might attempt to create disturbances or occupy the town. Each house is to be so constructed that horses and household animals can be kept therein, the courtyards and stockyards being as large as possible to insure health and cleanliness.

* From the Archivo Nacional, Madrid, MS 3017, *Bulas y Cedulas para el Gobierno de las Indias,* as translated by Zelia Nuttall, "Royal Ordinances Concerning the Laying Out of New Towns," *The Hispanic American Historical Review,* 5:2 (May, 1922), pp. 249-54. For both the Spanish text and an alternative English translation prepared by an anonymous individual(s), see Zelia Nuttall, "Royal Ordinances Concerning the Laying Out of New Towns," *The Hispanic American Historical Review,* Vol. 4:4 (November, 1921), pp. 743-53.

number of colonial capitals, each of which served as governmental, religious, and commercial hubs in a politically distinct dependency.

On 13 July 1573, Philip II formally issued a comprehensive compilation of edicts expanding and incorporating the previous decrees of Ferdinand and Charles V. What emerged was not just a set of ordinances dealing with aspects of site selection,

city planning, and political organization, but the most comprehensive set of instructions ever issued to serve as guidelines for the founding and building of Hispanic colonial towns. This represented an attempt of the Spanish Crown to establish a uniform and extensive urban plan of the colonies. King Philip's compilation reinforced the unilateral objectives of conquest, emphasized the urban character of Spanish colonization, and clearly specified the physical and organizational arrangements that were to be developed in the new cities of the Spanish empire.

The Royal Ordinance encapsulated, in addition to the actual planning experience encountered in the Americas, the classicist theories of urban design proposed by the Roman architect Vitruvius and the Italian Renaissance architect Leon Battista Alberti. The urban prescription, like that of Vitruvius, exhibited "a keen awareness of the function of open squares as essential arenas of economic and social life, as well as places for the exposure of monumental edifices" (Reed 1978, 41). The lengthy urban statutes provided overseas colonial administrators useful models for the design of town and urban sites for both inland and coastal geography.

Colonial cities in the Philippines were, hence, built according to rules codified in the Laws of the Indies of 1573, specifying an elevated location, an orderly grid of streets with a central plaza, a defensive wall, and zones for churches, shops, government buildings, hospitals, and slaughterhouses. The "plaza complex" evolved, which consisted of a grid pattern with the main plaza at the center surrounded by the church-convent, the tribunal, and other important government buildings, and the marketplace. Houses of various social classes are usually hierarchically distributed around this complex. As the settlements expanded, secondary plazas were established in different areas. The main plaza was ordained to lie close to the waterfront, the secondary plazas were found inland, where growth naturally gravitated.

Manila: The Genesis of an Intramural Colonial City

Royal instructions dispensed to Miguel Lopez de Legaspi's expedition required the establishment of a permanent urban base in the Philippines from which to springboard the imperial agenda in Southeast Asia. Spain's immediate objectives in the Philippines were to use the islands as a base for further expansion, to establish the colony as a center for the production and export of tropical spices, and to convert the natives to Christianity. Geographer Robert Reed (1978, 16) reports:

> The *Adelantado* (Miguel Lopez de Legaspi) was told to consider a number of potential sites before making a choice because strategies of efficient exploration, balanced territorial expansion, and profitable trade ultimately hinged on the selection of a strategically located headquarters. In addition, Spanish authorities offered advice concerning the proper layout of the proposed colonial capital. They envisaged a substantial fortress as the nucleus of the imperial outpost.

Hence, the foundation of a well-garrisoned political center, an adjoining space of residence for Spaniards and Christianized Filipinos, and the construction of a church designed to function as the fulcrum of the socio-religious transformation of the emergent colonial community were in the making.

Legaspi initially founded the early colonial settlements in Cebu and Panay. But these locations were beset by both natural and man-made problems, which included continuous shortage of food supply, sporadic Portuguese military threats, and persistent hostilities of Filipinos.

But it was the persistent plague of locusts that finally forced the conquistadores to search for new headquarters northward in the island of Luzon, to the fabled Muslim settlement at the mouth of a river—Maynilad. In 1570, Legaspi sent his lieutenant, Martin de Goiti, on a mission to Manila who returned a year later. Soon after being elevated to the rank of Governor-General by King Philip II, Legaspi was ordered to immediately begin the process of systematic territorial colonization and sailed without delay to Manila to set up the administrative center of the colonial government. Legaspi landed on the north shore, razed the defenses of the settlement, and eventually conquered Manila. Manila was captured without a fight because its head, Rajah Sulayman, had evacuated his fort after the inhabitants set fire upon their own settlement. On May 19, 1571, Legaspi laid the foundation of Manila from the charred remains of Sulayman's palisaded kingdom. By June 24, 1571, Legaspi officially inaugurated a municipal council and proclaimed Manila as the capital of the new territories under the Spanish Crown.

The newly conquered settlement was described by Legaspi in a letter to the King of Spain dated April 20, 1572:

> The village of Maynilad is situated on the tongue of land extending from east to west between the river and the sea, and a fort had been built at the extreme western end of the peninsula at the entrance of the fort. The sea makes a very large harbor about thirty leagues in circumference. Around the fort, a hundred and fifty huts for the Spanish officers were built by native labor, and the land around the city was apportioned to men of the colonizing party (Filipiniana Book Guild 1965, 195).

Despite the impermanent and flimsy physical appearance of the early colonial city of Manila, new activities were introduced which necessitated the creation of novel institutions characterizing urban life. Slowly a city was created in accordance with Hispanic law and urban heritage. The city of Manila was a modest one: barracks for soldiers, residences for officers, and a chapel, all of which were made of light materials—bamboo, wood, and nipa thatch. Covering less than a mile in area, spreading out from the point of a triangle formed by the river and the bay at Fort Santiago, Manila was envisioned as the Spanish *almacen de la fe* (display window of the Faith), and bestowed the title "*El Insigne y Siempre Leal Ciudad*" on June 24, 1574 by a decree by Philip II.

As they took full possession and administration of the city, the Spaniards ventured inland, spreading the cross and the reign of the Spanish Crown to the surrounding countryside. Capitalizing on the geographical endowment of Manila, they systematically extended the authority of the Spanish colonial officialdom in the archipelago by means of military force, the encomienda, and religious conversion. While the intramural city was being built and rebuilt, the friars took it upon themselves to evangelize the natives and to implement the reduccion policies throughout the archipelagic colony. By 1590, the colonialist proclaimed the foundation of three primary *ciudades de españoles* in Cebu, Nueva Caceres (Naga),

4.5 Map of Manila from *Diccionario Geografico-Estadistico-Historico De Las Islas Filipinas*, Madrid 1851

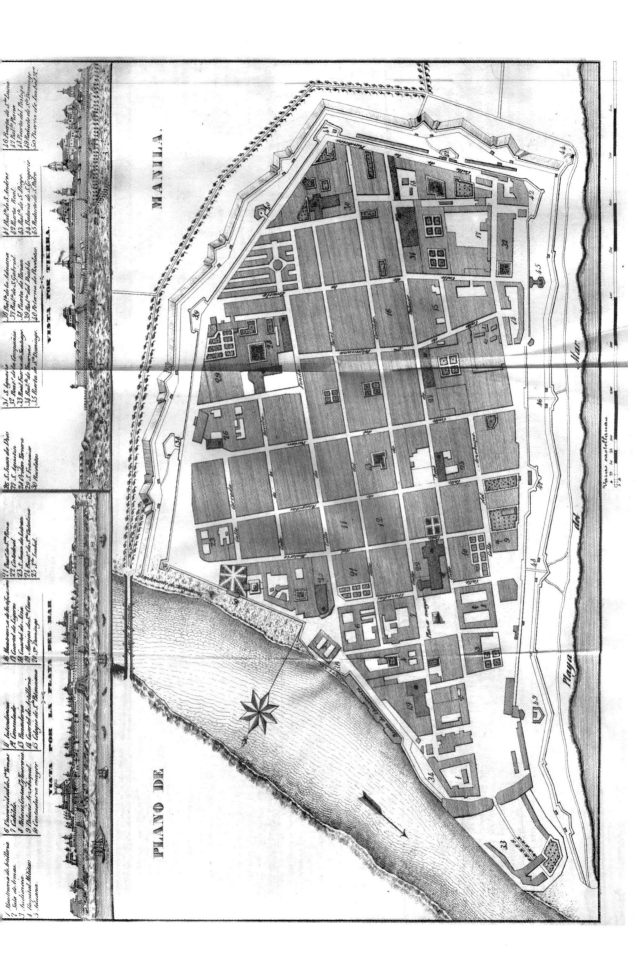

PLANO DE MANILA.

and Nueva Segovia (Lal-lo, Cagayan) and two *villas de españoles* in Vigan (in Ilocos Sur) and Arevalo (in Iloilo). Only Cebu, Naga, and Vigan flourished as major urban centers, for they were sustained by a concentration of population and economic activities resulting from their entitlements as diocesan capitals.

The Great Urban and Architectural Transformation
A decade after the founding of the city, Manila could lay claim to the possession of urban elements common with most established Hispanic cities. The city quarter was surrounded by a spiked log palisade. There was a central plaza, a *cabildo* (a municipal building), and a general market. As a port city, Manila had a wooden port and a garrison of soldiers. The residences of the Governor-General and of the Bishop were also located in it. The cathedral was under construction and was made of wood boards. The houses of the townsfolk occupied the rest of the area following the grid street system.

Manila was not spared its share of disasters and tribulations. For one, the city was persistently preyed upon by pirates from the sea, such as that which Limahong launched in 1574. Its internal peace was threatened by a sequence of Chinese insurrections, which began in the Parian quarter. Earthquakes and conflagrations took a heavy toll on life and property. For the early architecture of both private and public edifices, the colonial authority used readily available organic materials and traditional methods of construction. Similar to the vernacular houses of Sulayman's port settlement, all of which are constructed of wood, bamboo (*caña*), and nipa thatch, the edifices built by the Spaniards were of non-permanent, abundant, and highly combustible building materials. In 1583, as the remains of Governor-General Ronquillo lay in state in San Agustin Church, then made of bamboo and nipa, the draperies caught fire from the vigil candles and the flames spread rapidly reducing the entire city to ashes. This calamity reinforced the need to utilize more durable building materials by the many residents. It prompted the next Governor-General, Santiago de Vera, to order that all buildings of the city be constructed of stone and tile. Kilns or *hornos* for the manufacture of *ladrillos* or bricks, *tejas* or v-shaped roof tiles, and *baldosas* or square floor tiles were soon established. Stone quarries located near the insular metropolis were surveyed and exploited. Hence, the decree fostered an abrupt architectural change and urban renewal in Manila.

By the middle of the 1580s, Domingo Salazar, the first Bishop of Manila, and Father Antonio Sedeño, a Jesuit, pushed for the construction of buildings and houses using stones and tiles. Equally important was the opening of the newly

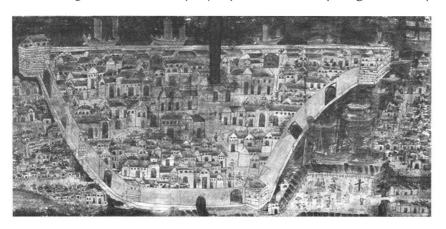

4.6 The city of Manila from an oil painting on the interior of a wooden chest, circa 1640–50. Museo de Arte Jose Luis Bello, Puebla, Mexico

discovered quarries along the banks of the Pasig River, particularly in Guadalupe, Makati, under the auspices of Bishop Salazar. These quarries not only provided a valuable source of local building blocks but gave rise to a stone-cutting industry in the country as well. Sedeño (1535–1595), using a soft stone of volcanic origin called adobe, built the first stone building, the residence of Bishop Salazar, and the first stone tower, which was used as one of the defenses of Intramuros to demonstrate the feasibility of building in stone. Edifices of cut stone were called *de silleria* or *de cal y canto*. This golden age of building in stone required the Chinese and Filipinos to learn how to quarry and dress stone, how to prepare and use mortar, and how to mud bricks. During the forty years that followed after the last fire, beautiful edifices and magnificent temples were built within and outside the walls of Manila. However, a devastating earthquake in 1645 shattered the ambitious plans of the Spaniards.

Arquitectura Mestiza
To avoid the consequences of both fire and earthquake, a new hybrid-type of construction was invented—the arquitectura mestiza—a term coined by Jesuit Francisco Ignacio Alcina in 1668 to refer to the structures built partly of wood and partly of stone (Merino 1987). This half-breed architecture used wood in the upper floor and stone in its ground floor to make it resistant to earthquakes. Thus, all edifices, except the cathedrals, rarely exceeded two floors and had walls of about three meters thick supported by buttresses. Aside from this, the indigenous framework, which relied on interlocking beams and house posts, was integrated to support the house effectively. In this type of construction, the house posts or *haligues* supported the second floor, while the stone walls at the ground floor merely acted as a compact curtain for the wooden framework of the house.

Although the character of the arquitectura mestiza was further influenced by amateur artisans and builders, the actual business of building was executed by the *maestros de obras* or master builders. They were natives who were apprenticed to friars, engineers, and other knowledgeable and experienced people. It was only during the mid-nineteenth century when numerous professional architects and

Baluarte de San Diego

Stones for Architecture

The quarrying of building stone was one of the period's important mineral industries. Adobe stone, *batong sillar*, and Guadalupe stone were popular names applied to consolidated water-laid volcanic tuff that occurs as a continuous blanket material from the Lingayen Gulf to southwestern Luzon. Adobe stones were principally quarried in Marikina, San Mateo, and Guadalupe in Rizal, Meycauayan in Bulacan, and other places. The stone is soft and easily quarried with an axe, but hardens rapidly upon exposure to air. The tuff has low compression and tensile strength, and when used in the construction of large buildings, very thick walls are generally required.

In several towns along the coast, notably in Cebu, coralline limestones had been quarried and used as building stones in the construction of houses and churches. Many churches in the Visayas were built of coralline limestone. The best-known ornamental stone is the Romblon marble, which is quarried in Romblon Island. Romblon marble is a gray-blue mottled stone capable of taking on a high polish. The stone has been used principally for monuments, tombstones, fonts, and similar articles. In certain parts of old Manila, slabs of granite imported from Hong Kong were used in flooring and sidewalk construction. In San Pedro, Makati, there was a brick factory, La Olimpia, which utilized the clay found there to produce roof tiles, brick blocks, balusters, and other manufactured clay-based products.

4.8 and **4.9** Architectural hybridity characterizes the arquitectura mestiza—a wood and stone structure that combines Spanish and indigenous building knowledge.

engineers arrived from Spain. It was during this economic boom that the first Filipino professional architect, Felix Rojas y Arroyo (1820–1890), arrived from his studies abroad.

Intramuros: The Bastion of Authority

The Walled City of Intramuros, patterned after the medieval city-fortresses of Europe, began to take form in 1590 when Governor-General Gomez Perez Dasmariñas undertook the massive project of building the 3,916-meter pentagonal perimeter walls of volcanic tuff (adobe) and brick filled in with earth, with one bastion in each angle. The designer and supervisor of the construction of this engineering feat was Leonardo Turriano, a military engineer and personal appointee of the Crown. Native labor was used to build the walls, exacting the services of tens of thousands of Filipinos conscripted from villages throughout Central Luzon (Reed 1978, 49). The wall was fourteen meters thick and 7.6 meters high above the moat that surrounded it. It had watchtowers and dungeons and entry was through seven gates. Bordered by Manila Bay on one side and the Pasig River on the other, the walls facing landward were marked off by a moat, thus making Intramuros virtually an island with drawbridges raised up every night, a practice religiously observed up to 1872 to maintain both the security and exclusivity of the Castillan residential enclave. When it was finished, Intramuros had sixty-four blocks, with most of its streets named piously after saints.

Governor-General Dasmariñas began a systematic building program for the city. Institutions for public welfare, such as hospitals and educational facilities, were established. He set about to build the cathedral church of hewn stone, and encouraged the citizens to continue building their edifices out of stone and finishing them with red tile roofs.

In due course, Manila, like many others in Spanish American port cities, became a well-garrisoned commercial emporium, playing a significant role in the trans-Pacific commerce called the Galleon Trade as a traffic point with merchandise being exchanged between the Western and Oriental worlds. The fortress of Nuestra Señora de Guía stood guard over the city. By the end of the sixteenth century the city was fully surrounded by a wall, which backed onto the river and the edge of the bay, with the Santiago Fort at its top end. Manila's physical transformation, from a dispersed cluster of nipa and bamboo structures fenced by a penetrable wooden palisade into an imposing and well-fortified city, was vividly described in Antonio de Morga's 1603 account in the *Sucesos de las Islas Filipinas*:

> The city is completely surrounded by stone walls...It has small towers and traverses at intervals. It has a fortress of hewn stone at the point that guards the bar and the river, with a ravelin close to the water, upon which are mounted some large pieces of artillery ... These fortifications have their vaults for storing supplies and munitions, and a magazine for the powder, which is well guarded and situated at the inner part; and a copious well of fresh water. There are also quarters for the soldiers and artillerymen, and the house of the commandant. The wall has sufficient height, and is furnished with battlements and turrets, built in the modern style, for its defense ... There are three principal city gates on the land side, and many other posterns opening at convenient places on the river and the beach for the service of the city ... The royal buildings are very beautiful and

sightly, and contain many rooms. They are all built of stone and have two courts, with upper and lower galleries raised on stout pillars ... There is a hall for the Royal Audiencia, which is very large and stately ... The houses of the cabildo [city government], located on the [main] square, are built of stone. They are very sightly also and have handsome halls. On the ground floor is the prison ... On the same [central] square is situated the cathedral church. It is built of hewn stone and has three naves (Translated in Blair and Robertson v.16, 137–43).

Intramuros was reserved for the nobility and the clergy; trading with the coolies and indios remained outside the walls. The monumental structures and other edifices were all designed to relieve the conquistador of his nostalgia and homesickness, away from his temperate homeland, in a strange tropical colony.

Extramuros: Living Beyond the Walls

Extramuros, which later pertained to villages outside the walls, became pueblos— Pueblo de Tondo, Pueblo de Binondo, Isla de Binondo, Pueblo de Quiapo, and Pueblo de Malate. Ermita, Sta. Cruz, Dilao, among others are the suburban nodes which were officially founded after the completion of the Intramuros walls. These areas remained as they were, even by name, and grew with Manila in its first century. But during this period, the Spaniards began to build their residences in the suburbs or *arrabales*, and the Church authorities began to expand its missions into Binondo, Quiapo, Ermita, and Malate. While the districts of Japanese Dilao and Chinese Parian were conceived and developed as segregated quarters designed to control the potentially mutinous aliens, the other arrabales proximate to Intramuros emerged unstructured, receiving no official directives from the Spaniards. Malate became the home of ambitious *maharlika* (noblemen), tradesmen who amassed their wealth from the new imperial order, while the *arrabal* of Tondo was identified with underprivileged natives who regularly provided fresh foodstuffs for the markets of Manila and could be readily marshaled for major public works or private constructions (Reed 1978, 63).

Mechanical trades and services were zoned outside the walls. The trade names were reflected in the street toponym in the areas of San Nicolas, Binondo, Santa Cruz, and Quiapo. Some old street names were Aceiteros (Oil Merchant); Aduana (Customs House); Alcaiceria de San Fernando (Silk Markets); Almacenes (Warehouse); Arroceros (Rice Dealers); Curtidor (Tanner); Jaboneros (Soapmakers); Platerias (Silversmiths); Salinas (Salt Works); Toneleros (Barrelmakers). From most of these streets came the goods and services which supplied the daily necessities within the walls.

4.10 Erected in 1663, Puerta Real was used exclusively as a ceremonial gate by the Governor-General for state occasions. The original gate was at the right of Baluarte de San Andres and faced the village of Bagumbayan. Destroyed during the British invasion in 1762, the present Puerta Real was relocated and rebuilt in 1780. The gate was damaged during the battle of Manila in 1945 and was restored in 1969.

To ensure the protection of the Spanish colonial elite, the colonial authorities decreed several official pronouncements limiting non-European population who could work or reside within Intramuros. This effected a more conspicuous colonial divide along ethnic lines, underscoring the status of Intramuros as an exclusive urban precinct for the Occidental elite. There were a few exemptions though; municipal employees, retail traders, and domestic servants were allowed to live inside the walls. But all Chinese, Japanese, and Filipinos were ejected from the intramural premises of Manila before the nocturnal closure of the city gates. The outcome of the colonial decree was the establishment of racially categorized residential districts in the extramural zone of Manila.

4.11 Manila and its suburbs in 1802 drawn by Bernardo de Larse

An additional tactic by which the Spanish authorities attempted to handle the increasing Asian population was through a "strict segregation and commercial control devised to confine Chinese and Japanese residents and visitors to particular districts, to strictly delimit their marketplaces, and to partly supervise social interaction with Filipinos and Spaniards" (Reed 1978, 52).

The Chinese Parian

With the increase of Chinese trading merchants and craftsmen, known as Sangleyes, a sense of anxiety began to surface among the Spaniards, some of whom lobbied for the closer monitoring of numerous alien residents. In 1581, a policy was enacted, designating to the Chinese community a separate urban quarter, known as the Parian, to be located at the northeastern sector of Intramuros, just within the city's wooden palisade. However, it was not long before such a policy began to show its consequences. The insecurity posed by the fast growing Chinese community as well as two serious fires in the densely populated Chinese neighborhood that threatened the surrounding structures of European proprietorship compelled the colonial government in 1583 to relocate the Parian eastward to a site immediately outside the walls, just south of the Pasig River and still within easy range of the cannon of Fort Santiago. The site was an estuarial swamp, rendered inhospitable due to daily tidal flooding and insect infestation. But the resourceful Sangleyes soon filled the marshland and reclaimed the land for settlement.

4.12 Chinese coolies in Binondo

4.13 Chinese district of Binondo at the turn-of-the-century

By 1590, the district, as initially programmed, proved ineffective to accommodate the permanent urban community of 3,000 Chinese and thousands of transients from mainland China who were engaged in the Manila-Acapulco trade. This condition resulted in a decree allowing the new immigrants to build additional shophouses along the fringes of the built-up district, which gradually expanded the Parian area in an accretionary pattern. The localization of most trades and personal services indispensable to urban life had transformed the Parian into a commercial core of colonial Manila for two centuries.

The increasing wave of immigration in the last decade of the sixteenth century triggered the Spaniards to allow some Chinese, especially the Christians who had Filipino wives, to permanently settle north of Pasig in the area of Binondo or, as the Spaniards called it, the *Isla de Binondoc*. The settlement was given limited privileges of self-government and to the Dominicans were delegated the tasks of Hispanization and Christianization.

With the population increase in the Parian and Binondo at the turn of the seventeenth century, Spaniards residing in Intramuros were ever more fearful of the potential uprising of the Sangleyes whose community surrounds their intramural enclave. Thus, a decree was issued by the colonial administration to limit Chinese presence in the designated ethnic quarters by sanctioning that no Chinese could

> live or own a house outside the settlements of Parian and of Binondo. Native settlements are not allowed in the Sangley settlements, or even near them. No Sangley can go among the islands, or as much as two leagues from the city of Manila, without special permission. Much less can he remain in the city at night, after the [intramural] gates are shut, under penalty of death. (Morga in Blair and Robertson v.16, 198)

These urban restrictions were intimidatingly reinforced by Intramuros cannons pointed at range toward Parian and Binondo. Fearful of the sanctions and penalty of death in cases of nocturnal loitering in the intramural premises, the Chinese themselves imposed a self-restriction that limited their movement in the city and confined their domestic realm in the officially allocated spaces.

4.14 The Chinese Parian district

4.15 Chinese migrant workers in Binondo

A Samurai in Plaza Dilao

A monument of a Japanese feudal lord, clad in samurai garb, stands at the center of a plaza in the Manila district of Paco, once a well-known Japanese settlement during the Spanish colonial era. The Spaniards referred to the Paco district as the *Plaza Dilao* (Yellow Plaza) because of the more than 3,000 Japanese who resided there. Plaza Dilao is the last vestige of the old town of Paco. When Japan began its Catholic holocaust in the seventeenth century, it claimed the lives of over a million Japanese Catholics and forced the exile of thousands to Macau and Manila. The statue of Takayama Ukon (1552–1615), Japan's well-known Christian daimyo who was exiled to the Philippines in 1614 for refusing to renounce his Christian faith, was erected in 1977 to preserve the urban memory of the district of Dilao in Manila.

The Japanese *Dilao*

Another potentially rebellious ethnic sector in the eyes of the colonial authorities was the Japanese. Trade had brought the Japanese to Philippine shores. Previous to colonization, the Japanese had forged a strong commercial link with the coastal communities of the Philippines. Japanese commerce with the Spaniards prospered during the colonial period as the Japanese supplied the Spaniards with goods and exotic items not obtainable in the Philippines but were bound for Acapulco.

As the Japanese population grew, a permanent Japanese community was assigned where they could be easily observed and controlled. The Spanish authorities found the Japanese proud and arrogant and less obedient to Spanish commands. They were settled in Dilao, a suburb east of Intramuros and yet within cannon range. The area was placed under the spiritual guidance of the Franciscans and provided a safe refuge for the persecuted Christians who fled Japan. With the onset of Japanese self-imposed isolation in 1639, the influx of Japanese migrants ceased and, gradually, the identity of Dilao as a distinct Japanese settlement faded out, only to exist in urban memory.

Military Architecture and Defense Installations

The building of garrisons, naval constructions, and fortresses was a military strategy to safeguard and protect the Spanish colonial possessions. These fortifications—such as Intramuros in Manila, Cavite, Corregidor, Cebu, Fort Pilar in Zamboanga, and others—guarded harbors and strategic coasts. They followed the European styles of the fifteenth and sixteenth centuries, and were characterized by heavy stone walls, moats, and grid road layouts (to facilitate movement of cannons, ammunition, and supplies). The European style of fortifications also used a series of bastions and keeps, which covered blind spots and prevented invaders from coming close enough to storm the walls. Where forts could not be constructed due to lack of funds or materials, watchtowers were built to warn the coming of invaders; the church belfry also served as a lookout and the tolling of its bells signalled the approach of enemies.

The total number of Spanish troops in the Philippines never exceeded 14,000, including native soldiers. Barracks both inside and outside the walls were built to house them and their weapons; a major naval base was built in Cavite. Main concentrations of the Spanish garrisons were in Manila, Cavite, Cebu, Zamboanga, Polloc, and Isabela, Basilan.

Cebu has long been acknowledged as a major commercial hub in the pre-Hispanic era. It was the first landing point of Magellan and Legaspi, thereby the initial base of Spanish colonization, Christianization, and permanent European settlement. Aware of their increasing number of enemies as a result of their expedition and colonization, Legaspi and his men in 1565 fortified the existing triangular fort of timber palisades which they found in Cebu, and named it Fort San Pedro. In the process of colonization, this fort turned out to be the forerunner of the succeeding fortifications all over the country.

The earliest stone fortress built by the Spaniards was a tower on the southern side of Intramuros, called Nuestra Señora de Guia, opposite the hermitage of the same designation. Designed by the Jesuit Antonio Sedeño and built circa 1587, the tower was later integrated into the defensive system which Governor-General Perez de Dasmariñas built around Manila beginning in 1590. The construction of the massive walls of Intramuros that surrounded the entire city was considered an engineering feat. Watchtowers were strategically located, and, at some sections there were compartments for the guards on the walls and gates. During this time, another fort was constructed over what was left of the fortification of the city's previous chieftain, Sulayman. The fort was named after the patron saint of Spain, Santiago. Fort Santiago was built at the sharpest angle, between the river and the bay, and this functioned as a citadel.

Intramuros was considered the foremost fortification built by the Spanish Crown. It underwent a series of overhauls to strengthen its defensive capability, especially after the British occupation in 1762 to 1764. Other major defenses include Fuerza de San Felipe in Cavite, Fuerza de Nuestra Señora del Rosario (1617) in Iloilo, Fuerza de San Pedro (circa 1600) in Cebu, and Fuerza de Nuestra Señora del Pilar (built 1635, demolished 1663, reconstructed 1719) in Zamboanga.

4.16 Fortification of the city of Manila drawn by Dionisio Kelly in 1770. The wall surrounding the Intramuros precinct had four fronts: one facing the river, one facing the sea, and two land fronts, one of which was called Bagumbayan. The apex of the triangle is the Bastion de San Diego, which today is an archaelogical site where three rings of stone connected by crossways were unearthed.

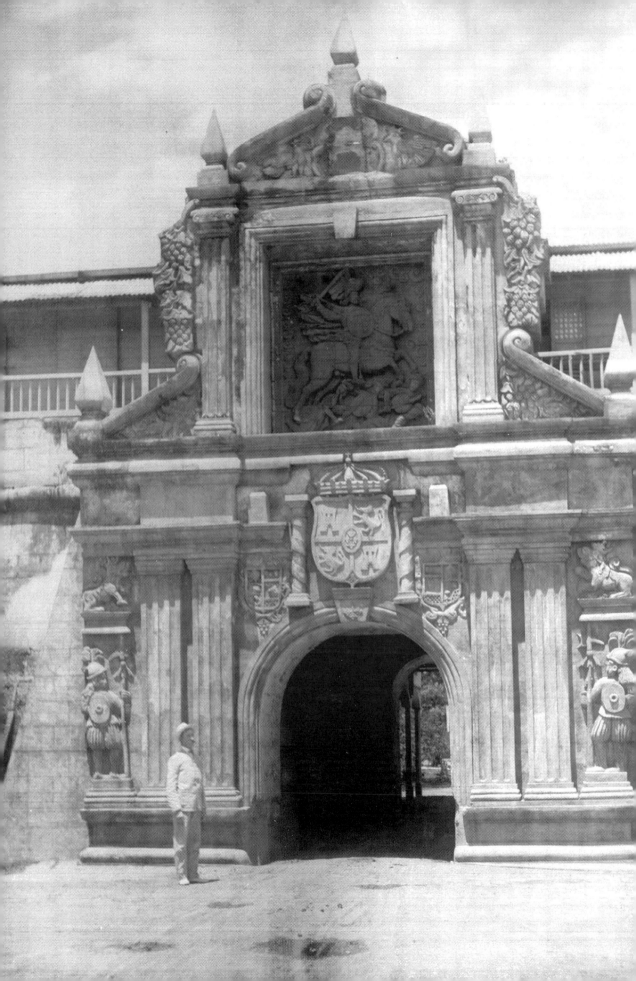

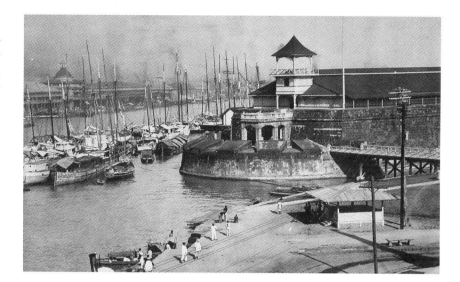

4.17 The gate of Fuerza de Santiago (Fort Santiago, opposite page) towering forty meters high. Construction work was commenced in 1591 and was completed in 1634. Fort Santiago was designed by Leonardo Iturrino. It was the second most important fortress to be built of stone in Manila, after the Nuestra Señora de Guía fortress.

4.18 Fort Santiago facing the mouth of the Pasig River

4.19 Fuerza de Nuestra Señora del Pilar in Zamboanga

The fortress architecture consisted of several sections: the sections that front the sea and the river, which were of less intricate and complex design; and the three-sided land fronts. Spanish fortifications were designed in accordance with the principles of the bastion system—straight stretches of polygonal perimeter wall connected by protruding precincts called bastions at every corner of the polygon. The typical fortifications may be three-sided or more, with walls called *cortinas*, three to ten meters thick. On top of some of these walls were stone embrasures, called *casamatas*, on which artillery weapons were propped up. Skirting cortinas on both ends were four-sided bulwarks known as *baluartes* or *bastiones*. Resting on other corners were little turrets called *garitas* or sentry box where sentinels kept watch. The moat or *foso*, a deep and wide ditch filled with water, surrounded the whole fortification as a form of defense. One side of the entrance was a massive structure known as *revellin*, a small outwork in fortifications consisting of two embankments shaped like an arrowhead that points outward in front of a larger defense work that was sometimes constructed. The interior of the fort could contain

one of the following: living quarters for the soldiers, a jail, a foundry, a chain of warehouses for ammunition, powder, and provisions, a well, and a chapel.

The forts were not always effective: Intramuros was captured by the British in 1762 and Fort Pilar in Zamboanga, although they satisfactorily stood up against the Dutch in the 1600s, had to be abandoned for a while due to shortage of manpower. By the time the Americans came to the Philippines, most of the Spanish defenses were old and antiquated; a few relatively new guns had been brought to Manila, Corregidor, and Cavite, but these were still smooth bore muzzle-loading weapons, which had limited range. Virtually all weapons were obsolete and were either destroyed by the Americans or turned into decorative pieces.

Barracks and military offices were old and not well-maintained, although more recent wood and nipa construction had been built in Malate, among other places. But all these would be taken over by the Americans in 1898.

4.20 Entrance gate to the Fuerza de San Felipe in Cavite

4.21 Ramparts of Guadalupe, Cavite

4.22 Fuerza de San Pedro in Cebu

4.23 Fort General Corcuera in Malabang, Mindanao

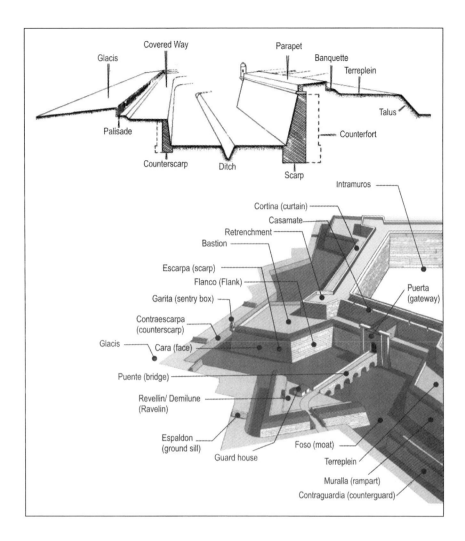

Edifices for Religious Conversion

Several religious orders undertook the spiritual governance of the Islands: Augustinians, Franciscans, Jesuits, and Dominicans. In the Philippines, the baroque churches of the Spanish colonial period constituted the most exemplary element of the country's architectural heritage. Charged with the mission to evangelize the islands, the religious orders filled the archipelago with ecclesiastical edifices—churches, monasteries, and convents—in newly founded parishes. The architecture that resulted was an artifact of cultural encounter, allowing unique architectural styles to flourish, native labor giving interpretation and tangibility to the friar's blurred memory of European baroque churches.

Prior to colonization, the early Filipinos did not worship in temples. Instead, members of families, dependents, and relatives met for some special rituals in private places called *simbahan*. Spanish friar Fray Juan Francisco de San Antonio recounts that the locals built their places of worship as extensions in their homes, which they termed *sibi*. It had three separates naves, with the third one being the longest. Leaves and flowers with small lighted lanterns adorned the shelter. A large lamp with many ornaments was placed in the middle, and this was their simbahan or oratory. Solemn feasts were held in the simbahan, with the *pandot* being the

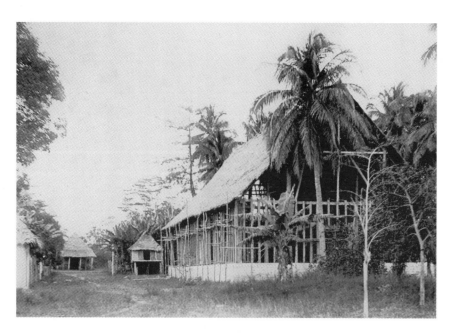

4.25 A temporary mission church built in Mindanao in the late nineteenth century

4.26 Interior of the Manila Cathedral in the early twentieth century (opposite page)

most solemn ritual, lasting for four days. Once the feast was over, all the ornaments were removed and the place once again became a nondescript residence.

Friars in the sixteenth century built plain chapels of bamboo, thatch, and other light indigenous materials. These worship structures were no different from the native houses—simple in plan and structure, with a rectangular nave and high pitched roof. The floor may have been raised above ground, or may have been on ground level or the bare earth itself. Friar chronicles described these early churches as *de caña y nipa* (of bamboo and nipa). Because of the material, these structures were easily devoured by flames. Later, these churches evolved into monumental stone sanctuaries fusing European styles with indigenous influences but retaining the simple rectangular plan. Thus, the single-nave colonial church owed the provenance of its form not from a European archetype but from an indigenous precedent. In traditional Western architecture, rectangular or longitudinal churches, as a rule, abide by the basilican plan, which featured a central nave with an aisle on each side formed by two rows of columns and, typically, a terminal semicircular apse. Although chapels (*kapilya*) may later evolve into churches (*simbahan*), both buildings adhered to a common spatial pattern: a longitudinal space, the nave, for congregation; at the end, the narthex or the vestibule, a preparatory space where the worshippers crossed themselves with holy water; and, on the opposite end, the sanctuary or presbytery where the priest said mass.

Characteristically, a colonial church had two focal points: the *altar mayor* (main altar) at the far end of the sanctuary where the Eucharist was celebrated and the consecrated host kept in the *sagrario* (tabernacle); and the *pulpito* (pulpit), an elevated structure usually of wood often placed at the nave or at the intersection of the nave and transept, or *crucero*, to amplify audibility of the homily. Side altars or *altares menores*, formed by the arms of the transept, could accommodate several priests celebrating mass simultaneously with the priest at the main altar.

An elaborately ornamented *retablo* or altar screen emphasized the importance of the altar mayor. The interior of the church was often richly furnished with side

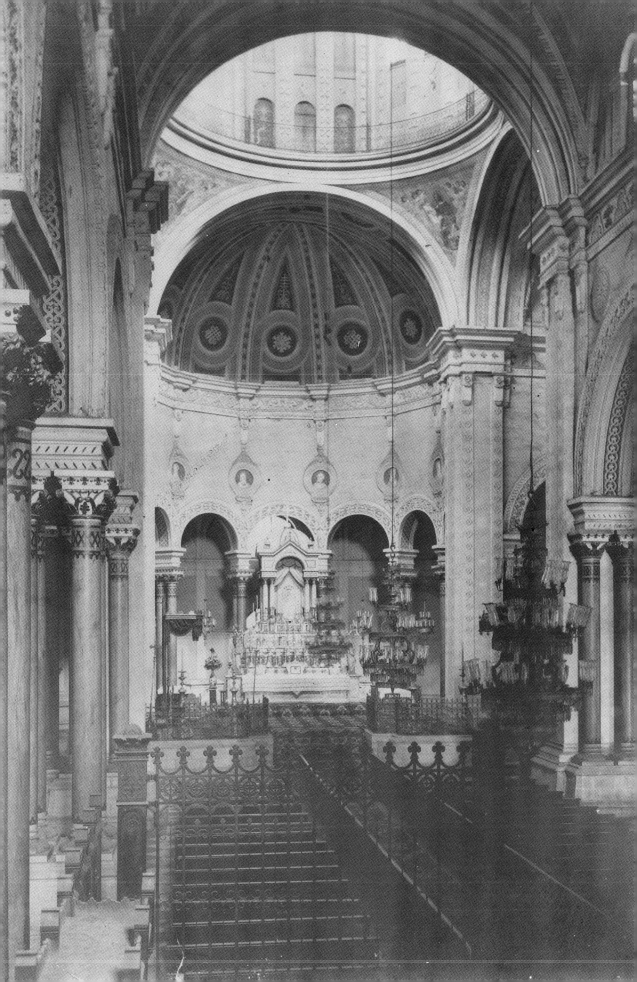

4.27 Construction of the Church of Santa Maria in Zamboanga, 1888

altars, paintings, and carvings of religious icons and biblical episodes—all of which were devised to direct the attention to the tabernacle at the center of the main altar. To one side or behind the main altar was the *sacristia* (sacristy) where the priest and his assistants put on their religious robes before saying mass. The band and choir performed at the *coro* (choir loft), a high platform formed by a mezzanine behind or over the main entrance. The organ was placed on a loft next to the coro in accordance with Spanish tradition. Majority of the worshippers were left to stand or kneel; long benches were provided only for the *principales* or leading citizens of the community. Persons who sought privacy could attend mass behind the *tribunas*, a screened gallery with entry from the second floor of the convento.

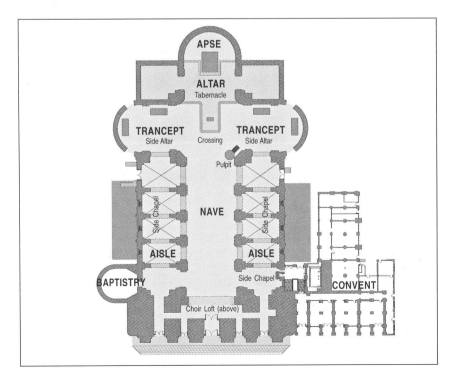

4.28 Typical cruciform plan of Taal Basilica in Batangas

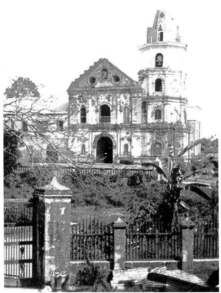

4.29 Santa Ana Church in Manila

4.30 Main altar of Santa Ana Church

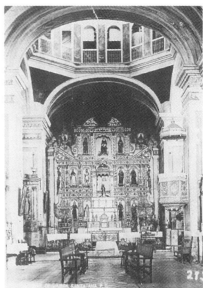

Adjacent to the church was the parish house or rectory, called convento in the Philippines. Another component of the church complex was the graveyard or cemetery. In the early days only the elites could be buried inside the church. In the nineteenth century, graveyards near the church were abandoned in accordance with the funerary and hygienic reform. New cemeteries were established in the outskirts of the town.

Key settlements some distance from the parish were established as visitas, visited by the priest or his representative on certain occasions, such as feast days, to administer the sacraments. Eventually, many of the visitas assumed independence as a separate parish from the mother parish or *matriz*.

4.31 The tandem of church and convent in the province

The early stone churches were of rubblework or *de mamposteria*. Later churches used hewn stone and were called de silleria or de cal y canto. The advent of stone churches began in Manila in the aftermath of the great fire at the turn the sixteenth century. In the mission areas, stone churches began to be built in the first half of the seventeenth century. The sheer weight and rigidity of these stone edifices made them prone to collapse during earthquakes. After the tremors, new churches were constructed, but this time following the style adopted in the seismic zones of America. Termed as earthquake baroque, these structures possessed a more robust proportion and were squat in appearance. The skill of hewing stone led to the craft of carving stone for ornamental purposes. Native artisans skillfully executed the stone relief ornaments to approximate the baroque and rococo design prototypes as recollected from the friar architect's memory of European churches.

When building a church, the natives contributed much of the needed labor force. But they were not always indispensable. Although the Filipinos were good builders of wood and bamboo, they were unskilled in building with stone. Hence, Chinese laborers were employed when such a specific skill was required. Muslims were also recruited to provide labor. In several churches in the south, this resulted in minaret-like belltowers with onion-shaped roofs, trefoil arches, and geometric patterns. One good example is the Carcar church in Cebu. Muslim influence also prevailed in the central north, as the Malate Church in Manila illustrates. The collective

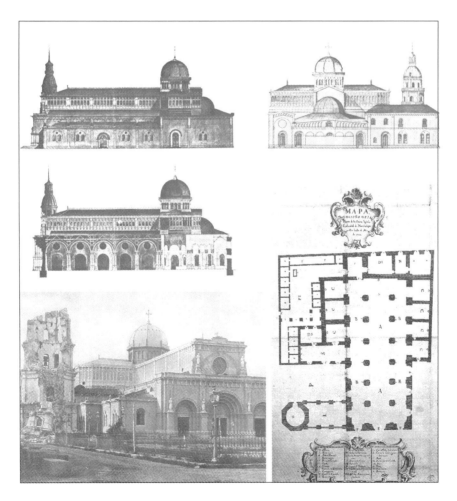

4.32 Plan and elevations of the Manila Cathedral. The cathedral was rebuilt seven times.

labor of artisans coming from a varied ethnic and cultural heritage eventually led to the confluence of nonwestern motifs into the architecture, further creating a hybrid style. Thus, classical ornaments in baroque or neoclassical designs were often incorporated with local motifs such as flowers, fruits, or a crocodile's head.

The colonial churches were actually a mixture and accumulation of fragments borrowed from medieval Spanish architecture as well as from Chinese, Muslim, and other foreign influences coming from as far as India. Church architecture, thus, became an architecture of improvisation, or the adaptation of form and design to suit the means, the purpose, the skills of the craftsmen, and their exposure to overseas ideas. The local adaptations of foreign forms and designs were plainer and highly selective. A high degree of originality is manifested in the emphasis of decorative woodwork in the interior, the fanciful treatment of pillars and columns balustraded, and the elaborately sculptured facades. The outcome was a unique vernacular interpretation of Spanish colonial architecture rendered through an aesthetic confluence of stylistic sources.

One fine example of the ingenuity of the local builders was their own rendition of the wattle-and-daub construction popular in Europe. Instead of using pliant branches of plants with a mixture of mud and straw applied on both sides of the wall and allowed to be sun-dried, the local builders used pliant bamboo with a mixture of mortar composed of sand, lime, and water. This was referred to as *tabique pampango*: tabique from the Arabic word *tasbbik*, meaning "wall"; *pampango*, from Pampanga, the name of the place where it was probably introduced and popularized.

The more permanent and sturdier churches were made of adobe stone or volcanic tuff, limestone, or brick. Regional availability and abundance of raw materials for church construction defined the material constitution of the building. For instance, churches in Northern Luzon were of brick, while churches in the Visayas and Mindanao were of coral stone, a whitish type of limestone formed from fossil coral reefs and accretions of shells and other marine life. Laying bricks or adobe was accomplished with the use of mortar or *argamasa*. A layer of plaster or *palitada* was laid over the brick or stone wall to protect it from direct exposure to the destructive effects of rain and wind. The mortar mixture was concocted from various formulas utilizing a mélange of ingredients, such as *apog* (lime), crushed coral, crushed shells, crushed eggshells, molasses, animal blood, carabao milk, sugar cane extract, and egg whites.

The church was generally rectangular or transept in plan. To configure the shape of a Latin cross, the single-nave church was extended by integrating a transept with the longitudinal apse. This appeared to be the basic plan of Philippine colonial churches, which was barely altered by such philosophy as baroque dynamism, rococo lighting, or gothic drama. Generally, colonial churches could be perceived as a plain stone box with an elaborately ornamented principal facade. The latter demonstrated the *halo-halo* (mix-and-match) or *tapal-tapal* (overlayering) stylistic attitude of fusing various architectural elements into a single compositional concoction. The elevational height was visually segmented and traversed vertically by columns and horizontally by cornices. Niches, parapets, blind arches, blind balustrades, false pediments, blind windows, pilasters, and bas-relief carvings provided texture and three-dimensionality to the otherwise uniform expanses of a

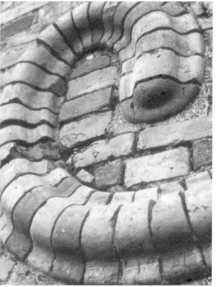

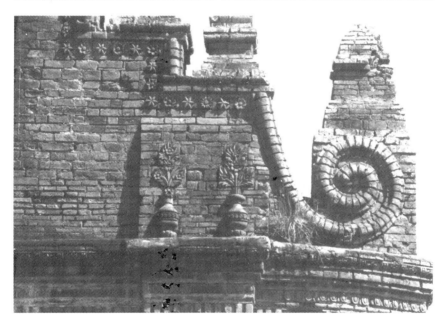

wall. Ornaments were derived from Classical, Romanesque, Gothic, Baroque, and Mudejar sources, with Chinese resonances and native influences. Chinese moments could be discerned in the decorative elements such as *fu* dogs, lions, stylized clouds, dragon-like scroll work, and geometric lattice screens. Exotic tropical decorative elements demonstrated the attempts toward subsequent local mediation such as in the facade of the Miag-ao Church in Iloilo, where the pediment portrayed a lush tropical environment.

While the church facade was often highly ornamented, the lateral surfaces remained plain. Such frontal indulgence deprived the sidewalls of grandiose decoration, yet the otherwise monotonous surfaces were broken to accommodate side portals with sparse but recurring decorative patterns and structural buttresses

4.36 Antipolo Church (photograph circa 1910)

4.37 Quiapo Church (photograph circa 1910)

4.38 Taal Basilica (photograph circa 1900)

assuming different silhouettes—flat and thin, bulky and rectangular, tilting, steeped, serrated, cylindrical, or curving.

Bell towers or *campanarios* ranging from three to five stories accompanied the whole composition. These structures could be as simple as the four-posted structures of early churches, or monumental, such as the detached bell towers of Ilocos. The bell tower served many functions for the colonial society: tolling the time, calling the parishioners to prayer, announcing important events in the parish, such as fiestas, weddings, and deaths, heralding the arrival of important personages, and warning of impending dangers such as fires and pirate attacks.

A bell tower could vary in design as well as in location. Some were detached from the church; some were linearly attached and integrated to the church; others

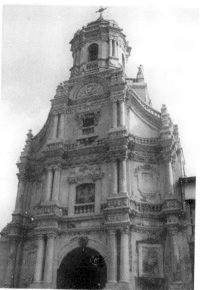

4.39 Miag-ao Church in Iloilo

4.40 Morong Chuch in Rizal

4.41 A variety of bell tower forms. Belfry of the churches of Masingal, Sarrat, and Bantay (from left to right) in Ilocos

stood near the front or some distance from the church. The towers attached to the church were usually provided with a baptistry at its ground floor. Ilocos churches had bell towers detached from the church at a considerable distance so that it would not topple and fall over the church's structure during earthquakes. In plan, bell towers may be square, octagonal, hexagonal or, in rare instances, circular in form. The number of bell towers may also vary; some churches have two, and a few have three. The church of San Luis Gonzaga in Pampanga, aside from exhibiting concave undulations attributed to European and Latin American Baroque found nowhere else in the Philippines, proudly displays three belfries in its facade.

The first buildings of architectural significance in the Walled City in Manila were the San Agustin Church and the Manila Cathedral. The mother churches of all religious orders, including all the largest monasteries, were concentrated in Intramuros. Constructed in 1587, the San Agustin Church is the only stone church of its size that is still standing as initially built. It is also one of the very few structures in the Philippines constructed with true barrel vaulting. The barrel vaults have

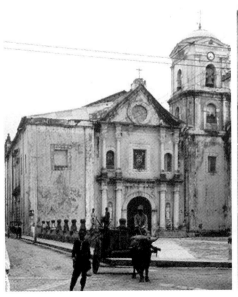

4.42 San Agustin Church in Intramuros

4.43 Detail of the arched portal and ornate door leaf of San Agustin Church

4.44 Santa Cruz Church in Manila in the early 1900s (opposite page)

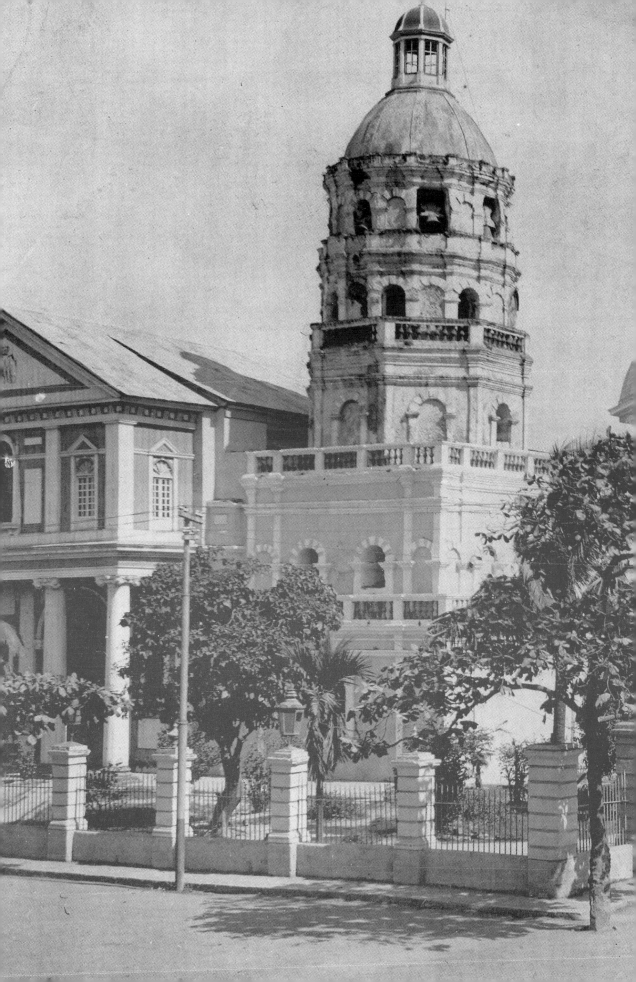

remarkably withstood even the strongest earthquakes. The original design of the church had three-story identical towers. Cupolas perched on drums topped the towers. However, the two upper storeys of the tower were damaged during the 1863 earthquake, and thus had to be removed subsequently. The Augustinians were also fortunate to have two Italian painter-decorators, Alberoni and Dibella, to paint the interior with trompe l'oeil, a technique that created an illusion of three-dimensionality in the recessed panels, rosettes, cornices, and mouldings.

The Augustinian churches in northern Ilocos are renowned for their massiveness, particularly their facades and side buttresses, with detached bell towers in close proximity. Another outstanding feature is the single nave, discarding the cruciform transepts predominant in other churches. Notable examples of Ilocano baroque are the churches of Paoay, Laoag, Badoc, Sarrat, Bacarra, and Dingras. Churches in southern Ilocos, on the other hand, are much smaller in scale but more elaborate in ornament, such as those found in San Vicente, Candon, Santa Maria, and Masingal. Chinese craftsmen who labored in the construction of these churches had left their mark though its Sinicized details, such as the scroll-cloud volutes and ornamental fu dogs resting on pilasters.

The Paoay Church, built from 1699 to 1702, invokes the aura of the stone architecture of Southeast Asia rather than Europe's. The composition depends on delicate mass and majestic silhouette. Detached from the church facade, the bell tower tapers as it rises from the ground in a fashion reminiscent of a pagoda. Enormous buttresses protruding on both sides curve sensuously with its voluminous, scroll-like base. The facade has no opening except from the arched portal that punctures the central axis of the front wall. Plain pilasters serve to negotiate the otherwise monotonous facade. A three-tiered wall punctuated by arched windows on the first level and a deep niche at the second level defines the pediment.

Built in 1765 under the supervision of the Augustinian order, the Santa Maria Church resembles a citadel located on the summit of a solitary hill rising above one side of the Santa Maria town plaza. The architectural ensemble presents its side

Fu Dogs

Stone zoomorphic sculptures of Sino-Buddhist origin, known as fu dogs or temple lions, are often mounted as guardians at the main doorways of colonial churches. These mythical creatures are believed to ward off negative energies and protect the church or sacred precincts. They can be found in three of the oldest settlements in the country established during the Spanish colonial period, namely: Cebu City, Intramuros, Manila, and Vigan (formerly known as Ciudad Fernandina) in Ilocos Sur. They are also present in the churches of Taal, Batangas and in Morong, Rizal. Undoubtedly, these stone lions are palpable emblems of a strong Chinese presence in the development of Philippine architecture.

4.45 Paoay Church in Ilocos

4.46 Detail of scroll-like buttresses of the Paoay Church

4.47 Santa Maria Church in Ilocos

4.48 Daraga Chuch in Albay

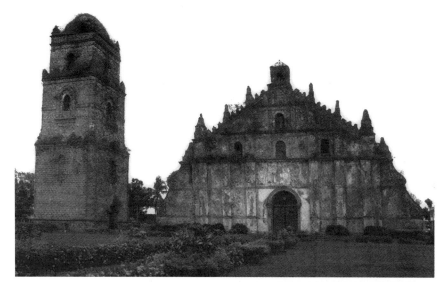

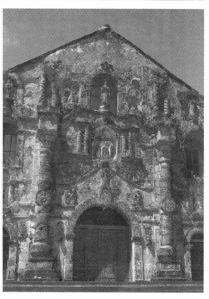

and detached pagoda-like bell tower rather than its facade to the town. The bell tower is detached some distance away from the church, protecting the main church structure from possible earthquake damage.

The Cagayan Valley lays claim to Dominican-built brick structures that include ascending or undulating volutes topped by massive finials. Excellent examples are the Tuguegarao Cathedral and the Tumauini Church.

The Franciscans, who covered the area of southern Quezon, Laguna, and the Bicol region, built churches in a range of unrelated styles, from the Renaissance-inspired church of Majayjay, Laguna to the fantastic carving of alcoves, seals, and twisted *salomonica* columns of Daraga Church in Albay. Built in 1815, the Daraga Church has a baroque-inspired facade where the absence of raking cornices is instead accentuated by salomonica that carries no entablature. Lavishing the facade further are niches and a medallion that roughly define the facade's three-dimensionality.

Augustinian-built churches in the Island of Panay are an impressive specimen of Philippine Baroque. The fortress church of Miag-ao features a massive triangular pediment portraying St. Christopher clad as a Filipino farmer and the Christ Child in a tropical environment verdured with stylized coconut, papaya, and guava trees. The San Joaquin Church pediment depicts the Battle of Tetuan, Morocco in 1859, where Christian cavaliers claimed victory over the Muslim regiment. This is the only secularized theme ever executed in a colonial Philippine church.

Churches in the Cebu and Bohol islands are huge coral edifices incorporating Muslim motifs, such as sun disks and pointed arches. The church of Naga in Cebu is decorated with disks, gargoyles, and minarets. The towers of Carcar Church are capped with bulbous mudejar domes. The interior of Argao Church exemplifies the fusion of eighteenth century rococo style and a restrained Islamic design. Exterior ornamentation in the Jesuit-built churches in Bohol is likewise influenced by Islamic sources, yet their interiors are triumphs of colonial ecclesiastical art.

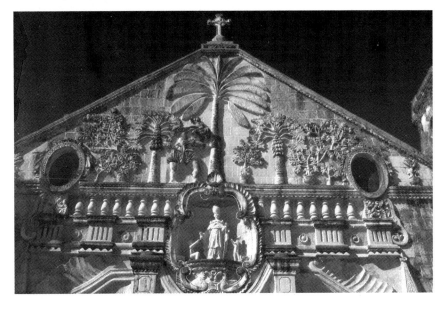

4.49 Detail of the pediment of Miag-ao Church in Iloilo

4.50 Detail of the pediment of San Joaquin Church in Iloilo depicting the Battle of Tetuan in relief

4.51 Carcar Church in Cebu

4.52 Argao Church in Cebu

4.53 Loboc Church in Bohol

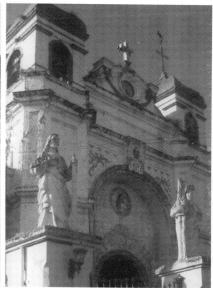

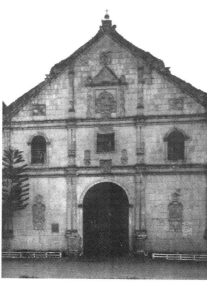

Extant religious murals of Loboc, Loon, Panglao, and Baclayon complement the grand array of baroque retablos gracing the transepts.

Some churches carry a strong statement of locally mediated architectural styles. Morong's baroque facade, completed in 1853 and designed by Bartolome Palatino (a native of the wood-carving settlement of Paete), is another excellent expression of the tropical baroque spirit. The dynamic and pulsating elements of baroque are also present in the facades of the churches in Binondo, Paete, Pakil, and Nagcarlan.

Other stylistic tendencies also figure in some churches. As a decorative style, gothic revivalism adorns a church with pointed arches and finials, Tudor arches, spandrels with trefoils, pointed niches, and lace tracery. Neo-Gothic-inspired churches include the ones in Cordova in Cebu, Bantay in Ilocos Sur, Sto. Domingo in Intramuros

4.54 Belgian-fabricated, all-steel church of San Sebastian (opposite page)

4.55 Gothic-styled Santo Domingo Church completed in 1868 in Intramuros and designed by Felix Rojas, the first Filipino architect to receive the professional title. The façade was derived from York Cathedral in England of thirteenth century.

(destroyed during WWII), and the Belgian prefabricated, all-steel San Sebastian Church in Manila. Neoclassicism is epitomized in the churches of Taal in Batangas, Malabon in Rizal, and San Ignacio in Intramuros (destroyed during WWII). The Romanesque strain is evident in the Manila Cathedral, with its deeply recessed round portals framing a tympanum with low-relief articulation and rose windows. The Pavia Church in Iloilo is inspired by the early Christian Roman basilicas with its rounded apse and a deep portico with three Roman arches of uniform heights. Non-Western motifs, like neo-Mudejar, characterized by trefoils arches, salominica columns, and arabesque wall tracery, lavish the facade of Malate Church in Manila as well as Carcar Church in Cebu, with its bulbous domes and pointed arches.

4.56 Early Christian designs of Pavia Church in Iloilo

4.57 Romanesque-inspired architecture of the Manila Cathedral

4.58 Neoclassical interior of San Ignacio Church in Intramuros

4.59 Gothic-styled Oton Chuch in Iloilo had a Greek cross plan

The church building enterprise of the Spanish missionaries set significant watersheds in the evolution of architecture in this part of the world. The Taal Church in Batangas is the widest church in Asia, while the San Sebastian Church in Manila, perhaps the crowning glory of colonial church building in the country, is the first all-iron church in Asia.

Ecclesiastical Architecture as a Colonial Mode of Production

The magisterial command of the "Lumang Simbahan" enthralls the populace with a pageant of consummate artistic expression harnessed through a colonial mode of production in the service of the Catholic Faith. Since the Church serves as the locus of propagating a system of beliefs previously unheard of, the colonial masters necessarily capitalized on a church's imposing image, together with the colorful ceremonies held within it, to enshrine their cultural superiority and inculcate among the natives the teachings of an unknown faith.

Colonial churches have been romantically heralded as monuments to God's greater glory, if not architectural inheritances we owe our colonial masters. However, this kind of historical framing needs to be rectified because it conveniently conceals the power relations at work in colonial arrangements, glossing over political strategies associated with colonial discourse, such as forced labor, religious tolerance, genocide, and obscurantism.

The celebrated grandeur of colonial church facades should not singularly overwhelm us with a blurring image of beauty but must also be subjected to the critical eye of socio-historicism. In doing so, we will be able to discover and understand issues of colonial cultural assimilation and encounters, native mediations and transformations, asymmetrical colonial power relations, religious subjection and domination, and possible native resistances.

In studying the grammar of colonial governance, one will need to read through the idiom of empire building that can be gleaned in architectural references. King Philip II, writing in the 1573 "Prescriptions for the Foundation of Hispanic Colonial Towns," makes it perfectly clear that the edifice of the church must demand attention, if not enthralling astonishment:

> In inland towns, the church is to be on the plaza but at a distance from it, in a situation where it can stand by itself, separate from other buildings, so that it can be seen from all sides. It can thus be made more beautiful and it will inspire more respect. It would be built on high ground so that, in order to reach its entrance, people will have to ascend a flight of steps (Reed 1976, 72).

King Philip II's prescriptions stipulate that the town plan should establish a main plaza from which a principal street traverses at one side with secondary streets laid out following a gridiron pattern. Built to designate the center of colonial authority, the plaza complex was to be dominated by the scale and presence of the church. In some instances where the church was not at the main plaza, the church should at least be situated at the highest point in the town or elevated in a prominent position. A bell tower of overwhelming height would serve as a panoptical device whose surveying gaze pierces through the quotidian affairs of the native population arranged strategically along the cuadricula planning system.

With the implementation of the ordinanzas, the native population was soon reorganized *bajo de las campanas*, "or under the sound of the bells." Resistance to the resettlement scheme assumed different forms, one of which was fleeing to the mountains. However, the natives were seduced by the theocratic authority by saturating the church and its premises, through a liturgical year of innumerable feasts and holy observances, with solemnity on the one hand and ostentation on the other. According to historian Teodoro A. Agoncillo (1990),

> the Spanish friars utilized the novel sights, sounds, and even smell of the Christian rites and rituals—colorful and pompous processions, songs, candle-lights, saints dressed in elaborate gold and silver costumes during the May festivals of Flores de Mayo or the Santa Cruzan, the lighting of firecrackers even as the Host was elevated, the sinákulo (passion play), the Christian versus Muslim conflict dream (moro-moro) [to] "hypnotize ..." the spirit of the indio.

During these commemorations, the performing arts, ranging from oral literature to theater to processions, would circumscribe the seductive theatrics of control that church culture held. Generally, the aura created by these colonial churches was scrupulously calculated to elicit colonial obedience and passivity among the natives. Behind the dissimulating beauty of each facade is an attempt to mask colonial reality and evade one poignant question: "How much forced labor was extracted from the natives by the colonial clergy to construct these houses of God?"

Juan Palazon, in *Majayjay: How A Town Came Into Being*, reveals a unique complexity in colonial church-building transactions. In Palazon's account, colonial subjects depicted are far from the image of an unquestioning believer who gained spiritual satisfaction from the building of a holy structure. Ultimately, the historian uncovers how colonial subjects ingeniously attempted to avoid the task of constructing the "house of God." Palazon (1964, 16) thus described the indio's cunning strategy to evade labor:

> One of the most common practices resorted to by the townspeople was to disappear from the towns in order to avoid carrying out those obligations that they considered too heavy for them to bear. We note from a decree issued in 1621 by the Audiencia that the townspeople of Majayjay were continually refusing to be counted as citizens of the town. To this end, if they had a house in the town itself

and a field in another town, they erected a house in their field, and when asked by the authorities of Majayjay whether they had fulfilled their duties, they replied that they had done so in the neighboring town. If the officials of the neighboring town asked them the same question they replied that they were domiciled at Majayjay and would fulfill their duties there. This practice became so widespread that the Audiencia was compelled to order the provincial governor to tear down the houses erected by the natives in their fields so as to compel them to live in the town.

Architecture for Colonial Administration

Monumental civic architecture, such as the Palacio de Gobierno, the Ayuntamiento, and the Aduana, epitomized the colonial institutions under the Spanish governance.

Bordering the Plaza Mayor of Manila were two of the most important administrative structures in the archipelago. The first was known by various names: *casa del ayuntamiento, casa del cabildo, casa consistorial, casa real.* This building occupied an entire block on one of the sides of the plaza mayor. As a seat of colonial governance, it housed several administrative offices and archives. The Ayuntamiento is best remembered for its elegant *escalera* and portal and its large hall where state banquets and dances were celebrated. It underwent several modifications and reconstruction works. In 1845, the main facade was refashioned in a style inspired from the Renaissance.

Across the Ayuntamiento was the residence of the highest official of the land: the *Palacio del Gobernador General* or *Palacio Real.* The *Real Audiencia* or *Tribunal* (trial court) was housed in another area until its abolition in the eighteenth century.

Both the Ayuntamiento and Palacio were European-inspired, two-storey stone structures with spacious inner courts. They sharply deviated from the architectural genre of the bahay na bato. Unfortunately, these important examples of civil architecture with distinct architectural features did not last long enough. The Palacio was toppled down in the earthquake of 1863, prompting the transfer of the governor-general royal residence to Malacañang Palace, formerly a vacation house of the governor along the Pasig River. The Ayuntamiento, after standing for eight decades, was also reduced to rubble in World War II.

Other important civic structures, were the Aduana (Customs House) and Hacienda Pública (Treasury), which further lavished the magisterial atmosphere of Intramuros with classicist architecture. The well-proportioned and solidly built edifices were situated right by the edge of the north wall of the city beside the river. The sprawling buildings had three principal entrances, two courtyards, and two principal staircases.

Meanwhile, in every provincial town in the archipelago was a smaller version of the Ayuntamiento, called the Municipio, Casa de Municipal, or Casa Real, symbolizing the secular power of the colonial state. The said structure was strategically located at one end of the town plaza, opposite the church, to signify governmental power. As a general rule, the casa real did not represent a special type of architecture. The building form was analogous to the convento and may be considered an oversized

bahay na bato. It was a two-storey structure with the lower floor made of stone and the second storey of wood. Emanating from a common architectural paradigm of the bahay na bato, civic buildings like the tribunal, cabildo, casa real, and schoolhouses, were architecturally indistinguishable from one another.

On the other hand, the administration of the hacienda or landed estate revolved around the *casa hacienda*, which was made up of one or several expansive structures housing spaces for the administrators and his workers. It also included a kitchen, a storage room, a carpentry atelier, a stable, and a chapel. The Augustinian-built casa hacienda in Mandaluyong, built in 1716, is regarded as one of the oldest extant structures of its kind and now houses the Don Bosco Technical School for Boys.

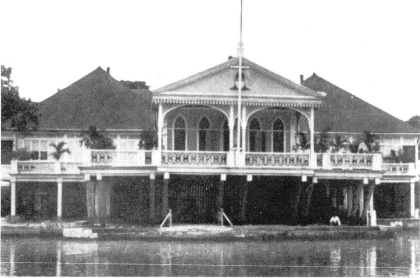

4.64 Plan of the Malacañang Palace designed by Luis del Rosario y Rivas, 1897

4.65 Malacañang Palace, the summer residence of the Governor-General, fronts the scenic Pasig River.

Educational and Scientific Facilities

The missionary tasks of bringing education, health care, and social welfare to the indigenous subjects were zealously fulfilled by the various religious orders. Through the commitment and initiatives of the Dominicans, Jesuits, Augustinians, and Franciscans, teaching facilities, hospitals, and orphanages were built and established.

The number of schools built by the Spaniards was inventoried by the Americans and published in the *Annual Report of the General Superintendent of Education* in 1904. It listed 534 school houses which were "still standing and to some degree serviceable in at least 374 municipalities" and described Spanish-constructed schools as "substantially built of stone or brick ... cloister-like structure situated in the heart of some municipality, and with no grounds or gardens except an interior court."

Two types of school buildings surfaced during the Spanish colonial period: the *colegio* or *universidad* found in urban areas and the *escuela primaria* found in different pueblos.

Six schools were built within the Walled City or Intramuros: Universidad de Santo Tomas, Colegio de San Juan de Letran, Jesuit Colegio de Manila, Colegio de San

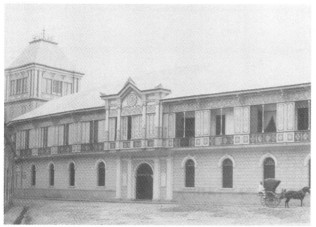

4.66 1887 Facade of the school of San Juan de Letran, founded by the Dominican order in Manila between 1830 to 1850

4.67 Library of the University of Santo Tomas in Intramuros, Manila, 1887

Jose, the Colegio de Santa Rita, and the Colegio de Santa Potenciana. Females were taught separately from males: males received instructions from priests and brothers; females learned from nuns.

In 1571, the Jesuits built the Colegio de San Jose and, in 1594, the Franciscans founded the Colegio de Santa Potenciana, both of which were established under the direct order and sponsorship of King Philip II.

The Colegio de San Juan de Letran and the Colegio de Santa Isabel were created in the first third of the seventeenth century to take in orphans and indigents of Manila, while the Dominicans founded the Colegio de Santa Catalina de Sena and maintained it through private donations. The college later became a training center for schoolmistresses in the nineteenth century.

The country boasts of the oldest established university in Asia, the University of Santo Tomas, which was founded in 1611 by the Dominicans. In 1680, it received the title of Royal and Pontifical University. Another important educational institution in the nineteenth century was the Ateneo de Manila founded by the Jesuit fathers. In Cebu, the Colegio de San Ildefonso was the precursor of the present University of San Carlos. Other schools inside Intramuros started as orphanages, such as the Hospicio de San Jose and the Asilo de San Vicente de Paul. These institutions had the luxury of having spacious buildings and broad courtyards with a chapel at the center. Permanent buildings were generally constructed based on the atrial scheme, usually a structure or cluster of buildings in rectangular configuration with a central courtyard extending the full height or several storeys of a building. On one side of the atrium was the church or chapel. The atrium itself was a garden with a well. The two or three-storey tall structures surrounding the atrium provided space for instructional facilities on the lower floors and dormitory facilities on the upper floors.

While the establishment of primary schools was an essential component of the colonial acculturation agenda, the construction of schoolhouses failed to gain a foothold in the colony until the nineteenth century, with the promulgation of the Educational Decree of 1863. Under its mandate, at least one *escuela primaria* or primary school for boys and one for girls were established in every village or town. Attendance in such a school was mandatory and failure to attend was strictly

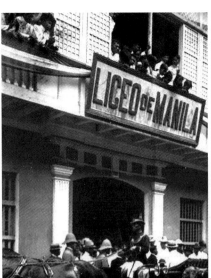

castigated. Primary education was designed to be catechetical as reading and writing were imparted with the aim to assist children learn prayers and the teachings of the Catholic doctrine.

Apart from educational needs, the religious orders also considered the health and medical needs of the colonial subjects. The Franciscans built the first hospital around 1564, the Hospital Real, which was also one of the first buildings to be erected in Manila. In 1587, the Dominicans founded an important medical center in Tondo, the Hospital de San Gabriel, which was demolished in 1744. The Hospital de Santa Ana, the oldest hospital in the whole of the Orient, founded in 1596 by the Franciscan Juan Clemente, was later to become the Hospital de San Juan de Dios and the Hospital de San Lazaro. The Hospital Real catered only to the Spaniards; the Hospital de San Gabriel was for the Chinese in Binondo; and the Hospital de San Lazaro was for lepers.

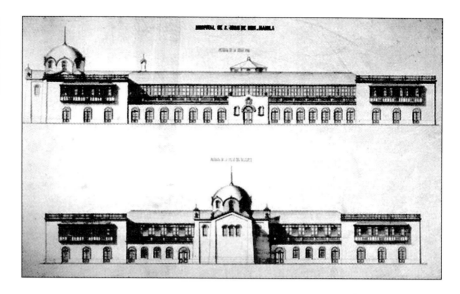

4.71 The plan for the reconstruction of the Hospital of San Juan de Dios by Luis Cespedes. Founded in 1596 by the Brotherhood of Mercy, the hospital was rebuilt after being destroyed in the 1863 earthquake.

The Observatorio Astronomico y Meteorologico de Manila, popularly known as the Manila Observatory, exemplified the efforts of the religious orders in the pursuit of scientific knowledge. The Manila Observatory was established by the Jesuit Orders in 1865 at the tower of San Ignacio Church in Intramuros. That year, Father Juan Vidal, Superior of the Jesuit Mission in the Philippines, assigned Father Francisco Colina, a professor of mathematics at the Ateneo Escuela Municipal, to set up an observatory that would consolidate the research in the science of meteorology to assist in forecasting typhoons. Realizing the advantages of predicting the approach of a storm, the business community contributed funds to improve the antiquated instruments used by Father Colina with a meteorograph designed by an Italian Jesuit, Father Angelo Secchi, and to enable the institution to continue its valuable work on a larger scale. In 1878, Father Federico Faura (the inventor of the Faura barometer) assumed directorship of the observatory. By 1880, cable connections had been established with other countries in the Far East and overseas request for typhoon warnings were received and granted by the observatory. A seismic section was added in 1880, a magnetic section in 1887, and an astronomical section in 1889.

In 1884, the Spanish government declared Father Faura's weather bureau as a state institution to be known as the Manila Observatory. It was then relocated from the Ateneo building in Intramuros to a new building built as a normal school of the Jesuits in the district of Ermita. In 1887, the Manila Observatory was rebuilt and it became a familiar landmark of colonial science at Calle Observatorio (now Padre Faura in honor of its foremost Jesuit scientist). The rectangular stone building was dominated by a huge steel cupola. The telescope's shaft and mechanism were built in Barcelona, Spain. The shaft was constructed in such a manner that despite its enormous size and weight of sixteen tons, it could be repositioned without difficulty even by a child. The equatorial telescope had a focal distance of seven meters, measured fifty centimeters in diameter, and weighed fourteen tons. The base of the telescope was fabricated in Munich, Germany, and the tube in Washington, United States. Unfortunately, in 1945, the structure was burned to the ground at the height of the Battle for Liberation in World War II. After the war, the observatory building was never reconstructed but the institution was initially relocated to Baguio, then to its present site in Quezon City in the 1960s.

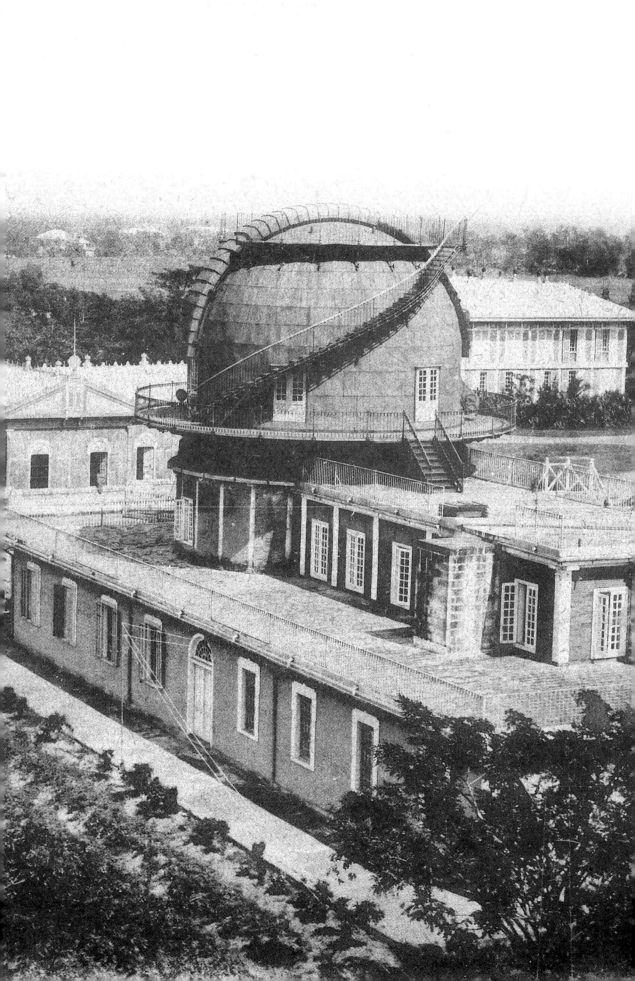

Obras Publicas and Colonial Building Regulation

Spanish military engineers, and, in later years, civil engineers, practiced their profession in the Philippines. At the onset of Spanish colonization, the construction of obras publicas or public works was assigned to a corps of military engineers who were tasked to build defense structures and government edifices. In 1705, the Corps of Engineers was established in Manila to take charge of all constructions, including the erection of churches, government buildings, and other structures. On record, the first military engineer was Juan de Ciscara y Ramirez, a native of Cuba. He directed many fortification works and initiated the momentum in the construction of religious structures, such as the cathedral of Cebu. In Manila, Ciscara pointed out the serious defects in the public works of the colonial city, particularly the carriage road made of masonry outside the city walls, which, in his opinion, might be used as a line of attack for potential marauders. He also drew up the engineering plan for the remodeling of Fort Santiago in 1714 to make it worthy of being a defense structure.

The early churches were built under the direction of architects or maestros de obras (master builders), many of whom were priests. These friar architects wishing to build or repair a church were required to present to the bishop a *presupuesto*, a proposal detailing the drawings, plan, and cost estimates. Aside from church-building, the friar architects were sometimes engaged in the construction of hospitals and schools and were consulted occasionally on government construction projects. From the late sixteenth century to the end of the eighteenth century, there were about nineteen architects on record.

The actual construction or repair of buildings was sometimes contracted to builders, many of whom were Chinese. This contractual system was called *paquio* (*pakyaw* in Filipino) and managed to persist to this day. The colonial government also employed the tax system of *polo y servicio*, which compelled every able-bodied male to render labor service for public construction for a period of forty days annually (reduced to fifteen days in 1884). Exemptions were made for the sickly, military servicemen, the principalia, or anyone who could afford to pay the monetary equivalent of the polo y servicio. The system assured the continuous supply of labor force for the many colonial infrastructures, such as roads, bridges, forts, and harbors. Under this system, friars could also obtain labor for the construction or repair of ecclesiastical structures, subject to approval of the colonial administration.

With the economic progress of the nineteenth century, new wealth was being created and a construction boom in the colony followed suit. In 1837, a decree was issued forbidding any construction which required blueprints to begin, unless the plans were duly submitted and approved by the proper agency of the colonial state. However, the decree was doomed to fail for there were not enough architects and engineers to implement its provisions and, moreover, no penalty was imposed on offenders. For security purposes, the Royal Ordinance of February 13, 1845, required the submissions of plans for repairs, alterations, or construction to be made on vicinities within a 1,500 *varas* (about 1.3 kilometers) radius from Intramuros for approval of the state engineer.

4.72 The Manila Observatory founded by the Jesuits (opposite)

To successfully enforce the decrees related to building regulation, the Asesor General, in 1852, declared that violators would be penalized by a fine in proportion

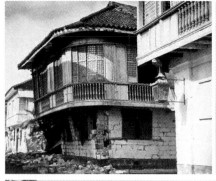

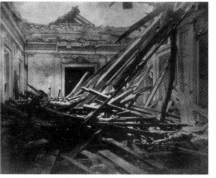

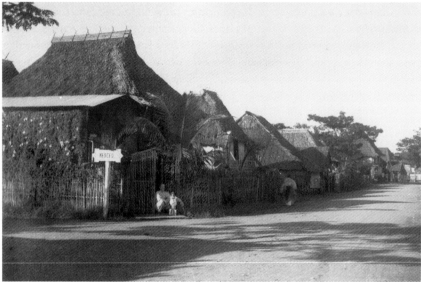

to the importance and magnitude of the work being undertaken. The Inspection General de Obras Publicas (General Board for Public Works) was created through a Royal decree dated May 1, 1866. It was under the direction of an engineer who was given the title of Inspector General de Obras Publicas, as the inspector was also the president of the Junta Consultiva de Obras Publicas (Consultancy Board for Public Works), a body mandated to examine and approve plans for buildings.

The destructive earthquakes of 1863 and 1880 finally compelled the city officials of Manila to collaborate and produce a set of building ordinances that would minimize the shattering effects of earth tremors.

For fire prevention, specific areas were zoned according to building materials. Ordinances were issued in relation to the construction of houses made of nipa, a highly flammable building material. A decree was issued on January 23, 1866, prohibiting the use of nipa in areas designated as *zonas de mamposteria* (zones for masonry structures).

Bahay na Bato: The Realm of Aristocratic Domesticity

In the latter years of Spanish rule, a new type of domestic architecture, the bahay na bato, would gradually emerge from two centuries of gestation. This novel housing prototype combined the elements of the indigenous and Hispanic building traditions to prevent the dangers posed by fires, earthquakes, and cyclones. Aside

from addressing the physical factors of the environment, the bahay na bato was also the outcome of profound social change. As the colonial society's needs expanded and socioeconomic progress was attained through the galleon trade and cash-crop agriculture, the simple house of nipa y caña could no longer satisfy the demands of the new urban elites and the provincial aristocracy. The urgent need was to acquire a new domestic prototype expressive of the owner's cultural attainment and affectations.

Despite regional variation and centuries of transformation, the bahay na bato has retained its essential features. Generally, it has two storeys, at times, three. The ground floor is made of cut stone or brick, the upper, of wood. Grillwork protects the ground floor windows, while the second-storey windows are broad, with sliding shutters whose latticework frames either capiz shells (*Placuna placenta*) or glass panels. Beneath the *pasamano* (window sill), auxiliary windows called *ventanillas* (small windows) reach to the floor. These are protected with either iron grilles or wooden *barandillas* (balusters) and have sliding wooden shutters. The house is capped by a high hip roof with a 45–degree–angle pitch to repel rain and discharge warm air.

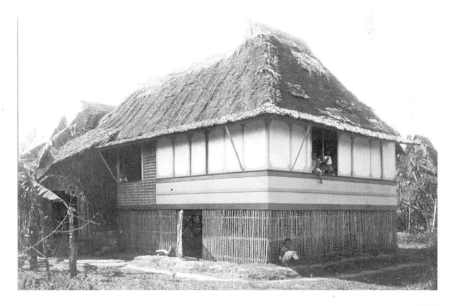

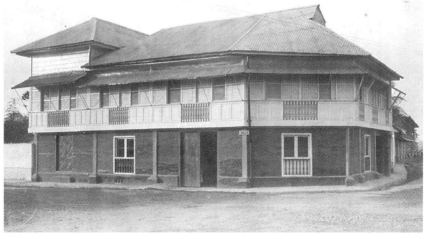

4.76 A Hispanized bahay kubo

4.77 A bahay na bato. The upper storey would be of wood, the lower storey of stone. The thick stone wall was merely a skirt concealing the wooden legs in the ground floor.

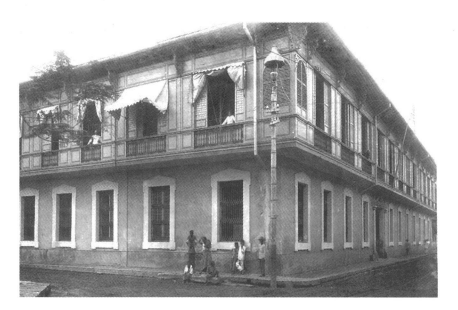

The first buildings put up by the Spaniards were similar to the native constructions, but after the many fires that devoured these structures, residents decided to rebuild their houses in masonry using hewn adobe stones quarried from cliffs facing the Pasig river. Houses built of stone were fire-resistant but caused more damage during earthquakes, as the accounts of the 1645 and 1658 tremors claim. Since it was observed that structures with wooden frameworks proved resilient to any movement of the earth, the logical solution was an architectural compromise which combined stone with wood, a hybrid earlier referred to as arquitectura mestiza.

Again, the design principles of the bahay kubo became the inspiration in developing a similar house having the same features but on a grander scale. Retaining the bahay kubo's basic characteristics, such as the steep hip roof, elevated quarters, post-and-lintel construction, and maximized ventilation, the new domestic form was similarly framed in wood with an elevated living space of hardwood. The entire house was supported by *haligi* (wooden pillars) in keeping with the endemic building tradition. The hardwood posts, 7.5 meters or more in height from ground to roof were, at times, unprocessed, twisted trunks. The upper storey would be of wood, the lower storey of stone. The thick stone wall was merely a skirt concealing the wooden legs on the ground floor. The roof would either be of curved tile or impenetrable thatch, which covers a frame of trusses and rafters. Tiles had the advantage over thatch for being fireproof, but since they were set in three or more layers, they were heavy and could easily fall apart during earthquakes. Thus, galvanized iron sheets began to replace the roof tiles, especially after the great earthquake of 1880.

One could enter the elevated living quarters through the *zaguan* (vestibule) on the ground floor, from where the grand staircase started. The zaguan, similar to the ground level of the bahay kubo, was also reserved for storage. Sometimes the vestibule had an *entresuelo* (mezzanine area), raised a meter above ground, for use as offices or servants' quarters. In business areas, some spaces were rented out to shop owners.

4.79 In commercial districts such as in Escolta, the zaguan, a vestibule on the ground floor of the bahay na bato, was converted to rentable retail and commercial spaces.

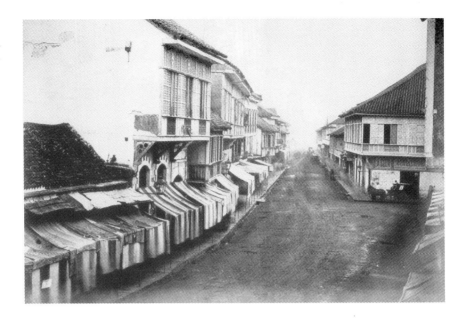

A wooden staircase, or *escalera*, with two landings led to the upper floor and directly onto the interior overhanging verandah (*caida*). As one ascended this staircase, one waited to be received at the caida or *antesala,* which was the most immediate room from the stairs, and was an all-purpose room for entertaining, sewing, dancing, or even dining. In the *sala*, or living room, dances and balls were held during fiestas and other special occasions. European influence was evident in the furniture, draperies, tapestries, paintings, porcelain jars, or piano adorning the sala. At one end of the room was the *comedor* or dining room, well-furnished with silverware displayed in *plateras* or glass-paneled cabinets, while food dishes from the kitchen were placed on a waist-high cabinet or *mesa platera*. The dining area led to the cocina or kitchen, with its distinctive *banguerra*. A walkway connected the kichen to the house, if it was built separately from the house. Adjacent to the kitchen was the *banyo* or *paliguan* (bathroom) and *latrina* (toilet). The bathroom was often built separately from the toilet. The *batalan* of the bahay kubo metamorphosed into the *azotea*, an outdoor terrace where the residents and their guests usually relaxed. At times, the azotea was used for food preparation and laundry activities as it was located either beside a *balon* (well) or over an *aljibe* (cistern). The *cuarto* or bedrooms surrounded and opened into the spacious living area. Room partitions did not reach up to the ceiling, ending instead in *calados* or fretwork that enhanced cross-ventilation inside the house. With the wide doors leading to the rooms open on most occasions, the house virtually had the essence of being one big space.

According to architectural historian Fernando Zialcita, the bahay na bato may be stylistically categorized into two: the *geometric style* and the *floral style*.

Between 1780 and 1880, the geometric style was widespread. In this style, the flying wooden gallery, now called either the *galeria volada* or the *corredor,* extended along the exterior walls, accentuating the horizontality of the buildings. It had dual sets of sliding shutters: the outer one of *concha* (shell) and the inner of wooden *persiana* (window shade) or jalousies or louvers. An intervening wall of plastered brick distinguished the volada from the adjacent rooms. Wooden doors

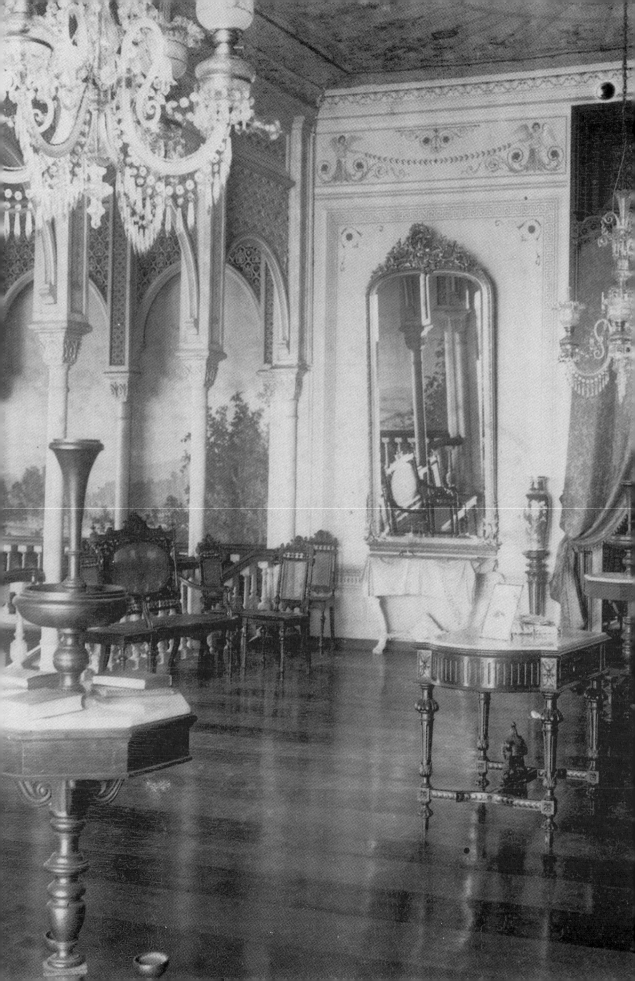

led into the volada. The wooden gallery allowed the inward passage of light and air and shielded out excess sunlight, for during this period, roof eaves were narrow. Surface decorations were kept to a minimum: translucent capiz shells in squares, diamonds on the window panels, and friezes with simple, neoclassical motifs. During the nineteenth century, the use of enormous pillars was minimized; false ceilings and wooden walls with geometric fretwork on their upper part defined the living quarters.

The floral style gained popularity during the last third of the nineteenth century when the volada turned into an open gallery decorated with vegetal motifs. Devastating earthquakes which shook Manila in 1863 and 1880 left many buildings in ruins. As a result, ordinances were issued stipulating that house posts must be made thinner but connected to each other by numerous bracings for more flexibility. Thin brick panels were inserted between the braces. Where brick was not readily available, the house posts stood alongside the walls so as not to fracture them.

Another decree prohibited the use of curved tiles and, instead recommended either flat tiles or imported galvanized iron or zinc sheets. Because it was cheaper and easier to install, the metal roof became more popular than flat tiles. Unfortunately, the absence of ventilators caused the metal roof to heat up easily, thus increasing the heat inside the house. But since metal roofs were light, they could project beyond the walls to create wide eaves, which had soffit vents to provide outlets for warm air accumulating under the roof. Windows were further screened by *tapancos* or *media agues* (metal awnings) made of sheet metal cutouts. With these innovations, which protected the house walls from rain and sun, the volada was abandoned, making the interior of the house more spacious. Moreover, the upper storey was almost entirely made of wood. Wall sidings were sometimes of wooden panels adorned with oval or rectangular, tray-like forms called *bandejado*. The calados were broadened and extended from post to post, and their fretwork took the form of butterflies, flowers, or lyres, which, with a play of lights, could cast decorative shadows. Floral motifs were abundant all over the exterior, enriching the surfaces of soffit vents, corbels, and iron grilles. Hence, this style of the bahay na bato, which appeared between the 1880s and 1930s, was aptly termed the floral style, typified by the houses of the Pamintuans (Angeles), Tecsons (San Miguel de Mayumo), Bautistas (Malolos), Tanjosoy-Bautistas (Malolos), and by the interiors of the houses of the Pastors (Batangas City) and Avenidos (Alaminos, Laguna).

To appreciate the bahay na bato's innovations, it must be compared to related houses in Spain, Mexico, the Spanish Antilles, and other former Spanish possessions. Doing so will show how the Philippine colonial house adapted to the climatic conditions and historical and social traditions.

The steeply sloping roof of Philippine houses differed from the almost flat tile roof of the Andalusian houses, deflecting the heat of the sun and protecting the house against strong typhoons. The enclosed volada, a gallery surrounding the front and sides of the house and skirting the major rooms, distinguished the Filipino stone house from related houses in colonial America where the balconies were usually exposed and protruding. It also buffered the rooms against the sun's heat and provided shade to the pedestrians below. Along with it was the liberal use of windows and barandillas. Sliding window panels controlled the glare coming

4.81 and 4.82 Bahay na bato residences were clad in a variety of historical styles imported and approximated from Europe. Such stylistic preference also reflected the European pretensions of the Filipino nouveau riche of the period.

from the outside without preventing cross-ventilation. A set of capiz shell shutters, instead of glass panes, diffused the harsh tropical light, rendering the interior with pearly white illumination. Between the window sill and floor ran the ventanilla, with sliding wooden shutters and wooden balustrades and iron grills. Large doorways reduced wall space to a minimum to let more air in. With all doors open, the house was transformed into one, big, multifunctional hall. Running above the partitions were panels of wooden fretwork that helped in filtering and circulating air. Ceilings were usually decorated with paintings of local flavor applied directly on the wooden boards or canvases.

The bahay na bato also found its way to other parts of the country and were presented in a number of regional variations. In the Ilocos region, especially Vigan, walls on both storeys were made of plastered brick encasing a wooden frame. Exteriors showed undecorated pilasters and simple, continuous cornices. However, in Mindanao and the Sulu archipelago, where Spain's control was minimal, stone

4.83 The bahay na bato is a tropically responsive building, allowing air and light to penetrate the interior—an indoor spatial quality known as *maaliwalas*, a concept which has no exact equivalent in the English lexicon.

houses developed artistic features more reflective of local aesthetic traditions. The residence of Sultan Harun in Maubu, Sulu demonstrated the aesthetic fusion of Islamic motifs with the basic bahay na bato pattern, manifested in the series of Mudejar arches on the stone walls and, in lieu of sliding capiz panes, the sequence of wooden jalousie casements spaced at regular intervals to cover the entire length of the wooden upper storey wall.

The Urban Divide

The last quarter of the nineteenth century witnessed a great urban transformation in Manila, brought about by the migration of a proletarian population lured by Manila's economic and industrial progress. Urbanization spilled over the old walls into the various arrabales of Binondo, San Nicolas, Santa Ana, San Miguel, Paco, Ermita, and Malate. The installation of a railway system also contributed to the urban sprawl, facilitating the unimpeded influx of labor force from the nearby provinces.

The allocation of urban space along the lines of land use and social or ethnic divisions was a crucial issue in the urbanization program of the colonial authority during the nineteenth century. The competition over urban space between stone edifices residents and those in nipa dwellings became more apparent with the mass exodus of the elite population from the confines of Intramuros to the nearby suburbs, which in effect drove away the nipa dwellers from their original site. The root of the urban discord between the two was simple: the structures made of botanical materials, especially nipa shingles, were highly flammable. The threat of fire in a congested city was great and ever-present. Thus, the deterrence of fire and its spread necessitated a radical measure: the establishment of a clear-cut zonal divide to separate stone edifices from nipa shacks, thereby allowing the effective containment of city fires. The zonal reassignment of the nipa dwellings to the city's periphery was greatly enforced by the colonial authority, often unjustly implemented through brute force.

The coexistence of two modes of architecture in urban areas forced the municipal authority to issue a decree which continued to take effect until 1898. It stipulated that stone buildings should, at all costs, be protected from the dangers posed by the nipa houses. Areas zoned for stone edifices were delineated as zonas de mamposteria. In areas designated as such, the flimsy nipa structures had no place. The colonial government considered each stone edifice a significant investment by the owner and an important source of tax revenue, which filled municipal coffers. Moreover, the absence of nipa houses in land parcels with stone houses was expected to fetch a higher market value. Land speculation, for instance, fueled the idea of making Binondo an exclusive area for stone houses. Thus, from the 1830s onward, nipa houses were transferred to San Jose, (Trozo) and a demarcation line sixty-five meters wide between Binondo and Tondo was established a kilometer from the shore. This urban imposition, however, was not fully implemented.

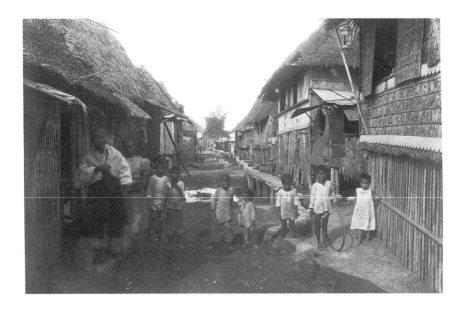

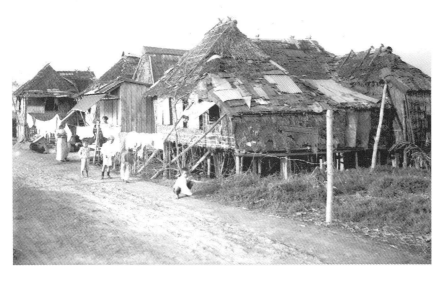

4.84 and 4.85 Nipa houses occupied by lower class Filipinos were considered fire hazards; thus they were confined to the periphery of the urban core, an area beyond the firebreak line known as Divisoria.

By 1860, a precise geographical demarcation line was set up, known as the Divisoria. As its name implies, Divisoria was not a roadway but a dividing line that traversed from east to west. In fact, Divisoria was a firebreak line (fifty meters) created to separate the areas set aside for stone houses and the areas dominated by nipa dwellings in the margins.

Those who lived in nipa houses represented the poor. Corollary to this, the rejection of nipa houses was linked with the stigma of a social outcast. The owners of nipa houses were looked down upon by the Spaniards and were often described in the official records as sickly, unhygienic, immoral, and rebellious.

The archives abound with narratives of eviction from the urban space and cases of quarrels and complaints brought about by demolitions, where residents were highly emotional, often seething with anger. The authorities implementing the policy complained of the vehement insistence of the natives in reconstructing their nipa houses on the same site. Military engineer Luis Angel Garcia disclosed having demolished more than thirty times the same nipa house during his entire tenure in the Philippines and reported the reappearance of nipa houses like mushrooms on the forbidden areas. The victims of expulsion lamented the unfair division of urban space, which uprooted them far from their place of labor and disengaged them from their symbolic tie to the land they once occupied.

The poor who refused to reside in the periphery would rather remain and bear the unhygienic and congested conditions in the slum colony or *posesiones*. These were ramshackle dwellings found in dead spaces, vacant lots, on coastal and swampy areas, banks of esteros, and ruins of buildings destroyed by earthquakes.

Tondo and Sampaloc lay beyond the fire-code/building-materials line established in the mid-nineteenth century. These dwellings were attractive to the poor migrant laborers because, aside from being affordable, they were also accessible to factories and places of work opportunity. In Tondo, makeshift dwellings or *chozas* could be constructed on a tiny leased lot or even on the foreshore area for free.

4.86 and **4.87** Informal shelters during the Spanish colonial period. Makeshift dwellings or chozas could be constructed on a tiny leased lot or even on the foreshore area for free.

Dwellings of the Working Class

The *accesorias* or apartment dwellings evolved from the need of migrant laborers for cheap housing in commercial and industrial areas. This new building type was developed in response to urban Manila's industrial revolution and was commonly found in the districts of Binondo, Tondo, Sampaloc, Quiapo, and Santa Cruz—areas characterized by commercial opportunities.

Accesorias were single or two-storey high structures having multiple units, each defined by common party walls shared with adjoining units and by a separate door or access at the facade. The accesoria unit occupied a floor area ranging from forty-five to fifty square meters per storey, with a narrow frontage of an average of 3.5 meters per unit and a ceiling clearance of 2.7 meters. The reasons for such proportion was the greater value given to the frontage area than to that more remote from the street.

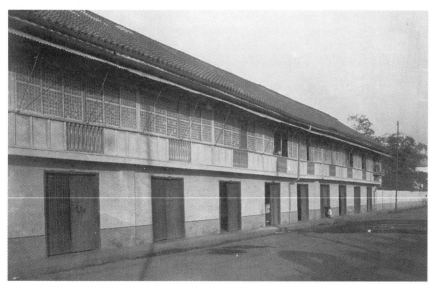

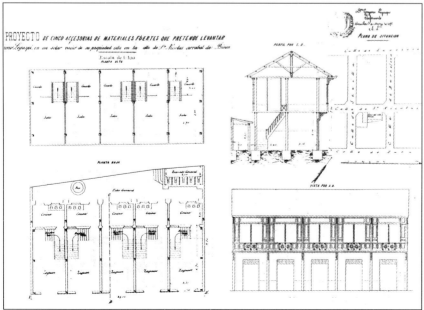

4.88 Accesorias or apartment dwellings addressed the need of migrant laborers for cheap housing in commercial and industrial areas.

4.89 The plan of a five-unit accesoria of Don Gregorio Legaspi, dated 1898. The structure had a common toilet at the rear. The second level of each unit is partitioned into a single cuarto (bedroom) and sala (living room).

The accesoria was defined by a common courtyard space or patio, which could be accessed through a main entrance. Each unit, called *vivienda*, had its own zaguan or vestibule, sala, and sleeping quarters. Service facilities, such as latrinas or comfort rooms, azoteas or service areas, and cocinas or kitchens were centralized and shared with other unit occupants. It was unusual for an accesoria unit to have its own azotea or latrina. In some accesorias, kitchens could be in the form of sheds separated from the main house structure. Latrinas, as a common facility, was located on the ground floor as outbuildings distinct from the main apartment house.

Differentiated from the bahay na bato, the accesoria was a low-cost housing devoid of an entresuelo (mezzanine floor), an area halfway between the ground floor and the upper floor of the house. In terms of materials, the accesoria was no different from the wood-and-stone construction of the bahay na bato, except that ornaments were sparsely applied. If ever, they would generally appear only in the exterior grillwork and, occasionally, in the decorative woodwork.

Infrastructures of Colonial Industrialization

The perpetuation of the Hispanic urban program was synonymous to the elevation of the living standards of its subjects through urban infrastructure and public works manifested in the provision of potable water, in the building of roads and bridges, and in the introduction of railway and tram lines in the metropole. In the design and construction of colonial infrastructures—ports, bridges, lighthouses, waterways, waterworks, railways, and an urban tram system—Spanish engineers brought and employed the most advanced construction methods and the leading building technology available at the time.

Colonial economy was highly dependent upon port and harbor facilities, as the latter functioned both as an entrepot and imperial base. Port facilities made possible the integration of the colony within the routes of global commerce and veins of world economy. Port improvements consisted of the erection of seawalls and small wooden docks in Manila, Ilocos, and Cebu. In 1881, the role of Manila as a maritime city was emphasized through the drafting of plans for the first port work project in Manila. The latest advances in methods and techniques for port construction were employed to provide a sheltered docking area for ships. Large areas were designated for the construction of sheds and warehouses to store produce and merchandise awaiting shipment to Europe and America.

Colonial industrialization of the nineteenth century also entailed the construction of railways to facilitate imperial penetration of the far inland. By and large, the colonialist used railways to integrate and annex territory, and to exploit the resources of the regions surrounding the ports they controlled. Colonial railways or *ferrocarril* were, thus, an essential part in the diffusion of economic processes, ideas, and institutions of the colonial powers, making the conquered lands available for investment and exploitation. The plan for an insular, locomotive-driven railroad system in the Philippines was officially initiated in 1875 by the royal order issued by King Alfonso of Spain addressed to the Office of the Inspector of Public Works to submit a railroad plan for the island of Luzon. Spanish engineer Eduardo López Navarro of the said public works agency submitted his Plan General de Ferrocarilles en la Isla de Luzon (General Plan for Railways on the Island of Luzon) in 1876. This plan aimed to construct a line network totaling 1,730 kilometers, consisting

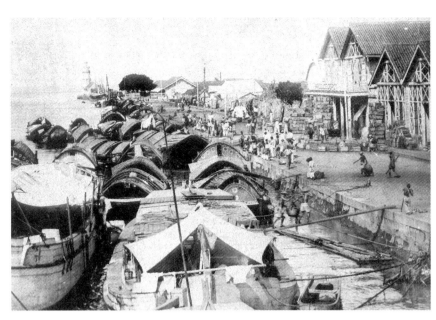

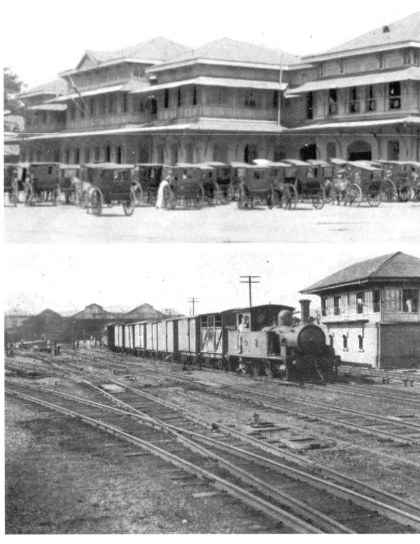

4.90 Port of Manila and entrance to the Pasig River

4.91 The Tutuban Station of the Manila-Dagupan railway line, designed by Juan Jose Hervas, served as a main terminal for all north-bound destinations. The building, completed in 1887, was built from masonry faced with brickwork at ground level, the upper storey being made of wood.

4.92 Train and tracks of the Manila-Dagupan railway line

of three lines, and sought to connect the productive agricultural areas of Luzon—Cagayan Valley, the Central Plains, and Bicol. Of these lines, the Manila-Dagupan line, and the Manila-Taal line were classified as first priority. A 192-kilometer stretch of track was constructed between Manila and Dagupan and began to service the public in 1892. Most of the construction materials were shipped from abroad. Railroad ties and bridge timber came from Australia. Portland cement, rails, switches, track spikes and bolts, steel bridges, and cast iron components were from England. The most outstanding works carried out on the railway system were the bridge over Pampanga River and the building of the Tutuban Station in the Tondo district. For the *estación de ferrocarril* (railway station) brick masonry was the material of choice, following British standards.

The Tutuban Station of the Manila-Dagupan railway line, designed by Juan Jose Hervas and completed in 1887, served as a main terminal for all northbound destinations. Adhering to the precepts of the bahay na bato, it was constructed of masonry faced with brickwork at ground level, the upper storey being made of wood panels graced by grilled windows. It had galvanized iron roofing and overhanging eaves made from the same material, providing perimeter shading for the first floor. The concourse shed, deriving its structural form from British design, was supported by riveted steel crowned by stylized acanthus-shaped capitals.

The immense urban growth of Manila led the administration to propose, in 1878, the installation of a public transport network. In 1878, Leon Monssour, an official of the Department of Public Works, submitted a proposal to Madrid for a *tranvia* (streetcar) system. Evidently motivated by the systems in New York and Paris, Monssour envisioned a five-line network, with a central station outside the walls of Intramuros. From Plaza San Gabriel in Binondo, the lines were to run to Intramuros via the Puerte de España to Malate Church, Malacañang, Sampaloc, and Tondo. The plan gained approval from the government, but its implementation had to wait for an entrepreneur's initiative. Entrepreneur Jocobo Zobel de Zangroniz, together with Spanish engineer Luciano M. Bremon and Madrid banker Adolfo Bayo, founded in 1882 the La Compañia de Tranvias de Filipinas to operate the

4.93 Steam operated streetcar (*travia de vapor*) plying the Manila-Malabon route, circa 1885.

concession awarded by the government. The plan for the Malacañang Line was abandoned and instead replaced by the Malabon Line. These five routes became popular with commuters. The Manila-Malabon Line was the first to be finished and began serving the public in October 1888. All five were constructed between 1885 and 1889. The first tranvias were horse-drawn omnibuses for twelve seated and eight standing passengers. The system totaled 16.3 kilometers long.

Also in the nineteenth century, the Puente Grande (Grand Bridge) was the first and only bridge to be built crossing the Pasig River. In the aftermath of the 1863 earthquake, a new bridge, the Puente de España, took over its place in 1875. It had eight arches—the two central arches were built of iron trusses and the other six were of quarried stone. The bridge was designed by Jose Echevarria, a Spanish engineer stationed in Paris, who was responsible for the specification and purchase of the central steel spans.

The second to be erected was the Clavería Bridge, a landmark suspension bridge that linked Quiapo with the Arroceros district. The suspension bridge was

4.94 Puente de España (Bridge of Spain), built after the 1863 earthquake. The bridge was designed by Jose Echevarria, a Spanish engineer stationed in Paris. The steel components of the bridge—the central arches, the balustrades, and the candelabra—were imported from France.

4.95 The Ayala bridge opened in 1890.

constructed by a private enterprise in 1852, which operated it on a toll basis. The project was drawn up by the French engineer, M. Gabaud. A third construction, the Ayala Bridge, was built in two separate sections; it crossed the river at Convalecencia Island (now the island where Hospicio de San Jose stands) and was opened in 1880.

Farolas or lighthouses were built to safeguard the colony's bourgeoning maritime industry during the time of the Galleon Trade. With the increase of maritime traffic during the second half of the nineteenth century, as the Manila-Acapulco galleon trade came to a close, the colony joined the extensive network of international trade and commerce, which required more shipping routes to and from island. This began the massive construction of lighthouses. The Plan General de Alumbrado de Maritimo de las Costas del Archipelago de Filipino (Master Plan for the Lighting of the Maritime Coasts of the Philippine Archipelago) issued in 1857 was carried out by the *Inteligencia del Cuerpo de Ingenieros de Caminos, Canales y Puertos* (Corps of Engineers for Roads, Canals, and Ports). This master plan ambitiously set its goal to build fifty-five lighthouses all over the archipelago, including its remotest corners. Philippine light stations were located on secluded islets, barren rock outcrops, points, cliffs, capes, and bluffs—a commitment of the Spanish colonialist to modernize the Philippines and make it competitive at the dawn of the nineteenth century.

The oldest lighthouse in the country was built in 1642 during the administration of Governor-General Sebastian Hurtado de Corcuera. This lighthouse, located at the mouth of the Pasig, guided navigators to the banks of the river, which served as the main port of Manila. Designed in the Renaissance Revivalist style, the Pasig Farola (also known as the San Nicolás lighthouse) was a complex composed of a tower, a pavilion, and service buildings. It underwent several renovations, of which the 1846 renovation was the most significantly documented. The reconstruction included the completion of the masonry tower, which began in 1843, using stones quarried from Meycauayan, Bulacan. Built entirely of solid stone, the lighthouse survived the earthquakes of 1852 and 1863.

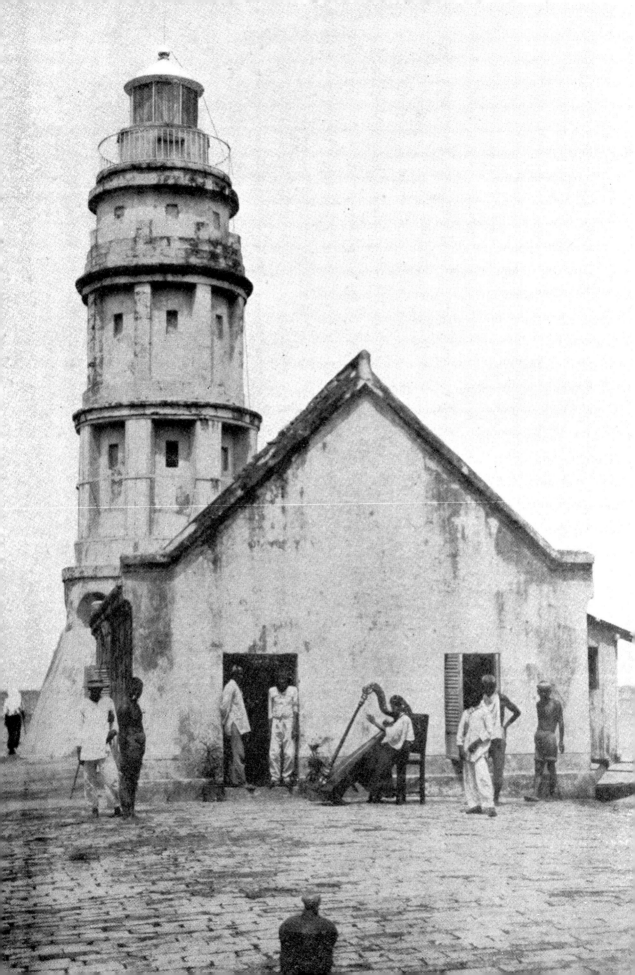

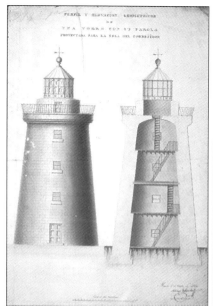

4.97 The Pasig Farola, the oldest lighthouse in the Philippines (opposite page).

4.98 Plan for a lighthouse on Corregidor Island, drawn by Mariano de Goicoechea, 1830.

4.99 The construction of a lighthouse at Cape Engaño in 1892.

Colonial Waterworks and Utilities

Before the installation of a piped-in water system offered by the municipally operated Carriedo waterworks in 1882, Manila's population were entirely dependent on surface water supplies, such as rivers and superficial wells, which were dangerously polluted. As water coursed through densely populated riverbank communities, it was subject to frequent and dangerous contamination.

Potable water could be obtained by channeling rainwater from the roof to household cisterns called aljibe. These cisterns were usually built of bricks or adobe and contained enough water to last for weeks. The water for daily consumption was drawn by means of pails and kept in smaller earthen jars (*tapayan*) to which small alum crystals (*tawas*) were added for purification. This water was used chiefly for drinking. But this system was not always dependable and could not guarantee a constant supply of water as it was held hostage to the unpredictability of meteorological phenomena.

The Pasig River readily provided the city with copious water supply. The water was used directly in the river for washing clothes and bathing, or transported to houses for drinking and domestic purposes. From the river to the houses, water was conveyed through various cumbersome methods. Those who resided near the brink would merely fill their *banga* (earthen water vessels) with water from a significant depth, after which they would cover the mouth of the vessel with a clean piece of cloth. Those who lived far from the river hired professional *cargadores* (water carriers).

In the district of Tondo, particularly among those who resided on the foreshore, the river water was distributed among its residents by means of a small watercraft called *lunday*. This native boat was brought into the Pasig River from upstream, where the water was supposedly clean, then filled with water. Then it was pulled down the stream into the Manila Bay by an empty boat run by one or two paddlers. Upon reaching the beach of Tondo, the water was loaded into *cargahan* (wooden

cans) to be distributed among the houses. One *carga* (two cans) was paid two centavos. In its unpurified state, the water was used for general washing, cleaning, and bathing.

For drinking and cooking purposes, the water underwent some technique of purification: filtration and application of alum and sulfur. Filtration was done by tying a piece of dry clean cloth, usually undershirt or tablecloth, around the mouth of the vessel; water was then poured, sieving the visible sediments and impurities. But even after filtration the water remained turbid. To make the water clearer, alum was added to the filtrate contained in large vessels resulting in the precipitation of suspended impurities at the bottom of the vessel. After some time, the resulting supernatant liquid was deemed fit for drinking. For storage purposes, the alum-treated water was infused with sulfur.

The affluent families, doubtful of the purity of water collected from the Pasig River, resorted to collecting water from far upstream and distant tributaries of the river, especially the Mariquina River. Here the water was believed to be pure as it was less subject to contamination and pollution. This method of gathering water was commercially undertaken by the Chinese who sold water at a price that depended upon the quality and distance of its source.

The water from the Pasig River, although readily available, could not support the entire population of Manila, especially those who settled in communities far from the river. Unable to buy their water from peddlers for economic reasons, these poor communities relied on superficial wells for their water supply. The typical surface well had no curbing, shed, or casing. In communal wells of this kind, people usually bathed and washed close to the well, which filtered the waste water back into the well, thus, polluting the same well from which they also drink. These wells proved to be extremely unsafe and dangerous for drinking, prompting the issuance of municipal orders for their absolute closure at the height of the cholera epidemic. The American proconsuls would later replace them with artesian wells.

Francisco de Carriedo y Peredo, a native of Santander, Spain and a governor of the Manila in the mid-eighteenth century, became Manila's benefactor when, in 1743, he bequeathed the sum of 10,000 pesos, including its interest, to the city for the purpose of bringing piped water to military barracks and other institutions, on the condition that the poor should benefit from its installation. The investments of this

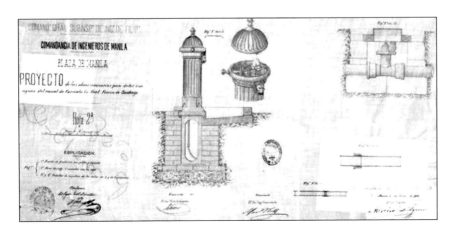

4.100 Plan for a piped water system in Fort Santiago, under the Carriedo Waterworks project, drawn by Narciso de Eguía, 1888

4.101 and **4.102** The Carriedo Waterworks had an ornamental public hydrant, the most arresting feature of which was a lion head water spout. The water that flowed through it was offered to the public free of charge.

sum were so well managed that, notwithstanding several vicissitudes and losses, it amounted in 1867 to 177,853.44 pesos. In 1867, the Municipal Council embarked on a project to supply fresh water to the entire city. By 1882, the first public water fountain gushed forth its waters. The establishment of the Carriedo Municipal Waterworks in 1882 greatly improved the quality of water consumed by the general populace. The installation of a new water system supplied the residents of Manila with moderately pure water, conveyed from the Mariquina River through an aqueduct to a *deposito*, a distributing reservoir composed of eleven arched compartments hewn from adobe rock that held a volume of sixteen million gallons. From there, gravity delivered water under mild pressure throughout the city via its numerous public hydrants, thereby reducing Manila's reliance on dangerous sources of water.

The waterworks system was designed by Genaro Palacios y Guerra, a civil engineer of the Royal Corps of Engineers in the Spanish Army, and provided five ornamental fountains, 200 hydrants, and 150 fire hydrants. Water was received from Santolan, directly from the Mariquina River, through two twenty-four inch cast-iron pipe intakes. From the intakes, water level was raised by pumps to a height of twenty-eight meters into a stone aqueduct structure known as Acueducto de Alfonso XIII, measuring eighty centimeters wide, 1 ¼ meters high and four kilometers long, with an arched top. By gravity, the water was channeled through a tunnel a quarter of a kilometer from the river to a subterranean reservoir in San Juan del Monte known as El Deposito. The Deposito was made up of parallel arched chambers tunneled out of soft adobe stone, and connected by two cross tunnels, forming groined arches at the intersections. The roof was at least eight feet in thickness. Ventilation was provided by 207 shafts, which kept the water cool and free from vegetable matter. The reservoir was to contain about one and a half days' reserve, and about two days' supply in wet seasons. From the Deposito, a cast-iron main, twenty-six inches in diameter and three kilometers long, conveyed the water to the city distributing system in Rotonda in the district of Sampaloc where it branched off to the different public hydrants in the city.

In 1892, a Spanish corporation, the Compania La Electricista, established the first power-generating plant in Manila. Its power house was located at Calle San Sebastian, now Calle R. Hidalgo in the district of Quiapo. On October 8, 1892, the Spanish municipal government granted the said company with a franchise to supply electric current for municipal lighting and private use. By 1902, La Electricista was operating a 1,000-horsepower plant, which supplied Manila's power requirements to light up street arc lamps, and domestic incandescent lamps and to run electric fans. In 1904, together with the Spanish horsecar company, Compania de Tranvias de Filipinas, the company was purchased by the Manila Electric Railroad and Lighting Company (MERALCO), an American company franchised by the municipality of Manila to generate and distribute electricity and operate the electric trolley system in Manila.

Architecture for Colonial Commerce and Industry

In the seventeenth century, Spain attempted to establish an Asian trading empire to be based in Manila. Soon the city had quickly metamorphosed from a small but active port town linked to regional trading networks into one of the major colonial port cities in Southeast Asia, rivaling Batavia (Jakarta) in the seventeenth and eighteenth century.

Chinese merchants dominated Manila's vital trading institutions, although their numbers were only small. They created the entrepot trade and controlled the internal traffic of commerce and credit networks essential to that trade. The locus of all economic activities was in Binondo.

4.103 Sculptural detail of one of the many ornamental fountains of the Carriedo Waterworks (opposite page)

4.104 and 4.105 Plan of the octagonal Alcaiceria de San Fernando, 1756

The very first large commercial structure was probably the Alcaiceria de San Fernando, a silk market established in 1758 in the densely populated Chinese district of Binondo, immediately across the river from Intramuros. The Alcaiceria de San Fernando was the first formal custom house and its distinct octagonal shape was an architectural form which had no precedent in Spanish colonial architecture. Designed by Fray Lucas de Jesus Maria, a lay Recollect brother who

designed many royal infrastructures in the colony, the two-storey octagonal edifice housed not only stores for the Chinese merchants but also government offices for the administration of trade. Inside the octagon was an inner courtyard or patio surrounded by porticos. The balconied upper floor was used as living quarters of the Chinese. Unfortunately, it was razed by fire in 1810 and never to be reconstructed. Its burned-down site was later occupied by Real Aduana (Royal Customs Building).

The 1767 royal decree mandating the establishment of the tobacco monopoly in the Philippines increased the revenue of the Public Treasury. The Spanish Crown also established in 1785 The Royal Philippine Company, which became an investor in export crops in the Philippines, making the colony a major producer of cash crops for the global market with sugar, tobacco, coffee, and abaca as major export products. The monopoly of the tobacco industry and investment in cash crop agriculture resulted in huge returns, which were, in turn, invested in infrastructure. By the nineteenth century, the colonial administration conscripted the services of a battery of engineers and architects to design and construct an infrastructure network pertaining to the processing, manufacture, packaging, and distribution of export products—the *almacen* (warehouses), *fabrica* (factories), and *camarin* (storehouses).

The tobacco and cigar factories, known as the *tabacaleras*, became foremost sites of colonial production. Four cigar factories in Manila—two in Arroceros, one in Meisic, and one in Malabon—employed over 17,000 workers at the outset of the nineteenth century. These tabacaleras used a predominantly female labor force drawn from surrounding suburbs. The employment of women in tobacco factories, who were called *cigarreras*, was prevalent not only in the Philippines but also in Spain and Mexico. The colonialists believed that women were more skillful and more patient for cigar production and that they were less prone to commit fraud.

4.106 to 4.108 Colonial factories engaged in the manufacture of cigars and hemp

The tobacco factory in Meisic was called Fabrica de Puros de Meisic. The factory was completed in 1873, rebuilt from a destroyed military barracks that had collapsed during the 1863 earthquake. Designed by Casto Olano, the manufacturing structure was defined by a two-storey office in the middle of a U-shaped factory block hugging an expansive open ground. It had two long factory pavilions internally illuminated with natural light emanating from a continuous band of clerestory windows integrated to the roof structure, which also afforded for good ventilation. Its plain masonry wall of adobe had openings for 147 windows and two entrances. The windows adorned sparsely by wrought iron grilles had louvered and capiz shell panels.

Erected in 1894 using the design of Spanish architect Juan Jose Hervas y Arizmendi, the La Insular Cigar Factory was a rare example of Mudejar-inspired architecture. The three-storey building continued to be a landmark structure, imposing its presence together with Hotel de Oriente at the Plaza Calderon de la Barca in

Binondo until it was consumed by fire in 1945. Its delicate facade was like fine lacework defined by slender posts that terminated in a succession of horseshoe arches that were incised into an arabesque piercework. The posts supported a third storey projecting into an open gallery that ran the entire length of the facade. This was a balcony protected by a balustrade and marked by a dozen electric lampposts recurring at an interval. Above the open gallery was yet another line decorative baluster that charmingly concealed the sloping roof, making it appear to be flat at street level. The corners of the building were cut into chamfers and provided with windows at every floor, but a third level emphasis was accomplished with the use of oriel windows.

In addition to the tabacalera, the Real Estanco or the Administration for the Monopolies, the sugar refinery in Manila, the wine administration, the Matadero (municipal slaughterhouse designed by Juan Jose Hervas in 1893) in Dulumbayan (now Aranque Market), and the Quinta and Divisoria markets were notable infrastructure initiatives of colonial authorities in the realm of trade and industry. The central market of Manila was in Quiapo and was known as La Quinta. This was connected by a suspension bridge to the Arroceros district (from the Spanish word *arroz* meaning rice), where the rice market was situated. Divisoria market in the district of San Nicolas would soon flourish as the country's premiere wholesale emporium.

Concomitant with the industrial success of the nineteenth century was an increase in foreign commercial investments in Manila, catalyzing the emergence of new building types. In 1809, European commercial houses were allowed to operate in Manila and the influx of foreign commercial firms followed suit. British, German, French, and other expatriates launched their businesses on Escolta and adjacent streets. By the end of the nineteenth century, the vicinities of Escolta and Binondo would earn the reputation of being the country's premiere central business district. The largest and most prestigious companies established by local and foreign entrepreneurs chose their business addresses within its proximity especially after the opening of Manila as a free port. Most of these houses were involved in the import and export of goods.

4.111 The Matadero, the municipal slaughterhouse of Manila in Dulumbayan (in the district of Santa Cruz), was designed by Juan Jose Hervas in 1893.

4.112 Shophouses at Calle Rosario in Binondo (opposite page).

4.113 Advertorials of various commercial and trading establishments in Manila at the turn-of-the-century. The zaguan of the bahay na bato was transformed into rentable commercial and retail spaces.

The early trading houses were the bahay na bato retrofitted to have room for commercial function. In this hybrid housing, the ground floor was occupied by offices and shops while the upper storey (usually the structure did not exceed more than three stories) functioned as the residence of the proprietor of the company. Ample space at the upper floor was devoted for keeping stocks.

The streets of Rosario and Escolta in Binondo played host to a contiguous line of business establishments, such as hotels, *boticas* (drugstores), cafés, restaurants, groceries, wineries, hardware stores, and specialty shops among others, endowing the vicinity with a cosmopolitan aura as can be found in some colonial cities in Southeast Asia, such as Singapore. Shops and stores had open ground floors, which offered wide visual access to the merchandise being sold by the establishment. Some were equipped with retractable canvas shade to block direct sunlight from penetrating the shop floor. The presence of signboards and advertorials established the nature of service or merchandise being offered for sale.

Like the shophouses, hotel architecture in the colony had a strong affiliation with the bahay na bato, sharing a common spatial and elevational character. Hotels provided ready accommodation for the itinerant foreigners. Spatially, bedrooms, and function rooms were zoned at the upper floors, while reception areas and cafés were located at the ground level. There were balconies from where the hotel guests could observe the street scene below. In Binondo, Hotel de Oriente and Fonda Francesa were renowned for their hospitality. Hotel la Palma de Mallorca, Hotel de Paris, and Hotel de España were the foremost hotels inside the walled city of Intramuros. Less expensive lodgings, rented out on a monthly basis, were offered by *casas de huespedes* or boarding houses, such as La Casualidad, El Cid, and Europa in Intramuros.

Related to the commercial success in the colony was the establishment of banking institutions. The first bank built was the Banco Español-Filipino de Isabel II, initially housed in the Aduana, a customs house in a portion of Intramuros. Later it moved to a new building in Santa Cruz. The second bank, the Monte de Piedad, originally

4.114 Hotel de Oriente in Binondo

4.115 The Monte de Piedad in Plaza Santa Cruz

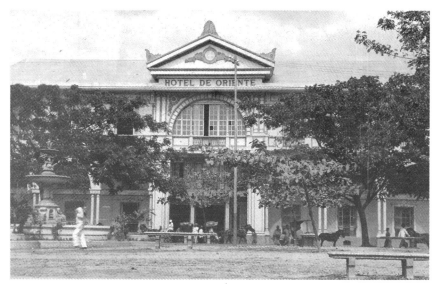

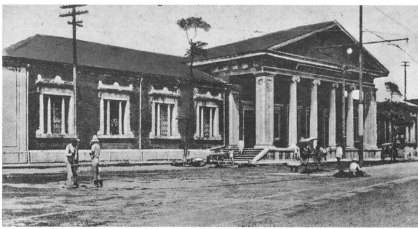

at the Colegio de Santa Isabel in Intramuros, moved to a new building in Plaza Goiti (at present, A. Lacson) in Santa Cruz. The bank had a principal elevation similar to that of Greek temples, with its imposing pediment and fluted columns, making it an important specimen of Classic Revivalism in Manila at the close of the nineteenth century. It was designed by the Spanish architect, Juan Jose Hervas, who also designed the Manila Railroad Central Station in Tutuban.

Spanish architect Juan Jose Hervas had a prolific career, figuring prominently in the design of commercial architecture. Hervas, as the municipal architect of Manila from 1885 to 1893, designed the offices of Rafael Perez on Anloague Street (now Juan Luna) in Binondo, the Ynchausti Brothers' office along the waterfront, and the Purchasing Agency office. He also designed commercial buildings, namely, Estrella del Norte on Escolta, the Heacock Store Building, the Paris-Manila building, the building occupied by the American Bazaar, the Hotel de Oriente building on Plaza Binondo, and the La Insular Tobacco Factory with its intricate application of neo-Mudejar motifs.

In the midst of all these landmarks in colonial architectural production, the sari-sari store—the perennial neighborhood retail institution—which began in the mid-

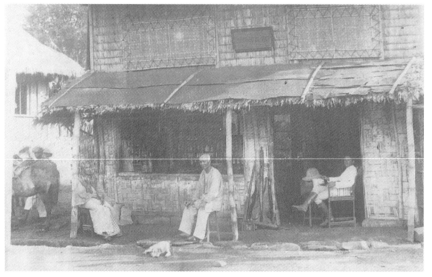

4.116 to **4.119** The sari-sari store and carinderia are Filipino retail institutions found on every neighborhood roadsides.

nineteenth century rose on a modest scale. Literally translated as "various kinds," it is a convenience store operated by small entrepreneurs, carrying an eclectic array of consumer products ranging from foodstuff to hardware, from cosmetics to medicine, which could be sold by *tingé* system (in small or apportioned quantities). Historically, the sari-sari stores were initially operated by the Chinese who favored selling goods *tingé*-style and on loan basis. The sari-sari stores of the period, like the contemporary ones, were conveniently attached to the residence of the retailer, generally fronting the street. Neighbors usually congregated in front of the sari-sari store where makeshift tables and benches served as venues for community exchange.

A cousin of the sari-sari store was the vernacular restaurant known as the *carinderia* or *turo-turo*. Generally, these were open-air structures consisting of nipa-and-bamboo sheds flimsily built along sidewalks and places of congregation. Bamboo counters were lined with *palayok*, or earthen cookware, containing ready-to-eat-dishes, which could be ordered by the simple pointing of the finger, thus, the name turo-turo (turo is the Tagalog word for "to point") for such establishments.

Architectures of Colonial Diversions

Theaters

Teatros (theaters) of the Spanish colonial era were structures designed specifically for theatrical, dance, and musical performances. Its architecture was divided into three sections: the *entablado* (stage proper) and related backstage areas; the audience space, consisting of rows of seats and several aisles in single or sloping levels; and the lobby or entrance. The audience section was either rectangular or circular in plan and later assumed a trapezoidal, fan-shaped plan with the stage at the tapered end. The earliest theaters in the Philippines were known as *teatros al aire libre* (open-air theaters), which were made up of a temporary podium surrounded by an open space for spectators. There were also portable stages usually assembled during fiestas and special occasions, only to be dismantled after the performances. Another type was the *camarin-teatro* (barn theater), a light structure of bamboo and thatch housing, which consisted of a stage and a patio with long benches, built in Arroceros and Tondo.

The two most significant, permanently built theaters were the Teatro de Binondo (inaugurated in 1864) and the Teatro del Principe Alfonso (built in 1862). Teatro de Binondo was a two-storey building of stone, brick, and wood with an arcaded first storey and an open colonnaded and balustraded balcony on the second level. It was located in a site formerly occupied by burned-down nipa huts along a street parallel to Escolta, on what is now San Vicente, between San Jacinto and Nueva Streets. It was built at a cost of 30, 000 pesos, sourced from the coffers of Caja de Carriedo and Obras Pias. The spacious lobby of the theater leads to a semicircular auditorium and an orchestra section with tiered seats. The stage was framed in a wide and pointed proscenium because of the angle of the roof. The theater soon became the hub of Manila's upper class. One account exclaimed that "the construction of the new theater has brought Manila a step closer to European civilization."

The Teatro del Principe Alfonso, constructed by Juan Barbero, a veteran stage director and actor, was open to all social classes, for it was a popular venue for zarzuelas and comedias. It was located at Campo Arroceros, a site located between

4.120 Teatro al aire libre (open-air theater) for temporary outdoor performances (opposite page).

4.121 *Teatro de Binondo*

4.122 Teatro Principe Alfonso

4.123 Teatro Circo Zorilla (de Bilibid)

4.124 A theatrical performance inside Teatro Rizal

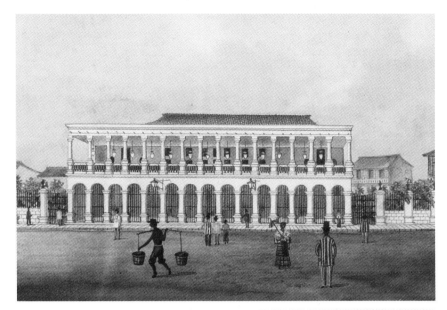

the present Quezon and MacArthur Bridges. The theater was described as a camarin with a roof of galvanized iron.

Regarded as the most celebrated in its heyday was the *Teatro Circo Zorilla*, named after the Spanish poet and playwright Jose Zorilla. Inaugurated in 1893, the theater had a circular hall, which can accommodate more than a thousand spectators. The Zorilla was a venue for zarzuelas, operas, dramas, concerts, and silent cinemas. It was torn down in 1936 and its former site is now occupied by Isetan Mall in Quezon Boulevard in Quiapo.

Sabungan

The native's immense affection for roosters and cockfighting made the game a vastly popular vernacular pastime, which even the colonial authorities failed to suppress. The inability to restrict cockfights was due to its potential to generate revenue for the colonial treasury that sought to regulate the game. Contracts for cockfights were given to each province. The *asentistas* (contractors) were allowed to subcontract the cockfights to towns. In the absence of contractors, cockfights

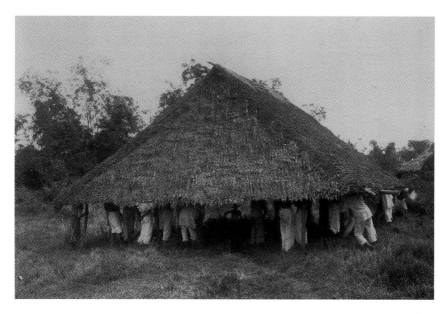

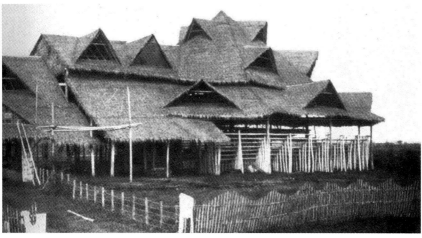

4.125 and 4.126 A sabungan or cockfighting arena made predominantly of thatch.

were organized by the hacienda. Cockfights were held during all feast days and other dates designated by authorities of the treasury. The asentista was responsible for building and maintaining the *sabungan* (cockpit), which was generally a large arena made of light materials capped by a voluminous thatched roof punctured by several openings for ventilation. On plan, the sabungan may be square, octagonal, or circular, wherein the *rueda* (arena) was centrally located. The arena's grounds were defined by a fence, enclosing a depressed area of packed earth to better absorb blood. Around the pit was a narrow, slightly sloping gallery, an array of benches arranged in an elevated platform following the form of an amphitheater. A portion of this gallery was devoted for the *ulutan* where cocks were preliminarily matched before the actual face-off.

Hippodrome

In 1867, a group of sportsmen composed of affluent Filipino, Spanish, and British nationals led by Jose de la Gandara y Navarro, a Spanish general of the Philippines, established a social club, known as the Manila Jockey Club, which held horse racing once a year as one of the club's events, thus, introducing the sport in the Philippines.

The club was organized purely for recreation; betting was yet unheard of and horses competed for medals and other ornamental prizes. Races were held on two sites: one, on a quarter-mile straight course between what is now the San Sebastian Church and the present location of Quiapo Church; another, between what is now R. Hidalgo and San Sebastian Church. The races were held only once a year, in April or May.

By 1880, the district of Quiapo had become an emporium, the fiefdom of business tycoons who set up their homes and trading offices in the area. To give way to commerce, the Club relocated its races to rural Santa Mesa. The new site, leased from the Tuason family, was a rice field abutting the Pasig River at the end of what is now known as Hippodromo Street. Built here was an open-air, oval track with a bamboo–and–nipa grandstand.

Racing events became much-awaited festivals, lasting three days, and were held twice a year. Racing days were declared holidays during which offices and commercial establishments were closed. The Spanish governor-general and the archbishop of Manila led the festivities, which included an elaborate parade on opening day and a dinner-dance on the closing night, attended by Manila's elite.

Bathhouses

Bathhouses flourished during the Spanish period in areas where hot springs and therapeutic mineral waters abound, such as those found in Los Baños in Laguna and in Sibul near San Miguel de Mayumo in Bulacan. The settlement of Los Baños (Spanish for "baths"), which had numerous hot springs and whose waters were said to have curative effects, attracted the Spaniards, especially the Franciscan friars. In 1589, Father Pedro Bautista established public bathhouses constructed of rattan, bamboo, and nipa erected over a course through which hot water from the spring passed through. The water discharged by the hot springs was collected and conducted through a stone aqueduct to the bathhouses. For the purpose of securing a stream bath, baths were formed by small, circular structures, two meters in diameter, erected over the point of discharge.

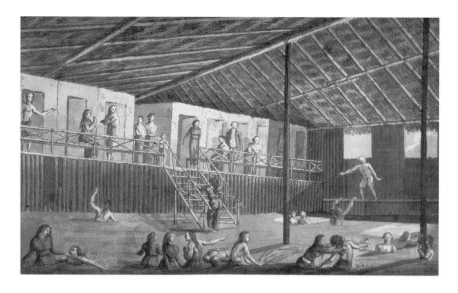

4.127 Public bathhouse in Manila drawn by Juan Ravanet, 1792

Houses of Ill Repute

Illegitimate forms of leisure also persisted in the urban precincts, especially in the commercial district of Binondo where new structures were introduced to cater to gambling, prostitution, and opium dependency.

The beginning of opium joints could be linked to the colonial authorities' intervention in the opium monopoly and the legalization of its importation in 1884. Under the terms of legalization, opium was sold exclusively to the Chinese but its use by Filipinos and Spaniards were prohibited. Thus, the recreational consumption of opium proliferated among the Chinese in the nineteenth century, which resulted in 478 opium dens in Binondo, according to the Spanish official record. With the coming of the American colonialists and the moral opposition issued by the Protestant Church, the number of opium joints decreased until it was declared illegal in 1908. The opium dens, or *fumadero de opio*, consisted of rooms provided with benches and mats for the smokers to lie on.

4.128 Opium den in the district of Binondo

Prostitution was a large and profitable business in many colonial societies, especially in zones that were open to foreign trade. Although prostitution was declared illegal, *burdels* (brothels) thrived in Binondo, the red light district of the period, and later shifted operation to the more secluded suburban district of Sampaloc to cordon the contagion of venereal diseases from the center of colonial commerce. The practitioners of the oldest profession in Manila were known as *mujeres publicas* or *prostitutas*. Not only were there native prostitutes and Japanese *karayuki-san*, as they were known, there were also Caucasian, French, and Russian prostitutes. Similar to opium joints, brothels were inconspicuous, hidden from the public eye.

Architecture of Colonial Discipline

From the confines of the *calabozo* (jail) inside the casa tribunal, the architecture of incarceration expanded with the establishment of penitentiary institutions and penal colonies in the nineteenth century, exemplified by the Bilibid Prison in Manila and San Ramon in Zamboanga. Another common penal practice during this century was deportation to Mindanao, Paragua (now Palawan), or the Marianas. Deportation had a double purpose: punishment and the creation of new colonies in areas where Spanish authorities had no control.

The main penitentiary was the Old Bilibid Prison, which was established in 1847. It was formally opened on April 1866 through a Royal Decree. About four years later, on August 21, 1870, the San Ramon Prison and Penal Farm in Zamboanga

4.129 Garroting inside the Bilibid Prison

4.130 Façade of the administration building of the Bilibid Prison

4.131 The radial configuration of the Bilibid Prison with a central panopticon tower. The prison was designed by Emilio Diaz and Armando Lopez Ezquerra in 1857.

City was established to confine Muslim rebels and recalcitrant political prisoners opposed to the Spanish rule. The facility, which faced the Jolo Sea, had Spanish-inspired dormitories and was originally set in a 1,414-hectare sprawling estate.

The construction of the Bilibid Prison (also known as Presidio de Manila) was implemented by Spanish military engineer Enrique Trompeta based on the plan designed by Emilio Díaz and Armando López Ezquerra in 1857. The prison, covering an area of thirteen hectares, was officially known as the Carcel y Presidio Correccional and could accommodate 1,127 prisoners. The Carcel was designed to house 600 prisoners who were segregated according to class, sex, and crime, while the Presidio could accommodate 527 prisoners.

The Bilibid prison occupied a quadrangular piece of land 180 meters long on each side, which was formerly a part of the Mayhalique Estate in Manila. It housed a building for the offices and quarters of the prison warden, and fifteen buildings or departments for prisoners that were arranged radially to form spokes, a panopticon type of configuration. The central tower formed the panoptical hub. Under this tower was the chapel. There were four cell houses for the isolated prisoners and four isolated buildings located on the four corners of the walls. The prison was divided in the middle by a thick stone wall dividing the enclosed space between the Presidio prisoners and Carcel prisoners. Historically, the panopticon was proposed as a prototype prison designed by Jeremy Bentham (1748–1832), a utilitarian philosopher and theorist of British legal reform in the eighteenth century. The panopticon, which means "all-seeing," functioned as a round-the-clock surveillance apparatus. Its design ensured that no prisoner could ever see the "inspector" who conducted surveillance from the privileged central location within the radial configuration. The prisoner would never know when he was being observed—mental uncertainty that in itself would prove to be a crucial instrument of discipline and self-regulation.

Twilight of an Empire at the Dawn of a New Century
The long distance mode of imperial governance from Madrid via Mexico to Manila caused much delay in the delivery of economic and political reforms in the Philippines. Spain in the Philippines, still clutching to its feudalistic system, lagged behind while other countries were at the helm of the Industrial Revolution.

The export economy led to the creation of powerful regional elites who owned large land estates. Their Spanish-educated children, known as *ilustrados*, were influenced by the liberal reforms in Spain after 1868. From the 1870s they began to claim the same rights as Spaniards, including representation in the Spanish parliament. Soon enough, Spain was confronted by a mounting ilustrado nationalist movement plus a rebellion led by the proletarian-based Katipunan movement. Fighting broke out in the Manila area between Katipunan forces and the colonial army. As Spain tackled the Philippine uprising, it was simultanously fighting a major rebellion in its Central American colony of Cuba. The situation led to the immense depletion of Spain's limited resources. Intervention by the United States in Cuba resulted in the Spanish-American war. Consequently, the United States Pacific fleet sailed into Manila Bay, destroyed the Spanish fleet, and, without difficulty, captured Manila.

Peace negotiations opened in Paris, which ultimately led to the Treaty of Paris of 1898. Under the terms of the agreement, the United States acquired Puerto Rico in the Caribbean, and Guam and the Philippines in the Pacific from Spain. The Treaty of Paris signaled the end of the Spanish Empire in the Philippines. The United States paid Spain twenty million dollars as compensation for these acquisitions and spent many more millions to subdue a fierce three-year rebellion against American rule in the Philippines. After pacifying the Filipino guerrilla, the American occupation forces began rebuilding the Philippines along the image of an American tropical empire, guided by the logic of Manifest Destiny.

Imperial Imaginings
Architecture and Urban Design in the New Tropical Colony of the United States (1898–1946)

Framing the Imperial Imagination

The demise of the Spanish empire at the end of the nineteenth century enabled the United States, through the Treaty of Paris, to acquire the Philippines, along with other island possessions. Such shift of colonial power signaled the advent of pseudo-Hispanic Mission style and the Neoclassic style in the Philippine architectural scenography. This stylistic alliance gave continuity, rather than disruption, to a form of government that had changed from Spanish to American colonial rule. The neoclassic style, in particular, served as a visible narrative of imperial ambition and cultural attainment transcoded in America's modern and imported building material—the reinforced concrete.

Colonial Mission Revival and Monumental American Neoclassicism were declared by the United States as its official style in its imperial enterprise in the Philippines at the beginning of the twentieth century. The Mission Revival, a style that swept America in the 1890s, manifested its presence initially in the works of Insular Architect Edgar K. Bourne through the romantic evocation of America's Hispanic heritage from Southwestern frontiers. This style was further articulated by William E. Parsons within associationist aesthetic credo that spawned hybrid architecture in the Philippines. This was, of course, in compliance with Daniel H. Burnham's architectural prescription to profusely use local building motifs in the design of state architecture. Adhering to Burnham's classicist urban master plan for Manila and Baguio, pensionado Filipino architects, like Juan Arellano, Tomas Mapua, and Antonio Toledo, upon finishing their architecture degrees abroad, went on to design public buildings in the grammar of Beaux Arts. They were the same personalities who would eventually takeover prominent positions in the Bureau of Public Works as architects. From the drawing boards of these architects, there emerged a reformation of spatial ecology and perpetuation of stylistic concoctions that take the visible politics of architecture to the highest orders to declare the ascendancy of America as a new world power, its civilizing presence and its pledge to spread democracy across the globe. Corollary to this, an imperial self-image became more evident with the onslaught of architecture and images mimicking European and Roman descent that was developed for the fairs that subsequently bombarded the American popular consciousness.

5.1 Detail of the pediment and entablature of Paco Train Station in Manila, designed by William E. Parsons, 1911

The White City of Columbian World's Fair of 1893 set the tone of building iconography in the Beaux Arts lineage, while the Panama-Pacific International Exposition in San Francisco of 1915 consolidated the revival of Mission Style or neocastilian architecture. They provided the paradigm for the creation of imperial spaces in Philippine soil.

Many of the studies on colonialism implicate how architecture functioned as a cultural instrument of colonial politics. Scholar Homi Bhabha relates one of his core concepts, cultural hybridity, to the politics of style and appropriation. The perpetuation of hybrid styles in colonial architecture was strategically pursued by the colonial authority as a mode of accommodating familiar vernacular styles so as to project a harmonious coexistence of the native and foreign. Such condition of appropriation was best manifested in the early stages of colonial architecture when, for instance, the English in India, and the French in Indochina and in their colonies in North Africa, attempted to retain control of the semantic content of the styles in which they built. As Thomas Metcalf (1989) and Gwendolyn Wright (1991) have shown, the history of architecture and urbanism in colonial settings develops into a narrative of adaptive strategies that were closely related to the changing policies of colonial rule. In both French and British colonies, there was a gradual move from building in styles imported directly from the metropole to the adoption of elements from local architecture. In the words of architectural historian Gwendolyn Wright:

> Administrators hoped that preserving traditional status-hierarchies would buttress their own superimposed colonial order. Architects, in turn, acknowledging that resistance to new forms is often based on affections for familiar places, tried to evoke a sense of continuity with the local past in their designs (1991, 9).

Similarly, in the manufacture of American colonial architecture, an associationist style was sought by Parsons as a response to Burnham's recommendations to

learn from the vernacular bahay na bato. The works of Parsons evidently rummaged familiar local architectural icons from Hispanized colonial structures overlaid with a neoclassical massing and consequently formed a so-called tropical hybrid style. This deployment of a Filipino type of fenestration could be understood as a hybrid intervention which unsettled the imperialist intent of Parsons' architecture. Such stylistic crossbreeding was no mere accident in the creation of an official architecture of the colony, as the building assumed an ideological position that made colonialism appear as the continuity of local culture rather than a rupture. Furthermore, the manufacture of architectures that celebrate hybridity was meant to justify cultural encounters and mediations between the colonizer and the colonized. Capitol complexes and state architecture, therefore, as they ideologically express the political power of the colonist and legitimize colonial rule through monumentalism and aesthetic exaggeration, have designs that were very conscious of interfacing with local architecture through a poignant reference to historical forms and architectural precedents in the colony. The extensive use of architectural allusions that accommodate local and familiar building motifs was meant to project among the natives, on a semiotic level, a harmonious coexistence between two contesting cultures as a way to solicit obedience and consensus from the unwitting natives. It is a strategy that disrupts the visibility of the colonial presence and makes the recognition of its authority problematic.

The Roots of American Imperialism

In retrospect, the United States by 1898, like the nations of Europe, was caught in a wave of imperialism. With its victory in the Spanish-American War, the United States suddenly became a colonial power and laid its claim to the status of world power. Prior to the war, the United States had taken an isolationist approach to world affairs. However, the ideology of Manifest Destiny, the desire to demonstrate its strength and power, and the desire to increase its wealth prompted the United States government to commence its own imperialist regime at the turn of the century.

5.3 *America Guided by Wisdom,* an engraving published by Benjamin Tanner, Philadelphia, 1816

Territorial expansionism was not new to America, but it had always limited itself to the North American continent until the federal Census Bureau announced the closing of the western frontiers in 1890. The census made certain that the United States had filled out the entire continental domain, compelling the nation to search for new lands overseas.

The spirit of Manifest Destiny, which had remained pervasive since the founding of the American Republic, reached its peak during the last decade of the nineteenth century to rationalize America's overseas expansion. The phrase was coined by New York journalist John O'Sullivan in 1839, when he wrote that "it was the nation's manifest destiny to overspread and to possess the whole of the continent which Providence has given us for the development of the great experiment of liberty and federated self-government entrusted to us" (O'Sullivan 1839, 426). Democratic republicanism was felt to be the best form of government and God's plan for mankind, and so it was believed to be an obligation to introduce it and "freedom" to as broad an area as possible. Manifest Destiny provided an idealistic and benevolent rationale for expansion than mere ambition for land.

Moreover, it was also during this period that powerful advocates of imperialism began to surface in America's popular imagination. In *The Law of Civilization and Decay*, Brooks Adams called upon the ideals of Social Darwinism, asserting that "not to advance is to recede" and, therefore, in order to survive, America must expand. Thus, America's national survival was equated with the triumphant march of the white race across the face of the earth. To expand is to thrive; to stay home is to expose oneself to be unfit for the global contest. The United States felt that it had to partake in the European race for empire. Aside from a source for creating mercantilist empires, colonies had become a symbol of national stature. Because

5.4 A political cartoon published in *Judge* (March 21, 1900), showing the Philippines as a mere stepping stone to a larger imperial goal, China)

of a strong sense of nationalism, America was bound to enter into the world of imperial competition. In the widely read *The Influence of Sea Power Upon History, 1660–1783*, US Navy officer Alfred T. Mahan emphasized the necessity of annexing the Caribbean Islands, Hawaii, and the Philippine Islands in order to create naval bases to protect American commerce. As the proper inheritor of this British power, Mahan continued, the United States must act quickly to build a large navy and emulate earlier British imperial policies. The application of Social Darwinism to international relations led to the conclusion that the United States should use its new economic and military power to protect what the British poet Rudyard Kipling called "the lesser breeds without the law" and lead them in the ways of republican democracy.

After defeating Spain in 1898, America was uncertain as to what to do with the Philippines. The debate raged between the expansionists and the anti-imperialists as the Treaty of Paris was being signed in December 10, 1898. Leaning toward the imperialist persuasion and imploring divine guidance, President McKinley explained publicly his dilemma as to how to proceed with the Philippines:

> I didn't want the Philippines, and when they came to us, as a gift from the gods, I did not know what to do with them.... I went down on my knees and prayed to Almighty God for light and guidance more than one night. And one night late it came to me this way ... that we could not give (the Philippines) back to Spain—that would be cowardly and dishonorable; that we could not turn them over to France or Germany—our commercial rivals in the Orient—that would be bad business and discreditable; that we could not leave them to themselves—they were unfit for self-government—and they would soon have anarchy and misrule over there worse than Spain's was; and that there was nothing left for us to do but to take them all, and to educate the Filipinos, and uplift and civilize and Christianize them, and by God's grace do the very best we could by them, as our fellowmen for whom Christ also died. And then I went to bed, and went to sleep and slept soundly" (Rusling 1903, 17).

In this brief statement, McKinley had summarized the motivating ideas behind imperialism in the Philippines: national honor, commerce, racial superiority, and altruism.

What began as a heroic project to liberate the Philippines from the tyranny of Spanish imperialism soon changed into a struggle to quell the Filipino independence movement. The United States faced strong, armed resistance from the supporters of the Philippine Republic. In February 1899, the Republic declared war on the United States, fighting a conventional war for several months and then resorting to guerilla warfare in response to major losses against the Americans. By April 1902, the war had ended, with the United States victorious, but unable to quell the native discontent that fueled guerilla warfare.

In the Aftermath of the Philippine-American War

After defeating the Filipino guerrillas, the American occupation regime began the massive rebuilding of the Philippines along the American model and planned an entire battery of infrastructure to facilitate ventures in military control, public health, education, and commerce. The establishment of the colonial administration and of the infrastructure of American rule in America's new tropical

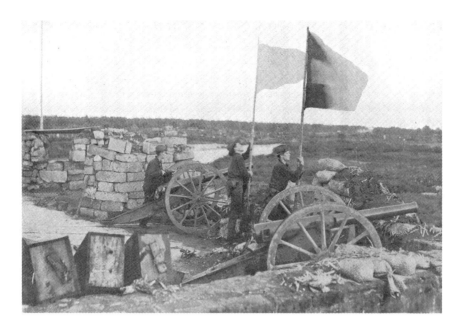

5.5 Signal corps at the walls o
Fort San Antonio de Abad ir
Malate signaling the Americar
troops to advance after the
surrender of the Spanish Army ir
August 1898.

possession was implemented through two Philippine Commissions. Initially, a military government was established to conduct various modes of pacification in the region. The American troops pledged freedom and a more civilized way of life. The Filipinos, with the exception of those who rebelled, responded with great optimism. However, to actualize this civilizing scheme, Americans had to supplant the existing cultural system through the establishment of new sociopolitical criteria under the persuasive theme of "benevolent assimilation."

On August 15,1898, all public works were placed under the United States Army Corps of Engineers. The corps took charge of all public works under the military government of General Arthur MacArthur. The infrastructure and buildings of Manila and other urban centers were appraised and those that incurred damage from the aftermath of the war were repaired immediately to make them serviceable. The Philippine Commission, headed by Judge Howard Taft, was in control of the development and improvement of the islands and eventually took over the civil administration. Taft was appointed as the first civil governor-general of the Philippines. Soon, the commission generously deployed its resources to rehabilitate the colonial city, restore and improve existing infrastructure, and introduce urban strategies that assured a comfortable, healthy, and secure settlement for the anticipated influx of American population.

Construction of Forts and Camps

With the declaration of the end of fighting, US Army officers in the Philippines decided to establish camps outside the urban centers. The construction of such military facilities was undertaken to better administer the enlisted men and maintain discipline as well as to lessen friction with the native population. Besides, the conditions in the ancient Spanish barracks were considered substandard from the perspective of a modern military: those in Manila were described as "crumbling stone hovels, dank, hot, airless, comfortless, and unsanitary," crawling with vermin. The Spanish buildings in Subic were decrepit; most of them leaked and needed new floors and had to be repainted.

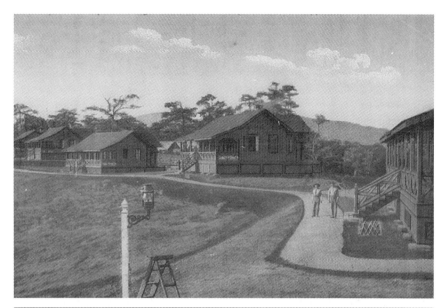

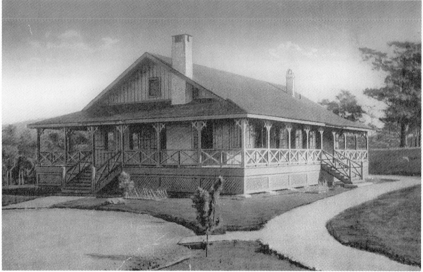

While it was originally planned to establish a dozen permanent posts in Luzon, only a few were actually built due to budgetary limitations. Some of the early posts included Camp (later renamed Fort) Stotsenburg near Angeles City, Pampanga, which was claimed by the US as a military reservation in 1902. Fort William McKinley, in the province of Rizal, east of Manila, was also established in 1902, and construction began immediately; troops first occupied the new buildings in 1904. Camp Wallace in Poro Point, La Union was established in 1903; while Camp John Hay in newly opened Baguio, in1904. Warwick Barracks in Cebu, originally known as the Post of Cebu, was established in 1899 in and around Fort San Pedro, with the old Spanish fort used as headquarters and additional barracks and warehouses constructed outside.

The establishment of more permanent camps in the Philippines followed a pattern and reflected American military operations and strategy. Camp John Hay protected Baguio and the nearby gold mines and projected the American military presence

in northern Luzon, at the same time serving as a rest and recreation camp for officers and men. Camp Wallace in La Union covered the Lingayen Gulf area, while Camp Stotsenburg covered central Luzon. Camp Gregg in Bayambang provided an additional garrison in northern Luzon. Fort McKinley became the home of the Philippine Division, the main American ground unit in the Philippines. It covered southern Luzon as well as Manila. Camp McGrath in Batangas provided military presence in the province, which the Americans had had trouble subduing. Camp Eldridge in Los Baños similarly provided a check in Laguna Province. Camp Wilhelm in Lucena, Quezon, and Camp Daraga (later renamed Regan Barracks) in Legaspi, Albay, rounded out the American military posts in Luzon.

In addition to headquarters, officers' housing, and enlisted men's barracks, the camps also had armories, warehouses, messes (sometimes located within the barracks), officers and enlisted men's clubs, hospitals, commissaries, post exchanges, recreational facilities, and a chapel. Landscaping, layout, and construction generally followed standard US Army designs.

As the posts took shape, the need for new construction became urgent and these buildings became more permanent. The early nipa quarters in Fort Stotsenburg were replaced by more solid wooden cottages and barracks built from 1903 to 1904. The cottages followed American designs adapted to Philippine conditions: they were built of American pine boards especially imported from the US mainland, were raised off the ground on cement columns, and had four-sided pyramidal or two-sided peaked roofs. Initially, these roofs were topped with thick tar paper (called "rubberoid"). One feature of the officers' cottages and most wooden barracks was the open-air porch. Many of these cottages still exist, and Stotsenburg became part of the Clark complex after the Second World War.

Wooden barracks also followed standard American designs adapted to the tropics. These were also originally built of American pine, especially shipped to the Philippines. These buildings were usually two-storey affairs, raised off the ground on cement pillars. Large windows kept the buildings cool; in time of rain, they were closed by large wooden shutters. Open porches and stairs allowed for easy access in and out of the barracks.

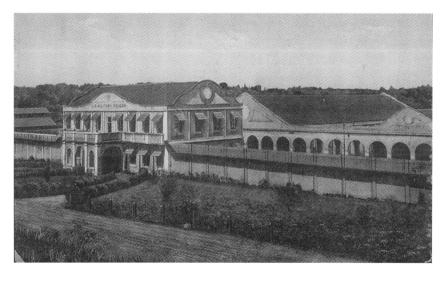

5.7 American military prison at Fort McKinley

The construction of permanent structures in Fort William McKinley in 1905 was hailed as the second largest military cantonment in the world (next to the British cantonment in Aldershot). It "heads the list of great military reservations which accommodate troops continuously, and in the matter of modern facilities, buildings, etc., it is said to be far away the greatest of all reservations of this character" (*Far Eastern Review*, October 1905, 124). The wooden buildings on the reservation were designed by Harry Allyn, the Supervising Architect, in a style that bore resemblance to American Swiss cottages or chalets. The structures, totaling 198, were "planned for the comfort and physical well-being of the troops, and to meet the climatic and other prevailing conditions in these tropical Islands" (ibid.). The wood-built structures principally utilized Oregon pine, except the posts, which were of native hardwood. The military architecture of Fort Mckinley was essentially characterized by the abundant use of galleries, balconies, large windows, and clapboards. Roofs were allowed to project widely around the structure to create deep shadows. Their long and narrow outside-galleries had crisscross-patterned pine railing. The use of reinforced concrete was recommended for all buildings constructed for the American army based in the Philippines in an order issued by General Leonard Wood, then commander of the United States military forces in the Philippines, on October 31, 1906.

5.8 and **5.9** The wooden barracks at Fort McKinley were designed by Harry Allyn, the Supervising Architect, in a style that resembled Swiss cottages or chalets adapted to the tropics.

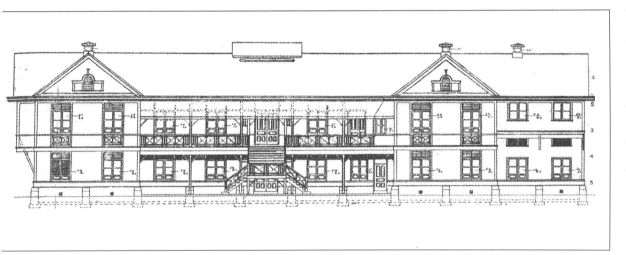

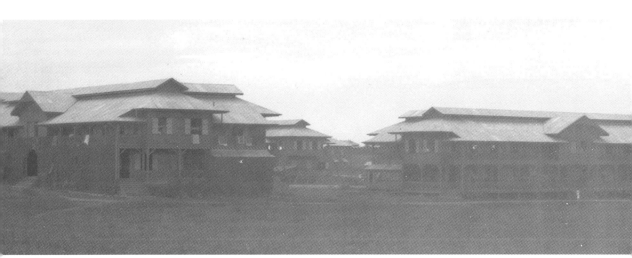

Architectural Inventory of the New Colonial Possessions

The first American architectural historian to survey Philippine architecture was the illustrious Montgomery Schuyler (1843–1914), who, in January of 1900, comparatively examined the architectures of America's newly acquired territories (Cuba, Puerto Rico, the Philippines, and Hawaii) for one of the most important architectural publications in America, the *Architectural Record*. Schuyler forewarned imperial America when he asserted: "The conqueror entertains a general contempt for the people he has beaten, and refuses to learn even what they have to teach ... and have proceeded tranquilly to apply to their subject their own view of the fine as well as the coarse arts" (Schuyler 1900, 312–13). Appraising the architectures of the new colonial possessions, "as photography enables us to judge," Schuyler recognized that "our acquired architecture in general ... sets us a standard to which we shall find troublesome to live up to." Looking at the extant Spanish architecture in the Philippines, he took notice of its distinguished qualities: "The architecture of the Philippines and of the Spanish West Indies is a great deal better being Spanish than it would ... had it been of the United States."

Schuyler was uncompromising in his belief that "the Spanish mode of building fits the requirement of the Spanish colonies better than ... the American mode of building." He went on to enumerate the distinct qualities of tropical architecture: "The thin walls impermeable to heat, the long, dark, open arcades along which one may make his way in the shade, these features of the architecture of the Peninsula which are equally appropriate, which are even more appropriate in the tropical heat of Cuba and Luzon ... these necessary features are susceptible of a most attractive architectural expression." He advised with caution the American authorities in the colonial bureaucracy assigned to matters of architecture in the newly acquired colonies: "No 'thoughtful patriot' could contemplate with equanimity the prospect of having designs for public buildings in Havana, in Manila, or in San Juan de Puerto Rico sent out from the office of the average Supervising Architect to come in competition with the architectural remains of the Spanish occupation. They really could not stand it." At this point, Schuyler acknowledged the need for a contextual approach in the design of public architecture in the colonies which would be both tropically and iconographically congruous with the architectural precedent set by Spain. Heeding Schuyler's advice, this direction in colonial architecture would manifest itself in the works of future consulting architects detailed in the Philippines.

5.10 American architectural historian Montgomery Schuyler (1843–1914)

Urban Cleansing and the New Tropical Hygiene

With the American colonial policy in full swing in the Philippines, urban planning and architecture served the needs of secular education and public services. The first act approved by the Philippine Commission on September 12, 1900 was the appropriation of $1 million for the construction of roads and bridges in the colony to open up new territory. Initially, a law was passed and adopted that required "every able-bodied man in the Islands to give five days of labor each year on road construction and maintenance, or, in lieu of that, to pay a sum equivalent to the local cost of such labor" (Forbes 1928, 199).

In the city and quaint suburban districts of Manila, overnight changes and improvements had taken place since 1898. The city was mapped and public works were started for new city streets. Some of these urban interventions by early architects were misdirected, such as the plan to demolish the Intramuros walls to use the stones for paving the new streets. The colonial authority initially devalued the Walled City of Intramuros as an "obsolete fortification of the middle ages, the walls of gray stone with parapets and bastions imposing enough and picturesque, but utterly valueless against modern artillery." Moreover, the health authorities singled out the stagnant moats surrounding the edges of the wall as a breeding ground for malaria-carrying mosquitoes and recommended that the moats be filled with earth. In 1902, the Municipal Board petitioned the civil government for permission to open suitable gates into the old Walled City as the narrowness of the approaches caused great traffic congestion. Plans for these openings were drawn by Major Sears and Captain McGregor of the Corps of Engineers and were authorized by the Philippine Commission by virtue of an act. The part of the wall that was torn down was, according to authorities, "the least picturesque and obstructive to commerce and its removal was regarded as a necessity to the progress of business." The portion removed was along the river front, extending from the Fort Santo Domingo Gate toward Fort Santiago. This section "obstructed the use of the river for wharf purposes and additional wharf facilities ... regarded as imperative by the Commissioners" (*New York Times*, May 19, 1903, 8).

5.11 House-to-house disinfection in the 1900s conducted by the Board of Health of the city of Manila

The effort to demolish the historic walls and drain the moats of Intramuros was also prompted by a health imperative dictated by Manila's colonial sanitarians, whose convictions resounded by virtue of a historically uninformed argument: "The walls are historically not of great importance, being a little over a hundred years old, and sentiments should not be allowed to interfere in the course of progress, and in the matter which affects the health of tens of thousands of people" (Ballentine 1902, 72).

The move to wreck the walls of Intramuros stirred much controversy to a point necessitating presidential arbitration. To resolve the matter, President Theodore Roosevelt requested landscape architect B. R. Slaughter from Mount Holy, New Jersey, to visit Manila and investigate the contested structure. Slaughter, after thorough inspection, recommended that the Intramuros walls be retained and transformed into a circumferential park—a plan which antedated Burnham's recommendation prescribed in the 1906 Manila Plan. Slaughter wrote the President, exclaiming that the preservation of the Intramuros walls would be more than an exercise of architectural mediation, the higher purpose of which was the solicitation of colonial loyalty among the inhabitants of Manila:

> I appreciate that question of commercial and utilitarian nature far outweigh historic and artistic considerations, but in dealing with a people who are not yet loyal to us, I think the preservation of their architecture and an appreciation of it go far toward conciliating them ... (letter of Slaughter to Roosevelt, April 11, 1902)

Secretary of War Elihu Root immediately sent a cabled instruction to Governor-General Taft in Manila "to suspend action for the removal of any portion of the wall" (*Manila Times* 25 June 1903, 1). Slaughter's recommendation prevailed, the ancient Intramuros wall was never torn down but its moats were filled and converted into beautiful and healthful parkways (*Cable News American*, January 15, 1903, 1).

Colonial sanitary reengineering was vital to arrest native unhygienic practices so as not to pose biological threats. According to Warwick Anderson, "the tropical

5.12 Demolishing portions of the Intramuros walls to improve vehicular traffic and urban ventilation within the walled city

5.13 Draining and filling the mosquito-breeding waters of the moats of Intramuros

5.14 Detail of a mural painting, *History of Manila*, by Carlos V. Francisco at the Manila City Hall, depicting the militaristic style of sanitary reengineering and hygienic surveillance at the early stages of American colonization

environment called for massive, ceaseless disinfection; the Filipino bodies that polluted it required control and medical reformation; and the vulnerable, formalized bodies of the American colonialists demanded sanitary quarantine" (Anderson 1995).

The indescribable sanitary conditions in the Philippines, according to the account of Dr. Victor Hieser in his *An American Doctor's Odyssey* (1936), were combated through the strict enforcement of a battery of sanitary methods, which focused on the natives' toilet practices, food handling, dietary customs, burial practices, and housing design. The Americans rebuilt the domestic architectures and markets using the more hygienic concrete, executed routine quarantines for suspected epidemic-stricken communities, petrolized stagnant waters to eliminate the breeding places of malarial mosquitoes, and even suppressed the unsanitary fiestas to contain disease vectors from spreading.

The bubonic plague of 1901 impelled the colonial authority to create a permanent detention camp at the San Lazaro grounds capable of accommodating 1,500 patients. A militaristic sanitary surveillance in the city was dispatched through the Bureau of Health. With a high degree of efficiency and frequency, this sanitary battalion went on a house-to-house inspection and arrested suspected carriers of the pathogen for quarantine detention at the San Lazaro. Plague houses and buildings incapable of thorough disinfection and rehabilitation were set on fire. The burning of infected houses resulted in the complete eradication of the plague.

Similarly in 1901, the cholera outbreak compelled the colonial authority to strictly monitor the Marikina water reservoir and to close all wells in Manila. The Insular Ice Plant was directed to increase the output of distilled water to the maximum, while the army distributed water in districts without city water supply and closed wells. The native population viewed the situation with contempt and "imagined that the health authorities were attempting to poison them." But their fears were soon dispelled.

The Farola district, with its closely packed, filthy shacks offering conducive conditions to the spread of cholera contagion, was strictly quarantined. When the conditions made it impossible to subject the district to thorough disinfections, the residents of the Farola were rounded up and taken to the San Lazaro detention camp and the entire district was burned. The burning of the nipa shacks to contain the epidemic, in most instances, provoked great resistance and hostility among the poor native populace. The secretary of interior, in his report to the US Secretary of War, remarked of the cholera situation in the city:

> For weeks the presence of cholera was denied by the ignorant, misinformed, and ill-intentioned person. The more ignorant Filipinos refused to believe of its existence because the daily deaths did not reach up to the thousands. The minds of the common people were poisoned by tales of horrible abuses in the detention camps and the deliberate murder of patients at the cholera hospital. The story was widely circulated that the houses of the poor were burned in order to make room for future dwellings and warehouses for rich Americans. These absurd tales gave credence among the populace, and together with some actual abuses committed by ignorant, inexperienced, or overzealous health inspectors, produced a state of popular apprehension, which proved a very serious factor in the situation, as it led to the concealment of the sick, the escape of contacts, and the throwing of dead bodies into the esteros and the Pasig River, the polluted waters of which were fruitful sources of infection (Secretary of Interior 1902, 19).

As a result of the bubonic plague and Asiatic cholera, the Municipal Board of Manila published fourteen ordinances for a more stringent sanitary surveillance. Some of these ordinances had architectural implications that penetrated the domestic sphere: (1) an ordinance relating to buildings and premises infected with bubonic plague; (2) an ordinance authorizing the board of health to install the so-called "pail conservancy system" at the expense of the property owner; (3) an ordinance relating to nipa houses; (4) an ordinance regulating tenements and lodging houses; and (5) an ordinance prohibiting the practice of cleaning ears, scraping eyelids, or barbering in the streets, lanes, alleys, and public squares.

Immediately enacted were orders to demolish "dangerous and unsanitary buildings" that were in violation of the ordinances; alluding to the hovels and huts inhabited by the poor. The domestic disenfranchisement was mitigated by the construction of a municipal tenement that was designed to accommodate forty families. This $6,000 tenement had an interior court with cookhouses, washtubs, and latrines.

The Architectural Implication of Epidemic Disease

The early years of American occupation were beleaguered by a succession of epidemics. Bubonic plague and cholera were fought by the American proconsuls with paramilitary firmness. Ordinances were issued to regulate and modify vernacular dwellings. This brought many technological changes to Filipino domestic space for the materials, layout, construction, and services of the nipa houses were found by the colonist to be inconsistent with colonial sanitation. Buildings were made ratproof in response to plague-carrying rodents. In 1905, the city's Building Ordinance, which brimmed with provisions against house infections was passed. This stringently fixed the minimum standards and stipulated medicalized guidelines for house density, illumination, ventilation, and waste disposal. The concept of the toilet was introduced in 1902 among dwellers of the bahay kubo in Manila by way of the pail system or *cubeta*. In the absence of metropolitan sewers, the system provided each household with wooden buckets, which were collected daily by the municipal excrement wagons. Public toilet sheds were also installed in congested nipa districts. A latrine system for remote areas was also developed based on a vernacular toilet structure found in Antipolo in the Province of Rizal.

5.16 Cholera-infected Farola district in Manila

5.17 The burning of the entire Farola district in the name of sanitary science in 1902

5.18 In the aftermath of the fire, new tenement houses were built by the Americans in the San Nicolas district in Manila

5.19 Public toilet sheds utilizing the pail system or cubeta

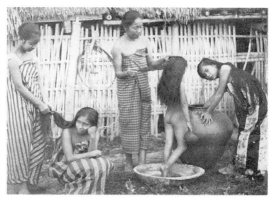

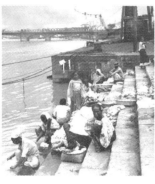

5.20 Cooking outdoors

5.21 Outdoor bathing and washing were later banned in the urban areas for reasons of modesty and social hygiene.

5.22 Bathing and doing the laundry in the waters of Pasig River near Quiapo. Public bathing and washing in esteros and rivers were criminalized after the introduction of the first public bath and laundry in 1913.

5.23 The first one-stop public architecture that combined the functions of bath, laundry, and toilet, completed in 1913 by the colonial authorities in the district of Sampaloc in Manila.

To put an end to the unsanitary practice of bathing and washing in the esteros, the authorities established a new type of communal architecture that combined the functions of toilet, bath, and laundry, with a continuous supply of clean water. The first public bath and laundry, a one-storey structure made of concrete, was built in 1913 at Calle Lipa in the district of Sampaloc.

As a measure against overcrowding, filth, poor ventilation, and fire, the Americans introduced in 1908 the neighborhood concept known as "Sanitary Barrios" which permitted nipa houses to be built on highly regulated blocks of subdivided lots. Each sanitary block had a built-in system of surface drainage, public latrines, public bath houses and laundry, and public water hydrants, which could be availed of by the residents free of charge. Imprints of these barrios could still be seen in Sampaloc, San Lazaro, and Vito Cruz.

With the success of the sanitary barrios, the American authorities focused their efforts to modernizing the Filipino house. In the quest for a sanitary domestic architecture, the American colonial architects, following what the British did for the Indian bungalow, successfully evolved a new kind of architecture that crossbred the tropical features of vernacular buildings with hygienic structural principles and modern materials that gave premium to light, ventilation, and drainage. This innovative hybrid house called *tsalet*—from the word chalet—would influence the domestic aspirations of the Filipino middle class beginning in the 1910s and continuing even after the Pacific war. This house was a single-storey structure constructed of either entirely of wood or a combination of ferroconcrete and wood. The living areas were maintained at an elevation between one to 1.5 meters above ground, slightly lower than the bahay kubo to discourage the placement of

5.24 Design for a new flyproof commode for the pail system, designed by George H. Guerdrum, 1912

5.25 Plan for a small detached house with corner rooms, a bath, and front porch, designed by George H. Guerdrum, 1912

5.26 Perspective of a neighborhood concept of a "Sanitary Barrio" for Manila, 1912

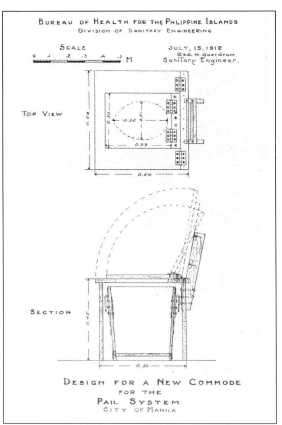

BUREAU OF HEALTH FOR THE PHILIPPINE ISLANDS
DIVISION OF SANITARY ENGINEERING

SCALE
JULY, 15, 1912
Geo. H. Guerdrum
Sanitary Engineer.

TOP VIEW

SECTION

DESIGN FOR A NEW COMMODE
FOR THE
PAIL SYSTEM
CITY OF MANILA

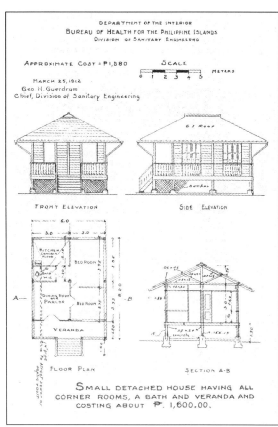

DEPARTMENT OF THE INTERIOR
BUREAU OF HEALTH FOR THE PHILIPPINE ISLANDS
DIVISION OF SANITARY ENGINEERING

APPROXIMATE COST = P1,580

SCALE

MARCH 25, 1912
Geo H. Guerdrum
Chief, Division of Sanitary Engineering

FRONT ELEVATION

SIDE ELEVATION

FLOOR PLAN

SECTION A-B

SMALL DETACHED HOUSE HAVING ALL
CORNER ROOMS, A BATH AND VERANDA AND
COSTING ABOUT ₱ 1,600.00.

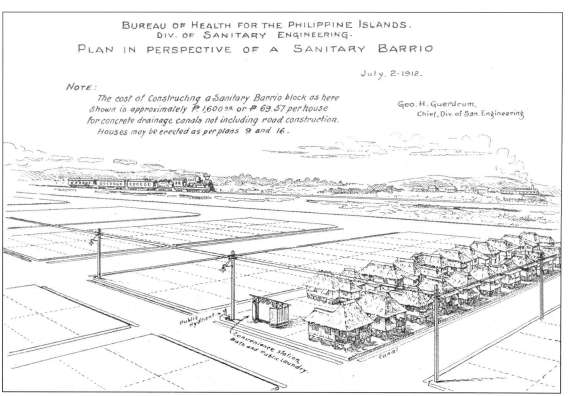

BUREAU OF HEALTH FOR THE PHILIPPINE ISLANDS.
DIV. OF SANITARY ENGINEERING.
PLAN IN PERSPECTIVE OF A SANITARY BARRIO

July. 2-1912.

NOTE:
The cost of Constructing a Sanitary Barrio block as here
shown is approximately ₱ 1,600⁰⁰ or ₱ 69.57 per house
for concrete drainage canals not including road construction.
Houses may be erected as per plans 9 and 16.

Geo. H. Guerdrum,
Chief, Div. of San. Engineering

domestic animals in the underfloor area. The most obvious innovation of this house was its extended porch or veranda in the principal façade, which could be accessed by either an L-shaped or T-shaped stairway. Unlike the bahay kubo, the interior space was defined by wall partitions, which divided it into a combined living and dining area, a kitchen, a toilet and bath, and two bedrooms.

Tsalet: The Healthy Housing Alternative

At the outset of 1900, the upper-class bahay na bato, a vestige of the Spanish colonial era, remained until the 1920s. But as the century flowed on, the wood-and-stone style ceased to be the preferred ideal for urban centers. While expressions in interior design continued to some stylistic variants derived from either Greek Revivalist Neoclassicism or the long, curving, dynamic, floral rhythmic lines of the Art Nouveau, domestic architecture was a product of a close collaboration between the architect/maestro de obras and the sculptor.

As an alternative to the bahay na bato, the Americans introduced a new domestic typology—the "tsalet"—to create a less formal dwelling design. As stated earlier, the tsalet's distinguishing feature was the extended veranda. Inside, bedrooms were laid out on a row on one side perpendicular to the front while living and dining rooms and the kitchen were laid out on the other.

In 1912, the Bureau of Health drew up the plans for sanitary habitations using the tsalet prototype. These plans, drafted by George H. Guerdrum, chief of the Division of Sanitary Engineering, were disseminated to the public via Health Bulletin No. 10, Philippine Habitations (*Viviendas Filipinas*), written in English and Spanish, instructing architects, builders, house owners, and occupants of houses in the few simple principles of sanitary house construction. Schemes were drawn for the general types of an urban house: single detached, semi-detached (duplex), row-house apartments (accessorias), and the one-storey concrete chalet.

New materials were being developed to replace the highly flammable nipa as the staple material for urban constructions, especially after the Great Fire of Manila in 1903. Philippine Assembly Act No. 1838 sanctioned the banishment of the nipa roof with the invention of incombustible material as substitute. The pinnacle of this material experimentation was the "ideal sanitary house" of 1917. A refinement of the tsalet, this modular prototype house introduced a fire-resistant roofing material composed of diamond-shaped shingles molded from a mixture of equal volumes of cement, sand, and rice husk and reinforced by woven bamboo. Its components, a cement floor and wall slabs, were implanted with sawali or woven bamboo, a technique analogous to a local building method known as tabique

5.27 and 5.28 Salubrious domesticity endorsed by the American colonial authorities through a new house design called *tsalet*.

5.29 Plan for a single-storey tsalet, designed by Bureau of Health in 1912 (opposite page)

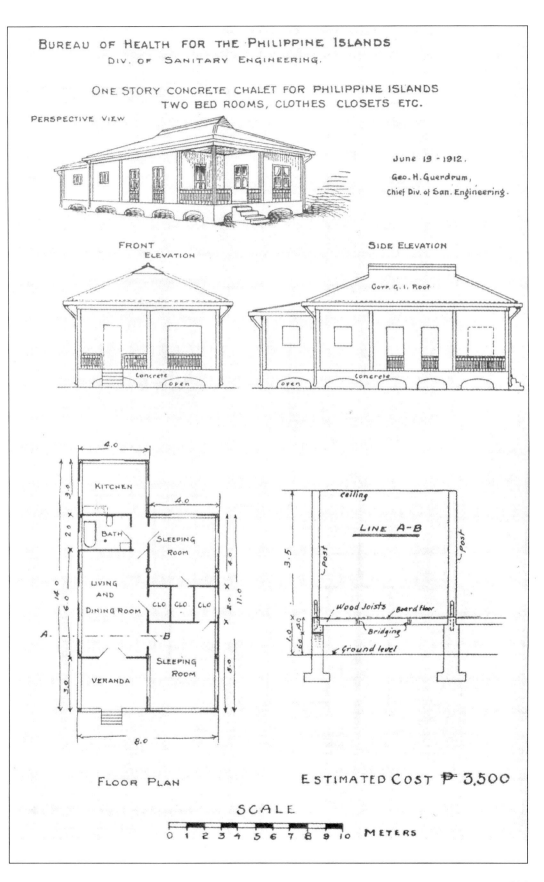

BUREAU OF HEALTH FOR THE PHILIPPINE ISLANDS

DIV. OF SANITARY ENGINEERING.

ONE STORY CONCRETE CHALET FOR PHILIPPINE ISLANDS
TWO BED ROOMS, CLOTHES CLOSETS ETC.

PERSPECTIVE VIEW

June 19 - 1912.

Geo. H. Guerdrum,
Chief Div. of San. Engineering.

FRONT ELEVATION

SIDE ELEVATION

Corr. G. I. Roof

Concrete Open

open Concrete

KITCHEN

BATH

SLEEPING ROOM

LIVING AND DINING ROOM

CLO CLO CLO

A. — — — B

VERANDA

SLEEPING ROOM

ceiling

LINE A-B

Post Post

Wood Joists Board floor

Bridging

Ground level

FLOOR PLAN

ESTIMATED COST ₱ 3,500

SCALE

0 1 2 3 4 5 6 7 8 9 10 METERS

Plans and Instructions Relative to the
Construction of the Sanitary Model House (1917)

Bulletin No. 16 of the Department of Public Instruction and Philippine Health Service issued in 1917 provided detailed plans and specifications for a "Sanitary Model House." This housing prototype, endorsed by the Director of Health and Chief of the Fire Department, was designed to discourage the use of nipa as construction material for houses by emphasizing the economic and sanitary advantages of the new housing model. Replacing the nipa shingles on the roof were fire-resistant, diamond-shaped, molded cement shingles reinforced by woven strips of bamboo (known as sawali), which were fabricated on site. The cement mixture for the shingles was made up of equal volumes of cement, sand, and rice husk.

In plan, the house was divided into five rooms, emphasizing privacy, isolation of the sick, and containment of domestic pollution: a front porch used for dining and reception, a sala and sleeping room combined, a bedroom, a kitchen, and a back porch with provisions for toilet and bath. The demarcation of spaces in compartmentalized rooms dictated a new kind of domestic life for Filipinos who were used to a one-room lifestyle. Furthermore, the Antipolo toilet system, consisting of a pit, a seat with a pipe connected to the pit, and a ventilating pipe was a major sanitary feature of the house.

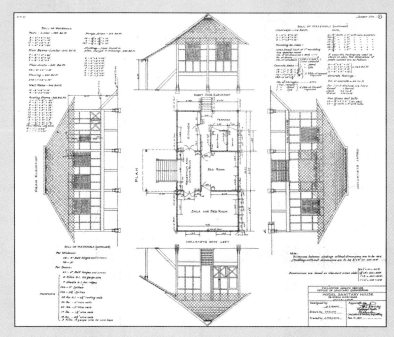

pampango. The concrete shingle-and-slab units could be fabricated on site with minimal skill and investment, with the labor supplied by the homeowner himself based on the blueprints of the Bureau of Health.

The Hygienic City and Its Modern Urban Facilities and Services

After the extensive sanitation maneuvers in support of the new tropical hygiene, the colonial authorities were geared up to lavish the urban space using the technologies of architectural aesthetics. Public spaces were laid out as lawns with promenades around them; the old Botanical Garden enclosure was removed and the site was converted into what is now known as the Mehan Garden; the Luneta Esplanade was rehabilitated and extended out to sea; the marshy field of Bagumbayan was drained; the roads and pavements in the Escolta, Rosario, and other principal thoroughfares in the heart of Binondo's business quarters were repaired and rehabilitated.

The provision of Manila's utilities and other urban services was undertaken by the Philippine Commission as early as 1902 with the authorization of a franchise granted on a competitive bidding to construct and maintain in the streets of Manila and its suburbs an electric street railway and the service of electric light, heat, and power. The franchise was awarded to an American capitalist, who acquired the existing antiquated power plants and installed modern ones which greatly contributed to the industrial development, economy, and living comfort in Manila and its suburbs. In 1903, the city of Manila had under its auspices the operation of 218 arc lights and 1,568 incandescent lamps on the streets and public buildings. Small tramcars drawn by native ponies were replaced by a modern American electric street-railway service and the railway service to and from other towns on the island of Luzon had been extended. Connected to Manila by electric railway is Fort William McKinley, a US army post in the hills five miles away, providing quarters for about 3,000 men.

Among other American improvements were: an efficient fire department, a sewer system whereby the sewage, by means of pumps, is discharged into the bay more than a kilometer and a half from the shore; a system of gravity waterworks whereby the city water supply was sourced from the Marikina river about twenty-three kilometers from the city and directed into a storage reservoir, which had a capacity of two billion gallons at sixty-five meters above sea level. An improvement over the outmoded Carriedo waterworks and the Deposito (the subterranean reservoir of San Juan del Monte), the new American-designed reservoir, following the plan drawn by military engineer Major James F. Case, was rectangular, 225 meters long, 155 meters broad, and six meters deep. Its capacity was fifty-four million gallons that necessitated the excavation of some 211,538 cubic meters of material, placing of about 6,925 cubic meters of concrete, and the use of about 55,000 kilograms of steel. This feat of American engineering made available twenty-two million gallons of water daily to inhabitants of Manila, or nearly a hundred gallons a day, quadrupling the water volume from the old Carriedo water system. The supply from the new storage basin went into operation on November 12, 1908. With the public utilization of the new water distributing system in Manila, the colonial health officials had observed "a reduction in the yearly average number of deaths of children from convulsion from 1,921 to 500" (United States Bureau of Insular Affairs 1913, 31).

5.30 Water-filtrating system installed by the Americans in the San Juan reservoir

Lighting the City

Electricity, a relatively new commodity at the beginning of the century, was made available to a broader range of Filipino consumers with the establishment of the Manila Electric and Railway Company (MERALCO) on March 14, 1903, by Charles M. Swift. Though the first electric power plant was built in 1892 by a Spanish corporation known as the Compania La Electricista, electricity came to Greater Manila only in 1903. Initially, its use in many households was limited to illumination, but the promise of a clean, smokeless, and odorless energy source spawned new inventions which made housework more efficient and less tiring, such as the electric fan, toaster, and flat iron. These common house appliances were specifically given away for free by the electric company if the household can consume more than ten kilowatts per hour.

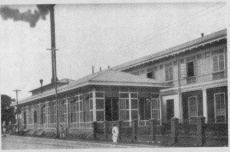

In 1904, a new powerhouse, containing four Westinghouse turbo generators was erected on Isla de Provisor, an island in the middle of Pasig River from where they drew their condensing water, to replace the obsolete 1,000–horsepower plant of the La Electricista. Aside from supplying the power of the street railways and public lighting, the same plant delivered 220 volts of electricity to households and other power subscribers (Snyder 1955, 384). The company serviced 3,478 households in 1906, increasing at an average of

6,000 additional customers per year, reaching 42,126 households in 1923. The plant also increased its power output to 55,000,000 kilowatts by 1923.

MANILA. TIENDA, (SHOP), BEFORE SANITARY REPAIRS.

MANILA. TIENDA AFTER SANITARY REPAIRS.

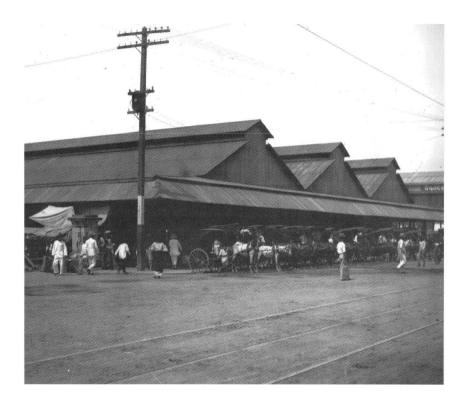

Further improvement of Manila's water supply was again undertaken in 1919 with the reorganization of the waterworks under the Metropolitan Water District, which constructed the Balara Filtration Plant. By 1920, a water purification plant was constructed in San Juan del Monte to address the increased demand for pathogen-free water, and a new water source was surveyed in Angat River in Bulacan.

The system of sanitary and modern public market buildings was also established in Manila under the control of the municipal authority. This consisted of seven markets: Anda Market, Intramuros; Aranque Market, Santa Cruz; Herran Market, Paco; Quinta Market, Quiapo; Santa Ana Market, Santa Ana; Pandacan Market, Pandacan; and Divisoria Market, Tondo. Quinta Market at the foot of the Suspension Bridge was completed at a total cost of $67,821.29 and opened for public use in October 21, 1901. The Divisoria Market at Plaza Mercado, Tondo, was completed at a total cost of $154,469.50 on November that same year.

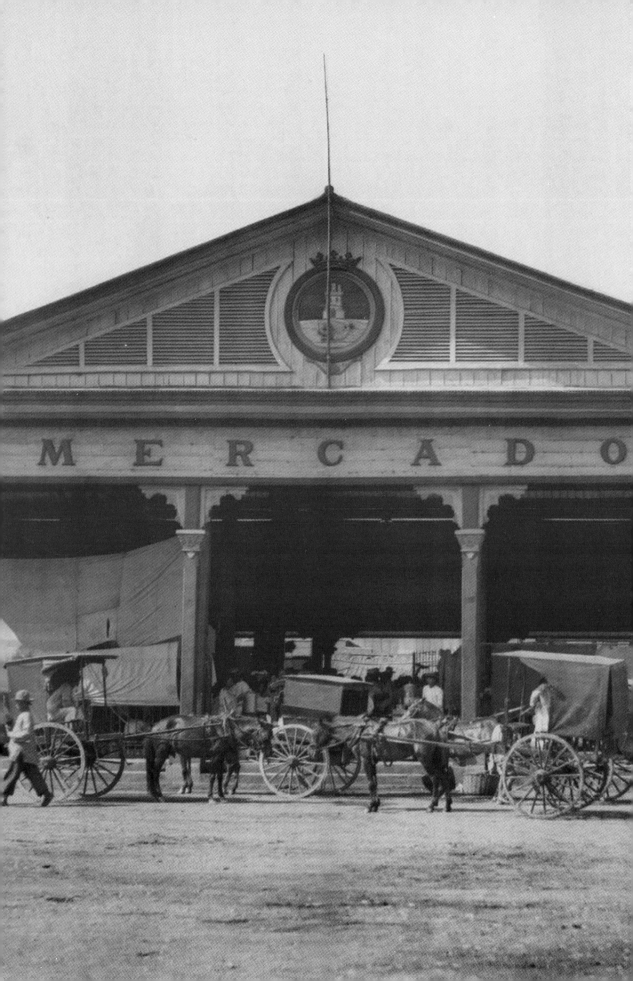

Ports, Canals, and Bridges of Manila

The project of immediate necessity was the improvement of the port of Manila to provide safe anchorage and wharf facilities for freight and passenger ships. In 1901, the improvement of the Port of Manila, under the stewardship of Major Clinton B. Sears of the US Army Corps of Engineers, was undertaken. The project was estimated to cost $3 million. This consisted of four divisions: the improvement of the outer harbor or bay of Manila; the improvement of Pasig River below the Bridge of Spain (now Jones Bridge), the bar at the entrance, the inner basin, and the canal connecting the latter with the river; the improvement of upper Pasig River to Laguna de Bay; and the building of a drawbridge across the Pasig River near its mouth, giving passage to steam and street cars, and other vehicles and foot passengers.

In summary, this project called for the completion of a breakwater and the dredging of designated harbor areas in which dredged materials were used to reclaim some sixty hectares from the sea. The Pasig River was also widened to seventy-six meters up to the Bridge of Spain and the river's intermediate arterial canals were deepened to 5.5 meters. The places from above the Ayala Bridge to Laguna de Bay shoal were dredged to a two-meter depth to allow for low water navigation. The highlight of this plan, which was never realized, was the construction of a through drawbridge over the Pasig River, near its mouth. This steel bridge, with a double-track railway, two wagon roads, and two foot walks, was to rest on three concrete piers and two abutment piers.

The construction of two breakwaters as part of the port improvement project transformed Manila's infamous reputation as the worst major port for freight in the Orient. The harbor metamorphosed from an open roadstead into a secure closed harbor. An area within the breakwaters was dredged; the refuse material from the process was used to fill in ground for a new commercial district on what were, before the arrival of the Americans, shoals in front of the shoreline of Manila. This was the Ermita and Malate district, a marshy area along the shoreline of Manila.

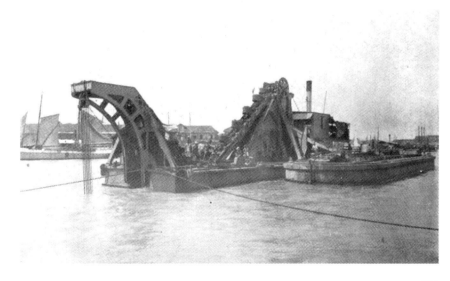

5.33 Improved sanitary arrangements of Divisoria Market in 1906 (opposite page)

5.34 Dredging the Pasig River with modern dredging machinery

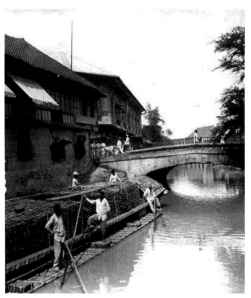

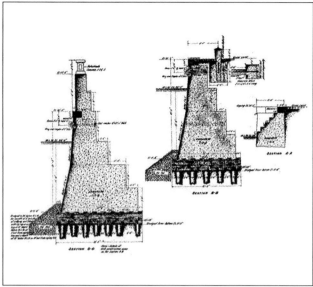

According to the Philippine Commission Report of 1903, there were over thirty esteros or branches of esteros within the city limits of Manila. Although they were dirty and foul-smelling, their value to the city as commercial waterways, sewers, open drains, and irrigating ditches was incalculable, playing a significant role in the cultural and economic life of Manila. These canals were depicted not only as picturesque destinations in vintage photographs but also as busy and sometimes congested thoroughfares, bustling with economic activities and doubling as home to Manila's floating population (15,000 persons who lived in cascos, lorchas, launches, and other small watercrafts). In the absence of an efficient road system during this time, the esteros of Manila became traffic avenues for the distribution of cargo coming from freighters anchored at Manila Bay. The extent of the navigable estero was estimated to reach more than 107 kilometers, according to an article in the December 1928 issue of the *Philippine Education Magazine*. A small casco, a native river vessel, could keep on traveling for several days in Manila's network of canals without traversing the same one twice. The navigable esteros were kept dredged to a mean depth of two meters at low water. The canals were kept in navigable condition through the Estero Agreement forged between the city of Manila and the Insular Government. Under this agreement, the government was responsible for the maintenance of all navigable canals through the Bureau of Public Works, while the city was mandated to take charge of the small and shallow canals, assuring their hygienic condition, and all the bridges over the esteros.

A more stable steel bridge, the Santa Cruz Bridge across Pasig, was completed and opened to vehicular traffic and public convenience on March 1, 1902, at a cost of $185,000. The Bridge of Spain was widened and Australian blocks were purchased to renew its pavement. The new Ayala Bridge, first built in 1872 by Don Jacobo Zobel de Ayala of the Ayala-Roxas family, was reconstructed in steel materials and connected the San Miguel district to Arroceros. This bridge, which opened in 1906, consisted of two spans of the Pratt double intersection type, with a curved upper chord, and was a riveted structure with pin bearings throughout. It had a

5.35 Navigable estero in Escolta

5.36 Sectional plan Pasig River wall project

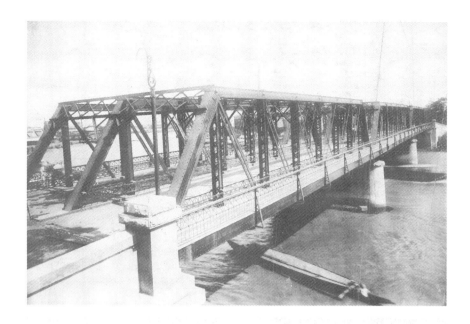

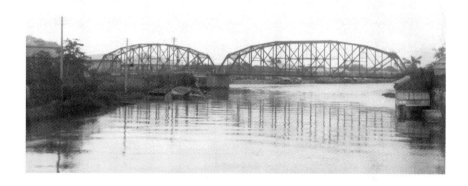

clear roadway of 6.70 meters with two sidewalks of a width of 1.75 meters. The floor consisted of buckle plates riveted directly to the floor beams. The south span had a length of 202 feet between end pins, and the north span of 242 feet between end pins. It was the intention to lay the roadway with asphalt as an experiment.

The City Engineer's office kept up a feverish pace in 1905 with significant projects, including the production of construction drawings for the new Pasig River walls on the north and south banks west of the Bridge of Spain; the concrete steel arch over the Estero San Miguel, made necessary by the extension of the electric street railway; a substructure of the Ayala Bridge; a substructure of the Binondo lift-bridge; and a redesign for the suspension bridge.

The construction of an automatic steel lift-bridge to relieve both land and water traffic over the Binondo Canal at the foot of Calle Soledad was a technological marvel of the period. This bridge effectively linked the business district and the customs house. The bridge's superstructure consisted of a movable platform with a clear roadway of 6.7 meters and two sidewalks of 2.3 meters in width. The span from the center to the center of supports was thirteen meters, and the clear channel

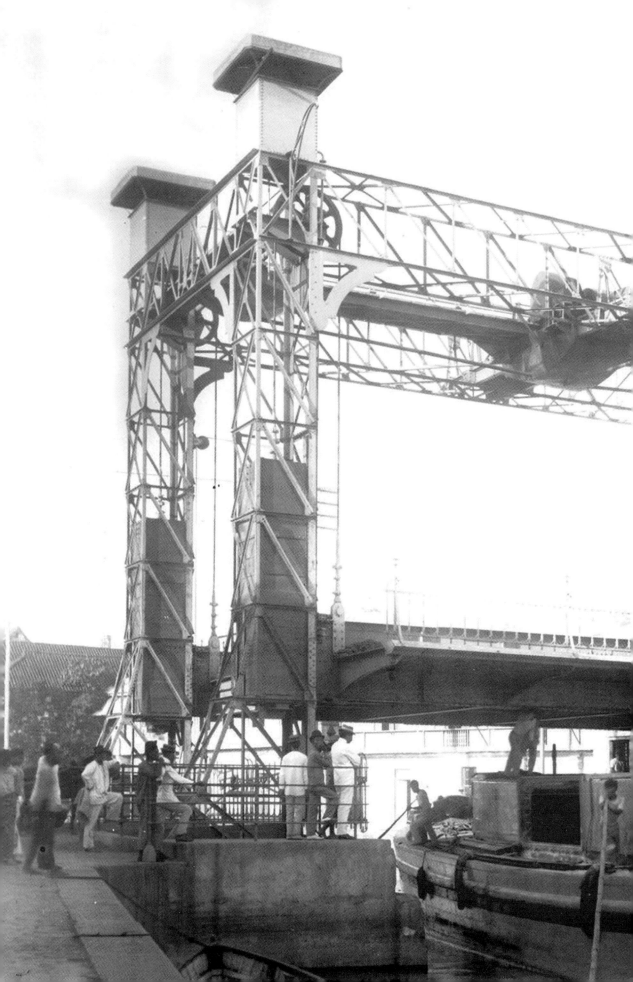

between abutments was twelve meters. This movable platform was operated by electricity through a small operating house situated north of the bridge at the Calle Soledad end. On the average, 13,400 pedestrians and 1,382 vehicles passed over the bridge, while 141 cascos traversed beneath the platform on a daily basis. This engineering breakthrough was coupled with the gradual phaseout of all wooden bridges over the esteros and canals of Manila beginning 1906. The wooden bridges, prone to rotting, were replaced with permanent constructions, ideally of concrete and steel, as these materials were almost maintenance-free.

Street Naming and Toponymic Signification

For the purpose of colonial rule, municipal authorities were empowered to establish networks of streets and place-names to make possible the identification, demarcation, and delineation of the urban space. A well-ordered and legible system of street and place naming was necessary for the colonial authorities as it was crucial to the surveillance function of the state, which ranged from taking census, policing, sanitary inspection, instituting arrest, posting notices, serving summons on occupiers, and tracing the source and spread of contagion. Aside from facilitating colonial regimentation of space, the toponymic importance of giving names to streets is an ideological tool of public commemoration, investing the urban landscape with colonial association to achieve a degree of political legitimization. Therefore, to officially name a street is to fabricate a system of mental images programmed by dominant cultural groups. The rigorous inventory of Manila's street names, which traced their toponymic origins, was undertaken by Col. H.O.S. Heistand of the US Army when he was stationed in the Philippines between 1902 to 1903. The Military Information Division in Manila issued the listing in 1903.

The first concrete step toward suburban expansion was taken in the first decade of the American occupation when the influx of American migration, mostly of businessmen, military men, and civil servants, became more remarkable. The creation of new residential enclaves outside of Intramuros was undertaken by Henry M. Jones, an American entrepreneur who founded the American Hardware and Plumbing Company. Jones saw the potential of the swampland south of Luneta. In this area, there were a few permanent structures along Calle San Luis, Calle Real (M.H. del Pilar), Calle Alhambra, and other streets along the bay, while the rest were mainly nipa districts built on undrained land. Jones bought most of the areas of Paco and Malate and did his own reclamation. Jones filled the low parts and subdivided the area into lots for sale from ₱1.00 to ₱2.00 a square meter and offered them on installment basis. Aside from Americans, Jones' buyers included wealthy families from the provinces whose children were enrolled in private schools in Manila and Filipino professionals, many of whom were doctors, dentists, and lawyers.

To inscribe the subdivided space with the nimbus of American presence and to underscore the enclavist bearings of the new neighborhood vicinity, Jones named the streets after American states such as California, Carolina, Colorado, Dakota, Florida, Indiana, Kansas, Nebraska, Oregon, Pennsylvania, Tennessee, and Vermont—names of home states of army volunteers who fought in the Philippine-American War. These street names are still being used today in the districts of Malate and Ermita. The district soon became Manila's fashionable residential center.

5.39 Electrically operated steel lift-bridge over Binondo Canal, 1906

Edgar Ketchum Bourne, the Insular Architect

On May 11, 1901, the pressure of architectural production and rehabilitation of buildings prompted the Philippine Commission via cablegram to request the Secretary of War to appoint a competent architect to head the Bureau of Architecture to be created by the Commission (Report of the Philippine Commission 1902, 422). In compliance with this petition, the Secretary appointed architect Edgar Ketchum Bourne, who arrived in Manila on October 10, 1901. A native of New York, Bourne was an architect reared in the style of eclectic revivalism. His major works prior to his Philippine appointment were Bedford Park Congregational Church (1891-92), and Greater Bethel A.M.E. Church (1891-92) both of which exist today as among New York City's landmarks of built heritage. No information has been recovered as to how Bourne was chosen for the position of Insular Architect.

A week later, October 18, 1901, Philippine Commission Act No. 268 was passed which founded the Bureau of Architecture and Construction of Public Buildings under the executive control of the Department of Public Instruction. As Chief of the Bureau of Architecture and Construction, Bourne was to receive an annual salary of $4,000 (Philippine Commission Act No. 258, 18 October 1901) and was tasked: "To make all necessary plans, specifications for construction and repair of public buildings, and to send these plans and specifications, with estimate of cost, through the Secretary of Public Instruction, to the Civil Governor for his approval, and when approved by the Governor, shall be presented to the Commission with a requisition for an appropriation or appropriations for execution"(Ibid.). Bourne, with his seven trained men (composed of a master builder, a superintendent of construction, a civil engineer, a clerk engineer, three draftsmen, and a disbursing officer) and a few support staff, was mandated to design, construct, repair, and supervise all public buildings belonging to the Insular government or proposed structures detailed by the civil governor (Report of the Civil Government 1903, 422). For the actual construction, Bourne's office employed a labor force composed of two Chinese, twelve Japanese, and 343 Filipinos, supervised by six English-speaking foremen (Report of the Philippine Commission 1903, 942). Bourne's initial works in Manila consisted mostly of extensive alterations, repairs, and additions of existing structures owned by the Insular government. Furthermore, he went on to develop a style predicated on the extant Spanish built-heritage of Manila in order to dispense a sense of imperial nostalgia and instill domestication of the local styles.

To shelter the novel government programs, the American colonial government generated many new building types that necessitated a "new architecture." In the American architectural schema were public school buildings, sanitariums, schoolhouses, universities, municipal halls, hospitals, industrial plants, prisons, slaughterhouses, public markets, public baths and laundries, and many other public buildings.

Bourne's Supremacy and the Colonial Mission Revival

A number of the architectural revivals popular in the United States proliferated in the Island. The initial architectural production was exposed to a broad array of stylistic influences, but only two had surfaced as the most influential. At the outset,

there was the Mission Revival, a style that originates from their previous exploits in continental expansion. The architecture of Mission Revival became widespread in the 1890s, taking the American Southwest by storm. Its essential elements—clay roof tiles, adobe, concrete, stucco, gables, arches, and towers were mimicked in countless schools, train stations, office buildings, and residences throughout Southern California. Such style creates a visual springboard that dares to reimagine their victorious advance in the American West where nostalgic Hispanic building iconography and infatuation with ruins prevailed. The American adoption of the Mission Style in the Philippines was fed by the assumption that the Philippines as a former Spanish colony shared the same Hispanic tradition with the American Southwest, thus perpetuating the logic of an architectural analogue. American architects introduced the Spanish Revival interlaced with vernacular forms as an effective means to create a convincing architectural paradigm that conveyed the sensitivity and responsiveness of the colonizers to local culture. Such an established architectural association further legitimized the operations of colonial cultural mediations.

This venerable architecture soon became an object of recollection to be romanticized and beckoned a return to the simple, authentic, and pedigreed past. Buildings that embodied the Mission Revival had successfully rummaged, mimicked, synthesized, and adapted architectural forms and details into a contrived architectural idiom, superimposing Spanish, Italian, Moorish, and Byzantine motifs on the condition that they generate a solar and heat resistive architecture.

The Mission Style was a readily exportable architectural style, which could easily be replicated since its essential character was expressed straightforwardly. Its bold, arched openings and expansive, plain, unadorned, whitewashed stucco surfaces, which to a certain extent evade finely detailed craftsmanship, rendered the style to uncomplicated reproduction. Terra-cotta tiles or shingles on the roof of a building seemed an appropriate fit for a unique architectural design that approximated the built forms of the American Southwest. The stylistic essentials of the Mission Revival include: curvilinear, parapeted, or scalloped rooflines and gabled roofs that recalled Spanish Baroque designs; round arched entrances; white or slightly tinted, smooth, plastered walls; pyramidal terra-cotta tiled roofs; exposed roof rafters; arched arcades and corredors; and, a dominant mirador tower.

Taking root from this aesthetic trajectory, Edgar K. Bourne designed a number of buildings that characterized the Spanish Revival lineage. His designs antedated Burnham's detailed visions for the future buildings of the Insular government, as outlined in Bourne's report dated August 15, 1905. This design inflection toward Spanish architecture was also strongly evidenced in the Bureau's purchases of books on the subject of Spanish architecture. On July 2, 1902, through the Insular Purchasing Agent, the Bureau ordered the following titles: *Die Baukunst Spaniens* (The Architecture of Spain) by Max Junghandel, *Details and Ornaments in Spain* by Owen Jones, and *Renaissance Architecture and Ornament in Spain* by Andrew H. Prentice. The aesthetics presented in these books could have inspired the architecture of the Insular government, most profoundly expressed in the Government Laboratory (which later became the Bureau of Science Building),

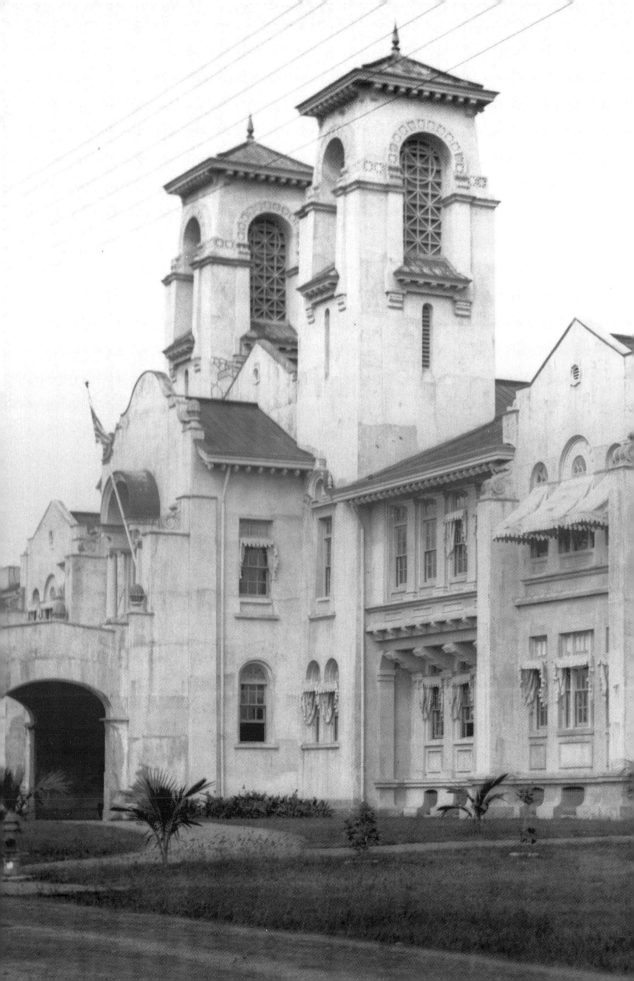

Customs House, Government Printing Office, San Lazaro Crematory, Municipal Building of Manila, the Office of the Bureau of Architecture, and the Insular Ice Plant and Cold Storage. The initial works of Bourne in Manila consisted mostly of extensive alterations, repairs, and addition of existing government structures. His renovation work had a strong affinity to Hispanic designs, boldly expressed in government buildings, such as the Malacañang, Ayuntamiento, Intendencia, Audiencia Building, Postigo Building, Oriente Building, Bilibid Prisons, Exposition structures at the Exposition grounds in Ermita (the site now occupied by Robinson's Place Ermita), San Lazaro Hospital, Santa Mesa Detention Hospital, and a Semaphore Station, as well as in several wooden resort cottages in Baguio.

The forward-looking Bourne seemed to anticipate Burnham's associationist architectural philosophy that sought to prescribe tropically responsive architecture and considerably took design cues from older buildings of Manila. Burnham recommended:

> The beautiful roofs of Spanish tile are losing ground before the invasion of galvanized iron ... there is no doubt that for permanent buildings the long-lived Spanish tile will prove more economical ... Spanish traditions are deserving of acceptance. In a tropical climate costly structures put up with granite, marble, or other building stones, in the manner of public buildings in Europe and America, would be out of place ... The old Spanish buildings with their relatively small openings, their wide-arched arcades, and large wall spaces of flat whitewash, possess endless charm, and as types of good architecture for tropical service, could hardly be improved upon. To mention a few examples in Manila: the Ayuntamiento, the Intendencia, the Cathedral, the tower of Santa Cruz, the circular cemetery at Calle Nozaleda, [and] the inner court of the present constabulary barracks at Paranaque are especially noteworthy (Burnham 1906, 17).

In addition, Burnham advised the use of overhanging stories for maximized ventilation and the utilization of Spanish tiles for roofs not just to address issues of urban contextualism but maintain continuity and mitigate potential resistance to alien forms as well. Architects have acknowledged that resistances to new forms were often based on the long-standing affection and established affinity to familiar places, and strived to induce a sense of continuity with the local past in their designs. They extolled the virtues of traditions—often resorting to what Eric Hobsbawm (1990) described as the "inventions of traditions," which relied on pageantry or other symbolic expressions of a rigid social order and concocted artificial revival styles to provide a semblance of continuity. In essence, the apparent respect for other cultures involved in the Euro-American imperial ventures aimed to legitimize colonial power while preserving a sense of locality in the colonial urban order.

5.40 The essential characteristics of the Colonial Mission Revival style from the United States was employed in Bourne's design for the Government Laboratory, which was later renamed the Bureau of Science Building.

Bourne's corpus of work was responsive to the cultural and environmental context of Manila. He introduced the application of concrete and lime masonry and the use of cast concrete ornaments which mimicked the familiar local building motif. But cement was in short supply and was only used for the important edifices of the colonial government. Cement was then imported from Macau, China, and from

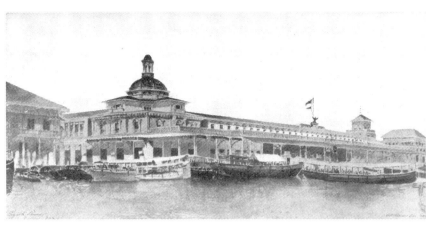

5.41 Bourne's perspective of the Customs House

5.42 The completed Customs House of Manila in 1903

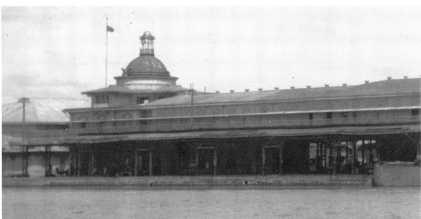

Japan. A large number of his works were built using Oregon pine and California redwood, which were shipped from the United States. Since many of his structures were constructed using these types of wood, which were prone to termite attacks and easily deteriorated in tropical weather, none of them had survived to this day. Even his iconic cement buildings, such as the Bureau of Science Building and the Customs House were reduced to rubble during the last world war.

The Customs House, an L-shaped structure at the corner of Calle Numamcia and Muelle del Rey, was "an honor to the city" (*Manila Times* 11 July 1903, 1). The construction of the edifice exacted $75,000 from the Insular coffers. It was a two-storey structure topped by a dome over which was a cupola with another gilded dome, which functioned as an observation point twenty-six meters from the ground for sighting steamers and reporting departures. Inside, at the junction were two wings forming an L-configuration. A 9.75-meter diameter rotunda extended from the second floor to the top of the roof, a distance of about twelve meters. On the second storey, the walls of the rotunda were pierced with eight arched openings, three meters wide and 4.2 meters high, and between the openings were fluted pilasters with Ionic capitals supporting a cornice at the base of the dome. At the line of the third floor and above the arches were square openings into a passageway around the rotunda. These openings, in connection with the sixteen openings which pierced the dome, supplied natural light for the rotunda. The collector's office was finished in native wood, while the rest of the wood finishing throughout

the building was of California redwood. All woodwork was in natural finish except at the rotunda where it was painted white to reflect the natural light coming from the dome's arched openings. The floors were made of Oregon pine. Concrete footings were used with stone walls for the first storey. The posts and girders and timber used below the grade line were of native timber, and all other structural works were in Oregon pine.

The principal façade of the Customs House faced the waterfront. The exterior was defined by a cornice, projecting nine centimeters, supported by heavy medallions of carved wood. The second storey was provided with three large windows on each side, with molded architraves and cornices carried on carved brackets. The dormers in the third storey were treated as balconies, with columned openings and heavy balustrades in front, supported on ornately carved brackets. The octagonal base of the dome had windows on four sides, which allowed light to penetrate the rotunda. The circular base was treated with eight pilasters, dividing the wall into eight divisions, each provided with two circular-top windows in the octagonal base. The dome itself was segmented into a series of circular and triangular molded panels and was crowned with a circular cupola with four openings and four Corinthian columns.

5.43 Elevations for the Manila City Hall designed by Edgar Bourne

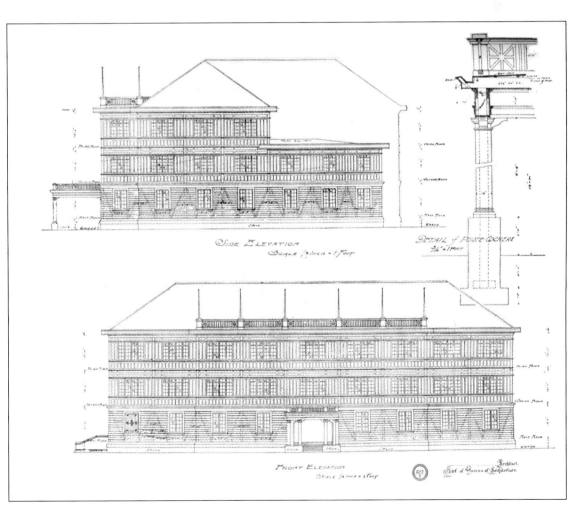

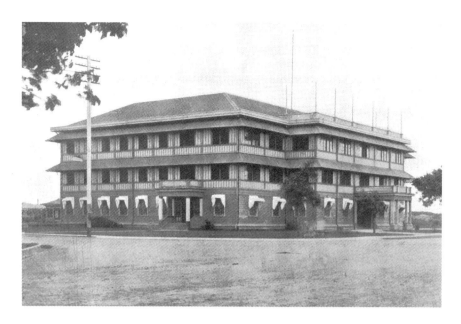

5.44 The Manila City Hall, made largely of imported Oregon pine, was occupied by municipal authorities in 1904.

5.45 The brick-clad façade of the Insular Ice Plant and Cold Storage (opposite page)

Unable to utilize the Ayuntamiento, the seat of central government, the American municipal authorities initiated the construction of a separate municipal building in 1901. The city government purchased and completed a half-finished hospital structure on filled ground at Calzada de Vidal left abandoned as a consequence of Philippine Commission Act. No. 247 which called for the creation of a large civil hospital. From the existing framework, Bourne designed a three-storey, Oregon pine structure fitted with an electric elevator, electric lighting, sanitary conveniences, and a septic tank. The city hall's iconography was modeled on the basic bahay na bato, except that the ground level was constructed of wood fashioned in the American clapboarding technique instead of heavy stone masonry. It was officially occupied on March 7, 1904, and for forty years, the said building, which was intended for temporary use, served as the Manila City Hall until it deteriorated and was replaced by the more familiar neoclassical structure of reinforced concrete with an iconic monumental clock tower in 1941, a building designed by architect Antonio Toledo.

Perhaps the largest of Bourne's designs was the Insular Ice Plant and Cold Storage (1902). So huge and expensive, it was criticized as an "unnecessarily huge refrigerating and ice making plant for the army commissary" in order "to provide supplies and comfort for American officers and troops not regularly appropriated for by [the US] Congress" (Le Roy 1914, 292). The building was constructed to house the Bureau of Cold Storage and Ice Plant created under the Philippine Commission Act No. 315 on December 10, 1901. The Insular Ice Plant and Cold Storage, built on the southern side of the Pasig River, was considered the first building of a permanent nature to be erected by the Americans. Its massive brick masonry was fashioned in the Mission Revivalist style, with low-relief false arches and pedimented portals bearing the insignia of the Insular government. A series of mirador towers cleverly concealed its industrial component and power plant. The cold storage section consisted of internal and external walls of brick masonry, while the floor, columns, and interior structural members were of Oregon pine. (McGregor 1914, 23). This modern industrial edifice was dominated by a slender smoke stack, almost 10 storeys high, which for a time served as a vertical landmark

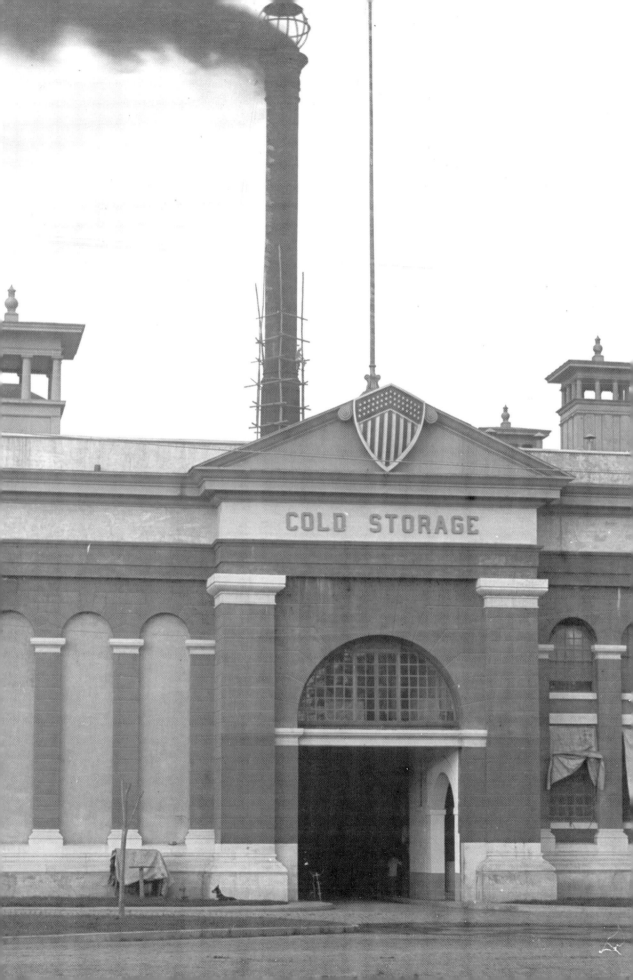

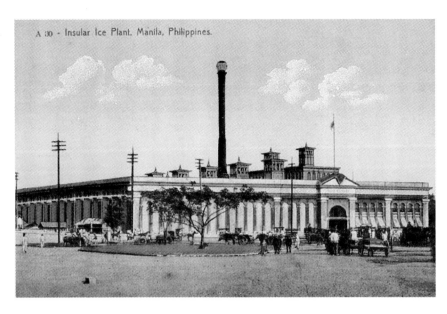

A 30 - Insular Ice Plant, Manila, Philippines.

of Manila's horizon as it could be seen far and wide. Bourne's Insular Ice Plant was demolished to make way for the superstructure of the Light Railway Transit (LRT 1) in the early 1980s.

Another outstanding work of Bourne was the Bureau of Government Laboratories Building, which was founded under the Philippine Commission Act No. 156 dated July 1, 1901. Ironically, the Mission Revivalist edifice was devoted to modern scientific research and colonial techno-science. Finished in 1904, the structure consisted of biological and chemical laboratory pavilions occupying the 24-acre site of the old Exposition Grounds. The building served as an architectural set-piece in a large tract that was destined to become a Science Complex and University Town, which would extend from Calle Faura to Calle Herran (now Pedro Gil) in Manila.

The Government Laboratory, whose masonry component was joined by a composite of lime-and-cement mortar, was smoothly plastered by hand. The foundation walls of the building were made entirely of poured solid concrete. The structural system was radically new, using a method in which,

> posts do not extend into the foundation wall, but, instead, are to be set on a 9 by 9 inch sill plate, running continuously around the foundation walls, the foot of each post being let into the sill by a small tusk and both sills and post bolted to the foundation with anchor bolts, extending four feet into the concrete foundation wall (Report of the Philippine Commission 1902, 1012).

The main façade was dominated by a central portal articulated by the scalloped parapet of a baroque silhouette. Verticality was established by two mirador towers flanking the entrance; the two towers were surmounted by a pyramidal tiled roof. The cast relief ornaments of mudejar design were made from forms handcarved in situ.

Internally, the building design was responsive to the tropical climate, as the plan manifested the grouping of the rooms on either side of the ten-foot wide corridor

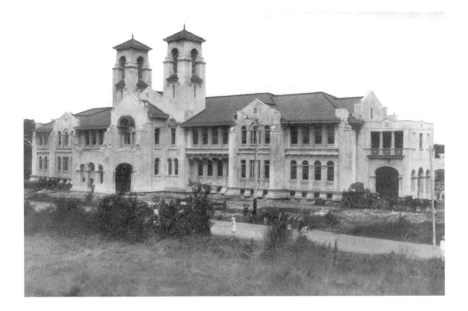

that ran the entire length of the building. The hallway opened at either end, allowing constant cross ventilation and air exchange within each room. The finished floor in the main halls and toilet rooms were surfaced with "a neat pattern of encaustic tile," and the floors in the laboratory rooms were finished with asphaltic material impervious to acids (Report of the Philippine Commission 1902, 1013).

Bourne's design for the Government Laboratory, which necessitated a new method and style of construction, served as the benchmark for succeeding government buildings and a testing ground for industrialized building techniques and new material applications combined with the extensive use of native hand crafting. The handcrafting of ornaments using concrete, a technique unknown to native skilled workers, were learned by the natives under the close supervision of American master builder David E. Graham.

In support of the government's medico-sanitary agenda, Bourne planned Manila's hospital architecture along the pavilion scheme. This can be seen in buildings such as the single-storey Contagious Disease Hospital on the San Lazaro grounds and the Santa Mesa Detention Hospital—wooden buildings set on masonry foundations. The pavilion-type hospital was an American innovation in the Philippines. The pavilion system, as conceived and advocated by colonial health officials, consisted of single-storey, if not, two-storey ward blocks, placed orthogonally to a connecting corridor, which might either be straight or enclosing of a large central square. The pavilions were amply separated, usually by open-air devices, such as gardens or lawns. In the wards, natural cross ventilation was achieved by opposite rows of tall, narrow windows whose height reached from floor to ceiling. The pavilion design, which placed emphasis on spaciousness and natural ventilation, was consistent with the logic of aerial conveyance of disease upheld by the miasmic theory of disease.

Also in San Lazaro, the Manila Board of Health commissioned Bourne to design a modern and hygienic morgue with a crematory. This one-storey structure with concrete floors had fitted tables for laying the corpses and autopsy tables with

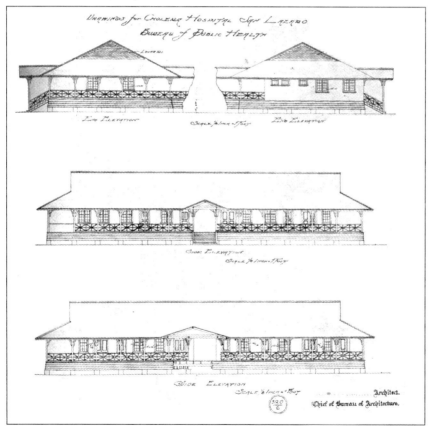

Italian marble tops (Report of the Philippine Commission 1903, 926). The notable external feature of the San Lazaro Morgue was the pierced, decorative wooden screen, obviously borrowed from the calado concept of the bahay na bato, to facilitate crossventilation.

Bourne also prepared a plan for the unbuilt, 1,500-bed hospital composed of four one-storey pavilions known as the Manila General Hospital. Bourne's scheme and plan followed those "used by F. Ruppel for the great Hamburg-Eppendorf" in Germany (Philippine General Hospital Medical Center 1986, 30). Since this building was part of a medical science complex in the Exposition Grounds where the Government Laboratory was, it took on the same Mission Revival aesthetics established in the area by the latter. The main central structure had ornate parapets; the façade design placed emphasis on the planarity of the central volume by flanking it with a pair of protruding cylindrical volumes surmounted by a dome which served as side entrances; the cylindrical drum, in turn, was sandwiched by two rectangular towers capped by a pyramidal tiled roof. The four pavilions were zoned for the following: a combined maternity and women's ward; a general surgical ward; a general medical ward; and a ward for native men and women. The four pavilions were linked to a two-storey building housing the administration offices, operating room, emergency ward, attendant's quarters, and a one-storey kitchen and dining room extension. The hospital, made of Philippine hardwood, was estimated to cost 240,000 pesos. Due to shortage of funds, plans for this colossal hospital building would be temporarily shelved and turned over to William Parsons who radically altered and toned down its ornate Mission Revival architecture but preserved its pavilion arrangement for what was to become the Philippine General Hospital.

Since the Bureau of Architecture was a branch of the larger Department of Public Instruction, which was also in charge of the Bureau of Education, Bourne was directly involved in the design of schools, not only for Manila but also for the entire archipelago. In fact, from September 1902 to August 1903, he had designed fourteen school buildings for various provincial locations. The gravity of such work was so immense that he pleaded for the authorities to design standardized school architecture. He recommended the uniform design of schoolhouses with preference for the one or two-storey structures built entirely of wood or wood frames with masonry walls and iron roofs. According to Bourne:

> It is believed that uniformity in schoolhouse construction would result in vastly simplifying the work, not only of this bureau, but also that of the Bureau of Education as well as that of the division

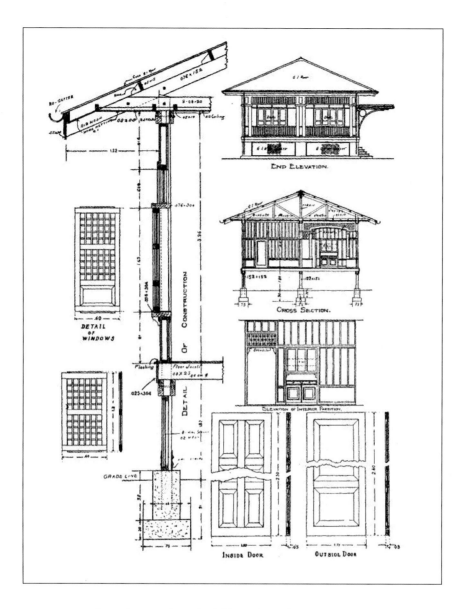

END ELEVATION.

CROSS SECTION.

ELEVATION OF INTERIOR PARTITION.

DETAIL OF WINDOWS

DETAIL OF CONSTRUCTION

GRADE LINE

INSIDE DOOR OUTSIDE DOOR

superintendents and provincial boards. Reference is made more particularly to uniformity of plan and arrangement, and constructive materials must necessarily be limited in a degree to local conditions (Report of the Philippine Commission 1903, 938).

His standard solution for schoolhouses was no different from the prototype schools which Parsons later developed for the Bureau of Education, codified and disseminated in 1912 through the Bureau of Education Bulletin No. 37-1912, entitled "School Buildings and Grounds."

Again collaborating with the Bureau of Education, Bourne designed the "Plans for a Model Filipino House," the blueprint of which was issued by the said Bureau in 1904. The building of the prototypical Filipino house on school grounds was part of the curricular plan of the Bureau of Education for the mandatory instruction of Filipino elementary and intermediate female students in the subject of "Domestic Science." The interior could accommodate a class of twelve and their teacher.

5.52 Building of the Bureau of Architecture

5.53 Courtyard of the Bureau of Printing

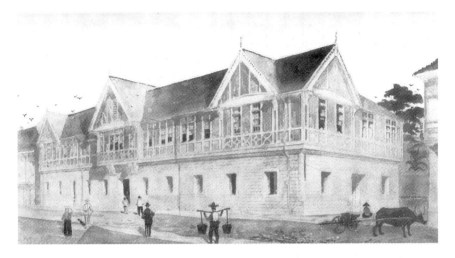

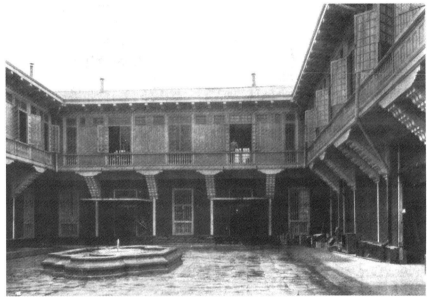

The wooden house had a raised floor, partitioned rooms, and an entry porch. It was estimated to cost from 2,000 to 2,500 pesos, with the following materials: "roof, galvanized iron; posts, ipil; girders, apitong; floor and steps, apitong or guijo; siding ("cove"), 5" to 8", tangili, almon, or lauan; doors and window frames of apitong; window sills, ipil, yacal, or apitong; sheathing and ceiling, tangili, 1/2" (half lap, or T & G); footings, concrete, one part cement, three of sand, and six of gravel" (Bureau of Education 1910, 43–44). The architecture of the house showed preference for the native style of construction and native hardwood. Perhaps, Bourne's model Filipino house served as progenitor of the Bureau of Health's sanitary model houses.

To maintain a sense of stylistic coherence, the municipal engineering department clad their design solutions for the sanitary architecture and public infrastructure of Manila with elements of Mission Revival to harmonize with the works of the Insular Architect. Thus, new building types, such as sanitary markets, public schools, slaughterhouses, police stations, and prisons, among others, were produced in a

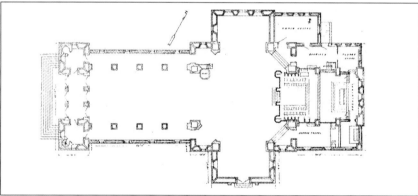

style that was unerringly a revival of Spanish Mission designs. Divisoria Market (1901), the Municipal Slaughterhouse (1901), and the Tondo Police Station (1904) among others exhibited this stylistic inflection.

In private constructions, the aesthetic language of Spanish Revivalism propitiously flourished in the architectural climate imagined and crafted by Bourne. One such work was the Episcopal Cathedral of St. Mary and St. John (1905) located on Calle Isaac Peral (now United Nations Avenue). Designed by architects Sturgis and Barion of Boston in the Mission Style and executed by the Atlantic, Gulf, and Pacific Company, the cathedral was the first of its kind to be built entirely of reinforced concrete. The monumental cathedral had a cruciform plan with minimal decorations, a steel trussed dome sheathed with copper, window openings shielded by capiz windows, and two sixty-foot rectangular towers punctured by arches—evoking "the dignified and classic lines of Spanish Renaissance" in its massive yet unadorned building skin (*The Far Eastern Review* November 1906, 175).

Bourne's position as Insular Architect soon ended in controversy. In July 1903, he was charged before the Office of the Secretary of Public Instruction with

incompetence, and the plaintiff, a group of contractors (Jones, Smith, Grant, and Bryan), represented by Attorney Sutro, pleaded for Bourne's removal from office "by reason of his arrogance and by reason of his arbitrariness" (*Manila Times*, July 17, 1903, 1). The government probe into Bourne's case made headlines in Manila's broadsheets. An American newspaper described the investigation as "a sensational event" (*Manila Times*, July 23, 1903, 1). But no factual evidence was presented to substantiate the complainant's "vague" allegations that Bourne was "incompetent to hold his office by reason of his unfairness both to Government and private individuals" (*Manila Times*, July 17, 1903, 1).

In 1905, with the reorganization of government agencies engaged in infrastructural delivery and architectural design, Bourne fell out of favor, resulting in the abolition of the Bureau of Architecture and Construction of Public Buildings. This was, perhaps, catalyzed by the submission of Burnham's report early that year, which shifted the attention of the colonial government to a much more auteur-centric and grander urban vision. The position of Insular Architect was abolished and replaced by Consulting Architect, a high-profile government position created to accommodate Burnham's favored architect, William E. Parsons, who would interpret Burnham's imperial aspiration for Manila and Baguio with fidelity and sanctity.

The Bureau of Public Works:
The Nerve Center of Colonial Architectural Production

The Bureau of Public Works (BPW) was formally organized on November 1, 1905, pursuant to the provisions of Act No. 1407, also known as the "Reorganization Act" passed by the Philippine Commission on October 26, 1905. From its embryonic stage of growth under the American colonial authorities, the Bureau's function was confined to the construction of roads and public buildings.

The Bureau of Public Works, as founded in 1905, was the consequence of a merger between two bureaus created in 1901 during the American military regime under the provisions of Acts Nos. 222 and 268, namely, the Bureau of Engineering and Construction of Public Works under the Department of Commerce and Police, and the Bureau of Architecture and Construction of Public Buildings under the Department of Instruction. The merged bureau soon became the nerve center of all state-initiated infrastructure and architectural works in the country.

The Bureau of Engineering under the Department of Commerce and Police was established on January 8, 1903. It provided the labor force and construction machinery for the execution of the designs of all insular work under the authority of the consulting architect. The functions of the bureau were: the maintenance and repair of insular buildings; advising the Governor-General, the Legislature, and the Secretary of Commerce and Police on all matters pertaining to engineering and architecture; the design of all municipal and provincial improvements; and the supervision over architectural features of buildings, parks, streets, and improvements throughout the islands and all infrastructure for drainage, sewers, waterworks irrigation, and ports works. The Bureau of Public Works was the principal implementing agency that interpreted and executed Burnham's urban designs, specifically all parks and landscape elements of Manila and Baguio.

BUREAU OF PUBLIC WORKS

MAGNIFIED 20 TIMES

1904 30 ENGINEERS 2000 LABORERS EXPENDED P 150.000

1910 110 ENGINEERS 20.000 LABORERS EXPENDED P 8.000.000

MAINTAINING 1467 MILES (2350 KMS.) ROAD.

CONSTRUCTING AT 70 POINTS. 155 MILES (250 KMS.) ROAD YEARLY.

CONSTRUCTING 300 BRIDGES AND CULVERTS YEARLY.

OPERATING 36 WELL BORING RIGS.

SUPERVISING WITH CONSULTING ARCHITECT. INSULAR AND PROVINCIAL
 BUILDING WORK.

IRRIGATION CONSTRUCTION. TRANSPORTATION FACILITIES.

MUNICIPAL WATER WORKS.

BENGUET ROAD AND INSULAR PUBLIC WORKS IN BAGUIO.

With the merger, the Bureau of Architecture and Construction of Public Buildings, which Bourne headed, was accordingly abolished in October of 1905 and its duties and mandates were effectively transferred to the Division of Building Construction and Repair under the Bureau of Public Works, Department of Commerce and Police.

In May 1906 by virtue of Act No. 1495, the office of Consulting Architect in the Department of Commerce and Police was established. Within the same month, William Parsons assumed the responsibilities left by Bourne in the newly organized Office of Consulting Architect. This government position may have been created to fit Parsons' credentials, stemming either from the recommendation of Daniel Burnham or from an initiative by Commissioner Cameron Forbes, head of the Department of Commerce and Police. The new Consulting Architect was in charge of preparing all the designs, drawings, specifications, estimates, and documents for all public constructions. As a supervisory government position, he was also mandated to "exercise general supervision over the architectural features of Government construction and of the landscape gardening of public spaces of recognized prominence" (Dakudao 1994, 9).

In January of 1914, a major reorganization of the Bureau of Public Works was enacted by the Philippine Legislature through Act. No. 2319 or the "Appropriation Act of 1914," which transferred the Office of the Consulting Architect to the Bureau of Public Works. The Bureau of Public Works was soon after reorganized with four principal divisions: the Administrative Division; the Designing Division; the Constructing Division; and the Division of Architecture, placed under the direct supervision of the Consulting Architect.

Within this institutional matrix, which lasted until the outbreak of the Pacific War, American–influenced modes of architectural production remained pervasive among Beaux Arts-trained pensionado architects who inherited the administration of the Bureau from the American colonial architects.

The Burnham Plan and the Creation of Tropical Imperial Space in the Philippines

To architecturally materialize the imperial ambition to build an American tropical empire in the largest overseas possession of the United States, the federal government conscripted the services of Daniel H. Burnham (1846–1912), assisted by Pierce Anderson, on a six-week official mission to the Philippines from December 1904 to January 1905 to survey Manila and Baguio and to recommend preliminary plans for the development of these American colonial cities.

Burnham enthusiastically accepted his new assignment and agreed not to take any compensation for his employment as he considered the work a patriotic duty. Burnham and Anderson reached Manila on December 7, 1904. During the period of their stay, their time was spent talking with government officials, inspecting and surveying pertinent sites, working over maps and "in situ," and socializing with the host officials. They surveyed Manila on the first and second week and spent the third, a Christmas week, up in Baguio. The first few days of January were spent working in the office in the Manila Municipal Hall until they sailed for Hong Kong mid-January.

5.56 Poster of the Bureau of Public Works, highlighting its accomplishments from 1904 to 1910

The master plans and final report were submitted on June 28, 1905, to William H. Taft, the Secretary of War, in Washington, DC. The plan of Manila appeared to resemble in many aspects the plan for Chicago and San Francisco. Burnham was a progenitor of and a proponent of the City Beautiful, a movement whose main advocacy was to transform cities into beautiful, orderly, efficient, healthy, and democratic places, with profound reliance on Beaux Arts formalism—a principle Burnham had previously applied in the Chicago Columbian Exposition of 1893 and the city of Washington, DC. Formulaic urban elements of the City Beautiful included a civic core, wide radial avenues, landscaped promenades, and visually arresting panorama.

Looking back, the City Beautiful Movement was conceived out of the ill effects caused by the Industrial Revolution to combat pollution, traffic and human congestion, lack of basic utilities, outbreaks of disease, and general social disorder plaguing American cities at that time. An early answer was the provision of parks and open spaces to improve the deteriorating quality of urban life. A profound example of this initiative was Central Park in New York City, designed by landscape architects Frederick Law Olmsted and Calvert Vaux.

Burnham's plans intermixed colonial expansion with the urban design principle of the City Beautiful. Parks, symmetrical pathways for traversing the city, and the importance of classical motifs were all fundamental to the total of the City Beautiful. These planned verdant spaces executed in the scheme of City Beautiful were envisioned to assume a kind of pastoral locus in an urban setting where citizens were to experience democratic cultivation and cosmopolitanism.

Through the aesthetic language of the City Beautiful Movement, an auspicious architectural climate for neoclassicism was now set and the tradition of neoclassicism gained a vigorous foothold in the colony as the official architectural style. The neoclassical architectural template rose to fabricate a persuasive metaphor of colonial supremacy and democratic iconology. The Insular government favored the neoclassic style for it alluded to some imperialist trope,

5.57 Daniel Hudson Burnham

5.58 Pierce Anderson

Columbian World's Exhibition

City Beautiful Movement

The City Beautiful was an aesthetic movement in American urban planning and architecture that started in the 1890s as an attempt by advocates to improve their cities through beautification, which was envisioned to sweep away social ills, as the beauty of the city would inspire civic loyalty and moral rectitude in the impoverished; bring American cities up to cultural parity with their European competitors through the use of the European Beaux-Arts idiom; and create a more inviting city center that would bring the upper classes back to work and spend money in the urban areas, but not live there. Exemplified by the White City at the 1893 Columbian World's Exposition, the City Beautiful Movement emphasized classical architecture for public buildings built around parks and lawns, the most successful application of which was the 1901 Plan for Washington, DC.

Origins of the Neoclassical Style

The style of neoclassicism was based on a precise study of ancient Roman and Greek buildings. At the heart of this style were the orders: Doric, Ionic, Corinthian, and two other Roman variations, Tuscan and Composite. Each had its own system of organization, composition, and proportion. During the Renaissance, architects rediscovered these systems, rigorously inventoried them, and carefully applied them in new ways to all types of Renaissance buildings. In the mid-eighteenth century it reemerged as a result of archeological discoveries of the ancient ruins and a renewed interest in Greek and Roman architecture. Architects and intellectuals of the time went on grand tours, which brought them through the major cities in the European continent, North Africa, and the near East and into direct contact with the cultures, art, architecture, and artifacts of Greco-Roman civilizations.

In the United States, towards the closing of the eighteenth century, Thomas Jefferson, in his role as architect and tastemaker, advocated a direct return to the architectural principles of Republican Rome as the true course for a new democracy—a classical revival. This shift in taste coincided with the American Revolution, and the Neoclassical style became closely identified with the political values of the young republic. This is seen in the civic, institutional, and religious architecture of the period. Thomas Jefferson was both a promoter and practitioner of this type of architecture, as seen in his University of Virginia campus complex. For a time in the mid-nineteenth century, the style saw competition from various other architectural "fashions," such as the Gothic Revival of Richardson and a nascent movement in a truly American "style" that saw honest expression of materials and structure in mainly high-rise buildings. This was the emerging "Chicago School" of architecture led by Louis Sullivan and his protégé Frank Lloyd Wright.

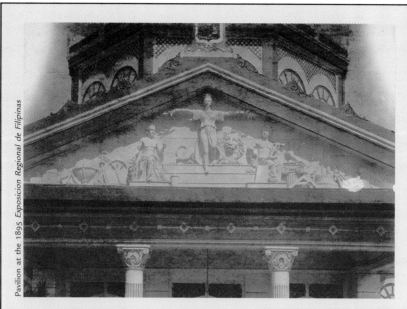

Pavilion at the 1895 *Exposicion Regional de Filipinas*

In the nineteenth century, the French architectural school, the *Ecole des Beaux Arts*, dominated architectural education. The institution promoted a rigorous yet eclectic application of classical design. Students were trained in an architectural language that was symmetrical, formal, and hierarchical, but used elaborate decorations. Beaux Arts design was a more exuberant excursion into classicism than the earlier revival had been. It also coincided with a technological revolution in construction methods, notably with steel, which allowed unprecedented ease in spanning great distances. Any space that could be framed in steel could then be clad with a classical veneer.

Classicism as a design approach valorizes the virtues of rationality, logic, beauty, order, and symmetry. It is more than an imitation of Periclean Athens or a utilization of columns, entablature, and peristyles, but is sustained by organization and proportion. Nowadays, there seems to be an attempt by mainstream postmodernism to resurrect, on a superficial level, the image of postmodernism and classicism which are not the same. Postmodernism makes reference to classical details ironically and indirectly, and intentionally tries to subvert the classical position that buildings can be rational and clear. Modern architecture, with its devotion to logic, is actually closer to classicism minus the ornamentation.

recalling the European approaches to colonialism and empire-building. Neoclassicism conferred the modern reinforced concrete building with an aura of civilizing heritage, instilling Jeffersonian purity that conjures the grandeur and spectacle of the ancient Greek and Roman temple archetypes. These monumental buildings were deemed as the embodiment of the American people's aspirations, an image which connected them to the glorious ancient civilizations of the West.

Burnham's intended city image of Manila reverberated with Eurocentric optimism and a predilection for European allusions. Burnham romantically located Manila along the lines of Western civilization, and declared in his report in 1906:

> Yet still small in area, possessing the bay of Naples, the winding river of Paris, and the canals of Venice, Manila has before it an opportunity unique in the history of modern times, to create a unified city equal to the greatest of the Western world with the unparalleled and priceless addition of a tropical setting (Hines 1972, 46).

Approved on June 20, 1906, by the US Congress, Burnham's recommendation included the establishment of a central civic core with streets radiating from it, cleaning and development of canals and esteros (waterways) for transportation, construction of a bay shore boulevard from Manila to Cavite, the provision of zones for major public facilities, such as schools and hospitals, the development of parks and open spaces for recreational activities, and the development of summer resorts near the capital. The plan included all elements of a classic City Beautiful plan. It had a central civic core; radials emanating from this core were laid over a gridiron pattern and large parks were interconnected by parkways, all of which recommended an architectural style from which future buildings were to be patterned. A scholar remarked that "if the plan had had a chance to be fully executed, Manila would have become the most beautiful city in the East."

American historian, Thomas Hines, remarked: "Despite Burnham's pro-imperialist political sentiments, and generally 'imperial' manner of his and all City Beautiful planning, the Manila plan was remarkable in its simplicity and its cognizance of the Philippine conditions and traditions. Concise and straightforward, its technical recommendations for streets, parks, railroads, and public buildings echoed much of Burnham's ideas for Washington, Cleveland, and San Francisco" (Hines 1972, 43). Burnham's Manila plan borrowed elements from the Washington, DC plan, as evidenced in the central civic core, where government buildings were arranged in a formal pattern around a rectangular mall. The imagery of the Philippine mall was reminiscent of the national mall in Washington, DC and overtly manifested a building silhouette of a capitol akin to that of the American Capitol. Completing the civic ensemble were the Hall of Justice complex, located south of the mall, and semipublic buildings, such as libraries, museums, and permanent exposition buildings, all along a drive towards the north. To directly quote from the proposal:

> Among building groups, the first in importance, the Government or National group, which would include the Capitol building and the department buildings, is located on the present Camp Wallace and the adjacent land back of Calle Nozaleda. Grouping itself closely about the capitol building at the center, it forms a hollow square, opening out westward to the sea. The gain in dignity by grouping this buildings in a single formal mass has dictated this arrangement, the beauty and convenience of which has been put to the test in notable examples from the days of old Rome to the Louvre and Versailles in modern times (*Far Eastern Review* March 1907, 326).

The eastern front of the Capitol group faced a semicircular plaza, from whose center radiated a street system communicating with all the sections of the city—an arrangement entirely fitting for both practical and sentimental reasons: practical, because the center of government activity should be readily accessible from all sides; sentimental because every section of the capitol city should look with deference toward the symbol of the nation's power. The plaza allows space at its center for a national monument of compact plan and simple silhouette.

Radiating from this Government Center was a series of radial boulevards superimposed on an efficient gridiron street system. These radials divided the city into five sections and produced a street system that directed traffic efficiently up to a point where diagonals were introduced as a continuous connection between

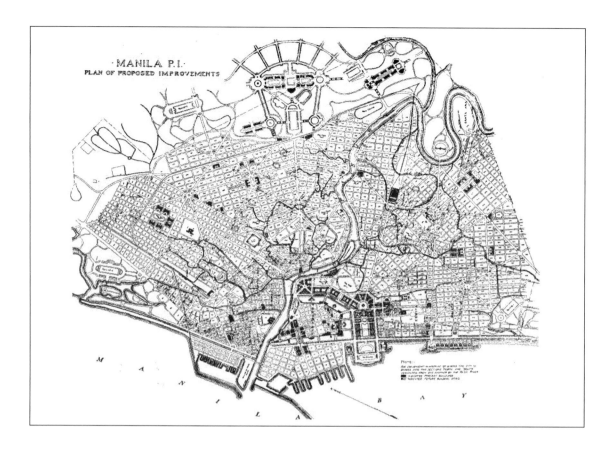

sections. Such a street pattern was patterned after Washington, DC and resonated in the Burnham-Bennett plan for San Francisco.

5.59 Plan of the proposed improvement for the City of Manila

Burnham also specified zones to locate the future capitol buildings, hall of justice, post office, railway station, municipal buildings, official residences, social clubs, new hotel, casino, public bath, yacht club, school center, and charitable institutions.

Waterways, like streets, were also imperative to Burnham's plan for facilitating transportation and commerce in Manila. For instance, Burnham observed that a system of existing narrow canals, called esteros, linked the various parts of the city and provided a practical means to move goods throughout Manila. He declared that these canals may not be aesthetically pleasing, but an estero, "it should be remembered, is not only an economical vehicle for the transaction of public businesses; it can become, as in Venice, an element of beauty. Both beauty and convenience dictate a very liberal policy toward the development of these valuable waterways."

Burnham also endowed great importance to waterfront development. He remarked in his report: "Manila possesses the greatest resources for recreations and refreshments in its river and its ocean bay. Whatever portions of either have been given up to private use should be reclaimed where possible, and such portions as are still under public control should be developed and forever maintained for the use and enjoyment of the people." Burnham prescribed a continuous parkway along Manila Bay, extending from the Luneta and southward all the way to Cavite.

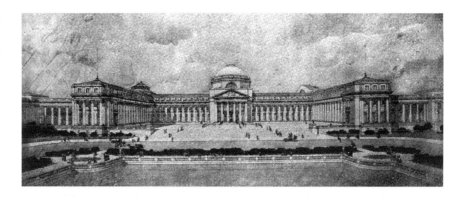

5.60 The proposed Capitol Building at Luneta

5.61 Plan of the proposed Government Center at Luneta

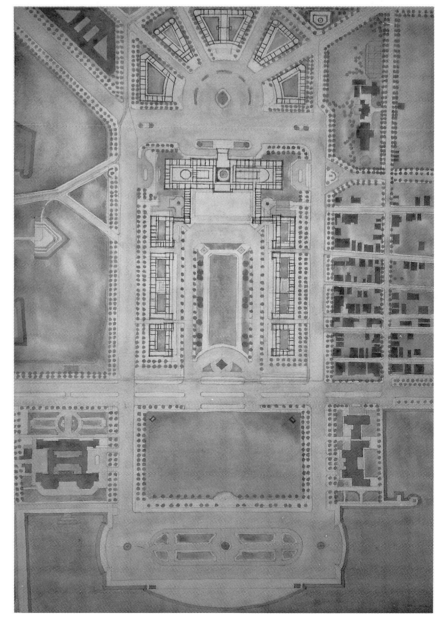

5.62 Similar geometry and urban arrangements of Washington, DC (left) and Manila (right)

This was to be a seventy-six meter-wide ocean drive "with roadways, tramways, bridle paths, rich plantations, and broad sidewalks and should be made available to all classes of people in all sorts of conveyances." Burnham further proposed shaded river drives along the Pasig, all the way to the south-bank drive going to Fort McKinley, and beyond this, to the lake area, as part of the park and parkway system.

Burnham, in an effort to disseminate American imperial ambition in the Far East to a wider audience, presented an abstract of his proposal to *The Western Architect,* a national journal of architecture and allied arts published in the United States. While his article focuses on the urban modifications that were to be performed in Manila, it inadvertently exposed his strong imperialist predisposition. At the initial passages of the essay, Burnham observed the absence of an urban plan in the previous colonial regime:

> In Manila, in the time of Spanish dominion, was an old walled city situated on the shores of Manila Bay, at the mouth of the Pasig River. There was no plan by which the city was built, and, as a result, the place was *ill-suited for the abode of white men* (emphasis mine). The plans for the development of the city should make it, not only healthful, but beautiful as well (Burnham 1906, 7).

In this passage, Burnham briefly declaimed his version of Manila's history. The lack of planning during the previous colonial era led to an urban accretion, rendering the city inhospitable to "white men." It can be surmised that Burnham's plan was generated from an imperialist desire to transform the Philippine space into a place where "white men" can feel disease-free and reimagine America in a tropical milieu.

The City of Pines: Designing America's Colonial Hill Station
Majority of Americans in the Philippines recognized the health hazards accompanying the imperial venture in the tropics. Some had been weakened by dysentery, typhoid, malaria, and a host of other tropical ailments, not to mention symptoms of depression. Later, medical scholars coined a term for it: "tropical fatigue." An upland climate was then believed to be an efficacious cure to tropical fatigue, and the search for the fabled cool place, set in the mountain ranges of the North, occupied the imaginations of the heat-crazed Americans. That chilly place was Baguio, whose environment offered an ideal site for an American health

resort. The great enthusiasm to develop Baguio as a place of American refuge and recuperation motivated the costly construction of Kennon Road, undertaken from 1901 to 1905. This two-million dollar road leading to a ten-room sanitarium in Baguio exacted hundreds of human lives from Filipino, Japanese, and Chinese road laborers.

Baguio was declared by the Philippine Commission on June 1, 1903, as the summer capital of the archipelago. In accordance with the declaration, Baguio would be transformed into a new city conceived, planned, built, and maintained by the Americans for the comfort and enjoyment of Americans.

Burnham's Baguio plan provided for this function, with emphasis on the city's tripartite role—as a health sanitarium for American servicemen, as a large market center, and as a hub of recreational activities. The proposal for Baguio had three objectives:

> 1. To provide a street system adapted to the changing contours, allowing easy communication, and avoiding east-west and north-south orientation of building lines;

> 2. To provide suitable locations for public, semipublic, and private institutions of importance; and,

> 3. To provide recreational areas in the shape of playgrounds, parks and open esplanades, and parkways.

In essence, the Baguio Plan was dominated by an elliptical space approximately 1.6 kilometers in length and 1.2 kilometers in width, an expanse of natural level land in the urban reservation. Along the perimeter of the ellipse, Burnham sited a commercial district and a government center. The central portion of the area was reserved for a public park. Overlaid with this elliptical core were a street system that conformed to the contours of the hilly terrain, broad residential zones, and a variety of private and public institutions.

For colonial leisure, the Baguio Plan recommended the development of playfields, parks, and an open-air theater. A country club was to be placed at Loacan where areas excellent for golf were located. The plan also prescribed that large portions of surrounding hills should be declared as public lands and maintained as informal parks. The preservation of existing forested areas was given premium so as not to destroy the beautiful verdant scenery of Baguio.

On October 3, 1905, Burnham submitted his "Report on the Proposed Plan of the City of Baguio Province of Benguet, P.I." Burnham was impressed by the topographical layout of the proposed city as well as the majestic natural beauty of the surrounding mountain areas. This ecological tenor resonates in his "Plan for Baguio," where he maintained:

> The placing of formal architectural silhouettes upon the summits of the surrounding hills would make a hard skyline and go far towards destroying the charm of this beautiful landscape. On the other hand, to place buildings on the sloping hillsides where they would be seen against a solid background of green foliage is to give them the best possible setting without mutilating their surroundings. The

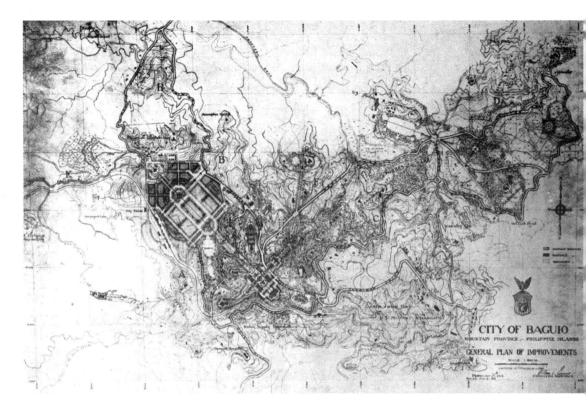

5.63 Plan of the proposed improvements for the City of Baguio

preservation of the existing woods and other plantings should be minutely looked after, not only on the eminences immediately contiguous to Baguio proper, but also for the surrounding mountains; and the carrying out of these precautions should be one of the first steps in the development of the proposed town. Unless early protective measures are taken, the misdirected initiatives of energetic lumbermen will soon cause the destruction of this beautiful scenery.

Burnham and Anderson admitted that the Baguio Plan was fragmentary due to the absence of surveys. Nonetheless, throughout the early decades of American rule in the colony, the plan provided an influential urban template in the organization of space within Baguio City.

Baguio was a hill station, a site of refuge invented by the colonialist itself. Hill stations were small towns carved from the rocky mountainsides or nestled in the meadows of high-altitude plateaus and whose genesis could be traced as sanitarium or convalescent centers. Baguio, in its transformation as a colonial hill station, to a certain extent, recreated the aura of the mother country in architectural and urban planning terms as an antidote to the colonists' longing for home. The style and atmosphere of an American mountain resort, particularly the Adirondacks, was consciously replicated in Baguio. The relatively high-altitude hill station was designed to be more than just a reinvigorating mountain retreat. To justify the expenses for its development, Baguio had to have some medical functions of sorts to substantiate an officer's taking recuperative leave, however unconvincing the excuse or ineffectual the cure. Some Europeans, in building their colonial hill stations, believed that trips to the cooler uplands strengthened their immune systems against infectious tropical diseases and decreased their susceptibility to depression. Such salubrious sites had to be beyond the reach of mosquitoes,

5.64 Early developments of
Baguio City

5.65 Baguio public market
flavored with an aura of the
American Southwest frontier
and cowboy nostalgia

though it was not known until the end of the nineteenth century that these insects also carried the malaria parasite. The hill station, with its pine forest, was also packaged as a genteel fantasyland, a retreat from reality where the homesickness of a colonial could be remedied by the simulation of an American hometown, down to its familiar architecture and its cozy institutions: the club, the library, and the village church.

Even before Burnham's proposal for Baguio, Edgar K. Bourne had designed government cottages in Baguio using the American Stick Style. The architectural imagery of these residences provided an instant cure for the homesick American. Its design would later influence the development of the new house model known as "tsalet."

5.66 Baguio City Hall

5.67 Baguio residence of Dean C. Worcester

5.68 Baguio Country Clubhouse

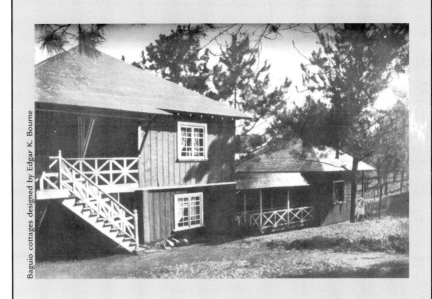

The American Stick Style

The American Stick Style homes expressed its inner structure through the use of exterior ornaments, such as trim boards. These trim boards were often applied to gable ends and upper floors to symbolize the structural skeleton. Generally, the Stick Style was allowed to interact with other revivalist styles but have maintained its essential character: pinewood construction; vertical, horizontal, or diagonal boards applied over clapboard siding or half-timbering; building forms expressing angularity, asymmetry, and verticality; roof composed of steep, intersecting gables; large veranda or covered porch that recalled Swiss chalet balconies; and, simple corner posts, rafters, brackets, and railings.

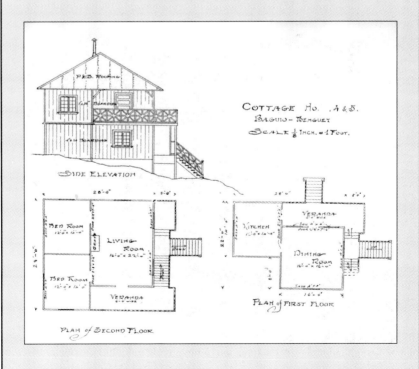

William Edward Parsons, the Imperial Consulting Architect

Aside from formulating the urban master plan, Burnham personally took charge of hiring the suitable architect to whom he could entrust the execution of his urban and architectural concepts for Manila and Baguio. After meeting several candidates, William E. Parsons's credentials stood out, prompting Burnham's endorsement for the pivotal position. On September 20, 1905, Parsons's appointment as Consulting Architect was authorized by Governor William Cameron Forbes who imposed upon his administration the responsibility of planning and developing the political and physical infrastructure

of the colony. Nicknamed "Caminero," a play on his name meaning "road builder," Forbes aggressively lobbied for the construction of a difficult and expensive road network leading to the Baguio hinterlands. By legislating Philippine Commission Act No. 1468, which established the position of Consulting Architect, he bestowed upon William E. Parsons his full support and gave the latter relative freedom in plotting the direction of colonial architectural production. After a prolific eight-year career in the Philippines, Parsons left a corpus of architectural works that exemplified the aggressiveness of the colonial building program, making the imperial image that America sought to perpetuate as more intelligible, visceral, and real. Parsons's most successful work in Manila included hospitals, schools, markets, hotels, clubs, and recreational structures governed by grandiose imagery and enthralling monumentalism.

William Edward Parsons was born in Akron, Ohio, on June 19, 1872. He graduated from Yale in 1895 where he earned an arts degree and entered the School of Architecture of Columbia University where he received his master's degree in Architecture in 1897. At Yale, one of his classmates was Francis Burton Harrison, who became a governor-general of the Philippines. Parsons was awarded a McKim fellowship which enabled him to study for three years at the Ecole de Beaux Arts in Paris. Parsons returned to New York City in 1901 where he was employed as head draftsman in the office of architect John Galen Howard.

Parsons arrived in Manila on November 17, 1905. But it was only on May 26, 1906 that the Philippine Commission Act No. 1495, establishing his position and defining his duties as Consulting Architect, was promulgated by the Philippine Commission. The position of Consulting Architect was created under the Department of Commerce and Police. He was to receive an annual salary of 12,000 pesos. Under the law, Parsons was tasked "to advise the Governor-General, the Philippine Commission, the Director of Public Works, and the Municipal Board of the City of Manila on matters pertaining to the architectural features of construction, repair, or alteration of a material nature of public buildings and

monuments of permanent character, including the treatment of walls, approaches thereto, the moats, and the area between the said moats and the boundary streets of Intramuros, and to perform such other works as may be directed by the Secretary of Commerce and Police." The Consulting Architect was also held responsible for the formulation of guidelines regarding the general type and style of building in a particular locality when public design competitions were to be held. In addition, he was to exercise general supervision over architectural features and landscape design of government and prominent public places. Another important stipulation of the Act was that he was charged with the interpretation of Burnham's preliminary plans for Manila and Baguio and the preparation of the details where architectural effects and monumental features were required. Section 4 of Act No. 1495 officially endorsed the Burnham plan as the canon on which the future development of Manila and Baguio would be based. The Burnham plan was, therefore, a law which Parsons's future designs must strictly observe. It was within this legal clause that Parsons brought many aspects of Burnham's imperial urban vision to fruition. Later in Parsons's career as an urban planner in the Philippines, he would draw up his own urban vision for the cities of Cebu and Zamboanga that undeniably resonated Burnham's planning criteria as the two provincial cities called for shoreline boulevard development, formulaic civic cores with diagonal avenues radiating from the central hub, and maintenance and integration of old forts and plazas as urban parks and public areas.

Under the terms of Parsons's appointment, he was vested with the authority to exercise general supervision over the architectural design of all buildings and parks throughout the archipelago, including works in the insular, provincial, and municipal spheres. He was also allowed to engage in private practice provided that such would not interfere in the discharge of his official function. He maintained an independent office during most of his years in Manila.

Parsons's foremost contribution to local architecture was the improvement of the quality of construction materials and techniques. Of course, this was achieved through the importation of building technologies from the United States, such as the Kahn Truss System and concrete hollow blocks (Cody 2003, 39) and the adoption of standardized plans and modularized systems for building types (i.e., markets, schools, dispensaries) to bring down construction costs. Upon his arrival, he observed that government standards of construction were poor. Inexpensive Oregon pine was the basic construction material and the beautiful, old tile roofs were being replaced by glaring galvanized iron sheets. He persuaded the government to discontinue the practice of using Oregon pine, which was prone to termite attacks, and encouraged the use of termite-resisting tropical hardwood. He then moved to advocate the use of reinforced concrete as the standard construction material for all government-sponsored architecture.

Consistent with the colonial government's sanitary obsession, the first building of the government to be executed entirely of reinforced concrete (with the exception of wood window frames and roof trusses) was the Insane Ward at San Lazaro, completed in 1907. However, Parsons noted the difficulty in expediting the construction of reinforced concrete buildings in the absence of skilled labor familiar with concrete's material plasticity and the formwork it required.

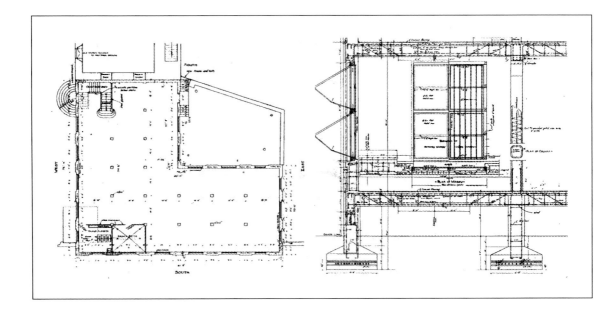

5.69 Plans for the Insane Ward at San Lazaro, built in 1907, the first reinforced concrete structure of the American government in the Philippines

The Insane Ward at San Lazaro (1907), contracted to the B.W. Cadwallader Company, marked "the beginning of a new policy for the construction of public buildings ... [and] its construction is being watched very carefully by not only the inspectors in charge but also by contractors and the public who are interested in this form of construction" (*The Far Eastern Review* April 1907, 356). The building was an L-shaped, two-storey structure; the length of each wing was twenty-three meters and the width twelve meters. The first floor level was raised 1.5 meters above ground with a well-ventilated underfloor space. The interior corners of the floors and walls were all rounded to facilitate cleaning and disinfection.

Reinforced concrete, thus, became the staple material for all the buildings designed by Parsons. The use of concrete in the Philippines coincided with the need to maintain hygienic conditions within these structures. An article from the *Architectural Record*, authored by A.N. Rebori, details how Parsons and his staff utilized concrete as a building material, which could be easily cleaned, washed, and sanitized. Concrete, therefore, was regarded as a composite material necessary to maintain the sterility of spaces within the structure and was considered as the cost-effective and ideal substance utilized by the American authority in its efforts to enforce its sanitation policies via architecture.

The largest individual structures Parsons designed were the government capitol buildings. These were for the provinces of Albay (1907), Pampanga (1907), Iloilo (1907), Capiz, and Laguna (1908). A study presented in the *Bureau of Public Works Quarterly Bulletin* (Vol.2, No.14) in 1914 outlined the philosophy of the colonial administration regarding the design and the location of these important civic structures. His concept and design of the Lingayen Capitol Building, possibly the most impressive of all those built during that era, was an excellent example from which his philosophy can be deciphered. Parsons also accorded capitol and municipal complexes with a logical and convenient scheme: placing them in park-like settings, in positions of dignity and repose. Parsons's neoclassic designs for the capitols became the archetype of all succeeding capitols built before and after the

Importing American Architecture and Building Technology

The production of architectures in the Philippines at the beginning of the twentieth century employed materials, technologies of construction, building typologies, and spatial programs—both modern and imported from the United States. During this period, methods of construction were greatly improved through the adoption of new building technologies promoted by the American authorities in the Philippines. Improvements in construction technology translated to larger and taller structures that allowed application of complex forms of articulation and ornamentation.

Steel-framed skeleton construction, reinforced concrete, and concrete hollow block construction were the primary construction technologies imported from the United States. This transfer of technology in the Philippines was only part of a larger, worldwide technological transmission of the United States that started at the end of the nineteenth century. Catalyzed by the successful construction of the Panama Canal in 1914, the American building industry gained world reputation, leading to an aggressive and massive export of American expertise and technologies to other parts of the world. In his book, *Exporting American Architecture 1870–2000*, historian Jeffrey Cody described the condition as "the first, most visible example of how assiduously US companies, planners, government agencies, and other 'brokers' of American architectural form and space positioned themselves to work in Asia and elsewhere" (Cody 2003, 3).

The American colonial period saw the rise of the use of concrete in major infrastructure and civic works in urban and provincial areas. **Concrete** is a highly adaptable and plastic material, which can be formed and employed in a range of applications, from massive structures to the most exquisite of architectural details. Concrete's plastic quality renders a smooth surface and crisp plane as well as an inexpensive way to precast relief ornaments.

The combination of concrete and steel reinforcements resulted in a medium known as **ferroconcrete**. The added reinforcement provided the needed strength for tensile forces while the concrete countered compressive forces. The use of this composite material in new construction meant that structures became taller, with longer spans, and larger openings. New architectural forms were made possible. The Insane Ward (1906) at San Lazaro, the first government building to be built of reinforced concrete, spurred the use of such material for private construction. For the fiscal year ending June 1, 1908, the total value of cement imported amounted to 1,384,000 pesos (Report of the Philippine Commission 1908, 32), and, despite the yearly increase in use, not a kilogram had been manufactured locally until 1915 when the first rotary plant for cement manufacture was erected in Binangonan, Rizal, known as the Rizal Cement Company. In 1910, the Municipal Engineer had observed the remarkable increase in the adoption of reinforced concrete for private construction. That year, the value of reinforced concrete buildings erected reached 1,144,050 pesos, an abrupt increase of 607,050 pesos over the previous year (Report of the Municipal Board of Manila 1911, 46).

Another system that made use of this steel-concrete mixture was Truscon, a company founded by Albert and Julius Kahn, designers of some of the more significant US automobile factories, such as Ford's Highland Park factory in Detroit. The company's main product was the "Kahn Trussed Bar," a horizontal main bar with flanges or plate-like projections from each side of the bar that were partially cut away from the bar and bent upward at forty-five degrees, apparently to act as shear reinforcing. This system was used as a reinforcement medium for concrete

construction as the trussed bars were placed within concrete molds for floor slabs and beams. The Army and Navy Club in Manila, designed by William Parsons in 1908, specifically used the Kahn system for its reinforcement requirements. This system became so pervasive that it was the primary construction system exported by the United States between the World Wars.

Initially, the demand for concrete for civic construction was supplied by manufacturers from Macau, China, and Japan. By the end of the 1910s, concrete was exclusively imported from the United States to the Philippines. Portland cement, named after the quarry in the United Kingdom from which the material originally came, was first produced in the US in 1872 and became very popular thereafter. In 1876, during the Philadelphia Centennial Exposition, Portland cement was shown as a viable building medium and was marketed aggressively. By 1897, US production of cement exceeded that of the importation of cement from Europe. Thus, the American construction industry by the 1900s favored and depended upon concrete as a primary building material.

Moreover, a number of American companies ventured into the production of time-saving machines that exploited the potentials of concrete. In 1906, the Ideal Concrete Machinery Company of South Bend Indiana developed machinery that manufactured **concrete hollow blocks** on the construction site, known as the "Hollow Concrete Building Block." Essentially, the machine compacts a concrete mixture into a mold to form hollow blocks. The machine had vertical cores, fold-down mold sides, and a pallet with cutouts so it would fit over the cores. The pallet was placed at the bottom of the mold and was used to lift the freshly molded block out of the mold after hand tamping. The company aggressively promoted and marketed the machine as demonstrated in a print advertisement depicting the global reach of the imported machinery that included the Philippines as one of its client bases. Concrete hollow blocks, as they were still manually produced but with the aid of a machine, were feasible building materials in the Philippines. The abundance of manual labor resulted in the inexpensive production of hollow blocks. These relatively low-cost blocks became the fundamental building material for constructing walls and other vertical components. This technology is still being used in the Philippines today as it has proven to be an economical building material compared to contemporary building materials, such as drywalls, curtain walls, and other prefabricated components.

Another important application of concrete was in the production of **prefabricated components** and **precast concrete ornaments** demanded by the neoclassical and the art deco style. This was an important aspect of construction, as a significant amount of decorative features (such as medallions, low-relief sculptures, statuaries, inserts) were repetitive in nature and, thus, produced in multiples. Original sculptures and decorative panels were first executed in plaster from which a mold was formed for the eventual concrete casting. The ornamental components were fabricated in Manila by a special corps of fifty to sixty sculptors and molders working under the supervision of the Consulting Architect, then shipped to various building sites in the archipelago. In such undertakings, the Bureau hired the master sculptors and artisans, such as Isabelo Tampinco, Vidal Tampinco, Ramon Martinez, Vicente Francisco, Eulogio Garcia, and Inocencio de Leon among others, to design the ornamental components of the building. Inocencio

de Leon's son, Conrado, continued the tradition and the mass production of precasts with the establishment of The House of Precast in 1950.

The use of **clay tiles** and **brick** was brought about by the research and experiments conducted by the Ceramic Division of the Bureau of Science. The former chief of the said division, Dr. S. del Mundo, together with the Tuason and Valdes families as investors, formed a corporation, the Ceramic Industries of the Philippines, in 1937. The factory, designed by Cheri Mandelbaum, was located at a 5,000-square-meter property in Barrio Potrero, Tinajeros, Malabon. The machinery and equipment for the plant was specially designed and built in France. The company soon became a leading manufacturer of clay products, chief of which were the Del Mundo roofing tile, ceramic hollow bricks and blocks, fire bricks, and blocks for soundproofing and insulation. The Del Mundo **roofing tiles** were flat clay tiles, with an admixture of locally produced asbestos for additional lightness and resistance to heat, fire, and corrosion. One square meter of roof area required thirty-five tiles, the total cost of which did not exceed that of galvanized iron. **Hollow building bricks** of the same clay mixture were made in several sizes, so that in one square meter there may be eighteen to seventy-two bricks. The permeability of these clay bricks was only twenty percent that of concrete and the insulating power of the hollow clay bricks was five times that of adobe or concrete, and twenty-five percent better than even solid brick. The hollow bricks could be painted, plastered, or otherwise treated.

Steel was also a staple construction material exported by the United States to the Philippines. In 1928, for example, the Philippines imported 23,998 tons of corrugated roofing, 11,474 tons of structural iron and steel, 16,316 tons of steel bars and rods plus other iron and steel products, such as pipes, fittings, nuts, bolts, washers, nails, and other construction paraphernalia. A report by Consul General Harrington in 1930 showed a considerable increase in steel products imported by the Philippines. Steel bridges were erected during this period, replacing worn down and deteriorating wooden and stone bridges built during the previous century.

Among faster and cheaper methods of construction, **terrazzo** was also a popular choice as an alternative to stone finish. The terrazzo technique was an inexpensive way of achieving a high-gloss, polished, and sophisticated surface. The method, often used for floor treatments, involved the mixing of granulated marble, granite, or stone chips with colored cement, sanding, and polishing after the concrete mixture has cured, sealing it with wax or polyurethane. Patterns and two-dimensional figures were formed on the floor by laying down brass strips to delineate the different color fields prior to the pouring of the marble chip-cement mixture. A high-gloss, polished look is usually intended to emulate more expensive marble or granite. Ralph Harrington Doane advocated its use in the absence of genuine stone because of its economy and aesthetic response "to the gorgeous colorings of tropical sunlight" (Doane 1919, 30).

Other forms of floor and wall finishes involved **veneering**. Veneers, technically, are thin materials applied to a surface, oftentimes to hide or cover up the inferior quality of the base surface. They often come in the form of wood, ceramic, or stone veneers. Wood veneers were particularly used on wall surfaces and wood parquet was applied on floors. Different types of Philippine wood, such as narra, dao, and mahogany were used. The varied hues of wood added to the juxtaposition of patterns, voids, and color fields on the floor. Stone veneers, using marble, granite, and sandstone, provided the finish and look of solid stone without using actual solid stone. Ceramic tile work, which made use of small vitrified tiles with polychromatic treatment, was used on exteriors for protective and aesthetic reasons. These provided a sumptuous aura in otherwise monolithic concrete edifices without compromising the limited sources.

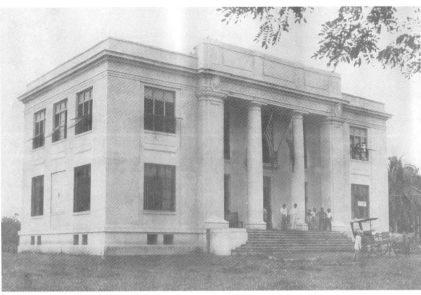

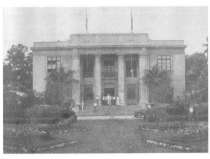

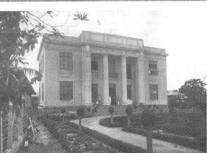

5.70 Lopez Muncipal Building, Quezon, 1926

5.71 Davao Municipal Building, 1930

5.72 Concepcion Municipal Building, Romblon, 1930

war. Like the schoolhouses, plans of municipal buildings of later years were also standardized, a necessary policy to maximize resources allotted for infrastructure development. For instance, the municipal buildings of Davao in Davao del Sur, Boac in Marinduque, Concepcion in Romblon, and Lopez in Quezon were built using the same standard plan.

The neoclassical provincial capitols were acclaimed for "their design, general proportion, exactness of detail, and the handling of material" (Rebori May 1917). These seats of municipal governance were innovative in their method of foundation construction. The Laguna Provincial Capitol, the prototype followed for the construction of provincial buildings, utilized the new spread concrete foundation, replacing the standard pile foundation. The provincial capitols of Rizal in Pasig and San Fernando in Pampanga had all the earmarks of the Laguna design except that these two structures had no colonnades. Standardization of municipal buildings and schoolhouses during the early decades of the American period was a necessary policy to maximize resources allotted for infrastructure development.

Plans of sanitary markets and tiendas were likewise standardized beginning in 1912. The plans nullified the unhygienic markets of bamboo and thatch with dirt floors, which were "prolific breeding places of vermin and insects" (Elliot 1917, 199). Parsons recommended concrete floors and steel trussed roofs in all of his four market prototypes and two standard tiendas (*Bureau of Public Works Quarterly*

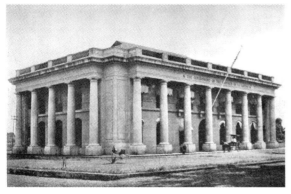

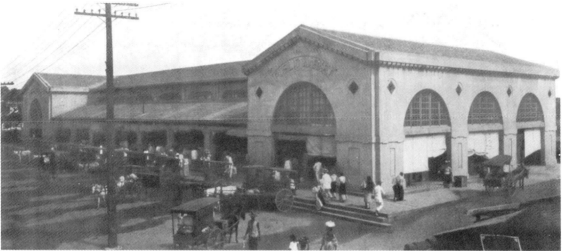

5.73 Provincial Capitol Building of Sta. Cruz in Laguna, 1908

5.74 Rear view of the Paco Public Market fronting the estero

5.75 Paco Public Market

Bulletin October 1914, 10). These were to be located in sites that "contain not less than two and one-half acres of land with distinct boundaries," and its central main building must measure between thirty-six to ninety feet in width, with the length in proportion with the required stores and stalls (Elliot 1917, 200). In these plans, where the structures are open on all sides, Parsons provided for maximum light and air and placed them, whenever possible, near an estero or river bank to encourage waterborne commerce. From a hygienist's point of view, the expansive concrete floors could, "be washed down with hose daily, allowing no food waste to remain overnight to rot" (Rebori 1917). This kind of market setup could be found in his 1911 Paco Municipal Market.

Parsons designed wooden and ferroconcrete buildings that adapted the horizontality, stasis, and symmetry of the neoclassical style to the hot humid tropical climate with hints of the Mission Revival style. He recognized the advantages of large windows over small ones. Windows must extend to the floor and be shaded from the harsh tropical sun and its glare, either by metal canopies, arcades, or colonnades. His plans contrived open spatial arrangements that allowed for maximum crossventilation. One feature of native architecture integrated with classically balanced masses of Parsons's neoclassic rendition was the use of translucent capiz shells instead of glass for window panels, thus suffusing the interiors with soft, pearly light. The Normal School (1914), the Women's Dormitory of the Normal School (1914), the Philippine General Hospital (1910), the Manila

Hotel (1912), the University Hall of the University of the Philippines in Padre Faura (1913), the Army Navy Club (1909), the YMCA Building (1909), the Elk's Club (1911), the Manila Club (1908), and the Paco Train Station (1914) were examples of Parsons's architectural experiment to synthesize local building tradition with the language of neoclassicism, superimposing architectural orders for the purpose of creating a hybrid colonial style that adjusted the neoclassical style to the climatological givens of a tropical environment. Moreover, in the same manner as the California architecture of the period, Parsons distilled from the older Spanish motif his architectural tactic, giving prominence to plain, broad surfaces of solid white or light pastel often topped by a tile roof. These edifices, as a result of using concrete, had an unembellished façade, and their rigid, box-like geometry seemed to anticipate modernist aesthetics. The otherwise bland exterior was mitigated by his familiar trademark aesthetic and functional elements: the wide, deep archways and the sun-shielded porches, pergolas, and loggias that linked the cool interiors with the lush tropical environment.

5.76 Philippine Normal School Dormitory

5.77 Philippine Normal School

5.78 Tondo Fire Station

The Philippine General Hospital (1910), encapsulated most of the outstanding elements of Parsons's architectural canon. The project was started earlier by Bourne, with Parsons taking over, amending the plans without abandoning the pavilion morphology set by the former. It was notable for its clear circulation network, flexibility for expansion, and the excellent ventilation and lighting provided by wide, interconnecting, open walkways. Built of reinforced concrete, with a low-angled roof, the sprawling, two-storey hospital featured service and medical wings architecturally integrated but hygienically isolated via a series of arched corridors. Such an arrangement allowed for generous and efficient future expansion. This hospital morphology would become the template for American army hospitals in other tropical territories, such as Panama. The rationale for the well-ventilated pavilion system stemmed from the miasmic theory of disease, according to which diseases were formerly believed to be caused by foul odors or vaporous exhalation,

5.79 to 5.81 The Philippine General Hospital

and better circulation of air would prevent its accumulation and dissipate the airborne pathogens.

Aside from the Philippine General Hospital, another crowning glory of Parsons's reign as Consulting Architect was the Manila Hotel (1912). Parsons designed it as early as 1907, but it took five years to complete. It was originally meant for American tourists and government officials but became the center for all social activity in the entire city. The *Manila Times* reported that a local official set the cornerstone for the Manila Hotel on August 29, 1910, and that this construction project allowed "residents of the Philippines as well as tourists from the United States and the China Coast ... (to) have every convenience which a modern hotel in any part of the world affords." The structure was five stories high, flanked by two wings. The grand lobby was arcaded on both sides with plastered twin Doric columns and full arches. Two grand staircases led to a mezzanine and the roof gardens. While the ground floor of the hotel was made up of an arcade of arched windows and Doric columns, the other floors had a horizontal line of windows that did not continue the Classical Revival motif found in the arcade. The upper floors of the hotel had a boxy appearance, with the flattened-out surfaces accentuating the building's horizontality. Floor plans showed that only guestrooms in the central part and smaller wing faced the bay, yet the larger wing has rooms extending all the way around its perimeter. The larger wing of the lobby contained a gift shop, a ladies' parlor, and toilets. The smaller wing, or east wing, housed the men's smoking room, a men's clothing shop, and a grill room. To the back of this gender-demarcated lobby was the main dining room that Parsons designed in the shape of a semicircle to provide panoramic views of Manila Bay. Parsons built the entire structure with ventilation as a consideration, resulting in large windows, placement of rooms in relation to sea breezes, and open verandas to circulate air throughout the extravagant lobby. Parsons sited the building facing the new Luneta Park and the clubhouses on the other side while maintaining prospects to the bay and the rear, which was originally meant to be a greenbelt, buffering it from the port.

Parsons's private practice yielded clubhouses that would cater to the recreational needs of American and British expatriates in Manila. These were the Army Navy Club (1909), the Manila Club (1908), the YMCA Building (1909), and the Elks Club (1911). The club buildings were typically two- and three-storey structures, usually in H-plan, with large loggias or verandas. The Army and Navy and the Elks Club are still extant (rebuilt from war damage funds) and have been refunctioned today as museums.

Dubbed as the most important construction of 1909 in the city of the Manila, the Army Navy Club was one of Parsons's private commissions. Burnham's plan had zoned an area for a small boat club, a casino, and public baths on a 100 meter by 200 meter-space opposite the hotel across the Luneta Extension. The site would be occupied by the building of the Army and Navy Club with a price tag of 300,000 pesos. The plan provided for three buildings composed of the club proper, a dancing hall, and a separate structure for a kitchen and servants' quarters following the general outline of the letter H. Made of reinforced concrete utilizing the Kahn System, the building had a flat roof, which Parsons avoided in his later works as he became acquainted with the torrential rains of the tropical colony. High ceilings

for maximized ventilation, a series of large windows spanning from column to
column, an imposing arched entrance, and deep loggias that surrounded the
building were some of the architectural features that were to comprise Parsons's
architectural idiom in his succeeding projects.

The British-owned Manila Club was acclaimed by *The Far Eastern Review* in 1908
as "one of the most modern buildings of its kind in the Orient." Located between
Calles Nozaleda and San Marcelino, the two–storey, reinforced concrete building
covered an area of forty-five by thirty-five meters, with the second floor covering
over one-third of the area of the spread foundation. The floors and interior finishes

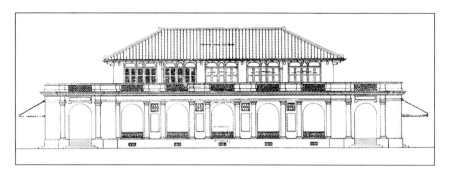

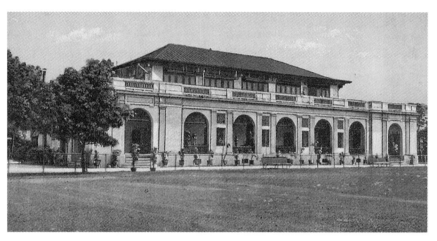

were made of local hardwood. The first floor was divided to contain a nine by twelve meter-dining room, ladies' room, office, card room, bar, and billiard hall. On the same floor, a covered loggia was located in front, while the rear had a colonnaded porch overlooking the tennis grounds. The second floor contained a large reading room and a number of private rooms with a communal toilet and bath. A nine by twelve meter-swimming pool was added after the construction of the building. The cost of the building was estimated at about 75,000 pesos.

With the aim of "spreading the Christian civilization of the West among the, peoples of the Orient," the International Committee of the Young Men's Christian Association (YMCA) commissioned Parsons to design its building in 1909. The YMCA Building was built at the corner of Calles Concepcion and Carlos IV, at the rear of the Manila City Hall (presently occupied by SM Manila mall). Parsons divided the building into three clusters: the athletic building on the right, the main building at the center, and the kitchen building on the left. The central main building was forty-five by thirteen-and-a-half meters. The plan of the ground floor was compact and well–maximized, accommodating rooms for dining, billiards, lectures, private offices, and a library. The rear of the building featured a wide veranda running the entire length of the building, overlooking the tennis courts. The second and third floors were designated as rooming apartments for sixty-five men, with each room provided with a balcony. Also within these floors were a common parlor, a lecture room, shower rooms, and toilets. The two-storey athletic building was twenty by twenty-five meters. The first floor had locker rooms with toilet-and-shower rooms, an eighteen by six meter-swimming pool area, and a

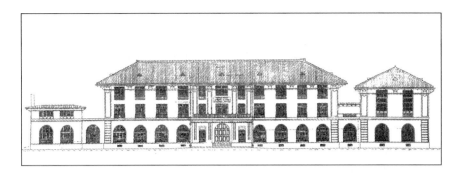

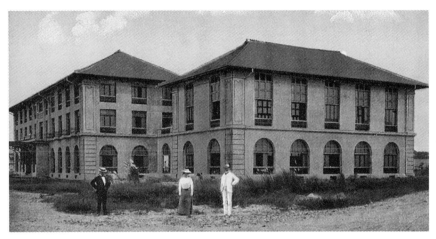

four-lane bowling area, while the second floor contained the gymnasium, director's office, and committee rooms. Though Parsons initially planned a roof garden over the athletic building, he replaced it with a more practical hipped roof with clay tiles. Overall, the project was estimated to cost about 170,000 pesos, a huge sum at that time.

One of the structures Parsons built in Baguio was the Brent Episcopal Church for Boys that he completed in 1909. While Parsons's work in Manila stressed classic forms molded in concrete, such as running arcades and pilasters, this school building was a simple wood structure that employed classic elements using local materials. A Classical Revival back porch, for instance, with Doric columns carved out of wood, leads students in and out of what is now known as Ogilby Hall.

Also in 1909, Parsons ventured into the design of schools by drawing the plans for the Tondo Intermediate School, which seemed to forecast his design for the Normal School (1914). The two-storey, concrete school building, built on Sande Street, had a rectangular plan with the customary Parsons's trademark of arched openings at the ground floor and rectangular capiz window panes on the upper storey. The façade was broken with triangular pediments, further articulating the roof gable. The design was to be replicated for the Cebu High School (1914) building. In 1911, Parsons designed a school for the training of teachers, the Philippine Normal School, completed in 1914. The Normal School, rendered in a style that allowed the California Mission style to mingle capiz window panes and ornately grilled ventanillas, was erected at the corner of Taft Avenue and Ayala Boulevard. The building, three storeys in height, followed a V-configuration plan, where an

auditorium was at the apex, while the rest of its segments were devoted to classrooms and laboratories linked by corridors. The construction, then budgeted at 374,000 pesos, was made of reinforced concrete. The exterior was relieved by panels of glazed polychromatic glazed tiles set in concrete (Parsons 1911, 20). In the same aesthetic trajectory, he designed the Central School (later to be renamed Bordner High School, and now a part of the Manila Science High School compound) on Taft Avenue, a stone's throw away from the Normal School. It was a public high school, which opened in 1914 under the administration of the Bureau of Education, but it was reserved for the use of American citizens.

Perhaps the most pervasive legacy of Parsons, which led to its mass reproduction, was the set of model schoolhouses he designed for the Bureau of Education in 1912. He came up with fifteen prototypes for a variety of site conditions and adapted ferroconcrete with the vernacular style. The plans were published by the Bureau of Education in 1912 as Bulletin No. 37, *School Buildings and Grounds*. These buildings were popularly known as Gabaldon Schoolhouses, a name attributed to Isauro Gabaldon, a member of the Philippine Assembly who authored

5.89 Manila Central Schoo (now the Manila Science Hig School)

5.90 Tondo Intermediate Schoo

5.91 University Hall of th University of the Philippines i Manila

92 Standard School Building
an no.2

93 Plan of a Gabaldon
hoolhouse

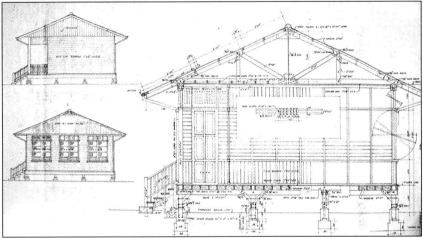

the bill appropriating ₱1 million for the building of modern public schools throughout the Philippines. The bill was passed into law on June 19, 1908, and came to be known as the Gabaldon Law. Materials, forms, windows, doors, and even blackboards were standardized to decrease building costs, save time and labor, and maximize construction efficiency. Most of the schoolhouses were one-storey high, constructed of 100-millimeter reinforced concrete walls on 250-millimeter square piers that functioned like stilts, in order to elevate the floor off the ground to allow easy inspection of floor timbers for possible termite attack (Rebori 1917, 433). Capiz windows were reinvented as pivot windows rotating on horizontal axes. In time, these schoolhouses became an enduring icon of colonial education and the program of assimilation. The school architecture created by Parsons was commended by Governor-General Forbes for its tropical attributes and symbolic presence:

> No other tropical country has attempted to build up a complete school system with a distinctive type of architecture ... A type of permanent, concrete school building has been evolved which is very satisfactory. These permanent buildings conform to the needs of the

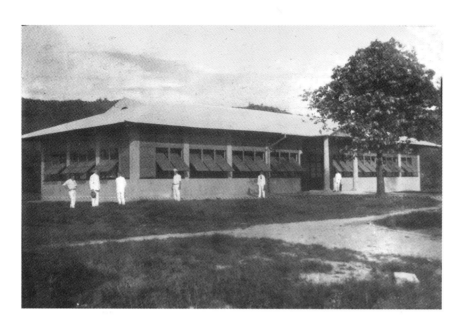

climate. Unless overcrowded with schoolchildren, they meet the standard setup for school hygiene in ventilation, lighting, and sanitation. They are simple and dignified in architecture. They are usually the most conspicuous, as well as the most artistically satisfactory, of the buildings in any community (Forbes 1928, 192).

Parsons's University Hall (1913) of the University of the Philippines was the first building to be erected on the campus grounds at Padre Faura (Report of the Philippine Commission 1912, 186). The structure, costing 250,000 pesos, measured 58.35 meters long by 25.8 meters wide and consisted of three floors and an attic. The foundation was made up of chain footings of reinforced concrete. Dwarf walls supported the frame of the first floor and distributed the load of the frame over the footing. The University Hall manifested the aesthetic shift of civic buildings from the austere combination of Mission Revival, plain, classical Doric orders with the obligatory allusive elements to local architecture (i.e., capiz windows) to a more ornate, precast neoclassicism requiring a complicated casting process and moulding technique. This style, however, which architectural critic Andrew Rebori had renounced, came close to the "stereotyped classic architecture," which strongly persisted in Parsons's private commissions when he returned to Chicago in 1914 (Hines 1973, 324-25). Outside, the hall exhibited a long colonnade of Ionic columns—ten on the longitudinal side facing Padre Faura, and six columns on both lateral faces of the building. The columns were eighty-six centimeters in diameter at the base and tapered to seventy-four centimeters at the capital. The columns were 7.6 meters in length from their base to the base of the cap and were 9.2 meters in length over all from the base of the pedestal to the crown of the cap.

His lesser known work, the Manila City Aquarium (1912), was built in the inner slope of a bastion in Intramuros integrated with a public playground constructed from the reclaimed moat surrounding the walled city. The Bilibid Prison Hospital and Gateway (1907), Cebu Custom House (1911), and Tarlac Provincial Prison (1913) were also attributed to him. Parsons had also designed small structures in Manila, which had long been forgotten. These obscure ones include the Tondo Fire Station (1913), the Cottage of the Singalong Experiment Station (1906), the

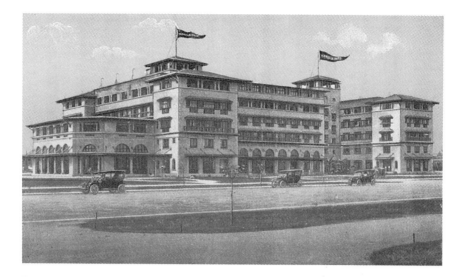

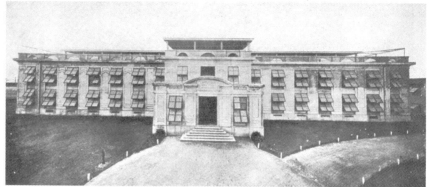

Gatehouse of the Reservoir of New Waterworks System (1907), the Sewer Pumping Stations of Manila (1908), the College of Medicine and Surgery (1910), the Communicable Disease Ward at San Lazaro Hospital (1913), the Philippine School of Arts and Trade (1914), and his own residence overlooking Manila Bay—all of which were destroyed during the last World War.

Like Bourne, Parsons's career in the Philippines ended in controversy. In 1912, the United States changed its policies by decreasing American colonial machinery and hastening the process of allowing the Philippines to pursue its independence. A new governor-general, F.B. Harrison, was sent to replace Governor Forbes, Parsons's ally. Moreover, in January 1913, the Philippine Commission passed Act No. 2314, transferring the powers of Consulting Architect to the Bureau of Public Works. With this piece of legislation, Parsons's position was jeopardized. The pro-

Federalist Parsons, who could not work with Harrison's style of administration, not to mention the looming reorganization of the bureaucracy, resigned in February 1914 because "there seemed to be no further progress to be made under the scuttle policy of the present administration"(Rebori 1917).

Marking the end of his architectural tour of duty in the Philippines was the Doric-inspired Paco Train Station (1914), built at the terminus of a newly laid boulevard fronting a semicircular Plaza Dilao. The building could be read as an ideological statement of the "White Man's Burden" frame of mind with the deployment of four garlanded American eagles surmounting the main cornice above the central motif on the building façade. Scholars recognized the strong resemblance of the Paco Train Station to that of the Pennsylvania Station (1910) of McKim, Mead, and White in New York. Nevertheless, the Paco Train Station echoed Parsons's pro-Federalist sentiments by leaving multiple icons of the Imperial Eagle. The Paco Train Station, shown through the imperialist lens, existed in a pictorial field that juxtaposed the slow-moving, carabao-drawn vehicle with the modern facility of colonial transportation—the train, a visual index of technological progress.

Parsons, upon his return to the United States, resumed his practice by forging a partnership with Edward H. Bennett and Harry T. Frost. Their firm, known as Bennett, Parsons, and Frost, became renowned as a specialist in the field of city planning and civic development.

Bureaucratic Change at the Office of Consulting Architect

When Parsons resigned from his post, George Corner Fenhagen, who joined the bureau in 1911 as Assistant Consulting Architect, was appointed as Acting Consulting Architect. But Fenhagen went on leave before the year 1914 ended. In the *Bureau of Public Works Bulletin* for July 1916, Fenhagen was still listed as the Consulting Architect in absentia, while Ralph Harrington Doane (1886–1941) was cited as Acting Consulting Architect. Fenhagen would eventually return to the United States and open an architectural office in 1915 with architects Howard Sill and Riggin Buckler who were based in Baltimore, Maryland.

Fenhagen is best remembered for the unbuilt Capitol Building in Manila. This structure was supposedly the centerpiece of Burnham's Capitol Group and a hallmark of Fenhagen's commitment to an architectural style that evoked America's federal presence in the Philippines. The general scheme of the building clusters were arranged in a U-pattern hugging a grand central plaza. Fronting a reflecting pool and dominating the clusters of compositional volume is a Neoclassical domed edifice—a leitmotif based on the Roman Pantheon—with an elevated portico and long wings of Ionic colonnades standing on a massive platform—a classical style favored by Thomas Jefferson. Parsons's grandiose capitol, in many ways, resembled Benjamin Latrobe's nineteenth century United States Capitol in Washington. This magnificent vision came with an outrageous price tag: the grand total of the estimate for the entire group, including the cost of general construction, plumbing, lighting, plans and specifications, and supervision was pegged at 6,113,606 pesos (Report of the Philippine Commission 1912, 188).

Fenhagen, like Parsons, was allowed to engage in private practice. Together with Fred Patstone and William James Odom, Fenhagen designed one of the first multi-storey concrete buildings in the Philippines, the Masonic Temple (1913) in Escolta. The Masonic Temple was a five-storey structure that displayed a Neoclassic facade, with a colonnaded ground floor, arched central portal, and divided, two-arched Florentine windows typical of a multistorey Italian Renaissance palazzo.

5.101 Model of the proposed Capitol Buildings in Luneta

During this time, Doane was actually managing the office in behalf of Fenhagen, and soon after, he took full charge of the Bureau as Consulting Architect in the last half of 1916. He held the office for two-and-a-half years, assuming management of the projects that Fenhagen and Parsons had left behind. He continued to oversee the implementation of the Manila and Baguio master plans. The MIT-educated Doane, like Parsons and Anderson, was bred in the Beaux Arts tradition. He was a Neoclassicist and sought to enhance the quality of public buildings as well as increase the richness of ornamentation and articulation for the most significant structures. He explained his disposition toward the decorative in his 1919 article in *Architectural Review* aptly titled "The Story of American Architecture in the Philippines."

> In the early days, the Americans enforced a bare, severe, undecorated architecture as an antidote for the prevalent garish tastes of the native people. Such a severe architecture as is only permissible in conjunction with the finest building materials was attempted in concrete, a material which, though structurally excellent, is artistically bastard, and in no way expresses the native luxuriance of the tropics or the prevalent case of life in the Far East. This architectural procedure met with local dissatisfaction on every hand. The Filipinos were willing to be shown a new architecture if it could be richly decorated, but were not willing that their public buildings should be devoid of any embellishment whatsoever, little more, in fact, than warehouses (Doane 1919, 30).

This philosophy was a marked digression from the architectural stratagem established by both Bourne and Parsons, who advocated simple and sparsely ornamented concrete public edifices.

The most notable of Doane's buildings were the Pangasinan Provincial Capitol (1918) in Lingayen, the Leyte Provincial Capitol (1918) in Tacloban, and the Legislative Building (1926) and the unbuilt Insular Post Office, both in Manila. Doane had designed the Legislative Building originally as the National Library, a component of the civic structures that Parsons developed, as deduced from the Burnham master plan. Construction began in 1918, but the shortage of funds

PROVINCE OF PANGASINAN
CTED CAPITOL BVILDING A D MCM
OVERNMENT FOR ADMINISTRATION OF A C
NG LIFE LIBERTY AND THE PURSUIT OF

caused much delay in its construction. Concurrently, the Philippine Legislature needed a venue to perform its lawmaking function so an official decision was made to convert the building to serve the said purpose. Juan Arellano later revised the plan to add a fourth floor and chambers for the legislators. The building was completed in 1926.

Perhaps the most visually arresting of all provincial capitols constructed during the American period, and still in use today, is the Pangasinan Capitol in Lingayen, described in the *Bureau of Public Works Bulletin* as "a successful adaptation of imposing Classic Architecture in Tropical Conditions." Designed by Parsons, with some modification by Doane, the building was constructed between 1917 to 1918 under the supervision of Doane, at a 300,000-peso budget. Made of poured concrete, it intentionally used imitation limestone on the exterior for a warm bright color. The capitol was to be the central nucleus of a complex to be constructed at a future date that would include a court house, jail, garage, storeroom, hospital, and residences for the governor and provincial treasurer at an estimated cost of 500,000 pesos.

The Pangasinan Capitol was designed with minimal wall surfaces and maximum window openings to take advantage of the cool sea breeze. It was shielded from direct sunlight and downpour by an imposing colonnade and a projecting cornice surrounding the entire edifice, while the interior was planned with large, open spaces, omitting interior walls as much as possible, to give the impression of an unbounded pavilion. A monumental main floor lobby and stair hall with a courtroom on the second floor, two stories high, was designed purposely for the architectural effect expressive of the dignity of the government office and surpassing the interior architecture of any provincial capitol previously built.

The capitol building, as it projects an impressive grandeur, inevitably exerts political authority and bears certain ideological meanings about colonial power relations. This was achieved through the use of symbols in the form of precast ornaments, such as the recurrence of the American insignia in relief, the sculpture of American eagles, and the most striking—the Philippine coat of arms where an American eagle nestles above as the dominant element of the pediment. The semiotics of the whole decorative ensemble is made more potent with an inscription just below it, which reads:

PROVINCE OF PANGASINAN
ERECTED CAPITOL BUILDING AD MCMXVIII
BY THE GOVERNMENT FOR ADMINISTRATION OF A CIVIL STATE
PROMOTING LIFE, LIBERTY, AND THE PURSUIT OF HAPPINESS

Such inscription explicitly inculcates the auspicious narrative of colonial presence and the benevolent role of the American colonial machinery in making possible a democratic veneer amidst colonial order.

The Executive Building (1919) at Malacañang also gave credit to Doane's design proficiency. Tomas Mapua describes the building in the 1919 *Bureau of Public Works Bulletin* as one of the notable works of Doane for its "rich simplicity expressing an agreeable combination of Italian and Spanish Renaissance motifs." Since it was to be the residence and office of the Governor-General, it was imbued with

5.109 Pediment detail of Pangasinan Capitol

"stately domesticity" manifested in the intricacy of its details—the wooden panels and carvings, the coffered ceilings, the precast concrete ornaments, and the ornamental iron. Akin to his aforementioned works, Doane profusely utilized classical ornaments and motifs in the design of the Executive Building, such as arched windows and doorways and classical columns for the porticos north and south of the building. The building was configured in an H-plan, having dimensions of sixteen by fifty-five meters. The two-storey central volume had surrounding loggias. Flanking the central mass were two office wings. The ground floor housed the Governor's and Vice-Governor's offices as well as offices for the staff, while the second floor housed eight bedrooms with individual toilets and baths.

Filipinization of the Colonial Bureaucracy and the Bureau of Public Works

The appointment of Francis Burton Harrison as Governor-General of the Philippines in 1913 saw the slow but sure Filipinization of the entire bureaucracy. Ultimately, the Republican perspective was replaced in 1916 by the Democratic commitment

to grant Philippine independence. The change in governmental structure was reinforced by the enactment of the Jones Law (The Philippine Autonomy Act) in 1917, which promoted a wide-scale recruitment of Filipinos in the bureaucratic system. With the implementation of the Jones Act, the number of Americans in government service dropped tremendously. As with the Bureau of Public Works, the volume of work had increased immensely, necessitating the employment of more Filipino staff and some of the senior personnel assuming high level positions left by their American predecessors.

The transfer of the Bureau to Filipino hands was given focus in the *Bureau of Public Works Bulletin* of July 1918. In this issue, Doane in his article, "Architecture in the Philippines," articulated the policy and responsibility of the government concerning architectural production. He asserted that "there can be no true democracy without leadership, and there can be no leadership worthwhile in democracy that is not in the interest of the people as a whole ... Real democracy must provide for the masses ... not only those things that protect the body, but, above all, those things which elevate the soul."

Doane equated architectural aesthetics with democratized cultivation of arts among the colonial subjects: "A government which fails to recognize the right of the people to enjoy the benefits of the great heritage of art; which fails to cultivate and encourage in its people the love of beauty; and which does not recognize, as one of its legitimate functions, the orderly and systematic development of the fine arts is no true democracy." Doane went on to clearly state the government's mandatory task:

> The Philippine Government, conscious of these inherent duties, has with respect to the fine art of architecture, established rigid Government supervision. It therefore becomes incumbent upon officials charged with these special responsibilities to carefully analyze past and present architectural accomplishments and procedures and to formulate an architectural policy, which in the future will produce splendid monuments as well as practical buildings, and which will maintain a high architectural standard in public works, commensurate with the dignity of the Philippine Government, and calculated to engage favorable public sentiment and promote a healthy civic pride among the Filipino people.

> [...] So let us hope that while the utilitarian aspects of Philippine architecture will not be neglected, its historical significance and artistic importance may be emphasized, and that the rich resources of the land may be marshaled in the production of an architecture sufficient in quantity and quality to announce to prosperity the constructive genius and artistic accomplishments of the present day.

Ralph Harrington Doane resigned from the Bureau in 1918. He returned to the United States and established his own architectural practice in Boston in 1919. He advised the city of Boston on various building codes and ordinances and won several awards. In 1927, he won the Harleston Parker Gold Medal for "the best architecture in metropolitan Boston" for the Motor Mart Garage. Doane developed a specialization in school architecture and later served as consulting architect for institutions of learning, such as St. Paul's, Northfield, and Mount Hermon.

Session Hall of the Legislative Building

Casting the Imperial Allegory: Sculpted Figures in Architecture

The colonizing power has long made use of many devices and agencies to create an emotional bonding with particular histories and geographies. The cultural mechanism and visual ideology of the colonial authority have been directed to nurture several iconic metanarratives: the spirit of the land; the cult of a hero; the ethic of progress; the rhetoric of benevolent assimilation; and the nurturance of democratic governance under a colonial order. These metanarratives are driven to ensure the consolidation of the colonial subjects' plural and emotive identities and the incorporation of peripheral loyalties to the body-politic that is constructed though hegemonic cultural construction of a collective identity, social memory, and social cohesion.

Since places are defined by tangible material realities and spatial coordinates that anchor identity, places, therefore, are essential to spatialization of the imagined colonial metanarratives. They are necessary in providing emotive sites of remembrance and in the cultivation of such metanarratives. Carefully chosen symbolic meanings, icons, and mythologies that serve as mnemonic devices are invested in these places. Architecture, monuments, statuary, and public spaces provide venues to establish spatial and temporal reference points of remembering that prop social continuity and collective memory in the colonial city. As Walzer puts it, "[t]he state is invisible; it must be personified before it can be seen, symbolized before it can be loved, imagined before it can be conceived" (Walzer 1967 in Zelinsky 1988).

Anthropomorphic figures integrated in architecture and public statuary serve as visual cues loaded with collective memory that is grounded in a mythic past, reified in the present, and projected into the future; they perform a didactic function, allegorically embodying the required values the citizen must perform for the state; they signify national progress; they are heroic figures of men who represent faceless masses; they are symbolic of rights, liberty, and patrimony.

From its classical origins, monumental public statuary in the nineteenth century cities constituted a mnemonic system of identification transcoded in stone. Historical monuments and civic spaces were didactic urban elements. They were iconographically articulated to civilize and elevate the aesthetic tastes and morals of the citizenry.

Statuemania, or the frenzy for erecting commemorative statues, peaked in 1870 to 1914 throughout Europe and North America and attained a social and political role not seen since the days of the Roman Empire. In imperial and colonial cities, the erection of monuments served to anchor the collective remembering in its site that mobilized shared rites of passage among the citizenry. They were tangible signifiers intended to be immortalized. More importantly, they represented the personification of the nation or colonizing state, the transmission of mythic histories, a material and visual connection with the past, and the legitimization of authority. Meant to function as visual prompts for the collective memorizing of an official state narrative, most monuments relied upon the depiction of the human form in colossal heroic statues

that rendered abstract principles in allegorical allusion. If effective, public monuments were consensus builders. They were focal points for identifying with a visual condensation of an imagined, state-ordained chronicle rendered in heroic symbolism.

State edifices built in the Philippines during the 1920s and 1930s were embellished with motifs of Classicism, such as pendants, acanthuses, volutes, relief figures, and allegorical statuary. What were the roles played by these architectural statuary and figurative elements in the civic architecture and public spaces in imaging the national imagination during the American colonial period? Although made predominantly by Filipino sculptors that have trained in the Beaux Arts academy, these sculptures were commissioned by the colonial authority to informally construct and consolidate a symbolic topography that allegorically depicts the benevolent virtues and democratic pledge of American colonialism in the Philippines. The iconic narratives cast in stone had to be clad in a manner that evokes the local to encourage native identification with the colonial state and reinforce its continuity and omnipresence.

The Classical Female Figures Clad in Filipina Dress

The conception of women as agents of civilization, education, and equilibrium is evident by the inclusion of various classical elements in nearly all of the personifications, such as the figures of Ramon Martinez's four variations of La Madre Filipina commissioned for the Jones Bridge or in his rendition of "Inang Bayan" (Mother Nation) surrounded by Greek deities at the pediment of the Legislative Building.

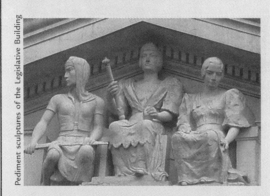

Pediment sculptures of the Legislative Building

The use of classical devices in this statuary proved an ideal tool by which to convey a sense of cultural achievement, since the Greco-Roman world, at that time, was perceived to be the epitome of sophistication. For the viewer looking at the personifications, accessories, such as togas, tunics, sandals, thrones, daises, cornucopia, crowns of laurel leaves, helmets and/or triumphal arches, were intended to evoke parallels between the enlightened achievements of the United States and those of the Greeks and Romans, creating an image of America as the natural heir to the ancient world. Such a comparison was also suggestive of an imperial conceit that America's reign as a world power and great colonizer would be as successful and influential as that of Athens or Rome.

Classical triumphal devices like arches, elevated daises or crowns of laurel leaves, apart from acting as a kind of imperial fable by way of historical analogy, when combined with a background revealing vistas and elements that declared prosperity and cultural achievements, were also intended to reveal the success of the colonizing process. Raised or enthroned female figures clutching symbols of fertility or affluence, such as agricultural paraphernalia, cornucopia, or commercial ledgers, were meant to draw stately likenesses to classical depictions of *Fortuna* (Lady Luck with her cornucopia of promises of riches and abundance).

The Philippines was first personified in the 1880s via Juan Luna's academic painting *España y Filipinas*, also known as *La Madre España Guiando a Su Hija Filipinas en El Camino del Progreso* (Mother Spain Guiding the Philippines on the Road to Progress). To dramatize the march to progress sought by Filipino reformists in the 1880s, Luna used a slim canvas, a format that helped focus on the grand steps, scattered with palms of victory and flowers, while also emphasizing the regal pose of mother Spain and daughter Philippines looking upward to the sky to signify both their hope and entente cordiale. Spain held her ward on the hips as if guiding her on their climb to progress. This mode of figuration was appropriated in a rotunda in Carcar, Cebu, built in the 1920s. Here Spain was replaced with the figure of America but still directing the Philippines at the crossroads to the metonymic road to progress.

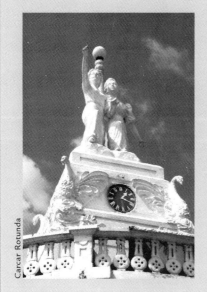

Carcar Rotunda

Ramon Martinez's (1860–1950) rendition of *La Madre Filipina* resonates the cult of motherhood, a figuration that seems to sanction the "pastoral power" (a form of power exercised by the state apparatus that focuses on the salvation of subjects). This group of allegorical sculptures once graced the portals of the prewar Jones Bridge (c. 1930) designed by Juan Arellano for the Bureau of Public Works. Salvaged from the ruins of war, one of those in the figural group stands side by side with the Rizal Monument in Luneta, while the other now flanks the main door of the Court of Appeals Hall along Maria Orosa Street.

Perhaps, borrowing the personified image of the Philippines from Juan Luna's figuration, Martinez's maternal figure, clad in a Tagalog native costume, is seated on a throne to represent the imperial ideals. Although clad in *baro't saya*, the figure exhibits a discernable classical female facial feature and hairstyle traceable to the likeness of Aphrodite. The gigantism or magnification of scale in relation to the other figure seems to echo her divine power.

La Madre Filipina is seen as a seated figure embracing a female child whose hands rest on her knees on the right side while on the other side, she comforts the seminude male figure crouching in painful grief by touching his back. The child looks up to her as she gazes with an emotionless expression toward infinity. At the back, the throne is textured with Greek floral motifs. Beside the throne are two symbolic figures, the imperial eagle and a funerary urn with a dragon design, whose lid is surmounted by a rooster animal form. By classical convention, innocence and passivity are symbolized by the child; the urn signifies death; the rooster represents resurrection; the eagle is Imperial power. Perhaps, the governing theme of the sculpture is colonial promotion of the new medical practices and perpetuation of the new tropical hygiene (resisted by the native population) to diminish the number of preventable deaths among the natives.

La Madre Filipina

The formula of the seated mother figure is repeated in the other pair of allegorical sculptures that were relocated to the colonnaded portals of the Court of Appeals. The first sculpture shows a male child holding a ball, as if assuming the gesture of play, and a man rising from a fall, while the seated mother figure looks after the male figures with parental assistance. This sculpture is telling of the parental figure that renders support to sons to ensure the pursuance of life, liberty, and the pursuit of happiness. The second sculpture shows a seated female figure with an adolescent male figure on both sides holding symbols of knowledge (scroll), enlightenment (key),

La Madre Filipina

and law and order (stone tablet). One common trend emerges from these sculptural compositions which beg to summon imperial intervention in the various endeavors portrayed in the allegorical pieces—the presence of the imperial eagle, both in animal form or as a decorative element on the throne. Martinez's placement of the imperial eagle in each of the sculptural pieces seems to echo the American presence in the narrated pursuits, transcribing in stone the hands of colonialism extending an altruistic

gesture—"a moral imperative, as wayward native children cut off from their Spanish fathers and desired by other European powers would now be adopted and protected by the compassionate embrace of the United States" (Rafael 2000, 21).

Previous to this commission, Martinez did several important public sculptures, such as the Grito de Balintawak (Cry of Balintawak), 1911, originally situated at the Clover Leaf Bridge, Caloocan City, going to the North Expressway and now located in front of the Vinzons Hall, University of the Philippines Diliman Campus. Martinez completed his artistic training at the Escuela de Pintura, Escultura y Grabado in 1898 and later specialized in sculpture. He also excelled in painting so much so that his *Coming From the Market* won a bronze medal at the Universal Exposition held in St. Louis, Missouri, in 1904.

Another important personality in the field of architectural ornamentation was Vidal A. Tampinco, son of the great Filipino sculptor Isabelo Tampinco. His first major commission was the Capitol Building in Tacloban, Leyte. In 1916, he was commissioned to do the statuary, ornamentation, and woodwork for the Legislative Building, the foundations of which had already been laid. But the project was soon abandoned for lack of funds; he resumed work on the Legislative Building in 1922. In the interim, he had been called to do the statuary for the Jones Bridge, and to help in the renovation of the Malacañang Palace. The panelwork and carved ceilings of the Palace were his work. With his father, he also designed a scale model for the proposed Philippine Capitol, which was to occupy the area behind the present Legislative Building. The domed scale model was exhibited at the St. Louis Exposition where it was awarded a medal. Together with Ramon Martinez, Tampinco designed the ornamental sculptures of the Legislative Building prior to World War II. In the same aesthetic figuration of Martinez's *La Madre Filipina*, he made the enthroned maternal icon a central figure in the pediment of the Legislative Building while being surrounded by a group of Greek mythological figures in different positions as her counsel, thus invoking the guidance of the great twentieth century civilization of America. Represented as an archaic royalty, she holds a scepter of power and is accompanied by two seated consorts, a male and female, on both sides. The male figure is clad in tribal attire and holds a spear, while the female figure is dressed in toned-down, Hispanized baro't saya. Here, the nation is depicted as a product of an unproblematic social cohesion of the Christianized (Hispanized) and tribal, non-Christianized native population.

Pediment of the Legislative Building

At the end of the Pacific war, the Legislative Building had been completely devastated. In 1949, the edifice was rebuilt entirely from memory, with the aid of a blueprint lacking measurements, which had providentially been kept by Tampinco. The architects of the Bureau of Public Works declared that the reconstructed building is a replica of the original, except that it is less ornate.

Drawing upon the heightened diction of classical figuration, Vicente Francisco (1865–1936), a founding faculty of the University of the Philippines School of Fine Arts, executed sculptures gracing the entrances of the different colleges of the old UP university town in Padre Faura. Since the University of the Philippines was the bastion of colonial education, his works not only sought the evocation of inspiration and a

sense of historical continuity with classic civilizations of antiquity, but also endeavored to communicate among the students a particular kind of colonial consciousness, responsibility, and conformity to the colonial order.

Francisco's *Education and Youth, Agriculture,* and *Law* were all female figures that wore classical tunics. Unfortunately, none of these sculptural pieces survived the Pacific War. Archival photographs reveal a representation characterized by a contemplative attitude, absorbed in their thoughts or work. They also wear attributes of their art or hold paraphernalia of their expertise and instruments of their work in their hands: *Education* carries a lamp of enlightenment; *Agriculture* lifts a farming spear; *Law* clutches a stone tablet. These statues were placed on simple pedestals, standing and guarding the portals of learning.

Filipino Architects in the Bureau of Public Works

Beginning in 1903, the Insular government had launched a scholarship program that allowed Filipino students to pursue university education in the United States. Known as the pensionado program, the first recipient of the scholarship for architecture was Carlos A. Barretto, who received academic training at the Drexel Institute of Philadelphia. He worked with the Bureau of Public Works (BPW) from 1908 to 1913 and resumed his service in 1917. Due to the loss and destruction of many official documents, very little is known about the life and professional accomplishments of Barretto in architecture and civil service.

Joining Barretto in 1911 was Antonio M. Toledo, who graduated from Ohio State University in 1910. Toledo rose from the ranks, and, in 1928, he became the Consulting Architect, a post he held until his retirement from government service in 1954. Two other architects followed: Tomas B. Mapua, a Cornell University graduate, in 1910, who worked at the BPW from 1912 to 1915 and from 1917 to 1927, and Juan G. Arellano, a product of Drexel Institute in 1911, who stayed with the BPW from 1916 to 1941.

As they received academic training from the US east coast, the bastion of Beaux Arts philosophy and pedagogy, it was expected that their homecoming would signal the surge in the number of structures in the Neoclassic style that departed from the straightforward volumes and sparse surface decoration initiated by Parsons. The returning young architects, instead, deflected from the grandeur of the Five Orders of Neoclassicism as they were compelled to design more elaborate structures that represented the aspiration of a soon-to-be independent nation worthy of world estimation.

5.111 One of the many allegorical sculptures surrounding the quadrangle of the University of the Philippines in Manila circa 1930

These pensionados, together with the maestro de obras Arcadio Arellano and Tomas Arguelles, formed the first generation of Filipino architects. All six had individual distinctions to claim. Arcadio Arellano was the first Filipino to be employed by the Americans as one of their architectural advisors. He pioneered in the establishment of an architectural and surveying office in the country. Carlos Barreto was the first Filipino architect with an academic degree from abroad, the Drexel Institute in Philadelphia, from which he graduated in 1907. He became one of the pioneering staff of the Division of Architecture. Tomas Arguelles was known as a public administrator who advocated the enforcement of the Building Code of Manila. Antonio Toledo was a master of the Neoclassic style and was among the first architect-educators. Tomas Mapua was the first registered architect in the Philippines and established, in 1925, the Mapua Institute of Technology, the first architectural school offering academic training along the lines of American architecture education. Juan Arellano was the most prolific designer whose first major work was the Legislative Building, a project he inherited from Doane. His influence as an artist and versatile designer spread from Manila to the provinces.

Other architects, who later became prominent figures in the profession and would influence the course of Philippine architecture in the decades to come, joined the BPW to jumpstart their careers. They were Fernando Ocampo from 1923 to 1928, Juan Nakpil from 1926 to 1928, and Alejandro Arellano from 1927 to 1930. Pablo Antonio, then a high school student, also worked with the Bureau in 1918.

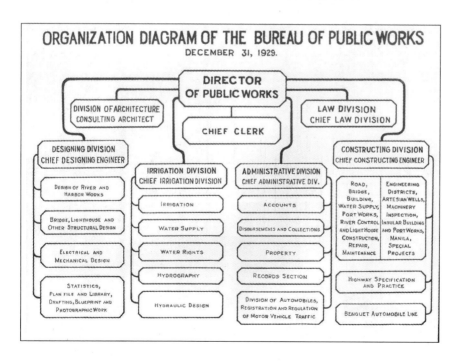

5.112 Organizational hierarchy of the Bureau of Public Works in 1929

ARCADIO DE GUZMAN ARELLANO (1872–1920)

Arcadio Arellano supervised the repair of the convent of Barasoain Church for the Revolutionary Government when he served as Captain of the Engineering Corps of Volunteers of Aguinaldo's revolutionary army in 1898. In May 1909, he was appointed by the Governor-General as a member of the Manila Municipal Board and served on the committee that drafted the Building Code of Manila. In the years that followed, Arellano went into private practice with his brother, Juan, from 1913–17, after the latter graduated from the Drexel Institute. He designed residences and commercial buildings in the Classical Revivalist style, incorporating some innovations of his own. Some of his works contained Renaissance features, touches of the neo-Gothic style, and Art Nouveau motifs and plant forms as decorative motifs. He continued to practice until his death in 1920.

Major Works: Ariston Bautista Lin House, Carmelo and Bauermann Inc., Carmelo Residence, Casino Español, El 82 (Roman Ongpin's Bazaar), Gota de Leche Building, Gregorio Araneta Residence, Hidalgo House, Hotel de Francia, Mausoleum of the Veterans of the Revolution (North Cemetry)

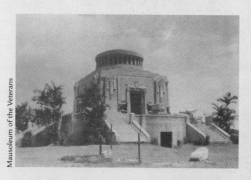

Mausoleum of the Veterans

The **Mausoleum of the Veterans of the Revolution (c.1910)**, a neoclassic mausoleum at the North Cemetery, was commissioned by the government (through Executive Order No. 87, issued by Governor-General James F. Smith on August 28, 1908) to commemorate the revolutionary valor of the Filipinos against Spain. The structure was square in plan, elevated on a podium. The roof is made up of a dome resting on a drum punctured by a series of openings to allow natural daylight. The motifs, such as swags, frets with key patterns, and anthropomorphic relief sculptures alluding to death and mourning completed the neoclassic ensemble. The mausoleum is also known as Panteon de los Veteranos de la Revolución.

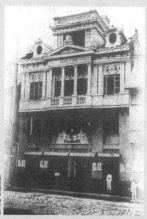

El 82 Bazaar

The four-storey **El 82 Bazaar (1911)**, located at Plaza de Calderon de la Barca (Binondo Plaza), evoked a Revivalist flair expressed through classically balanced Renaissance façade details, such as oval dormer windows, a four-column porch capped with Ionic capitals, a pediment, and a balustrade.

Gota de Leche Building (1917) at Lepanto was modeled after a Rennaissance icon, the Ospedale degli Innocenti, an orphanage in Florence. Arellano utilized an arcaded façade with a row of columns supporting the arches to create a loggia. In between the arches were terra-cotta medallions with relief sculpture of infantile motif.

The **Bautista Lin House (1914)** incorporated Art Nouveau motifs to complement the set of Vienna Sezession furniture around which the house was designed.

ANTONIO MAÑALAC TOLEDO (1889-1972)

At sixteen, Antonio Toledo was the youngest of the pensionados sent to the United States in 1904. He started working with the Bureau of Public Works in 1911 as a draftsman under William Parsons. In 1915, he was promoted to the position of Superintendent Architect and became Consulting Architect in 1938, a position he held until his retirement from government service in 1954. Collaborating with Parsons, Toledo designed the Women's Dormitory of the Philippine Normal School. With Parsons's departure from the Bureau, Toledo assumed custody of implementing the designs for the buildings of the UP Manila campus, including the College of Medicine Annex and the University Library. His fidelity to neoclassicism yielded monumental and memorable edifices, such as the twin Corinthian buildings in AgriFina Circle in Luneta, the Leyte Capitol, and the Manila City Hall among others, making him a legitimate master of the style. In 1947, he became a member of the Architects and Engineers mission that toured the United States and South America to prepare for the planning of the Capitol buildings and the UP Diliman Campus in Quezon City. He was among the first professors at the Mapua Institute of Technology (MIT) when it opened in 1925 and taught there even after his retirement until 1967. Toledo was a master of the neoclassic style and has been known for his design of the UP Padre Faura campus buildings and the AgriFina buildings.

Major Works: City Hall of Manila (1941), Department of Agriculture and Commerce (now the Tourism Building), Department of Finance Building (now the National Museum) (1934), Leyte Capitol (1920s), Cebu Provincial Capitol (1937), Manila Custom's House, UP College of Medicine Annex (Padre Faura Campus), UP University Library (Padre Faura Campus), Women's Dormitory of the Philippine Normal School.

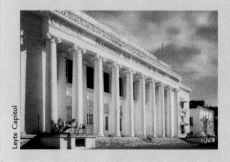

Leyte Capitol

Leyte Provincial Capitol (1917) was defined by a high and imposing Ionic colonnade comprised of two rows of ten Ionic columns, which stretched across almost the entire façade of the building. The outer rows of columns carried the weight of a projecting entablature, while the inner rows were attached to the front wall. Ornamental details and reliefs were executed by sculptor Vidal Tampinco. The front of the structure was approached by a monumental flight of steps. Just behind the colonnade was a public lobby, with a vaulted ceiling and arcaded walls, from which a broad staircase leads to the spacious Session Hall on the second floor that extends up through the building by means of a clerestory treatment.

Agriculture and Finance Buildings (1934) were identical buildings located on opposite sides of the AgriFina Rotunda, which was originally planned by Burnham as a semi-circular plaza on the eastern portion of the National Capitol Buildings from where radial boulevards were to commence. The concave façade was set off by grand steps leading up to the colonnade of six columns with Corinthian motifs. From there, four huge archways punctuated the façade.

Manila City Hall (1941) The construction of this building started in 1936 and was finished before the outbreak of war in 1941. It occupied a long and almost trapezoidal site between the Legislative and Post Office buildings. Due to the shape of the lot, lack of symmetry, and monotonous detailing, the principal façade and main entrance were indistinguishable. The south elevation had an entrance with a balcony defined by three arches separated by Corinthian columns. The north entrance was articulated in the same stylistic treatment with the addition of pediments and a tall, hexagonal clock tower terminating into a miniature dome.

5.113 Gota de Leche Building designed by the brothers Arellano in Manila

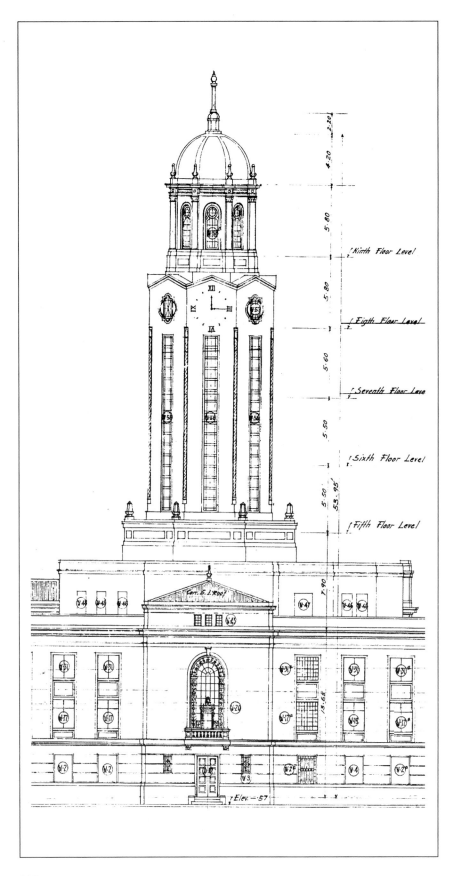

Nimth Floor Level

Eigth Floor Level

Seventh Floor Level

Sixth Floor Level

Fifth Floor Level

5.114 Drawing of the Manila City Hall 's iconic clock tower

5.115 Detail of the Manila City Hall viewed from the central courtyard (opposite)

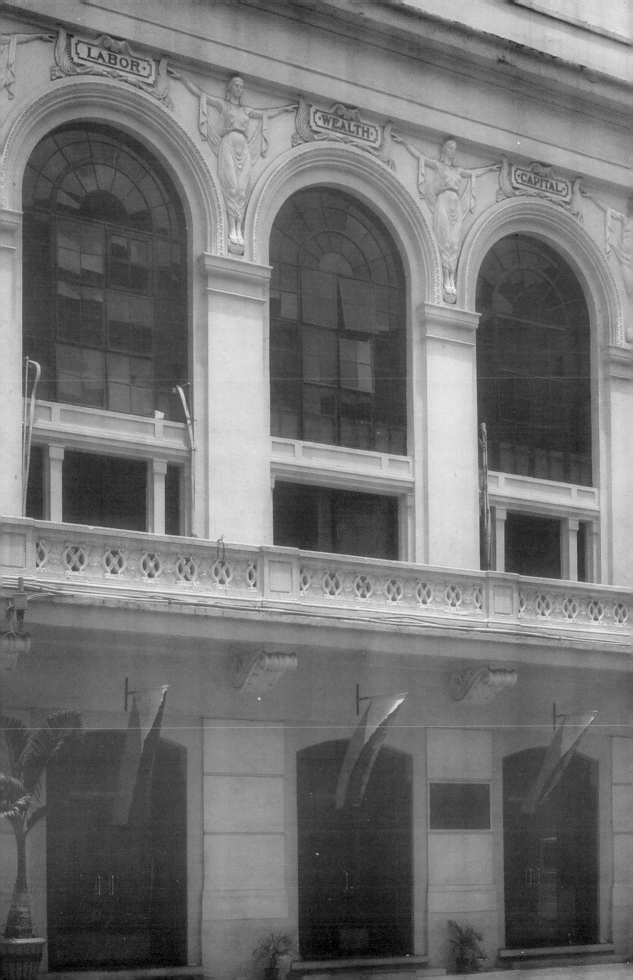

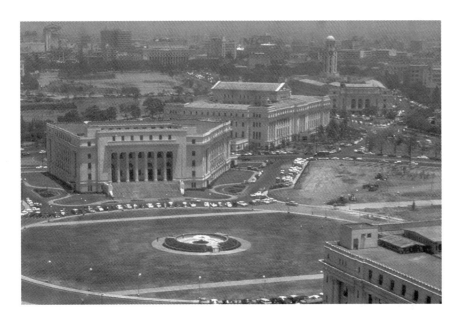

TOMAS BAUTISTA MAPÚA (1888–1965)

Tomas Mapua was the first registered architect in the Philippines. He worked at the Bureau of Public Works where he became supervising architect from 1918 to 1927. He later left government service and established the Mapua-Yuchianco-Tiaoque Construction Works Inc., which supervised the construction of various major buildings, such as the Post Office Building. The founding of the Mapua Institute of Technology (MIT) in 1925 is his most significant contribution to Philippine architecture. Mapua became the first chairperson of the Board of Examiners for Architects in the Philippines. He also became a cofounder of the Philippine Association of Colleges and Universities and of the Philippine Architects' Society, later renamed Philippine Institute of Architects, where he became one of its presidents.

Major Works: Arsenio Locsin House, Tomas Mapua Residence, Centro Escolar University Building, De La Salle College (now University), J. Mapua Memorial Hall, Nurses' Home at the Philippine General Hospital

Nurses' Home

Nurses' Home, Philippine General Hospital (1920s)
The building's architectural imagery was derived from the Renaissance idiom. The symmetrical façade was apportioned into three horizontal zones: a Florentine arcaded entry on the first level; quadrangular windows, laced by simple cornices on top on the middle level; and a balustraded balcony with arches severed by Ionic pilasters on the last level. The entrance, accentuated by slightly protruding Corinthian columns crowned by anthropomorphic Renaissance statues, led to an open patio.

5.118 Centro Escolar University designed by Tomas Mapua

5.119 Mapua Institute of Technology

5.120 De La Salle College (now University) by Tomas Mapua

TOMAS FERNANDEZ ARGUELLES (1860–1950)

Tomas Arguelles worked as an inspector of roads and public works for the Street Car Company from 1884 to 1892 and at the Manila Railroad Company from 1892 to 1896. He then served as the commander of the main body of Filipino Engineers in the Philippine Revolutionary Army. Active in public service, he was a councilor for the City of Manila from 1902 to 1907 and became a member of the Committee for the Revision of Tax Assessments and Honorary Commissioner to the Saint Louis Exposition. He was reelected city councilor in 1917 until 1919. Because of Arguelles' familiarity with local conditions, he was made President of the Board of Appeals of Real Estate in Manila. After he received his license to practice architecture under the Engineers and Architects Law of 1921, he became a senior partner in the firm Arguelles and Magsaysay. He later formed an architectural partnership with Fernando Ocampo. In 1950, he was elected fellow of the Philippine Institute of Architects. He was also a member of the Board of Directors of the Academia de Arcquitectura y Agrimensura de Filipinas, the first professional organization of architects, engineers, and surveyors in the Philippines founded in 1902.

Major Works: Elizalde (Ynchausti) Building; Heacock's Building

Heacock's Building (1931)
The Heacock's Building (1931) was a collaboration among Architect Arguelles and Engineers Odom and Cantera. The eight-storey edifice was one of the major department stores of the period that stood on the corner of Escolta and David streets. Scholars have established a strong similarity between the façade treatment of this structure with that of Luna de San Pedro's Insular Life Building. In this building, however, the protruding and chamfered corner was plainer in articulation. This terminated in balconies with art deco grillworks and surmounted by bas-relief sculptural panels. The 1937 earthquake that shook Manila scarred the building with irreparable damages which led to its demolition.

Heacock's Building

Colonial Tutelage and the Diffusion of Architectural Knowledge

In a colonial society, the knowledge systems of the colonist assume a privileged position while local knowledge may be subdued or repressed in the pursuance of modernity. Colonial tutelage or the act of teaching or channeling knowledge originating from the metropole to the local artisanal populace who would comprise the corps of professionals in the colony was accomplished through the pensionado program.

The homecoming of pensionado architects spurred the establishment of architectural schools where they were recruited as faculty members, advisers, and consultants. Apart from the pensionados, these educational institutions employed

the expertise of some foreigners like the American architect Cheri Mandelbaum of the Bureau of Public Works who worked as chief draftsman during Parsons's tenure. Overall, their architectural training from the United States and Europe served as the backbone for the pedagogical framework disseminated in these schools, which was basically oriented towards the Beaux Arts method. This institutionalized what American architects Parsons, Doane, Fenhagen, Mandelbaum, and even Burnham himself had professed in their works in the Philippines as they were all nurtured in American east coast Beaux Arts tradition. Moreover, the pensionado architects were trained at Cornell, Drexel, and Harvard—institutions firmly grounded in the Beaux Arts pedagogy. The curriculum for the Bachelor of Science in Architecture at the Mapua Institute of Technology and the University of Santo Tomas reflected this French school lineage through the emphasis on rendered drawings and perspectives, highly symmetrical planning and massing, and Classical Revival preferences in details and motifs. Even up to now, vestiges of this Beaux Arts system are still widely practiced in architecture schools in the Philippines. The design problems done with rapidity are still called *esquisses*, while complex problems are called *charettes*. For the licensure examinations for architects, prospective architects still study the classic orders of architecture and how to graphically represent them. It was through the teaching of Western doctrines, technologies, and aesthetics within an academic institutional setting that the neoclassical style was firmly entrenched and transmitted to future Filipino architects.

Prior to American colonization, the architectural profession was essentially embodied by the maestro de obras (literally translated as "master builder"). There was no actual title of "architect." Instead, the maestro de obras was responsible for the construction and supervision over the erection of public and private structures. The nearest form of architectural education during the Spanish period was the Escuela Practica y Profesional de Artes y Oficios de Manila, which was established by the Spanish government in 1890. Among the first graduates of this school were Arcadio Arellano, Juan Carreon, Julio Hernandez, and Isidro Medina. Later, private schools, such as the Liceo de Manila, was established in 1900, granting the academic title of maestro de obras. Francisco Agraran, Carlos Diaz, Antonio Goguico, Angel Tampinco, and Zoilo Villanueva were among the first graduates of the Liceo. The Liceo, together with the Academia de Arquitectura y Agrimensura de Filipinas, the first professional organization of architects, engineers, and surveyors, founded in 1902, offered a four-year course in civil engineering and architecture in 1904.

The Mapua Institute of Technology (MIT) was a pioneer architectural school established in 1925 by Tomas Mapua after his return from the United States. MIT, originally a night school for working students, offered courses leading to

degrees in architecture and engineering. In 1930, the University of Santo Tomas (UST) established its School of Architecture and Fine Arts. Soon after, Adamson University opened its architecture program in 1941. That same year, the Philippine College of Design was founded and it recruited the luminaries of the design profession in the Philippines as its faculty. However, the Pacific War halted its operation and it never reopened after the war. Other schools of architecture outside Manila would also institute architecture courses after World War II, such as the Cebu Institute of Technology (1946) and Mindanao Colleges (1953).

In 1921, the very first Engineers and Architects Act No. 2895 was passed by the Philippine Assembly. Under this act, two separate boards of examiners (one for engineering and another for architecture) would be created to oversee the administering of licensure exams. Licensed maestro de obras or "master builders" were also automatically granted the title "architect" under a grandfather clause in the act. Through this legislation, the practice of architecture was officially recognized as a profession subject to state regulation. The formation of the professional organization also served as a unifying force among architects of the early twentieth century. The Philippine Architects Society was established in 1933 as a response to the growing number of architecture professionals in the Philippines. The first president was Juan Nakpil, with Tomas Mapua as Vice-President, Harold Keys as Secretary, and Sidney Rowland and Fernando Ocampo Sr. as directors. Some of the organization's undertakings were the drafting of its Constitutions and By-Laws, the "Rules of Charges and Professional Fees," and the Canon of Ethics of the Society.

Apart from the training received from an academic setting, another form of tutelage was the master-apprentice system that existed within the office of the Bureau of Public Works. As the BPW was basically tasked to supervise the design and construction of public structures and landscapes in the islands, it operated like an architectural firm. The office was headed by an American Consulting Architect and a host of draftsmen. The office was a man's world as the employees were all male. Like in any architectural office, the main designer might be the principal architect. The draftsmen, under the direct supervision of the consulting architect, churned out construction plans, details, specifications, and blueprints for the office. The architects-to-be were trained as interns, learning the rigors of the architectural practice in an actual office setup. In fact, by the time of the Commonwealth period, almost all of the ninety-six registered architects in the Philippines were either trained at an American university or the BPW. That is how pervasive the influence and bearing of the BPW was on the creation of public architecture in the Philippines during that time.

Emergence of New Building Types

By the middle of the 1910s to late 1930s, Manila's skyline gradually grew as corporate and commercial buildings rose in the districts of Binondo and Escolta. Liberal economic policies of the Americans provided a propitious climate for businesses to flourish. Improved commerce and the influx of foreign capital generated a construction boom where the multistorey commercial building made its debut. Apart from the government architects who moonlighted in private practice, there were a few American design professionals like R.S. Rewell, Sidney Rowland, Arthur Gambler Gumbert, and Harold Keys who were practicing in prewar Manila.

The new, concrete, multilevel structures were emblems of prosperity in the heady atmosphere of free enterprise and economic growth. American cultural influence also grew with the increase in the number of apartment buildings, shopping arcades, diners, movie houses, restaurants, and nightclubs. Vaudeville, social clubs, baseball, boxing, and moving pictures were typical forms of entertainment that required new building types. For one, the Spanish colonial churches, which had helped placate the natives in the previous colonial era, yielded to American-inspired cinema palaces as the new congregational space where the Filipinos watched the alluring liturgy of Hollywood. The dim interiors of the cinema houses facilitated cultural indoctrination as Filipinos participated in the rituals of faith in the "Great American Dream" that was projected onto the fourth wall of the cinema.

Multistorey structures during this period did not exceed more than thirty meters. In the absence of air-conditioning technology, high ceilings, courtyards, large windows, and arcaded ground floors were the norm in such a typology. In 1912, Manila's first reinforced concrete multistorey structure, the Kneedler Building, was completed by William James Odom. Built at the intersection of Carriedo Street and Rizal Avenue, the Kneedler Building was a sparse, four-storey structure with an arcaded ground floor. All the concrete was mixed and poured by hand since mechanical mixers and elevated chutes for mechanically distributing to the forms had not yet been imported. Odom, teaming with Fred Patstone, a former Manila City Engineer, and George Fenhagen, Consulting Architect, completed the imposing Masonic Temple in 1913. Odom got carried away with the building fever. Considered as the father of commercial concrete edifices in Manila, he embarked on a building spree on the streets of Escolta and Dasmariñas, which resulted in the Burke Building, Yangco-Rosenstock Building, La Estrella del Norte Jewelry and Auto Palace, and the four Gibbs Buildings.

5.122 Plaza Cervantes in Binondo, dominated by Manila's early skyscrapers, the Uy-Chaco Building and Insular Life Building (opposite page)

5.123 The Kneedler Building in Rizal Avenue, Manila, was the first multistorey reinforced concrete structure in the Philippines.

New technologies, such as telephones, lifts, and plumbing, were first integrated in the Manila Hotel in 1912. The Burke Building in Escolta, constructed in 1918, earned the distinction of having utilized the first Otis elevator for a commercial structure in the country. The American Hardware and Plumbing Co. Building (1912) was one of the first modern stores to operate a department store-type of merchandising. The Roxas Building (1915) at the corner of Calle David and Escolta was a notable, multistorey commercial edifice of the period, which was later expanded by Andres Luna de San Pedro to occupy an entire block, then renamed Regina Building in 1926. Tall corporate and commercial buildings like the neoclassic El Hogar Filipino Building (1914), Hong Kong Shanghai Bank Building (1921), Filipinas Insurance Co. Building (1922), Pacific Commercial Company Building (1923), and China Banking Corporation (1924); the French Renaissance Luneta Hotel (1920s); and the Art Nouveau Mariano Uy Chaco Building (1914) altered Manila's skyline in the 1910s and early 1920s.

5.124 William James Odom

Arcades on the ground floor of buildings were the most noticeable architectural element in the commercial, multilevel structures. The practice of integrating covered arcades and loggias on street level was a long-standing practice in Spanish colonial architecture, providing pedestrians a more shaded and comfortable path to tread. This architectural feature made its presence felt in highly urbanized areas, such as Escolta, Rizal Avenue, and Binondo in Manila and in the urban centers of the provinces of Cebu and Iloilo, precisely because of the density and proximity of the

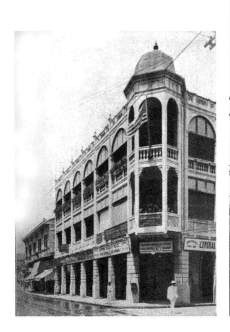

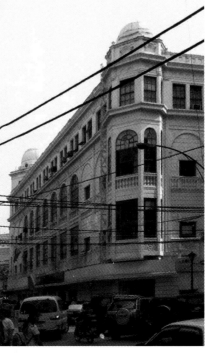

5.125 The Roxas Building (left) completed in 1915, wa expanded by Andres Luna d San Pedro in the 1920s, an renamed Regina Building (right)

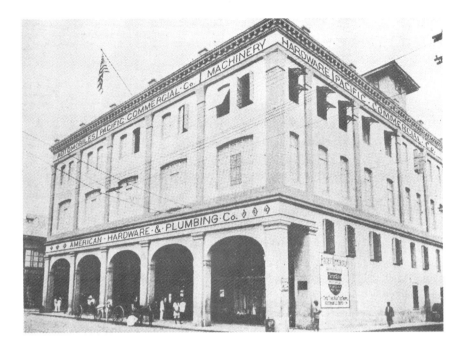

buildings to one another. An uninterrupted succession of shaded arcades was created on the ground level of several commercial and institutional buildings when these buildings were built beside each other. The shaded walkways not only protected the pedestrians from the intense heat of the sun but also doubled as cover during thunderstorms and monsoon rains. During the rainy season, the arcades became the link between the streets and the building, creating a more intimate relationship with the horizontality of the street level with the verticality of the structure.

In 1906, William Parsons recommended the construction of arcades over sidewalks in certain business streets for protection against sun and rain and for the convenience of wholesale and retail dealers and the general public (Report of the Philippine Commission 1906, 366). This recommendation was codified into a law by the Municipal Board: "On streets or portions of streets designated by the Municipal Board, the building of arcades shall be obligatory. In all cases, the general form of arcades or projections shall be determined by the City Engineer. All projections shall be at least three meters above the established sidewalk grade at the established street line" (Revised Ordinance No. 109, from Malcolm 1927). These arcaded streets were in the whole of Calle Echague, Calle San Fernando, Calle Rosario, and Avenida Rizal.

The neoclassic El Hogar Filipino Building (also known as the Building and Loan Association), designed by Ramon Irureta-Goyena and Francisco Perez Muñoz, was completed on September 14, 1914. Its name was derived from a financial cooperative founded by Antonio Melian who formed the company in 1910 for the purpose of issuing mortgages and returning the earnings to its members in proportion to what they had contributed. The building was also occupied by Smith, Bell and Co. and the Warner Barnes and Co. It was located on the northwest corner of Juan Luna Street and Muelle de la Industria. The El Hogar had three storeys, with a fourth penthouse storey on the southeast corner to achieve some verticality in order to neutralize its otherwise squat, palazzo-like appearance. The façade was

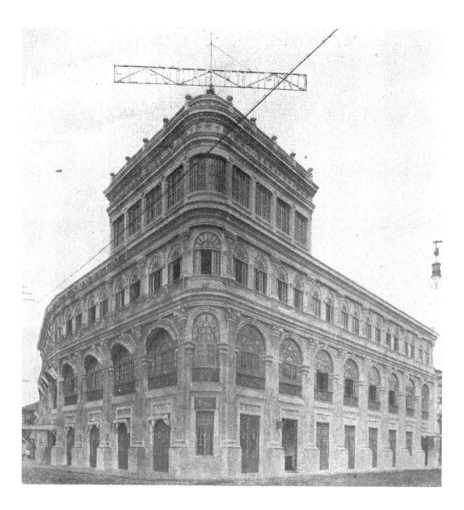

defined by flat pilasters rising from plinths that reached up to the second floor and terminated in arches. Over the arches was the entablature, surmounted by a cornice and crowned by the third storey balustrade. The windows of both the second and third floors were fitted with fanlights—those on the second floor were twice the size of those on the third floor, which were grouped together in pairs. Notable neoclassic architectural details were the pilasters topped by Corinthian capitals with two helices and two layers of acanthus leaves. The second storey had stylized Doric capitals, which supported the banded arches over the fanlights. Each arch had a key console. The second to the fourth floors had cornices that were followed by dentils.

Departing from the neoclassic norm was the Art Nouveau Mariano Uy Chaco Building (now the Philtrust Building) designed by Samuel E. Rowell in 1914. The building was the headquarters of Uy Chaco and Sons, a hardware firm that imported and distributed American products locally. The six-storey structure, located at the northwestern corner of the former Plaza Cervantes, featured undulating balconies with florid wrought iron grilles set into its apex. Such organic patterns, manifested in the ironworks and fluid curves exhibited in the balconies that recalled botanic growth, were the essential characteristics of the Art Nouveau style. The building possessed well-articulated bays totaling to eight; each consisted of an

arch on the first floor and a slightly projecting, curved balcony on the third, fourth, and fifth floors. The solid facade was broken at the sixth floor by an open circulation space delicately accented by alternating narrow and wide, oval-shaped frames. The most arresting architectural element was the ornamental, projecting turret crowned by a ribbed, eight-sided, bell-shaped cupola surfaced by iron tiles made to appear like shingles. The turret doubled as a clock tower, with a series of clocks surrounding the circumference of the cupola's base. Perhaps, the most anachronistic portion of the building's facade was the first floor, as it evoked a neorenaissance character with its stylized rusticated bands and stepped arches with false keystones.

Next to the El Hogar Building was the five-storey, neoclassic Hong Kong and Shanghai Bank (HSBC) Building designed by British architect GH Hayward. Completed in 1921, the building's first floor was occupied by HSBC, while the upper floors were leased to other foreign firms, such as Sun Life of Canada and Smith, Bell and Co. In the 1980s, it was sold and renamed the Hamilton Building, serving as a warehouse for lighting fixtures. Stylistically, the building employed Revivalist elements, such as Ionic pilasters, large grilled windows, an arched doorway, and mouldings. The ground floor had vertical rustications, with each window distinctly defined by a projecting console. Ornamental details, such as

ART NOUVEAU

While the neoclassical style gained widespread application in civic architecture, the Art Nouveau style assumed popular application in the design of residential and commercial architecture, graphics, fashion, and accessories in the first two decades of the twentieth century. Its dominant characteristic was its abhorrence of right angles in favor of the whiplash curve that influenced both the form and surface decoration of objects. Art Nouveau's organic fluidity was inspired by the pattern of plant growth and its principle could be applied to the design of anything, from architecture to graphic design. Art Nouveau distrusted the machine age and its assembly-line production and favored the guild system of handcrafted products. Its principal motif was the curving whiplash, which found permutations ranging from a woman's windblown hair to ocean waves and lilies found in graphic arts, paintings, sculptures, and architectures.

horizontal dentil bands and egg and darts, unite the neoclassic composition. The principal elevation was located on the chamfered side of the edifice, distinguished by a pair of crowning turrets on the top floor. The main door was distinguished by a relief of triumphal arches at street level.

The five-storey Pacific Commercial Company Building (also known as the National City Bank) was designed by American architects Murphy, McGill, and Hamlin of New York and Shanghai, and was completed in 1923 at a cost of two million pesos. Occupying about 1,800 square meters of an irregularly shaped corner lot adjacent to the El Hogar, it has a frontage of forty-three meters on General Luna Street and forty-six meters on Muelle de la Industria, along the Pasig River. The building derived its design from the trademark architectural features set by the International Banking Corporation of New York for its overseas branches. The bank's prototype was made up of a row of colossal columns *in antis*, which was faithfully reproduced for its Manila headquarters. The ground floor was fully rusticated to effect a textured finish. This floor had arched openings with fanlights emphasized by stones forming the arch. The main doors were adorned with lintels resting on consoles. Above the ground floor were six three-storey high, engaged Ionic columns, ending in an entablature topped by a cornice. These six columns dominating the south and west facades were, in turn, flanked by a pair of pilasters on both fronts. The fifth floor was slightly indented and also topped by an entablature crowned by strips of anthemion.

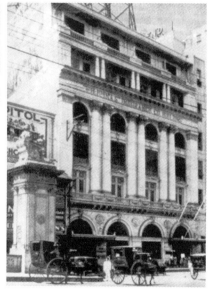

A similar treatment could be found in buildings, such as the Filipinas Insurance Co. Building and the China Banking Corporation, within the vicinity. The Filipinas Insurance Co. Building's ground floor had wider and more defined arches. The middle portion of the building utilized three pairs of fluted Corinthian columns, and the windows in between were treated with pediments and arches. The same imagery was evoked in the China Banking Corporation, built in 1924, with the second to the fourth floors having fluted Corinthian columns with pronounced acanthus leaves and volutes as well as engaged pilasters. The third and fourth floors had swags in heavy bas-relief. The corner swags had a female face at the center. These floors also contained consoles, which supported medallions on each bay. There were bands of dentils and acroteria on the cornice.

Juan Arellano: Crossing the Gaps between the Beaux Arts and the Vernacular

Attested by a body of works that consistently manifested judicious planning while exhibiting a style that had been scrupulously sieved in the midst of fanciful eclecticism and revivalism, Juan Arellano was considered the most creative and architecturally gifted among the first generation of Filipino architects. For this distinction, Arellano was posthumously awarded the Centennial Honor for the Arts by the Cultural Center of the Philippines in 1999.

Juan Arellano (1888–1960) was born in Tondo, Manila. He was the son of Bartola de Guzman and master builder Luis C. Arellano. With his father's sudden death when he was only thirteen, he quit studying at the Ateneo to work at the Bureau of Lands where he eventually became a draftsman. During that period, he studied painting under Lorenzo Guerrero after office hours.

When he was eighteen, Arellano ran away and traveled to the United States to study architecture. There, he was able to find work, first as one of the numerous Filipinos who were "displayed" at the Jamestown Exposition, and, later, as a photograph colorist in a commercial museum in Philadelphia. Propitiously, a couple took interest in him and decided to sponsor his education at the Philadelphia Academy of Art. In 1906, he enrolled at the Architectural School of the Drexel Institute in Philadelphia. After graduation, he and his two American friends went on a tour of Europe. A year later, he returned to the United States, finished a postgraduate course in architecture at the University of Pennsylvania, and attended the Beaux Arts School in New York, further enhancing the influence of the Paris Ecole de Beaux Arts tradition on his stylistic slant.

Arellano returned to the Philippines to become one of Manila's most important architects. With his equally esteemed brother, Arcadio Arellano, he worked on such projects as the Gota de Leche Building and the old Casino Español. Afterward, he was employed at the Bureau of Public Works, rising from the ranks as an assistant, supervising, and, finally, consulting architect. In the long haul, however,

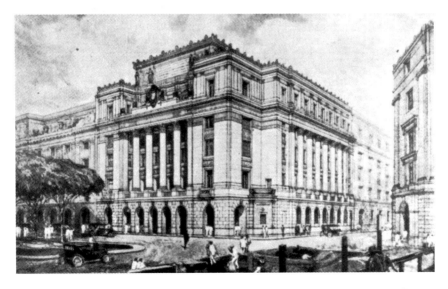

5.132 Arellano's award-winning design for the Bank of the Philippine Islands

he steered the development of Philippine architecture, from its neoclassic phase to its protomodern (art deco and streamline moderne) and nativist phases.

Arellano was also a painter, an aquarellist of note. His 1913 work *Forest* is considered as one of the first impressionist paintings done by a Filipino artist. Some art historians believe that he was instrumental in conditioning the climate for modernism to flourish in the country.

Arellano's virtuoso articulation of neoclassicism assumed international stature, receiving world acclaim in a competition held in New York where he submitted a design for the Bank of the Philippine Islands. Through his famous works, such as the Legislative Building (now the National Museum), the Jones Bridge, and the

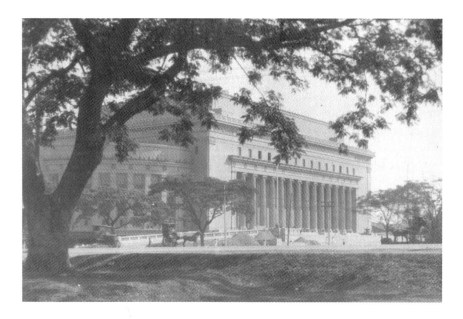

Manila Post Office, his espousal of monumental neoclassicism in the Philippine architectural scenography imbued the American form of government and civic culture with presence and made unerringly palpable its imperial aspiration in ferroconcrete. To some extent then, Pax Americana in the Pacific translated into a global urbanism of a neoclassical standard and a civilizational dynamic predicated on the marmoreal tradition of the ages.

This said, it must at once be pointed out that Arellano interpreted and appropriated the grammar of Beaux Arts in the context of the tropical milieu, successfully conversing across two architectural idioms in structures that hint at hybridity. Again, as with his predecessors, this aesthetic choice was in cadence with Burnham's urban directives, the spatial logic in which the imperialist time dwelled. His architecture teaches us a lesson or two about so-called indigenization, which as it is evidenced here, is not simply a matter of nativist will and pride, but also an imperialist strategy appealing to pastoral nostalgia.

As one of the official architects of the government, he designed other notable structures, such as the Chamber of Commerce Building, the Manila Yacht Club buildings, and the Villamor Hall (now the Supreme Court Building) in the University of the Philippines in Manila. He also initiated the master plan of the University of the Philippines Diliman campus and did projects in the regions of Banaue, Ifugao, and Cotabato. As an architect, he was credited with appropriating Western architectural styles within local requirements and resorting to stylized native motifs and forms in his works, thus contributing to a highly nuanced idiom of neoclassic, art deco, and nativist aesthetics in Philippine architecture.

The Post Office (1931) boasted of a harmonious combination of proportions, purity of lines, and chastity of detail that paralleled the Lincoln Memorial. The façade was defined by a huge, rectangular volume flanked and buttressed by two semicircular wings. The composition was crowned by an attic storey which negated the otherwise severe simplicity of the façade. Emphasis was placed on the portico where the rhythm of sixteen Ionic columns rendered their beautiful entasis.

Jones Bridge (1921) was lavishly designed in consonance with the ideals of the City Beautiful endorsed by Daniel H. Burnham and in a manner akin to Pont Alexandre in Paris. The bridge had three structural arches resting on two massive piers. Both ends of the bridge were marked by allegorical statuary on large plinths.

The Villamor Hall of the University of the Philippines in Manila (now the Supreme Court Building) emanated from a Renaissance pedigree. The main portal was sheltered by a recessed portico with an arch supported by free and engaged columns. A bracket or ancones accented the arch; while the flanking pilasters were crowned by cartouches.

Arellano's twin buildings (Benitez and Malcolm Hall) at the University of the Philippines Diliman campus revivifies the design vocabulary popularized by William Parsons at the beginning of the twentieth century through its sparse use of classical details and tiled roofing. Finished in 1941, the two edifices were the last government buildings to be constructed before the outbreak of the Second World War.

5.135 Drawing of the Jones Bridge with allegorical statuary by sculptor Ramon Martinez

5.136 Arellano's neoclassic tandem of the Post Office Building and Jones Bridge evoked the grandeur and elegance of Parisian urbanity in the American tropics.

Though he excelled greatly in the classical style, Arellano shifted to art deco as most prominently revealed in the Metropolitan Theater. Art deco was a synthetic form of stylization mediating between the traditional and the avant-garde. The building silhouettes of the art deco were given to profuse abstraction and stylization, rich ornamentation, colorist effects, dramatic massing in simplified geometric forms as well as exotic imagery derived from archeological sources. Nativist iconography is expressed in telltale Philippine details, such as bamboo banister railings, carved banana and mango reliefs, and batik mosaic patterns.

Turning away from the classicists, decorative indulgences, Arellano collaborated, in 1934, with other architects of the Bureau of Public Works and came up with the archetypal streamlined deco, the Rizal Memorial Stadium. Its aerodynamic curves suggested speed, efficiency, and, most of all, modernity. This structure, considered a precursor of the Modern International style, was a horizontal, rectangular container, with aspects intimating mass production: rounded corners or semicircular bays; mechanically smooth building skin; punctured porthole windows; tubular steel railings; and projecting, thin roof slab.

Arellano's romantic nativist stance was exemplified by his proposals for government buildings in Banaue, Ifugao, and in Glan, Cotabato. This collection of works proved to be a departure from his neoclassic lineage and most probably undertaken in the pursuit of his nationalist calling. The work required the grafting of elements quoted from the vernacular architecture of the region where the proposed edifice was to be sited. Acquiring their basic contours, Arellano's designs transformed and magnified the Ifugao fale, Bontoc dwelling, and Tausug house into a city hall, government hospital, and municipal building, respectively. For the Cotabato municipal house, he appropriated the Tausug gable roof and pinnacled it with an elaborately carved crossgable finial based on the naga tajuk pasung. In a similar nativist vein, his master plan for the University of the Philippines Diliman campus drew inspiration from autochthonous architectural sources, such as the salakot and nipa hut roof for the design of major buildings.

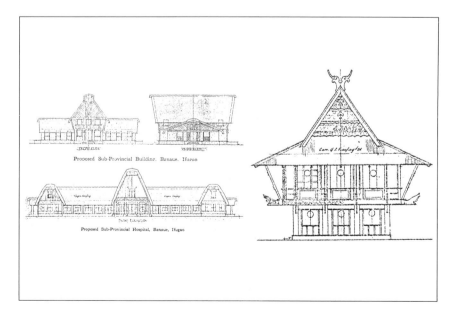

5.137 Villamor Hall in Manila, formerly occupied by the University of the Philippines' College of Music and Fine Arts (now the Supreme Court Building, opposite page)

5.138 Arellano's native-inspired designs for government buildings in the 1930s

5.139 The Legislative Building

5.140 Negros Capitol

5.141 Chamber of Commerce Building

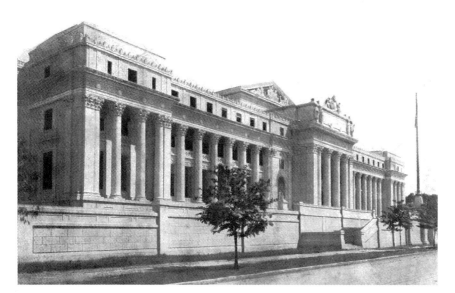

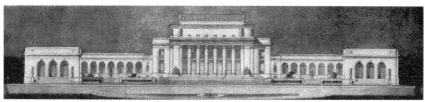

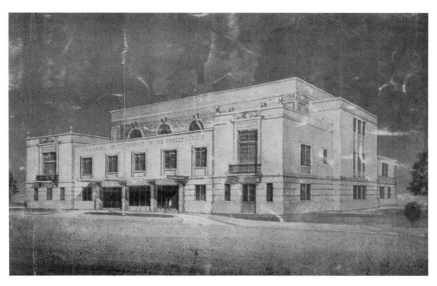

Aside from being recognized for his design of government buildings, Arellano, in the course of an accomplished career, had made extensive studies for the enhancement of the Burnham plan and was credited with the landscape design of certain sections of Manila, particularly Padre Burgos Avenue, Harrison Park, the North and South Port Areas, Dewey (Roxas) Boulevard, and the Malacañang grounds. Here, Arellano's interest as an architect and as a painter—a venturesome Impressionist—found convergence. The modernism he cherished in architecture resonated with his explorations in the visual arts, culminating in cityscapes and

habitations where people came to belong and felt a sense of country with all the nuances of patriotism.

But it was around the area of the present-day Lawton where Arellano really made his mark, with all the structures from the Pasig River (the Post Office) to Taft Avenue (the Supreme Court) bearing his signature. It was this modernity that marked the history of the city as a center, and, at the same time, as a vortex of a decline. But, it was throughout the islands of the archipelago where the architect had divined and drafted signs of the native that resided with a more progressive modernity, a home not made to fit to scale.

The Second-Generation Architects and the Shift to Art Deco
The so-called second-generation architects, such as Andres Luna de San Pedro, Pablo Antonio, Fernando Ocampo, and Juan F. Nakpil, flourished amidst the struggle for political independence from America. Like their predecessors, they were trained in American universities and had traveled extensively to Europe, exposing themselves to a new style that quickly swept the Western hemisphere—the Art Deco.

Armed with the new aesthetic from Euro-America, they returned to the Philippines to challenge the dominance of the neoclassic style in the local practice. These architects could be seen as cultural agents in the shift toward the new, stylistic phenomenon. With innovative ideas and novel ways of utilizing ornaments, they designed structures that departed from the Beaux Arts idiom, and propagated among the public the mantra of art deco.

Andres Luna de San Pedro, the most senior of the group and the most European in orientation, returned to the Philippines in 1920. Fernando Ocampo graduated from the University of Pennsylvania in 1921, but was sent to Rome as a student fellow. Juan Nakpil received his Master's degree at Harvard in 1926, and supplemented his knowledge by attending the Ecole des Beaux Arts for one summer. Pablo Antonio returned, in 1930, from the University of London, after completing the five-year architectural course in a span of three years.

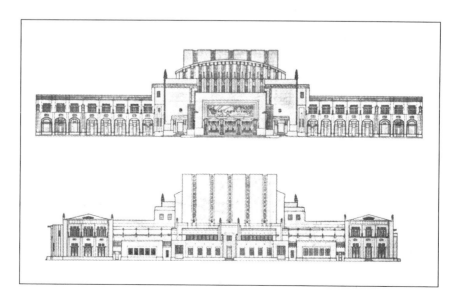

5.142 Drawings of the facade and rear elevations of Arellano's art deco Metropolitan Theater

Andres Luna de San Pedro and Fernando Ocampo initially utilized the revivalist styles, but by, 1930, they had produced some of the most modern buildings in Manila. Juan Nakpil and Pablo Antonio, on the other hand, were vanguards of art deco modernism from the very outset of their design practice.

As pioneers in modern design in the country, the four architects were notable for their contributions that represented a new direction in Philippine architecture. Luna de San Pedro introduced new architectural forms in the Philippines by incorporating modern and exotic design motifs through the grammar of art deco. Likewise, Ocampo designed buildings with straightforward simplicity, synthesizing traditional designs with art deco ornaments typifying the *moderne style* of the period. Nakpil worked largely in the art deco style, combining stylized flora and angular forms. Nakpil's prewar architecture was marked by the presence of rounded corners, round columns, plain surfaces, continuous horizontal walls and windows, and minimal ornamentation. These structures were archetypal of an art deco strain known as *streamlined moderne*. Some of Nakpil's works were protomodern, which seemed to anticipate the emergence of the International Style of modernism in the postwar years. In similar trailblazing concepts in architecture, Antonio veered away from the traditionalist and academic styles to embrace moderne streamlining with his use of bold, clean lines, straightforward surfaces, and spare, rectangular masses.

From this generation, Juan Nakpil and Pablo Antonio were to emerge as the country's National Artists for Architecture, the highest honor given by the Philippine government to artists.

ANDRES LUNA DE SAN PEDRO (1887–1952)

The son of the great Filipino painter Juan Luna and himself a highly-acclaimed painter, Andres Luna de San Pedro served as an architect of the City of Manila from 1920 to 1924. He later went into private practice and trained Filipino architects who worked under him. Although schooled in the academic and revivalist Beaux Arts style, he was one of the pioneers of modern design in the Philippines. His works in the revivalist style include the Legarda Elementary School and the Rafael Fernandez House, which was used by President Corazon Aquino as her official residence during her term. Works in the art deco and modern styles include the Perez-Samanillo Building and the Crystal Arcade, which was regarded as his masterpiece and considered as Manila's most modern building before World War II. The neocastilian Perkin's House, as mentioned in pre-World War II publications, was said to be the most modern in the country when it was built and was awarded first prize in the 1925 House Beautiful Contest.

Major Works: Alfonso Zobel House, Basa Residence, Crystal Arcade (1931), Evangelista Residence, Fernandez-Martinez House, Insular Life Building, Plaza Cervantes (1930), Jacobo Zobel House, Legarda Elementary School (1922), Perez-Samanillo Building (1930), Perkin's House, Rafael Fernandez House, Regina Building (1926), San Vicente de Paul Chapel (now Church), St. Cecilia's Hall of St. Scholastica's College, Sy Cong Bieng Mausoleum.

JUAN FELIPE DE JESUS NAKPIL (1899–1986)

Juan Nakpil started as an assistant architect at the Bureau of Public Works in 1926. He then became a partner in the firm of architect Andres Luna de San Pedro and structural engineer Jose G. Cortes in 1928 and with them designed the Perez-Samanillo Building in Escolta. From 1928 to 1931, he was a designer of Puyat and Sons where he introduced art deco motifs into the furniture industry. In 1930, he won the second prize in the Bonifacio Monument Competition. He taught at the Mapua Institute of Technology (MIT) from 1927 to 1931 and at the University of Santo Tomas (UST) from 1931 to 1938. Nakpil took part in various initiatives to upgrade building standards and improve the condition of architects. He designed more than 200 buildings, including office buildings, movie houses, school buildings, churches, and residences. The range of his style is represented in the neobaroque Quiapo Church; the art deco Nakpil-Bautista Pylon; and the Manila Jockey Club done in the International style.

Major Works: Avenue Hotel and Theater, Baldwin Young House, Capitan Pepe Building, Commercial Bank and Trust Building, General Vicente Lim Residence, Geronimo de los Reyes Building, Manila Jockey Club, Nakpil-Bautista Pylon, Philippine Trust Building, Quezon Institute Administration Building and Pavilions, Quiapo Church, Rizal House (reconstruction, 1950), Rizal, Ever, and State Theaters, Rufino Building, Security Bank and Trust Building (1954), UP Administration and Library Buildings (1950s).

FERNANDO HIZON OCAMPO (1897–1984)

Fernando Ocampo began working for the architecture division of the Bureau of Public Works in 1923 and was named assistant architect in 1926. In 1928, he started his own private practice and formed a partnership with Tomas Arguelles. He later cofounded the UST School of Fine Arts and Architecture, which was established in 1930. From 1929 to 1930, Ocampo was a member of the Board of Examiners for Architects and, in 1933, was among the founders of the Philippine Architects' Society, later renamed the Philippine Institute of Architects. Although presently better known for having designed the Manila Cathedral, Ocampo was, in fact, one of the pioneers of modern architecture in the Philippines, a contemporary of Andres Luna de San Pedro and Juan Nakpil. Not only did he work in the traditionalist mode, Ocampo incorporated art deco ornaments in his works.

Major Works: Admiral Apartments, Arguelles Building, Angela Apartments, Benigno Aquino Sr. House, Cathedral of the Immaculate Conception (restoration), Central Seminary Building, UST, Church of Our Lady of the Most Holy Rosary, Cu Un Jieng Building, Oriental Club, Paterno Building (FEATI Building), Sacred Heart Novitiate Building.

PABLO SEBERO ANTONIO (1902–1975)

After becoming a registered architect in 1932, Pablo Antonio was appointed as the architect of various institutions and corporations, such as the Philippine National Bank, Manila Railroad Company, and the Far Eastern University (FEU) where he designed several of its buildings. Aside from school and government buildings, Antonio also designed theaters and apartments. Among his works, he considers the Manila Polo Club as one of his best. His buildings were characterized by clean lines, plain surfaces, and bold rectangular masses—a striking digression from the traditionalist and academic style prevalent at the time. Moreover, his works have been imparted with a distinctive form and character, as he avoids anything that might be seen as a trademark. Antonio also became president of the Philippine Institute of Architects.

Major Works: Boulevard Alhambra (now Bel-Air Apartments), Capitan Luis Gonzaga Building, FEU Administration and Science Buildings, FEU Building, Galaxy Theatre, Ideal Theater (1933), Manila Polo Club (on Roxas Boulevard), Ramon Roces Publications Building, White Cross Preventorium.

The Aesthetics of Art Deco

Sleek, exotic, and modern—these were the hallmarks of Art Deco, an international style that originated in Europe and influenced nearly every facet of art and design in the first half of the twentieth century. The word art deco was a recent term coined only in 1966 to describe the aesthetic and stylistic system emanating from the 1925 *Exposition Internationale des Arts Decoratifs et Industriels Modernes,* held in Paris. The Paris world fair showcased more than a hundred pavilions representing twenty European, African, and Asian nations with the aim to catalyze a wider application of decorative arts in light of technology and mass production. The group of artifacts from the exposition was seen as a progressive departure from previous styles, thus, the term *modern* or *modernistic* to describe the antihistorical standpoint of art deco aesthetics and the search for "new" approaches to the decorative arts. Art historians considered the experimental event as the climax of French moderne style and a take-off point for American adaptation and worldwide derivatization of the style.

Having gained global popularity, thereafter, the term has become a catchall to designate the stylistic tendencies that appeared in the period between the two World Wars. It reached its pinnacle in the 1930s and was hailed as the Jazz Age Baroque, which permeated virtually every aspect of the design world, making its presence known in Hollywood films, fashion, applied arts, furniture, interior design, graphic design, industrial design, sculpture, painting, and especially in architecture.

Art deco was a synthetic form of stylization mediating between the traditional and avant-garde, as art deco works drew inspiration from diverse sources, such as Cubism, Art Nouveau, De Stijl, Bauhaus, Fauvism, and Primitivism. Building

silhouettes of the art deco asserted themselves in profuse abstraction and stylization, rich ornamentation, colorist effects, dramatic massing in simplified geometric forms, and exotic imagery derived from polyvalent archeological sources, such as African, Egyptian, Mayan, Aztec, and other primitive archetypes. Thus, the art deco movement played freely with historical precedents, abstracting traditional forms beyond recognition. Its imprint on architecture was confined to surface ornamentation, decorative appendages, and streamlined motifs, and not upon moral, ideological, or functional imperatives.

The recurring motifs in art deco ornaments include spirals, sunflowers, steps, zigzags, triangles, double triangles, hexagons, fragmented circles, and nautilus shells, which are rendered in low relief with sharp, angular contours. Art deco ornaments appeared to be flattened as surfaces lacked articulated depth or projection. Its later phase, the streamlined moderne, proclaimed a "flash-and-

gleam beauty" as it evoked machine aesthetics and the industrial innovations of the era with its hygienic, flat, stuccoed walls, rounded corners, glass bricks, projected or recessed horizontal bands, and tubular metal railings and round windows or portholes reminiscent of yachts and ocean liners.

Motifs of Art Deco

In her germinal book *The World of Art Deco,* author Bevis Hillier (1971) provided a list of recurring motifs in art deco imagery. One such motif was the frozen fountain, which symbolized vitality, life, and dynamism. In its different mutations, the fountain motif would oftentimes be the central icon in a composition or repeated in a pattern. For skyscraper designers, the frozen fountain was a conscious design metaphor. Claude Bragdon, in his 1932 book, *The Frozen Fountain,* said, "In the skyscraper, both for structural truth and symbolic significance, there should be upward sweeping lines to dramatize the engineering fact of vertical continuity and the poetic fancy of an ascending force in resistance to gravity—a fountain."

5.144 The motifs of art deco may include: geometric and abstract designs, stylized forms found in nature, natural and man-made energy, fountains and gushing water, stylized human and zoomorphic figures, and exotic and orientalist motifs.

5.145 Floral cornucopia designs found above the front balcony of the Emralino Mansion, built 1927, in Sariaya, Quezon

5.146 A series of medallions lavished with reliefs of fruits, flowers, and leaves suggesting profuse tropical gardens and forests at the Metropolitan Theater

5.147 Ornamental panels at the Metropolitan Theater. Logarithmic spirals were embroidered in the form of unfurling plant fronds, growing flowers, and nautilus shells

5.148 Symmetrical intricacies characterized the decorative wall motif composed of fan shapes, chevrons, and triangulated, floral buds on the façade of the Rizal Memorial Stadium.

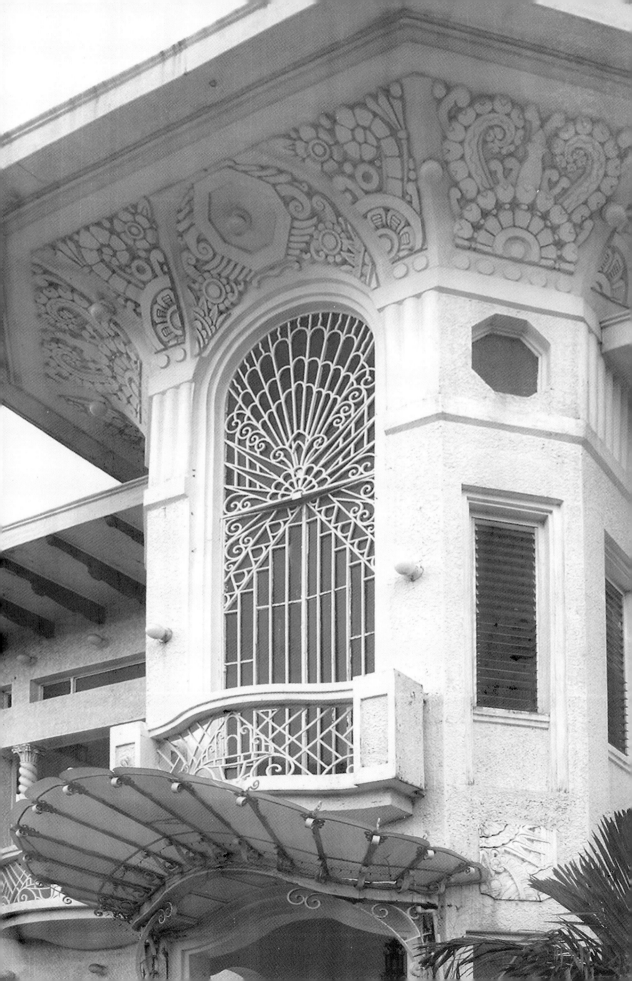

5.149 The liberal application of stylized and geometricized flora gave art deco structures a playful aura, charm, and grace that contrasted with the severity of the architectural proportions of neocastilian residences of the 1930s, such as this house in Sariaya, Quezon (opposite page).

5.150 Boomerang-like chevrons layered with spirals and lancet arches found on the lamp of the Perez-Samanillo Building in Escolta

5.151 The straightforward arrangements of basic geometric shapes—squares, circles, and triangles—of the decorative screen of the Quezon Bridge in Manila closely resembled the geometric motifs of Frank Lloyd Wright.

Another persistent pattern was the sun ray or sunburst motif. Sunburst patterns were expressed either on metalwork, terra-cotta, or concrete relief work as architectural details to again evoke the notion of vitality. The provenance of such solar design could be traced to the sun worship rituals of ancient cultures, such as in Egypt and Peru.

Other pervailing themes in the art deco style included floral and botanical motifs, animal forms, celestial motifs, mythological characters, and anthropomorphic figures. Stylization of flowers, animals, and even human figures gravitated towards fragmentation, simplification, and cubistic geometry. Zigzag moderne focused on angularizing rounded corners and figures; while streamlined moderne rounded off angular corners and sharp edges.

In Manila, the period between the 1920s and 1930s brought in two building typologies—the movie house and the apartment block. Both were mostly built in the art deco style. The art deco apartments were built in Ermita and Malate, both enclaves of expatriates and the local upper class. By the 1930s, these areas were getting crowded, so the solution was to expand vertically. About a dozen of these apartments are still extant.

Taxonomy of Philippine Art Deco

There were various strains of art deco that suffused the Philippine architectural terrain with a myriad of themes ranging from tropical exotization to the emulation of the aerodynamic machine. Art deco architecture in the Philippines was neither a monolithic nor a homogenous style; rather it was a highly eclectic and hybridized aesthetic practice that gave birth to a diversity of expressions. Architectural historian Edson Roy G. Cabalfin, in his extensive study, "Art Deco Filipino: Power, Politics, and Ideology in Philippine Art Deco Architectures (1928–1941)," proposed three taxonomic categories to classify the variety of art deco architectures in the Philippines. Cabalfin, however, forewarned that the proposed formalistic groupings are not to be thought of as highly distinct, autonomous, and discreet but rather as permeable categories that incessantly overlap, intersect, and interconnect at various points in time and space.

Eclectic and Classical Deco

This category can be loosely defined as a transitional version of art deco that appeared during the late 1920s. Characteristically, this version straddles two or more styles. In this sense, Filipino art deco is seen in a hybridized manner wherein earlier historical revival styles coexist with elements of art deco. The revivalist languages of architecture, such as neoclassic, Hispanic Revival, and neorenaissance among others, were evident in terms of overall planning and volumetric scheme, but their surface ornaments were palpably art deco.

Residences produced in the late 1920s demonstrated these eclectic and hybridic tendencies in the early phase of Philippine art deco. The Mapua Residence exemplifies these strains, as it stylistically departed from the Mediterranean-inspired residence, yet its interiors, upon closer scrutiny, revealed a fusion of diverse elements: art deco ornaments (on columns, ceilings, and low-relief medallions), chinoiserie (on the furniture and upholstery), and European (on the furniture). Similarly, the Santos Residence in Malolos, Bulacan, showed an undeniable bahay-na-bato spatial order and form, yet the application of modern art deco features on its

5.152 Residence of Tomas Mapua in Manila

ceilings, walls, statuary, and grillwork differentiated it from its Hispanic predecessors. In such instances, the use of art deco appliqués could be seen as a convenient way to redress existing building typology for a more fashionable, modern, and updated look.

The extant residence of Tomas Mapua, along Taft Avenue in Pasay, stands as a proud testament to Mapua's virtuosity in the Philippine art deco style reflected in its residential architecture and interior design of the 1930s. The house combined neoclassic and art deco aesthetics, as evident in its flamboyant architectural details and elements—wood and plaster bas-reliefs of stylized foliage and floral designs, geometric iron grillworks, stylized carving and inlays, and hand-rendered faux veneers.

Another manifestation of Classical Deco was Stripped Classicism, as epitomized by the Iloilo Municipal Hall (1930s), Bulacan Provincial Capitol (1930), and Tayabas Provincial Capitol (1933), all attributed to Juan Arellano, and the Cebu Provincial Capitol (1937) by Antonio Toledo. From a distance, the overall symmetrical composition would seem to indicate a neoclassic pedigree, an architectural image set by William Parsons for capitol complexes in the Philippines, but, upon closer inspection, the simplified columns, pediment, and friezes reveal art deco aesthetics. The Cebu Provincial Capitol represented the interaction of classically balanced masses with emphasis on symmetry and horizontality as demonstrated by its inward-curving façade that supported a dome raised on an octagonal base, which tends to dissimulate the flat art deco ornaments. The Iloilo Municipal Hall (now the University of the Philippines–Iloilo campus main building) showed a classical compositional massing, yet the ornamentation by Francesco Monti, the free-standing allegorical statues Law and Order guarding its portal and the relief of a man and a woman at the doors of the building, were sharp-edged, angular, and modernistic. On the other hand, the Bulacan Provincial Capitol was a simplified version of a neoclassic monument, possessing a highly austere classical composition with octagonal columns with plain capitals and dashes of art deco medallions.

THE AUTHORITY OF THE GOVERNMENT
EMANATES FROM THE PEOPLE
· ERECTED A.D. MCMXXXVII ·

 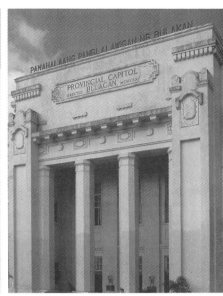

With the turnover of the Bureau of Public Works to Filipino design professionals, there was a conspicuous shift in the design of provincial capitol buildings across the Philippines from a highly ornate neoclassic style toward a more toned-down, restrained rendition. Moreover, the economic recession of the 1930s discouraged the application of ostentatious decorative elements in buildings in favor of cost-effective, straightforward, and austere structures, making art deco a suitable pretext for stripping away the classical features or replacing them with a more stylized breed of ornament.

Another explanation might lead to the fact that art deco was a mediating style in the shift from Beaux Arts to Modernism. Art deco structures adapted classical references, such as the strong symmetry in the massing, planning, and composition of structures, and the incorporation of classical details (such as columns, friezes, and acroteria) in decorative elements and motifs in stylized renditions. Meanwhile, the columns on porticos had simplified incarnations in the form of flattened flutings on the surfaces but still maintained the familiar aura of a colonnaded, neoclassic building—an architectural image which the public were well-acquainted with and could easily relate to.

At some point in history, Art Deco was referred to as the "Protomodern" style, a forerunner of Modernism. Since modern architecture had a tendency to be excessively radical, too elitist, and ideologically lofty for many people, Art deco cushioned its impact through its ability to synthesize older styles with new approaches in form-making. Art deco, thus, facilitated the gradual public acceptance of modern aesthetics in the Philippine context, especially in the postwar period. Take for example the Metropolitan Theater with its Beaux Arts propensity in planning, and yet, it installed the art deco style in terms of ornamental articulations. The symmetry of the building was achieved by the very balanced composition of the elevations and plan. But the decorative treatment in its skin, such as scrolls and sunburst and fountain patterns obvious in the tile work, grillwork, and low-relief treatments, was very much inclined to Zigzag Moderne, as these elements take inspiration from the zigzag pattern, stylized abstractions of flora

El Nido

NEOCASTILIAN STYLE

In synch with art deco aesthetics was the neocastilian (or Spanish-Mediterranean) style, pervasively embraced by the upper-class during this period. Andres Luna de San Pedro popularized this style among the elite with his design for the Perkin's Residence, also known as "El Nido" (The Nest, above), located along Dewey Boulevard. The house was mentioned in pre-World War II publications as the most modern in the country when it was built and was awarded first prize in Manila's 1925 House Beautiful contest. Its architecture set the familiar design trend in the late 1920s to the 1930s, the pseudo-Spanish, stylistic mode, a style characterized by an amalgam of neoclassic ornamental motifs, white stuccoed walls, clay tile roof, arches, salomonica (twisted) columns, and a tree-level, square mirador tower capped by turrets, which was to dominate the residential architecture of the new upper class for the next three decades. Some of the surviving examples are still to be found in New Manila, San Juan, which was the enclave of the rich in the 1930s. Shown below is the residence of the Benitez family in Cubao, Quezon City, known as the Miranila, designed by Achilles Paredes in 1929.

Miranila

and fauna, sunburst and fountain themes, and other motifs culled from astrology and mythology.

Zigzag Moderne

This art deco variant emanated from the contours formed by a "zigzag" or stepped ziggurat. Abstracted forms of flowers, plants, animal, humans, mythical figures, and nature-inspired objects found their place among its imagery. Zigzag Moderne, as it flourished before the 1929 Great Depression in the United States, leaned toward a flashier, more opulent, luxurious, and generous decorative expression. Reflecting an optimistic and prosperous era, this early deco phase was distinct because of its lavish attention to detail and embellishment.

The use of geometric patterns was prominent in commercial structures that aspired to be modern and progressive, yet such structures were not entirely apathetic to civic and institutional buildings maneuvered in the classical vocabulary. The Geronimo Reyes Building (1930) in Plaza Cervantes, Binondo, designed by Juan Nakpil, was predominantly decorated with a combination of chevrons, octagons, rectangular blocks, receding stepped bands, and other geometric permutations on the parapet, colonnade, and windows. In the same way, Luna de San Pedro's Perez–Samanillo Building (1930, now renamed as the First United Building) in Escolta suggested geometric lines with the vertical pipe moulding that ran along the height of the building. The central tower was defined by a canted arch and crowned by elongated octagons that framed a tableau. A highly stylized floral arrangement on an urn accentuated a parapet with equally spaced, low-relief medallions. Fernando Ocampo's Paterno Building (renamed the FEATI Building), a fusion of Mission Revival and Zigzag Moderne, similarly featured a simplified

5.159 Perez–Samanillo Building

5.160 Geronimo Reyes Building

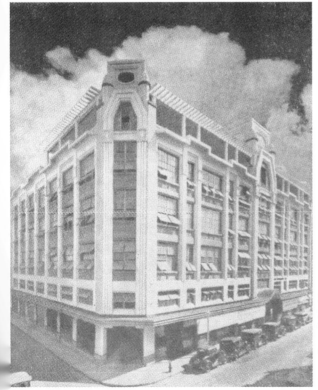

5.161 Juan Nakpil's ziggurat-topped Capitol Theater is symmetrically balanced, with a recessed central tower ornamented with geometric art deco grillwork. The vertical wall planes flanking the central grillwork provided a setting for low-relief, stylized, modernist figures of two Filipinas clad in *baro't saya*, each carrying the symbol of cinema and sound. These wall relief sculptures, including the lobby sculptures, were done by Severino Fabie (opposite page).

5.162 The Eucharistic Monument, designed by Juan Nakpil, became the centerpiece altar in the celebration of the International Eucharistic Congress when Manila hosted the event in 1937.

pediment with geometric medallions. Yet again, the stepped recessed banding framing the windows and the flattened columns defined the façade, while the columns that supported the simplified pediments were topped by floral accents. The building was demolished to make way for a high-tech, glass-clad edifice of FEATI University called Bridgepoint.

Included in the array of the "zigzag" idiom was the pylon motif that appeared in several commercial and institutional structures. The Eucharistic Monument (1937), designed by Juan Nakpil as a centerpiece for the International Eucharistic Congress of 1937, was a tall, slender structure composed of three columns topped by a circular beam and a cupola. The soaring columns of the pylon were decorated with stylized human figures in a gesture of prayer that served as capitals. This was akin to his Bautista-Nakpil Pylon at the North Cemetery in Manila, built a decade earlier. The funerary pylon, a tribute to the Bautista and Nakpil families, employed the maiden figures near the top of the structure. The central portion of the pylon was decorated with a densely-packed bouquet of geometricized flowers, spiraling

foliage, and nautilus shells which were rendered on low-relief concrete panels. The stepped towers were similarly manifested on the piers of the Quezon Bridge, Perez–Samanillo Building, the University of Santo Tomas Main Seminary, the Capitol Theater, and the prewar Saint Anthony Parish Church (in Singalong, Manila). This sense of verticality had been apparent at the 1925 International Exposition in Paris as well as in the 1933 Art Deco Exposition in Chicago and the 1939 World's Fair in New York. The idea of verticality embodied in these pylons was the same notion of verticality that skyscrapers expressed. It was no accident that the flourishing of skyscrapers, after its inception in Chicago during the 1890s, happened during the Jazz Age, a manifestation of the prosperity and lofty aspirations of the booming period. This idea of verticality was thus associated with optimistic ideas of prosperity.

Zigzag Moderne was more affiliated with French renderings of art deco in terms of stylization and reductionism. The dense treatment of low-relief sculptures, the geometric scrolls, and the stepped forms adorning many of these Philippine art deco structures were drawn from the stock of art deco motifs popularized during the 1925 Exposition or the apogee of Le Style Moderne. Edgar Brandt's five–panel screen entitled "Oasis," exhibited at the Paris fair, launched several imitations across Europe and the United States. Perhaps this was the same design source that inspired the low-relief articulations that Juan Nakpil used in some of his works (such as the Bautista-Nakpil Pylon). The frozen fountain motifs found in such

5.163 Quezon Bridge

5.164 Pylon of the Quezon Bridge

5.165 The prewar art deco belltower of St. Anthony Parish Church in Malate, Manila

5.166 The ornamental plaster panel from the Bautista-Nakpil Pylon in Manila's North Cemetery has an exuberant motif of unfurling plant fronds, bouquet of tropical flowers, and nautilus.

5.167 A detail of Edgar Brandt's "Oasis," a five-panel screen exhibited at the Paris fair in 1925. Several imitations were launched across Euro-America and even the Philippines.

buildings as the Metropolitan Theater and the Santos House were undeniably descendants of Edgar Brandt's wrought iron works that featured water spouts and were linked to such motifs as those in Rene Lalique's *Parfumerie Francaise* pavilion at the Paris Exhibition. Some of the patterns and motifs might not be necessarily new or radical, since a lot of the motifs were also derived, in one form or another, from classical Greco-Roman sources, but the difference was more in the geometricized treatment.

French ornamentations were present in the early versions of Filipino art deco. Among the desired motifs were the pylons (as in the Bautista-Nakpil Pylon at the North Cemetery in Manila), frozen fountains (found at the Metropolitan Theater, Santos House in Malolos), sunburst motifs (Santos House in Malolos), and exoticized maidens (Metropolitan Theater, Bellevue Theater) as well as geometricized flowers and foliage patterns (Mapua House, Metropolitan Theater). The French decorative technique was often very jam-packed and opulent, at times to the verge of *horror vacuii*, as demonstrated by the ELPO Building (El Porvenir Rubber Products, Inc., a pioneer rubber shoes and car tire manufacturer in the

5.168 Zigzag Moderne aesthetics of Bauan Municipal Building in Batangas

5.169 ELPO Building (El Porvenir Rubber Products, Inc.) in Divisoria, Manila (opposite page)

5.170 Elevation of the Jaro Municipal Building drawn by Juan Arellano in 1934

Philippines) built in 1933. Such opulence was also evident in the use of materials such as granite, marble (Mapua House), deep–colored wood panels, crystal and stained glass (Metropolitan Theater), and trompe l'oeil paintings (Santos House).

Concurrent with all of these was the Filipino designers' fondness for exotic cultures as their fountainhead of inspiration, similar to their American and European counterparts that attempted to interpret distant cultures in their own terms. A prevailing sense of exoticism and primitivism forms the underlying theme of motifs from ancient cultures, such as Assyrian/Babylonian, Egyptian, and Mayan/Aztec. Easily identified with the Zigzag Moderne strain of art deco, the stepped massing from the Assyrian and Mayan ziggurats and stepped pyramids appeared consistently in several Philippine art deco structures. The Capitol Theater (1935) and the Metropolitan Theater (1931) in Manila, the Jaro Municipal Building (1934, now the Jaro Police Station) in Iloilo, Bauan Municipal Building (1930) in Batangas, and the Sariaya Municipal Building (1930s) in Quezon are decidedly zigzag because of the stepped silhouettes that predominate the volumetric massing of the facades. Simpler and more two-dimensional versions were also unmistakably noticeable in the parapet treatments of the Geronimo-Reyes Building (1930) and the Paterno Building/FEATI (1929, now demolished). Islamic and Mudejar features were prominently featured in theaters, such as the Lyric Theater (1935) and Bellevue Theater (1933). Zigzag motifs were juxtaposed with formulaic Islamic designs, such as the onion dome (and its variants), ogee arches, and delicately filigreed pierced-screen panels. Figures of exotic Siamese dancers grace the parapet of the Metropolitan Theater. Greek allusions to theater, such as the comedy and tragedy masks, can also be found among the plethora of motifs used by sculptor Isabelo Tampinco and Francesco Monti in Juan Arellano's Metropolitan Theater of Manila.

Indigenous and vernacular designs also penetrated art deco expressions in the Philippines. One of the primary categories of local sources came from indigenous flora and fauna. Typically used were flowers (such as hibiscus, birds-of-paradise, and sampaguita), fruits (such as mango, banana, and guava) and other vegetation (such as bamboo, palms, and ferns). Philippine wildlife was also exemplified in several edifices. The head of a carabao, or water buffalo, for example, was prominently displayed on the façade of the State Theater. Tropical birds and other varieties of fowl were also important design features, oftentimes combined with indigenous foliage. Human figures garbed in native costumes, such as those on the elevations of the Capitol Theater, were also part of this indigenized leaning. Other art deco evocations included rural and pastoral idyllic scenes which were meticulously rendered in paintings or as low-relief sculptures. In most of these works, the

local vegetation and human figures were very much stylized or geometricized so as to render a more simplified representation of objects or people. A kind of abstraction was thus achieved through the simplification of form.

Occupying the forefront of the art deco style in the Philippines was Juan Arellano's Metropolitan Theater (1931) in Plaza Lawton which marked his deviation from his Beaux Arts lineage. For this project, Arellano was sent to the United States to study under the tutelage of Thomas Lamb of Shreve and Lamb, then one of America's leading experts in theater design. In a style observed by A.V.H. Hartendorp as "modern expressionistic," Arellano took inspiration from the phrase "On Wings of Song" to design a rectangular-shaped auditorium bounded on each side by pavilions. Stylized from Philippine vegetation and wildlife, the motifs were executed with the assistance of Arellano's elder brother, Arcadio, and Isabelo Tampingco, the leading decorative sculptor of the day.

The façade of the Metropolitan could be likened to a stage whose focal point was a framed, proscenium-like central window of stained glass that corresponded in scale and shape to the theater proscenium inside. This window was emphasized on both sides by curving walls that were lavishly decorated with tapestries of colored tiles reminiscent of traditional Southeast Asian batik patterns. Sponged, multi-colored paint rendered the wall surface with heavy texture. The walls above and behind the window took the form of a segmented arch with a series of small finials lining the entire edge of the wall. The entrance doors had grillwork resembling stylized birds of paradise.

The rear of the theater displayed a prominent stage loft that simulated the shape of a vertical, rectangular prism embellished on the side by geometric motifs. The form of the auditorium ceiling was reflected on the exterior by stepped vaults.

The theater proper could be accessed through a wide foyer with a two-storey, semi-vaulted ceiling, flanked on both sides by wide marble stairways leading to the lounges and balcony. Two mural paintings of Fernando Amorsolo, *The Dance* and *History of Music*, were placed above the stair landings. Modern statues by Italian sculptor Francesco Monti enhanced the opulence of the lobby.

The space above the proscenium was an exquisite setting for bas-relief figures allegorically depicting Music, Tragedy, Comedy, and Poetry, while both sides of the proscenium were adorned by a cascade of silver, jewel-like plaques. Long, tapering tubes of translucent white glass resembling bamboo stalks which

5.173 The exotic figure of a Siamese dancer displayed at the exterior of the Metropolitan Theater was the work of Italian sculptor Francesco Monti. Art deco sculptors recreated exotic styles of Asia and the ancient Americas, confidently mixing and matching motifs. Sculpted figures revealed a combination of archaic and exotic traits borrowed from Egyptian or Oriental sources.

5.174 Stylized banana leaves and fruit bunches at the ceiling of the Metropolitan Theater

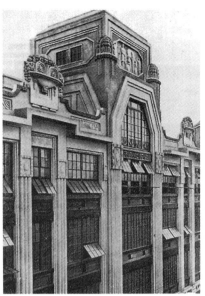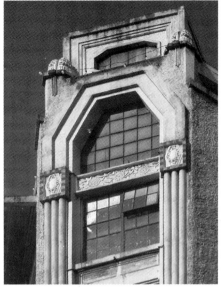

functioned as lamps served to break the monotony of the bare longitudinal walls of the auditorium. The auditorium ceiling was enriched with rows of stylized tropical leaves, bananas, and mangoes done in deep-relief. The Metropolitan Theater was destroyed in the 1945 Battle for Liberation and was not fully restored until 1978 under the supervision of Otillo Arellano, Juan Arellano's nephew.

The Perez–Samanillo Building (1930), designed by Andres Luna de San Pedro, was defined by a rectangular plan but articulated by two open light wells, one on each side of the central tower, similar to a figure eight on its side. The central span contained the elevator, while internal corridors wrapped the enclosed well. The slightly complex façade reflected the tectonic qualities of the structural frame. The façade featured a main entrance tower flanked by corner towers on both ends of the building. The corner tower was set on the diagonal, allowing it to divert the corner unhindered. The three towers received the same ornamental articulation: multiple tubular mouldings that terminated in square plates garnished by hexagonal treatments. The plates braced the beveled arches, which corresponded to the sixth level windows. Over the arches, the towers are made more dramatic by octagonal lozenge windows flanked on both sides by stout finials. A pergola with protruding rafters originating from the girder connected the bevels.

Juan Nakpil's first commission for his own architectural firm, established in 1930, was the Geronimo Reyes Building (1930). The building, located at Plaza Cervantes, was characterized by flatness and deep recessions, stepped up progression, and vertically oriented symmetrical massing. The three central bays assumed a curtain wall-like appearance. The flatness of the façade was broken by end bays, which protrude orthogonally in plan, while ornamental art deco panels (of a chevron pattern) enriched the surface. The same protrusions recurred in the three central bays on top. A decorated parapet with decorative lozenges surmounted the pylon-like composition.

The Insular Life Building (1930), a design collaboration of William James Odom and Fernando de la Cantera, stood on the southeastern corner of Plaza Cervantes

facing the Art Nouveau Uy-Chaco Building (now Philtrust). The edifice was a recipient of an award as an outstanding commercial building in 1930. On the prominent corner of the seven-storey building was an important feature: a globed lantern with an imperial eagle perched on top. Below the lantern was an octagonal window. The corner of the tower was accentuated by engaged columns that originated from the finials on the first floor arcade and terminated into turrets. The remaining façade was segmented into bays with three horizontal bands each. Panels adorned by geometric bas-relief ornaments separated the windows on each band. The windows were terminated by arches on the sixth floor, over which was a decorated parapet that doubled as the balcony of the seventh floor.

The Nakpil-Bautista Pylon (late 1920s) at the North Cemetery was a mausoleum designed by Juan Nakpil as a tribute to his uncle and benefactor, Dr. Ariston Bautista Lin. The design, featuring a combination of stylized and angular forms, was square in plan, whose verticality was emphasized by a tall column on each of its from corners that end as bodies of praying figures. The huge, square podium was decorated with bas-relief carvings of stylized plant motifs. Above the podium was a lantern buttressed by another set of shorter pillars and crowned by a dome with an ornamental finial.

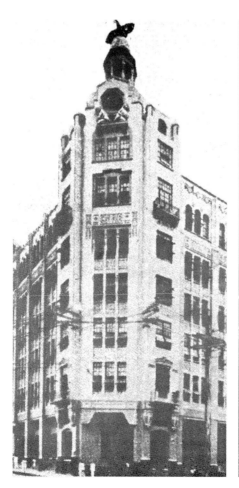

5.177 Insular Life Building

5.178 Bautista-Nakpil Pylon

5.179 Paterno Building

5.180 Central Seminary of the University of Santo Tomas (UST)

5.181 An archival photo of the Central Seminary of the UST

Fernando Ocampo Sr.'s Paterno Building/ FEATI University Building (1929) at the foot of MacArthur Bridge in Sta. Cruz combined the language of Art Deco and Mission Revival. It had a symmetrical rectangular plan with a straightforward simplicity in design, having blocks of windows organized in a series of regular bays. Two passageways were punctuated by canopies and plain art deco treatment over the second level windows and on the raised pediments.

The Central Seminary of the University of Santo Tomas (1930s) was also designed by Fernando Ocampo. The plan of the seminary was configured in the form of the letter E, with courtyards bisecting the wings. The boxy building had an elongated frontage assembling a continuous band of balconies and windows on the second and third level. The structure's horizontally-oriented massing was contravened by an engaged central section at the main entrance and two other similar treatments at the end portions. An art deco relief, bud-like finials, and a tableau adorned the stepped pylon at the entrance.

Streamlined Moderne

The later phase and variation of the art deco style was sustained by the principle of *streamlining*. Adapting a scientific definition, streamlines are defined as "lines whose local direction corresponds with local flow speed." In design, streamlining means the "aesthetic of minimized drag," which means the achievement of an aerodynamic form with the least wind resistance. The architectural vocabulary of the streamlined moderne was relatively limited to a particular set of visual lexicon. Semicircular bays attached to rectangles, rounded corners, flat roofs, cantilevered ledges, extended parapets, and narrow horizontal bands were mainstays of this idiom. New materials, such as Vitrolite, Formica, Lucite, Carrara glass, porcelained enamel, metal alloys (such as nickel, aluminum, chrome), stucco, plywood, and various forms of veneering were utilized extensively. Sheathing and surface cladding were more important than showing the actual structure. Thus, unsightly building materials, such as pipes, conduits, structural frames, and all the other "messy" building components were hidden from view by covering them with sleek surfaces.

The main characteristics of streamlined deco were clean lines achieved by having very thin concrete slab protrusions with emphasis on the horizontality of the massing, sunbreaks or *brise soleil* over windows, mechanically smooth wall surfaces implying mass production, and, sometimes, by using flat roofs, speed stripes, curved edges, rounded corners, and the prolific application of glass and metal. Also found in this variation were maritime motifs, such as porthole windows and ship-inspired tubular railings of thin, horizontal metal stripes or bands. Included in this category are such examples as the Far Eastern University Building (1935) in Manila, designed by Pablo Antonio, which exhibited rounded corners and smooth surfaces, and Arellano's Rizal Memorial Stadium (1936), with its oceanliner imagery. In its archetypal form, the streamlined moderne building was a horizontal, rectangular container with rounded corners or semicircular bays and smooth building skin and topped by a parapeted or projecting thin slab roof. Wuderman and Becket's Jai-Alai Building (1940), Pablo Antonio's Bel-Air Alhambra Apartments (1937), and Andres Luna de San Pedro's Crystal Arcade (1932) were outstanding specimens of Philippine streamlined moderne.

5.182 Michelle Apartments in Manila

5.183 Streamlined residence in Paco, Manila, built in 1938

5.184 Rizal Memorial Stadium

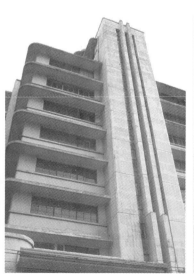
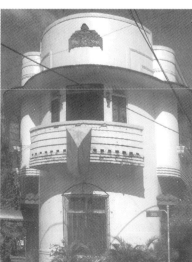
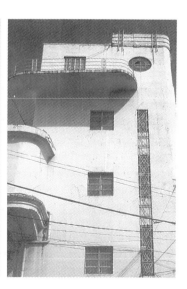

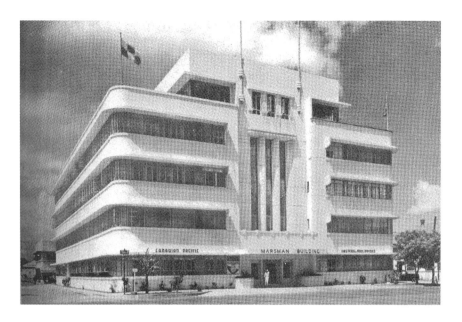

The American streamlined vocabulary of the late 1930s adapted more austere, sparse, and simplified forms that contrasted with the opulence of the French decorative technique of the early strain of art deco. The rounded corners and edges (such as that of the Lopez House), the small sun-shading projections known as the "concrete eyebrow" (Bel-Air Apartments; Jai-Alai Building), the use of chrome and glass (Crystal Arcade, Alcazar Club interiors), and the use of neon signs (Ideal Theater, Capitol Theater) all form the range of streamlined modes of representation. More economical materials, such as concrete, glass, and veneers (including laminates, plastics, and wood veneers) were popular choices for this art deco variation. Ornamentation was more geometric and abstract. Grilles, such as those found in the Mayflower Apartments (1938) and the Quezon Bridge (late 1930s), which relied more on interlocking basic shapes—squares, circles, and triangles—coupled with wavy lines, came into vogue during this time. These wavy lines were distinctively deco motifs that can be found on sculpture (hair on women statuary) and maritime sources.

Related to the streamlined motif was the style's infatuation with maritime motifs. Buildings resembling boats and ocean liners also became popular in the Philippines. Fernando Ocampo's rendering of maritime building iconography resulted in the Lopez House (1936). Popularly known as the Iloilo Boathouse, this white, four-storey mansion of Eugenio H. Lopez in Iloilo featured portholes for windows, deck-inspired projections over the garage, horizontal steel balustrades, and towers resembling a captain's bridge and a ship's viewing deck. The Ramon Roces House (1932) in Pasay, designed by Pablo Antonio, similarly evoked an image of an ocean liner through its streamlined features. In these residences, the experience of cruising the high seas was recreated to somewhat fulfill the owners longing for an exotic destination. Materials usually involved reinforced concrete, brushed or satin-finished metals, and glass to create a glossy and smooth appearance.

The streamlined moderne had a close affinity with the modern movement. In form, the streamlined moderne closely resembled the architecture of the Bauhaus-International Style of Modernism because of its formal alliance with simplified

massing, no-nonsense details, and absence of ornamentation. As the characteristics of these two styles overlap and lack a clear-cut delineation to separate them, there is difficulty in distinguishing streamlined deco from the early modernist structures. Consider, for instance, the Manila Jockey Club designed by Juan Nakpil in 1936. The glass-enclosed main staircase of the club was similar in form to the staircases of the factory designed by Walter Gropius for the 1914 Werkbund exhibition. At first glance, the machine aesthetic embodied in the use of highly industrialized materials, such as glass and metal, was expressive of the functional qualities of modernism. However, on closer inspection, some parts of the building were, in fact, highly decorative. The horizontal bands at the balconies, the stripes at the lighting rod, and the rounded edges were not necessarily a response to pure function; rather they were part of an aesthetic championed by the burgeoning streamlined method. The MERALCO Building (1936) at San Marcelino, Manila, built in the late 1930s, belonged to this category. A highly asymmetrical composition was achieved by a tower on one side and a long horizontal mass on the other. The building had a rounded corner at its base, juxtaposed with window projections running along the length of the building on the second level. A low-relief sculpture at the left side of the structure indicates its alliance with art deco rather than the International Style.

The Crystal Arcade (1932) was the forerunner of our modern-day shopping mall architecture. The building earned distinction as the most celebrated building of the early twentieth century before its annihilation in the last days of the Pacific War. Its name was derived from Joseph Paxton's London *Crystal Palace* (1851), as both buildings made an abundant use of glass as a major building component. Aside from being an excellent specimen of streamlining, it was the first commercial edifice to introduce a concourse walkway leading to the glass-walled shops on the first level. Designed and partly owned by Andres Luna de San Pedro, the original plan proposed a seven-storey building with a ten-storey central tower but was partially completed as a three-storey mall. The ₱1.5-million building used to stand on the Pardo de Tavera property, a lot accessible from both Escolta and San Vicente streets. Its site is now occupied by the Philippine National Bank. Recovered

photographs and plans suggest that the edifice had a mezzanine on both sides of a central gallery that traversed through the length of the gallery. An atrium opened to a spacious lobby, which featured cantilevered winding staircases. The front and rear portions of the gallery were roofed by simulated skylights made of polychromatic glass (resembling that of Galleries Lafayette in Paris). Continuous strips of concrete walls and glass windows conjoined to emphasize the building's horizontality. Art deco bays were interrupted by vertical windows piercing both ends of the facade to counterbalance the tower at the central lobby. Each window storefront was of curved glass, while glass blocks were used at the mezzanine level. Ceramic mosaic tiles in tricolor adorned the floor with fan-shaped patterns. Colored Italian marble and granite endowed the interior with a sleek, cosmopolitan flair. Grillwork and stucco ornaments were infused with art deco motifs in the form of diagonal lines, triangular geometric forms, and stylized foliage. The symmetric

5.189 Crystal Arcade

building facade featured continuous, horizontal bands of concrete and windows that boldly curve inward as they converge over the central mall. The storefront level was rendered in a material a shade darker to make the upper bands visually light. Above the marquee-like canopy of the main entrance was a three-paneled stained glass wall bordered by a granite frame and flanked by three narrow, vertical sculptural friezes to highlight the processional access. In 1936, the building was sold to L.R. Nelson for 1.5 million pesos. The building was destroyed beyond repair during the last days of the Second World War.

The streamlined Rizal Memorial Stadium (1934) was a result of a design collaboration among a team of architects of the Bureau of Public Works, headed by Juan Arellano. Built for Manila's hosting of the Tenth Far Eastern Championship Games in 1934, the complex had a baseball and soccer stadium, natatorium (indoor swimming pool), and tennis stadium. It featured a coliseum entrance dominated by a flat wall flanked on both sides by curving walls that were edged on

5.191 Rizal Memorial Tennis Stadium

top by a double band of mouldings from which flagpoles were attached. The flat wall was punctuated at regular intervals by square mouldings with beveled corners in the middle of which were nail head ornaments.

Pablo Antonio defined the façade of the Bel-Air Alhambra Apartments (1937) by employing a series of nautical porthole windows complemented by the rectangular horizontal planes formed by the canopy that protected the glass windows at every floor level. The absence of ornaments, spare use of elements, washed color, and the use of glass were attributes which installed the edifice as a veritable record of early modernism in the country.

Antonio utilized three strong vertical piers projecting at the opposite ends of the façade of the Far Eastern University Main Building (1935), completed in 1940, to neutralize the apparent horizontal monotony of the building block. Projecting and receding, the horizontal and vertical elements set at regular intervals countervailed the fatness of its sprawling rectangular mass. At street level, an arcaded pedestrian

5.192 Bel-Air Alhambra Apartments

5.193 Far Eastern University (FEU)

5.194 Jai-Alai Building

walk was supported by square columns adorned with narrow horizontal bands. The arcade parapet itself configures a wide horizontal band. A thin concrete parapet, running the entire span of the façade, capped the building.

Designed by American Welton D. Beckett with local associate Carlos Santos-Viola, the Jai-Alai Building (1940) employed a streamlining technique that prefigured the International Style decades earlier. A strip window that formed a semicylindrical volume was set against massive walls to form the backdrop for *pilotis* or slender columns. The pilotis rose vertically from the *porte cochere* to a projecting, disk-shaped concrete roof. The profusion of chrome and glass were the only means to embellish the building, emphasizing the straightforward volumes. At the central pavilion, wall friezes depicting jai-alai players rendered in silver bedecked the interior. This building was demolished in 2000 to give way to the Manila city government's Hall of Justice.

Tickets to Deco Fantasy

State Theater

The technology of the cinematograph in the early twentieth century spawned a new breed of architecture, a new building type that combined the traditional planning scheme derived from classic theater design with compelling doses of fantasy played out in the realm of darkness—a space lit only by a streak of light projected onto a fourth wall. The design of cinema palaces reached its pinnacle between the 1920s and 1940s, a period when watching movies established itself as the Filipino national pastime. For a mere price of a ticket, one can engage in an exotic trance facilitated by the materiality of art deco architecture and the potential myth created by Hollywood's dream factory.

The origin of cinema houses as a building form can be traced through the first exhibition of film in the Philippines. Such a cinematic encounter was made possible by the construction of the first electric power plant in the country in 1895. Between the 1910s and 1930s, cinema architectural design began to evolve and distinguish itself from the legitimate theater design. Movie theaters assumed a different tactic to attract potential cinema patrons from the street into the showcase, then leading them into a dreamworld concocted by film. From the exterior to the interior, designers tried to inveigle the patrons' imagination with fantasy utilizing architectural elements. Thus, fantasy was a necessary ingredient to animate the moviegoing experience with a sense of astonishment and adventure.

During this period, when motion pictures gained popularity and audience devotion, movie palaces probably vied for dominance as the public congregational space, competing, perhaps, with the monumental church edifices. Adapting the pomp and theatricality of colonial churches from the previous era, not to mention their axis of seating arrangement and proscenium scheme, the new

Cine Savoy

architectural form for spectatorship further amplified the spectacular effect by using the rich idiom of art deco aesthetics. Inside these art deco cinema palaces, Filipino audiences eagerly received the liturgy of Hollywood Americanism and obtained sanctification from the screen icons they worship. As Filipinos sat in the dark escapist realm of cinema houses, they were gripped with potent doses of illusion framed by film aesthetics and art deco architecture—to suspend disbelief about their colonial existence and embellish their mundane lives with the myth of the celluloid for an hour or two.

By the late 1920s, fantasy in cinemas was made possible through the application of visually seductive art deco architectural spectacle (learned from the Hollywood deco sets) strategically initialized at the façade of the cinema. More importantly, the entire experience inside the cinema house was framed in such a way that the experience was potently suffused with a sense of "suspension of disbelief." With this technique, the audience was conditioned to be more receptive and interested, as they were cut off from the realities of their mundane existence outside the cinema premises and transported into a rich and self-contained auditorium where their minds were emancipated from their usual preoccupations and freed from their customary lives.

Typologically, Philippine movie houses could be likened to that of a box with a decorated façade. Exteriors of cinema buildings resorted to architectural gimmickry and fantastic

5.195 The Jai-Alai Building, demolished in 2000 by the city government of Manila, was a significant social and recreational landmark of Manila, famous for its *Sky Room* nightclub. The building featured a semicylindrical glass volume set against massive walls and a cantilevered disk canopy suspended by slender pilotis.

ornamentation, but only at the front façade. These frontal indulgences were designed to lure audiences inside a contrastingly dark and sparsely ornamented main viewing hall. Theater owners realized that the cutting edge design of architecture sold tickets and gave the theater a unique identity. The Philippine *sinehan* had to assume the diverse schema of art deco whimsicality in its richly articulated façade, a far detour from the early Filipino movie house of plain wooden or reinforced concrete with a restrained neoclassic festooned façade in trompe l'oeil. The design of art deco cinemas gave film audiences a new experience beyond the mere visual appeal of the façade appliqué. The circulation of theatergoers was orchestrated in a sequence of spaces, a progression that approximated the basic structure of a narrative film—exposition, rise of conflict, resolution, climax, and dénouement. Upon entering a theater, a moviegoer would pass through a series of spaces: the entrance vestibule, foyer, lobby, lounge, upper level promenade, and waiting room, all of which were meant to provide comfort and escape from real life. Among these spaces, the lobby was considered the most monumental event to stimulate the imagination of the crowd. Thus, the lobby was embellished with stained glass, relief sculptures, ornate fountains, and statuary.

Within the premises of the cinema space, slow but effective means of channeling the great American Dream were being played out. Movie theaters, together with the Hollywood cinema industry, would play an indispensable part in the Americanization of the Filipino. When monumental public buildings of the neoclassic lineage rose in the architectural landscape to project an image of American benevolence and civilizing presence, so did motion picture palaces that tapped exotic archeological sources for their themes and motifs, but on a less grand scale. Not to be outdone, the theater's modest size was countervailed by its polychromatic façade that contrasted with the black-and-white movies and the cornucopia of stylized decorative elements emanating from a myriad of Orientalist influences that interpret Indo-Islamic, Chinese, Mesopotamian, and South Seas familiar cultural icons, or even a Hollywood film set.

The art deco craze coincided with the rise of the cinema house as a democratized architectural space where a large number of people from all social strata, at a given time, were accorded the same sorcery framed by a common architectural experience. art deco as an aesthetic movement was valorized for its mass reproducibility, so was cinema's engagement with mass reception. The art deco style was keenly received through the architecture of movie houses and sparked the popular imagination in the interwar architectural milieu.

The ornateness of art deco combined with judicious interpretation of Philippine motifs was expressed in the Juan Arellano's Metropolitan Theater (1931), where Filipinized forms were found in the details, such as Philippine floral motifs, bamboo banister railings, carved banana and mango ceiling reliefs, South Sea masks, and Batik mosaic patterns. In preparation for the project, architect Arellano went to the United States to study with Thomas W. Lamb, then one of the foremost experts in theater design. Incidentally, the proportions of the façade, the huge square concrete frame that played host to a central window of stained glass, and the two South Sea masks in relief were elements derivative of Shreeve and Lamb's design for the Ziegfeld Theater in the US. However, a low, segmented arch with a series of finials at the summit of the façade distinguished Arellano's design from the latter. Sponged paint brought out the textural qualities of the exterior walls.

Juan Nakpil's ziggurat-topped Capitol Theater (1935) in Escolta was symmetrically balanced with a recessed central tower ornamented with geometric art deco grillwork. This grillwork, composed of squares overlapped with circles, were framed by large square pillars in receding bands that bounded the square top. The vertical planes flanking the central grillwork were an exotic setting for low-relief, stylized, modernist figures of Filipinas clad in baro't saya carrying the symbols of cinema and sound, respectively, on both sides. The façade was designed in a series of setbacks emphasizing the strong and severe geometric form.

Inaugurated on January 9, 1935, the Capitol's original interior (destroyed during the war) boasted the use of the Philippine national flower, the sampaguita, as its central motif. A bunch of budding sampaguita done in chromium occupied the central design of the grilles of wrought iron of the stairs, lobby, and foyer. At the center of the proscenium arch were sampaguita flowers in bloom, in white seashell finish, and from

them radiated four concentric circles of short bamboo nodes and internodes finished in concrete.

Other cinemas which Juan Nakpil designed were the State Theater (1935) and Avenue Theater (1939). State Theater followed the art deco contoured silhouette highlighted by a decorative parapet with a central medallion and art deco stylization of a carabao head. State and Avenue were rebuilt in 1946.

Bellevue Theater (1931), a small theater in Paco, Manila, adopted Philippine Islamic imagery as its art deco theme (perhaps borrowing inspiration from the tradition of moro-moro theatrical scenography or from the set design of LVN Studio's Arabesque swashbuckling movies). The theater was symmetrical, with a central plane of elaborate concrete pierced work dominating the building's composition and flanked by two rectangular volumes topped with domes on both sides. At ground level, the cinema opened to a small foyer that led to a pseudo-grand staircase, which was guarded on both sides by sculptures of harem maidens. At street level, two emergency doors emphasized the facade with pointed arches on opposite sides.

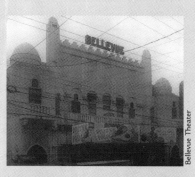
Bellevue Theater

In the 1930s, the design of cinemas gave way to the "smooth curves and the aura of precision and exactitudes of the streamlined style, with its signification of the power of machinery." Designers responded to the economic constraints of the time by eliminating from the structure the abundance of applied ornament in favor of a more austere variant of art deco known as "streamlined moderne." Inspired in part by great transatlantic ocean liners, the new style featured aerodynamic curves, smooth wall surfaces, and steel railings, and was often marked by the signature trio of horizontal speed stripes that were meant to suggest motion.

The streamlined moderne in the Philippines was considered the precursor of the International Style. Its architectural translation was based on horizontally oriented buildings with aerodynamic curves, flat roofs, glass blocks, banded windows, tubular steel railings, speed stripes, and mechanically smooth wall surfaces and interiors that were far less sumptuous. It paralleled the imagery used in airplanes, ocean liners, locomotives, automobiles, and household appliances by industrial designers.

Times Theater

The archetypal streamlined building was simply a horizontal rectangular container with rounded corners or semicircular bays, smooth building skin, punctured porthole windows, and surmounted by a parapeted or projecting thin slab roof. Pablo Antonio's Ideal Theater (1933) and Luis Ma. Araneta's Times Theater (1941) exemplified the adaptation of the streamlined moderne.

Pablo Antonio's first architectural work for cinema was the Ideal Theater (1933), originally built of wood in 1908, on Rizal Avenue. The Ideal Theater was a statement in streamlined art deco aesthetics. The entrance to the theater was flanked by two massive pillars between vertical bands. During the Japanese occupation, Ideal was made into an exclusive theater for Japanese movies.

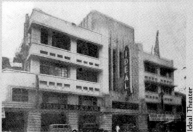
Ideal Theater

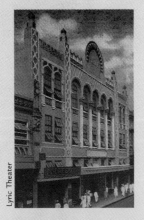

Lyric Theater

The Lyric Theater (1935) in Escolta was Antonio's deviation from art deco's machine aesthetics. Here, he abandoned streamlining in favor of an exotic Middle Eastern theme. The façade featured a wide central bay bounded by smaller bays on both sides, segmented by protruding pilasters pinnacled by finials. The middle bay was defined by pointed Islamic arch windows, which were further delineated by bell-shaped emblems at the center. The Lyric was destroyed during the war.

Luis Ma. Araneta designed the Times (1941) on Quezon Boulevard. To grace its opening with American presence, no less than Gen. Douglas MacArthur inaugurated the theater. Times Theater was the first to utilize backlighting as a decorative effect in its façade. It featured an undulating wall broken in the middle by a flat concrete surface. Vertical window strips on the undulations were capped by small, curving eaves. It was also the first theater to install a permanent equipment with ozone to cleanse and deodorize the air inside.

Life Theater (1941), designed by Pablo Antonio, on Quezon Boulevard, was a first-class cinema showing only Filipino movies. The white façade fused art deco streamlining and neoclassicism with its exaggeratedly scaled round columns topped by a conical finial.

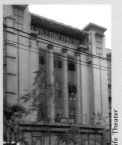

Life Theater

Cathay Theater (1937) on Gandara Street, Manila, was located at the heart of the Chinese community. It was the only theater to showcase exclusively Chinese movies. It can only be surmised that its architecture was of a Sinicized deco style via the stylization of its graceful *tou-kong*.

Pines Theater (1939) and Session Theater (1930s) in Baguio City utilized art deco's plasticity, horizontality, and rounded edges.

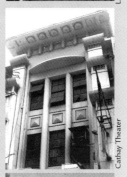

Cathay Theater

The concurrence of postwar reconstruction and the Golden Age of Philippine cinema provided a suitable condition for the phenomenal increase in the number of movie houses, as moving pictures allowed Filipinos to recover from the psychological trauma inflicted by the war. In the 1950s, Pablo Antonio established prolificacy in the production of modern cinema spaces. He can be credited as the "Father of Philippine Cinema Palaces" for his works, which included the Ideal Theater (1933, theater; 1954-1955, expansion and alterations), Lyric Theater (1935), Life Theater (1946, theater and auditorium, and 1954, reconstruction and expansion), Lyric Theater (1947, rehabilitation), Scala Theater (1947), and the modern and almost sci-fi Galaxy Theater (1955).

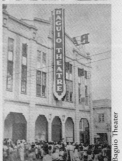

Baguio Theater

With the costs of maintaining the extravagantly decorated theaters increasing while movie receipts were declining, theater owners found themselves demolishing, gutting out, dividing, abandoning, or converting many of the old-style palaces. The renovated cinema spaces, like the newer theaters that were constructed between the 1970s and 1980s, lacked the glamorous aesthetics of yesteryears— their facades were reduced to small, back-lit plastic signs listing the names of movies inside, typical of SM cinemaplexes. Auditoriums were smaller, with screens set in the center of a blank wall, embellished by neither proscenium curtains nor decorative walls nor seductive lighting. Nowadays, the monolithic malls with multiscreen offerings have replaced the ritual and spectacle of watching movies of yesteryears. As spectators cue out of the cinema palaces, the theaters themselves are making their final bow.

The Commonwealth and the Founding of a New Capitol City

In 1934, the United States Congress mandated the granting of Philippine independence within twelve years. As a first step, in 1935, the Philippine Commonwealth was established as a transition government, autonomous in domestic affairs, with Manuel Quezon sworn in as its first president. The Philippine economy continued to prosper, attributed to a sizable fund built from taxes collected from the Philippine coconut industry that the US government turned over to the Quezon administration. The funds were used for infrastructure and other development projects. The Philippines' traditional export commodities—abaca, coconut and coconut oil, sugar, and timber—were also doing very well as the breakout of the war in Europe in 1939 increased the demand for these products, especially coconut oil and timber.

In 1937, Manila was no longer just a big town as it laid claim to the status of a world city when it hosted the International Eucharistic Congress. To project a modern image of a soon-to-be independent nation state, Juan Nakpil, the architect of the international event, employed the grammar of art deco in the design of the Eucharistic Monument and its ancillary structures. The thirty-meter high monument, built on the Luneta grounds, housed an altar and was supported by three carved columns symbolic of Luzon, Visayas, and Mindanao. Philippine identity, achieved through the use of indigenous materials, was also showcased in the design of Processional Arches and Pilgrim Arches, which combined bamboo and salakot designs.

As Manila rapidly grew into a hub of international trade and commerce, the city was forced to expand to accommodate its ever-increasing population. A new city was being contemplated to cushion the impending urban sprawl. President Quezon considered transferring the capital from Manila to a new and improved site with sufficient contiguous land directly accessible to Manila. What Quezon envisioned was a new Capitol City in the mold of Washington, DC and a place where the common man could settle with dignity. His main objective was to provide inexpensive lots for the landless of Manila and implement a government low-cost

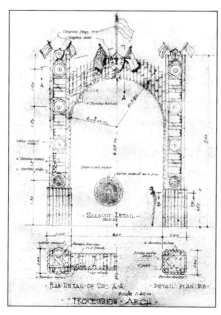

;.196 Drawing of the Processional Arch designed by Juan Nakpil for the 1937 World Eucharistic Congress

.197 The altar of the 1937 World Eucharistic Congress

Commonwealth Triumphal Arch

To commemorate the inauguration of the Commonwealth on October 25, 1935, the University of the Philippines Alumni Association planned to construct a monument in the form of a triumphal arch. Fresh from the success of his design of the Bonifacio Monument, Guillermo Tolentino was chosen to allegorically interpret the ideals of the new Commonwealth. In due time, Tolentino presented the maquette of the arch to the President and the National Assembly for their approval. An act was passed that authorized the construction of the arch in Manila.

The design, having a dimension of 27 m tall x 22 m wide x 8 m deep, featured a flat arch with streamlined edges typical of art deco. Supporting the arch on both sides were classically proportioned bodies in a heroic gesture of carrying the massive structure to allude to the spirit of bayanihan in nation-building. Relief carvings portrayed the national narrative through the image of the motherland. The monument was budgeted at a huge sum of ₱500,000 and to raise the amount, the Post Office issued commemorative stamps bearing the image of the model of the triumphal arch. The shortage of funds did not weaken the faith in continuing the project and on November 15, 1938, Mrs. Aurora Quezon laid the ceremonial first trowel-full of cement on the monument's foundation in front of the Legislative Building. But the Second World War frustrated its realization and the dream of a Commonwealth Triumphal Arch exists today only as a maquette kept as part of the Guillermo Tolentino memorabilia in Pasig City Museum.

Arch of the Philippine Commonwealth

housing project. In 1938, President Quezon ordered the acquisition of the vast Diliman Estate of the Tuason Family, with an area of 1,529 hectares, a rolling property northeast of Manila.

The National Assembly approved on June 8, 1939, Commonwealth Act 457, which authorized the "construction of National Government and public buildings on a site to be selected by the President of the Philippines within a radius of thirty kilometers from the Rizal monument of Manila, including the acquisition of privately owned land and buildings."

Quezon emphasized the urgency of the project in his speech addressed to the Second National Assembly on September 18, 1939. He invited the assembly to consider:

> the urgent need of provision for the adequate control and development of an area in the vicinity of the new site for the University of the Philippines and the People's Homesite Corporation's Subdivision project near the City of Manila ... The purpose of transferring the University is to provide an adequate educational plant in an atmosphere conducive to moral and scholastic standards appropriate to our highest public institution of learning. The homesite project is designed to provide the workingmen and permanent employees with homes at reasonable cost and also serve as a model residential and community center (Quezon 1940).

Quezon's dream of a blissful "Barrio Obrero"(Laborer's Village) was to become the nucleus of the city. The city received its charter from the National Assembly on October 12, 1939, under Commonwealth Act 502. It was fittingly named after the President—Quezon City.

In line with his concern for social justice, Quezon earlier initiated programs and enacted legislations to improve the housing conditions of the masses, which included the acquisition of land for subdivision into residential lots, housing, and subdivision projects for low-income families, such as the Vitas Tenement Housing Project (1936), and the acquisition of land at the Diliman Hacienda (1938) to be developed as a barrio obrero.

Barrio Obrero: Communities for the Working Class
The demand for housing in the 1920s created a construction boom of tenement houses and apartments such as "acessorias" or "posesiones" for lease. Privately owned estates were in the hands of a few wealthy families and religious orders. The grievances and conflicts over land were increasingly felt in the urban slums, along with the deplorable housing conditions of the laboring class. The period's labor agitation resulted in the establishment of barrios obrero or laborer's villages. In 1915, labor leader Isabelo de los Reyes launched the very first working-class district. The Barrio Obrero scheme became a staple item in the list of labor demands, which the colonial administrators of the City of Manila addressed in the 1920s. The Barrio Obrero aimed to promote the welfare of the laboring class and to free the poor laborers from rapacious and racketeering landlords.

The Barrio Obrero concept was also a method adopted by the Manila Municipal Board to relieve urban density. In essence, the concept of Barrio Obrero was overlaid on the sanitary barrio scheme and incorporated the public facilities of the

latter. The new housing scheme offered home lots for sale and, sometimes, new dwellings as well. Another phase of the project included both houses and lots for sale or for lease. The pilot project site was in Tondo, purchased by the City of Manila in 1922 pursuant to its Charter. The city government acquired a 170,105-square meter piece of land for ₱387,685. This was subdivided into twenty-six blocks of 513 lots with an area of 108 square meters for every single detached house. Eleven of the lots were designated for communal facilities, such as a school site, public toilet sheds, parks and playgrounds, markets, a theater, public baths, and other public amenities. The residential lots were exclusively sold to laborers who were bona fide Manila residents whose wages did not exceed ₱60.00 a month or ₱2.40 a day. Each lot, at ₱2.50 per square meter, would cost about ₱240.00, which could be paid by the laborers in 120 monthly installments for a period of ten years. The terms were liberal and within the means of thrifty laborers. It was estimated that about four or five thousand applications were received for the 511 lots, and a special board had to be appointed to make an equitable distribution of the lots. Nevertheless, the spirit and enthusiasm, which animated the applicants in the formative period of the Barrio Obrero, dwindled as some owners failed to sustain their monthly installments.

Several barrios which replicated the original scheme were later established, the largest of which was envisioned by Commonwealth President Manuel Quezon as an essential component of a new capital site in 1939 and managed by the People's Homesite Corporation.

To design his new capitol city in a suburban site, Quezon employed the services of architect William Parsons to lead the project. Parsons confirmed the Diliman site as the nucleus of Quezon City and identified the site of the University of the Philippines new 493-hectare campus. However, Parsons died shortly afterward in December, and his former partner, Harry T. Frost, succeeded him as Quezon's consultant. Together with assistants and architects Juan Arellano and A.D. Williams, they produced a grandiose plan for the capitol, which now included the new campus. Frost completed the comprehensive plan in 1941. The cornerstone and foundation of the Capitol Building were laid and constructed in the same year. The implementation of Quezon's urban vision ground to a halt when the clouds of war began to blur the materialization of the dream.

5.198 President Quezon's vision of the Barrio Obrero housing project catalyzed the growth and development of Quezon City.

War and the Nostalgia for the Nation

The Second World War, which commenced in Europe in 1939, entered its Pacific phase with the Japanese bombing of Pearl Harbor, a US air base in Hawaii, on December 8, 1941. Four days later, on December 12, the Japanese Information Bureau announced: "The present war against US and Britain, including the Sino-Japanese conflict, shall from now on be called the Great East Asia War" (Shillony 1981, 141). The area covered the Southeast Asian countries of the Philippines, Indonesia, Malaysia, Thailand, Burma as well as China. It was Japan's project to place these countries of Asia under the autonomous Greater East Asia Co-Prosperity Sphere under the leadership of Japan.

To spare the city from damage from the advancing Japanese Imperial Army, General Douglas MacArthur declared Manila an "open city" on December 27, 1941. In his communiqué, he explained:

> In order to spare the Metropolitan area from ravages of attack, either by air or ground, Manila is hereby declared an open city without the characteristics of a military objective. In order that no excuse may be given for possible mistake, the American High Commissioner, the Commonwealth government, and all combatant military installations will be withdrawn from their environs as rapidly as possible. The Municipal government will continue to function with its police powers, reinforced by constabulary troops, so that the normal protection of life and property may be preserved. Citizens are requested to maintain obedience to constituted authorities and continue the normal processes of business (GHQ, USAFFE 1941).

The citizens of Manila were caught in a state of shock as they realized that the Americans had abandoned the city to the Japanese. Yet, Manila's open city status did not stop the invaders from assaulting the defenseless city and the first bombs were dropped the following day. Five waves of bombers in formations of eight to nine aircraft flew leisurely over Manila's waterfront. In the port area, their first objective, one bomb hit the north end of Pier 7, a second hit its center, and a third hit a mess hall at the north entrance. Pier 3 was damaged, and Pier 5 took several hits that started cargo fires and rendered the pier unserviceable.

5.199 Manila was declared an "open city" to spare the city from damage.

5.200 Manila at the height of the Japanese occupation

Once the aircraft had left, the casualties of the Japanese air raids were soon ascertained. San Juan de Letran College had burned to the ground, as did a press building of *The Philippines Herald*. Several bombs had landed inside the walled city of Intramuros, one of which hit Fort Santiago, in the northwest corner of the ancient city. Two bombs pounded the old Intendencia Building. Smoke rose from the twin towers of the neo-Gothic Santo Domingo. The roof collapsed, bringing down the dome. The upper part of a tower crashed into the Santa Catalina girls' school, which was also on fire. By the time the fires were extinguished, little of the Church of Santo Domingo remained except its walls.

The Japanese forces entered Manila on January 2, 1942. The takeover would usher in a period of confusion and contradiction for both the invaders and the vanquished. During the occupation, they launched several programs designed to rechannel Filipino loyalty from the United States to Japan. The Japanese offered incentives to encourage a culture in conformity with the interest of the Greater East Asia Co-Prosperity Sphere. As early as February 11, 1942, the educational and cultural program of Japan for occupied Philippines was delineated in Order No. 2 of the military administration, which set the following guidelines:

> 1. To make the people understand the position of the Philippines as a member of the East Asia Co-Prosperity Sphere, the true meaning of the establishment of a New Order in the Sphere, and the share which the Philippines should take for the realization of the New Order and, thus, to promote friendly relations between Japan and the Philippines to the fullest extent;

> 2. To eradicate the old idea of reliance upon the Western nations, especially upon the USA and Great Britain, and to foster a New Filipino culture based on self-consciousness of the people as Orientals;

> 3. To endeavor to elevate the morale of the people, giving up overemphasis on materialism;

> 4. To strive for the diffusion of the Japanese language in the Philippines and to terminate the use of English in due course;

> 5. To put importance on the diffusion of elementary education and promotion of vocational education; and,

> 6. To inspire the people with the spirit to love labor (*The Official Journal of the Japanese Military Administration*, Vol. 1, p. 13).

In its cultural and educational policy, Japan's principal ideological line was that Japan had come to liberate the Asians, and Filipinos in particular, from exploitation by Western colonialists. Japanese empire building in Asia required the eradication, if not annihilation, of Western influence in the region. Its apparently benevolent discourse was grossly contradicted by the everyday realities of tortures, massacres, burnings, severe inflation, and food shortage—all of which greatly decimated the population, spawned widespread misery, and fueled anti-Japanese resistance.

The political instability and economic difficulties spurred by the occupation proved to be detrimental to architectural production. No significant architecture was built during the period. The three-year tenure of Japan in the Philippines was too

5.201 Japanese propaganda cartoon extolling the construction of a Pan-Asian ideology of a "Greater East Asia Co-Prosperity Sphere" that never was

short for an evolution of style to take place. Moreover, an encounter between the two architectural traditions was thwarted by the political climate. What happened instead was a takeover of private and public buildings by the Japanese Imperial army for military purposes, the erection of ephemeral arches of friendship and temporary grandstands for the purpose of glorifying the legitimacy of the state (in the form of parades and Taiso demonstrations), and the renaming of streets to eradicate Western influences by replacing the American names of certain roads, throughfares, bridges, and plazas with names that signify Japanese or Filipino ideas, values, or personalities. The toponymic alterations were implemented by virtue of Executive Order Nos. 41 and 110 of the Japanese Military Administration, which essentially aimed to eradicate "all traces of Anglo-Saxon influence in East Asia" (*The Official Journal of the Japanese Military Administration*, Vol. IV, 32–33).

With the outbreak of the Pacific War and the downfall of the nation to Japanese occupation, the architectural trend from 1942 to1945 was toward defensible architecture. Piles of sandbags used to buffer the impact of wartime explosives became part of the building design. Glass windows were protected by masking tape to prevent the glass from shattering. Windows were also darkened by using black paint or curtains in consonance with the "Total Blackout" scheme. The only plans endorsed by the Japanese that had an architectural bearing were drawn instructions for the construction of four types of air-raid shelters published in the propaganda magazine *Shin Seiki*.

In February 1945, the stage was set for the liberation of Manila. Gen. Tomoyuki Yamashita, commanding all Japanese units in the Philippines, saw no need to leave troops behind to fight a battle in Manila and ordered his men to evacuate

5.202 The design and production of defensible architecture was a great concern during the war years. Instruction for the construction of four types of air-raid shelters were published in the Japanese propaganda magazine *Shin Seiki*.

5.203 Japanese triumphal arch at Manila's business district

5.204 The Japanese army undertaking the repair of a bridge somewhere in Luzon

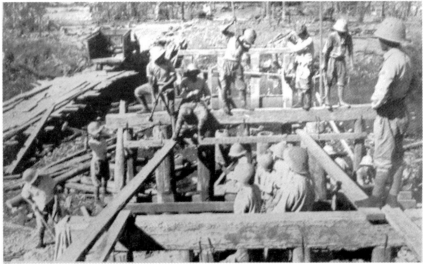

Manila to head eastward. Gen. Yamashita, unlike Gen. MacArthur in 1941, did not declare Manila an "open city," which would have spared Manila from utmost destruction. Rear Admiral Sanji Iwabuchi, commanding the naval troops, renounced the explicit orders from Yamashita and decided to stay to defend the city's harbor installations from the Americans for as long as possible.

As the Americans entered Manila, Admiral Iwabuchi set his plan into operation. Part of his plan was to fortify Manila with barbed-wire entanglements and barricades of overturned trucks and trolleys. He ordered his men to blow up all of the city's military installations, bridges, and water and electric supply. Buildings were rigged for demolition. Fires were set in certain areas of Manila, perhaps, to stop the advance of the Allied troops.

In the final stage of the War, in early 1945, the fighting was conducted from street to street, house to house, floor to floor. A large part of Manila, south of Pasig, was

Architecture Tailored for World War II

The quonset hut was the most famous of the mass-manufactured, mass-distributed, prefabricated structures of World War II. This prefabricated steel tunnel stucture was invented in 1941 by a team of engineers working for the Fuller Construction Company at the Davisville Naval Construction Battalion Center on Quonset Point, Rhode Island. During the war, 170,000 quonset huts were produced to provide inexpensive, portable, and easy-to-assemble housing for the armed forces and their military equipment.

The quonset hut was loosely modeled on the Iroquois Indian council lodge, and featured rows of semicircular steel beams covered with corrugated metal sheets. Quonset huts came in several sizes, with varying insulation, door, window, vent, and interior finish configurations to suit climates all over the world. It was made of galvanized corrugated steel sheathing over a frame of lightweight steel ribs, purlins, floor joists, and beams. Quonset huts could be covered with sandbags and were designed to withstand hurricanes, but removing the skin revealed remarkably light framework. The structures' incredible strength was a product of all their components working in unison. Once the war was over, the structures were sold as surplus and have endured as houses, movie theaters, retail outlets, warehouses, and chapels. At the University of the Philippines Diliman campus, a former American military garrison during the Second World War, there are a few remaining quonset huts that are still being used, such as the building of the Procurement Service. A concentration of the said structures could still be found intact within the block bounded by Osmeña and Magsaysay Avenues, and Apacible and Jacinto Streets.

Quonset Hut

Extant quonset hut, UP Diliman Campus

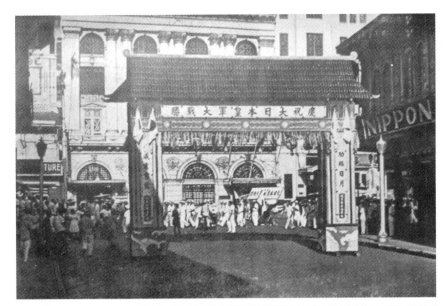

Manila to head eastward. Gen. Yamashita, unlike Gen. MacArthur in 1941, did not declare Manila an "open city," which would have spared Manila from utmost destruction. Rear Admiral Sanji Iwabuchi, commanding the naval troops, renounced the explicit orders from Yamashita and decided to stay to defend the city's harbor installations from the Americans for as long as possible.

As the Americans entered Manila, Admiral Iwabuchi set his plan into operation. Part of his plan was to fortify Manila with barbed-wire entanglements and barricades of overturned trucks and trolleys. He ordered his men to blow up all of the city's military installations, bridges, and water and electric supply. Buildings were rigged for demolition. Fires were set in certain areas of Manila, perhaps, to stop the advance of the Allied troops.

In the final stage of the War, in early 1945, the fighting was conducted from street to street, house to house, floor to floor. A large part of Manila, south of Pasig, was

Architecture Tailored for World War II

The quonset hut was the most famous of the mass-manufactured, mass-distributed, prefabricated structures of World War II. This prefabricated steel tunnel stucture was invented in 1941 by a team of engineers working for the Fuller Construction Company at the Davisville Naval Construction Battalion Center on Quonset Point, Rhode Island. During the war, 170,000 quonset huts were produced to provide inexpensive, portable, and easy-to-assemble housing for the armed forces and their military equipment.

The quonset hut was loosely modeled on the Iroquois Indian council lodge, and featured rows of semicircular steel beams covered with corrugated metal sheets. Quonset huts came in several sizes, with varying insulation, door, window, vent, and interior finish configurations to suit climates all over the world. It was made of galvanized corrugated steel sheathing over a frame of lightweight steel ribs, purlins, floor joists, and beams. Quonset huts could be covered with sandbags and were designed to withstand hurricanes, but removing the skin revealed remarkably light framework. The structures' incredible strength was a product of all their components working in unison. Once the war was over, the structures were sold as surplus and have endured as houses, movie theaters, retail outlets, warehouses, and chapels. At the University of the Philippines Diliman campus, a former American military garrison during the Second World War, there are a few remaining quonset huts that are still being used, such as the building of the Procurement Service. A concentration of the said structures could still be found intact within the block bounded by Osmeña and Magsaysay Avenues, and Apacible and Jacinto Streets.

Quonset Hut

Extant quonset hut, UP Diliman Campus

5.205 An American bomb being dropped in Manila's urban center during the last days of the Second World War

burned to the ground; the severest hit were the districts of Malate, Ermita, and Paco where elite families did not leave their residences for safer and less exposed places.

Manila experienced the horrors of urban warfare. The Battle for Liberation destroyed most of the irreplaceable architectural treasures of Manila. The Americans bombed, then shelled Intramuros relentlessly. All of the Walled City was reduced to a heap of rubble and almost everyone trapped inside perished. The only building left intact was San Agustin Church. Manila was still burning as the last corner of Japanese resistance—the Finance Building—was crushed. When the fight in Manila was over, most of the city lay in ruins, suffering the worst damage next only to Warsaw, Poland.

As General MacArthur drove to inspect the ruins of Manila, he keenly observed:

> As I passed through the streets with their burned-out piles of rubble, the air still filled with the stench of decaying unburied dead, the tall and stately trees that had been the mark of a gracious city were nothing but ugly scrubs pointing broken fingers to the sky. Once-famous buildings were now shells (Reports of Gen. MacArthur, 1944).

The bombed-out shells of buildings were physical reminders that life after the war would never be the same again. As Filipinos moved on to postwar reconstruction, they would be gripped by a nostalgia for the nation that was and a sense of mourning for things lost during the war. Rising from the ashes of war, it was time to build a new nation.

6 Postcolonial Modernity
Architecture of Early Independence
(1946–1960s)

Rising from the Ruins

The 1945 Battle for Liberation witnessed the massive decimation of Manila's urban-built heritage and the irreplaceable treasures of colonial architecture. Despite the seemingly impossible task of rehabilitating war-ravaged Manila, the city rose again. Out of the ashes, makeshift structures built from the debris itself and other salvaged materials emerged as the period's architectural symbol of survival. In the midst of postwar destitution and economic limbo, shantytowns mushroomed sporadically in the urban areas in response to the shortage of housing. The residential area south of the Pasig River was transformed early in 1945 from an almost unpopulated countryside to ad hoc communities formed by quonset huts and shelters of light material to address massive homelessness. Financially broke, physically exhausted, and facing a massive housing crisis, the Filipinos, in the aftermath of war, found an opportunity to build a new nation and to rectify the worst mistakes of the past.

Although modernism possessed a symbolic allure of a new architecture for rebuilding a brave new world ravaged by war, its expression in architecture and fearless avant-gardism took quite a while before reaching the Philippine shores. Its local florescence in the latter half of the 1940s was held in abeyance due to the shortage of building materials, the absence of knowledge in new building methods, the lack of technology and equipment, and, most of all, the postwar austerity that placed architectural production to a standstill. Modernism had to wait for the 1950s when the economic and cultural climate was auspicious enough for its development.

The Commonwealth government was immediately reconstituted by President Osmeña on March 7, 1945, and Congress reconvened afterward to address the problems of rehabilitation. Against the backdrop of postwar rehabilitation, the last American designer to directly influence Philippine urban architecture was Louis P. Croft, a Harvard-trained landscape architect and engineer. Brought to the Philippines two years before the war by President Quezon to establish national parks, Croft visited various sites in the archipelago and prepared preliminary reports on twenty scenic sites. Croft also supervised revisions of the original Frost Plan of 1941 under the aegis of the National Urban Planning Commission. He prepared a

6.1 Aerial photograph of the Quezon Memorial Circle in the early 1970s

6.2 The bombed-out shell of th
Post Office Building after th
Battle of Manila in 1945

6.3 The Manila City Hall in th
aftermath of war

reconstruction plan for a burnt area in Tondo. But this plan to transform the congested slum district of Tondo into a model community was frustrated by the War and never took off. As adviser to the Philippine president and as head of the City Planning Office in Malacañang, he was responsible for the physical rehabilitation of war-torn Manila and assisted in selecting designs for the new capital. Collaborating with Filipino planners, such as Antonio C. Kayanan, and the American corps of engineers, he prepared the Metropolitan Thoroughfare Plan for Manila in 1945 and, later, the Downtown Manila Plan in 1947. The Metropolitan Thoroughfare Plan for Manila proposed the laying of six circumferential and ten radial roads covering Metropolitan Manila from Nichols Field on the south to the Bulacan-Rizal Boundary on the north and the Marikina Valley on the east.

6.4 The Legislative Building (now the National Museum of the Philippines) in a pile of rubble at the end of the Battle for Manila's Liberation

Despite the shaken state of the country, the United States and the Philippines decided to proceed with plans for independence. In accordance with the terms of the Tydings-McDuffie Act, on July 4, 1946, the Philippine Islands became the independent Republic of the Philippines, with Manuel Roxas as the duly elected president.

To rehabilitate the Philippines, US Senator Millard E. Tydings sponsored the Philippine Rehabilitation Act, which appropriated $620 million for war damages. However, the United States-sponsored postwar reconstruction package had certain prerequisites attached to it that the new nation-state could not refuse. In exchange for the US aid to rehabilitate the Philippines, the United States gave a singular condition: that the Philippines grant the Americans parity rights to enable them to enjoy the same rights the Filipinos have to develop and exploit the natural resources of the Philippines and to operate public utilities in the country. The Filipinos had no choice but to accept the condition, resulting in the amendment of the Philippine constitution granting parity rights to American citizens in exchange for US economic aid.

In April 1946, the US Congress passed the Tydings Rehabilitation Act, which disbursed $120 million for the rehabilitation of public buildings, roads, and bridges. The bulk of this fund was channeled through the Bureau of Public Works, which was tasked to rebuild and design necessary infrastructures for the nation to be fully operational in the shortest possible time. An office of the US Bureau of Public Roads was set up to collaborate with the Philippine Bureau of Public Works in implementing the highway program, as authorized by the Philippine Rehabilitation Act of 1946.

The US War Damage Rehabilitation Fund was also instrumental in resurrecting to their original splendor the prewar neoclassic government buildings. The Manila City Hall, the Post Office building, the Agriculture and Finance buildings, the Legislative building, and a group of buildings of the University of the Philippines in Manila were fully restored following faithfully their original plans.

Privately owned buildings also underwent reconstruction but without the same logistical backing that sustained government infrastructure. The haste to erect buildings at the lowest possible cost took its toll on the design integrity of the building. Art historian Winfield Scott Smith, in appraising the mid-century architectural development in the Philippines, reported the following observations:

> The uncontrolled and too hasty building and rebuilding from the extreme shortage of buildings for living, work, and recreation brought about the worst examples of architecture in the Philippines. The early postwar years were a period dominated by fly-by-night contractors, builders, and mediocre designers whose collective architectural capacity did not exceed the ability to resurrect in three dimensional forms the dramatic photographs published in architectural magazines. It was a field day for the architects, and the public was treated to a magnificently mad display of architectural trash ranging in style from classic to garish and hopelessly misunderstood interpretations of "modern architecture" (Smith 1958, 55).

Around 1950, when the back pay and war damage claims reached their respective beneficiaries, a construction and building boom followed suit. The architects, after a long, inactive practice, dusted off their drawing boards to design new and

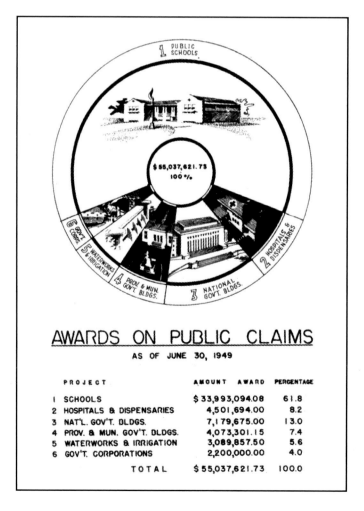

6.5 Pie chart from the *Report of the Philippine War Damage Commission* showing the allocation of the War Damage Rehabilitation Fund to various postwar infrastructure projects

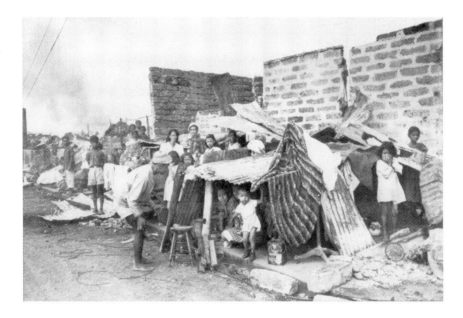

radical architecture that befitted the aspirations of a newly born nation-state. Those who had a chance to study and travel abroad during the period of dormancy reoriented their design practice in accordance to the philosophy preached by the masters of modern architecture, while those who could not afford to travel had to be content with the visual approximation offered by imported architectural magazines and slides. For the next two decades, Richard Neutra, Louis Khan, Le Corbusier, Frank Lloyd Wright, Mies Van der Rohe, Alvar Aalto, Eero Saarinen, Edward Durrel Stone, Walter Gropius, and Oscar Niemeyer would lend inspiration to the outstanding local interpretations as well as the ersatz version of modern architecture in the Philippines. Brise-soleil or sunbreakers, glass walls, pierced screens, and concrete shells were staple architectural features in the 1950s and 1960s.

The need for new government buildings was greatly felt in the 1950s as old government edifices could no longer accommodate the state's burgeoning bureaucracy and expanded services. The building program of the new Republic grew beyond the capacity of the Division of Architecture of the Bureau of Public Works, necessitating the revision of its policies in 1952. Previously, only government architects could design government edifices, but with the new policy, private practitioners were allowed to engage in the preparation of designs. Moreover, the policy spawned a diversity of modern government edifices and an adventurous exploration of new forms.

The economic recovery in the 1950s resulted in the surge in architectural production. The building boom was handled predominantly by a young generation of architects, the so-called "third-generation Filipino architects," who readily addressed the demands of a clientele who were eager to embrace modern life and ideas. They were Otilio Arellano, Carlos Arguelles, Cesar Concio, Cresenciano de Castro, Gabriel Formoso, Leandro Locsin, Alfredo Luz, Felipe Mendoza, Angel Nakpil, Jose Zaragoza, Francisco Fajardo, Augusto Fernando, Carlos Banaag, Gines Rivera, Antonio Heredia, and the Mañosa Brothers (Jose, Francisco, and Manuel Jr.) among others. Architects Cesar Concio and Carlos Arguelles earned their master's

degrees from the Massachusetts Institute of Technology; Alfredo Luz had a bachelor's degree from the University of California at Berkeley; while Angel Nakpil held a master's degree from the Harvard University and was also a disciple of Walter Gropius. Leandro Locsin, Gabriel Formoso, and Felipe Mendoza, although they had no foreign training, were considered important personalities who shaped the architecture at that time.

The architecture of the early 1960s maintained the fervor set in the '50s. But the adoption of nostalgic and retro design was a pervasive theme in the second half of the 1960s and early 1970s. A backward-looking aesthetic couched in the retrospection of local traditions and the vernacular past manifested itself in graphic design, architecture, interior design, and the allied arts. Oriental-themed and

6.7 Binondo, Manila' commercial and trading distric was reborn, and businesse boomed in the 1950s.

6.8 Rizal Avenue, th entertainment and shoppin hub of Manila, brimmed wit urban vitality in the atmospher of postwar optimism an economic recovery in the mid 1950s.

tradition-bound interior design and architecture became the main thematic preoccupation.

Though the third-generation architects continued to promote the modern and progressive ideas of their modernist idols in the first half of the 1960s, for better or worse, a hegemonic modernism in the Philippines began to take form. Glass-box, high-rise buildings, biomorphic forms, folded plate architecture, and the rational functionalism of the International Style were the principal interests which guided the teaching and practice of architecture in the Philippines at the time. Generally, the architecture of the period could be described as a Third World imitation of the International Style, bearing no philosophical agenda or relation to any climatic and cultural context of the place. In the midst of the hegemony of the International Style, young architects and designers of the mid-'60s began to reappraise the country's rich architectural and cultural heritage as a source of design inspiration. They began to question the relevance and authenticity of this form of architecture that was devoid of relevance and reference to local or regional culture, climate, ecology, and historical traditions. The serial monotony of buildings all over the world was becoming very apparent, and regionalism or the need to express local identity became an important parameter in the practice of architecture. This retrospection was partly fueled by the quest to create a national identity in a postcolonial environment, implying that every form of artistic expression must be ingrained with Filipino identity. Thus began the Romantic phase in design and architectural production.

The Philippine Pavilion for the 1964 New York World's Fair, designed by Otilio Arellano, expressed the design sentiments of the period, commingling the native with technological icons of the Space Age. Despite the strong evocation of high technology and aerospace, the pavilion was held hostage to the well-beaten nativist approach, failing to go beyond the predictable translation of the familiar salakot, the wide-brimmed farmer's hat. Nevertheless, the message was lucid: modern architects should explore vernacular cultural artifacts and similar antiquities for symbols of national identity.

Mapping the Modern

Modernism was the leading movement of the twentieth century architecture, whose official history was written in the West. According to this account, which has become a key component of the mainstream cultural history of the twentieth century, "Modernism," or the "Modern Movement" as it was then called, encompassed a revolutionary aesthetic canon and a scientific doctrine in architecture originating in Europe during the interwar period. The use of reinforced concrete, steel, and glass, the primacy of cubic forms, geometric shapes, and Cartesian grids, and, above all, the absence of decoration, stylistic motifs, traditional roofs, and ornamental details have been its defining features in the twentieth-century aesthetic consciousness. For most people, the works of masters Le Corbusier, Walter Gropius, and Mies van der Rohe epitomized this modernist aesthetic. Notwithstanding its European origins, it was a doctrine that had claimed universal validity and rationality. The new needs, tools, and technologies of complex industrial societies that informed this modernist vision were presented as necessary ingredients for a rationally progressing universal history—an epochal force that no nation, culture, or geography could evade.

The terms "modernity," "modernization," and "modernism" are intricately linked, but each term needs further distinction. Behind the semantic subterfuge, we can define these terms as follows: modernity as a historical stage; modernization as a social process that attempts to construct modernity; and, modernism as a cultural process that takes place at several points along the development of capitalism.

In a broad sweep, modernism encompasses a constellation of intellectual and artistic movements, which includes movements such as impressionism, symbolism, cubism, futurism, art nouveau, imagism, international style, and so on. As an aesthetic and cultural tendency, modernism can be broadly defined as a movement grounded in the rejection of classical precedents and styles. It is said to coincide with "modern history" or a period "including the present but excluding the Greek and Roman epochs." Thus, modernism is characterized by the deliberate divergence from tradition and the use of innovative forms of expression that distinguish many styles in arts and architecture.

Though modernism takes place in different cultural fields, it could be commonly characterized as being: positivistic (knowledge and truth systems is verified by way of scientific inquiry); technocentric (progress in knowledge is achieved through advances in technology); rationalistic (knowledge is achieved by the application of reason); and marked by strongly held beliefs in universal progress, the possibility of absolute truth, and the rational planning of ideal social orders. It cogently professed the ideals of democratic collectivism, industrialization and machine aesthetics, devotion to a utopian future, and aspiration towards the creation of a universal culture.

Modern architects, in the quest for pure architecture, believed that buildings should strip themselves of pretensions and truthfully reveal their function, their construction, and their organization. They believed that buildings were intended to be experienced not only in space but also in time. To wholly appreciate the experience of architecture, they thought that one should move through its spaces, which are simply shaped by light and massing. The tectonic components and material capabilities of the new age should be shown, not disguised or concealed behind ornamentation. Applied decoration was, hence, no longer necessary or desirable. In the quest for a universal architectural language, context and symbolism became immaterial. Devoid of a cultural or social framework for understanding building, modernism could become a style for the entire globe.

Modern architecture was, to a certain extent, a reaction to the extreme ornamentation of buildings of the nineteenth century, an antithesis to grand symmetry and highly decorated surfaces of the architecture of the period. It was also a political and social statement by Europeans to divorce Europe and its architecture from its aristocratic image. If anything was implied by the movement, it was the rejection of the past and denial of historical precedents.

In the United States, architects like Louis Sullivan and Frank Lloyd Wright began to break with the past. Sullivan coined the phrase "form follows function," a mantra for modernists ever since. The phrase meant that the appearance of a building should be derived solely from its use or should grow from its intended purpose. Viennese architect

6.10 Philam Life Building, designed by Carlos Arguelles with Lawrence B. Anderson and Herbert L. Beckwith as design consultants

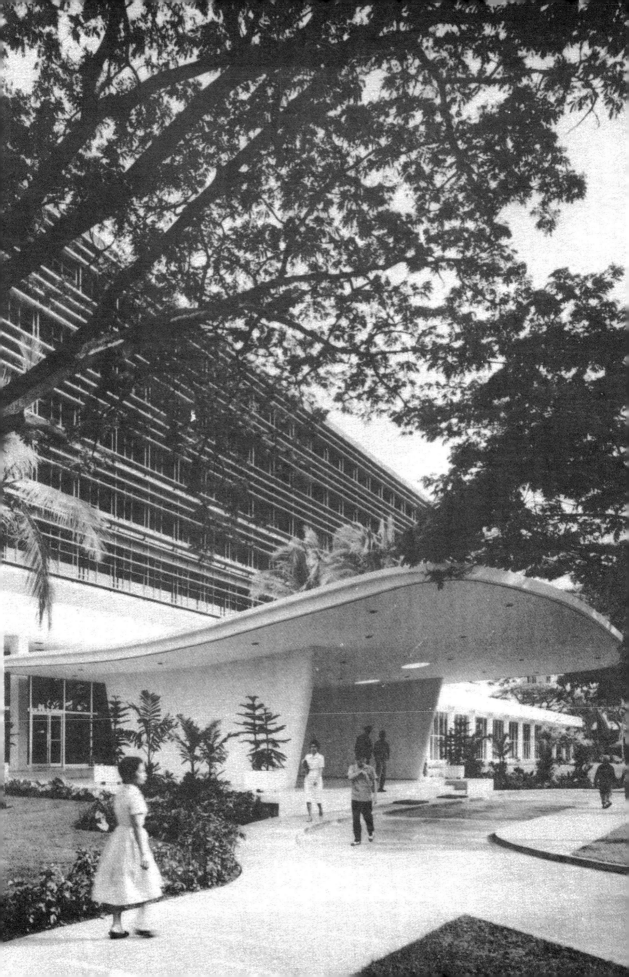

Adolf Loos also made his famous attack on architectural ornament: "Ornament is a crime, like a tattoo on the human body; a sign of degeneration," which became the modernist's rallying call for the proscription of arbitrary applied decoration.

After World War I, Germany's Bauhaus became the locus for modern design. Artists and designers of this school wanted to gain autonomy from the symbols of European aristocracy, including the Beaux Arts, and used the machine as the paradigm for their aesthetic. They experimented with forms and designed products that captured the simple beauty of mass-produced forms. They also used the machine itself as a motif. Ocean liners, trains, and skyscrapers fascinated them as harbingers of a new age. Many Bauhaus architects later fled from Adolf Hitler's Nazi regime and sought refuge in the United States. Yet, the influence of Bauhaus on modernist architecture was profound. The demand for standardization, the experiments in mass production, and the pioneering concept of industrial design all influenced the modernist approach to building and design.

Proponents of architectural modernism insisted that it was a universal form-language, which was applicable to all cultures and societies at all times. It was perceived as a logical consequence of rational design intervention and engagement with new materials and techniques whose architectural products were devoid of any signifier of heritage to reiterate the notions of formal economy and the dicta of "less is more." In the almost prescriptive catalog for the 1932 Museum of Modern Art exhibition, Hitchcock and Johnson summarized the modernist stylistic principles in these words: "There is, first, a new conception as volume rather than as mass. Secondly, regularity rather than axial symmetry serves as the chief means of ordering design. These two principles, with a third proscribing arbitrary applied decoration, mark the productions of the international style."

Divorcing from tradition meant the uninhibited exploration of new materials and methods. Applied ornaments were seen as carapace that diverts onlookers from the architectural essence and inner truths of a building, which ultimately interfered with its utility. With this philosophical basis, the utilization of reinforced concrete, steel, and glass; the predominance of cubic forms, geometric shapes, and Cartesian grids; and, most all, the absence of decoration, stylistic motifs, traditional roofs, and ornamental details have been modernism's essential lineaments in the twentieth century architectural consciousness. Modern architecture's simplified geometries were in accordance to the demands of honesty expressed in materials, structure, and form; navigated in restraint rather than indulgence; and valuing simplicity instead of complexity.

Monterrey Apartments

The Capital Dilemma

The emerging nations of the postcolonial world were all keen to use architecture not only to house their new governments but also to be the focus of the symbolic presence of the new state. The building of capitol edifices and the development of a new capital city site could be read as the ultimate proclamation of the worthiness of new regimes, seeking to manipulate the built imagery to define a nation, to promote national identity, and to declare the rightful existence of a new state in the global arena. Modern architecture, in the midst of postwar recuperation and national independence, provided the appropriate architectural image that represented growth, progress, advancement, and decolonization.

At this juncture in Philippine history, architecture and urban planning assumed a significant site of political control to consolidate the diverse domains of culture, society, and geography into a body politic constituting the "nation." The adaptation of modern architecture as the official architectural style was not arbitrary but a strategic choice for it possessed a symbolic appeal of technological advancement, economic prosperity, and cultural progress that an emerging nation aspires for. The design of modern architecture clad in the façade of "national styles" was systematically sought to emblematically instill the "visual politics" of nation-building and to confer materiality to the intangible imagination of the nation.

The newly independent Philippine state found in modern architecture and modernism a way to divorce itself from the vestiges of colonization and to create new built environments that conveyed freedom from the colonial past. Modernism provided the means for a new nation in the midcentury to craft a kind of architecture that not only represented progress but also offered a decolonizing agenda because modernist architecture was perceived as untainted by stylistic vocabularies and images associated with Western colonization. It is paradoxical to note, however, that while modernism was viewed by non-Western societies as a means of creating an identity free of Western colonial images, modernism itself was sourced from Western ideas. In this way, Western domination subtly continued. The old colonial styles of architecture were not acceptable as models for new independent nations, and indigenous or traditional architecture was viewed as primitive, rural, and backward. Modernism, therefore, became a popular choice that provided the progressive images that were being sought. This was particularly true in the case of the widespread proliferation of the International Style in the form of glass, steel, and concrete buildings, which had little or nothing to do with the culture, climate, lifestyle, and other local conditions.

The design of new capitols and parliament buildings could be viewed as an exercise in the promotion of national identity, an elevation of national over regional interests, and was symbolic of the national unity within the new nation despite ethnic diversity. Of issue here was the question of a homogenous, imagined or invented, group identity that the state sought to officially consecrate when, in fact, the Philippines, as a geographic and ethnic entity, was far from being culturally and socially monolithic.

In planning the new capital city of the Philippines in 1948, the Capital City Planning Commission took into account the role of the new city in various aspects of nation-building:

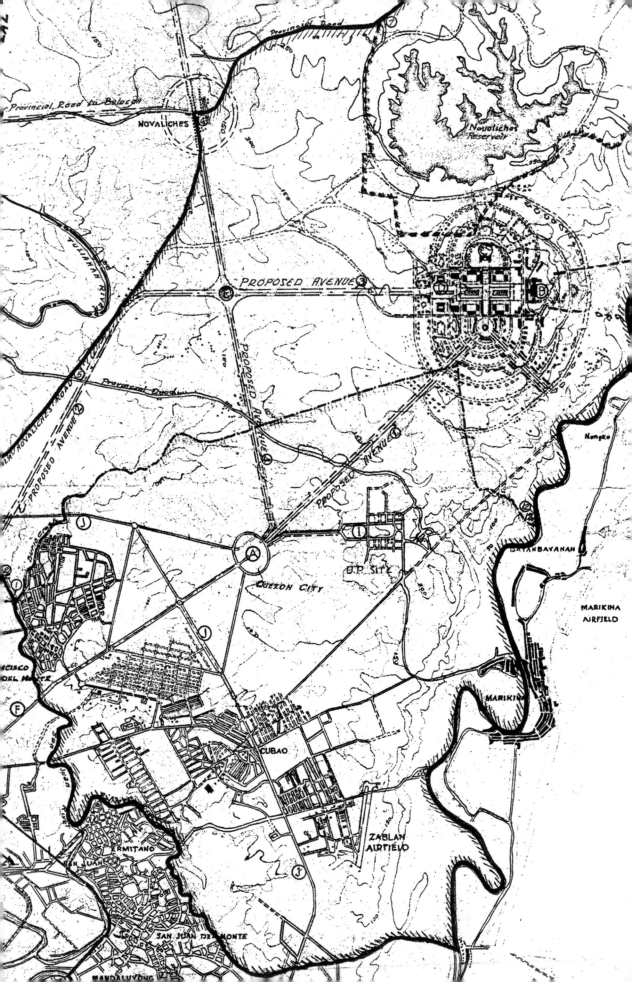

politically, as a seat of national government; aesthetically, as the showplace of the nation, a place that thousands of people will come to visit as an epitome of the culture and spirit of the country; socially, as a dignified concentration of human life, aspirations, endeavors, and achievements; and economically, as a productive self-contained community (Capital City Planning Commission 1949, 7).

Burnham's plan for the bayside capital failed to reach its full materialization. After the war, nothing much was left of Manila's imperial image as envisioned by the former colonial masters. Heaviest hit was Burnham's capital center at Luneta. Virtually all the principal government edifices were reduced to rubble, leaving a very faint intimation of America's imperial ambition. President Manuel Roxas, realizing the magnitude of reconstruction work that had to be done, promptly decided that the new set of government buildings that had to be built, would be located away from the ruined Manila in cognizance with the capital city's growing needs.

On July 23, 1946, President Roxas, through his Administrative Order No. 5, formed a Capital Site Committee, entrusted with the responsibility of choosing the most appropriate site for the capital of the new Republic.

This committee, headed by Senator Melencio Arranz, put in a whole year's work of investigations, hearings, inspections, and research. Sixteen sites were considered. Subcommittees made special studies in relation to general sanitation, public works development, strategic consideration, scenic resources, and administrative coordination. The final choice was the old Quezon City, including the underdeveloped plateau territory going to the Novaliches watershed. With the announcement of the new capitol site, land values went up from one peso to 3.50 pesos per square meter around the approaches of the new city.

In the intervening time, President Roxas, in order to build the capital city that would measure up to the latest trends in construction and architecture, decided to dispatch, in the summer of 1947, a mission of Filipino architects and engineers on a study junket of the United States, South America, and Central America. Included in this official travel were architects Juan Arellano, Juan Nakpil, Cesar Concio, and Engineer Manuel Mañosa Sr., among others. The mission returned with ideas influenced by modernist architecture and urban planning, and its members later assisted in the formulation of the master plan for the modern capital city.

The death of President Roxas did not dampen the official and public interest in the capital city project. President Elpidio Quirino continued what President Roxas had started. On July 17, 1948, he signed Republic Act No. 333, creating the new capital city of the Philippines and the Capital City Planning Commission for the preparation of the master plan. Quezon City's inauguration as the capital city was marked by the laying of a cornerstone for a capitol building in Constitution Hills on October 22, 1949. Subsequently, the construction of the government building began. The city remained as the Philippine capital until the enactment of Presidential Decree No. 940 on June 24, 1976, that reverted the title back to the City of the Manila.

In conformity with Republic Act No. 333, the Capital City Planning Commission, chaired by Juan Arellano, submitted to the President on March 18, 1949, "The Master Plan for the New Capital City." The master plan provided a detailed urban

6.11 Urban design and master plan for Quezon City, 1949

framework that would ensure that the "new Capital City where our constitutional offices will function in an atmosphere of dignity, freedom, and human happiness, will rise as the citadel of democracy in the Orient" (Capital City Planning Commission 1949, 5).

In the master plan, the entire Capital City site was to be divided into four major districts: the Metropolitan Area, the North Neighborhood District, the West Neighborhood District, and the South Neighborhood District. The Metropolitan Area, with an area of 7,627 hectares, was the locus of the entire development and was zoned into three main units that formed a triangle. The triangle was formed by: Constitution Hill, which was located on the northeast; the Executive Center (which consisted of the Executive Department, the Bureaus, and the main housing projects for government employees) on the south; and, the Business Center on the west.

Three major thoroughfares, the Avenue of the Republic, Commonwealth Avenue, and Mindanao Avenue, would link these three zones. Bisecting the triangle was Congressional Avenue. Traversing it were Luzon Avenue and Visayas Avenue. These six avenues would provide traffic routes and segregation for the metropolitan area.

Of the three zones, Constitution Hill would serve as the imposing centerpiece of the city. The twenty-hectare Plaza of the Republic, the thirty-hectare park fronting Constitution Hill, the seventy-meter wide avenue encircling the Plaza and connecting the three main groups of buildings in Constitution Hill, and the six thoroughfares converging at the hill would provide sufficient space for free movement of thousands of vehicles and people.

Constitution Hill was to be the site of the government center. According to the master plan:

> The center motif and the most beautiful part of the city is the high plateau, which we call Constitution Hill. It will be the seat of the

6.12 Perspective of the proposed Quezon City Capitol Site, 1949

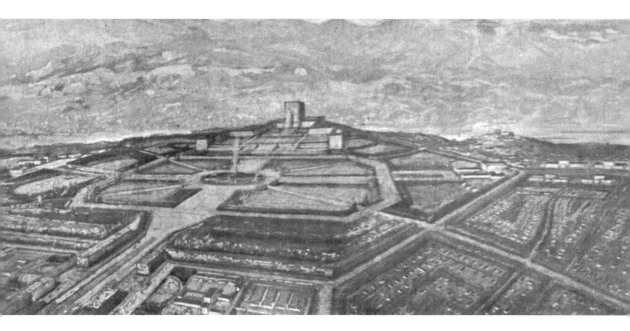

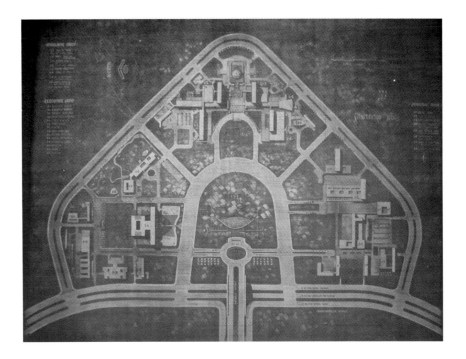

Constitutional Bodies distributed in three groups of buildings. In the center, fronting the Plaza of the Republic, will be the House of Congress. It will accommodate the Senate and the House of Representatives in two wings projecting from a central tower where the Hall of Fame and the Library of Congress will be located. The Hall of Fame will be the temple of our patriots, where our heroes will receive the proper memorial due them ... At the back of the Hall of Fame and facing the San Mateo Hills and Mariquina Valley, we propose the erection of a Hall of Brotherhood to be used as the assembly hall for important international meetings and conventions, a place dedicated to the peace and progress of the world.

To the right of the House of Congress will be located the Palace of the Chief Executive ... To the left of the House of Congress will be located the offices of the moderating constitutional bodies of our government ... These three buildings will symbolize for generations to the whole world, the government and culture of the nation (Capital City Planning Commission 1949, 10–11).

The master plan also specified allegorical names to be given to the main buildings of Constitution Hill to approximate the democratic aura of the existing parliamentary edifices of Europe and America. It prescribed the following toponymic directives:

It is imperative that symbolic and dignified names be given to each one of them. These could be called Palaces or Houses. We have the Palace of Justice in Paris and the Buckingham Palace in London. We have the House of Parliament in Washington. Being a democracy and a republic, we favor the designation of Houses to our main buildings. The House of Congress could be very appropriately and symbolically called the House of Wisdom; the Palace of the President, the House of Prudence; and the Offices of the Supreme Court and other moderating bodies, the House of Justice.

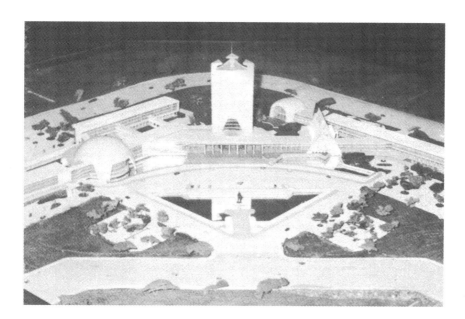

6.14 Scale model of the buildings for the Legislative Group in the capitol complex at Constitution Hill, 1956

> Wisdom, Prudence, and Justice, the three main virtues so often mentioned and extolled in the Proverbs, would become the distinguishing qualities of the three main departments of our government; names that could add prestige to the place, inspire great deeds, and restrain the improper use of power (Capital City Planning Commission 1949, 11).

Years later, in 1955, during the administration of President Magsaysay, the national government had perfected the plan to move all national offices from Manila to Quezon City. The design developments of each building group of Constitution Hill were assigned among collaborative groups: the Judiciary Group under the Philippine Institute of Architects; the Legislative Group under the Bureau of Public Works; and the Executive Group under the League of Philippine Architects.

In May 1956, the proposed design and scale models of buildings for the Legislative Group in the capitol complex at Constitution Hill were presented in a forum attended by leading architects and engineers. Called by the Secretary of Public Works Florencio Moreno, the forum sought concrete suggestions and impartial criticism from the luminaries of the local architectural profession. The plans and models of the proposed legislative center, which was estimated to cost ₱30 million, were prepared by Federico S. Ilustre, the consulting architect of the Bureau of Public Works.

Ilustre's design met several criticisms in the professional front as the work combined unrelated volumes and flamboyant forms; made excessive use of building height for monumental effect but which had no practical value; and, applied the superficial and carnivalesque use of Philippine stylistic motifs for simplistic semiotic equation. In the name of national identity, the state building manipulated volume and mass to an intimidating scale reaching 100 meters high and taking the form of a Kalinga *kalasag* (tribal shield) as the centerpiece of the whole composition. To its left was a Brasilia-inspired, dome-shaped building for the House of Representatives. The Senate Hall, to the right, assumed the form of an over-scaled

Malay roof punctured with glass skylights. Moreover, the formal and stylistic experiment of the Bureau of Public Works earned a scathing commentary from the League of Philippine Architects:

> The Legislative group was designed in the Malayan style but the expression shown is purely artificial in nature. Sculptural treatments to the building are not architectural in spirit. In spite of extensive research work, Malayan Architecture has no basic personality and has the physical appearance of an exposition building (*Design Magazine* May 1956, 7).

However blemished by controversy and negative response from the design world, the project began its construction phase in February 1958. The first building to be constructed was the House of Representatives of the Legislative Group. This was supposedly the tallest of all the buildings, having thirteen floors, excluding the roof deck, with a total height of fifty-two meters from the basement to the deck, with a storey height of four meters. The width of the building was sixteen meters, divided into one bay of four meters and two bays of six meters each, while the length of eighty-eight meters was divided into eleven bays.

Due to insufficient funds, construction stopped in August 1960, leading to the eventual abandonment of the entire project. What remained of the project was the eleven-storey structural steel framing, which cost some ₱7.5 million. The steel framings were to remain exposed to the elements until 1976 when the government of President Ferdinand Marcos revived the plans for a parliamentary complex at the same site. The very same steel framing would support the structure of the Batasang Pambansa, a building designed by Felipe Mendoza and finally completed in 1978.

The Rise of the Suburbia and Bungalow Housing

Immediately after the war, subdivision development went full blast to address the widespread homelessness. These planned satellite communities were patterned after the American suburbia, which encouraged an automobile culture. New roads and transportation systems were created to efficiently link these suburban communities to the urban core. The structure and arrangement of the postwar Philippine suburbia was generated from planning concepts advocated by social reformers of the early twentieth century, such as the "Garden City" of British reformer Ebenezer Howard (1850–1928) and the "neighborhood units" of Clarence Perry (1872–1944).

The provenance of a massive suburban development could be traced to the efforts of Commonwealth President Manuel Quezon, who created the People's Homesite Corporation (PHC) as the first government housing agency on October 14, 1938. Its charter contained an ambitious plan to ameliorate the living conditions of those belonging to the low income bracket by establishing model residential communities. With such a mandate, the first resolution that the PHC Board of Directors approved was the purchase of a tract of land consisting of approximately 1,600 hectares of rolling hills in the Diliman estate owned by Doña Teresa Tuason at ₱0.05 (five centavos) per square meter. The PHC accordingly appropriated two million pesos to finance the development of the area for the proposed "model city" in the Diliman Estate. But the implementation of the project was eclipsed by war and had to wait until the war was over.

In September 1945, the National Housing Corporation (NHC) was created, which constructed, in 1947, what is now known as Heroes Hill, the residential units for the officials of the then Philippine War Damage Commission and the Joint US Military Advisory Group (JUSMAG). This was the first housing project constructed immediately after the liberation. The development area, consisting of fifty-five single detached residential structures, occupied a sprawling area of 38.8 hectares which was bisected by a network of five asphalted streets.

The two agencies, the PHC and the NHC, were subsequently merged on October 4, 1947, into what was to be known as the People's Homesite and Housing Corporation (PHHC). Under the guidance of the National Planning Commission and the leadership of Director Anselmo T. Alquinto (an architect and civil engineer who was a prewar government pensionado to Harvard University on town planning and landscape and a 1949 United Nations fellow in Europe for town planning and housing), the PHHC designed and developed new and expansive suburban communities, including the design and mass-fabrication of low-cost bungalow units. Under its auspices, the Kamuning Housing Project in Quezon City was begun in 1940; Project 1 in the Roxas District was concretized in 1949; followed by Project 2 in the Quirino District in 1951. Other housing projects such as Projects 3, 4, 5, 6, 7, and 8, all in Quezon City, and Project 16 in Caloocan City were consequently completed. On the macro level, the open layout of these developments and the bounding greenbelts that surrounded these communities were in accordance with Ebenezer Howard's concept of a "Garden City." As formulated by Howard, the "Garden City" was intended to bring together the economic and cultural advantages of both city and country living, with land ownership vested in the community, while at the same time discouraging metropolitan sprawl and industrial centralization. Howard envisioned the "Garden

6.18 Bungalow housing of the University of the Philippines in Diliman, Quezon City, built in 1956

6.19 Government-buil
bungalows came in a variety o
models, such as: a 2-bedroom
duplex bungalow (top); a 3
bedroom bungalow (middle)
and, a 5-unit row house
(bottom).

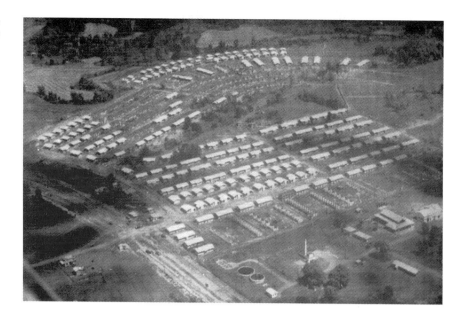

City" as a circle, with a park in the center, housing civic buildings, and with a grand avenue circling the city about half way from the center to the periphery. At the periphery would be a light industry district, next to a circular railroad that linked the city to its neighbors.

In all these suburban projects undertaken by the People's Homesite and Housing Corporation (PHHC), a unitary planning feature could be discerned: a site for schoolhouses, a school playground, a church, a hospital, a marketplace, commercial lots, and the residential district itself—all of which were bisected by conveniently located, asphalted roads. Such configuration employed the "neighborhood unit"—a self-contained residential area bounded by major streets, with shops at the intersection and a school in the middle—advocated by Clarence Perry for New York City in the 1920s. Perry defined the neighborhood as a component of a town and quantified its size based upon a five-minute walking radius. The radius was measured from the center, and at the center was located the cultural functions, such as a school.

These projects contain three types of residential units: the three-storey row house-type dwelling, the single-detached-type house (identified with the letter S, i.e., 35-S), and the twin or duplex type (identified with the letter T, i.e., 40-T), but with the bungalow providing a convenient model from which all low-cost housing was to be patterned. The row-type homes resembled the prewar accessoria in its exterior appearance. They were usually designed with two bedrooms, a kitchen, a small dining room, and a toilet. The duplex house, along with the single-detached house, was set in a small lot with a garden plot. These types of houses were architecturally uniform and plain as they were designed to cater to employees belonging to the family income bracket of ₱150 to ₱350 per month.

The PHHC model houses were designed to accommodate a Filipino family with an average composition of five individuals. The 40-T type, an example of a standard dwelling which was adapted by the PHHC in each of its projects, would provide the typical features of a low-cost suburban dwelling of the period. The 40-T type

dwelling, with an area of forty-seven square meters, was built of reinforced concrete hollow block exterior walls and interior partitions. The floor was made of concrete slab. These materials were chosen for their durability and low maintenance cost. The roofing was of cement-asbestos sheets on wooden framework to insulate the interior from heat. (It was not yet known during this period that asbestos readily separate into long flexible fibers that have been implicated as causes of certain cancers.) Installation of ceilings was considered unnecessary. The 40-T dwelling, a duplex unit–type designed for two families, was separated entirely by a concrete hollow block fire wall from floor to rafter. Each unit of this type was built on a 200 square meter-lot with a four to five-meter setback from the road. The unit covered forty percent of the lot, providing occupants with enough outdoor space. The 40-T unit contained two bedrooms, each having an approximate area of nine square meters. The bedrooms were integrated in the general plan for better and efficient circulation. The living and dining space of the unit occupied almost half of the entire area of the dwelling. Ample windows (usually of wooden jalousies) and openings were provided for proper ventilation.

Philam Life Homes, on the other hand, was developed in 1955 by the Philippine American Life Insurance Company to address the housing needs of moderate income families, particularly those with a monthly salary of about ₱600. The community was located in a forty-five-hectare site in Quezon City, about 400 meters north from the intersection of Highway 54 (now EDSA) and Quezon Avenue. This was the third community development project undertaken by the company, the first and second of which were in Iloilo City and Baguio City, in that order.

As a modern, self-contained community, it was complete with a church, a community center, a business and shopping center, a school, and open spaces for parks and a children's playground. The planners took advantage of the hilly terrain of the site and programmed a road system that corresponded with the contours of the ground.

To minimize construction costs, the basic plan of the house was designed on a modular system typical for all schemes, using typical, prefabricated millwork, such as structural members, closets, cabinets, doors, louvered transoms, and standard–sized steel windows to accomplish maximum efficiency and economy. Furthermore, to mitigate the uniformity of mass-produced houses, its architect, Carlos Arguelles, came up with twenty-four schemes for a bungalow derived from a single typical floor plan. Bungalow units on 450 square meter-lots had a floor

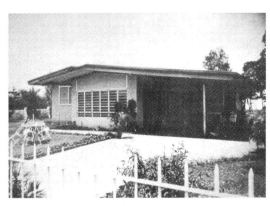
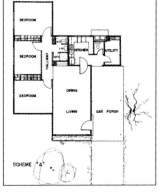

6.21 An example of a bungalow and its plan in Philam Life Homes in Quezon City

area of either seventy-five or ninety square meters, while those on 700 square meter-lots had a 120 square meter-floor area. Some models were provided with carports that converted into play spaces for children when the car was out.

New satellite communities were also created to cater to the housing needs of Manila's upper crust. The most prolific developer of exclusive suburban villages was the Ayala y Compania, which, a decade before the war, consolidated its resources and focused on real estate development. They developed their first subdivision in Singalong, Manila, marketed to the middle class in the 1930s. The development of the new town of Makati was also attributed to the Ayalas who have been closely adhering to their master plan to transform Makati into the most modern community in the country. In 1931, they transformed 930 hectares of the original Hacienda Makati, starting with Forbes Park, into an integrated residential and business community under a 25-year controlled development program. A thirty-eight-hectare area was set aside to form a regional shopping center, which is now known as the Ayala Center. By the 1950s, Forbes Park became an exclusive residential enclave that attracted affluent families, foreign capitalists, business tycoons, and industrial moguls.

From Manila's city core, the rich migrated to the gated villages of the suburbia developed by the Ayalas. Between 1952 to 1962, prime residential communities, such as San Lorenzo Village, Bel-Air Village, Urdaneta Village, San Miguel Village, Magallanes Village, and Dasmariñas Village were developed in Makati. These exclusive villages were sites of affluence and architectural display. Unlike the communities previously mentioned, the houses within these residential enclaves were not designed by a company architect but by an architect commissioned by the individual homeowner. Hence, there were more variants of modern residential architecture that emanated from the template of the bungalow, split-level, and one-and-a-half storey houses. These houses, as the "the new machine for living in," incorporated the most up-to-date features, such as single pitch roofs, split-level roofs and floors, slabs, wall screens, pierced screens, wide overhangs, and porte cocheres, and, more often than not, took inspiration from "California-style" residences.

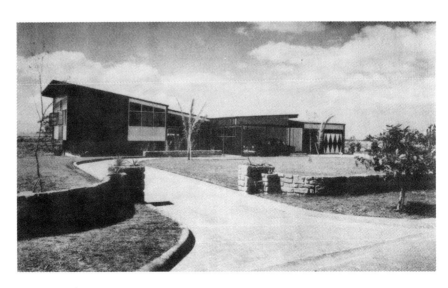

6.22 Rufino residence, designed by Juan Nakpil, in Forbes Park, Makati

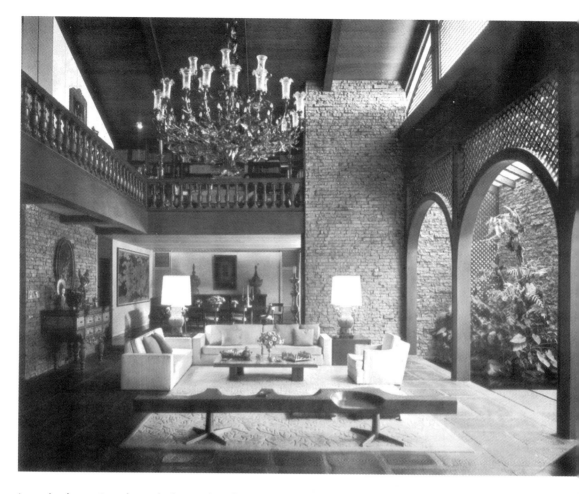

6.23 Bahay na bato-inspired interior of the Locsin residence in Forbes Park, Makati

Later in the 1960s, through the works of architects Luis Ma. Araneta, Leandro Locsin, Gabriel Formoso, Mel Calderon, and Marcos de Guzman, residential architecture began to blur the boundary between the exterior and the interior by integrating gardens within domestic spaces. Locsin's Residence (1963) in Forbes Park, Makati, challenged the climate-insensitive, dysfunctional, and noncontextual houses copied from American suburbia. This landmark residential architecture was the first to fully integrate indigenous materials into a modern building. Here, he reinterpreted aspects of the bahay na bato, such as the lattice work, adobe walls, voladas (window galleries), and organic continuity and arrangement of spaces without superficially mimicking the original in order to contemporize the bahay na bato in the cosmopolitan context.

Following the success of Makati's villages and Philam Life Homes, several new, middle-class subdivisions emerged in Manila in the 1960s, most of which were located along or near Highway 54 (now EDSA) to fill residential gaps between the points of Makati and Cubao/Philam along the freeway. These were Greenhills, White Plains, Blue Ridge, and Wack Wack subdivisions. These subdivisions were named after famous planned communities in eastern United States. These place names, however, bore no relation or reference to the environmental character of the site they signify. Nonetheless, these communities provided suburban refuge to the middle and upper class escaping the declining quality of urban life of central Manila.

Bungalow

The bungalow derived its name from *bangala*, a Bengali term for a small, thatched house with a porch or veranda. Nineteenth-century British colonists in Bengal reinterpreted this tradition, creating a hybrid cottage style that featured verandas, plenty of windows, and open interiors to maximize crossventilation. During the 1870s, the style made the transit to England, where inexpensive bungalows with billowing roof lines mimicking the thatched huts of India began to appear in the country or at the seaside, usually as vacation homes for the middle class. In the United States, the bungalow gained popularity from 1890 to 1920 and was usually a flat-roofed, one-storey house that evolved from the Craftsman heritage in California. The typical bungalow consists of a low, one-storey, spacious building, internally divided into separate living, dining, and bedrooms, the latter with attached bathrooms. A veranda, forming an integral part of the structure or, alternatively, attached to the outside walls, surrounds part or all of the building.

Locally, the bungalow was a one-storey house with large windows and sometimes a lanai. The lanai, derived from Hawaiian residences, was a roofed terrace walled on one, two, or three sides. Bungalows, like the tsalets, were introduced in the Philippines during the American period. Those built in the 1920s and 1930s had a porch on the front and sides. The bungalow could be compact or sprawling in plan, slightly elevated from the ground or practically on ground level.

The bungalow, in its stripped, basic form, provided the model for low-cost housing as the convenient answer to postwar homelessness. Standard schemes and standardized building components were designed by the People's Homesite and Housing Corporation (PHHC) to lend the bungalow to mass-production. The most common variations were the single unit and the twin or duplex units. A unit had one small living room, one or two bedrooms, and a bathroom.

Bungalows of the middle class occupied lot areas of 200 to 400 square meters. A typical dwelling had a carport, a living and dining area, a kitchen, two to three bedrooms, a small garden in front of the house, and a service area at the rear.

In the 1960s, more upper-class bungalows were built in villages developed by the Ayalas in the Makati area, such as Forbes Park and Magallanes Villages. The sprawling domiciles in these subdivisions stood on 1,000 to 2,000 square meter-lots, which contained gardens, swimming pools, garages, and maids' quarters. The bungalow's stylistic permutations were numerous but its manifestation in Philippine residential architecture had problems related to ventilation brought about by the gross duplication of American bungalows that dispensed climate-insensitive features, such as butterfly roofs, narrow eaves, false chimneys, low ceilings, and glass picture windows.

Architecture as Statecraft

Architecture maneuvered within the genre of statecraft laid bare the deliberate ways by which the state stages an elaborate architectural spectacle and spatial intervention designed to mobilize mythic images of tradition and common rites of passage within the framework of a political liturgy and nationhood. Capital cities, state architecture, and national monuments were potent symbols of national power. Through the architecture processed in the enterprise of spectacle and statecraft, the state strived to solicit from the citizenry support, obedience, and loyalty to the intangible state and imagined nation. The state is invisible; it must be symbolized architecturally before it can be loved, imagined before it can be conceived. Architecture and public monuments make this national imagination more palpable and consumable as sites of collective memory and symbols of national identity.

Postindependence architecture, particularly in the design of new capital cities, would endeavor to dispense an image that arouses nationalistic spirit and inspires patriotism and faith in the unknown future. Through the edifices of the government and the techniques of statecraft, architecture could be seen as a semiotic package dispensing a unitary image of national identity reflective of the aspiration to establish a link to a mythical past and a bridge to an idealized future. Architecture in the service of statecraft must thus possess an inspirational inertia.

Influenced by the aforementioned philosophical framework, Federico S. Ilustre, the Consulting Architect of the Bureau of Public Works, executed the new design concepts for government buildings in the 1950s with preference to modernism as the springboard for design.

Immediately after the Philippines became a Republic, the architects in the Division of Architecture of the Bureau of Public Works were obsessed with the creation of a new form of architecture indigenous to and synonymous with Philippine art and culture, not necessarily a style or symbolism but a distinguishing expression of Filipino individuality and personality.

> The metaphoric process of development towards the materialization of this concept of design has much to consider especially for a young independent nation like the Philippines with a history interfused by various outside racial influences and with a tradition of composite oriental and occidental foundations ... Whatever we produce along this matter is purely an outgrowth of borrowed Western ideas dressed superficially with some ancient native trimmings of Maranaw, Igorot, or Kalinga artwork.

> Spurred by the desire to give substance to the newly acquired national independence and to mark the milestone of this historical era, the architects and engineers in the Division of Architecture have collaborated and dedicated themselves to pursue an obsession in the search and creation of a distinguishing Filipino character in architecture as well as in the arts, born out of an emerging new culture blended with the touches and tones of the resurging past.

> Soon after the Rehabilitation period, many war-damaged municipalities and cities were in dire need of municipal buildings and town halls to replace those demolished during the war, and due to the rush for plans and construction, the resulting design in general

6.24 Winged figures of allegorical maidens, each representing the three major islands of the Philippine archipelago, were used as finials for the Quezon Memorial Monument.

proposed **BUREAU OF LANDS BUILDING**
to be erected at the DEPARTMENT OF AGRICULTURE
and NATURAL RESOURCES COMPOUND
DILIMAN ESTATE QUEZON CITY

6.25 Government Service
Insurance System (GSIS)
Building

6.26 Veterans Memorial Building

6.27 The Bureau of Land
Building of the Department of
Agriculture and Natural
Resources, Quezon City

showed a strong tendency towards pseudoclassicism, which is characteristic of marked severity in lines and masses, the absence of ornaments and mouldings in the building facades and interiors ... It was during the early years of the Philippine liberation that this architectural movement [modernism] was felt in this country. Dominant features of buildings during this period are the open plan and framed rectangular fenestration. Exterior columns are made to appear heavy and too protruded; likewise, the projection of fascias or eaves and roofing. Outer mass composition of the buildings was generally informal or asymmetrical in balance, with a play of solid and light wall spaces. Flanking end walls are usually solid and overstressed with use of rough stone ashlar or simulated brick finish typical of the early works of Frank Lloyd Wright, Marcel Breuer, and Le Corbusier. Examples of this type are the Bureau of Public Works Building, the Motor Vehicles Office Building [LTO Building] in Quezon City, the GSIS Building, the Veterans Building, and the many newer provincial capitol buildings all over the island.

Later on, the design trend became more rational, functional, formal, and rhythmically uniform in aspect. The general building mass, although appearing solid, followed a pleasing and disciplined pattern accented by a balanced proportion of harmonized materials and textures. The plan schemes were generally rectangular and simple, oftentimes based on a modular system of layout. Tones of shades and shadows produced by carefully chosen decorative designs of overall perforated, precast sunbaffles and other sun-control devices brought out the delicate façade of the buildings. Using exposed aggregate, pebble, and washout finishes gave a subtle contrasting effect to the exterior. Also noticeable was the use of contemporary structural designs, such as thin concrete shell cantilevers and plate slabs. Among the buildings falling under this type are the new Philippine Postal Savings Bank Building, the Reforestation Administration Building, the Manila International Airport, the Independence Grandstand, the various multistorey tenement buildings, and others.

During the succeeding years up to the present, intensive research and experimentation on more improved concepts of practical architectural forms are being consistently undertaken with primary emphasis on the adoption of indigenous, fabricated, and natural materials, such as concrete and wood, to contemporary methods and techniques of construction and engineering technology coupled with the renaissance of native art forms ... And, in the process of this development the architects and designers of the government have been watchful and careful in avoiding distasteful vulgarism and inane symbolism. Instead, they have been concentrating on the search for true utilitarian forms that could make civic architecture in the Philippines one that is truly our own (Bureau of Public Works Bulletin 1957).

The Division of Architecture, under the stewardship of Ilustre, had produced structures for the bureaucracy. They were modern buildings that became not only tools of governance but a signifier of bureaucratic advancement as well.

The Government Service Insurance System (GSIS) Building (1957) in Arroceros was one of the first of the new buildings programmed for the New Republic to be completed. Designed by Federico Ilustre, the structure adhered to a stylistic tendency that stood at the intersection between neoclassical and modern aesthetics. As a

6.28 The Government Service Insurance System (GSIS) Building is now abandoned and in a state of deterioration.

6.29 The Veterans Memorial Building was demolished in 2007.

transitional style for government architecture, its imposing façade generated a series of soaring fluted pillars that had neither bases nor capitals to assume a stripped and simplified modern composition, yet, at the same time, it evoked classical massings and proportions. The corner of the building had been rounded, forming a corner tower with three vertical bays of windows ascending from the entrance canopy. To the left of this corner tower, a flat wall was fenestrated with vertical louvers and pierced screen insets. The elevation in the other corner was defined by horizontal bands of windows and concrete planes.

North of the GSIS Building was the Veterans Memorial Building (1957). Again designed by Ilustre, the edifice had a modern semicircular, convex façade flanked by two massive, vertical walls. The curved façade was countered by a dome structure

over the circular vestibule supported by slender pilotis. Transparent plastic bubble skylights punctured the dome to provide natural daylight to the lobby.

The old capitol site in Diliman, Quezon City, in the 1950s, played host to several government agencies that boasted of leading-edge architecture. These were the Motor Vehicles Office (now the Land Transportation Office), Department of Agriculture and Natural Resources, the Agricultural Extension, People's Homesite and Housing Corporation (now the National Housing Authority), and the Philippine Coconut Administration (PHILCOA) Buildings.

The Motor Vehicles Office (1957) of Ilustre along East Avenue was a long, rectangular edifice whose longitudinal axis corresponded to the street. The façade was punctuated at regular intervals by sun control devices that incorporated vertical baffles and concrete visors to modulate direct heat and glare. Brick and fiber glass added texture and visual interest to the façade.

Identical designs characterized Ilustre's Department of Agriculture and National Resources Building and the Agriculture Extension Building (1959). Their symmetrical plan was rectangular with a slight convex curvature to conform to the arc formed by the Elliptical Road along which the buildings were constructed. The tall and wide portal at the center of the façade was lucidly defined by a square

6.30 Perspective of the Philippine Coconut Administration (PHILCOA) Building, Quezon City

6.31 Perspective of the Motor Vehicles Office, Quezon City

6.32 Aerial perspective of Department of Agriculture and National Resources Complex at the Elliptical Road in Quezon City

6.33 The People's Homesite and Housing Corporation Building

frame and by a series of piedroits (square pillars attached to the wall that lacked both base and capital). Vertical slabs were symmetrically placed at both ends of the façade, one of which contained a precast relief of a carabao, the symbol of Philippine agriculture. The carabao motif was repeated in a more abstracted form in the grillwork creatively obscured by the concrete pierced screen.

The People's Homesite and Housing Corporation Building (1958), designed by the Architecture Division of the PHHC, was an expression of avant-gardism for public buildings as it abandoned the transitional style that adhered to classicist proportion and symmetrical planning. Instead, the building extolled the merits of nonsymmetrical arrangement and unbalanced volumetric composition. It was a long, rectangular block surmounted off-center by a shorter block. Its southern block, which was protected from the sun by vertical louvers, seemed to float as it was suspended through a system of pilotis. The front of the long northern block was differentiated from the rest of the volume by having thin bands of horizontal louvers that corresponded to the top floor windows. The plain masses confronted

FEDERICO S. ILUSTRE (1912–1989)

State architecture during the postwar years were produced mainly by the government architects of the Division of Architecture of the Bureau of Public Works under the direct supervision of Consulting Architect Federico S. Ilustre. As consulting architect, Ilustre's career at the Bureau spanned two decades, from 1954 to the 1970s. During the length of his tenure, he witnessed shifts in government policy toward nation-building and architecture, with changes in the presidency reflected in the style of the official architecture that steered from high modernist to neovernacular persuasion.

Federico Ilustre received his degree in architecture from the Mapua Institute of Technology and secured his license from the Board of Architecture in 1937. Prior to his employment at the Bureau of Public Works, he worked as a draftsman in the office of Juan Nakpil in 1935 and as an interior and furniture designer for Puyat and Sons in 1936. He joined the Bureau in 1936 as a draftsman, a position he held until the war broke out. During the Japanese occupation he was promoted to consulting architect at the Bureau. After the war, he joined the AFWESPAC of the US Army as supervising architect, assisting in the infrastructural aspect of postwar rehabilitation. By 1947, he assumed the position of supervising architect for the National Housing Commission. He rejoined the Bureau in 1949 as supervising architect.

Ilustre is best remembered for the Quezon Memorial Monument, the artistic landmark in Elliptical Park in Quezon City. The Quezon Memorial was a result of a national design competition held in 1951 where he won the grand prize. His other works, the plans and drawings of which are still extant and in storage at the Department of Public Works and Highways archives, include: the GSIS Building and the Philippine Veterans Memorial Building in Arroceros, the Independence Grandstand (Quirino Grandstand) and the Planetarium in Luneta, the buildings of the Department of Agriculture and National Housing Authority along Ellipitical Road in Quezon City, the old Manila International Airport in Nichols Field in Parañaque, and various Philippine embassies abroad that evoke Filipino vernacular silhouettes.

The Quezon Memorial Complex as envisioned by Ilustre in the 1950s

textural monotony by articulating shades and shadows through its recessed vertical louvers and protruding horizontal slats.

The Philippine Coconut Administration (PHILCOA) Building (1958) was a buoyant rectangular volume supported by stilts. Ilustre, its architect, created a principal elevation that was entirely protected by a latticed screen of open-work masonry to shield the internal structure from heat and glare. The vertical space left in the façade was covered by a number of glass windows. The verticality was further heightened by two equally spaced, upright louvers running the height of the building.

The focus of the government center on Elliptical Road in Quezon City was the Quezon Memorial Circle (1950s), designed by Federico Ilustre. Aesthetically, the monument was a testament to the persistence of art deco even in the mid-twentieth century design consciousness. Built on a thirty-six-hectare elliptical lot, the monument rises sixty-six meters from its base, the tallest structure of its kind in the Philippines. The metric height of this monument represented the late President Manuel L. Quezon's age when he succumbed to tuberculosis. A spiral staircase led to the top where an observation platform that could accommodate sixty people

provided a panoramic view of the city. The winged figures atop the three pylons represented Luzon, Visayas, and Mindanao. The regional identity of each female figure could be discerned in the traditional costume they were clothed with.

The Veterans Memorial Hospital Complex (1950s), designed by Enrique J.L. Ruiz, was one of the hallmarks of Philippine-American cooperation and was presented as a gift of the American people to the Philippines as a sign of gratitude to Filipino soldiers who fought side-by-side with the Americans in World War II. The design was characterized by no-nonsense composition, symmetry, and axial spatial configuration for efficient delivery of medical services.

Federico Ilustre's Manila International Airport (1962) showcased to foreign visitors the aspiration of the Philippines for modern progress. When the airport terminal opened in 1962, it was reputed to be the largest and most modern in the Southeast Asian region. To fit the terrain and airport requirements, the terminal was designed along a finger-type plan. Having a total area of 22,773 square meters, the building was divided into four functional buildings interconnected by sheltered passageways. A wide expanse of tempered glass fronting the apron gave a full view of the terminal

Quezon Hall viewed from the lagoon

Architecture for the Premier State University

Upon his appointment as Diliman's master planner in 1939, William Parsons responded with a grand design focused on a core of green park space approachable via a grand boulevard (now known as University Avenue), and calling for a series of paired structures that were built opposite each other in the oval-shaped center, its perimeters surrounded by hectares of open parks. Only two buildings, Benitez and Malcolm Halls (1941), were completed in accordance to Parsons's plans before World War II halted further development.

By 1949, the responsibility of building UP Diliman was given to Architect Cesar H. Concio, the first campus architect, who also designed Palma and Melchor Halls. In this transition period, from postwar Liberation to Independence, the ideals of the City Beautiful Movement were still very much in the consciousness of planners. This could be seen in the fulfillment of Parsons's plans of having structures built as pairs opposite a vista of park space. Hence, Quezon Hall was mirrored across the lagoon by Gonzalez Hall, while Palma Hall was paired across the Academic Oval by Melchor Hall, both exhibiting similarities in massing and volume.

Administration Building Approved Scheme (Concio & Nakpil)

But between the late thirties and forties, a crucial shift in architectural taste occurred. The neoclassical ideals in architectural aesthetics gave way to a more functionalist modernist style, which privileged function over form. This was manifested in the façade styles of the Benitez/Malcolm Halls vis-à-vis the Palma/Melchor Halls: the former display arcaded hallways, balustrated verandas, pedimented entrances, columns, and capitals reminiscent of the buildings of the UP Manila campus; whereas the latter are notable in their lack of ornamentation. Rather, the structures were treated as a simplified masses of volumes and planes. The grand stairwells, porticoes, and open atriums that characterized the main entrances of Palma, Melchor, and Gonzalez Halls, however, indicated an earlier variant of modern architecture which was quite popular during the late forties. Such a transitionary style could also be seen in the open colonnade of Quezon Hall, where the classical fluted columns had been paired with a plain entablature and had no capitals. The Quezon Hall merged preliminary schemes proposed by Cesar Concio and Juan Nakpil in 1949. The Carillon, also designed by Nakpil and completed in 1952, continued the tradition of art deco after the war. This art deco campanile took the simplified form of a massive capsule with a domed top and plain pilasters defining its verticality.

University Theater

From the mid-fifties onward, the International Style of Modern Architecture became the unifying motif in the construction of buildings in Diliman. This is characterized by the spare, minimal treatment of volumes and detailing; and a more functional application of design. Examples of this trend would include: the Church of the Holy Sacrifice (1955) designed by Leandro Locsin; the Church of the Risen Lord (1955), and the Student Services Center or Vinzons Hall (1957), designed by Cesar Concio; the University Health Services or Infirmary (1957), designed by Esperanza Siochi Cayco; the Conservatory of Music or Abelardo Hall (1960) and the old University Theater or Villamor Hall (1960) designed by Roberto Novenario; the Faculty Center or Bulwagang Rizal (1964), designed by Carlos Arguelles; and the Law Center (1968) and the International Center (1968), designed by Victor N. Tiotuyco. Some of the unique characteristics of Filipino Modern architecture, as exemplified by these structures, are: the use of openwork masonry to increase ventilation (Vinzons Hall); the use of honeycombed pierced screens to shield the structure from direct sunlight (Benton and Abelardo Halls), the use of folded plates (International Center), and a thin shell concrete dome (Church of the Holy Sacrifice).

In addition, the building design from the sixties onward would veer away from the strictly symmetrical order to a more fluid arrangement of dissimilar volumes. This is perhaps due to the perception that planning and design ought to follow a more liberal, democratic, and human approach in siting buildings, rather than emphasizing an imperious order of planning that awes, dominates, and regulates its users. Hence, the Faculty Center is not paired across the Oval with a similar structure. Neither does another tower stand on the opposite side to balance the Carillon.

Melchor Hall

6.37 An ultramodern Rizal Pa
redesigned by Juan Nakpil in t
1960s for the centennial of th
national hero Jose Rizal

activities from the main lobby. It was also provided with an overhanging control tower with a view of two runways to facilitate efficient ground control of incoming and outgoing flights. The building burned down in 1981.

A wave of nationalism engulfed the design practice in the late 1950s, which continued in the next two decades. This phenomenon was partly spurred by celebrations of Jose Rizal's birth centennial in 1961. As early as 1958, the Jose Rizal Centennial Commission unveiled the plan to build a National Shrine composed of a national theater, a national library, and a national museum at the Wallace Field in Luneta. The centerpiece for this project was Juan Nakpil's unbuilt National Theater (1959), an edifice that combined a concrete folded plate and spherical, thin shell roof to achieve a sculptural and monumental effect. Based on the plans, the large thin shell roof with a radius of approximately seventy-six meters and span of 110 meters covered a 2,600-seater auditorium hall. The spacious lobby would be shaded from the afternoon sun by gold anodized aluminum or copper diffusers. At night, the grille and glass façade would be well-lighted. Philippine identity was reflected in the traditional motifs used, such as sampaguita and *ilang-ilang* ornaments for the chandeliers and pencil-thick stainless steel rods shaped like bamboo for the stairs.

The importance of this cultural shrine was underscored by President Garcia in his speech during the laying of the cornerstone in July 1958:

> In the patriotic and unending task of nation-building, I consider the laying of the cornerstone of the Rizal Shrine a significant event because Jose Rizal was the greatest and the most enlightened of our nationalists ... The shrine that we now erect will therefore not only perpetuate his memory to the last syllable of time, but also attest to the invincibility of Philippine nationalism to the deathlessness of the cause and to the eternity of truth (*Rizal Centennial Bulletin* 1958).

To improve the setting for the National Shrine, the Rizal monument was improved and provided with a reflecting pool. A retrofitting of the monument commenced with the superimposition of a stainless-steel shaft over the obelisk that increased

the height of the monument from 12.7 meters to 30.5 meters. The towering shaft was installed with a beacon light on top. Such intervention was made to make the monument conform with the ultramodern National Theater in terms of proportion and cutting-edge imagery. The retrofitting of the Rizal monument caused a public uproar, labeling the intervention in derogatory terms—monstrosity, commercialized, and nightmarish—in the popular press. The criticism was too strong that the steel shaft was later removed and transferred to Baclaran, Pasay City, remaining there as a landmark until the 1990s.

The National Theater, on the other hand, failed to materialize on Wallace Field. With a revised plan and less grandiose scheme, it instead rose on another site, in Makati, becoming the historic Rizal Theater (demolished in the 1980s to make way for Shangri-La Hotel). The overall design integrity of the theater was maintained except for the deletion of the spherical thin shell. On the other hand, the plan for the National Library became a reality in 1962 under the hands of a consortium of architects known as Hexagon Architects (composed of Jose Zaragoza, Francisco Fajardo, Edmundo Lucero, Gabino de Leon, Felipe Mendoza, and Cesar Vergel de Dios). The National Library (1962) was a plain rectangular prism whose façade was almost wholly covered by grids of vertical slats except at the center where

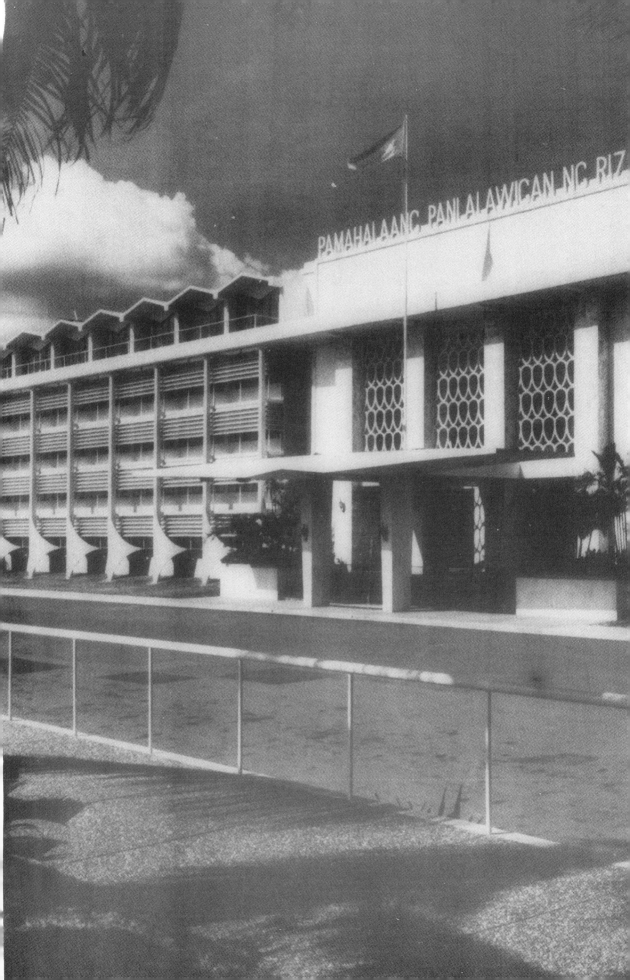

planes of curtain wall rendered transparency to the building. The planes of glass were further defined by towering and slender piedroits, dividing it into five vertical sections.

Ruperto Gaite's Rizal Provincial Capitol (1962) was one of the important postwar capitol edifices that deviated from Beaux Arts formalism. The modern building exuded the feel and look of Oscar Niemeyer's architecture, particularly the diamond-shaped concrete supports extracted from his design for the President's Palace (1959) in Brasilia. Moreover, as a tropicalized modern building, it was replete with wraparound louvers and sun baffles. The extensive use of concrete translated into a saw-tooth folded plate roof and abstracted and repetitive façade details. Despite its modernism, the whole complex was laid out in classical proportion and axial symmetry.

Ilustre and Gaite, along with other Filipino architects belonging to this era, were heavily influenced by the new architecture and planning espoused by the famous "Team 10." This avant-garde group, which included Le Corbusier and Oscar Niemeyer, produced modernist layouts and architecture that saw the most visible expression in the new South American capital city of Brasilia.

In Gaite's design for the Quezon City Assembly Hall (1960s), he achieved visual weightlessness of a massive, elongated, octagonal structure with the use of two tapering stilts. Such an architectural maneuver could again be traced to South American modernism. The octagonal structure with surface dimensions of ten

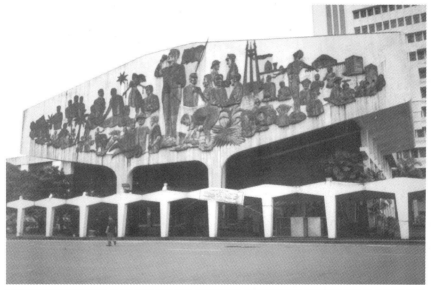

5.40 The Rizal Provincial Capitol in the 1960s (opposite page)

5.41 Quezon City Assembly Hall

5.42 Perspective of the stillborn complex of buildings for the Department of Education in Arroceros, Manila

A Modern Clone

The architecture of Quezon Hall pays tribute to Finnish-born American architect Eliel Saarinen's Main Hall at the 104-hectare Cranbrook Educational Community in Bloomfield, Michigan. Saarinen's 1940s structure is considered as one of the most instructive and inspiring examples of twentieth century academic architecture. Here, Bauhaus modernity, traditional building materials, outstanding urban design, landscaping, and sculpture were judiciously blended to compose a contemporary academic village. Cranbrook's highest architectural achievement is the Main Hall's classic grand peristyle, which served as the basis for Nakpil's colonnaded central void concept for UP's Quezon and Gonzalez Halls.

Quezon Hall's architect, National Artist Juan Nakpil, did not only take inspiration from the horizontal profile of Cranbrook's compositional massing but also undoubtedly extended the syndrome of architectural mimicry beyond mere coincidence. Nakpil's sons, Ariston and Francisco, received their respective Master's degrees in Architecture at Cranbrook Academy before they formed the partnership Nakpil and Sons in 1953. Probably, Juan Nakpil considered Cranbrook as the purest expression of a modernist vision for campus planning. He took the cue from the superior campus planning professed by Saarinen in Cranbrook and sought to reproduce the same in the then new University of the Philippines in the 1950s.

At first glance, the architectural imagery and environmental elements borrowed from Cranbrook makes Quezon Hall an almost perfect facsimile of the former. Yet, Nakpil transcended the sheer architectural replication by extracting from Cranbrook the architectural fundamentals which make UP's Quezon Hall truly unique and memorable. Such is manifested in the duplication of the building's strategic location at the terminus of a long processional approach (University Avenue); the horizontally oriented volumetric arrangements punctured by a classic grand peristyle at the center; and the utilization of landscaping elements, such as a reflecting pool and a sculpture (the Oblation) as a counterpoint.

meters by forty meters was a setting for relief sculptures carved out of adobe depicting the life and accomplishments of Manuel L. Quezon as a national leader.

Similarly, the plan for the Department of Education Complex (1967) in Arroceros, Manila, though an aborted project, was demonstrative of Niemeyer's strong influence among the architects of the Bureau of Public Works, which undeniably translated into government edifices with a tinge of Brasilia. Designed by Ilustre, the complex featured a rectangular block whose mass was suspended by sculptural stilts to attain visual weightlessness. The surface of the block was accented with fenestrations of delicate vertical louvers. Another feature lifted from Brasilia was the thin shell dome structure, whose geometry was sectioned-off to taper before reaching the ground.

Space Age and Technology-Inspired Architecture
Architecture in the fifties and sixties had drawn its imagery from science and technology. By then, space had been the subject of exploration; atomic power had been harnessed to generate electricity; the polio vaccine had been discovered; and

6.43 Space age design was ushered in by the Church of the Holy Sacrifice in the University of the Philippines Diliman campus.

the structure of the DNA had been identified. These events fueled much faith in technology and in the future, which was transcoded in architecture and design. Architectural design looked toward the skies for inspiration beginning with the 1950s.

Mid-century technology was not just the driving force in engineering advances but also a design inspiration in itself for architecture and consumer products. The space age of the 1950s promised a greater, more exciting future with the potential of becoming citizens of the solar system. It was a time when the future seemed glamorous and without threat. The enthusiasm for air and space travel had been translated into a visual language of long, lean horizontal lines suggesting airplane wings, soaring upright structures and parabolic arches directing the eye to the sky, and sharply contrasted angles expressing speed.

Advances in building materials, including reinforced cement, plastics, and steel, as well as building technology, such as prefabrication and post-tensioning, made it possible for architects to make buildings become sculptures. World fairs and expositions, which had been showcases for new technologies and design trends, were a cornucopia of leading-edge, innovative architecture. Advanced engineering techniques made possible new and exciting architectural shapes that deviated from the uniformity of mass production and the code that had led to the modernist box. Complex mathematical computations allowed new shapes and structural works to be devised from thin concrete shells, concrete folded plates, and space frame structures. A thin shell is a three-dimensional curved plate structure of reinforced concrete whose thickness is small compared to its dimension and is characterized by its three-dimensional, load-carrying behavior, which is determined by the geometry of its form, by the manner in which it is supported, and by the nature of the applied load. The typical geometrical forms generated by thin shell engineering are the hyperbolic paraboloid (Church of the Risen Lord) and spherical dome (Church of the Holy Sacrifice). A folded plate, on the other hand, is a roof structure in which strength and stiffness is derived from pleated or folded geometry. It is a special class of shell structure formed by joining flat, thin slabs along their

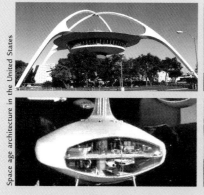

The "New Look" and the Space Age

The 1950s was a decade of new hope. People believed that they were entering a new age in which anything was possible. Fresh from the ruins of war, the nation had a strong economy, having an exchange rate of 2 pesos to a dollar. People ironed out their war-traumatized lives by turning to movies played in downtown cinema palaces. The postwar austerity measures were definitely over when Christian Dior's "new look" arrived in Manila. This return to extravagance was not merely a reaction to the postwar austerity by creating a style of fuller silhouettes which needed an abundance of fabric, but also heralded a "new look" that lasted for an entire decade. This new aesthetic mode, with its exaggeration of the female form, spawned a wide range of expressions—forms were new (soft and organic); patterns were novel (under the influence of Jackson Pollack and Joan Miró); materials were innovative (formica and synthetic fibers); and, images were fresh (mostly derived from science).

The scientific achievements of the decade roused much faith in technology, which were translated in popular architecture and design. Loscin's architectural debut in 1955 seemed to anticipate the "space age" as the Chapel of Holy Sacrifice resonated an image of a flying saucer, while, the molecular structures inferred by the scientist—the double helix of the DNA—were portrayed in textile design, graphic design, and sculpture as a recurring motif.

The growing space race between the United States and the Soviet Union, combined with new technologies developed during World War II, shifted the concepts of "modern" and "futuristic" to space. Better yet, this space-age design was applied to consumer goods. The boomerang, a shape that suggests speed and flight, adorned clothes, fabrics for furniture, advertisements, and decorative artwork on buildings. Lamps were topped with flying-saucer-shaped shades. Furniture, created by designers like Mies van der Rohe and Eero Saarinen, had large, chunky shapes perched on top of spindly legs with flat feet, making them look more like a lander resting on the moon's surface than a sofa sitting in a living room. Businesses adopted starburst and rocket logos, whether or not the imagery fitted their product or service.

6.44 Commercial Bank and Trust Building (now Allied Bank) near the Quezon Avenue-Rotunda intersection

edges so as to create a three-dimensional spatial structure (i.e., the International Center in Diliman and canopies of the SSS Building along East Avenue, whose geometry could be likened to a folded paper fan).

The folded plate and concrete shell were not more functional or economical than the cube. In extreme cases, new shapes demanded elaborate methods—a formwork painstakingly built of compacted earth for a multi-curved concrete shell—which contradicted the technological developments of the twentieth century. Of the new methods of construction of the 1950s, they were the least expressive of mass-production techniques, and were indeed anti-universal, reminding architects that all the technical possibilities of the twentieth century were not necessarily bound for mass production.

Engineers examined every possibility of concrete shell construction and translated the spirit of the space age into dramatic buildings. In 1955, the first venture into thin-shell experimentation yielded the Church of the Holy Sacrifice, a collaborative work between architect Leandro Locsin and engineer Alfredo L. Junio with David M. Consunji as building contractor. It is an engineering achievement at that time because the thin shell was molded astonishingly in its entirety using mere plywood forms. The edifice was of a spherical dome with a total central angle of 106 degrees and radius of 21.3 meters. The main concrete shell was ninety millimeters thick and was supported by a 100 millimeter–thick ring beam that in turn was supported by thirty-two reinforced columns measuring 1.06 by 0.36 meters. The columns were curved with the same radius as the dome and made tangent to it to maintain the continuity of the outline. The shell terminates at a smaller ring beam at the top center of the dome through which a triangular steel-frame punctures to the point from which the central cross hangs over the altar. The overall composition of the worship space seemed to defy gravity with its visually buoyant, spherical dome and imagery reminiscent of a flying saucer.

Attributed to architect Cresenciano de Castro, the National Science Development Board (NSDB) in the 1960s provided the public with two ultra-modern edifices: the Science Pavilion and the Planetarium. The Science Pavilion, built mainly for

6.45 National Artist for Architecture, Leandro Locsin, shown with the scale model of the Church of the Holy Sacrifice

6.46 Plan and section of the Church of the Holy Sacrifice

9.47 The Science Pavilion and the Planetarium of the National Science Development Board (NSDB)

9.48 The Araneta Coliseum, the architectural centerpiece of the new Cubao commercial district in the late 1950s

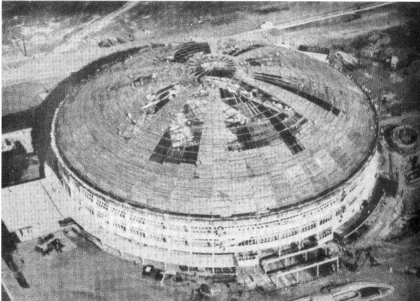

scientific conferences and movie projections for a maximum of 300 persons, was a thin shell concrete domical structure resting on a two-storey glass cylindrical base. At one point, the dome meets the ground in the form of a concrete carabao head. The Planetarium, on the other hand, was a thin shell, yoyo-shaped structure with a highly-textured staggered base. The Planetarium housed in its core a 2.4-meter Copernican planetary gadget, a device that visually projects simulated movements of celestial bodies on the concave ceiling of the thin shell.

The Araneta Coliseum (1959), located on a thirty-four-hectare site in Cubao, Quezon City, was an engineering achievement during its time. The coliseum was named after J. Amado Araneta, an industrialist-sportsman and president of the Progressive Development Corporation, a company which initiated the design and construction of the said structure. Between the years 1960–1963, it reigned as the biggest domed coliseum in the world. The coliseum was constructed as a reinforced

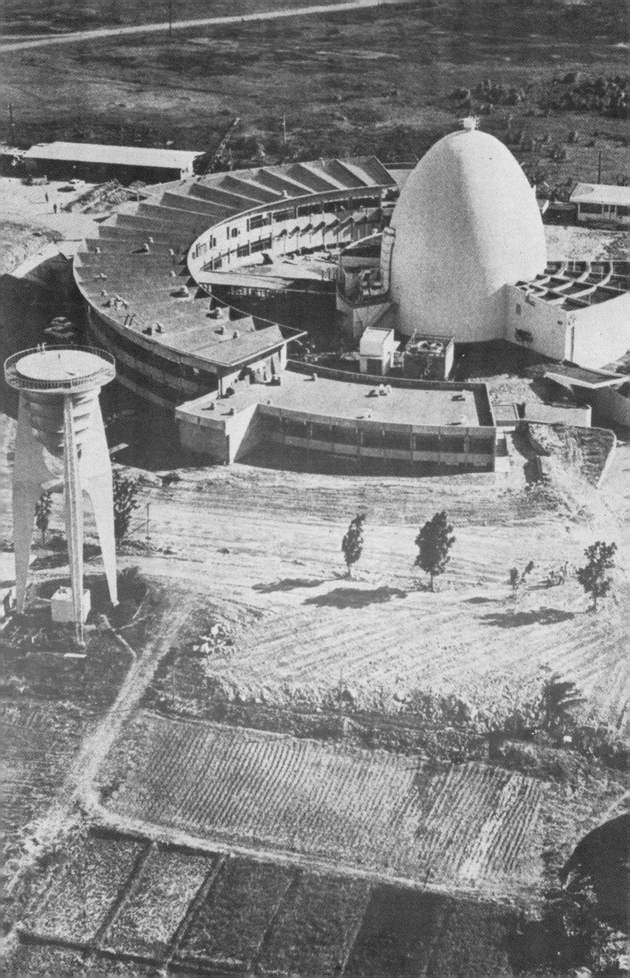

concrete cylinder capped by an aluminum dome structure having a diameter of 108 meters. The base of the coliseum and its tiers were of cast concrete. The framework of the dome, designed and fabricated by Atlantic, Gulf, and Pacific Corporation, was made of forty-eight main steel ribs meeting in a compression ring that floated high above the floor. The dome was suspended ten stories (36.8 meters) above the arena floor whose area itself was 400 square meters. Even today, it still remains as one of the largest clear-span domes in the world and the largest indoor facility in Southeast Asia.

On August 26, 1963, the first atom to be split on Philippine soil was done inside the ooidal structure in Diliman, Quezon City, marking the advent of nuclear science in the country. The said structure, the Philippine-American Bilateral Research Building (later known as the Philippine Atomic Research Center), was designed by Cresenciano de Castro and took seven years of research, planning, and construction to complete. The facility was comprised of an arc-shaped nuclear laboratory building and an egg-shaped reactor building of the Philippine Atomic Energy Commission. The reactor building was an airtight concrete structure whose circular plan had a base diameter of 20.7 meters and a height of about twenty-six meters. East of the reactor building and connected by an entrance tunnel was a semicircular administration and auxiliary laboratory.

The aspiration of the jet age was extended even to cars when Cadillac introduced its aircraft inspired tail fins to the world. Such styling was to dominate automobile design in the fifties. The Cadillac fins reached their peak in 1959 and greatly influenced the design of jeepneys and tricycles. Jet-age styling was to manifest itself even in mundane structures of the late fifties, such as the 50,000-gallon water tank elevated on a twenty-eight–meter steel tower at the Philippine Atomic Research Center in Diliman, whose overall form alluded to a launching rocket ship.

Juan Nakpil introduced the use of folded plates as a structural shell in the 1960s. This was the time when Nakpil's work was characterized by more pronounced

6.49 Philippine Atomic Research Center in Diliman, Quezon City (opposite page)

6.50 Auditorium of the World Health Organization Building at the United Nations Avenue, Manila

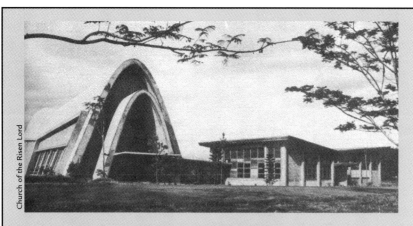

Church of the Risen Lord

The Modern Ecclesiastical Shell

Mid-twentieth century architecture in the Philippines took inspiration from the buildings of modern masters from the West. Rising from the ruins of war, architects began to experiment with bold and new forms that emphasized material and functional simplicity. This modernist philosophy was charged with the symbolic appeal of building a brave new world in the aftermath of war. One such design tendency was soft modernism, which, as the name implied, experimented with the sculptural potential of concrete's plasticity to come up with soft and organic forms with the use of thin-shell technology. Shells are thin, curved plate structures shaped to transmit applied forces acting on the surface of the plane. Thin-shell construction was heralded as a method that took advantage of the inherent structural strength of certain geometric shapes, such as hemispherical and elliptical domes; in thin-shell construction great distances were spanned with very little material. Yet, thin shells had to face aesthetic obsolescence: the very designs that looked so modern and progressive in the sixties seemed dated a few decades later.

Church design after the Second World War renounced the well-worn transept configuration to explore sculptural shapes that implored complex mathematics to ratify its geometry. Such an experimental path was initiated by Victorias Chapel (1949) in a sugar-milling community in Negros Occidental. The structure, designed by Raymond and Rado of New York, was composed of two independent structures connected by movable beams as a precaution to seismic movement. The longitudinal nave rested on foundations disengaged from the sanctuary, crowned by a rib-like campanile. Victorias Chapel, hailed as the first modern church in the Philippines, also features an altar whose central figure is the "Angry Christ."

By 1955, Leandro Locsin's space age circular chapel capped by ninety millimeter–thin concrete shell arrived at the UP Diliman campus. Equally path-breaking and technologically congruent was Cesar Concio's Church of the Risen Lord, a stone's

Church of the Risen Lord

Church of St. Francis

throw from Locsin's circular chapel. The structure was proclaimed in the fifties as "an engineering masterpiece with its double parabola." The chapel was saddle-shaped—a hyperbolic paraboloid with flat ends. The lower slopes of the vaulted wall were punctured by windows and vertical louvers at both sides of the longitudinal elevation. The glass-clad façade had an opening defined by a smaller arch that supported a cantilevered porte-cochere. This entrance directly led to the processional nave, terminating the vision at the austere altar. Just above the entrance, a choir loft could be ascended via a circular winding stair. The anonymity of soft modernism and the lack of iconographic religious references underlined the ecumenical aspiration of this ecclesiastical structure.

Architectural critic I.V. Mallari in his 1957 article in the *Sunday Times Magazine* entitled "The Ugly City" identified and lambasted specimens of modern architecture in Manila as miniaturized facsimiles of modern architecture abroad. His enumeration included Concio's chapel in Diliman which he claimed to have been drawn from a chapel in Wichita, Kansas. This comparative presumption was too hasty and lacked the value of historical explication to be the sole basis of disputing the church's conceptual originality.

Tracing the genealogy of the architectural concept that the structure sought to uphold would lead us to no less than the Brazilian architect Oscar Niemeyer. Niemeyer was best remembered for tropicalizing modern buildings by using adjustable brise-soleil in his design for the city of Brasilia, Brazil's new capital in the mid-fifties. The fact that he was part of Brasilia was essential to explain the conceptual provenance of Concio's parabolic church.

But, what could be more illustrative to explain Concio's imitative tendency (or perhaps a "homage" to his modernist idol) than the photograph of Oscar Niemeyer's St. Francis Church in Pampulha, Brazil? The Church of St. Francis was completed in 1943 as part of the Pampulha Lake district. This quarter is looked upon as an early example of contemporary architecture in Brazil, which reached its climax in Brasilia.

Concio's and Niemeyer's paths crossed in the late 1940s when, in 1947, Cesar Concio was appointed by President Manuel Roxas as a member of the Philippine Government Engineering and Architectural Mission to the United States, South America, and Central America to observe trends in architecture and city planning for the development of the site and design of buildings for the University of the Philippines in Diliman and the National Capitol at Capitol Hills, Quezon City.

Included in the itinerary was a visit to Niemeyer's office in Rio de Janeiro in 1948, where Lucio Costa's Brasilia master plan was being interpreted at the time. It could be surmised that Concio's encounter with Niemeyer acquainted him with the latter's corpus of work, where Concio drew inspiration. Concio's infatuation with the tropical responsiveness of Niemeyer's architecture yielded many buildings that resonated the judicious application of brise-soleil in simple lyrical forms (e.g., Palma and Melchor Halls in UP).

The striking similarity between the Church of St. Francis and the Church of the Risen Lord is incontestable. Their affinity extends beyond the use of the parabolic shell as the dominant composition as both churches exhibit the same space planning concept, identical choir loft placement, and matching vertical louvers. The Church of St. Francis was the obvious model for Concio's ecclesiastical shell (minus the Catholic iconography, rear parabolic transept, and the tapering campanile). Seen in the light of authenticity, it is indeed a successful knock-off. Yet, the issue here is not to expose originality or falsity, but to question the abiding gift of the Filipino to transform the foreign into an exciting product of architectural hybridity and appropriation.

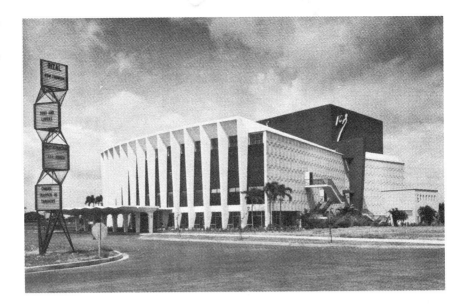

geometric lines. The profusion of folded plates as a structural envelope spurred the utilization of diamond–shaped supports on the exterior. His interiors now featured a sumptuous play of textures—pebble-washed floors, adobe screen walls, wooden stairs, and screens with natural finishes. Examples of this new style were the demolished Rizal Theater in Makati, Rufino Building on Ayala Avenue, and the Commercial Bank and Trust Building near the Quezon Avenue-Rotunda intersection. Rizal Theater (1960) in Makati featured a slightly convex façade with fourteen pilasters tapering downward. The windows were deliberately made dark to give an illusion of visual lightness as the facade seemed afloat. The uniformity of composition was broken by a cantilevered canopy extending over the driveway.

Juan F. Nakpil and sons, Eulogio, Ariston, and Francisco [shown with the model of the SSS Building (1965)], created an excellent example of the ingenious use of modern concrete to provide beauty and utility. The innovative structure was composed of a low podium and a sixty–meter slab tower clad in curtain wall. The building could be accessed at the podium level through an open ramp protected by a folded plate canopy. The tall slab tower was serviced by an external spine housing the elevators. Aluminum louvers in continuous bands were found on both the main facades of the slab block. The interplay of glass, steel frames, precast concrete panels, and porcelain-enameled spandrels with concrete mullions had produced a distinguishing quality for the building. The precast concrete diffusers on the east and west were designed to give a strong pattern of light and shadow to the structure.

The UP International Center (1968), a collaborative architectural and engineering achievement of Victor Tiotuyco and structural engineer Cesar Caliwara, was renowned for its lobby building, built with a large-span folded plate, which rested on four radiating beams rising at an acute angle from a polygonal ornamental pool. The lobby's roof beams, formed as a diagonal line, became its anchoring pier.

Departing from the form-follows-function appearance, a strain of modern architecture surfaced in the 1950s that adapted space-age styling. This exaggerated

form of modernism first appeared in Los Angeles, United States, and was commonly referred to as "Googie" to describe its dynamic and futuristic tendencies. The buildings most associated with Googie were car-oriented, commercial, and popular. Buildings of this strain were visually arresting as they exaggerated building elements by oversizing, canting, or accentuating roof planes, eaves, pillars, visual fronts, signs, or other architectural members. The use of elaborate roofing systems, such as butterfly roofs, undulating canopies, and steeply pitched A-frames, were introduced to heighten the aspiration toward the skies. Visual theatrics were further achieved by the use of canted vertical members, angled planes, and tapered spires. The futuristic overtones took their inspiration from aerospace technology, referencing jet aircrafts, rockets, and satellites, with the occasional inference toward inner space in the form of amoeboid-shaped signs and atom-like imagery.

Motifs characteristic of the style included: upswept roofs that allowed larger glass windows in the façade and made the buildings look as though they were about to take off and fly; large domes usually made of concrete that evoked either the image of a flying saucer or environment-controlled extraterrestrial cities from science fiction; large, sheet glass windows, which made roof structures seem to float; boomerang shapes that made its appearance in archways, road signs, gate designs, swimming pools (often called kidney-shaped), tile mosaics, formica patterns, butterfly chairs, and textile prints; amoeba shapes, which were amorphous blobs suggesting organicism; atomic models whose interlocking rings were symbols of man's scientific ingenuity and represented the unlimited power that would make the futuristic utopia possible; starbursts, which were symbolic of the outer space waiting to be explored; exposed steel beams that had geometric holes punctured in them which served the double purpose of making them lighter and enhancing their visual association with rocket gantries; and, flying saucer shapes, which were symbolic of the human aspiration to explore unknown galaxies.

Architect Marcos C. de Guzman excelled in the theatrics of exaggerated modernity that virtually defied gravitational pull. He designed several commercial, institutional,

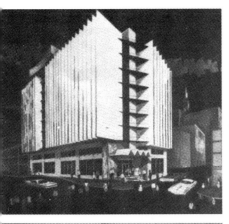

.54 Perspective of Hotel Timberland

.55 Lobby of Hotel Timberland

.56 Pacific Tower

.57 Residence of Artemio Reyes

and residential structures that expressed the playful spirit of space age aesthetics. De Guzman's Hotel Timberland (1965) in Manila boasted of a lobby with squiggle design made of light diffusing patterns of wood. The irregularly maneuvered, rigid lines of the ceiling treatment was perhaps influenced by random gestural abstractions.

The familiar *pateriform* or saucer-shape motif was playfully unravelled by de Guzman in the residence of Artemio Reyes (1959) in Quezon City. The domicile was a Jetsons-like futuristic house whose main feature was the 7.5 centimeter-thick concrete shell thickening slightly towards the sides. The shell roof was punctured with bubble skylights. Waterproofing posed no problem as the saucer-form naturally shed of any water while the aerodynamic shape surpassed any onslaught of cyclonic winds. A band of windows running the entire midsection of the saucer provided light and ventilation. Verticality was achieved with the addition of a crescent-cut observatory tower where a cantilevered disk protruded and served as an observation deck. At the summit of the tower shaft, a circular antenna was attached that completed the fantasy of intergalactic communication.

Although the Mañosa Brothers were renowned advocates of modern and vernacular-inspired designs, they were also caught in the current of technologically propelled space age aethetics. Such tendency and infatuation with technology was made evident in their cutting-edge design of the residence of Ignacio Arroyo (1960s). Situated at the edge of a cliff in Marikina, the house juts out from the landscape like a space craft. Its undulating thin-shell roof and twelve-meter semi-circular cantilever projections endowed the structure with an extraterrestrial aura. The plan of the house was generated from a half circle, whose every point in the curvature provided a panoramic view of the Marikina Valley.

A residence in Baguio City, designed by Aida Cruz del Rosario in the 1960s, derived its iconography from a sci-fiction flying saucer. Overlooking a mountainous panorama, the house was made up of an octagonal concrete shell punctured by sloping windows at the entire perimeter of the structure. The octagonal superstructure was elevated some six meters from the ground via curved supports.

The saucer-shaped superstructure persisted in the 1970s as an eye-catching architectural feature perched on top of some high-rise buildings. They were mostly circular revolving restaurants or decks that offered a 360-degree view of the city.

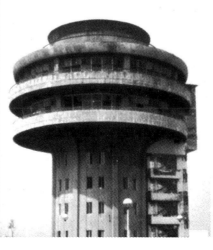

6.58 Residence of Ignaci Arroyo

6.59 Sci-fi-inspired residence i Baguio City

6.60 Circular viewing deck an revolving restaurant known a Mutya ng Pasig in Pasig City

Industrialized Construction in the Philippines

Industrialized design and construction began in the Philippines in the 1960s, coinciding with the establishment and operation of the Philippine Pre-Stressed Concrete Co., Inc. (Philstress). An *industrialized construction system* is a set of building parts which may be combined or assembled and mass-produced in a variety of ways to create different building configurations via a highly organized production line of both equipment and labor. There are three types of building systems for industrialized construction: the box system or modular; the bearing panel system; and, the off-site fabrication with the assembly on site.

The box system is a three-dimensional space enclosing a unit which is usually manufactured at an off-site location. These boxes are either load-bearing or stacked on top of the other. They are nonstructural and are inserted into a structural frame system consisting of prefabricated columns and beams wherein panels and planks are inserted. The system is economically feasible only for high-rise constructions.

The bearing panel system is differentiated from the box frame system in terms of vertical and horizontal elements. The vertical elements are wall panels instead of columns, and the horizontal components are floor panels instead of beams. The precast panels are more widely used for building construction in the Philippines, and a variety of fabrication processes is employed for their production.

The general aim of an off-site fabrication with an on-site assembly process is to minimize on-site construction time. Here, the components are fabricated at the factory and delivered to the site where the bulk of the assembling process is done.

The first precast construction utilizing columns, beams, and slabs as well as stairs and wall panels was employed in 1964 with the Rizal High School, designed by Ruperto Gaite, and this was followed by other projects such as the Maoay Technical School and the Pasig Expansion School Building.

The 1970s Bagong Lipunan Condominium of the National Housing Authority utilized composite bearing structural components, a system patented by Gaite. This four-storey housing project was erected in three days together with the walls and windows, floor units, and stairs. The Tondo Foreshore Row-Housing Project is another example of a structure built with concrete bearing wall structural components. A total of forty-eight units was accomplished in a matter of thirty days.

The grandstands and bleachers of the Marikina Sports Stadium, designed by Gaite and built by Prestress, Inc., was made with a precast, prestressed structural system. Prestressing was employed in most of the precast units including the seat risers and channel-shaped wall unit, which had window openings. Post-tensioning was used for roof girders and columns and for securing the matched-face joint between the cantilevered roof frames and the vertical columns. Eight vertical cables were post-tensioned to secure the joints and resist bending moments in the column. Nearly 4,000 tons of precast and prestressed concrete were erected in only two months. It would have taken a year for this structure to be erected if the conventional construction method was used. The design of the Marikina Sports Stadium received an international award in 1974 for its outstanding precast system by the United States-based Prestressed Concrete Institute.

The lift-slab method was adopted at the Club Strata Building and the Makati Hotel. Through this method, an entire post-tensioned flat slab floor system is fabricated on ground, one on top of the other, and each is lifted on a predetermined elevation to the column then anchored through a shear steel block. Another method was slipforming, which was first employed in the construction of Century Park Sheraton Hotel. Rising at fifteen to thirty centimeters an hour, the tower was built of reinforced concrete shear walls using slipform construction, which involves inner and outer form faces open at the top, into which concrete is poured. As recently-poured concrete cures enough to support its own weight and retain its shape, the slipform is inched upward by hydraulic jacks that climb on vertical rods embedded in the concrete. Slipform construction was developed in Germany to build missile silos during World War II.

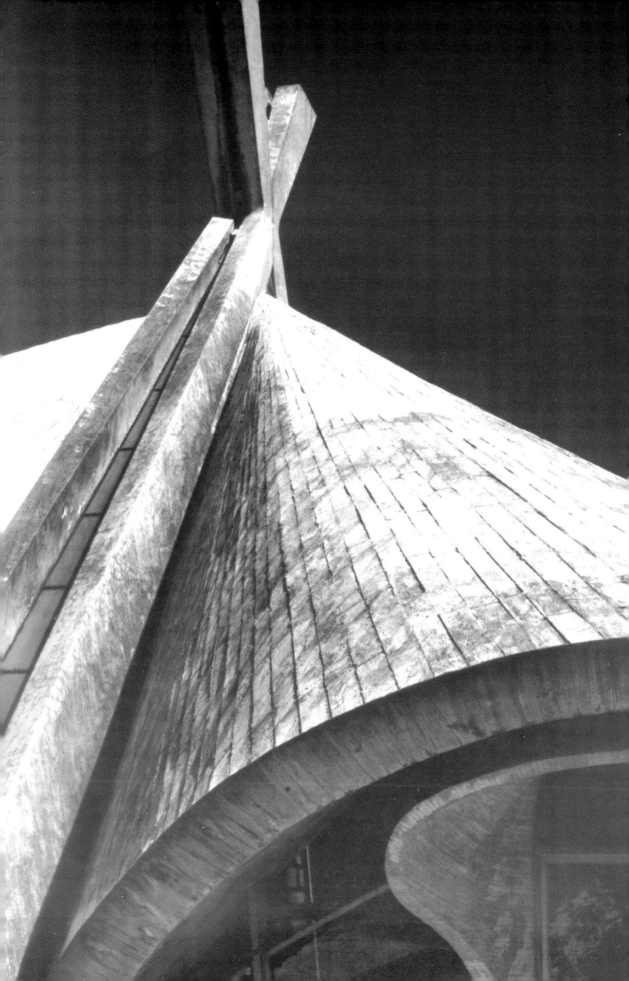

Modern Liturgical Spaces

Worship spaces in the mid-twentieth century adapted the new and straightforward geometries. Victorias Chapel (1949) in Negros Occidental was praised in *Life Magazine* as the first modern church in the Philippines. The chapel was designed by American architect Antonin Raymond, a follower of Frank Lloyd Wright. On the facade and in the baptistry were glass mosaic murals by Ade de Bethune.

The 1950s witnessed the sculptural acrobatics accomplished with the use of poured concrete, the so-called liquid stone. The plastic quality of concrete resulted into ecclesiastical gems such as the Church of the Holy Sacrifice (1955) and the Church of the Risen Lord (1955). The Church of Our Lady of Perpetual Help (1950s) in Baclaran, designed by Cesar Concio in the 1950s, had a modern façade and a ceiling that captured the complexity of Gothic architecture's ribbed vaulting translated in concrete.

Jose Ma. Zaragoza gained his reputation as the foremost designer in liturgical architecture in 1954 when he designed the plans and supervised the construction of the Santo Domingo Church in Quezon City. Unlike his contemporaries who looked toward the United States for inspiration, Zaragoza found his in Europe and Latin America. Turning away from the baroque ornamentation of earlier churches, the Santo Domingo Church exploited the plainness or simplicity of concrete using a modern, unornamented rendition of the Hispanic Mission Revival.

In 1968, Leandro Locsin again experimented with the biomorphic potential of concrete and stunned the residents of Bel-Air, Makati, with an organically shaped post-Vatican II church, the Church of St. Andrew. The basic structure was metaphorically derived from St. Andrew's X-shaped cross from which a billowing roof and a butterfly-shaped floor plan was fluidly generated.

Churches of the Philippine Independent Church, more popularly known as the "Aglipayan" Church, resemble those of the Catholic Church, since the Aglipayans did not significantly deviate from Catholic rites.

The Cathedral of the Holy Child (1969), located on Taft Avenue, Manila, was designed by Carlos Arguelles. The building had a rectangular nave and a rectangular apse with an east window. The exterior consisted of a suspended block with sloping trapezoidal walls and textured with horizontal grooves all throughout. This grooved trapezoidal mass was then supported by a rectangular block. The sides of the

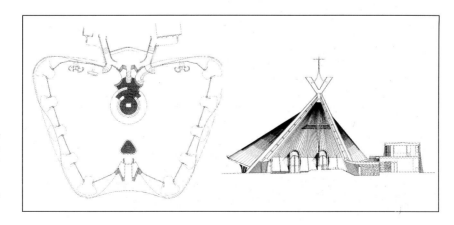

.61 The sculptural poetry of "soft modernism" epitomized by the Church of St. Andrew in Bel-Air, Makati (opposite page)

.62 Plan and section of the Church of St. Andrew

6.63 The altar of Victoria
Chapel in Negros Occidental
The chapel was hailed as the firs
modern church in the country.

6.64 Church of Our Lady o
Perpetual Help in Baclaran

6.65 Santo Domingo Church i
Quezon City

6.66 Union Church in Makati

suspended block sloped beyond the walls of the lower block to form wide overhangs. The roof was peaked with a cross. Behind the cross and directly above the central aisle, the roof was lined with upright equidistant concrete planes.

All churches, or kapilyas, of the Iglesia ni Cristo (INC) closely follow the patterns of Gothic architecture that had been interpreted by modernists like Juan Nakpil and Carlos Santos-Viola. The congregation's stylistic hallmark are pointed arches, triangular or tudor arches, towers and spires, and wall traceries.

Evocative of Niemeyer's cathedral in Brasilia, Jose Zaragoza capped his design for the Union Church (1975) in Makati with the graceful crown of a radial roof, a form generated from a monolithic concrete folded plate that resembled the iconic *anahaw* leaf. Here, Zaragoza digressed from the traditional cruciform plan of churches to adapt an elliptical spatial arrangement as dictated by the biomorphic shape of the roof.

The design of the regal Manila Mormon Temple (1983) by Felipe Mendoza in Greenmeadows, Quezon City, reflects the trademarks of Mormon temples with its precipitous roof and impressive spires.

Stripped Gothic

Dominated by the ubiquitous Gothic spires and finials, the reinforced concrete chapel of the Iglesia ni Cristo, more popularly known as kapilya, made its first appearance after the war. The records of Iglesia ni Cristo (INC) revealed that the campaign to construct more concrete chapels in the modern Gothic style commenced in the late 1940s and the early 1950s. Yet as early as 1918, its founder, Felix Y. Manalo, had contemplated on the need to build worship spaces for its increasing congregation for it was no longer enough to conduct services in the houses of its members. Using bamboo and sawali, the construction of the first Iglesia ni Cristo kapilya in Tondo, Manila soon followed. This chapel of light-weight construction inspired several replicas in other provincial sites where the congregation's presence was greatly felt. But the modern neogothic, reinforced concrete edifice characteristic of Iglesia ni Cristo chapels, made its first appearance in 1948 in a site located in Washington Street (now Maceda), Sampaloc, Manila. The chapel, designed by Rufino Antonio, was a castle-like concrete house of worship possessing precast tracery and rosette ornaments, lofty spires, and lancet-arched windows—elements that leaned toward a twentieth century interpretation of the Gothic style. The structure, along with its details and articulation, would set the familiar stylistic template for the congregation's later worship spaces.

Four years later, Juan Nakpil and Carlos Santos-Viola designed the Bishop's Palace and Chapel, located in San Juan, Rizal. The fully air-conditioned building could seat 1,200 worshippers. Later, in 1954, partners Carlos Santos-Viola and Alfredo Luz designed and completed the kapilya in Cubao, Quezon City. After Santos-Viola set up his own firm, he was commissioned to design most of the larger kapilyas. In 1971, the Iglesia ni Cristo (INC) established its Engineering and Construction Department (INCECD), an arm which undertakes the design, construction, and maintenance of INC buildings.

From 1968 to 1971, the central office complex at Diliman, Quezon City, was constructed. A decade later, from 1981 to 1984, a much bigger edifice, in fact, the largest and most expensive house of worship, was built. The magnificent temple is an important landmark in Quezon City. Here, six major towers and twenty-two spires accentuate the verticality of its roofline. The middle tower, with a diameter of 10.15 meters, is the tallest point in the structure, rising 285.36 feet above ground. Slightly lower but larger in girth, are the east and west towers each measuring twelve meters in diameter, ascending from the hexagonal top of the side chapels. Two octagonal towers flank a triangulated façade.

In general, INC kapilyas are characterized by a façade composition that is dominated by a triangular or tudor arch flanked by tall, slender towers which taper and terminate in a spire. Sometimes a central spire rises between the two. At the rear elevation, two more towers flank the central mass. A cantilevered canopy defines the entrance. Decorative motifs, such as rosettes and interlocking trapezoids, provide textural appeal to the smooth and crisp external planes.

6.70 The first Gothic-influenced church of the Iglesia ni Cristo in Washington Street (now Maceda Street) in Manila

Tropicalizing the International Style and the Mania for Brise Soleil

Filipino architects in the 1950s experimented with climatic designs with the use of brise soleil (sun breakers), deep overhangs, and pierced screens to control the effects of the sun. The presence of sun-shading devices on facades was nonetheless innovative; and created a strong, startling, formal effect of ever-changing contrasts of light and shade.

The notion of tropicality is a category contingent upon the climatological dictates of a tropical environment, which greatly influences the morphology of architecture. Tropicalism has been sentimentally embraced by architects since the late 1950s for a dual purpose: to maintain cultural differences in the era of homogenizing the International style; and, to ensure that the built forms were responsive to both the meteorological and cultural givens of the tropical site. Thus, tropicalism creates an environmental rapport between architecture and the tropical ecology.

Programmed to counter the hegemony of the International Style, tropicalism runs congruently to the throes of decolonization. It is in this sense that tropicality in architectural design becomes an expedient transformative intervention that coincides with the process of liberating oneself from the political and taste-dictates of the former colonial masters. This is attained by transforming the imported vocabularies of modern architecture in accordance with the context of a tropical and cultural environment.

As tropicalism renews links between architecture and local cultural heritage, it gains currency as a form of counter-aesthetics to the sterility and anonymity perpetuated by the International style of Modernism. The essence of tropicalism is intertwined with the incorporation of either literal or abstract attributes of the region's endemic and traditionally built environment—massing, spatial psychology, solids and voids, anthropomorphism and scale, use of light and shadow, and construction and structural principles.

Few architects have succeeded in giving justice to the ideals of tropicalism, as architectural structures that belong to this category are expected to bear symbols of local culture and, at the same time, be responsive to climatic givens without leaning to superficiality of form. The predictable tropicalist response has been to create a pastiche by grafting a pitched roof to a high-rise. Such a mélange becomes a question of legitimacy and remains fundamentally alien even if it bears the stamp of familiar, local, cultural symbolism. Unless scientific principles of tropical architecture, energy, and materials are integrated into the design of buildings, these structures are fated to be superficial.

Another instant approach would be the application of the ubiquitous brise soleil or sun breakers, invented in the 1930s. Brise soleil is an architectural baffle device placed outside windows or projected over the entire surface of a building's facade. Many traditional methods exist for reducing the effects of the sun's glare; these include lattices, pierced screens, blinds, and verticals—all used outside windows. The French architect Le Corbusier designed a more substantial baffle in 1933. Four years later, as the consultant architect to the Brazilian Ministry of Education and Health, he introduced horizontal, gear-operated, adjustable baffles for the new multistoried office building in Rio de Janeiro. Consequently, many other forms

6.71 Capitan Luis Gonzaga Building in Santa Cruz, Manila

6.72 The Capitan Luis Gonzaga Building at the intersection of Rizal Avenue and Carriedo Street

of sun baffles were developed in South America, Africa, and Asia. They included fixed vertical baffles set beyond a wide, heat-dispersing balcony and grid-like baffles applied at varied distances over the whole face of a building.

The device became a ready-made solution to refashion modern buildings of the 1950s and 1960s to address the solar radiation in the tropics. The device, largely made up of reinforced concrete louvers and screens, easily became an architectural staple in the Philippines in the 1950s. However, its indiscriminate use by unqualified designers to provide tropicality to modern buildings often degenerated it into a cliché architectural accessory of the period. A mania for the brise soleil seemed inevitable as some buildings bred ad hoc variations of the devise in their building skin. Some brise soleil departed from their pragmatic tropical application, disregarding the knowledge of correct solar orientation and sun paths, and thereby reducing them into mere useless fashion accessories and expensive decorative appendages of modern edifices.

Pablo Antonio's postwar oeuvre, the Capitan Luis Gonzaga Building (1953) at the corner of Carriedo Street and Rizal Avenue, successfully transfigured the modernist box into a building that was perfectly suited to the tropics by utilizing double sunshades. Curved bands of concrete horizontally traversed every floor of the structure. The horizontal bands wrapped the corners with a wide curvature. These bands were then accented by projecting vertical louvers that alternated at every floor.

The Engineering and Architecture Building (1952) of the University of Santo Tomas, designed by Julio Victor Rocha, initiated the successful application of the Niemeyer-inspired brise soleil in local buildings. The facade of the three-storey building flaunted a continuous sun breaker that protected its second and third-storey windows. The craze for brise soleil followed suit, which created many variations.

The general headquarters of the Boy Scouts of the Philippines (1955) exploited the benefits of brise soleil as both a solar modulating device and as a decorative

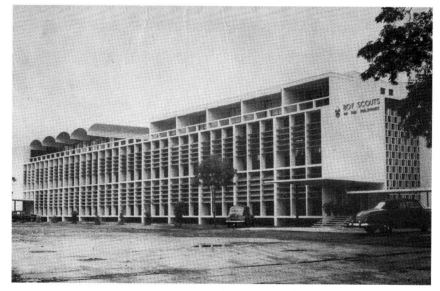

articulation on the principal face of the edifice. Juan Nakpil, its architect, accentuated a section of the top level with a series of scalloped roof shells of reinforced concrete that projected beyond the wall of brise soleil.

Alfredo Luz's World Health Organization Building (1958) was a long, four-storey rectangular block along United Nations Avenue with vertical fins that were finely spaced over three bands of horizontal louvers. His Ermita Center (1967) on Roxas Boulevard, on the other hand, experimented with horizontal bands, which took over the horizontal fins, functioning as braces, and thereby endowing the building with stronger horizontal lines.

The seven-storey Philam Life Building (1961), designed by Carlos Arguelles, was a rectangularly-planned structure with a centralized core that allowed some 20,000 square meters of office space to be naturally daylighted. Arguelles utilized

wraparound horizontal aluminum sun baffles supported by pipes and mullions. The banding of the aluminum imbued the building with its extraordinary look. This horizontal definition countered the bulk and height of the building, allowing it to blend with the design context of the low-rise district of Manila.

With the Consolidated Mines Building (1963), Arguelles relied on a series of serrated, horizontal concrete louvers to protect the glass-clad office building.

Jose Zaragoza's Commercial Bank and Trust Company (1960s) was an L-shaped building located at a corner lot along Ayala Avenue. The exterior of the building was entirely covered by egg-crate-type sun baffles, except the mezzanine, which was protected by vertical louvers. His fourteen-storey Meralco Building (1968) earned distinction as the first building to rise along Ortigas Avenue. The most prominent feature of the Meralco building was the series of tapering mullions that defined the façade. The vertical sun breakers with slight curvature were conceived not for decorative purposes but also for the deflection of light and sound. The ends of the building were emphasized by two, massive, marble-surfaced walls splayed at an angle.

Cesar Concio's Insular Life Building (1963) at the corner of Ayala Avenue and Paseo de Roxas, displayed a gently curving façade entirely covered by narrow vertical aluminum projections that were set close together within square modules to conceal the curtain wall behind it.

The L-shaped Rufino Building (1960s) on Ayala Avenue, designed by the tandem of Nakpil and Sons, distinguished itself with its use of white, reinforced concrete, elongated–diamond sun baffles, which covered the entire structure. The overall

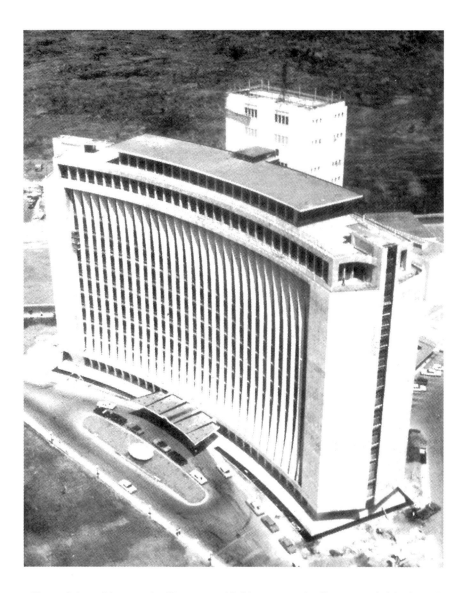

effect of the white sun baffles was a highly geometrically-textured, black-and-white edifice.

Cresenciano C. De Castro's Vermont Towers (1966) was a rectangular edifice perforated by window openings defined by sun baffle-like mouldings, which maintained a balanced blending of horizontal and perpendicular lines on the exterior.

The use of open-work masonry, an ornamental or structural work that is perforated, pierced, or lattice-like, offered a more delicate facade than the brise soleil in the 1960s. Popularly known as pierced screens, they were adopted as a sort of improvement over brise soleil. Pierced screens functioned mainly as diffusers of light and doubled as exterior decorative meshes. They were fabricated from perforated concrete or ceramic blocks, precast concrete, or aluminum bars.

The United States Supplementary Office Building (1961) along Roxas Boulevard, designed by American architect Alfred L. Aydelott of Memphis, Tennessee, was

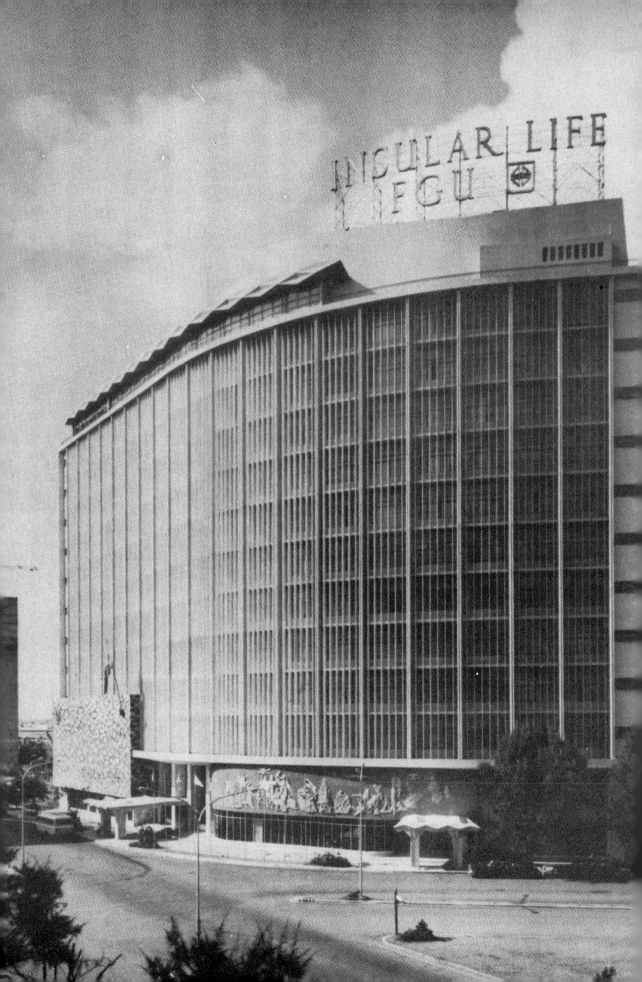

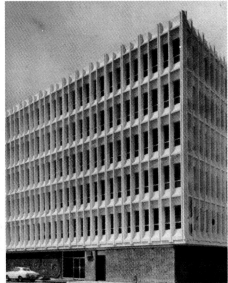

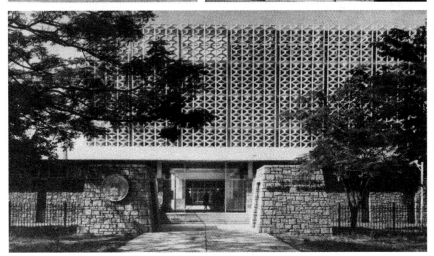

one of the most noteworthy applications of pierced screens in Manila. Aydellot visited Manila in 1955 to study aspects of Philippine culture and history to come up with an architecture of diplomacy that was sensitive to Philippine customs, culture, and traditions. For the building, he used the walled city of Intramuros as an iconographic reference, which was depicted in the thick, sloping, adobe stone wall of its first storey which was interspersed with narrow window openings. The precast concrete pierced screen surrounding the upper four storeys was suggestive of bamboo slats or blinds in typical nipa huts.

The pierced screen became popular not only as a ready-made, climate-modulating device but also as an ornamental contrivance that redressed the monotonous planes and boxes of modernist structures. They were profusely applied on various building types ranging from residences to institutional buildings. An almost full-screened building, which was divided into square modules, was the Phoenix Insurance Building (1960s) in Intramuros, designed by Gines Rivera. The Abelardo Hall (1960), by Roberto Novenario, at the University of the Philippines was screened by honeycomb-like sun baffles.

Redefining the Metropolitan Skyline

Modern buildings rose in Escolta, Manila's central business district, in the 1950s. These were Luis Ma. Araneta's Botica Boie Building and Araneta-Tuason Building, Antonio Mañalac's Madrigal Building (1956), Juan Nakpil's Rehabilitation and Finance Corporation (1952), and Rufino Antonio's Tuason-Araneta Building. Botica Boie was a pioneering pharmaceutical company in the Philippines engaged in the manufacture of household remedies and production of its famous ylang-ylang oil. Its building had seven horizontal bands of concrete which served as railings for the floor. The thin vertical mullions of the glass windows sandwiched between the bands formed a rhythmic contrast. The Araneta-Tuason Building was an eight-storey building whose façade was graced by a series of lean and unique solar shades designed by Luis Araneta himself. The Madrigal Building utilized fixed upright sun baffles arranged at regular intervals on the protruding frame on the whole façade. Thick bands underlined by narrow bands divided the five floors, resulting in a recessed pattern combining horizontal and vertical rectangular forms. The rectangular façade pattern recurred in the seven-storey building of the Rehabilitation and Finance Corporation, one of the largest buildings in Escolta. Here vertical rectangles and corresponding small horizontal ones were encased in moulding and not within a frame. Finally, the Tuason-Araneta Building was the first building in Escolta to use vertical brise soleil as a decorative feature. But as a solar device, it failed miserably as it was not deep enough to project shadows.

One of the landmark structures of the 1950s was the National Press Club Building (1954). It was designed by Angel Nakpil, whose architectural training in Harvard had exposed him to the works of Bauhaus professors Walter Gropius and Marcel Breuer. The National Press Club Building was a breakthrough in sculptural composition and derived its three-dimensional form from the unison of two simple geometries that also defined the functional program of the building. One was the elongated hexagon, which housed shops, offices, and the club. The other was a transparent cylinder containing the main stairs that spiraled around the core elevator shaft. Nakpil greatly acknowledged the influence of Gropius upon his works. His cylindrical glass tower paid homage to Gropius's early work, the Werkbund

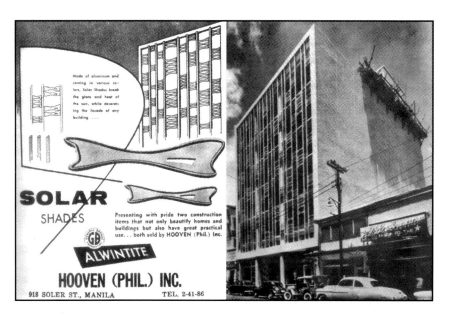

6.83 Advertorial for solar shades applied to the Tuason-Araneta Building in Escolta, Manila

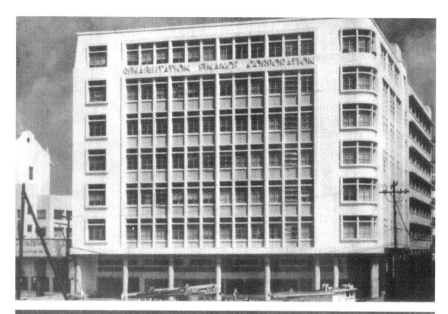

6.84 Rehabilitation and Finance Corporation

6.85 National Press Club

Exhibition Building (1914) at Cologne, Germany. In 1960, Angel Nakpil also designed the Lopez Museum (1960), which cleverly used cantilevers to suspend the upper floors of the triangularly planned, multistorey structure.

Tall and multistoried apartments played a new role in providing Filipinos with modern housing. Monterrey Apartments (1957) and Carmen Apartments (1958) epitomized the modernist high-rise apartments built in the 1950s. The Carmen Apartments, designed by Carlos Arguelles, was distinguished for its curved plan, which posed an elegant contrast to the surrounding structures in the vicinity. All the floors and units had wide cantilevered balconies that provided entertainment space as well as shade from the sun. Steel railings and large windows combined with these floating slabs endowed the building with lightness and transparency counteracting the bulk of the reinforced concrete core. The Monterrey Apartments, on the other hand, was one of the first high-rise structures in Makati. The Ayala Corporation commissioned Leandro Locsin, who came up with a structure of extreme transparency. Strips of glazing were wrapped around the building while one wall of the central stairwell was encased wholly in glass. Front balconies were

6.86 Modern edifices lining the stretch of Ayala Avenue in Makati, a new area developed in the 1960s to become the financial capital of the country

treated with aluminum louver eaves while rear balconies were provided with louvered railings. Continuous floor slabs or balconies visually impart a buoyant effect.

In the 1950s the height of buildings was limited by law to thirty meters. This thirty-meter height restriction was enforced not because of structural imperatives (in relation to earthquakes or the load-bearing capacity of the ground) but due to the difficulty of bringing water to higher heights. This was perhaps due to the absence of commercially-available water pumps and overhead tanks at that time. With the amendment of Manila Ordinance No. 4131 on May 5, 1959, the allowed maximum height of buildings was increased from thirty to forty-five meters, giving rise to a vertical euphoria in the 1960s. Considered as the first skyscraper in the Philippines, the Picache Building (1962), located at the Plaza Miranda in Quiapo, rose to a twelve-storey height on a rectangular lot. Its architect, Angel Nakpil, emphasized the verticality of the structure by attaching thin, vertical mullions on the window ledges. However, the vertical thrust was contravened by treating the last three floors with wide concrete overhangs. In Makati, on the other hand, Cesar Concio's Insular Life Building (1963) was the first office building to surpass the old thirty-meter height restriction, paving the way for the high-rise construction boom in the district.

The Architectural Center (1962), designed by a team of architects led by Gabriel Formoso, was a sleek modern building along Ayala Avenue whose façade was lined with vertical louvers spaced closely together. This eight-storey building served as a venue for those engaged in the profession of design and construction to interact socially and transact business.

The Asian Development Bank Headquarters Building (1964), located along Roxas Boulevard facing Manila Bay, was another architectural achievement and a significant vertical development of the period. In a design competition, participated in by top architects in the country, Cresenciano de Castro's entry was adjudged the best and most suited design to embody the bank's philosophy. The ADB headquarters was comprised of four major structures linked together by their

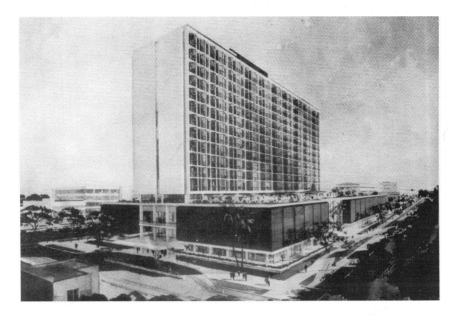

brutalist finish and architectural detailing. Dominating the complex was the fourteen–storey ADB Tower that appeared to float in space via a seventeen–meter cantilever made possible by a core-supported floor suspension system. Beveled curtain window wall openings were oriented to the north and south directions, with the building side wall curving slightly for a better view and for natural daylighting. Alongside the tower were a five-storey annex building, a convention hall, and a connecting three-storey apron. The building is now occupied by the Department of Foreign Affairs.

Another skyscraper was the Manila Hilton Hotel (1967), a collaborative work of Welton Becket and Carlos Arguelles. The structure stood at twenty-two storeys high, becoming the tallest building of its time. A tall hotel slab rose above a podium enclosed in a twelve-meter solar screen of timber slats. The roof form was shaped along the lines of the native salakot, which was an attempt to crossbreed the modern and the traditional.

The Ramon Magsaysay Center (1968) along Roxas Boulevard was designed by Alfredo Luz. The office building was composed of a massive rectangular block

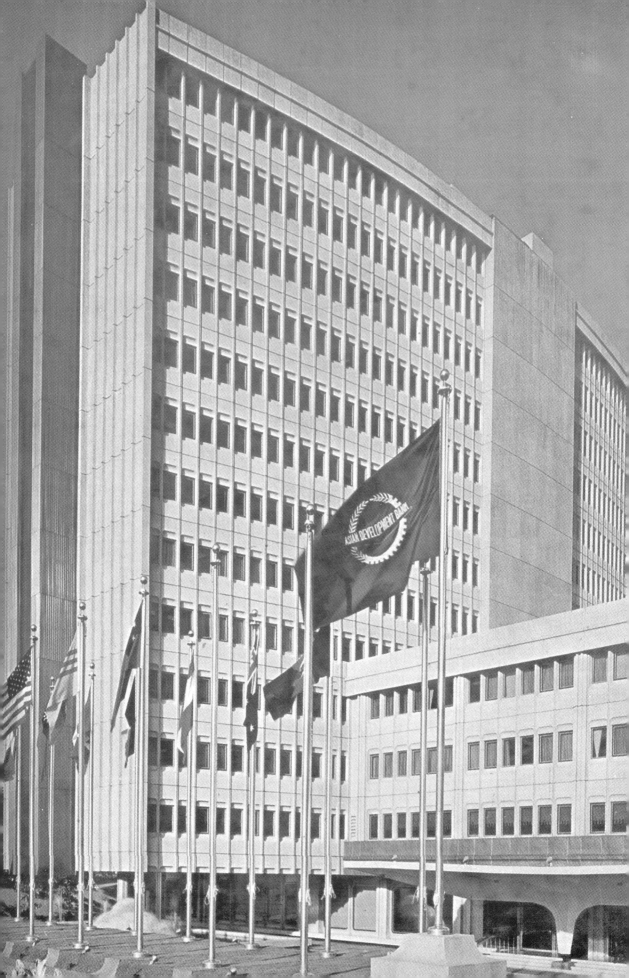

lifted from the ground by a group of massive square columns lining its perimeter. Actually, the sheer mass of the slab was partly carried by the central structural core. The surface of the tower was mechanistically smooth and punctured by repeating rows of deeply recessed square windows.

Cresenciano de Castro introduced the use of an exposed aggregate finish. This eliminated the need to paint the exteriors of structures. An excellent example of this brutalist tendency is the Asian Development Bank Building (1964) in Roxas Boulevard. Locsin adapted the technique for his rough textured finish (the aggregates were crushed shells derived from the site) for the Cultural Center of the Philippines Building (1969).

Aside from achieving verticality, Philippine architecture in the 1960s accommodated new building technologies. Precast construction and prefabrication were introduced to industrialize building methods. Arguelles's Philippine National Bank Building (1966) in Escolta occupied the limelight as the most spectacular example of high-rise, precast construction in the Philippines in the 1960s. Outstanding prototypes of industrial construction of the period using prestressed and prefabricated concrete were the Filipinas Cement Plant and the Aircon Plant. While the Greenhills Theater (1968), designed by Antonio Heredia, was the first structure to use the technology of the post-tensioned structural system, which allowed a clear span of fifty-two meters and an overhang of six meters.

Brutalism

The term "brutalism" is derived from the French word *beton brut*, which means "rough concrete," suggesting a sense of brutality expressed by this style. Brutalist structures are massive and unrefined with coarsely formed surfaces, usually of raw and exposed concrete. Their highly sculptural shapes tend to be crude and blocky. The boundary between brutalism and ordinary modernism is not that clear-cut since concrete buildings are so common and run the entire spectrum of modern styles. Designs which embrace the roughness of concrete or the heavy simplicity of its natural forms are considered brutalist. Other materials including brick and glass can be used in brutalism if they impart block-like effects or strongly articulated concrete forms. Brutalist architects, such as Leandro Locsin and Cresenciano de Castro, in their late 1960s and 1970s works, manifested a willful avoidance of polished elegance and slabs of concrete were exposed to convey a stark and austere rectilinearity.

Vernacular Nostalgia and the Adaptation of Tradition

The global proliferation of the International Style resulted in the obliteration of many traditionally built environments and created buildings and environments that purged any references to local culture, tradition, climate, or identity of the place. The initial reaction to this lack of local, regional, or national architectural identity was for architects to "dress up" or graft modern international style designs with architectural forms or materials that instantly suggested alliance to local architectural traditions and cultural contexts.

The early responses were stylistic, superficial, and copyist in nature and were merely based upon image-making. Traditional forms, colors, motifs, and other elements of nativism were merely applied to the facades of international style designs. Numerous examples of this appliqué surfaced in the sixties and seventies not only in the Philippines but also in other parts of Southeast Asia and the Middle East.

This search for regionalist expression catalyzed an interest in the study of local and vernacular traditions in architecture. Traditional non-Western architecture, which was formerly viewed as primitive and backward, now began to be studied and understood for their underlying principles as well as their social, cultural, and environmental relevance. Former UP College of Architecture Dean Geronimo V. Manahan narrated the temper of this period in a survey of twentieth century Philippine architecture:

> The conscious architecture of native and traditional forms received greater meaning. The variety of regional conceptions of space was systematically analyzed for territoriality. The appropriation of building science and new materials gave distinct vernacular meaning to the romantic thrust of the period

> Regionalism and vernacular were seen as counter forces to the worn-out rational and universalizing tendencies of modern architecture. Regionalism was treated as less concerned with abstract issues and more for adding sensual physicalities, depth, and nuances to the Filipino's comprehension of architecture. (1994, 58)

This architectural retrospection was intensified internationally by a series of publications in the late 1960s that reassessed the value of vernacular architecture. Among them were the now classic Rudofsky's *Architecture without Architects* (1964) and Rapoport's *House Form and Culture* (1969).

The iconographies and cultural patterns derived from a primeval ancestry, as they existed in the distant precolonial society, were sources of architectural inspiration. This sentimental longing for the primeval was rooted in the notion that these archetypes were the true fountainheads of identity, of which the citizenry can share a collective memory, and from which the "national essence" can be distilled. This approach has produced what is now referred to as *neovernacular architecture*, a nostalgic attempt to recreate a style from the past—in this case, the vernacular traditions—in the same way that neoclassic architecture approximates classical motifs.

"Folk architecture" and the bahay kubo became architectural archetypes in the quest to forge a national architecture that sparked a vernacular renaissance,

bringing to the fore an architectural imagery of high ceilings, large capiz windows, *tukod*-like (awning) windows, traditional carving and decorative interior details, and the use of indigenous botanical materials and earth-toned or sepia-varnished interiors in Filipino domestic architecture. A mania for collecting Filipiniana antiques and folk or ethnic objects to adorn the interiors of structures aspiring to be Filipino followed suit. Authentic and reproduced "antique" elements were rampantly used in newly built houses to add a sense of history in these brand new "ancestral" houses with archaic pretensions. The period of "architecture in retrospect" ushered in an illusory opportunity for the contemporary urban denizens to connect with and indulge in their lost identity.

This nativist orientation in architecture becomes problematic as it essentially defines itself in terms that inescapably privileged a singular dominant cultural group. Therefore, the rich polyphony of architectural expressions within the heteroglot cultures of the archipelago is muffled or suppressed. Furthermore, the imprudent confiscation of symbols from indigenous cultures to sustain nationalist fantasies, with little or no respect for propriety, scale, and materiality, does a disservice to the native itself by way of constructing stereotypical or romanticized images of an ethnic culture that unwittingly promotes the consumption of the "exotic" as a mere tourist commodity.

One of the early evidences of vernacular appropriation programmed for modern building types could be dated back from the early 1930s with Juan Arellano's design for government buildings for Banaue, Ifugao, and Glan, Cotabato. This corpus of work was an excursion from his neoclassic lineage as his designs derived their substance from regional architecture typologies. The paradigm for these nativist government structures was limited to domestic architecture prevalent in the region. Taking their basic building silhouettes, he transformed and magnified the Ifugao fale, Bontoc dwelling, and Tausug house into a city hall, government hospital, and municipal building, respectively. For the Cotabato Municipal Hall, he appropriated the Tausug gable roof and pinnacled it with an elaborately carved cross gable finial based on the naga tajuk pasung.

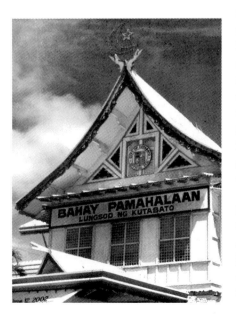

Indigenous roof forms still have an appeal today as signifiers of local identity. This is the recurring motif spliced onto modern buildings, such as hotels, resorts, airports, and municipal buildings. Utilizing archaic roof forms persists not only in the Philippines but also in other post-independence states of Southeast Asia as a convenient and formulaic symbol of local identity.

By the late 1950s and the 1960s, Orientalism became a profound design route unwittingly adapted by local architects in the design of commercial architecture. The Occidental culture's fetish for the

6.95 Cotabato Municipal Hall

exotic installs otherness and stereotypical images upon the cultures of the Orient as a way to exercise hegemony. This brand of Eurocentric framing, when applied to architecture, encourages the consumption of the exotic, the unfamiliar, and the primeval. For instance, the American fascination with the South Seas culture and ecology had spawned the "Polynesian Tiki Style" immediately during the post-WWII days. Such interest in South Pacific motifs was largely a result of World War II servicemen returning from tours of duty in that region. Tiki elements included exposed wood beams, A-frame roofs, and carved wooden *tikis* (an anthropomorphic image of a Polynesian supernatural being). Tikis traditionally represent the spiritual world in Polynesian culture—a fact only marginally understood by most who saw them in restaurants, bars, bowling alleys, and motel lobbies in California.

6.96 Sulo Hotel

The adaptation of the tiki style in the Philippines came in the form of ersatz "Filipiniana exotica" that replaced Polynesian elements with Philippine ethnic symbols. Local architects adapted Maranao and southern Philippine motifs, exploiting vinta colors and roof silhouettes resonating ambiguous Polynesian figuration. The mode of tiki cloning found expression in the works of the Mañosa Brothers for Sulo Hotel and Francisco Fajardo for Max's Restaurant and Luau Restaurant, which heavily relied on an exaggeratedly sloping roof and Filipinized totem poles; the Mañosa Brothers' Esso Gas Stations that transcoded the naga pattern in reinforced concrete; Felipe Mendoza's Holiday Hill's Golf Club House

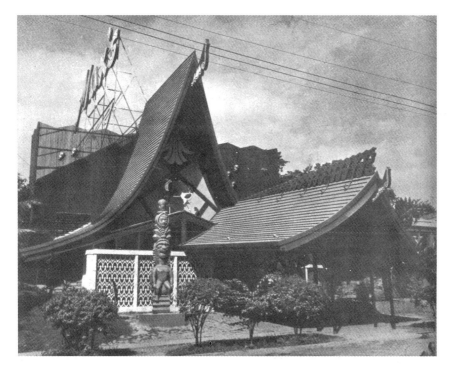

6.97 Max's Restaurant wa heavily influenced by th Polynesian vernacular imager of the South Seas.

6.98 Holiday Hill's Golf Club House

6.99 Valley Golf Club House

6.100 Entrance to the 1953 Philippine International Fair

6.101 Advertisement for the Philippine International Fair held in Manila in 1953

that liberally used the naga's head in ornately carved end beams; and Otilio Arellano's FILOIL Service Stations that used the Maranao panolong as decorative accent—all of which unwittingly mechanized "self-Orientalism" in the process of professing allegiance to an imagined Philippine vernacular civilization.

This vernacular tendency in architecture extended beyond Philippine shores as manifested by a number of Philippine embassies designed by Federico Ilustre in the 1960s. These embassies—Philippine embassies in India, Jeddah, and Brazil—were grafted with traditional building motifs particularly evident in the silhouette of the rooflines.

A bird's-eye view of Gabriel Formoso's Valley Golf Club House (1960) showed a floor plan that merged a circle and a triangle to literally suggest the form of a golf ball resting on a tee. Although displaying such strong architectural humor and literal frankness, the structure at close range evoked the grace of the steeply sloping roof of the Philippine vernacular archetype.

In similar fashion, designs for Philippine pavilions for various International Expositions appropriated exotic building motifs for the projection of a national image in the international arena, which began when Manila hosted the Philippine International Fair in 1953. The fairground at Luneta's Wallace field was dominated by Otilio Arellano's symbolic gateway, which was supposed to showcase the "500 years of Philippine progress." The structure was made up of a series of huge pointed arches, the summit of which was crowned by a conical salakot.

In the 1958 Brussels Universal Exposition, the country was represented through a pavilion designed by Federico Ilustre. The design of the Philippine pavilion was conceived along the criterion of expressing "a symbolic summation of the cultural and scientific achievements" of the Filipino people in every visible aspect and detail of the building (*The Bureau of Public Works Bulletin* April–June 1958, 16). But the result was no more than a replica of a bahay kubo with a high-pitched plastic transparent roof (known as "perspect glass") and simulated sawali sidings.

For the 1962 Seattle World Exposition, the Philippine Pavilion of Handicrafts and Industries took a less literal interpretation of vernacular architecture via a cuboidal pavilion designed by Luis Ma. Araneta. But the surface ornaments that lavished this simple cube were no doubt exotic. These were enlarged wooden tribal artifacts and a pair of overscaled wooden spoons and forks carved with ethnic figures—items usually peddled as tourist souvenirs in the Mountain Province. The pavilion projected exoticism combined with kitsch as the entrance simulated a fearful precolonial tribal deity whose mouth was exaggeratedly open, allowing it to function as the main door. Such iconography was more Polynesian than Filipino, not really existing in Philippine culture.

6.102 Philippine pavilion at the 1958 Brussels Universal Exposition

6.103 and 6.104 Exposition buildings of the Philippines in the 1962 Seattle World Exposition

6.105 The salakot-like exposition pavilion of the Republic of the Philippines in the 1964 New York's World Fair

The Philippine pavilion for the 1964 New York World's Fair resonated the romantic sentiments as well as the aspiration for high technology of the period. Designed by Otilio Arellano, the circular pavilion seemed to float over a body of water. Though it attempted to project the penchant for crossing native design with space-age aesthetics, it failed to go beyond the literal translation of the familiar salakot, the wide-brimmed indigenous hat, resting above the ground on what looked like a flying saucer launching pad.

In the 1970 Osaka World Exposition, Philippine identity was signified by a pavilion designed by Leandro Locsin. The pavilion was a structure of steel, concrete, and precious Philippine hardwood, whose exaggeratedly protruding form could be variously interpreted as a bird in flight, a prow of a Muslim vinta, or as a metaphor for the nation's noble aspiration.

The vernacular renaissance in Philippine architecture was to reach its pinnacle in the 1970s when the Marcos regime launched its New Society. Under the auspices of the regime, a systematic cultural revivification program was to take effect, nourished through the reinvention of a precolonial, barangay-based vernacular heritage. At this historical moment, architectural aesthetics would be employed by the state to ordain its patrimony and to legitimize its seizure of power. Notwithstanding its Imeldific excesses, the regime unwittingly ushered in a fleeting Golden Age of Philippine architecture.

7 Vernacular Renaissance
and the Architecture of the New Society

The Marcos Regime and the Promise of National Rebirth

The presidency of Ferdinand Marcos (1965–1986) was a period of great political unrest, transgression of human rights, and great economic instability. Yet, at the outset of Marcos's governance, the promise of national rebirth and resurrection of old Filipino traditions was his principal preoccupation. The cultural and architectural agenda of the regime was placed under the auspices of First Lady Imelda Marcos who took charge of the cultural renaissance of the nation using the aesthetic maxim: "the true, the good, and the beautiful."

Marcos's first term witnessed monumental strides in agriculture, industry, and education. By the middle of his second term during the early 1970s, however, his administration was increasingly troubled by student demonstrations and violent urban guerrilla activities. Marcos, approaching the end of his constitutionally delimited eight years in office, decided to narrow his goals. Faced with the prospect of a new Philippine constitution, he pressed for the adoption of the parliamentary style of government, which would allow him to stay in power indefinitely.

On September 21, 1972, claiming that it was the last defense against the rising disorder caused by increasingly violent student demonstrations and insurgency, Marcos imposed martial law. The nation stood at a standstill. In his self-authored propaganda book, *Notes on the New Society*, written to persuasively propagate a sociopolitical criteria necessary in the foundation of the new social order in the form of *Bagong Lipunan* (New Society), he dramatically narrated the events that justified his declaration of martial law. In the same propaganda literature, he professed the ideological promise of the New Society with an air of nostalgia in making the Philippines a great nation once more. The New Society required sacrifice from its citizens who would undergo the rigorous processes of social reengineering and cultural rejuvenation.

With the declaration of martial law, euphemistically branded as "constitutional authoritarianism," power was concentrated in Marcos himself, giving him absolute and incontestable control over the executive and legislative branches of the Philippine government. To complement this new omnipotency with a matching

7.1 The Main Theater of the Cultural Center of the Philippines

image, Marcos encouraged a cult-like devotion to himself and his family. First Lady Imelda Marcos's involvement in the propagation of this contemporary mythology was far from merely symbolic. Her conspicuous participation in affairs of the state, primarily in cultural, diplomatic, and architectural matters, made her the second most powerful, and certainly the most visible, political figure in the country. The First Couple jointly established their firm hold over the entire New Society, prompting political observers to refer to the twenty-year reign as a "conjugal dictatorship."

In the period of dictatorship, President Ferdinand Marcos and First Lady Imelda Romualdez sought to ordain a native civilization bred from a Malayan ancestry. For him, the promise of implanting the eternal values of an imagined "Great Malayan culture" proved to be a potent reason for initiating national renewal during the Martial Law years. He nurtured a myth for which some historians had coined the term *palingenesis* or *palingenetic*, a form of utopianism which evoked the idea of rebirth or spiritual regeneration. It stressed the imperative to reconnect with the past to promote a "rebirth" of the Great Malayan nation as a common destiny, the birthright of a people piloted by a Great Leader.

It was therefore mandatory that a national culture be fostered and preserved. And, in recreating Filipino national identity, Marcos expressed:

> To be a dynamic instrument of nation-building and social reconstruction, he (the Filipino) therefore seeks to recuperate his identity. He must get back to his roots, his culture. Necessarily he must, for the culture of a people is their covenant. It is the distinguishing mark, the source of identity that sets them apart from other peoples. It provides them inner strength that shapes their collective will of their body politic and the structure of their national society.

> The process of such rebirth is not only monumental; it is also complex as it is creative. In resculpturing his identity, he must, with all consciousness and consummate skill and artistry, dedicate every detail of his acts and thoughts as purposive ingredients in the process of creating a new Filipino (F. Marcos 1978, 172-73).

The regime's manipulation of art and architecture entailed the reincarnation of a vernacular civilization fashioned from a synthesis of indigenous and cosmopolitan aspirations of modernity. As political scientist Donald Preziosi (1998, 290) asserted, "One simply cannot *be* a nation-state, an ethnicity, or a race, without a proper and corresponding art, with its own distinctive history or trajectory which 'reflects' or models the broader historical evolution of that identity" The palingenetic ideology's potency is, therefore, best felt when culture becomes the first target, for culture is like a permeable membrane by which the state can penetrate the consciousness of its citizens. Cultural and historical revisions, consecrated by the state, were Marcos's first step in initiating social renewal. The cultural policy of the dictatorship cannot be divorced from this messianic vision of the state's capacity to reengineer society and thus lead the citizenry into a new, heroic phase of nationhood. The martial law regime consolidated nationalism with a mode of identity and modern progress.

The official art and architecture of the martial law regime reverberated with this regeneration of a national myth through the creation of a new sociopolitical and ethical order portrayed as a radical alternative to existing ideology. The regime's manipulation of the arts sought to prescribe a reincarnation (palingenesis) of a vernacular civilization fashioned from a synthesis of indigenous and cosmopolitan aspirations of modernity: (1) identity as a derivative of primeval ancestry, and (2) identity as evidence of human progress, made possible through art. Thus, the modernizing impulses relied on some contradictory, antimodern features, such as the leader cult, the veneration of force and violence, the invocation of the past, and the notion of Bagong Lipunan as the revivified epitome of Malayan culture. Nostalgia was made possible through modern media and technology, such as state-funded modern architecture, state-sanctioned art, and government-controlled mass information systems.

Marcos further legitimized his martial rule by embellishing his vision of the New Society with the romanticized iconography and evocations of precolonial society. Through the revival and establishment of a countrywide network of *barangays*, the smallest local government unit in the Philippines, he was able to establish an efficient system of social control and regulation at the grassroots level.

Within this barangay-based framework, the First Couple assumed a mythic mantle, establishing themselves as modern-day personifications of *Malakas* and *Maganda* (the Strong and the Beautiful), protagonists in a vernacular genesis myth of the first man and woman.

Shortly after the revival of the precolonial barangay, the palingenetic agenda became more pronounced as symbols of the archaic and the indigenous bombarded the public consciousness. The regime promoted traditional culture through the building of museums devoted to folkloric culture. It refashioned ethnic symbols in every imaginable form: it integrated vernacular icons, abstract or literal, in the form of the bahay kubo or salakot-shaped roofs grafted on top of monuments in the name of national architectural identity; it represented the Philippines in the 1970 World Exposition in Osaka, Japan, with the icon of a prow of a Muslim vinta in a pavilion designed by Leandro Locsin; it popularized the sarimanok, a mythical bird of the

7.2 The First Lady Imelda R. Marcos in front of the Cultural Center of the Philippines

7.3 A front page news clipping where the Imelda Marcos "extols Filipino architects"

First Lady Extols Filipino Architects

Impressed by the architects' concern in the various projects and programs of the administration, the First Lady, Mrs. Imelda R. Marcos, who was Guest Speaker during the Honor-Dinner of the Philippine Institute of Architects on the occasion of its 37th annual anniversary held at the Savoy Hotel, praised the architects on "your exhibit now on display at the Cultural Center" which "dramatizes your commitment of social in- volvement—that under this administration of President Marcos, the government and you joined in partnership for the fulfillment of a people's vision."

The First Lady who was

(Continued on page 7)

THE FIRST LADY, Mrs. Imelda R. Marcos, who was accompanied by President Marcos, cuts the ribbon opening the exhibits on "Social Involvement of the Architects" at the Cultural Center last July 10. Assisting Mrs. Marcos is PIA first lady, Mrs. Inday Mañosa and Architect Rosalina Orobia. At background are Architects Francisco Fajardo, and Gabino De Leon.

Maranao, which became the logo of the Miss Universe Pageant in 1974; it commissioned public murals known as the *Kulay Anyo ng Lahi* (Color Form of Race) to paint the walls, water tanks, and firewalls of buildings with large-scale reproductions of masterworks of Philippine fine arts; it created the Design Center Philippines to translate indigenous designs and forms into contemporary modes applicable to commercial and industrial design, packaging, and marketing of Philippine products; it revived the *alibata*, a native script, appropriated as part of the ritual of the martial law nation-state, to ordain its heritage. These archaic symbols were co-opted to substantiate the nationalist fantasies of the Marcos regime, which was inclined to impose an invented homogenous Filipino identity.

Architecture for the New Society

As the state became the new patron of the arts, the First Lady involved herself in all matters relating to arts and culture. The Marcos regime took the nexus of architecture and society more seriously than any other administration in promoting the aesthetics of power in built form. The regime's sonorous flirtation with monumental, modern architectural imagery signified the modernizing thrust of the government. Imelda Marcos even wrote monographs—*Architecture: The Social Art* (1970) and *Architecture for the Common Man* (1975)—to instill the role of architecture in building the New Society. Consumed by the power of architecture, she poured generous logistical assistance to each building project and personally looked after the progress of construction.

To assert the nativist identity and promote the image of the nation as a progressive economy in the Third World, the First Lady built the Cultural Center of the Philippines (CCP) complex, a cultural-convention facility on land reclaimed from the historic Manila Bay. The center was built with money from the Cultural Development Fund, which was supported by the Special Fund for Education, which in turn originated from the Philippine War claims from the United States. The success of her first architectural venture, under the guardianship of architect Leandro Locsin, would later inspire her to expand the reclaimed area of the Cultural Center to construct more edifices of modernity.

The grandiose long-term plan for this part of Manila Bay was to reclaim about ten kilometers of land along the foreshore and on it build:

> a modern city complete with a financial center, an area for hotels and restaurants, an embassy enclave, high class residential areas, yacht basin, and other appurtenances of luxury living Florida-style (*Far East Economic Review* January 2, 1976, 39).

The Cultural Center of the Philippines, a huge block of a cantilevered building for performance and art, marked the commencement of Mrs. Marcos's extravagant, long-standing intoxication with megalithic construction, symptomatic of the *edifice complex.*

The reclaimed land of CCP was a site that conveyed state power, modern progress, national identity, and, most of all, the aesthetics of development. It served as a launching pad for the First Lady's extravagant folk festivals and spectacular state rituals, such as the *Kasaysayan ng Lahi* (History of the Race) and the Miss Universe Pageant in 1974, and the Manila International Film Festival (MIFF) in 1982. It was in the same venue that the government enshrined National Artists, whose body of work approximates the highest standards of artistry that "reflect the essence and mystique of the Filipino soul" (I. Marcos 1981, 129).

7.5 The Cultural Center of the Philippines Complex in the early 1980s

Immediately after the declaration of martial law, the government attempted to craft a singular national identity under the slogan "*Isang Bansa, Isang Diwa*"

PREFAB LIGHTWEIGHT PANELS
BAMBOO TRIPOD

7.6 The prefabricated structural components of a BLISS housing project in the University of the Philippines

7.7 Kapitbahayan housing project in Tondo, Manila

7.8 To bring down the cost of housing, Imelda Marcos, as Minister of Human Settlements, encouraged the research and development of prefabricated building components made entirely or partly of indigenous building materials. With this process, she hoped to discover "the true, the good, and the beautiful" in Filipino architecture.

(One Nation, One Soul), with a backward-looking cultural development agenda. In consonance with the "invented" homogenous identity, a singular "national architectural style" was formulated to symbolize the "nation" undergoing the palingenetic process of social reformation of the Bagong Lipunan (New Society). The Marcoses apparently believed that architecture was at the heart of Philippine cultural recuperation and the construction of national identity. Architecture being a social art is seen everywhere and is in every dimension of the citizens' lived experience. In the minds of the Marcoses, a building was not merely a walled structure but a metaphor for a Filipino ideology, and the process of construction was synonymous to the building of a nation.

In 1975, Imelda convinced all competing architectural organizations, the Philippine Institute of Architects (PIA), the League of Philippine Architects (LPA), and the Association of Philippine Government Architects (AGPA), to coalesce under one omnibus organization, the United Architects of the Philippines (UAP). Her successful effort to unite all architects in the Philippines under a single organization and her fervent advocacy of architecture as an important constituent in nation-building all qualified her to be an "honorary architect." On December 9, 1979, Mrs. Imelda Marcos was conferred the title of First Honorary Member of the United Architects of the Philippines and awarded a gold medal in recognition of her contribution to the enhancement of architecture in the Philippines.

Her ideals of Bagong Lipunan architecture were inscribed in buildings such as the Malay-roofed Batasang Pambansa Complex and in her native-style housing projects such as the BLISS (Bagong Lipunan Improvement of Sites and Services) project, the Maharlika Village, and the Kapitbahayan in Tondo. Her advocacy of using indigenous materials reached its pinnacle with the construction of the ₱18-million Tahanang Filipino (now popularly known as the Coconut Palace), designed by Francisco Mañosa. A total of 2,450 coconut trees were felled to build this state guesthouse by the bay. This was also in consonance with her Coconut Utilization Program, a project funded by the UNIDO (United Nations Industrial Development Organization). The result of the project was the coconut-based Imelda Madera, a new kind of lumber product especially suited for construction purposes. A versatile timber that can be used as structural piers, posts, bridging, and electrical posts, the Imelda Madera was produced using a special breed of coconut created by the Philippine Coconut Authority and was undoubtedly named in her honor.

After successfully establishing the Cultural Center of the Philippines, the First Lady had the Folk Arts Theater built in 1974, just a stone's throw of the CCP. An arena-type, 10,000-seat theater constructed within an incredible seventy-seven days, it was intended to serve as the venue for the country's hosting of the 1974 Miss Universe Beauty Pageant. By virtue of Presidential Decree 279 (signed August 24, 1973), she also undertook the conception and construction of the Design Center Philippines, also at the CCP Complex.

Through Letter of Instruction No.73, dated May 14, 1974, a body was formed "to study ways and means of making Greater Manila more attractive as a site for locating the Asian regional headquarters of international companies." This was further amplified when the Metropolitan Manila Commission was created with the First Lady as the appointed governor, her first formal position in government, in November 1975. She christened her dominion the "City of Man"—"an environment

7.9 Cover of the *Philippines Yearbook* for 1977, highlighting the building boom of the decade

within which man can develop his full potential, where any man can live fully, happily, and with dignity" (I. Marcos in Maramag 1978, 69). Subsequently, it was to be developed as a "Convention City," where "the great minds, the scientists, the artists, the financiers can meet and leave us not just their money but also their know-how and values, a part of their culture." The International Monetary Fund-World Bank Conference in Manila was seen as an important opportunity to portray President Marcos as the leader of the Third World. For the conference, Mrs. Marcos completed the state-of-the-art Philippine International Convention Center (PICC), occupying a floor area of 65,000 square meters at the CCP complex, in less than two years. Adjacent to the PICC, she built the PHILCITE (now demolished), which was destined to be an international trading arena. Simultaneously, that year, she initiated the speedy construction of numerous luxury hotels, fourteen of which got $500 million in foreign loans at the government's recommendation to address the anticipated influx of foreign guests in the country. The Admiral Hotel, Century Park Sheraton, Holiday Inn Manila, Hotel Mirador, Manila Garden Hotel, Manila Hotel (Renovated), Manila Mandarin, Manila Midtown Ramada, Manila Peninsula, Philippine Plaza, Regent of Manila, Silahis International Hotel, El Grande, Pines Hotel, Makati Hotel, Mayon Imperial Hotel, Davao Insular, Mabuhay Hotel, Punta Baluarte, Ambassador Hotel, Sulu Hotel,

10 Folk Arts Theater

11 Philippine International
Convention Center

12 PHILCITE

and Philippine Village Hotel were among those that received state-guaranteed loans.

The international conference spurred the construction boom of the 1970s not only of hotels but also of exhibit halls, such as the Museum of Philippine Art, the Metropolitan Museum of Manila, and the Museum of Philippine Costumes, to augment cultural affluence and tourism potential that the "City of Man" lacks. The Manila International Airport and regional airports were constructed to imbibe internationalist impulse and claim world city stature.

As the massive, albeit skin-deep, beautification drives went into full operation in the "City of Man," as many as sixty thousand squatters were evicted from their shanties to literally whitewash the shantytowns into obscurity and to eradicate all signifiers of urban dereliction. Greening the city meant Imelda's Roadsides Beautification Program, which encouraged the planting of arbor and shade trees along major thoroughfares. Her other urban cosmetic interventions included the erection of white reinforced concrete walls and oversized sidewalk planters to screen out the eyesores and shanty communities along major thoroughfares, planting banana and coconut trees, spray-painting dried grass and brown coconut leaves green, and tying coconut fruits to trees for a rustic effect. The strategically placed whitewashed walls that conveniently hid the eyesores from the line of vision were symbolic of the regime's inhumanity and the overall failure of Marcosian modernity in addressing the problem of urban squatter settlements.

The impacts and ill effects of uncontrolled urbanization were manifested on a massive scale in the 1970s. Problems relating to human settlements exerted much pressure on the martial law regime. In 1971, the Philippine government, with the assistance of the United Nations Development Program (UNDP), initiated three development projects to be funded by the World Bank. These were the Physical Planning Strategy for the Philippines, the Manila Bay Metropolitan Region Strategic Plan, and the Mindanao Development. In 1973, Executive Order No. 419 was

7.13 The Kulay Anyo ng Lahi project aimed to bring color and art to the drab wall surfaces of metropolitan Manila

issued creating a Task Force on Human Settlements (TFHS) to express the commitment of the government to provide a more "viable environment and human habitat." The main functions of this planning entity were to undertake and support a national human settlements program and to handle land use planning and resource management activities. This body was later renamed and became the regulatory arm of the Ministry of Human Settlements, which the First Lady headed.

It can be recalled that the full force of martial law was exercised to drive away the informal settlers from the urban precincts. The prevailing anti-squatting schemes became more ruthless with a new presidential decree promulgated in 1975, which made squatting a criminal offense subject to imprisonment, and directed the state authorities "to remove all illegal constructions including buildings on and along esteros and river banks, and those along railroad tracks and those built without permits on public and private property" (Presidential Decree No. 772).

In May 1979, the government hosted the United Nations Conference on Trade and Development V (UNCTAD), a month-long conference at the PICC. Before this international event, Imelda feverishly embarked on the construction of PHILTRADE, a huge, longitudinal complex of vernacular-inspired pavilions with steep-sloping roofs reminiscent of the bahay kubo, at the CCP complex. The complex of exhibition pavilions was designed by Planning Resources Operations Systems (PROS) originally as a prefabricated structure to be used for schoolhouses. Construction workers toiled day and night to complete the complex within a span of twelve days, just enough time for Imelda to inaugurate the project before the delegates left Manila.

Speaking of vernacular-inspired structures brings to mind the National Arts Center. Located some sixty-four kilometers from Manila, the center, rising 300 meters above sea level, is a verdant, 500-hectare mountainous complex in Makiling, Laguna. Imelda envisioned it to be a Shangri-la for young artistic souls and "a

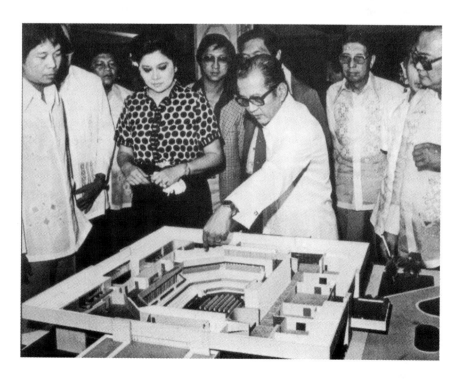

4 The First Lady being shown
e scale model of the Batasang
mbansa Building

launching pad of cultural leaders whose ultimate goal is to assist the greater number of Filipinos, and, in the long run, the cultural upliftment of the Philippines" (Veloso-Yap 1976, 6). The architectural centerpiece of the 104-cottage art school complex, now called National High School for the Arts, is Locsin's pyramidal auditorium, again inspired by Philippine vernacular houses.

Imelda, being an architectural demigoddess, managed to recreate an entire archipelago in one Filipino-themed park. The Nayong Pilipino, a miniature village simulating the folk art and architecture drawn from different Philippine regions, was created near the Manila International Airport by virtue of Presidential Decree No. 37 on November 6, 1972. The Nayong Pilipino was also the first cultural park established in Asia and the world. It was said to have inspired Madame Suharto and Queen Sirikit to replicate Imelda's idea in Indonesia and Thailand, respectively.

One of the regime's remarkable interventions on the ecological landscape was the creation of a Philippine Safari in the island of Calauit in Palawan. On August 31, 1976, President Marcos issued Proclamation No. 1578 establishing a game preserve and wildlife sanctuary on a 3,760-hectare tropical island as a response to Kenya's appeal through the International Union for the Conservation of Nature (IUCN) to provide sanctuary to wild animals threatened with annihilation by a raging civil war in the Tanzania-Uganda-Kenya region. Marcos permitted the relocation of eight African species.

The First Lady was also preoccupied with architectural conservation and restoration. Through the National Parks Development Committee of which she was the chairperson, she restored several churches, the walls of Intramuros, Fort Santiago, Paco Park, Luneta Park, the Goldenberg mansion, Malacañang Palace, and the Metropolitan Theater, among others, to their former glory.

For the Metropolitan Theater, Manila's foremost prewar art deco landmark, the First Lady allocated ₱30 million in August 1979. The bulk of the renovation budget came from a loan granted by the Government Service Insurance System (GSIS) through her Metro Manila Commission. The project proceeded at an incredible speed, with about 1,600 workers toiling in three shifts. The building was reopened on 11 December 1979, barely four months in the making. The rationale for speedy restoration was that Mrs. Marcos wanted the project finished before Christmas so that the building would look as if it was a symbolic, multimillion-peso "aguinaldo," or gift, to the people of Manila.

On January 4, 1977, by virtue of Presidential Decree No. 1277, the President ordered owners and administrators of buildings encroaching on the walls of Intramuros to vacate the area within three months. The historic Intramuros had become one of Manila's major slum areas after the Pacific war. A brutal eviction process and demolition of encroachments took place, enforced through the military corps of engineers. The clearing was completed and the Intramuros Administration was created through a presidential decree. The agency was tasked to preserve and revive the culture of Old Manila to feed the market for heritage tourism and to coincide with Imelda's vision of a pedigreed city to be commodified as a tourist attraction.

The First Lady's idea to transform Manila into a film capital in Asia similar to Cannes made world headlines as she rushed to complete the Manila Film Center for the 1982 international film event. Tragedy struck when the sixth floor slab collapsed, killing an unknown number of laborers beneath the gigantic slump of quick-drying cement. Stories about the gory event, including the unaccounted dead bodies of construction workers persist to this day as a subject of urban legend

.18 The beautification of Rizal Park and the creation of an open-air venue for the "Concert at the Park"

.19 The restoration of the war-torn gate of Intramuros

and ghost haunting. Despite the accident, the building was completed as scheduled. Aesthetically, the Manila Film Center, designed by Froilan L. Hong, approximated the mathematical proportions of the Parthenon to satisfy the First Lady's claim to classical antiquity in the modern era. It was not uncommon to link Marcos state architecture with the classical architecture of Western civilization to give it pedigree.

Imelda Marcos also worked for the construction of several medical institutions. She had visited the Houston Medical Center and wanted to have something similar so she organized the Heart Foundation of the Philippines "in response to the need for a philanthropic, civic-oriented institution dedicated to curb the increasing incidence of heart disease in the country." To construct what is now known as the Philippine Heart Center for Asia (inaugurated February 14, 1975), she turned to the GSIS for loans. The so-called "designer hospitals"—the Lung Center, Kidney Institute, Eye Center, Lungsod ng Kabataan (Children's City), and Research Institute for Tropical Medicine—were collectively Imelda Marcos's brainchild.

7.20 The Manila Film Center wa Imelda Marcos' grand vision t make Manila the Cannes c Asia.

7.21 The Parthenon-lik proportion of the Manila Fil Center was generated from scaling analysis that employe the golden section.

The First Lady, through architect Jorge Ramos, also took up the renovation and expansion of the Philippine General Hospital (originally designed by American architect William Parsons) in Manila to upgrade the facilities of public medical institutions. The first phase of the PGH was constructed within an Imeldific timetable to reach its inauguration day on July 2, 1985, to coincide with the birthday of Mrs. Marcos, the chairperson of the PGH Foundation.

As a way to curb uncontrolled urban population and sprawl, she laid the groundwork for the Population Center in 1974. Designed by Leandro V. Locsin, the Population Center is part of a complex constructed in Makati, whose two other structures are the Ecology Center and the Asian Centre for Social Welfare. Her aim was to consolidate the fractured

7.22 The expansion of th Philippine General Hospital i the mid-1980s

efforts of various government agencies and private population- and family- planning councils under one complex. The cost of the construction was partly funded by the Rockefeller Foundation ($l.5 million) and USAID ($800,000).

An institution for learning was created under Imelda's initiative in the 1980s. This was the sprawling complex of the University of Life or the Pamantasan ng Bagong Lipunan in Pasig City. The site also served as a village for games and a training ground for athletes and officials when the Philippines hosted the 1981 Southeast Asian Games.

Imelda's ideals of Bagong Lipunan architecture were emblazoned in buildings using indigenous materials and traditional silhouettes ranging from the steeply roofed, Malay-inspired Batasang Pambansa complex to her native-style housing and resettlement projects, such as the Bagong Nayon, BLISS (Bagong Lipunan

Improvement of Sites and Services), Maharlika Village, Sapang Palay, Dagat-Dagatan and Tondo Foreshore development projects, and Kapitbahayan in Tondo.

In 1979, Imelda, as minister of Human Settlements, bared her idea of a model community plan, a self-reliant and self-sufficient settlement designed for fifty to 100 families in a two-and-a-half hectare area, known as the Bagong Lipunan Improvement of Sites and Services (BLISS). The urban BLISS community was initiated to provide low and middle-income residents inexpensive yet comprehensive housing services on a lease-to-own basis. BLISS architecture consisted of a vernacular-inspired, four-storey building with two or four units per floor, supplemented with necessary amenities to expedite the delivery of basic services. The template for the urban BLISS housing project was a product of a collaborative architectural and scientific study undertaken by architects and urban planners Gabino de Leon, Manuel T. Mañosa Jr., Honorato Paloma, and Geronimo Manahan.

The Tondo Foreshore and Dagat-Dagatan urban development projects were the first massive upgrading of slums and depressed communities undertaken by the Marcos regime. The projects entailed the reclamation and development of 504.31 hectares wherein integrated communities constituted by residential, institutional, commercial-industrial, and recreational components were to be sited. The design for the urban renewal got international participation through a competition sponsored by the International Architectural Foundation. Ian Athfield of New Zealand conceptualized the winning design proposal. While the Tondo Foreshore project was supposed to alleviate the habitation of 27,520 families through the re-blocking of 137 hectares of development area, a Filipino prototype community known as Kapitbahayan, the 367.31-hectare Dagat-Dagatan project was expected

7.26 and 7.27 Development of multilevel urban housing and communities through the BLISS project

to serve an estimated 32,000 families through two residential schemes of row houses and duplex units.

On the other hand, Imelda's Maharlika Village project, covering a development area of 33.9 hectares in Taguig was meant to address the housing needs of Muslims in Metro Manila, particularly those who were displaced by the Mindanao conflict of the 1970s. A permanent mosque was to be the locus of the community, where residents may worship according to the tenets of Koran. Recognizing that "Muslims are among the country's best swimmers," an Olympic-sized pool was built in the village "for future Olympics medalists to practice their skill" (*Moderna*, March 27, 1976, 34).

Endorsed by Mrs. Marcos as a simultaneous solution to decongest Metropolitan Manila and to move the city from its historic but disaster-prone cradle was a plan that required the extension of Metropolitan Manila eastward in what was to be known as "Lungsod Silangan" or eastern city. She envisioned a more rationally planned Manila to be repositioned farther inland, up in the virtually-unpolluted Sierra Madre foothills east of Manila Bay. The precise location, as she pointed out in her speech, "Earth: The City of Humanity," delivered at the United Nations Conference on Human Settlements in Vancouver on June 7, 1976, was a conclusion arrived at by Filipino scientists headed by Dr. Celso Roque using an "ecological information decision system," which used a computer-generated land use map that took into account the preservation of the ecological attributes of the area. As envisioned, Lungsod Silangan would sprawl over 20,300 hectares of prime agricultural and forested land in Antipolo. The pilot community named Bagong Nayon (New Town), whose master plan was made by the Planning Resources

7.28 Lungsod Silangan

The Schoolhouses of the Marcos Era

To effectively accomplish the agenda of social reorientation, cultural renaissance, and national recovery, literacy was one of the main priorities of the Marcos regime. It built a network of educational infrastructures for primary, elementary, and secondary instruction throughout the country, reaching the remotest barrios of the archipelago. This was accomplished through the mass-built Bagong Lipunan Type School Building, which had a six by twenty-four-meter plan. The design was crafted by the Ministry of Public Works and Highways. Later, the same agency, through its Building Research and Development Staff (BRDS) attempted to infuse indigenous designs to these plain and monotonous school buildings in keeping with the First Lady's unwavering promotion of national identity in architecture.

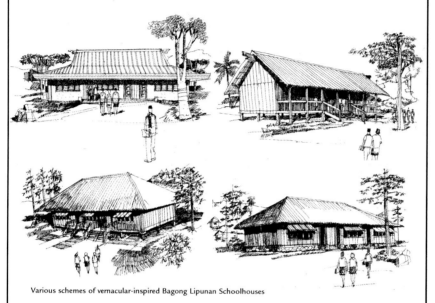

Various schemes of vernacular-inspired Bagong Lipunan Schoolhouses

The time- and cost-saving system held by the technology of prefabrication allowed new school buildings to be mass-produced at low cost and erected efficiently on site. The so-called Marcos Pre-Fab was developed by the Philippine Construction and Development Corporation (PHICONDEC) in the late 1970s. The design of the Marcos Pre-Fab was based on the system for prefabricating wall panels, floor beams, and floor slabs applied earlier by PHICONDEC in a low-cost housing project. The scheme shown in the accompanying drawings utilized the same dimensions of the standard Bagong Lipunan Type School Building. Only four types of wall panels, four types of floor beams, and two types of floor panels were necessary—all of prefabricated concrete of reduced thickness. Because of the reduced thickness, components were lightweight and could be carried and erected by two to four men. The assembly of components was twice as fast as compared to more conventional methods of construction.

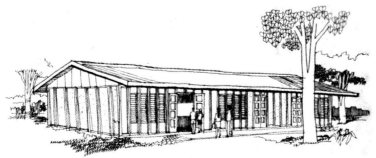

A typical Bagong Lipunan Schoolhouse

Operations Systems (PROS), was inaugurated in 1977. Bagong Nayon was foreseen as a model habitat to propel the movement of Manila eastward via the newly built East-West highway linking Manila to Infanta. The satellite city that boasted of its ability to absorb 200,000 families was meant to be "a staging ground for expanding the boundaries of Metro Manila towards Infanta-Real in Quezon Province, right off the edge of the Pacific Ocean" (Nells-Lim June 1981, 59).

Bagong Lipunan Modernism and the Invention of National Architecture

The desire for national self-assertion in built form had a profound repercussion on both designed space and architectural discourse. Encouraged by Imelda Marcos, a wave of nostalgia in architecture emerged in this postcolonial society, valorizing the primordial and colonial lifestyle and rekindling the fire of the golden past in contemporary built environments. This sentimental longing for the primeval was rooted in the notion that these archetypes are the true fountainheads of identity of which the citizenry can share a collective memory and from which the "national essence" can be distilled.

Largely through the First Lady, backed by a battery of technical assistants, architects, and planners, the New Society made a "major contribution to the evolution of a Filipino architecture" of which she was the tireless exponent. She defined the new Filipino architecture as the "rational rediscovery of traditional shapes, indigenous building materials, methods of construction, and usage of space which have proved to be the most suitable to the climate, the culture, and the land," (Manuel 1979, 199). The blueprint of her Bagong Lipunan architecture thus aspired to resuscitate locally derived pure Filipino forms, a goal which worked to "restore" or "recreate" those "unadulterated" forms. This further reinforced the neovernacular direction that Philippine architecture pursued in the beginning of the 1960s.

During the 1970s and 1980s, neovernacularism was highly encouraged with the launch of the Bahay Filipino Awards by the First Lady when she became minister of Human Settlements. Through this award, she gave recognition and cash incentives

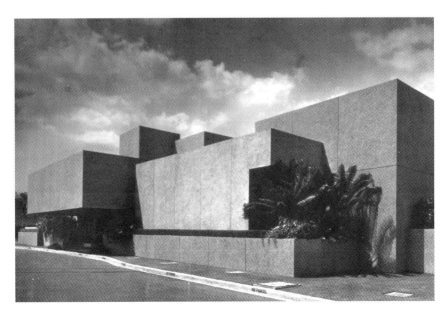

7.29 Assembly of modernist cubic mass constituting the architecture of the Philippine International Convention Center

7.30 "Search On For True Filipino Architecture" was the banner headline of the July 1978 issue of *Architectscope*, a journal of the Philippine architectural profession.

7.31 The First Lady Imelda Marcos viewing the model of one of her designer hospitals.

7.32 The National Arts Center emerging from the picturesque forest of the legendary Mt. Makiling (opposite page)

to homeowners who built houses that met the criterion of being "Filipino," those that would serve as models in developing designs for the government housing program. This award sought to "exemplify the search for the *authentic Filipino house*, one that is beautiful and innovatively built of low-cost materials" [emphasis mine] (I. Marcos 1981, 132). She clearly stated the objective of the award: "In building this prototype house, we aim to return to our traditional styles of constructions in which shapes, materials used, construction methods, space allocations, and spiritual purposes are integrated in memory of our historical and racial heritage."

The project was intended as a catalyst in the propagation of the indigenous building materials industry and new construction technology, while serving "the development of new architecture." The project, while impressive in its intent to unify into one architectural concept the vast indigenous traditions of our archipelago, was essentially a system of rejecting aspects deemed "inappropriate" and emphasizing those that were judged "proper."

The very characteristics of the bahay kubo—its visual lightness, material simplicity, volumetric buoyancy, exterior-interior continuum, harmony with environment, and noncompartmentalized arrangement of interior spaces which flow organically—were reinterpreted by means of a crisp modernist vocabulary to celebrate the sculptural plasticity of concrete, purity of space and distinct lines, simplicity in the manipulation of primary Cartesian rectangular masses, and spatial drama in the cantilevered projections of Leandro Locsin's buildings at the CCP complex. Locsin's application of abstract expressionist tenets to distill the essential and floating qualities of the bahay kubo prompted Nick Joaquin (1969, 68) to hail Locsin's Cultural Center building as his "most daring and dramatic sculpture."

A more profound allusion to the bahay kubo and a slight departure from his modernist boxiness was Locsin's design for the National Arts Center (1976). Acquiring outright inspiration from early Philippine edifices, the Makiling National Arts Center was Mrs. Marcos's reimagination of the mythical Temple of the Muses at Mount Parnassus. Locsin's neovernacular version of the temple was a building dominated by a huge, truncated, pyramidal, tiled roof supported at the four corners by eight triangular buttresses. The pyramidal superstructure resonated with the lines of ancient Austronesian amphibious habitats, which were also raised above ground. The overall architectural imagery coincided with the regime's production of nationalist architecture that was supposedly rooted in the remotest antiquity.

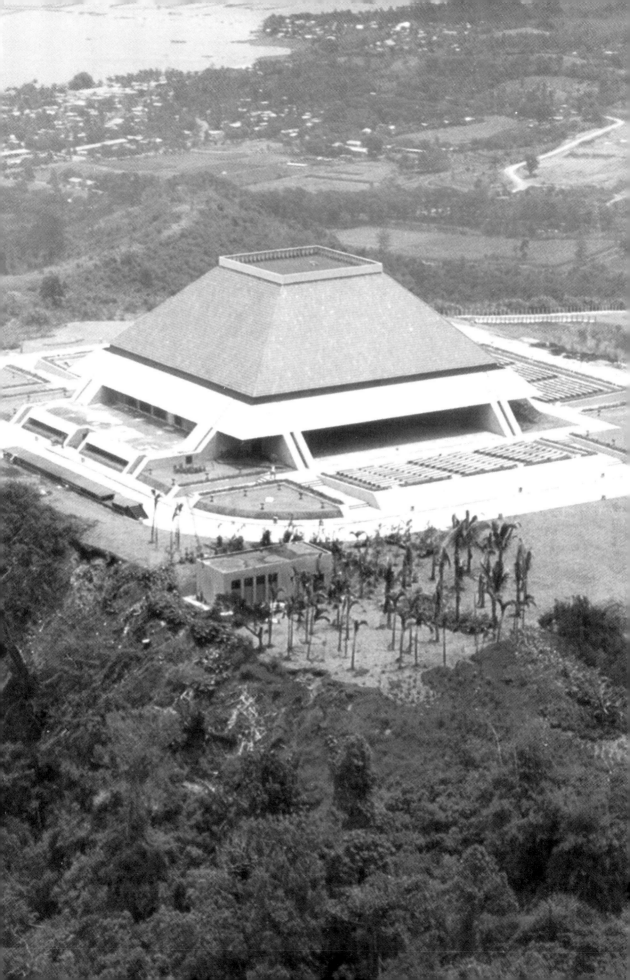

Taking a different route from the same romantic nationalist organ, architect Francisco Mañosa used a distinctly literal and straightforward execution of autochthonous allusions in his Tahanang Filipino (Coconut Palace). Made almost entirely of coconut-derived building materials, it showcases a double roof reminiscent of the salakot and swing-out (tukod-type) windows borrowed from the bahay kubo. This architectural opus asserted Filipino cultural identity through indigenous materials. Similarly, his 1984 Light Railway Transit (LRT) project had stations with prominently steep hip roofs evoking the thatched roofing of rural and mountain houses but opted to employ painted galvanized iron sheets to suit the metropolitan context. His works were specimens of the neotraditionalist vogue, clear expressions of a sentimental bourgeois desire to return to a romanticized bygone era when life was supposedly simpler, purer, and more tranquil.

By the late 1970s and early 1980s, the growing exponents of the regionalist neovernacular strain insisted on a nationalist philosophy that would be responsive to both local climate and culture. Felipe Mendoza's Batasan Pambansa Complex (1978), the Philippine Parliament building in Quezon City, conflated the international style with regional architectural elements. Again, the prominent, steeply sloping roof borrowed from traditional Philippine architecture was strategically chosen to reinforce vernacular identity.

The truncated, pyramidal roof motif and soaring gable roofs (taken from the Austronesian amphibious house form) were grafted to the superstructure of most

state-sponsored architecture, constituting the nativist trend of the period. Snatching the same pyramidal roof paradigm created by Locsin at Mt. Makiling, Jorge Ramos's Baguio Convention Center attempted to transcode the roof of the Ifugao fale, the windowless, pyramidal Benguet dwelling, into a huge congregational space.

Jorge Ramos's Zamboanga Convention Center utilized the stylized rendition of Austronesian outward-soaring gables blown up to a preposterous scale. The

building was dominated by the roof, whose ridge created a subtle saddle-back profile derived from the extant vernacular house form from the South. An ornamented gable end in the form of a naga (a mythical Southeast Asian serpent) rendered in okir fashion completed the designer's claim to regional character. A variant of the same aesthetic cliché resurfaced in the design of the Zamboanga International Airport. The forcible and promiscuous grafting of traditional elements as a mere appliqué to this modern building became an injudicious attempt to cast symbols of local ethnic identity. These ethnic elements were indiscriminately rummaged and uprooted from their historical context, their ritualistic function, and their original meaning, reducing them to a convenient "stick-on style" that guaranteed allegiance to a local culture orchestrated by the state to feed the demand of the tourism industry for the exotic.

For the Quiapo mosque in the heart of Manila's Islamic community, Ramos designed a modernist interpretation of a traditional Middle-Eastern onion dome and Islamic lancet arches elaborated with pastiche Maranao okir design patterns. The mosque was renovated in record time to coincide with the expected state visit of Libyan President Muammar el-Qaddafi in 1977. Architectural critics lambasted the mosque as a "wholesale arbitrary architectural transplant" (Klassen 1986, 144) by which it employed mechanistic architectural processing of traditional icons only to forfeit the symbolic potential of Filipino folk Islamic ornament.

Fort Ilocandia Resort Hotel, again by Jorge Ramos, "recreated" an unconvincing brick-veneered Spanish colonial architecture in the midst of sand dunes. The architect blew up the scale of the bahay na bato (house of stone) into a five-star hotel to recapture the eighteenth-century splendor of Ilocos Norte, a splendor which never existed even at the pinnacle of the Spanish baroque culture in northern Philippines.

In 1981, the Government Service Insurance System (GSIS) Building made international architectural news when its architect, Jorge Ramos, forged a partnership with an American firm, The Architects Collaborative (TAC), to design a climate-conscious architecture. The project aimed to reduce the energy consumption of the building by half through the scientific measuring of sun paths, the application of appropriate brise soleil (sunbreakers), and the use of a terraced building configuration by employing computer-aided analysis. This building was a modernist statement that embraced the trope of tropicality to resonate the traditional methods of passive cooling technology in a hot, humid climate.

41 GSIS Building at the claimed financial center of the anila Bay

42 The Golden Mosque of uiapo

43 Fort Ilocandia

Overall, the architectural style that the regime nurtured was expressive of a strategic essentialist position in asserting Filipino identity in architecture. In such a scheme, the powerful and poetic imagery of the native bahay kubo provided a profound source of inspiration for Filipino architects. This intervention termed romantic nationalist architecture is a political category that creates national symbols rather than a style. The elements, building materials, and construction methods of architecture to be (re)discovered in such locales were intended to provide both inspiration and technique for the enrichment of the romantic nationalist architectural idiom.

As romantic nationalist architecture was a nonstyle, it encompassed and accommodated broad taxonomic categories, such as neovernacularism, modern abstract vernacularism, or romantic pragmatism in architecture. Whatever the stylistic strands, they were consolidated under a common denominator which supported a politically motivated aesthetic and social vision, focused on the imperative of self-identity, the creation of a "nation," and linkage to the past, dealing with "imitation," "tradition," and "roots" in the built form.

Architecture for the Nation

National mythologies that would support the architecture of the New Society were carefully consolidated and cogently dispensed by the regime through the potentials of architecture to convince and impress upon the citizenry the legitimacy of the regime. The myth of monumentality through the use of overscaled buildings invoked

.44 The huge concrete bust of
resident Marcos juts out of a
ʼountainside in Benguet
rovince.

.45 The defaced Marcos bust
ʼter it was blasted in December
002 by the New People's Army

ideas of a greatness of civilization and assured cultural inheritance to classical
antiquity. The use of monumental scale in architecture was panoptical in intention,
which created the impression of Marcos's omnipresence. The myth of modern
progress involved the construction of favorable cosmopolitan architectural images,
which the Marcos administration used fully to encourage civic duty, tourism, and
capital investment. The regime's massive loaned investments in buildings were to
project to the international community an impressive myth of "overnight
industrialization" and to render an illusion of fast-paced progress at work in the
country. The myth of modernity implicated the use of a historical modern
architectural grammar. In building her monumental romantic nationalist
architecture, Imelda, instead of breaking away from the past, encouraged her
architects to conjure self-conscious vernacular allusions and iconography. The
architectural and aesthetic program slavishly borrowed icons from the remote
past to be imitated, interpreted, and improved upon and capitalized on the nostalgic
allegory of a lost age and a utopian metaphor for the future world in the New
Society. Through public monuments, national memory was therefore constructed
or invented. Its narrative was meant to inspire nationalism and the sacrifice of the
self for the common good.

By the early 1980s, new economic and political weaknesses had become obvious,
signalling the decline of the Marcos regime. Huge investments in signature
architecture and infrastructure resulted in deficits that were far beyond the domestic
economy's ability to absorb. Marcos's extravagant modern erections, which acted
as a veil to conceal the inflationary conditions crippling the Philippine economy,
can no longer hide the ailing condition of the nation. As the economy plummeted,
many Filipino design and construction professionals suffered unemployment and
decided to work overseas. The migration of labor siphoned many architects and
designers to the oil-producing countries of the Middle East that were converting
petroleum revenue into infrastructure investment. Cracks began to surface in the
façade of Marcosian modernity, revealing the abrasive reality beyond the sterile
white fences once erected to screen the anathema of modernity—the squatters.

7.46 Church of the Monaste
of the Transfiguration i
Malaybalay, Bukidnon

Romantic Regionalism

After the oil crisis of the mid-1970s, the clamor for more economically operated buildings became more urgent. Architects in the late 1970s and 1980s began to realize the failure of modern buildings to cope with the imperatives of the tropical climate. Design strategies were reevaluated to achieve energy-efficient architecture amid the economic slump. Modern buildings of the international style were heavy consumers of energy as they rely greatly on the technology of artificial ventilation and air-conditioning to provide comfortable interior living conditions. Moreover, Filipino architects were compelled to reassess local building traditions and vernacular architectural symbols to address the need for a more energy-efficient and culturally-responsive tropical architecture. They saw the potential of vernacular architecture as a solution in combining the parameters of climate, culture, and craft. Regionalism or the expression of the local identity of a particular region thus became a factor in architectural practice as well as architectural education, particularly in non-Western societies and developing economies. Early responses to regionalism were mostly superficial and copyist—traditional forms, colors, roof silhouettes, and decorative motifs were merely applied or appended to the facades of international style designs. Numerous examples of this appliqué are seen not only in the Philippines but also in the Middle East and Southeast Asia during the 1970s. In 1981, Geronimo V. Manahan, collaborating with the Ministry of Energy, developed a prototype house known as the "Passively Cooled Urban House," signaling the collaboration of scientific knowledge with indigenous building technology in the quest for energy conservation.

The works of Leandro Locsin, Felipe Mendoza, Gabriel Formoso, and Francisco Mañosa in the 1980s attested to a kind of sentimental retrospection and contextualism that regionalism espoused as a means of developing a truly local style of contemporary architecture especially in an era of multinationalism and global enculturation. Synthesized with the modernist language, their works involved appropriating indigenous architectural traditions to fit new programs in terms of their formal and spatial characteristics (such as resorts, hotels, and state architecture), adaptation of such traditions in parts (for instance applying some

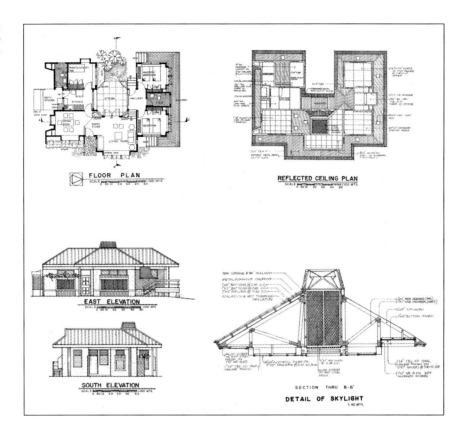

7.47 The "Passively Cooled Urban House," designed by Geronimo V. Manahan for the Ministry of Energy

FLOOR PLAN

REFLECTED CEILING PLAN

EAST ELEVATION

SOUTH ELEVATION

SECTION THRU B-B'
DETAIL OF SKYLIGHT

iconographic elements to new buildings), or interpreting them in accordance with contemporary aesthetic sensibilities in terms of construction technique or use of materials. These interventions, however varied, were propelled by a singular motivation: to steer Philippine architecture away from the universalizing tendencies and cultural insensitivity of generic modern architecture.

7.48 The young Leandro V. Locsin, shown with the scale model of the Monterrey Apartments

The Poet of Space

Leandro Locsin (1928–1994) had been described by his peers as a "poet of space" for his lyrical articulation of space defined by stark modernity, spatial purity, strong space, distinct outlines, and straightforward geometry. From 1955 to 1994, his prolific architectural practice resulted in seventy-five residences, eighty-eight buildings, and a sultanate's palace. These included landmark ecclesiastical edifices, such as the University of the Philippines Chapel of the Holy Sacrifice (1955); Bagong Lipunan monuments, such as the Theater of Performing Arts (1969), the Folk Arts Theater (1974), the Philippine International Convention Center (1976), the Philippine Center for International Trade or PHILCITE (1976), the Philippine Plaza Hotel (1976, now Sofitel Philippine Plaza), the National Arts Center (1976, now the National High School for the

Arts) in Makiling, the Manila International Airport (1979); and, corporate towers, such as the Ayala Tower One (1996) in collaboration with San Francisco-based Skidmore, Owings, and Merrill (SOM). His grandest and most impressive work was for Sultan Bolkiah of Brunei, a commission he had won in an international competition in 1980. The sultan's Istana Nurul Iman (Palace of Religious Light), completed in 1984, reinterpreted the traditional Islamic Southeast Asian motifs along the grammar of modernism. Undeniably, the Istana Nurul Iman shared the same dynamism and compositional massing with Locsin's earlier work, the 1970 Philippine Pavilion for the Osaka World Exposition.

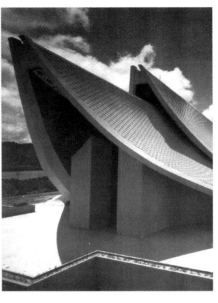

7.49 The Istana Nurul Iman c the Sultan of Brunei

7.50 Benguet Corporatio Building in the Ortigas busines district in the early 1980s

All his buildings consistently bear his architectural trademark—lightness in form, transparency, and grace imparted by slender tapering columns; delicately thin brise soleil (sun breakers); and the projecting and suspended balconies and overhangs. Sculptural, interpenetrating spaces, governed by his fascination with strict geometric inclination, were a mainstay of Locsin's architecture. His works were sculptural manipulations which were established through the interplay of geometric solids and voids while transgressing the defined boundary between the enclosure and the environment. The interaction between Cartesian solids was a product of his intense exploration of the plastic possibilities of concrete, and, for him, this material "was by no means cheap and gave the opportunity to create plastic shapes, forms, and sculpture" (Polites 1977, 10).

The concept of visual lightness applied to a suspended buoyant volume is characteristically Filipino. It is achieved idiosyncratically in the vernacular house resting on stilts, which gives it its volumetric buoyancy. The CCP Theater of Performing

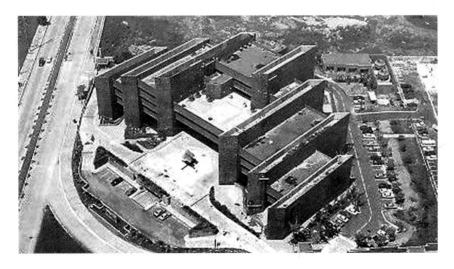

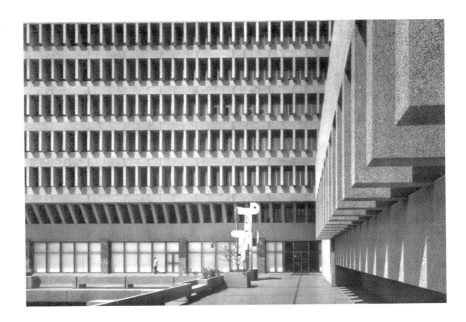

Arts recreated this suspended volumetry in reinforced concrete propped up by cantilever supports.

Locsin's architecture and interiors, as they rediscover traditional Filipino spatial concepts, bridge the lacuna between tradition and modernity. Interior spaces ingeniously yield unanticipated spatial poetry, creating an impression of transparent order and organic unity in his architectural composition. Refined minimalism lauding unadorned beauty as the purest form of aesthetic manifestation is evident in his treatment of raw textures, grains, and repeated rhythm of materials, luminously elevating the structure's materiality and sensuality to transcend the ephemeral. In his CCP buildings, the highly tactile texture of concrete is created by mixing cement with crushed seashell particles derived from the site, to achieve for the building a strong congruity with a place that was previously in water.

As he veered away from the literal interpretation of Filipino traditional forms and patterns, he imbued his works with a fusion of nostalgic air and freshness realized through modern geometric abstraction and the virtuoso treatment of reinforced concrete. By intimately observing vernacular structures, he came to realize that longstanding building practices—wide overhanging eaves, big and steeply sloping roofs, massive supports, interior lattices and trellises, organic interior space schemes, and raised floors of the vernacular and provincial houses on stilts—were valid for the Philippine geographic-climatic conditions, even in an era of cutting-edge technology and a technology-driven society. This ambitious philosophy was overtly inscribed in the design of the Cultural Center of the Philippines. The massive, cantilevered, travertine block served as a protective overhang above the balcony, which surrounded the lobby. The wide, open sides of the Folk Arts Theater and PHILCITE buildings allowed for continuous ventilation without artificial or mechanical means to maintain the comfort levels inside the building. His neovernacular Benguet Corporation Building (1983) evoked the regional topography and materiality of the rugged grandeur of the stone-walled Banaue Rice Terraces of the Benguet region. Composed of a heavy mass of vertical volumes clad irregularly with flat, black stones, it alluded to the upland riprap engineering of the Cordilleras.

The Paternal Figure of Modern Landscape Architecture

Landscape architect Ildefonso P. Santos Jr. (1929–), distinguished himself by pioneering in the practice of landscape architecture in the Philippines. His design career, which began in the 1960s, resulted in hundreds of parks, plazas, gardens, and outdoor settings that have enhanced contemporary Filipino life.

As a practitioner and educator, Santos advocated the practice of landscape architecture as a viable profession that requires knowledge of architectural, engineering, and aesthetic principles, steering it away from the long-standing public perception of being merely glorified gardening. Exterior spaces became his primary medium, transforming the nondescript outdoors into areas of congregation, contemplation, leisure, and aesthetic delight.

His corpus of work constitutes an important contribution to the development of landscape architecture, ranging from prestigious business and residential complexes, shopping centers, private gardens, memorial gardens, and parks that create open spaces for meditation, commerce, recreation, and commemoration. There are also formal topiary gardens, large tracts of planned urban spaces, organic tropical parklands, and leisure wonderlands.

Although educated in the United States, he adapted his training to the realities of the tropical milieu and Filipino sensibilities thus evolving a landscape architecture suited for the local tropical weather and topography and for a people with specific cultural values. His works, to a large extent, introduced the art and science of creating humanized space that resonated the Filipino artist's sense of space, form, and materials. His designs emanated from the Filipino concept of free-flowing, positive, *maaliwalas* [bright and airy] space. He understood and accommodated Filipino physiological, behavioral, and social needs in providing spaces for shade,

7.52 Father of Philippi landscape architectu Ildefonso P. Santos Jr.

7.53 Perspective of t promenade of the Mak Commercial Center, late 196

thereby creating opportunities for congenial seating and sharing of food and laughter in public spaces. His palette of materials embraced the whole range of tropical flora, often using plant material ignored by fashion or treated with disdain because they were locally grown—such as the *makahiya* or mimosa as ground cover or the *catmon* as shrub planting. His designs for hardscape elements, such as walkways, trellises, gazebos, and outdoor furniture were always harmonious with the soft planting elements and complemented the buildings that sat in his landscapes.

Through the late 1960s and 1970s, Santos's works were easily identified for their innovative approaches to design. He dominated the field with works that integrated free-flowing circulation and multiplicity of vistas within the geometry of space. An analysis of his work reveals underlying principles of sculptural consistency, harmony in botanic manipulation, clarity of scale and proportion, a choice of natural materials that merged function and form, and a craving to liberate space to reach its full possibility. His signature and innovative style that took high regard for both organic and built environments significantly revolutionized Philippine urban and regional landscape aesthetics.

In Paco Park (1967), the tranquil beauty of nature was allowed to mingle with the concentric geometry of colonial funerary architecture. The spatial elegy of the Loyola Memorial Parks (1967–1974) was his visionary statement for modern cemetery design, fusing abstract sculptures allusive to death and redemption within a geometricized environment. Crystals Springs (1975) is a leisure waterscape that illustrated his mastery in taming the fluidity of water to harness its experiential and healing powers. Tagaytay Highlands (1995) ingeniously transformed a mountainous mango plantation into a fictive tropical wonderland.

His innovation for the Makati Commercial Center (1967), one of the first pedestrian malls, acquainted Filipino shoppers for the first time with a promenade of commerce akin to a park with trees, street furniture, patterned walkways, artworks, modern fountains, and a cluster of ornamental plantings. Notable here was the use of the sunburst radial pattern derived from Philippine vernacular design that

paved the 196-meter walkway. The integration of Philippine vernacular motifs in landscape architecture continued in the Maranaw Commercial Center. Here, Santos departed from the material norm by introducing synthetic adobe and bush-hammered or ax-finished surfaces. He experimented with textures and shapes, dynamic and stylized fountain forms, and planting composition to heighten the dynamic movement within the space inspired by Filipino Islamic patterns.

Rizal Park was expressive of his ability to create spatial narratives and sequenced spatial events. Within this site, three works emerged to manifest his astuteness as a spatial storyteller: the Garden for the Blind (1969), the Kanlungan ng Sining (1991), and the Martyrdom of Dr. Jose Rizal (1996). The Garden for the Blind was an achromatic, walled-in garden with routes designed primarily by means of touch, smell, and sound. Meandering paths that unleashed vignettes of spatial surprises through environmental art defined his Kanlungan ng Sining. On the other hand, the Martyrdom of Dr. Jose Rizal created an ideal tableau to reenact the saga of the national hero through light-and-sound presentation.

The San Miguel Corporation Complex (1982) in Ortigas reflected the successful union of architecture and landscape design. The organic foliage countered the rigidity of the corporate edifice, thereby creating an urban oasis in the middle of harsh cosmopolitan terrain. Such an artificial environment transports urban denizens to a place embraced by nature, both in visual and experiential mode.

From gardens and parks, to roadways and pedestrian walks, I.P. Santos's works have not only set the benchmark for his successors, but have also provided spaces that enhance the possibility of Philippine life that could be lived outdoors.

Pragmatic Tropicalism

Through the design of landmark structures, Felipe Mendoza (1917–2000) imbued the sterile modernist spaces with a distinct architectural style and philosophy that took allusions from autochthonous Philippine architectural paradigms and enshrined the dicta of tropicalism to a philosophical plane, questioning the utopic and eurocentric character of modern architecture. His architecture, thus, aspired to be more than just an ideal shell for habitation but served as a counter-discourse that challenged homogenizing dictates of the international style. This is achieved through a successful transformation of modernist cubical forms into crisp geometries that are tropically responsive and sensitive to local identities.

Mendoza succeeded in doing this even without resorting to exoticism, folkloric consumption, and automatic grafting of predictable Philippine cultural icons to assure the commitment to national identity prevalent during his time.

After forging a partnership with Gabino De Leon and Homero Ingles, he established in 1951 his own architectural office, which bore his name. Through this firm, he continued to design buildings stamped with his distinct architectural style and philosophy deserving recognition. Among the benchmarks of his aesthetic and functional achievements were the Batasang Pambansa Complex, Ministry of Education and Culture Building, Ministry of Foreign Affairs Building, Development Academy of the Philippines in Pasig, Philippine Veterans Bank along Bonifacio Drive, Antonino Building in Luneta, Great Pacific Life Building in Makati, Church of Jesus of Latter Day Saints in Green Meadows, institutional buildings for Bicol University, Palawan National Agricultural College, Mariano Marcos State University in Batac, Ilocos Norte, Central Mindanao University in Musuan, Bukidnon, University of the Philippines Los Baños, and College of the Holy Spirit.

As a true advocate of architectural tropicalism, Mendoza considered nature and ecological concerns in his approach to design. He was meticulous about orientation

.58 International Rice
Research Institute in Los Baños,
Laguna

when planning a building and made the fullest possible use of natural light and ventilation. Through the use of large openings, wide eaves, balconies, and lush interior gardens, he broke the strict boundaries between the outdoor and indoor, making the architecture virtually a permeable mesh. This permeability of structure permitted his architecture to negotiate and establish rapport with the tropical environment, endowing architectural volumes with a distinctly modern yet tropical character.

7.59 Asian Institute of Management (AIM) in Makati (opposite page)

Forthright Modernist

Gabriel Formoso's (1915–1996) works were characterized by an almost religious adherence to the doctrine of modernist architectural concepts. He had designed structures that are now considered outstanding specimens of Filipino modern architecture. His years in practice were spent fruitfully in designing and planning clubs, residences, hotels, industrial and commercial buildings, inns, and recreational centers that totaled to eighty buildings and more than 150 residences.

His architecture was contrived within the mantra of stark simplicity, austere configuration, honesty of materials, rational functionalism, and clinical efficiency. He described his work as the embodiment of "honesty of conception and the principled concern for human requirements transcending the irrelevancies of prejudice and instinct." Formoso's disciplined practice strived for a built and designed environment with a three-fold objective: first, to communicate lived human experience spatially; second, to underscore the social dimension of the architecture, emphasizing the dialogic relationship of architecture and society; and, to probe into the question of identity by implicating the culture and climate in the design of structures.

Bearing the modernist fervor, Formoso's work focused on volumetric manipulation rather than decorative ostentation, restraint rather than indulgence, simplicity rather than complexity, as all irrelevancies were purged from the structure, allowing buildings to reveal their inner truths—the honesty of material, the integrity of structure, and the logic of utility. The vertical and horizontal volumes of his architecture were juxtaposed to spark austere tension and generate minimalist sculptural geometries. The outcome were elevations that were uncluttered and reliant on the bulk of elements for character, making their distinct silhouette and Spartan disposition stand out in the overall fabric of their vicinity.

Representative of Formoso's architectural ideology was his late-modern Pacific Star Building (1989) in Makati that paid tribute to the structural poetry of the Roman arch. In the Central Bank of the Philippines Building (1972), hi-tech iconography was allowed to intermingle with Bauhaus philosophy when he utilized the metaphor for the computer age through his prudent abstraction of the IBM computer punch card translated into a dominantly horizontal massing and serial window punctures. His Valley Golf and Country Club (1960) exuded a potent blending of architectural humor and modernist frankness with its floor plan that merged a circle and triangle to literally suggest the form of a golf ball resting on a tee. The MWSS Headquarters in Diliman allowed him to experiment with raw

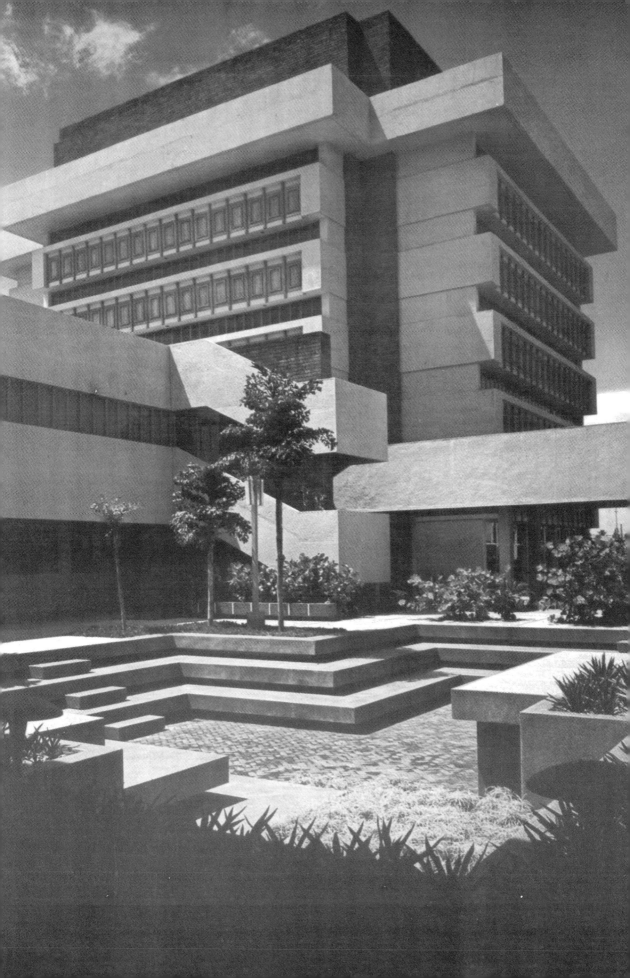

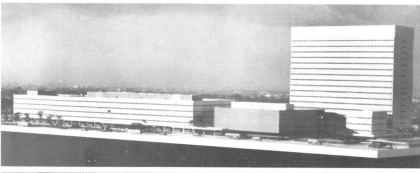

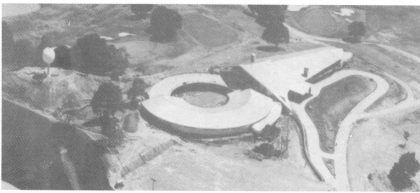

concrete finishing in a style known as brutalist. His design for the Asian Institute of Management (AIM), built in 1970, established an allusion to the bahay na bato with walls of stone masonry and contemporized bandeja panels. In the same temperament, his Club Filipino (1970) in Greenhills simulated the architectural character of the traditional house with a hip roof, capiz windows, ventanillas, and stone walls.

Futurist Monumentality

José María V. Zaragoza's (1912–1994) stature in Philippine architecture history is defined by a significant body of modern edifices that address spiritual and secular requirements. Zaragoza's name is synonymous with modern ecclesiastical architecture. Notwithstanding his affinity to liturgical structures, he greatly excelled in secular works: thirty-six office buildings, four hotels, two hospitals, five low-cost and middle-income housing projects, and more than 270 residences— all demonstrating his typological versatility and his mastery of the modernist architectural vocabulary.

Zaragoza graduated from the University of Santo Tomas in Manila in 1936, passing the licensure examinations in 1938 to become the 82nd architect of the Philippines. With growing interest in specializing in religious architecture, Zaragoza also studied at the International Institute of Liturgical Art (IILA) in Rome in the late 1950s, where he obtained a diploma in liturgical art and architecture. His training in Rome resulted in innovative approaches, setting new standards for the design of

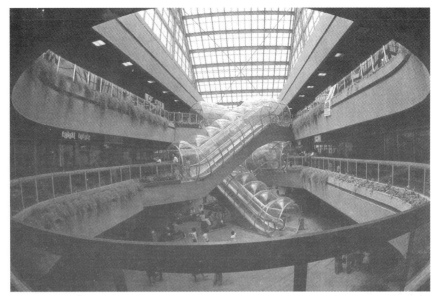

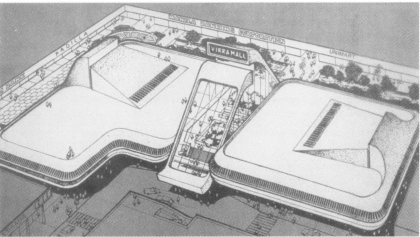

mid-century Catholic churches in the Philippines. His prolificacy in designing religious edifices was reflected in his body of works consisting of about forty-five churches and religious centers, including the Santo Domingo Church, Our Lady of the Rosary in Tala, Don Bosco Church, Convent of the Pink Sisters, San Beda Convent, Villa San Miguel, Pius XII Center, Union Church, and the controversial restoration of the Quiapo Church, among others.

His postwar commission, the Holy Rosary Church (1950) in Tala demonstrated his skill in architectural improvisation. Amid the postwar shortage of building materials, he was able to ingeniously refunction a quonset roof donated by the Americans from the Clark Air Base as a focal feature in this modern house of worship.

His reputation as a designer of architecture for worship reached its pinnacle in 1954 when he designed the Santo Domingo Church in Quezon City. Here, the aesthetics of Spanish mission revivalism underwent a modernist simplification that resulted in a magnificent ecclesiastical monument of the time.

His designs for residential architecture in the 1950s and 1960s developed an identifiable visual framework that fused nostalgic neocastilian style and Wrightian functionality. This created a new stylistic prototype that paid homage to Philippine Hispanic ancestry yet was modern in essence. This stylistic fusion was best illustrated in his Casino Español de Manila (1951) that featured a series of interior courtyards framed with arcaded loggias and arched door and window openings. Terra-cotta tiles framed the edges of low-pitched roofs. Heavily varnished wooden beams supported sloping interior ceilings. In the rooms were red cement tile floors and plain painted concrete walls.

In 1960, world-renowned Brazilian architects Oscar Niemeyer and Lucio Costa invited Zaragoza to be among the guest architects participating in the massive project of designing Brasilia, the new capital of Brazil. This Latin American exposure added a new flair to his modern repertoire that hinted toward the tropicalization of the international style. His endeavor to tropicalize modern architectural design assumed an expedient transformative intervention. This was attained by transforming the imported vocabularies of modern architecture within the context of the tropical and cultural environment.

His post-Brazil work, notably the Meralco Building on Ortigas Avenue and the Philbanking Building in Port Area demonstrate the remarkable use of brise soleil not just as a device to modulate tropical heat and glare but also as an expressive and sculptural element to nullify the sterility and anonymity of the international style. The Philippine Banking Corporation (1968) was an L-shaped building located at the corner lot along Ayala Avenue. The exterior of the building was entirely covered by egg-crate-type sun baffles, except the mezzanine, which was protected by vertical louvers. His fourteen-storey Meralco Building (1968), whose façade was defined by a series of tapering mullions, earned the distinction of being the first building to rise along Ortigas Avenue.

His works later gravitated toward the biomorphic forms popularized by South America. These works probed concrete's versatility in generating organic, sculptural, and aerodyamic forms, as evidenced in the Commercial Bank and Trust Company Building in Escolta, Manila (1969), Virra Mall in Greenhills (1975), Union Church in Makati (built in 1975, now demolished), Saint John Bosco Parish Church in Makati (1977), and Our Lady of the Miraculous Medal Shrine in Sucat, Parañaque (1979). The folded plate crown of the Union Church (1975) in Makati was an

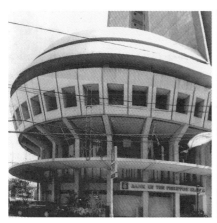

7.64 and 7.65 Commercial Bank and Trust Company Building in Escolta, Manila

outstanding manipulation of concrete which resulted in delicate, fan-like biomorphism. The Commercial Bank and Trust Company Building and Virra Mall were his visionary odes to futuristic design and his homage to the mid-century fascination with astrospace and space travel.

Zaragoza was a pillar of modern architecture in the Philippines, buttressed by a half-century career that produced ecclesiastical edifices and structures of modernity that glorified both divinity and humanity.

Neovernacular Master Builder

Francisco Mañosa formed a partnership with his brothers Manuel Jr. and Jose after his graduation in 1954. The firm, known as the Mañosa Brothers, was a success in vernacular experimentation, yielding the Maranao-inspired Sulo Restaurant in Makati in the 1960s and the San Miguel Headquarters Building in the 1980s. The climate-responsive San Miguel Headquarters Building, designed in 1975 but completed in 1984, was a terraced, crystalline building alluding to the verdant grandiosity of the Banaue Rice Terraces. The deep and slanting glass walls recalled the vernacular passive cooling technology of tukod windows to modulate heat and illumination. The vertical landscaping further enhanced the building's tropical qualities.

Following the restructuring of the partnership in 1976, he formed his own firm, Mañosa & Partners. Immediately after, he was faced with an innovative project commissioned by First Lady Imelda Marcos. This demanded the creation of a state guesthouse that would showcase Filipino identity through the extensive use of indigenous materials and display the myriad architectural applications and possibilities of the coconut tree and its by-products. The First Lady chose him because of his vocal advocacy of Philippine architecture, as he professed: "My philosophy is that everything started with the nipa hut." Mañosa had actively promoted the use of native architectural forms and indigenous materials, such as bamboo and thatch, in the creation of a distinctively Filipino architecture.

The project, the Tahanang Filipino (nicknamed Coconut Palace), a luxurious guesthouse at the CCP Complex, gave him prominence and stature as a neovernacular master builder. The edifice was the apotheosis of his bahay kubo-based architectural philosophy. It showcased a double roof reminiscent of the salakot (a wide-brimmed hat) and swing-out (naka-tukod) windows borrowed from the bahay kubo. It was his architectural opus to assert Filipino cultural identity with a plethora of indigenous materials, such as the coconut, bamboo, rattan, capiz shells, and other native textures in its architecture and interior. Here, Mañosa's hexagonally-moduled plan was generated from the concept of the hexagonal cross-sectional pattern of lumberyard-cut coconut trunks.

Since then, he has promoted the return to the use of vernacular concepts of space and the utilization of native thatch, bamboo, coconut, and other indigenous materials, launching a wave of neovernacular following in the 1980s. His notable works that steered the neovernacular current include the Shrine of Our Lady of Queen of Peace along EDSA, Mary Immaculate Parish, Pearl Farm Resort, Mañosa Residence, Aquino Center, Ateneo Educational Building, Ateneo Professional Schools, Bamboo Mansion, and Lanao Provincial Capitol among others. His devotion to Philippine vernacular design has made him the most sought-after architect by the Philippine state to design its pavilions in international expositions and fairs.

The Paradigm Shift

Modernism in the Philippines was beginning to lose its ground by the 1980s. The canons of modern architecture were seen to have created a serial anonymous product, epitomized by sterile box towers and concrete blocks. There was a full-scale condemnation of the modernist movement, a reaction against a building style now found to be boring, indifferent to its surroundings, and devoid of historical and cultural associations. Such deficiency was momentarily mitigated by regionalism's contextual approach, which consciously incorporated the history, culture, and tradition of the site in the design of buildings. But an all-pervasive style would soon engulf the architectural landscape, serving as an antidote for modernism's renunciation of history and tradition. This began a new period which liberated designers from the stern modernist paradigm and sanctioned an "anything-goes" exuberance to craft pluralistic architectural expressions.

8 Architecture of Pluralism
and the Postmodern Urban Scenography

The Revision of the Modern and the Resurgence of Ornament
The 1986 "People Power" Revolution in EDSA finally toppled the twenty-year
Marcos regime. The art forms, monuments, and cultural practices associated
with the dictatorial regime were either revised or obliterated to erase the memories
of repression. The Malacañang Palace was opened to the public as a museum of
the extravagance of the conjugal dictatorship. With democracy restored, the post-
EDSA euphoria brought a myriad of artistic expressions that signified the national
struggle to survive amid political turbulence and social change. Concomitantly,
Philippine architecture was also undergoing change in the mid-1980s. It began to
denounce the strict modernist principles as new buildings rose in the post-Marcos
landscape. The new architecture defied the draconian rules of modernist
composition and shunned the brutality of its materials and forms in favor of a
plural stylistic procedure characterized by an overt application of historical
references and blunt symbolism. The postmodern era in Philippine architecture
had begun.

Postmodernism is an umbrella term that refers to a style of architecture prevalent
in the 1980s to the present characterized by inarguable historical eclecticism and
placing of emphasis on the façade. Postmodernism in architecture began as an
academic movement in the late 1960s as a counter-reaction to the rigidity and
hegemony of the universal modernism of the mid-twentieth century in the Western
hemisphere. Architectural theorists maintained that the messages or meanings
conveyed by the buildings must be complex, intrinsically contradictory, and that
history and symbolism could no longer be disregarded. They declared that, since
modern architecture did not value notions of historical fundaments and the
communicative potential of architecture, it left us alienated and estranged from
the modernist boxes and utopian aspiration.

American theorist and architect Robert Venturi, one of the first to swerve from the
modernist dogma, found inspiration in the kitsch and glitz of the commercial
advertising of Las Vegas as the framework to erect the foundation of postmodern
architecture. The generic apartment blocks and glass towers of the modern canon
seemed to him humorless and soulless, lacking the vitality which diversity brings to

8.1 Detail of the Fusion House
(Tan Residence) in Cebu

the urban landscape. Venturi even extolled the architectural virtues of art deco and admired the gaudiness of Las Vegas as the new design paradigm. He lambasted Mies Van Der Rohe's famed minimalist dictum "less is more" with the counter doctrine "less is a bore." He summoned architects to enrich the experience of architecture by making deliberate use of the multiple connotations of the architectural sign. "A valid architecture," Venturi proclaimed in 1966, "evokes many levels of meaning and combinations of focus: its space and its elements become readable and workable in several ways at once." Architects soon became aware of the linguistic aspects of architecture and its capacity to connote and denote meanings. The linguistic mandate of postmodernism generated a kind of architecture that collapses familiar historical references into deflated images and ambiguous spatiality in order to engage people with familiar imagery, allowing them to freely decipher the multiple meanings of buildings.

Postmodernism adopted a populist aesthetic language heavily influenced by classical architecture. It worked like decorative packaging, reanimating the otherwise uninteresting facades by juxtaposing symbolic elements and enveloping them with irony and metaphor. Visually, postmodernism is exemplified by the garish application of color, return to ornament and traditional design elements (such as gables, Palladian windows, conical roofs, classical orders, pediments, elaborate mouldings, overscaled arches, and robust masonry details), and eclectic mix-and-match of every imaginable detail for an ostentatious façade effect. It allowed pastiche, the unrestricted juxtaposition of stylistic elements from radically different contexts and epochs, to preside over its compositional strategy. Postmodernism permitted greater tolerance for diverse styles to coexist, ranging from conservative imitations of classical architecture to flamboyant, kitsch, and playfully outrageous designs.

The flexibility of postmodernism that allowed the eclectic combination of decorative elements scavenged from the catalogue offered by architectural history was prone to abuse and misuse by indiscriminate designers. Too much attention was given to applied ornament and exterior form that made postmodern buildings appear as

mere exercises of facadism. Moreover, this iconological emphasis of postmodern buildings moved the profession away from structural innovation and social issues and much closer to the tactics of consumer marketing. Although the buildings looked new and dazzling, they were, fundamentally, a testament to private plundering and consumerist values that would colonize the public realm with false grandeur and excess, nurturing a kind of urbanism that approximates the atmosphere of a theme park environment.

Postmodernism consciously evokes an affective power of nostalgia. Nostalgia or "the return" to an idealized era constitutes an important trope in postmodern aesthetics. Remembrance of history in fragmentation or its nonchronological presentation is the basic characteristics of postmodernism. Buildings from the past could be ransacked for design motifs or its imagery be recycled without apology or respect for propriety. The past becomes an endless source of styles that could be mingled eclectically without inhibition as postmodernism gives premium to the consumption of surface and image for their own sake rather than for their function or for deeper values they may symbolize. Images from the past, recreated or simulated, are consumed for their surface appearance at the expense of content, substance, and meaning. In the use of the flexible time sequence or nonchronological time, or the fragmentary use of time, we often face a kind of postmodern nostalgia where everything is stylistically possible.

In charting the transmission of postmodernism in the Philippines, it would reveal itself as an effort to revert to the use of the traditional language of signs and symbols. Its engagement in rummaging historical references came in the form of plastic decorations, aluminum column capitals, robust masonry details, neon pediments, and trompe l'oeil. The sprawling Asian Development Bank Headquarters (1986), designed by Skidmore, Owings, and Merrill (SOM) with Filipino counterpart Engracio L. Mariano and Associates, initiated the move toward postmodern sophistication through the liberal use of classical arches of granite. The massing of the building reinterpreted the classical Renaissance façade proportion through the simplification of geometry and detail articulation. With this building as an impetus, the craze for the "return of ornament" followed suit, launching a wave of architectural imitations.

The Asian Development Bank building in the Ortigas Commercial Center is an outstanding specimen of regionalist yet postmodern architecture that sets an eloquent and pragmatic response to local context. This is shown in its application

of original tropical design concepts and climate-modulating devices that are integral to the structure, such as aluminum grillage, louvers, perforated barriers, and deep recessions.

In the same tendency for classical architecture, Rogelio Villarosa became a master of precast classicism when he first introduced this postmodernist "stick-on style" in his design for King's Court Building II (1990), a six-storey, tourmaline-like glass block, whose severity was alleviated by appending oversized mouldings and solid arches of granite. Here, the postmodern aesthetic was simply attained through the juxtaposition of contemporary and traditional elements and the resurrection of simplified classical and Italianate decorative elements in the building's crystalline skin. Villarosa's work in the pseudo-classicist genre reached its apogee when he made the Tektite Tower (1995), Renaissance Tower (1995), and AIC Gold Tower (2000)—all manifesting the period's penchant for superscaled faux-traditionalism.

Shifting from hard-edged modernist cubes, Gabriel Formoso's late-modern Pacific Star Building (1989) paid homage to the structural poetry of the Roman arch in a series of monumental arches that punctured the high-rise structure.

The faux-classicist strain of postmodernism continues to this day with the works of Felino Palafox Jr. for institutional edifices, such as the Nueva Ecija Capitol Building (2003) at Palayan City, which is a straightforward expression of bare classicism, and the Supreme Court Annex Building (2004) at Padre Faura, which is guilty of a meretricious proportional experiment.

Institutions in the late 1990s, such as the branches of Metrobank, designed by Dewey Santos and Felix Ngo, have also brought into play the humorous tactic of postmodern aesthetics in their signature architecture. Instead of dispensing a singular institutional image, they spawned a dynamic series of stylistically diverse branches nationwide with no two branches exactly alike. The appreciation of historicist vocabulary has demonstrated the rich and varied possibilities that postmodern exploration can offer.

Combined with the luminance of neon lights and technicolored hues, postmodern architecture provides a scintillating and exciting venue for commercial and recreational functions. Nowhere has this been fully explored than in Sunshine Boulevard (2003) as it sticks out in Quezon Avenue with its exaggerated use of vivid colors and flamboyant combination of volumes. The same flashy exhibition of color and form is an architectural tactic used by fast-food giant Jollibee to stimulate consumer patronage. Then again, nocturnal architecture, such as Classmate Digital KTV (2001), demonstrates the promiscuous handling of classical details to the depths of debasement. On the other hand, the renovation of the nondescript Great Eastern Hotel (popularly known as Aberdeen Court), now clad

8.5 King's Court Building

8.6 Pacific Star Building

8.7 AIC Gold Tower

8.8 Renaissance Tower

8.9 Nueva Ecija Capitol Building at Palayan City

in aluminum, is an unrestrained copy of the freestanding pediment pierced by a hole of the AT&T Building, a canonic postmodern building in New York. Commonwealth Ever Gotesco (1997) enchants us with a windowless concrete architecture that feeds on the iconographic gimmickry of Disneyland kitsch. Apart from exhibiting the unrestrained use of bright colors, Gilbert and Willie Yu's Isetan Cinerama (1986) at the corner of Recto Avenue and Quezon Boulevard in Manila monumentalizes the Roman arch with a series of plain arches in low relief that define the windowless concrete façade. The iridescent Waterfront Hotel (1998), designed by Richeto Alcordo in Lahug, Cebu City, with all its turrets, excels in postmodern theatricality that hints of a cartoon-like fairy-tale castle. The West Burnham Place (2001), a mixed-use building in Baguio City, is an entertaining visual spectacle of plastered pop-classicism in a highland terrain. Meanwhile, apart from its unrestrained use of a translucent plastic dome, overscaled historicism predominates the architecture of the Sanctuarium (2006), the largest columbarium complex in the country, located along Araneta Avenue in Quezon City.

The aims of the ornamental "cut-and-paste" design of familiar, local cultural icons were to make the buildings work on two levels (double coding) so that both architects and the common people could appreciate it. Yet, Philippine adoption of postmodernism failed to explore the potential of "double coding" to evolve an

8.10 and 8.11 Branches of Metrobank adhere to the principle of stylistic plurality of the postmodern idiom. Corporate architectural identity valorizes a rich diversity of styles. No two buildings of Metrobank are the same.

8.12 A Jollibee fast-food branch—the playful combination of vivid orange and yellow had become the company's architectural signature, conspicuously sticking out in any urban or rural town setting.

8.13 The architectural style of the nocturnal Classmate Digital KTV along Quezon Avenue, a long stretch of adult recreational venues in Quezon City, is generated from a mishmash of historical references.

identifiable Filipino design. Instead, it was maneuvered superficially as a mere style and look typified by the standard "ornament-the-pediment" or arch over a pastel-colored, multistoried structure whose horizontals are defined by oversized classical mouldings. Despondently, this brand of postmodernism resulted into kitschy architectural forms that misinterpreted the elements of Western classical architecture.

Mainstream real estate developers have appropriated postmodernism in the 1990s to increase property and market values. What was once an avant-garde movement against modernism became an essential ingredient in multimillion-peso real estate ventures, as postmodernism provided the appropriate visual imagery for image-conscious developers. To make the building look contemporary, it was clad in granite and stone-like precast concrete. The historical references and ornamentation became literal but seldom had the finesse and beauty of the original for they were reduced to an eclectic visual feast processed in the name of populism and consumerism. As a result, qualities such as artistic merit, integrity, seriousness, authenticity, realism, intellectual depth, and strong narrative tend to be undermined in most postmodern built environments.

As of 1992, high-rises in Makati and Ortigas in Pasig have reached beyond 140 meters. The postmodern skyscrapers allude to the timelessness of the classical column. As a way to break its vertical monotony, the postmodern skyscraper has adopted the tripartite division of columnar architecture, segmenting the tall structure into vertical segments: podium, shaft, and crown. Typologically, this formula, called "tower-on-the-podium," was predominantly adopted for commercial and corporate towers because of their mixed-use potential, where the

three to five-storey podiums are leased for retail, commercial, and entertainment use to establish visual and social interface at the pedestrian level. Rising on the podium are one or more towers containing offices, hotels, and/or residential spaces. This columnar configuration could be seen in Columns (2006), Sunview Palace (2003), Gold Loop Towers (1990s), Renaissance Tower (1995), Rufino Tower (1994), World Trade Exchange (1996), and BSA Twin Towers (1995) in the manner that they are crowned by an elaborate, capital-like ornament.

An ever-present leitmotif in the art of skyscraper design is the sense of timelessness, which postmodernism willingly confers upon. A building would either incorporate the timeless façade of richly ornamented granite or the perpetuity of a gem-cut crystalline façade in order to achieve standards of eternal qualities that are not easily devalued. The ideal skyscraper imagery is able to leap back and forth in time, designed in such a way as to foresee the future and at the same time to look back to an elegant past. While most of skyscrapers follow the column's tripartite division, others are visually distinct with their unique evocation of 1930s New York

8.24 Art Deco-inspired details the Shang Grand Tower

nostalgia. The stepped contours of art deco resonate in William V. Cosculluella's *Orient Square* (2003), while rich geometric treatments and the silhouette of art moderne are discerned in Wong Tung's *Enterprise Center* (1998). The *Shang Grand Tower* (2006), designed by Palmer & Turner and Recio+Casas, is a residential tower that conjures the art deco nostalgia of an Oriental utopia.

The Postmodern Cityscape and the Politics of Urban Cosmetics

With urban revisions, the cityscape is constantly being reinvented and scenographically transformed into a postmodern illusion of a packaged environment in the name of "revitalization." While the new suburban developments and gated communities have become a site of fantasy production and flashy confections of domestic escapism, the model houses marketed within these suburban, gated neighborhoods are stylistically wrapped in slipcovers derived from an international menu of domiciles that range from Swiss chalets to Mediterranean villas that will never assume a Filipino character.

8.25 Neovictorian–influenced clocktower in Eastwood City in Quezon City

Postmodernism has gradually transformed the urban space into an environment akin to theme parks, in which urban facilities and infrastructures are judged by how well they comply with the demands and speculations of business and tourism, and in which images are remodeled according to certain political criteria. Through the amalgam of history, myth, reality, marketing gimmicks, and fantasy, postmodernism concocts a brand of urbanism that results in the "Disney"-fication of the city, an urban fiction whose origin could be traced to the successful marketing management strategies of Disney World in controlling its domain and in fabricating illusions and marketable images. Disney-fication manifests itself in the invention of fantasy environments that are now as common as the commercial enclaves or the so-called "microcities," such as Eastwood City or Rockwell Center, the retail mall environment, and the suburban development dream houses. The theme park lexicon of false arches and pediments, fake columns, and revivalist and retro ornaments seductively layers with saccharine imagery the complexity of urban life besmirched by criminality and poverty, resulting in a place of manufactured and controlled imagination.

Such a phenomenon could also be seen in the aestheticization of the city of Manila during the term of Mayor Joselito Atienza from 1998 to 2007, when Manila's urban renaissance scheme melded together heritage, politics, and myth-making. In the guise of an urban revitalization program known as "Buhayin ang MayniLA" (Revive Manila), Manila was given its cosmetic salvation through the Roxas Boulevard Baywalk, the Rizal Avenue Shopping Strip and Promenade, the New Muelle Del Rio, the New Plaza Miranda, the New Liwasang Bonifacio, and the Pandacan Linear Park, among others. The bleakness of Rizal Avenue (caused by the construction of the Light Rail Transit in the 1980s) metamorphosed into a lively pedestrian promenade lined with pastel-colored façades—a cosmetological intervention that revivifies the lost glory of Manila's shopping district of the 1950s. Also, the once old, dingy, and crime-infested pavement along the seawall that stretches from the US Embassy to the Manila Yacht Club was transformed into a pleasing promenade complete with spectacular street lights (reminiscent of the 1950s molecular motif), public art, and a variety of food stalls and park benches.

.26 Bayfront development along Roxas Boulevard, fronting he Manila Bay

8.27 and 8.28 Manila's Baywalk promenade and alfresco restaurants

8.29 The redeveloped Plaza Miranda in Quiapo, Manila

Between 1999 and 2000, Plaza Miranda, the *theatrum sacrum* of Quiapo's Black Nazarene devotion, received a major facelift at a cost of 49 million pesos. The new plaza was lavishly paved with unpolished granite, bordered by reinforced concrete baroque arcades evoking the church's Solomonic designs, and marked by a granite obelisk monument at the margin of Quezon Boulevard. The whole of Plaza Miranda was framed by colonnades, topped by planters brimming with synthetic vegetation, effectively filtering out most of the "profane" activities from the adjacent streets. These segmented colonnades also mitigated the flow of pedestrians in the plaza's central open space, compartmentalized into pockets of spaces to discourage groups of people to linger and loiter. Plaza Miranda, in effect, had become a self-contained space, enclosed and cut off from the surrounding urban fabric. It can be likened to an oasis amidst the cosmopolitan dereliction, replete with the nostalgia of an imagined order and heritage fantasy. Plaza Miranda is inwardly oriented—an introverted space. Introversion is the negation of the profane outside environment, the fragmenting and disconnection of the space from its surrounding city fabric.

Manila's urban renewal schemes are sites of political propaganda and contestation. Huge billboards hailing the aesthetization-cum-urban-renewal projects presented Mayor Atienza's larger-than-life image. Displayed prominently

8.30 and 8.31 The pedestrianized Carriedo and Rizal Avenue in Santa Cruz, Manila

at strategic locations, these billboards signified the promise of economic prosperity held by the urban altruism of his governance. The ubiquitous slogan "Buhayin ang MayniLA" program confined the effort to resuscitate the dying city via the visible politics of redevelopment and infrastructure with Mayor Atienza as the central messianic figure of these urban regeneration undertakings. The centrality of his persona in Manila's recuperation could be read in the semiotically-charged slogan that deliberately and boldly capitalized the last two letters of the city's name, L and A, referring to the initials of Manila's then paternal figure, Lito Atienza.

When Atienza, who occupied the mayoral position for three consecutive terms, finished his maximum tenure of office in 2007, he was replaced by his political rival. On his first day on the job, Manila's new mayor, Alfredo Lim, reversed two of Atienza's most controversial decisions—the closure to vehicular traffic of a portion of Rizal Avenue in Sta. Cruz and of the Arroceros Forest Park. Lim ordered the removal of interlocking pavers in Rizal Avenue to facilitate the reintroduction of commuter traffic in the area. He also banned the peddling of liquor and removed the kiosks and alfresco diners at the Baywalk, which virtually ended the effervescent nightlife in the bayfront promenade.

Correspondingly, urban theatricality managed through Disney-fication was the driving force in President Gloria Arroyo's polychromatic transformation of the slum communities located in Manila's prime thoroughfares aimed to make the city an attractive investment destination by mere facadism. Under the catchphrase *"Pook na Bulok, Negosyo Di Papasok"* (In a Decayed Place Business Will Not Enter), the urban fix-up scheme involved the repair and repainting of flower and plant boxes along Ninoy Aquino International Airport Road and the entire stretch of Roxas Boulevard; replanting of palm trees and shrubs; repaving of sidewalks; and, painting and repair of the façades of shanties along the major thoroughfares from the Ninoy Aquino International Airport to Roxas Boulevard and all roads leading to the Malacañang Palace. In the city of Parañaque alone, some 246 dilapidated houses received façade makeovers for free. Time and again, these stretches have been relandscaped and beautified whenever international events

were held in Manila. The latest was when the drab residences of the urban poor were magically transformed virtually overnight into candy-colored confections of plywood architecture to make them more visually palatable to the foreign dignitaries attending the Inter-Parliamentary Union Conference held in April 2005. This similar tactic went into operation in the city of Cebu when the city hosted the 12th ASEAN Summit in January 2007. For the entire event, the government spent an estimated 1 billion pesos to beautify and construct new facilities along the ceremonial route leading to the controversial Cebu International Convention Center (CICC). Such maneuvers manufacture a fictive urban image that makes urban life akin to a staged extravaganza.

In a similar slant of a systemic urban makeover, the Metropolitan Manila Development Authority (MMDA), headed by the stern Chairman Bayani Fernando, launched in 2006 the "Metro Gwapo: Looking Forward to a Good-Looking Metro," a five-year, head-to-toe facelift program for Metro Manila. With an estimated cost of roughly 23.3 billion pesos, Metro Gwapo includes projects that would address traffic management, roadways clearing, resettlement, flood control, and disaster management. The most salient feature of the project is the eradication of physical and social eyesores in the city, through the implementation of the following programs: Street Nomads Care, a 247-million peso program that seeks to remove beggars, vagrants, and the homeless from the streets and take them to facilities that provide decent meals and a bed-and-bath; Sidewalk Dwellers Inventory and Relocation, a 400-million peso project to transfer 11,000 informal settlers to resettlement sites; Waterways Dwellers Relocation, a project to remove 70,000 families dangerously living on waterways to safe areas; and the Pook Na Bulok Program, meant to upgrade blighted areas of Metro Manila. Chairman Fernando has even come up with slogans on education and enforcement of rules and regulations, for dissemination to residents of Metro Manila, on how to conduct themselves properly to ensure the successful implementation of the Metro Gwapo project. These include: *Walang Sagabal: Lansangan ay Ligtas, Mabilis*; *Walang Nakakainis*; *Walang Kalat*; *Walang Pook na Bulok: Maganda, Hindi Nakakatakot*; *Walang Sakit—Hangin, Tubig, at Pagkain ay Malinis*; *Walang Mabaho: Kanal at Sapa ay Malinis*; *Walang Bastos: May Urbanidad*; *Hindi Nakakasakit ng Kapwa*; and *Kaisa: The Metro Way.*

In all of this urban revitalization and cosmetological interventions, postmodernism takes center stage as a diversionary layer in the urbanscape, fabricating a sanitized, historicist mythology of infinite civility. Thus, it creates a synthetic place of refuge filtered from the abrasive, the hideous, the inefficient reality, the violent ideological clashes, and the class tension of the city.

Globalism and the Vision of "Philippines 2000"

By the middle of the 1990s, the Philippine economy was back on track, approaching an economic level comparable to those achieved elsewhere in the ASEAN region. In 1997, the Asian Financial Crisis halted the ambitious real estate development in the Philippines. The crisis was partly fueled by excessive real estate speculation throughout Southeast Asia. Meanwhile, the diffusion of postmodern culture coincided with the technological breakthrough of the period—the "information superhighway." Such coalition of aesthetics and technology unleashed the Digital Age, an era dominated by computers and wireless communication. Computers and cellular phones have become indispensable extensions of the human body, linking the corporeal to the entire world that has become a single entity bound together by complex conduits of digital information. The Global Village was a by-word coined to refer to the community connected by new technologies that made possible instant communication with virtually any part of the globe.

Fidel Ramos's ascent to presidency launched an ambitious economic program—the "Philippines 2000"—which aimed to elevate the nation to the status of a "newly industrialized country" (NIC) by the start of the new millennium. His tactics toward economic recovery and global competitiveness were hard sell. Through Ramos's persuasive promotion of the Philippines as an investment destination, foreign businesses came in by bulk, creating an auspicious climate necessary for another construction boom. High-rise euphoria was in the air and intelligent buildings were under construction to keep the Philippines in cadence with the entire global village. As foreign investors arrived, they carried with them the suitcase of multinational global economics, which compelled the production of "global architecture" in the Philippines.

The architecture of global multinationalism is typified by buildings that serve as corporate headquarters in Makati and Ortigas as well as the architectures of mixed-use commercial districts with master plans, such as the Rockwell Center, Eastwood City Cyberpark, Madrigal Business Park, Filinvest Corporate City, Bay

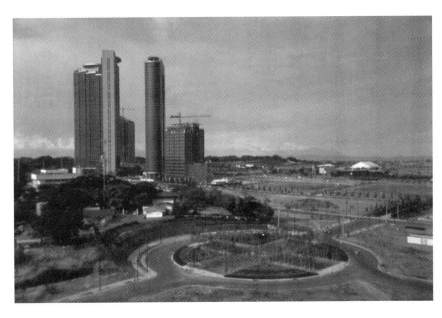

8.34 The early stages of implementation of the Fort Bonfacio Global City development master plan

City, and Fort Bonifacio Global City. The building components, planning, design, and architectural expertise of these buildings came from all over the world, and their sites could be anywhere where labor is cheap and government-submissive.

Global architectural firms bestow "designer labels" to most of these building projects, specifically those that are larger in scope and magnitude, such as those in the central business district of Makati, Mandaluyong, Pasig, Manila, Quezon City, and Cebu City, or in the emergent districts at Rockwell, Eastwood, Bay City, and Fort Bonifacio. Part of the marketing machinery of these developments is putting out construction billboards that proclaim the participation of global architectural firms as design consultants and validate the international status of the project as well.

Clients or developers justify the commissioning of foreign consultants on large–scale projects by claiming that such ventures require expertise that is unavailable locally. The ethical and professional approach is to form a partnership between local design firms and foreign consultants. As the names of Michael Graves, I. M. Pei (Pei, Cobb, Freed & Partners), KPF (Kohn, Pendersen, and Fox), SOM (Skidmore, Owings, and Merill), HOK (Hellmuth, Obata & Kassabaum), Gensler, NBBJ, RTKL, and Arquitectonica orbit the firmament of the international architectural star system, they provide local projects with an aura of globality, which real estate developers hope to translate into aesthetic prestige and guaranteed marketability. Michael Graves's World Trade Exchange (1996), I.M. Pei's Essensa Towers (2001), Arquitectonica's Pacific Plaza Tower (1999), KPF's LKG Tower (1998), and SOM's Yuchengco Tower (2001) bear the stamp of an architect-auteur pedigree, certifying an edge over aesthetic value and global estimation.

Other building types which have been featured prominently in the portfolios of these global firms are five-star hotels, corporate headquarters, and residential constructions, including satellite towns, suburbs based on North American models, and high-rise towers. The types of projects that foreign architectural firms are called upon to design expose architecture's role in the larger process of globalization.

The demand for overseas design services does not simply reflect the construction requirements; it also manifests which building types have high profiles in the global economy. Thus, office towers as symbols of corporate power and hotels catering to the international business traveler often require the signature of a foreign design firm to herald their participation in the global economy.

Consequently, with the influx of foreign design firms commissioned in high-profile projects, a new system in the mode of architectural practice and production is taking shape in the country. A foreign architect collaborates with a local firm under the pretext of consultancy. The local firm is the architect-of-record and assumes all liabilities for the project. This firm also usually acts as a liaison between the design architect and any regulatory agency that must approve various aspects of the project. Because foreign firms are usually hired for their design expertise, the division of labor seems to be ordered under this condition: the foreign firm does the conceptual design and design development, then the local firm takes over, produces the construction documents, and oversees the construction process.

36 World Trade Exchange in Binondo, Manila

37 Essensa Towers in Fort Bonifacio

38 Pacific Plaza Tower in Fort Bonifacio

39 Yuchengco Tower in Makati City

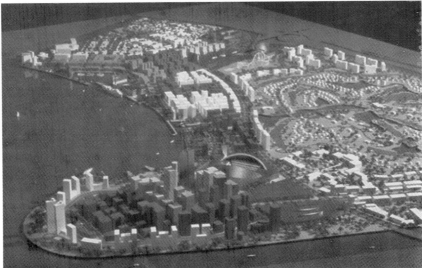

Construction documentation is the most labor-intensive phase of the architectural design process, and professional labor costs are lower in most Asian countries. Under this labor scheme, the relation between the foreign and local firm is inequitable.

Meanwhile, the Philippine Independence Centennial Celebration of 1998 fostered an atmosphere of nationalism. National pride found expression in state-subsidized infrastructure projects, such as the Expo Filipino (1998) in Pampanga and the Boulevard 2000 at the foreshore of Manila Bay. The Expo Filipino was a 60-hectare theme park that paid tribute to the achievements of the Philippines as a republic in the last 100 years. Aside from dispensing replica architecture of Philippine landmarks ala-Disneyland, Expo Filipino acquainted the Filipino, for the first time, with the technology of tensile architecture through Prosperidad Luis's Freedom Ring (1998), a 35,000-seater amphitheater, and the largest of its kind in Asia. The stretched membrane of the structure is configured to form the shape of an anahaw leaf and when the structure is lighted with colored lamps from the inside it becomes a giant Pampanga lantern. The 1.2 billion-peso Freedom Ring now stands virtually unused in the middle of what used to be barren, lahar-filled land inside the Clark Special Economic Zone.

8.43 Aquino Center in Hacien Luisita, Tarlac

8.44 Ateneo Science Educa Complex

8.45 The New Medical City

Neovernacularism continued as a strain of postmodernism, sanctioning the interaction of nostalgia with current building technologies. Again, Francisco Mañosa dominated this stylistic niche. He managed to transcend the Filipinized kitsch, which used to stand out in his design in the previous decade, by crafting lyrical and exquisite architecture that probed the discourse of Philippine identity. The Aquino Center, the Ateneo Professional School, the Ateneo Science Education Buildings, and the New Medical City are testaments to his neovernacular maturity.

The advocacy of using indigenous materials, such as bamboo, for sustainable modern construction has been pursued by Rosario Encarnacion-Tan through teaching and writing. She once crafted a contemporary bamboo house for herself in Quezon City to prove the relevance and viability of such a material in the context of a modern metropolis. Her neovernacularist fervor, both in theory and in practice, has yielded groundbreaking research and design work in bamboo architecture for the twenty-first century.

Green Architecture and Ecological Design
Green architecture is a category used to describe economical, energy-saving, environment-friendly, sustainable development. A green building, as it problematizes

the relationship between architecture and ecology, is expected to address the following criteria: the construction and operation of the building should reduce the negative impacts on the immediate and distant environments, and the building should provide an excellent indoor quality for its users and inhabitants. In recent years, the doctrine of green architecture became a significant design approach in response to the negative effects of global warming, air pollution, water pollution, the depletion of energy reserves, and deforestation that a building may have on the environment, disrupting the complex ecologies of the earth.

The practice of green architecture, thus, endeavors to increase the efficiency with which structures and their sites harness and utilize energy, water, and materials, thereby reducing the building's impact on human health and the environment through better siting, design, construction, operation, maintenance, and disposal. Green design often emphasizes taking advantage of renewable resources.

Green architecture, together with sustainable construction in the Philippines, is still in its infancy. Advocacies in the promotion of green architecture are undertaken by nongovernment organizations such as the Holcim Foundation for Sustainable Construction, a foundation established by a multinational cement manufacturer to encourage sustainable responses to the technological, environmental, socioeconomic, and cultural issues affecting building and construction. To achieve this goal, the foundation conducts an international sustainable construction competition (Holcim Awards) and an academic symposium (Holcim Forum); provides financial support for research and construction projects (Seed Funding); and promotes collaboration through publications and exhibitions.

Individual initiatives have yielded inventive prototypes that utilized alternative and abundant local materials with unconventional construction methods. These projects promise the economic utilization of material and swift fabrication that requires minimal skilled labor. However innovative and economically sustainable these projects may seem, the sociocultural impact and climate-response of these structures are yet to be tested and evaluated.

.46 The egg-shaped earth bag shelter in Escalante City, Negros Occidental

My Shelter Foundation, under the directorship of Illac Diaz, created a prototype dome house in poverty-ridden Escalante City, Negros Occidental. It adapted the "Earthbag Construction System" from the technology developed by American-Iranian architect Nader Khalili of the California Institute of Earth and Art Architecture and by Earth

8.47 Earth bag construction system

Architecture of the UNESCO. Dubbed as the "Rio Dome," the structure is made of 80 percent earth that would cost 30 percent to 60 percent less than a conventionally built house. Long spools of rice sacks are packed firmly with a waterproof mixture of earth and a small amount of cement. These are then piled together on a circular trench two-rice sacks deep.

In between the overlapping layers of earth bags are barbed wires which hold the earth bags in place and prevent them from shifting. The earth bags are then stacked together forming a dome shape, a self-supporting form that eliminates structural columns, guided of a large, compass-like tool. To make the dome house watertight and weatherproof as well as to enhance its appearance, its outer and inner surfaces could be plastered and painted. The entire fabrication process employs a community of at least six persons and could be finished in a matter of days.

Filipino scientists at the Forest Products Research and Development Institute (FPRDI) at Los Baños have been improving a particular kind of cement-bonded board (CCB) called "wood-wool cement board" (WWCB). The main component

a. The scaled model in the packed folded state

b. The roof panels at each side of the case are raised

c. The roof panels are temporarily supported

d. The floor panels are unfolded from the rigid case

e. The floor panels are levelled

f. The walls are drawn out from the rigid case

g. The walls are locked in place and the roof temporary supports are removed

h. The shelter is fully unfolded and essentially ready to be occupied.

8.48 Diagram showing the step by-step procedure in erecting the F-Shelter using a scale model

of the boards is wood-wool derived from shredded wood of gmelina, acacia, and eucalyptus. This type of board also requires less cement than other types of CBB and can be readily manufactured by hand or semi-automated process. In building projects, WWCBs, like other CBBs, are so adaptable that they can be used as exterior cladding, weatherboards, roof tiles, flooring, ceilings, or internal partitions. Their semiporous structure makes WWCBs excellent natural thermal insulators, and they also absorb and dissipate noise. For exposed applications in walls and roofs, the boards can be easily rendered with weatherproof cement, paint, or pitch.

The WWCBs have been successfully tested as the basis of "F-shelters"—fast-to-build, firm, and foldaway emergency shelters using locally manufactured medium- and high-density WWCBs for floor, wall, and roof boards—designed by Dr. Florence Soriano and the scientists of the FPRDI. The design concept was inspired by the versatility and adaptability of tent architecture. Similar to a tent, the F-shelter can be quickly assembled, folded, packed, stored, and used repeatedly. The entire process of erecting the prototype F-shelter on site takes only half an hour—fifteen minutes to unfold the prefabricated components and fifteen minutes to attach the architectural accessories—with four workers equipped with simple carpentry tools. But unlike a tent, the F-shelter has a floor that can be elevated on specially designed, prefabricated footings. The height of the footing pedestals can be adjusted when the terrain is not flat. Doors and windows, similar to those in site-built shelters, make the F-shelter more secure than a tent. In fact, the F-shelter makes such a comfortable dwelling that the inventor is concerned that residents of these temporary shelters will want to use them as permanent homes. The scientists at FPRDI are now studying ways to mass-produce the F-shelters and explore the potentials of F-shelter technology for the production of multifunctional shelters.

Veneers of High Technology

The new millennium mania cultivated among Filipino designers a new optimism, a desire for a new world and a better life, which translated to the fascination with the utopian promise of cutting-edge technology and the sleek machine iconography of the digital future. The high-tech look and cybertopia-inspired aesthetics were the logical path to take in the pursuit of the "new." Thus, postmodern megastructures took on a high-tech veneer, creating shimmering façades of metallic surface treatments and extending the technology of cladding systems. The sleek, unadorned industrial facade with exposed steel appendages is exhibited in Philip Recto's One San Miguel Building (2001), SOM's PBCom Tower (2001), and KPF's GT International Tower (2001). Green or blue curtainwall, aluminum cladding, metallic sun visors, and metal mullions have become mainstays in the surface articulation of millennium skyscrapers. At a horizontal scope, the high-

3.49 Hi-Tech skyscrapers of the Makati central business district

3.50 The skyline of Makati's Rockwell Center

tech NAIA Terminal 3 (2004) stretches over a kilometer long and emanates from the efficient machine iconography with the sleek engineering of its V-support and efficient transit apparatuses. The ultramodern, 189,000–square meter international terminal facility was designed by Skidmore, Owings, and Merrill (SOM).

The High Tech came to be known as the new multinational style. These monuments of technology-worship claimed to have overcome the appalling environmental defects of the previous century's steel-and-glass boxes (International Style) by incorporating the latest technology. Drawing inspiration from aircraft technology and robotics, the exposed structures are light and strong, using heavily insulated wall panels, steel and aluminum frames, and mirror glass in neoprene gaskets. The World Center (1995), Professional Tower (1996), Robinsons Equitable Tower (1997), Petron Mega Plaza (1998), AMA Tower (1999), Discovery Center (1999), One Roxas Triangle Tower (1999), Pacific Plaza Towers (1999), RCBC Plaza (2001), the United Architects of the Philippines Headquarters (2002) and 1322 Roxas Boulevard (2004) fall under this taxonomy. Their reflective, sleek verticality represents the city's claim to World City status where global trade and finance are controlled by a powerful capitalist corporation.

8.56 The skyscrapers of t
Philippines and their heigh
relative to one another

High-tech Domesticity

In 2005, the first-ever Metrobank Art and Design Excellence accolade was conferred to an architect, Noel K. Tan, for his revolutionary residential architecture in Talisay City in Cebu known as "Fusion": The Tan Residence. The structure is a three-storey house of crisp neomodern geometry emanating from a provocative spatial and formal experimentation that combines the indigenous with the ultramodern style. Such approach to residential design is an architectural statement which addresses the issues of tropicality and vernacular building technology, orchestrating the negotiation of local culture with matters of ecological sustainability. The house, according to Tan, "is suited to a fast-paced lifestyle but remains sensitive to cultural and environmental factors," thus instigating a redefinition of our concept of Filipino domesticity in the tumult of a highly globalized culture.

Though couched in abstract form, his design solution for the Fusion House acknowledges tradition. The buoyant and sparse geometry alludes to the floating and transparent qualities of vernacular architecture. Its visual drama—overlapped by planes of solids, voids, and permeable sunscreens—is dependent upon the straightforward manipulation of lucid travertine and concrete volumes juxtaposed with a slatted network of horizontal louvers forming a truncated mass that wraps

and protects the faces of the house exposed to intense heat and glare. Such a simple form also aligns itself with the time-honored vernacular strategies of passive cooling and natural daylighting principles, creating not only an extraordinary architecture but also an ecologically sound and energy-efficient built form.

Externally, the house appears as a sequence of stepped, sloping, cut-out, and cantilevered volumes. A vertical travertine volume, which acts as a structural spine, is articulated with indentations as it rises, dispensing an inverted stepped contour. The travertine mass, at every level, is punctured and defined by a narrow strip of windows.

A series of horizontal metal slats form a rectilinear volume truncated at an exaggerated angle. This protruding metallic façade element, which is also replicated at the side elevation as vertical trellises, does not only endow the exterior with visual drama and architectonic layer, but also functions as an environmental filter to modulate direct heat and light entering the glass windows it conceals.

Its climate-responsive building envelope allows the structure to maintain a comfortable internal thermal condition despite the house's exposed location at the ridge south of Metro Cebu. Remarkably, the structure also takes advantage of a panoramic vista, overlooking the straits between Cebu and Bohol, offered by the site's elevated and sloped terrain.

Natural light, filtered by external sun-shading devices and diffused by glass blocks walls, penetrates the structure's lofty internal volumetry, endowing the interior with airy luminosity. The living area, marked by extreme transparency, virtually becomes a vessel of light. Much more, the system of projecting aluminum brise soleil and metal trellises, made from off-the-shelf aluminum extrusions, casts an alluring interplay of *sol y sombra* [light and shadow] in the interior.

Finishes and materials are spartan: planes of transparent glass, gleaming wood, and white walls exquisitely articulate the interior. Light and shadow have been

handled as an almost tangible ingredient of the architecture, transforming the austere aura, giving edge to surface and form, and imbuing the house with a sense of ethereal enlightenment. It is a beautifully detailed home, interweaving the Filipino concept of dwelling, culture, and ecology, which makes it a truly engaging form of domesticity and gives a lasting impression.

Deconstruction and the Architecture of Disjuncture

Part of the postmodernist language is Deconstruction. Emerging from the theoretical concerns of the past three decades, deconstructivism in architecture has very little to do with any given philosophy of design. The term "deconstruction" began as a philosophical method of analysis applied specifically for literary text. First formulated by theorist Jacques Derrida, deconstruction implies the breaking apart of something in order to ascertain its failure when it was still whole.

Architecturally, deconstruction as a "style" refers to a radical set of formal and compositional strategies that are constituted by simple forms yet are capable of producing a geometry of instability and disorder. Thus, deconstructivist architecture is a spatial/architectural manipulation that attempts to exaggerate the conflicts and contradictions inherently possible in a geometric composition; that is, to elicit and expose what architects have traditionally subverted. The resulting buildings exhibit the qualities of being dismantled, fractured dissassemblages, with no visual logic, no attempt at harmonious composition of facades, and with no functional reason.

The architecture of deconstruction is sustained by ideas of controlled fragmentation, a nonlinear design process stimulating unpredictability, manipulation of surface or skin, and the use of asymmetric geometries and orchestrated chaos. These potpourris of jarring and incompatible elements are maneuvered to foster

architecture that is rich in contradiction, optical illusion, and multiple perspectives, suggesting ephemerality, uncertainty, ethereality, and even danger.

Disregarding the philosophical baggage of deconstruction, some local architects have appropriated it as superficial exterior treatments. Such is the case in Shangri-La Plaza Mall, whose plan still adheres to an orthogonally defined composition, but, with exposed structural elements jutting from nowhere, and with a few dashes of skewed lines and sharp corners, it manages to pass itself as deconstructivist.

Nowhere is this deconstructivist tendency made more profound than in the cutting-edge edifice of Eduardo Calma, the School of Design and Arts (SDA) of the College of St. Benilde, which challenges the ordered and cubic rationality of modernism. The building's vertical presence and volumetric exaggerations within its vicinity is a transgression of the existing urban milieu predominated by low-rise structures with varying degrees of obsolescence and dereliction arranged along the urban grid. Moreover, it boldly defies the strait-laced certainty of the classicist institutional iconography dispensed by the De La Salle University's signature

8.59 to 8.61 Saint Benilde's School of Design and Arts

columnar edifices, redefining the conventional image of a school building and institution of learning.

The façade is a juxtaposition of incongruous truncated volumes and angular masses of concrete, glass, and metal stitched together with varying degrees of tilting verticals and interpenetrations, eschewing orthogonality. A huge, cantilevered canopy, angled to follow the slope of the theater within and jutting out of the façade, boasts of architectonic grace and antigravitational elegance. The complexity of the building is energized by geometric abstractions, compositional chaos, rigid planar surfaces, and pleated geometry brought in perfectly orchestrated dissonance and explosion—a "violated perfection" so to speak.

High and puritan white internal volumetry is punctured unpredictably by irregular planes of glass, permitting the penetration of natural illumination into the building envelope. Apart from its enthralling scale, the openness, extreme transparency, and kind of materiality galvanized by skewed white planes, metallic shimmer, and crystalline glass all connive to generate unpredictable, fractured, and colliding fragmented forms. This fragmentary spatiality allows spaces to be simultaneously revealed and concealed in a lyrical sense via multiple deep vistas, infinitely variable vantage points, and fluid sequences of interpenetrating and overlapping spaces.

Domestic Disjuncture

A house in Cebu, designed by Alexius Medalla, has assumed the conditions and design vocabulary set forth by the Deconstructivist movement. The house, aside from espousing this avant-garde style, is a statement that radically redefines and contests our elemental concept of a house and deeply rooted notion of domesticity. Altogether, this house proposes an alternative to the strait-laced certainty of a lived life enacted inside the confines of the predictable grid and modules associated with "box" architecture. Instead, it proffers a domestic universe mapped out in an architecture that mediates the exciting collusion of dynamic skewed lines and polygonal planes of concrete and glass, exploring and developing alternative typologies.

The organizing principle for this house originates from a geometry that literally goes around trees. In plan, the trees at the backyard create a reference line, which serves as a datum from which indoor spaces, garden elements, subpaths, and water features are organized by virtue of location and position. Thus, the spatial scheme radiates from this vegetative datum that organically consigns a continuous flow of interior space from one room to another without doors but without loss of privacy either. Since the building envelope is of a transparent surface, living areas extend and relate to the immediate environment, bringing the outdoors inside. This architectural datum and the transparent planes of glass contribute an illusion of expansive space and reconcile the interior with ecological aspiration. In effect, the house manages to effectively dissolve the preconceived lines that divide the interior and the exterior, attempting to explore the "in-betweens" of inside and outside dichotomy and other opposing ideas.

This house's coherent plan clearly condescends rigidly demarcated and compartmentalized space. Rooms are formed with fixed, freestanding, punctured, angled, or retractable planes. Internal views are framed with an array of window devices. Disdain for pigeonholed space is clearly negated in the dynamic and fluid

sequence of interpenetrating layered spaces. In plan, the composition could be seen as a combination of straight lines of different thicknesses with a dynamic slope.

Double-height living areas with white walls punctured at an interval with crystalline glass surfaces permit the diffusion of direct, indirect, and reflected natural daylight to penetrate through, literally bathing the whole interior with light and space. This high volume is also diagonally transgressed by a flat catwalk lined with glass that leads to the living quarters at the second floor.

The stark whiteness of the interior is interrupted by a sensible dash of wooden planes (veneered wood walls and natural wood floor). Strong accents of primary colors (red and yellow) rendered in Mondrian-like fashion are utilized at strategic locations and in the colors of the interior elements to fracture the otherwise bland emptiness.

At street level, the façade is a play of seemingly incongruous, truncated Cartesian volumes stitched together with varying degrees of tilting verticals; interpenetrating rectilinear concrete planes; polygonal glass volumes; exposed structural elements that boast its architectonic qualities; and a dominant roof appearing to float effortlessly in space.

It is a remarkable house that orchestrates a sumptuous subversion of the predictable, grid-based, orthogonal architecture and a scintillating response to a new form of living. Yet it is not an easy structure to come to terms with, as its complex and fragmentary form can be likened to that of an inhabitable sculpture or dismountable Expressionist film set and does not conform to the conventional image of quaint and informal domesticity. The question of its acceptability and functional efficiency as a domestic environment, without the wisdom of time, is impossible to assess as of the moment. But for the time being, it is a building that represents a leap into the future, expressing the formal and technical potential of our time.

Neomodernism or Retromodernism

As the century moves forward to a brave digital future, nostalgic imagination continues to captivate the postmodern designer. Futuristic fantasies coexist seamlessly with retro reimagination. The yearning for an idealized past has created retromodern or neomodernism, a term used to describe a "new simplicity" as a reaction to the complexity of postmodern architecture and eclecticism. Sometimes called minimalism, this design terrain is ruled by mid-century architectural retrospection of lucid lines, transparent volumes, clean-cut massings, uncluttered presence, and achromatic surfaces. The omnipresent exponents of the neomodernist genre are designers Eduardo Calma, Jorge Yulo, Joey Yupangco, Anna Sy-Dupasquier, and Andy Locsin.

Nostalgia, Heritage, and Design

As previously mentioned, the postmodern condition favors the recollection of the past. In a highly technologically driven world, people are drawn to images of the past, to times that seem slower and more peaceful, where life gives an appearance of being better-off than what is offered in the fast-paced present. Postmodern theorists may explain these longings as the dreams of people seeking places of

connection and meaning in a chaotic world—places that offer grounding in terms of community, landscape, and history. Through the effable charm of nostalgia, the past is imagined, idealized, desired, and consumed.

Nostalgic imagery in architecture is tied to the evocation of memories and myths of the past characterized by nonspecific space and time. New combinations of memory fragments are reconstituted and rearranged to celebrate the past, often consumed in leisure forms. Retromodernism, fueled by a fascination for mid-century sleekness; real estate developments like Ciudad Calamba and Dos Rios, sustained by the promise of a neo-*ilustrado* lifestyle and the mystique of colonial urbanity; the perpetuation of recreational farming at Leisure Farm and Plantation Hills in Batangas, romanticizing the bucolic agrarian life for the urbanite longing for a weekend escape; the theme-parking of sites, like the revitalization of Avenida Rizal to generate tourist interest and the visual identity of a bygone era that never was are all clear examples of the contemporary passion for pastiche. The past is recuperated in fragments that can be packaged and consumed at the present time, yet the full context of each memory is dismissed and recollection is thus trivialized: it is the "quaintness" of the past that is reutilized. Our memories are partial for we are enamored with the idea of old glorious figures and we construct their "difference" from us, irrespective of our continuities. The simple, pure, ordered, easy, beautiful, or harmonious past is constructed (and then experienced emotionally) in conjunction with the present—which, in turn, is constructed as complicated, contaminated, anarchic, difficult, ugly, and confrontational. The aesthetics of nostalgia might, therefore, be less a matter of simple memory than of complex projection; the invocation of a partial, idealized history merges with

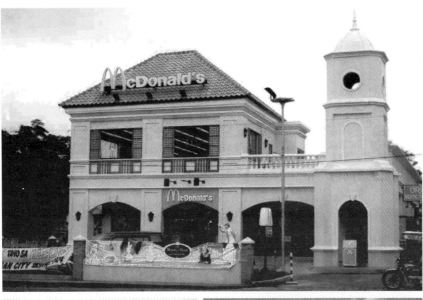

dissatisfaction with the present. Our recollection is trivial for it simplifies, distorts, and disrespects the continuity of historic time.

According to Christine Boyer (1996), speaking of the new urban spectacle, we are in a "crisis of collective memory"—a shared disjunction of our links with the past. This is entwined with the rapid urban changes brought by modernization and industrialization which rupture the myriad of ways in which cities play host to a collective sense of history. The crisis of collective memory provokes a neurosis to desire and to recollect the past only in a token manner and to reframe it in the urban scenography. Such scenographic representations repress the mystery and disorder of urban life, which is reduced to idealized but fragmentary "scenes" manifesting in shopping malls and gated communities. A potent example is the manner by which the Alabang Town Center has confiscated the Spanish baroque elements of our colonial past, and sought to reframe it in a quaint, provincial market-town that it never was. Utilizing Spanish Mission architectural elements— thick walls, deep recessed openings, arcades and towers, balconies, tile roofs, eaves, and wood frames—it insinuates a nostalgia for a false historical past more Spanish Mexico-California than Colonial Philippines. Another nostalgic allusion is the Power Plant Mall at Rockwell; so named as to recall the industrial past that the building had represented for more than half a century. The architecture recalls the memory of the place only in name and but fails to bestow recognizable images from the past as its iconography is more of the Moroccan marketplaces. A more illustrative example is how a global company like McDonald's would place itself in

a heritage site like Vigan. For the sake of misguided contextualism and evocation of the past, McDonald's shows a falsified version of an eighteenth to nineteenth century ancestral architecture (with its own campanile tower that conceals a watertank, a nonexistent detail in a bahay na bato).

The condition where the past is idealized and fetishized is also captured in the new Calamba development project by property developer Filinvest Land Inc. It reinvents Calamba into "a fast-rising, modern Hispanic community, while reviving the traditions and values of the Spanish era." A 350-hectare master planned community known as the Ciudad de Calamba, it utilizes a town planning scheme that allows the past to freely mingle with the present as spectacular images of staged consumption and manufactured authenticity:

> Ciudad de Calamba is a modern take on the old historic township from which generations after Dr. Jose Rizal were nurtured to become ilustrados of note, engaging in business, taking special roles in the community as stalwarts of virtue and raising their children on strong values ... the flavor of Ciudad de Calamba seeks to recreate Rizal's Calamba into a progressive alternative residential and commercial center for the new generation (*The Philippine Star*, March 20, 2004).

The aforementioned instances demonstrate how the past is appropriated as a product, packaged and consumed, a condition symptomatic of a postmodern neurosis whose prescription for cure is saccharine nostalgia.

Gated Communities and Domestic Fantasies

The combined demographic processes of population growth and urbanization in the last two decades created a high demand for new residential construction and suburban development designed after North American models. New gated communities and mixed-used developments embraced the strategies of New Urbanism, a planning principle preached by Miami-based architects and town planners Andres Duany and Elizabeth Plater-Zyberk. Fundamental to New Urbanism is the creation of a community pattern that favors walking over using automobiles as the mode of circulation and movement. It is also motivated by a community character derived from the traditional urban model of a modestly scaled neighborhood and greater tolerance to architectural heterogeneity. Such neighborhoods, as Duany and Plater-Zyberk envisioned in their projects in Canlubang, Laguna, and San Jose, Bulacan, are provided with generous, green, open spaces interwoven in a spatial arrangement where living, working, shopping, and all activities of daily life all exist within walking distance of each other, a characteristic conforming to a neighborhood geography of centrality, protectionism, self-containment, and introversion.

With the proliferation of middle-class and upper-middle-class gated communities, new forms of exclusion and residential segregation are created, exacerbating a social polarization that already exists. Suburbanization, in particular, has created and maintained patterns of segregation that have directly contributed to the development of gated communities. Historical research points to the evolution of the suburb as an exclusionary enclave. From its earliest beginnings, the suburb has been an "anti-urban" community where the upper-class, followed by the middle-class, residents searched for sameness, status, leisure, and security in an ideal "new town" or "green oasis." In the late 1980s, real estate speculation accelerated the building of gated communities around golf courses designed for exclusivity, prestige, and leisure.

Scholars also suggested three primary motivations in residing in a gated community—protection of the amenities associated with a certain lifestyle (centered

on clubs, sports, and leisure); projection of an elite image and exclusive compound (protection of the rich and famous from the public gaze); and security against crime. The secured enclaves and walled architecture, made possible through the installation of guardhouses, walls, and entrance gates in established neighborhoods, are responses to rising urban paranoia and criminality. As the political and economic democratic practices that mediated some forms of class separation in the built environment break down, the creation of new gated communities is sought to maintain the social hierarchy and status quo. The protected domain of the gated neighborhood thus offer a communal camaraderie of the privileged, shielded against the poverty-stricken class.

Recently, the concept of a "self-contained leisure paradise," such as Tagaytay Highlands, has created an ideal community combining the concepts of recreational organic farming, a theme park, a resort, a golf course, and a mountain hideaway. A Tagaytay Highlands publicist maintained:

> Ah, picturesque Tagaytay Highlands. If you ever have a chance to tag along with a member of this exclusive (for members only) community and catch a glimpse of the 900-hectare leisure estate offering spectacular views of Taal Lake then leave your worries behind the urban lowlands. Stress does not belong in this postcard-perfect setting. But there's more to Tagaytay Highlands than just cleansing one's body and soul.
>
> Behind the 6,820-yard championship golf course, the sports facilities, luxury log cabins, Swiss chalet-styled condominiums, and Spanish-Mediterranean houses are gestures of respect and gratitude for the environment. Mother Nature, after all, is a permanent member of Tagaytay Highlands, and she holds a powerful seat in the club's hierarchy (Salazar, September 4, 2003).

The enclave development is a packaged version of a dream of an ideal community—pure, secure, and natural. An inventory of the subdivision names of a leading, middle-class subdivision developer, such as Sta. Lucia Realty, is a telltale sign of

8.70 to 8.73 Sampling of mod
houses and thematic gate
communities clad in a menu
imported styles marketed by re
estate developers

such a tendency and marketing ploy. Placenames appropriated by Sta. Lucia Realty—Acropolis Greens, Baybreeze, Greenland, Greenwoods, Glenrose, Evergreen, Glenwood, Golden Meadows, Lakewood, Meadowood, Mira Verde, Parkhills, Ridgemont, Summerhills, and Valley View among others—would reveal a consistent toponymic theme evocative of a refreshing imagery of nature. As the names of subdivisions hint, the dream of suburbia is an escape from the city to a life enveloped by nature.

The suburban home is a symbol of an escape not only from the cosmopolitan environment but also from the broader problems of everyday life. Suburban domesticity does not only provide a sanctuary, it actively participates in the production of domestic fantasies as well. Thematic subdivisions and gated communities exploited the Filipino fixation with anything foreign by creating an illusionary neighborhood with the aura of a "Mediterranean villa" or an "American suburbia." The house is a symbolic package establishing the status and refined taste of its occupants. Some developers would even furnish these communities with houses with facades of Swiss chalets, American neocolonial houses, and neovictorian homes modified for the tropics to address the demand for distinction and all things imported.

The quest for authenticity has led to a propagation of archetypal imagery as reinforced by international architecture magazines like *Architectural Digest*. With the demand for Mediterranean houses, realty developers have churned out various interpretations to approximate the look of the highly marketable design. In reality, these houses imitated the "Mediterranean look" by imprudently synthesizing available styles drawn from the vast domain of the Mediterranean world. The entire Mediterranean assemblage was unified by the profusion of arches, courtyards, warm pastel wall surfaces of stucco finish or with planes of brick, wrought iron balconets, curvilinear gables or parapets, and red-tiled roofs.

74 Victorian rowhouses, aptly called Victorianne, recreated in La Posada, Brittany Bay development

Display or model houses are advertised to embody an illusion—they offer an experience of an ideal world (rather than the lived) which we are enticed to consume. Tagaytay Highlands excels in this stylistic sorcery, merging together four diversely themed neighborhoods in one locality: a complex of condominiums much like Swiss chalets is called Pinecrest Village; Spanish-Mediterranean detached houses are named The Villas; a hillside condominium on the ridge is known as Belleview; and luxury log cabins (built with Western Red Cedar logs imported from the United States) is called Woodlands.

Another developer, Brittany Corporation, boasts of its postcard-pretty, Victorian-inspired model houses in its webpage:

> The moment you see Victorianne at La Posada, one thing strikes you immediately: it's just like San Francisco. Inspired by San Francisco's famed "postcard row," Victorianne offers the stylish, old-world elegance of neovictorian design with flat canopies, bay windows, roof shingles, and eaves with brackets. Once there, you just might find yourself looking towards the bay for the Golden Gate (http//www.brittany.com.ph/victorianne.asp).

The sampling of model houses available in the market today denies and defies the reality of the site's cultural and physical geography. All of these suburban model houses indicate a Eurocentric and heterotrophic imagery declaring that the ideal home is found in other places and other times.

The Postmodern Retail Environment

Megamalls have become a ubiquitous urban fixture generating new urban spatial experiences under a singular, enclosed domain. Yet, the advent of the supermall is fairly recent, which could be traced as a post-Marcos, urban phenomenon, creating an alternative, quasi-public congregational space in privately owned estates. The latest concepts in the design of retail mall environments are embodied by the architectures of SM Mall of Asia (2006), Gateway Mall (2004), and Ayala Greenbelt (2004). The last two have been very successful in revitalizing the worn-out districts within their respective vicinities—Cubao and Makati.

The development of large-scale retail environments has always been attributed to ShoeMart (SM), which began as a modest shoe store in Carriedo, Manila, in 1958. Owned by Henry Sy, a native of Fujian Province, China, the establishment came up with a formula for a surefire, income-generating strategy by selling shoes in large quantities at very low prices, resulting in the swift turnover of stocks. Venturing into other merchandise, such as textiles and household goods, Sy opened his first Shoemart department store in Makati in 1962, followed by one in Cebu in 1965 and another in Cubao in 1967. While other developers stayed away from new business ventures during the economic recession of the 1980s, Sy invested capital into new business deals and began to build his colossal malls. The first SM, as Shoemart is now called, rose in Cubao in 1985, in the wake of the crisis caused by the Ninoy Aquino assassination. Shortly after the EDSA Revolution in 1986, SM City North in Edsa was built, followed in rapid succession by SM Megamall (1991) in Mandaluyong, SM City Cebu (1993), SM Southmall (1995) in Las Piñas, SM Iloilo (1999), SM Pampanga (2000), SM Davao (2001), SM Cagayan de Oro (2002), SM Baguio (2003), and SM Batangas (2004).

In 1992, the six-storey SM Megamall, designed by architect Antonio Sindiong, earned its distinction as the "largest mall in Asia," with its concept of a "self-contained city" spanning half a kilometer long. The SM chain of department stores used to be identified with "shoebox architecture" (perhaps in remembrance of SM's humble origins) distinguished for its template of a windowless, brutalist façade whose median was accentuated by the huge, blue, backlit letters of "S" and "M." Renovations and new constructions began shedding monotonous and unremarkable presence in support of plural imagery and consumption-stimulating facades. For instance, for SM City Baguio (2003), architect Jose Siao Ling deconstructed the well-beaten SM box into a structure of terraced masses roofed by a series of five overlapping skylight canopies that are made of stretched Teflon-layered membranes, thus creating a strikingly complex geometry. The canopies are arranged in such a way that both sunlight and strong breezes reach the promenade areas on the mall's ground floor.

As of 2008, the number of SM Supermalls have reached the 33rd mark with more than 4.1 million square meters of combined gross floor area. The grandest and most ambitious of them all is the SM Mall of Asia (2006) in the Bay City, Pasay City, designed by Arquitectonica with Robert Carag Ong and Associates as architect-of-record. Envisioned as the premiere destination mall in the Asia Pacific region,

the 386,000-meter mall occupies a nineteen-hectare property in the Bay Boulevard. It offers a panoramic view of the world-famous Manila Bay and features over 600 local and international brands and 150 indoor and alfresco dining outlets.

The SM Mall of Asia complex consists of four buildings linked by elevated walkways— the Main Mall, the North Parking Building, the South Parking Building, and the Entertainment Center Building. The Main Mall houses shopping and dining establishments, the Food Court, and the country's first Olympic-sized ice skating rink. The South Parking Building is where the SM department store and half of the 5,000 parking spaces are located. The North Parking Building includes the SM Hypermarket, and the Entertainment Center Building houses ten theaters, including a Director's Club and the country's first IMAX theater.

Outside, walls are expressed as curving planes intersecting with oval forms at the entrances and performance areas. Skylights are a varied progression of squares and oval forms. Pedestrian streets are lined with zigzag forms and parapets to give them a variety of human scale. Though the overall effect seems one of randomness, the design is, in fact, a well-balanced composition, which reduces the considerable mass of the building, lending structure to the dynamic configuration.

The US-based retail design company, RTKL Associates Inc., have designed a master plan for Araneta Center in Cubao, in which Gateway Mall (2004) is the first phase of the ambitious US$1.25 billion plan to reinstall the area as the prime business and retail complex within twenty years. The two-billion peso Gateway Mall is composed of five levels of shopping, dining, and entertainment destinations, linking two major transit lines (MRT 3 and LRT 2) to benefit its patrons. Gateway has also brought elegance to shopping and has set the standard for the upscale malling experience in the area. Anchored by the 25,000-seater Araneta Coliseum, the 100,000 square-meter mall features ten-screen Warner Bros. cinemas. A remarkable architectural feature of the mall is the Oasis, a glass-encased floating garden, which opens to the sky and is adorned with fifteen-meter palm trees, rare

8.76 Cubao's Gateway Mall

plants, and designer waterscapes. Indeed, Gateway Mall is the symbol of Cubao's urban renaissance, breathing new life into Araneta Center, attracting new customers, and catalyzing future residential and office developments within its vicinity.

The Ayala Greenbelt (2004) development in Makati exemplifies the new urban strategy that endeavors to create a highly pedestrianized urban center by limiting dependency on vehicular movement, providing housing closer to the place of work, and preserving green open spaces. With such goals realized, Makati's Greenbelt development made international headlines by winning the Urban Land Institute Award of Excellence. The institute is a US-based international research and educational organization that provides leadership in the use of land to enhance total environment and community life.

In retrospect, Greenbelt's developer, Ayala Land Incorporated, was the one that pioneered the development of shopping centers in Metro Manila in the 1960s beginning with Makati, then still considered as Manila's suburbia. Since then, the company has grown phenomenally and has ventured into condominium and residential community development in the area. In no time, Makati has become the country's premier central business district, with a built-up area so dense that it seemed unlikely that a new shopping mall could be squeezed in within the remaining open space.

As an innovative development, Greenbelt veers away from the retail architectural formula that has dominated the urban landscape in the last twenty years. The prevailing model was the climatically controlled enclosed environment characterized by massive, monolithic, windowless box architecture punctured by a central atrium. Greenbelt, as the name suggests, is located in a park that architecturally establishes an environmental rapport with verdant tropical foliage in a highly dense cosmopolitan area, reclaiming green spaces for the public. Hence, it reverses the popular perception that malls have invasively conquered and taken over the city's remaining open parks and plazas.

8.78 Tropically responsive architecture of Greenbelt Mall

Greenbelt 2 and 3 are additions to Greenbelt Mall (now renamed Greenbelt 1) at the corner of Paseo de Roxas and Legaspi streets. These urban accretions occupy what used to be an open parking lot on Esperanza Street. As part of the Ayala Center, along with its sister mall, the Glorietta, Greenbelt 2 and 3 are seamlessly integrated with a 2.6–hectare urban park teeming with 600 full-grown trees, a virtual tropical forest amid the asphalt jungle. The master plan, which judiciously incorporates the urban park with the extended mall configuration, is attributed to the collaboration of Seattle-based Callison Architecture with local counterpart GF and Partners for Greenbelt 3 and Recio+Casas for Greenbelt 2.

Greenbelt 2 was originally intended as a parking structure. But from the drawing boards of Recio+Casas, the mundane parking building becomes the trajectory of a daring architectural experiment as its main function is disguised by two rows of arcaded restaurants on the northern and southern sides of its first floor. The dining spaces in the northern side extend beyond the arcaded walkway to blend with the landscaped areas, providing a sumptuous alfresco dining space. The second and third floors of the structure are, of course, solely devoted to parking spaces. But who could have imagined that at the fourth level are twenty-eight exclusive garden townhouses (aka "The Residences") for lease. According to Ayala Land, these domestic abodes are

> an inviting cluster of townhomes with the feel of a small village that seems to spring from nowhere. From the main entrance at the ground floor of the Residences at Greenbelt and through an exclusive lobby, one rides the elevators to the residential level. When the elevator opens, you see a central garden around which the townhomes are clustered and you think you are on ground level again. You enter a unit whose size may range from a comfortable 150 square meters to a spacious 217 square meters and open a door into a pocket garden, a standard feature of each of the units. The gardens make you feel you are in a quiet residential enclave. You look beyond the greenery and see the surrounding rooftops. You catch yourself and realize you are not on ground level but actually four levels up (http://www.ayalaland.com.ph/news/view.asp?news_id=32).

This planning maneuver is a gem in exercising maximization of real estate potentials through a simulation of a ground-anchored New Urbanist neighborhood.

Immediately at the east of Greenbelt 2, at the corner of Esperanza Street and Makati Avenue, is Greenbelt 3, designed by GF and Partners. Greenbelt 3 houses the familiar retail functions. The largest structure among the three buildings, it houses theaters, a food court, shops, and restaurants. The building, crescent in form, opens to a landscaped area that includes a lagoon, waterfalls, and fountains. This palm tree-lined area is the principal exterior plaza that acts as the focal point to the development. As a focus, however, it does not overwhelm the whole development or compete for attention but works with the other elements in a responsive and symbiotic manner. This design intervention that blurs the boundaries of the inside and the outside creates a congenial context for consumption, encouraging pedestrian activities to reclaim the outside as a possible site of conspicuous consumption.

Internally, the ground floor of Greenbelt 3 contains a double-loaded corridor lined with commercial establishments. The mall itself detours from the pervasive retail emporium cliché as orthogonal spaces or atrium volumes are absent, replaced rather by sensuous, curvilinear circulation paths. Curved corridors, walls, and ceilings provide this mall with added grace and spaciousness, qualities which are absent in extant, boxy mall chains. The upper floor is open in plan, reminiscent of arcades of the past. Unlike the historic precedent, however, the Greenbelt arcade combines soaring walkways, grand staircases, elevators, and water elements, totally enhancing the dramaturgic aspect of mall theatrics and offering stage-set architecture designed for uninterrupted visual pleasure that veils the exchange relations between the consumer and the producer. Generous, open-air corridors act as balconies where one can view the lagoon, trees, and fountains.

The mall architectures of SM Mall of Asia, Gateway, and Greenbelt have offered retail destinations that veered away from the worn-out aesthetic formula—a monolithic, rectangular, and sprawling architecture whose façade perpetuates nothing more than seductive images and signs to reinforce the culture of conspicuous consumption. These recent developments have created environments that are enriched by concepts of tropicality and pedestrianization. These retail environments, however, in order to be globally competitive, must nurture a globally recognized, postmodern, architectural presence, constituted by highly marketable images, colorist confections, structural exhibitionism, brash collages of surface treatments, and global brands. To be in these places is to participate in the consumption of visual luxury and calculated leisure, which to a certain degree deny the existence of urban squalor and massive poverty outside their domains. The success of a retail mall environment is equated with its ability to cloak the mechanisms of capitalistic extraction, consumer exploitation, and the exchange relation between the producer and consumer—the very basis of their operations.

Ecclesiastical Eccentricity: New Architecture for Worship

Places devoted for worship are spaces where faith becomes concrete. Regardless of the differences in beliefs, rituals, symbolic functions, and subject of adoration, architecture for worship has a singular raison d'etre—to channel the devotee to the route of spiritual transcendence through spatial manipulation. Such space, as it bears the symbolic link between the terrestrial and the celestial, is designed to

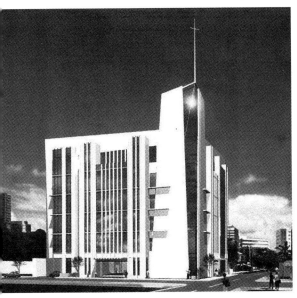
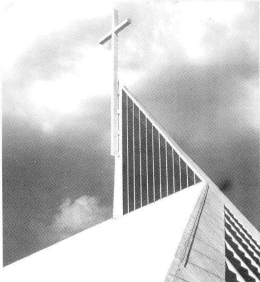

.79 New Millenium Evangelical hurch

.80 Church of Gesù

inspire a feeling of aspiration toward God and Heaven through the human approximation of the metaphysical beauty of Heaven and the constant solicitation of other-worldly allure.

New liturgical environments of neomodern persuasion have enriched the landscape of worship. The Church of Gesù (2002), in the Ateneo de Manila University campus, is a remarkable specimen of Filipino church architecture, creating a new symbol for the Christian faith and the Jesuit institution. Designed by Jose Pedro Recio and Carmelo Casas, the edifice is dominated by a triangular structure symbolizing the Holy Trinity. The minimalist triangular geometry is prefigured in the three points of the outstretched hands and head of the Sacred Heart statue that originally sat on the hill and had been incorporated into the new site. Moreover, the lucid triangulated outline calls to mind the vernacular roof forms which form a huge "A."

The New Millenium Evangelical Church (2003) stands out as a deviation from the solemn atmosphere of churches. The ultramodern, six-storey edifice is defined by planes of white concrete accentuated by turquoise reflective glass. A tapering trapezoidal tower topped by a sleek steel crucifix and punctured by glass planes at the corner gives the building height and sharp edges.

The Ampoanan Sa Kalinaw Ug Kinaadman (2002) chapel of peace and wisdom at the botanical gardens of Southwestern University in Cebu is an eccentric architectural-cum-sculptural experiment that defies orthodoxy in the design of liturgical environments. Clutching onto postmodernist aesthetic credo, the edifice, or full-sized sculptural installation, as the building auteur claims it to be, is a rich evocation of allusive interreligious imagery, and, at the same time, is scenographic in its brash applications of color on the building skin.

Designed by one of the pillars of Philippine modernist sculpture and a state-proclaimed National Artist for Sculpture, Napoleon V. Abueva, the Ampoanan is an aesthetic departure from the pervasive Hispanic Baroque genealogy in Philippine

church design and branches off from the progressive tenets of Soft Modernism, a movement that renounced the well-beaten transept configuration of the church in the 1950s to explore new sculptural geometries using the plastic potentials of concrete.

The annals of modernist design have validated Abueva's corpus of sculptural works, earning him the title of the father of modern sculpture in the Philippines. Armed with his experimental and bold approaches, he etched his presence in the art world from doctrinal dissent to a modernist mentor in a career spanning half a century. Through his prolific work, he was able to tilt the balance between classicism and modernism in favor of the latter. In his work, he employed sacred symbolisms, as evidenced in his double crucifix (1957) for the Chapel of the Holy Sacrifice at the University of the Philippines; his Transfiguration (1979), a towering Christ figure at Eternal Gardens Memorial Park in Caloocan, and his 14 Stations of the Cross, installed along the circular inner walls of the Claret School Chapel in Diliman, Quezon City. He has done altars in wood with metal trim, combining modern with folk in the ornate reliefs. A number of aspects emerge from his work: the purely figurative, the fantastic, the constructional, the highly stylized, the abstract, and the functional.

Employing the same penchant for religious iconology that characterized his earlier works, Abueva sought to reify the abstract concepts of religion into lived spaces of worship through the physicality of his architecture-cum-sculpture called Ampoanan. Originally conceived as the Chapel of the Resurrection, the huge art piece has been redesigned to address the needs of the university and has reemerged as a house of prayer for peace and wisdom. Here, a myriad of religious metaphors and highly symbolic concepts are juxtaposed to infuse the architectural volume with an aura of spirituality and sacredness. These surface maneuvers and compositional inventions are clever enough to engage the devotees with familiar liturgical and sacred imagery, which overrides the artist's occasional provocation of esoteric symbols lifted from other dominant world religions, to sustain the chapel's claim of being an ecumenical congregational space.

Places of worship are adorned with numinous symbols of devotion either in the form of figurative sculptures or highly stylized design elements to conceal the referents (for faiths that forbid mimetic representation of nature and religious deities) as a mode to teach the doctrine visually, while conditioning the psyche of the devotees for worship, spiritual contemplation, and oblation to higher powers. In Ampoanan, God is truly in the details, as symbols derived from diverse religious creeds are allowed to intermingle and interlace with one another without privileging one religious culture. Overall, the interpretation of these architectural symbolic elements provides opportunities to decode the embedded content that speaks of the universal mystery of spiritual inquiry and the human aspiration to transcend material existence.

From the outside, the monolithic, convoluted, and azure columns that form into an overlapping entrance canopy valorize the plasticity of concrete and symbolically portray the gesture of hands in prayer. At the chapel portal, a grooved fiberglass disk having a diameter of nine feet and made to simulate the materiality of stone partly conceals the circular front door. Such a design element is a direct quotation from the biblical narrative of the Resurrection where the stone in the tomb of Jesus

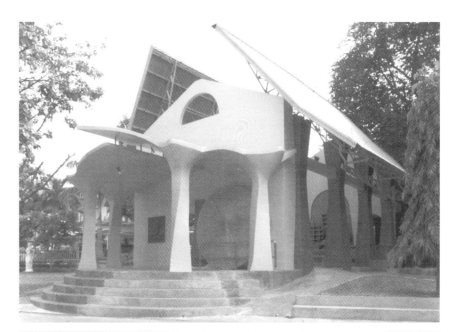

was rolled away upon his rising from the dead. This passage represents the commencement of a spiritual quest and the consequential attainment of spiritual insight.

As an interfaith house of prayer, the interior is enriched with calligraphic symbols of Hindu, Buddhist, Islamic, and other religions engraved in its eight main columns. Water, a universal element of nearly all faiths, is given reverence via the floor terrazzo pattern that recalls the sinuous "river of life," with streams branching and flowing through the unwalled building laterals, suggesting the union of varying

religious persuasions into a universal belief system auspiciously accommodated by Ampoanan. The organic flow created by the floor pattern easily breaks the rigid axis formed by the central nave and the rectangular floor plan.

On the altar wall, acting as the terminus of the axial plan, is a mobile assembly that rotates on a pin with bookshelves mounted on the reverse and holds scriptures of different faiths further reiterating Ampoanan's ecumenical and scholarly concepts. At the back of the altar is the sacristy roofed by a sculptured concrete canopy. The circular forms rotating at a common center can be variously interpreted as an abstraction of the holy cross, as a representation of axis mundi, or perhaps as a homage to the mandala. Through this centerpiece, the devotional space succeeds in its ambiguity and absence of any clear-cut imagery identified with a specific religious affiliation.

Visually and symbolically arresting is the retractable roof—a light steel-framework construction with metal sheets—that divides longitudinally into half to open the roof system. Aside from modulating the atmospheric quality of the interior space, it assumes a symbolic portal when opened through a combination of motor and manually controlled pulley mechanisms, literally directing the worshiper to the celestial and allowing the devout to pray straight to the heavens. It is interesting to note that in such a sacred space, the terrestrial world and the world of the gods meet—a point that bonds heaven and earth—creating an imaginary vertical axis of communication between God and man.

However, spatial sanctity and sacred imagery, the very qualities that a worship space aspires for, have been dampened by the introduction of profane pop colors and the meretricious packaging of the exterior—design interventions ordained by the widespread commodification attributed to commercial architecture. Here, the potency of the architecture to reroute the devotee from the profane and worldly to the realm of meditation and spiritual contemplation is simply annulled by the choice of a distracting chromatic scheme and forfeits the intellectual iconology invested inside Ampoanan. The candy-colored external skin does a disservice to the whole composition and poses a threat to the entire semiotic-spiritual concoctions and the interfaith pretensions of the chapel. The façade is symptomatic of an unholy alliance of religion and postmodern vulgarity and of an attempt to pass off an eccentric sculpture as architecture. The layering of garish humor and the techno-whimsicality associated with the Disney-fying aesthetics of late-capitalism are postmodern design maneuvers that Ampoanan absurdly perpetuates. These become incompatible with the creation of sacred edifices, whose intent is to prop up spiritual imagination, nourish and enhance religious experience, and convey meaning to reveal ontological truths.

The Production of Postmodern Megastructures in the Global Cities of Manila

Amid the dramatic reconfiguration of Manila's urban landscape, nothing typifies the emergent character of the late capitalist space more graphically than the production of commercial megastructures sited in microcities that profess allegiance to the globalizing paradigm. Three local urban developments—Fort Bonifacio Global City, Rockwell Center, and Eastwood City Cyberpark—portend the concept of self-contained total environments that internalize the multiple functions of the surrounding city. These triumvirate urban environments play host to fantastic

architectural set pieces, boasting a master plan that purges the harsh realities of Third World urban conditions and deviates from the pitfalls of other world cities. They are "ideal" urban environments brought about by the globalization of capital that reflects the logic of corporate consolidation and conflation of public and private cooperation. To be in these places is to be seemingly a part of an environment of luxury and to forget (at least for awhile) the squalor caused by widespread urban destitution.

Theorizing the Global/Local in Relation to Urban Placemaking

It is assumed that the spatial and architectural manifestations of what we crudely refer to as "globalization" can be sighted/sited in the CBD (central business district), the downtown, as evidenced by the presence of multinational corporation headquarters, international banks, or the pervasive sign of franchised global corporations, such as McDonalds, Nike, Sony, etc. Though these evidences are quite obvious, there is more to the effects of globalization upon urban placemaking and architectural production. What we need to know, as Crang (1999) suggests (drawing on and condensing Henri Lefebvre's [1991] three key concepts of "representations of space, spatial representations, and representational practices"), is how globalization phenomena take place through "conceived, perceived, and lived spaces" and in changing patterns of spatial production and consumption.

The notion of globalization initially strikes us as a homogenizing force that sees the world as a single place (Robertson 1992, 30). Without a doubt, the worldwide revolution in communications and the global ecological, political, and economic affairs facilitates "intensification of the consciousness of the world as a whole" (Robertson 1992, 18). Other scholars have pointed out the repercussions of this phenomenon in the urban form through the notion of "world cities," referring to those places that take on particular organizational structures and other functions in the world economy (Freidmann 1986) resulting in their having distinctive economic, social, spatial, and architectural characteristics. The awareness of the interconnectedness among these urban centers has spawned the idea of "global cities," a term used by Sassen (1991) to refer to those unsurpassed loci in the

3.83 World-class buildings inside the Eastwood City enclave

world economy—such as New York, London, and Tokyo, with their assembly of international banks, multinational headquarters, and unique occupational features—which are assumed to possess "global control capability."

These globalization theories provide seminal suggestions for understanding urban transformation and architectural development. Historical phases of the globalization process are inscribed in the cities in varying intensities of modernity, not only in the traffic of capital but also in the transplantation of ideas, institutions, and cultural practices.

The urban transformation in these key sites of Metropolitan Manila fuses local politics and strategies of the global market forces. Globalization incorporates a myriad of accelerating trends, all of which have palpable effects on the urban form—a heightened flexibility and mobility of capital investment, the neutralization of geographical space and distance, and the amplified flow of people around the planet (King 1990). These globalizing ramifications raise the power of global cities as a vortex of authority and control of the global enterprise.

Such cities create an urban paradigm that packages itself to entice banking and financial institutions, the bases for the new class of managers and image-makers. A global city is a place where ideas are conceptualized, capital is invested, and global implementation is managed. Global cities attract investment, therefore, growth in wealth and power is accelerated. London, New York, Tokyo, and perhaps, Paris, Hong Kong, and Los Angeles epitomize the prescription of a global city (Sassen 1994). Cities that do not measure to the level of these cities compete most fiercely for position in the global hierarchy. Such competitive gestures influence the manner by which urban projects and infrastructures are formulated, designed, and implemented.

Before turning to the local manifestations of this global-urban paradigm shift in Manila, the discussion of globalization must include some issues linked with its consequences on urban architecture and planning. The dominant tropes by which these packaged urban cities become present in the local/global arena must be fleshed out.

There is a sweeping polarity and contradiction between the local and global forces on both cultural and economic spheres. Local culture is ingrained in a community of face-to-face encounters and infused within the matrices of everyday life; consensual memory is grounded in a particular locality. Localities/local places assume "local character" based on the summative or combinatorial character of the inhabitants' basis of self-definition—ethnicity, gender, class, and age—which are layered with an amalgamation of cultural geography, urban form, and architecture. The local, with its multifaceted character, may seem insignificant with respect to the global, yet as Hannerz (1996, 28) maintained in his book, *Transnational Connections,* "in aggregate it is massive."

Local differences and nuances of urban character are appealing to global marketing stratagems. Digressing from the concept of globalization as a homogenizing process, Robertson suggests that such a process is filtered through and mediated via local culture, histories, political power, geography, fluctuations in capital, and the policies of local space of a given state. Resulting manifestations of the process,

represented through the transformation of the built and designed environment, are modulated through the rules, mores, codes, and policies of the individual places and states. Thus, the logic of global capital is rearticulated by the local culture to dispense a unique urban texture. Globalization does not simply mediate and dissolve differences between cities, it also catalyzes them. The difference will be the selling point of any city as an economic space that serves as a conduit where global capital flows. The local character of the urban scenography becomes the basis for marketing the city. Thus, local places are valued and charged to compete for global consumption, which brings to the fore a renewed investment on urban imagery and spectacle as well as a heightened interest in the construction of city identity. For instance, Manila's global cities capitalize on the semiotic capacity of architecture to invoke scenographic iconography plus an image-making strategy heightened by place naming and cultural associations to fabricate the identity of a particular city. Fort Bonifacio Global City is charged with historical allusions pertaining to the Philippine revolutionary hero, Bonifacio; Eastwood City Cyber Park passes itself of as a mecca of information technology; buildings in Rockwell Center are named after Philippine art masters, such as Joya, Rizal, Amorsolo, and Manansala, to bestow the urban space with a cultural pedigree that was never there. Here, local places are then appropriated for global strategies. Urban marketing requires civic imagery, which can identify places and cities as different products and packaged landscapes. This catalyzes the market for iconic imagery entrenched in "signature architecture" designed by world-renowned and high-profile architects and planners, who both work to signify a genus loci (sense of place) for global consumption and to ensure its value as a "symbolic capital." The competition for building the tallest building is part and parcel of this discourse where the city becomes a "prop" for the "world stage" (King 1997). This principle applies to a range of scales, from a mere background to a CNN television interview, to smaller scale images, such as street life, to be used in civic marketing. Cities without recognizable architectural icons (think Eiffel Tower in Paris, Manhattan skyline in New York, Petronas Towers in Kuala Lumpur, or Millennium Dome in London) are not in the market.

Sakia Sassen (1994) maintained the notion that competition among cities for large-scale urban developments lends power to global developers who obtain concessions from the local government through the threat of reallocating their flexible capital to another place. In the process, established local policies are bent or bypassed to favor global concessions that require unusual prerequisites ranging from tax reduction, circumvention of planning protocols, agreeing to contractual secrecy, and making public lands available. Local and central governments, in an effort to entice global investments, are prepared to offer public subsidy and a semblance of public support and consensus. According to Kim Dovey, such power relation affords globalization "a condition under which cities seeking global investment are asked to suspend processes of democratic participation and to exclude public scrutiny under the cover of commercial secrecy." (1999, 159) As this condition is achieved, public interest cannot be lobbied nor debated, since this vision of the urban future and its cost and prospective benefits remain hidden, rendering the entire community absolutely blind.

The influx of global capital results in the increase of the city's material wealth, yet, at the same time, magnifies class polarity and social inequity within the larger urban matrix, exemplified through the physical juxtaposition of glossy skyscrapers

with urban dereliction. Or it can be expressed in the process of gentrification or the process of renewal and rebuilding accompanying the influx of middle-class or affluent people into deteriorating areas that often displaces earlier but usually poorer residents.

Megaprojects perpetuate highly asymmetrical urban developments. Local governments seek investors and offer large chunks of public lands or in-fill properties for megaprojects, which are often mixed-zones of upscale consumption and housing enclaves. But the "mixed" criteria in such projects are formulas based on the consumption of a specific market sector, thereby heightening the spatial detachment of the social class. As this dichotomous landscape toughens the boundaries and fixes identity at one surface, at another stratum they construct what Zukin (1995) terms as spaces of "liminality"—spaces between categories and identities where public and private interests are falsified. In a sense, this is similar to the realm of the shopping mall at a magnitude of urban scale—a de-politicized, "psuedo-public" realm open to public access but lacking the spontaneity and freedom of a public domain. A coalition is forged between the public state and the private estate, whereby public interest is signified while private interest is served; public meanings are maneuvered by private control. Like in the mall, these urban spaces generate a zone where vagrancies, deprivation, and political acts are evicted from its premises without forfeiting the legitimacy of the state.

The liminal zones amalgamate and demolish boundaries between culture and consumerism. Heavy investment in public art becomes meshed with the logo techniques of advertising in which the framing, location, and content of art are geared towards the spectacle of consumption. Public art becomes neutralized by corporate sponsorship, with subtle censorship of any idea that does not catalyze or mechanize consumer fantasies. Places are framed in the mode that dispenses artistic expression as docile as the passing people. Commercialism dominates public space. It colonizes the consciousness of the passersby through the alchemy of advertising strategies—signages, paving patterns, billboards, and corporate architecture—making its presence felt in the streetscape that constantly bombards one's visceral self. The culture of both the masses and the elite is colonized as public museums, galleries, sporting arenas, and even educational institutions become active sites of corporate events (NBC tent in Fort Bonifacio, Lopez Museum and Ateneo Graduate School in Rockwell, and International Center of Information Technology Education in Eastwood City). Such facilities are constructed to imbue corporate dealings with an aura of civility and cultural pedigree, creating an alluring environment bereft of the vagaries of urban life and concealing or disguising economic exchange relations among economic actors. Commerce fuses well with sports, culture, and art—fields of production wherein economic interest is constantly denied (Bourdieu 1994).

This testimony in the fusion of culture and commerce is evident in the conceptual narrative used in Fort Bonifacio Global City's website. Invoking the values of art in the urban setting, the text cogently asserts:

> Aesthetic values, modern architecture, green and cool surroundings, glorious food, boundless excitement, soul-lifting arts and culture—all converge in the Global City, in an abundance that nurtures and enriches the qualify of life. The City's theme, "the way life should be," has been fashioned into a reality that will elevate the Global City into

a destination comparable to any of its worldwide counterparts. Apart from these, the City will serve as a cultural hub. Culture will evolve as it does in any commercial gateway, with the establishment of galleries, concert halls, museums and cultural centers (http://www.fort-bonifacio.com/index.html).

The globalizing forces dominating cities have dissolved the notion of a local and "pure" cultural identity as the juxtaposition of the difference of cultures give way to dispersed heterogeneity. Borders, fragments, cultures, and hybrids intermingle and redefine the urban space. However, as Henri Lefebvre (1991) points out in the analysis of "social space," this is not a mere juxtaposition that threatens the "local" into dissolution, as "the worldwide does not abolish the local."

Turning to Manila, the triumvirate cities have internalized the manifold function of the surrounding city. What differentiates these cities from the extant cities of Manila is that they are artificially conceived, fantastically aestheticized, and dispensed with a culture of pretensions among its occupants. They are synthetic cities (as opposed to real cities which are founded through a natural agglomeration of settlers). Borne out of capitalist urbanization that seeks to develop in-fill land in the city, they consequently generate a patchwork of "cities within a city" or self-contained "microworlds" that constantly repudiate any signifier of poverty in its periphery, becoming an exclusive space for fantasy and lived escapism. This urban phenomenon occurs primarily within a fragmented development, such as Manila, distinguished by the absence of a comprehensive or strategic vision as to how the city will develop and function holistically. Foucault (1986), though referring to the system of disciplinary and institutional spaces, coined the word *heterotopia* to encapsulate the logic of a society where spatial alienation and isolation become a widespread tendency. This notion can be appropriated and extended to an urban context. The contemporary megastructures exemplify the dual logic—they are at once systematically segregated from the city outside and at the same time become "claustrophobic" colonies of space that endeavor to reimagine "the genuine popular texture of the city life" within them (Davis 1990, 86).

The heterotopic inflection reaches its apotheosis in the three microworlds. Spaces as grandiose set-piece megastructures are designed as autonomous entities with concern only for what is immediately adjacent or directly contributive to their rental value. Standing authoritatively against the skylines of Manila, their buildings fall dominantly under the mixed-use development (MXD) category, which is reflective of this centrifugal movement or self-centric spatial programming of activities within the confines of the city. MXD subscribes to the principles of New Urbanism, preached globally by Miami-based architects and town planners Andres Duany and Elizabeth Plater-Zyberk. New Urbanism is trumpeted locally by Felino Palafox Jr., Rockwell Center's master planner on record (with SOM as design consultant), as a planning alternative to eradicate automobile-dependent communities and transform them into traditional urban models of the neighborhood, a place where living, working, shopping, and all the other aspects of life exist within walking distance of each other—all conforming to the geography of centrality, protectionism, and introversion. A mixed-used development, as in the case of Rockwell Center, is hailed by its master planner as "an ideal, master planned mixed-use development that incorporates the elements of sustainable living in one place" (Lico 1999a, 73). Here human activities are framed inward as it offers a balanced blend of dwellings, workplaces, shops, civic buildings,

recreational facilities, and landscaped open spaces (the proximity of activities reduces the number and length of vehicular trips), and pedestrianized street networks that discourage motorized movement (structures are independently accessible without any singular reliance on cars). Walking is further encouraged by making the tree-lined streets not just mere routes but destinations themselves, and devoting more public open spaces which will serve as focal points for all structures and sub-blocks. The basic principle of this city is that it can stand alone, intentionally divorcing itself from all forms of urban dereliction existing beyond its margin.

Fort Bonifacio

The "Global City" of Bonifacio presents several dimensions. First, former President Ramos had underscored the principal significance of "Bonifacio's symbolic national role in demonstrating to the world the Filipino's ability to carry out projects of this magnitude" (Lico 1999b, 109). The Fort Bonifacio Development Corporation has prescribed the specific auspicious attributes that make up the global city, all of which are of "international standards of creativity and execution" (Ibid.). This constitutes advanced technological capabilities leading to an "intelligent city," provisions for verdant open spaces, and a competent integrated transportation system, all of which are designed to attract and serve the larger international community. Bonifacio City aims to achieve a unique, sensuous, and multidimensional environment that must function within demanding financial parameters, thus, invoking the need to triumph as a commercial venture. These conceptions of a "Global City" can be construed as an international showcase, sanctioned as a symbolic carrier of national development aspirations within the larger "global village."

In 1995, at the outset of Bonifacio Global City's master planning, the 440-hectare former military fort had been the focus of intense international interest, prompting the media to hail it as "the deal of the century." With a bid of US$1.6B Bonifacio Land Corporation won the bid based on the plans of RTKL and PROS. The proposal was to acquire a fifty-five percent share, 214 hectares of the property, to develop what they envision to be Southeast Asia's best city. Canonized as the "nucleus of Philippine progress in the twenty-first century," Fort Bonifacio City is destined to be the model for future developments.

The contiguous 440-hectare Bonifacio property is bounded by three road arteries: the South Luzon Expressway, EDSA, and C-5. Its distance of one to four kilometers from Manila's other business centers—Ortigas and Makati—and, likewise, its adjacency to low-density residential enclaves—Forbes Park and Dasmariñas Village— are proof of its real-estate value. Strategically located at the center of the Laguna Crescent, an area comprised of the economic subregions of Ortigas Center, Makati, Boulevard 2000, NAIA Terminal 3, and industrial parks along South Superhighway and Filinvest Corporate City, Ayala Alabang, it is a potential catalyst for an entirely new economic mechanism in Metro Manila. Aside from its claim of being the country's potential business gateway, it also boasts of the best natural vistas in Metropolitan Manila and offers a sweeping view of Laguna Lake, Manila Bay, and the surrounding mountain ranges.

Since this city will emerge from scratch and defy the traditional conception of a city that evolves in response to external forces, it needs to adhere to a final master

plan designed by Hellmuth, Obata, and Kassabaum, Inc. (HOK), a San Francisco-based urban planning and architectural firm, and Planning Resource and Operations Systems, Inc. (PROS), the Philippine counterpart. The Fort Bonifacio Development Corporation (FBDC) became its implementing arm. The FBDC has been mandated "to create in Fort Bonifacio a well-planned, well-managed, well-developed, environmentally sustainable, and globally competitive metropolis to serve the needs and aspirations of the Manila urban community in the twenty-first century" (Lico 1999b, 111). In 2004, Greenfields Development Corporation and Ayala Land gained ownership of the project.

The Bonifacio master plan is a powerful amalgamation of world and regional planning schemes, realized within the contextual layering of functional, systematic, innovative, and visionary parameters. The developer asserts that the master plan's synthesis of international conventions is characteristically Filipino. The "Filipino-ness" of the master plan as well as its cosmopolitan mix is cursorily rationalized by citing the parallelism that exists between Filipino culture and Bonifacio's urban design: both having evolved from a mixture of assimilated foreign influences.

The morphology of Bonifacio's city pattern sprung from a consolidation of physical and conceptual inputs, yielding a final geometry that interweaves: (1) an organic framework (which adapts to the topography of the land but leads to less efficient land uses); (2) a gridiron pattern (which creates an efficient land utilization scheme but results in a static, predictable, and boring city pattern); and, (3) a radial/concentric pattern (which gives focal elements, images, and identity, but results in inefficient land use and problematic road networks). The explorations for the ideal city form for Bonifacio culminated by bestowing the scheme with morphological and conceptual continuity achieved through the fusion of the advantageous elements of grid, geometric, and organic city patterns, with primary North-South and secondary East-West ceremonial axes and a green, circular "heart" of the city at the center of the plan.

The city's plan grid was established by passing the centerline of Bonifacio Boulevard through the center of an existing traffic rotunda fronting the American Battle

Memorial. The Bonifacio Boulevard's axis was then rotated to N 18.5 degrees E. The NE-SW city street orientation creates a climatically adapted and feng shui-responsive design. The grid converges at the Central Commons. The established grid is then overlaid with the geometry of four concentric circles and a singular form, which stretches from McKinley Road to the institutional areas. On the other hand, the framework for "The Villages," a low-density residential enclave located at the southwest of the Bonifacio City proper, combines curvilinear parkways with dual, geometric-patterned villages, each with a perpendicular, central, green axis.

To neutralize the impression of a well-contrived urban environment, zoning allocation was designed to ensure the heterogeneity of a city and conjure an illusion of a city bred by communal collectivism. Heterogeneity characterizes great cities; they are an agglomeration of districts with physically distinct identities. The complex fusion of pragmatic and aesthetic considerations, which form the essence of Bonifacio City, is streamlined into districts that stipulate the desired city structure and individual neighborhood and architectural character along with their special features and landmarks. The concepts underlying the Bonifacio development are stratified into the following districts: Gateway Districts, Crescent West, City Center, Station Square, Bonifacio Boulevard, Institutional District, and The Villages.

The division of Bonifacio City into districts and the articulation of each district in a scheme of relationships establish an ordered and rational transformation of the site, at the same time, giving the site spectra of visual richness. Each district, while carrying specific neighborhood character and elements, is intelligently woven by such a scheme into what the designer conceives as a special and memorable urban tapestry.

The patchwork of differentiated districts is woven together by a rich, dignified, and layered system of open spaces, which provide ecologically viable focal points for each neighborhood and connections between neighborhoods. In Bonifacio, open spaces assume the form of community parks, neighborhood parks, perimeter greenways, plazas, and water features. The landscaped environments dispense an opportunity for showcasing Philippine flora and horticulture (for instance, the arched tree-tunnel alameda of McKinley Road renders a superb front door approach to Bonifacio) and a venue for exhibiting public art and sculpture. Streets become destinations, not just mere routes, by providing all streets with assigned "street tree concepts," thereby also defining and differentiating street hierarchies and introducing human scale to the streetscape.

Another key concept applied to the Global City is pedestrianization to make the city more humane, convenient, and comfortable. Several connected pedestrian systems are integrated into the plan: streetscaped sidewalks with a canopy of trees and street furnishings; skywalk-covered, direct, level-separated pedestrian connections across City Center Boulevards; arcades incorporated in the design of buildings with store fronts; passageways in the form of outdoor passages or enclosed air-conditioned gallerias; and greenway-sidewalks and bike lanes providing landscaped pedestrian settings.

The development density of the site entails a high concentration of development in the City Center and along Bonifacio Boulevard and sequentially lower concentrations away from the core. At the pinnacle of the development, it is

expected that there will be 8.6 million square meters of gross floor area on the 150-hectare Northern CBD. This area will showcase a dynamic volumetric montage of image-conveying glass towers and other world-class infrastructures that define Bonifacio's unique skyline. But given the imperatives of tropical climate, the reflectivity of exterior building skins is regulated. High-rises are required to be of first class materials, such as stone and metal. The execution of buildings is controlled by international building codes and standards. Utility systems supporting building operations are sunk below grade: for instance, the excrescence of overhead cables are avoided, thus, maximizing the sky exposure plane. These are just some of the conscientious details taken into account, attesting to Bonifacio's commitment to not leaving any design component, however small, to chance.

Bonifacio Global City, as it positions itself globally, has resorted to trans-nationalizing architectural imagery, planning, and design services. This is accomplished through the utilization of foreign design consultants teaming up with their local counterpart while providing contextual modification of imported Western architectural frameworks to assure its acceptance in the global market.

Now, the global city is in the first of four phases of implementation, with the creation of "The Fort" retail and entertainment center and the ongoing construction of several high-rises, including Essensa East Forbes, Pacific Plaza Towers, and One McKinley Place, at the 57.2-hectare Big Delta area. These structures and facilities of global caliber provide a preview of what Bonifacio City can offer to its future denizens.

There are many aesthetic and pragmatic aspects of the Fort Bonifacio development that are worth mentioning. Assuming a sociocultural perspective, however, it is indeed a city that tries to eliminate Manila's urban pathologies; but, several questions come to mind: In its aim to project a global image, will Bonifacio City attempt to shun the encounter of poverty and luxury and of social justice and privatization? Is it an urban paradigm that assumes the position of "consensus"— that there is little that we can do but accept the status quo by focusing the development on the upscale and simultaneously excluding the poor? It is hoped that Bonifacio City would not proffer fictitious allure and exalt synthetic images that entail a shrouding of the harsh incongruities and contradictions of the urban reality plagued with Third World dereliction.

Rockwell Center

Another global city paradigm being implemented is the spanking new Rockwell Center at a site that used to be zoned as an industrial district in Makati. An urban in-fill development rising on the site of its namesake, the former Rockwell Thermal Plant, the Rockwell Center take its cue from past shortcomings through the introduction of planning alternatives directed toward a mixed-use development. Rockwell's development is toward New Urbanism and an affirmation of ecological significance for a better quality of life and sense of place.

The master plan of the 15.5-hectare property is attributed to Skidmore, Owings, and Merrill (SOM) with Felino Palafox Jr., as the local counterpart.

Rockwell Center is a joint undertaking of Rockwell Land Corporation, the real estate arm of the Lopezes, together with Benpres Holdings, Meralco, and First

Philippine Holdings. Aside from Rockwell's interest in designing facilities and structures of global caliber, the utilization of international expertise can be justified in that it provides the maximum amount of leading-edge experience for Filipino architects, creating a probable impetus for design and architectural consultancy as a Philippine export. Working with international teams will not only enhance the local architects' expertise, but will also advertise Filipino professionals in the global market through Rockwell's characteristics.

The 730,000-square meter Rockwell Center is a superblock located in Makati City. It is bounded by J.P. Rizal Street and Pasig River on the north, Amapola Street on the south, Palma Street in the west, and Estrella Street in the east. Its strategic central position conjoins the central business districts of Ortigas, Makati, and Bonifacio Global City, and affirms its role as a potential urban development catalyst for Makati City. In addition, it will utilize the Pasig River as the front door of the development, thereby revitalizing the river as a transport corridor linking the western and eastern part of the metropolis, and hopefully triggering future riverfront development.

The physical framework of Rockwell Center exhibits a synthesis of grid and geometric elements arranged within a superblock whose edges are part of a network of corridors connected to the dominantly sprawling residential neighborhood. Its ceremonial axis traverses the north-south and terminates at a landmark block where the monumental Lopez Center—a fifty-storey office tower designed to dominate Rockwell's high-rise scenery—is to be situated. The Lopez Tower is intended to be the tallest in the country, rising to 320 meters (sixty-five floors). The axis conveniently dissects the property into a luxurious residential block on one side, with office blocks and the Power Plant Mall—the development's centerpiece—on the other.

Around the low-rise shopping center is an assembly of glossy tower blocks that break the monotonous uniformity by the volumetric montage of each building's individualized form and character. Each building in the residential block is named

after a Filipino art master—Luna Gardens, Amorsolo Square, Rizal Tower, and Hidalgo Place—eliciting the same regard we have for these personalities. Such a move is a clever marketing scheme, which bestows the building with the same aesthetic prestige associated with the historic personalities, at the same time, increasing the cultural value of the place.

Supporting the mixed-use concept, aside from the landmark Lopez Center, are the Power Plant Mall (a nod to its industrial past), the Ritz Carlton Hotel (as the locus of the Rockwell Center), the Nestle and Phinma Buildings (office blocks), and the completed Ateneo Graduate School (an institutional block). The low-rise Ateneo Graduate School, designed by Architect Francisco Mañosa, uses a profusion of ochre-toned bricks in its facade, asserting a neovernacular idiom, and is one of the outstanding buildings in Rockwell.

The provision of open and green spaces is an essential component of Rockwell since the project has an environmental slant. In its aim to be the "lungs of the city," Rockwell has devoted half of its area to landscaped spaces. They are designed to showcase imported tropical flora and approximate the landscape ambience of Florida. Soil treatment in these open areas eliminates the possible effects of toxic industrial residue due to the former thermal plant's operation.

Streets are quite wide, but priority is given to pedestrians over cars, pedestrianization being one of the key concepts to create a total community where congenial face-

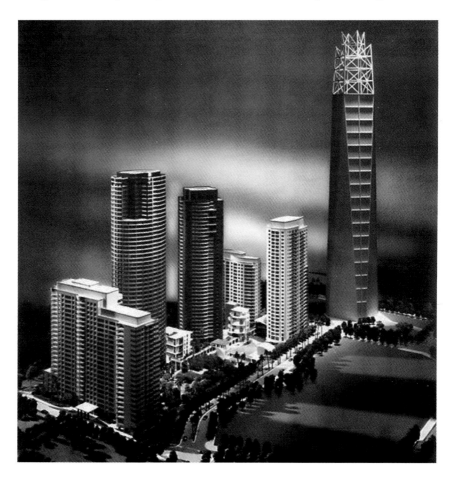

8.87 Models of signature buildings constituting and defining the cosmopolitan aura of Rockwell Center

to-face encounters are encouraged. Street networks are well-conceived. To slow down vehicular traffic, the intersections are provided with stone paving material instead of resorting to the unsightly hump. This material treatment is not only functional but also provides visual accents along the streets.

Eastwood Cybercity

In October 1999, President Estrada issued Proclamation No.171 creating and designating Eastwood Cyber City in Quezon City, as the first Information Technology (IT) Park in the country. This master planned urban area, a project of Megaworld Properties, is strategically situated a few minutes away by car from Manila's major universities and is also very accessible to the Makati and Ortigas business districts and major routes to the Manila international and domestic airports. Designed mainly to cater to locators engaged in IT software and multimedia R&D companies, which could avail of special incentives under Republic Act No. 7916 (Philippine Economic Zone Act of 1995), as amended by Republic Act No. 8748, it combines residential, business, commercial, and leisure components. Developers of the Cyber Park also plan to set up in the campus-like site a university of information and communications technology. At the behest of Estrada's agenda in fostering a culture of information technology, three infrastructures were approved by the state, namely, the Eastwood Cyber Park in Quezon City, the Northgate Cyber Zone in Alabang, and the Fort Bonifacio-Silicon Alley IT Park in Fort Bonifacio, Taguig— where competitive financial and tax incentives are offered.

Eastwood City is another of Manila's in-fill developments, trumpeted by its developer "as a premier showcase of urban master planning, transforming a fifteen-hectare superblock in Quezon City, on the northeastern side of Metro Manila, into a state-of-the-art residential, business, and retail/entertainment core" (http://www.eastwoodcity.com/home.asp). Megaworld has commissioned California, US-based Klages, Carter, Vail & Partners to design the community. When fully developed, Eastwood City will be the premier urban center of its kind in the country: fully integrated and self-contained.

Eastwood City is totally wired to the needs of the hyperactive lifestyle of the cyber age and operates twenty-four hours a day. It provides multiple, redundant, and state-of-the-art fiber optic and wireless telecommunication systems for clear transmission of voice, video, and data in and around the city. Reliable electric power supply with a 100 percent back-up generation set, and a biomechanical sewage treatment system ensure the maintainance of a high quality general environment.

The entire Eastwood City master plan has been divided into specific zones or phases to guarantee that construction development proceeds in accordance with the planned timetables. The first phase of the development includes the construction of the office buildings located at the entry point of the project, along Eastwood Avenue, the main road of Eastwood City. The IBM Plaza, Cyber One, and Citibank Square will comprise the first IT buildings. The fast-tracked development of this first phase will ensure its competitive edge over similar developments found in neighboring countries. Moreover, Megaworld has already attracted IT-based companies, such as Citibank and IBM, to relocate their major operations to Eastwood City.

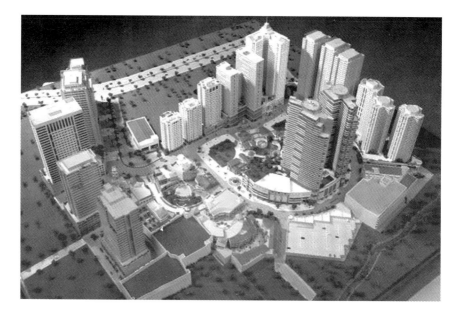

Similar to the city planning formula adhered to by the other two global cities, Eastwood is basically an MXD and markets itself as a walkable community. A popular walkable destination in Eastwood is the Eastwood City Walk, which attempts to construct a semblance of a bustling urban life, civility, and coffee shop culture in the midst of frenetic construction activities simultaneously occurring in the area fenced off from public view. The Eastwood City Walk is the quintessential expression of scenographic gimmickry as a seductive and deceptive art form. Like a Hollywood film set, Eastwood City Walk's mise-en-scène is marketed in its website as having the status of:

> a leisure town of bars, restaurants, and cafes. Destined to be the "happening" place of the hip and fashionable, the Eastwood City Walk features an eclectic Mediterranean design theme with its salmon and blue landscape. Palm trees and ornate pottery line the main entrance. The outdoor theater is set against lush greenways, water features, and boardwalks. A new center of culture and entertainment, the City Walk is the perfect counterpoint to the work buzz in the neighboring row of office buildings. Whether you want to get connected, or just unwind, the City Walk is it! (http://eastwoodcity.com)

Postmodern architectural eclecticism exemplified by the buildings' facades in the City Walk is executed in a mélange of historically disjunctive styles, and, by the configuration of experiential character of this primary pedestrian space, it attempts to simulate a small street teeming with urban vitality. These features follow the developer's recollections of similar retail and cafe streets in a number of European cities, and their combined effect is to approximate a visit to a small, impeccably built theme park or a disconcertingly permanent film set that escaped to the public realm of Quezon City.

Analyzing Manila's Global Cities in the Context of a Larger Urban Matrix

To be presented is a counter discourse on the overriding representations of Manila's three urban megastructures. Their roles in the aesthetic and discursive practices in

the reformation of the local urban landscape as a response to the processes of modernity and globalization are to be critically analyzed. It is possible to perceive Fort Bonifacio, Rockwell, and Eastwood Cities as a cautionary text of ongoing changes in the relationship of property development and aesthetics. Thus, we demystify the logic of their ideologies and resound the silences in their architectural text. First, there is a need to smash the putative representations of these developments as benevolent private initiatives that fulfill the essential need to rehash Manila's urban grids for global competition. Then, it is necessary to point to their speculative and competitive nature and heavy reliance on public support systems, both legal and financial. Contrary to the aestheticizing perspective of the projects as triumphs of beautiful, ideal, livable environments, it shall be shown how the coterie of design professionals and cultural actors involved in these megaprojects have succumbed to the logic of commercial architecture and have resorted to concocting cultural alibis to legitimize and enhance the symbolic capital of these developments. Moreover, how they have projected themselves as rescuers of public space while masking the design maneuvers for public control and social polarization shall also be discussed.

The myth of local hero cannot be missed out in the Fort Bonifacio Global City's poetic development credo:

> The Fort Bonifacio Development Corporation believes that land is not inherited from our forefathers. Rather, it is borrowed from our children.
>
> Guided by this conviction, we commit to create in Fort Bonifacio a globally-competitive metropolis with the best urban environment that will serve the needs and aspirations of the communities of today and tomorrow.
>
> To accomplish this, we shall strive for product leadership which will require from us creativity, innovativeness, a global perspective, foresight, and environmental consciousness.
>
> We shall hold sacred, excellence in attitude and accomplishments, honesty and integrity, profit earned with honor, teamwork, and open communications, and a respect for the dignity of man that springs from our faith in a loving God; and
>
> We shall, at all times, seek to please our customers, care for our employees, nurture our shareholders' investment, and contribute to nation-building.
>
> As a result of this, FBDC will become the leading and most respected real property company in the Asian Region (www.fbglobalcity.com).

Here, the persuasive tone is laced with nationalist slants, a development agenda aligned with the ideals of nation-building that elides all economic interest. This sustains the belief that architects are not serving particular needs of profit but are addressing the general need and welfare of the citizenry. Such statements also combine the private agenda with the public sentiments, and connect corporate structure with state apparatus. It is a simple appeal to a vague sense of collectivity, serving to give redevelopment a semblance of democracy.

Semiotically operating is the presence of national hero Andres Bonifacio's name and image in the city's official logo, clearly verifying the postulate I have presented at the beginning of this study regarding the connivance of the state and private enterprise in development. This conjecture creates a condition whereby the state or cities that aspire to the "global city rank" must suspend processes of democratic participation and public hearing to evade public scrutiny under the mask of commercial secrecy.

The tasks of fashioning the mental and physical representations of megastructures in these three cities were conscripted on the drawing boards of top-caliber international architects and urban planning consultants. The entourage of foreign design firms such as Hellmuth, Obata, and Kassabaum (HOK), Skidmore, Owings, and Merrill (SOM), Kohn Pedersen Fox (KPF), NBBJ, and RTKL were allowed to practice in the Philippines only through partnerships with local counterparts. The power relation in this partnership has been criticized by local professionals who have been threatened by such alliances. Such a devaluating system downgrades the role of the Filipino counterpart to a "glorified draftsman" servicing the needs of the foreign consultant hired by the developer, acting as a dummy liable for all legal aspects of the project. In another light, the collaboration with international experts has been justified in terms of providing the maximum amount of leading-edge experience for Filipino architects to create a probable impetus for design and consultancy as a Philippine export. In effect, local architects, through their participation in a project of "global caliber," would benefit not only in terms of expanding their experience but also in advertising Filipino expertise in the international market.

These projects are illustrative of the heightened value attached to "designed" signature architectural products in a highly competitive market culture. They epitomize the search for distinguished, novel buildings that will lease faster, command higher rents, and rent out for longer durations, providing the potential occupant headquarters or an abode stuffed with "symbolic capital" substantiated by bearing the signature of a high-profile, internationally recognized architect. Moreover, as in Bourdieu's (1984) original conception of symbolic capital, signifiers and cultural acumen can be liquidated and converted into economic capital.

Architecture for Sale:
Postmodern Packaging as Marketing Gimmickry
The chosen design vocabulary for buildings in these projects is postmodernism. The three areas adoption of the design tenets of postmodernism was not simply governed by the postmodernist desire for a more meaningful, communicative architecture, but rather by the twin concerns to be up-to-date and to employ those design superstars legitimized by architectural criticism. The cultural validity of buildings and their saleability clearly reside in the credentials of the architects who fashion the buildings according to the image-conscious and conspicuous consumption behavior of real estate buyers. In this sense, the choice of Pei Cobb Freed & Partners for Fort Bonifacio's Essenssa Towers is an ideal cultural investment; IM Pei's designs and those of the other global architects are endowed with the consecration of "high" architectural culture and popular recognition. In a sense, architects are asked to reduce architecture to a form of consumer packaging.

These packaged landscapes are artful fragments of urban development governed by globalization. They are set-pieces that draw a cloak over the realities of intensifying social polarization, ghettozation, and informalization of urban settlements which characterize Manila. As Harvey suggests of the standardized application of postmodern design tenets in urban regeneration initiatives, they mimic a "carnival mask that diverts and entertains, leaving the social problems that lie behind the mask unseen and uncared for. The formula smacks of a constructed fetishism, in which every aesthetic power of illusion and image is to mobilize the mask of intensifying class, racial, and ethnic polarization going underneath" (1989, 21). This fetish gains power in the form of aestheticisms as the answer to the social problem. The strategy in these cities is to engineer an aesthetic foregrounded in local historical conditions in order to make the megastructures familiar.

Mythology of Collectivity in a Pseudo-Community
The control over the spatial structure is reinforced with strong control over behavior, enforced by a surveillance camera and security personnel. These microcities recapture the traditional lucid center, the Philippine plaza complex, to create an illusion of urban civility and an open space of social communion, yet they are highly purified and controlled domains, where anything different from the norms set forth by the developer is subtly excluded. These places fabricate an ideal community, an illusory site of public life, devoid of poverty, factions, or eccentricities. There is perpetually a festive atmosphere geared toward spending and conspicuous consumption (a mode of consumption intended to affirm or enhance an individual's social prestige). The presence of a Foucauldian regime of normalization, whereby potential disruptions to the designed effect are pinned down and evicted, are strictly enforced. As everyday practices, these forms of control are invisible as the rules are embodied in the habitus of the places where genuine conflict is expunged from the premises. These become heterotopic sites, assuming pseudo-public facades that embody the utopian desire for a purified community of social harmony, wealth, and classlessness.

These places also embody the contradiction of a "private community" as a space of private control but attached with public meanings that rely upon the illusion of public space. Thus, these spaces simulate community life or draw upon recognizable images from real street scenery to be transplanted within its property while transmuting these borrowed images in sanitized forms.

Investment in urban spectacle lends the urban space into manipulation, as the urban spectacle is experienced in distraction, potentially triggering dreams and memories for the culture of stylish materialism. They are communities of affect rather than communities of interest, sharing dedication to the iconolatry of visible wealth and distinction. Residents of such communities are offered sequestered settings with an expensive package of amenities. The very names of these communities are carefully selected in order to set the required tone of distinction, heritage, and authenticity. The net result is a landscape studded with glitzy nodes, a microlandscape of mixed-use development carefully packaged with striking architecture, luxurious-looking materials and fittings, and open spaces planted with expensive tropical vegetation—all in the name of conspicuous consumption and exclusivity.

Global Cities as New Sites for Habitus of Conspicuous Consumption

Global cities can be seen in relation to Bourdieu's (1994) habitus—embodied values, cognitive structures, and orienting processes of an individual class faction. The habitus is a collective perceptual and evaluative schema originating from its members' everyday experiences and operating at a subconscious level through commonplace daily practices, dress codes, use of language, and patterns of consumption. Each class group contracts, sustains, and extends its own habitus through the appropriation of "symbolic capital"—luxury goods confirming the taste and distinction of the owner. Spaces are endowed with symbolic capital, then translated into the schema of urban placemaking of Manila's image-conscious global cities (i.e., deployment of signature architects, investment in public art, etc.).

Urban Repercussions

Local "global cities," like all other major developments, have costs and benefits manifested in various forms. The "naysayers" may ask about the value of this new community on several levels. On the physical level, the following questions may be raised: with a population influx, will there be competition over water supply, electricity, utilities, waste management, and so on among the original and new occupants of the place and the surrounding vicinities? Also, as a population magnet, can the administrative machine cope with the demands? The road networks inside these microcities are designed to accommodate the projected population, but can the same be said about the streets, linkages, and access ways leading to the introverted cities? Will these structures create wind tunnels that will bombard the low-rise structures, or will they deprive the low-rise occupants of the view of the sky and of sunlight, or will the reflective glass skins on its fenestration produce glare and redirect heat on the sprawling neighborhood? On the social level: As a city within a city, will this development succumb to the pitfalls that overpowered its antecedents? Will this development create a diaspora of low-rise dwellers, since a microcity must expand? On the psychological level: Does it subconsciously perpetuate social polarization instead of integration? What are the possible effects of the imposing high-rises on the occupants of the development's periphery dominated by low-rise residences? The question can even assume a psychological form involving antagonism, invasion of privacy, and, worse, paranoia. Or they can even be ideological: Will global cities be seen as a mecca of conspicuous consumption, a privatized "City of Illusion" against the backdrop of Third World squalor? Places filled with magical and exciting allure, these landscapes of pleasure are purposefully detached from the menacing city. Controlled by the rules of the market system, these invented cities offer a synthetic charm and a semblance of communal collectivity. Mapping the geography of marginality, they may also define a structured social distinction focused on one end of the social strata and withdrawing from its polar opposite.

Undoubtedly, the postmodern condition will continue to enrich the visual fabric of the architectural environment. Its appreciation of the past and tolerance to diversity guarantee more plural expressions of the Filipino imagination. The tumult of changes imposed by globalization is ushering the emergence of a new generation of Filipino architects whose vision is to redefine and realign Philippine architecture within the matrices of history and society.

Glossary

Abong — (*Ifugao*) A dwelling of impoverished Ifugao natives, built in nonuniform measurements using substandard materials. It is raised slightly above ground, with no rat guards (*halipan*) on its posts and can be accessed through a single door. Only on odd occasions does it have a pyramidal roof. The abong's walls do not incline away from the bottom, but stand perpendicular to the ground.

Adaptive Reuse — Improvements made to a building to make it suitable for a purpose other than its original.

Adobe — A grayish volcanic tuff commonly used for buildings from central to southern Luzon during the Spanish Colonial period. They are quarried and made into large blocks. Adobe walls are, therefore, very heavy and need to be very thick to be strong enough to bear not only their own weight but also the weight of the roofs, especially if made of tiles.

Afayunan — (*Manobo*) The kitchen of a Manobo house which is usually the first section or area to be built. It is the lowest level of the house, about 1.5 meters above the ground.

Afong — (*Bontoc*) Dwelling place occupied by families; the general name for Bontoc dwellings. These are generally of two types: the *fayu* and the *katyufong*, occupied by more prosperous and poorer families, respectively. See *fayu*.

Afung — (*Gaddang*) Dwellings perched on the high branches of trees, built about six to twenty meters from the ground, with a detachable ladder drawn up at night to prevent the entry of intruders.

Agamang — 1. (*Ifugao*) Communal segregated dormitories [Scott 1966]; dormitory of the unmarried. In some sections of northern Ifugao, a special building is constructed to house the unmarried, although, generally, a vacant or widow's house is used. 2. (*Sagada Igorot*) Granary on the upper level of the Sagada house (*inagamang*); its 1.5 meter-high walls support the roof of the house. Other inagamang have granaries with their own wooden gable roofs as protection against rats. A granary can hold some 300 to 500 bundles of palay. It has one door and no windows. It could also be constructed separately from the inagamang, in which case, its construction would be similar to how it would be if it was part of the house.

Aisle — The main aisle that runs laterally down the nave of a church. It is divided from the rest of the nave by rows of pillars or columns, which support the roof or an upper wall with windows (called a clerestory). Other aisles may run off from the main aisle in larger churches.

Alambre — (*Tagalog*, from *Spanish*) Wire; metal in the form of a very flexible thread or slender rod.

Alameda — Spanish for "Cottonwood Tree." This word has come to mean a road or a public promenade bordered with trees.

Alang — A granary house where rice is stored. It is typically found in the Cordillera Mountain Province.

Al-Haj — (*Tausug*) The time or month of the traditional Islamic pilgrimage to Mecca. It is believed that building a house at this time of the year will enable the owner to travel to Mecca, and, consequently, gain religious and social prestige.

Aliwalas — (*Tagalog*) 1. a. A spacious or pleasant condition b. A clear, open space.— *adj.* 2. Neat, spacious, well-lit, and well-ventilated; conveying a sense of well-being and lightness of feeling, sensation, and movement.

Altar — A structure found in churches before which the priest recites divine offices and upon which the Eucharist Mass is celebrated. Often elevated, it is typically a table of stone or wood covered with cloth.

Altarpiece — A panel, painted or sculptured, situated above and behind an altar. If it is made up of three panels hinged together so that it can be folded, then it is called a triptych.

Alulod — (*Tagalog*) Gutter; trough or channel along or under an eave which carries rain water as it flows from the roof or its slope.

Alzado — (*Spanish*, literally "raised") In the context of sculpture, designs brought out in high or low relief on a surface so that the impression is of heavily worked cloth, etc.

Amácan — (*Bisaya*) Matting made of bamboo strips; (*Tagalog*) sawali.

Ambulatory — An aisle around the apse at the east end of a church.

Anahaw — (*Tagalog; L. Livistona rotundifolia Lam. Mart.*) Fan palm; large, round-leafed palm with various uses. Its sturdy trunks, when kept dry, can function as durable pillars. The hard outer skin of the trunk can be stripped and used for flooring, while the water-repelling leaves can be used for roof shingles.

Anito — (*Filipino*) Deity or idol, especially referring to its physical representation.

Antesala — See *caida*.

Ápog — (*Bisaya*) Lime.

Apse — **1.** A recess, usually singular and semi-circular, arched, or dome-roofed, at the east end of a Christian church, usually containing the altar. **2.** Space at the "head" of the church where the main altar is located and where mass is celebrated; also known as sanctuary or presbytery; (*Spanish*) *capilla mayor, presbiterio, santuario.*

Arabesque — Ornament consisting of garlands of foliage with figures fancifully interlaced to form graceful curves and painted, inlaid, or carved in low relief; a geometrical and complicated decoration.

Arcade — A series of arches supported by columns or piers, usually freestanding, or a passageway formed by these arches.

Arcading — An uninterrupted series of arcades.

Arch — A curved structural member that spans an opening and is generally composed of wedge-shaped blocks that spread out the downward pressure laterally.

Architectural Integrity — Refers to staying true to the original style in which the building was designed. Additions should be complementary to the architectural style of the original building and be readily apparent to public view.

Argamasa — (*Spanish*) Mortar; a mixture of water and powdered lime obtained from limestone quarries, coral reefs, and seashells.

Arquitectura Mestiza — A term coined by Jesuit Ignacio Alzina in 1668 to mean structures built partly of wood and of stone.

Art Deco — A popular design style of the 1920s and 1930s that reflected the streamlined aesthetic of the machine age and was characterized by bold outlines and geometric, zigzag, or stylized forms; took many forms, including the geometric Art Moderne and the more fluid Art Nouveau, and reached its apex at the Exposition Internationale des Arts Décoratifs et Industriels Modernes held in Paris in 1925.

Art Nouveau — A style of decoration popular during the turn of the nineteenth century, characterized by organic, curving forms and whiplash lines. An architectural style that uses the circle as the basic form for furniture, arches, and trellises; characterized by curvilinear and floral motifs.

Arts and Crafts — Derived from an artistic movement of the late nineteenth century based on the ideas of William Morris which promoted traditional forms of design and the use of craft techniques in construction. Its architectural expression is seen in the use of traditional materials and restrained vernacular decoration.

Atep or **Atip** — Roof or roofing material.

Ato — (*Bontoc*) A small, rectangular structure where young and old men sleep. It also functions as a public structure, a place for religious, public, and social meetings and ceremonies. It is divided into two sections: the *fawi* (sleeping area for older men) and the *faabafongan* or *pabafunan* (sleeping area for younger men). The *ato's* walls are made of stones piled one on top of the other and held together with mud or clay. The roofing is made of cogon or galvanized iron sheets. There are no openings except a small, low, and narrow entrance. Inside, an elevated bed serves as a common sleeping place at night. Near the door is a fireplace upon which logs are burned throughout the night in cold weather.

Atol — (*Ifugao*) High stones suitable for use as lookout positions.

Atrium — An inner courtyard of a home or building that is open to the sky or covered by a skylight; in an ancient Roman structure, a central room open to the sky, usually with a pool for the collection of rainwater; in Christian churches, a courtyard flanked by porticos.

Awning — A retractable or permanent device on a storefront or over a building entrance or window that provides shelter from sunlight or the elements.

Azotea — (*Spanish*) An open terrace usually at the back of a house or convent. A Spanish word for an "outdoor terrace" of the bahay na bato.

Azulejos — (*Spanish*) Glazed tiles. Though the *azulejos* most familiar to Filipinos are blue (*azul*) and white, the term, in fact, does not have any relation to color; it derives from the Arabic *atzulahiyi*, a polished piece of pottery.

Badjao Stilt House — Stilt house built along the shoreline like the lumah, but made of lighter materials, such as bamboo and nipa. See *lumah*.

Bahay — (*Tagalog*) **1.** House; residential structure; dwelling. **2.** Combining form, such as to signify the type of construction (e.g., *bahay na bato, bahay kubo*), or purpose (e.g., *bahay-ampunan, bahay-bakasyunan*).

Bahay Kubo — **a.** A native term for "nipa hut," which has become a symbol of folk architecture in lowland Philippines. **b.** (*Tagalog*) cube house; the traditional lowland, one-room, steep-roofed structure of Christians, elevated from the ground by stilts, posts, or poles to

avoid dampness, rats, and other pests. It is made of light materials, with parts woven, fitted, or lashed together. The steep, high roof is put together separately; bamboo-slatted floors and walls, plus windows and doors allow maximum ventilation, reducing tropical heat as well as providing sufficient illumination. The walls, windows, and roof may be of bamboo, nipa, cogon, or rattan.

Bahay na Bato — A "stone house" in the Spanish colonial tradition.

Balai — (also *balay*) General term for Southeast Asian domestic architecture bearing a general pattern of houses elevated on stilts or wooden posts, thatched roofs, woven bamboo siding, bamboo flooring, and bamboo or banana frond roofing; highly adaptable to varying climates, geography, terrain, and available materials. It is generally a dwelling with a single room, which nevertheless serves a variety of purpose: sleeping areas double as eating, family, and work areas, and territorial spaces are merely suggested. Light and airy in appearance, it is surprisingly stable despite the seeming vulnerability of materials used against the elements. It has a steep, thatched roof. The elevation of the house serves to ventilate it and protect it from dampness; floors are usually made with bamboo slats to increase ventilation, while woven bamboo wall sidings and nipa or cogon roofing block the heat. See *bahay kubo*.

Balangkas — (*Tagalog*) **1.** Framework. [Vicassan]. **2.** (*Pinatubo Aeta*) One of the four types of dwellings with four vertical walls and whose main roof beams equal that of the floor length.

Balcony — A platform projecting from a wall, enclosed by a railing or balustrade, supported on brackets or cantilevered out, and usually placed before windows or openings.

Baldachin or **Baldachino** — A richly ornamented canopy supported by columns. It is suspended from a roof or projected from a wall, as over an altar.

Baldaquin — An ornamental canopy over an altar, usually supported on columns.

Balkon — (*Tagalog*; from *Spanish balcon*; *Panay*/lowland Christian) A secondary area or enclosure of the bahay kubo; an open gallery at the front of the bahay kubo that serves as an anteroom or lounging area. Its roof may be gabled, and it has its own ladder leading to the ground. Windows and benches encircle a small open area fronting the main door. The balkon is semiprivate and semipublic; here, visitors, acquaintances, or strangers are welcomed with the understanding that there is no need to proceed to the more private sala. Members of the family can also nap here.

Baluarte — (*Spanish*) A bulwark; but, in the Philippines, the term came to refer to many other types of fortifications, such as towers, walls, etc.

Baluster — A curved or straight spindle or post, usually of wood, that supports the railing of a porch or the handrail of a stairway.

Balustrade — Row of columns supporting a railing or a parapet consisting of a handrail on balusters, which sometimes also includes a bottom rail.

Bamboo — (*L. Bambusa blumeana Schultz.f.*) A type of grass growing as high as twenty-five meters, with hollow, segmented stems, thin branches, and short, narrow leaves. Bamboos grow in clusters, and are extremely versatile, since they can be used for house frameworks, fencing, and wall and floor matting.

Bandeja — A tray-like panel.

Bangkô — Native term for "bench."

Banguera — An open shelf made of bamboo slats or wood used for storing and drying dishes.

Banwa — (*Alangan Mangyan*; also *paykamalayan*) Traditional communal long house, consisting of some twenty to as many as fifty families, nuclear or extended. It has one large entrance (*sakbawan*) and an unpartitioned interior. Each family has its own hearth consisting of three stones (*segang*). Apart from the physical structure, the *banwa* also has a social dimension; it is a small community in itself, with a council of elders who settles disputes, gives counsel, and enforces laws.

Banyo — Another word for "bathroom" of the bahay na bato.

Barandillas — Spanish word for "balusters" of the bahay na bato.

Barangay — A local term that originally referred to ocean vessels; the unit of social and political organization.

Barong-barong — (*Tagalog*) A makeshift shack or shanty, usually made from odds and ends of light material, such as scrap metal or galvanized iron sheets, discarded wood, layers of newspaper or plastic, plasticized roofing, and used tires and rocks as roof anchors. The barong-barong is usually found in slum or squatter areas where low-income families are densely packed into a small piece of self-appropriated land.

Baroque — A style associated with late Classical architecture that flourished in the seventeenth and eighteenth centuries based on a desire to show movement and drama; it is marked by exuberant decoration, curvaceous forms, and

a grand scale generating a sense of movement overlaid on classical architectural details. Later developments show greater restraint.

Barrel Roof — Like a covered wagon, or inverted ship; a plain vault of uniform cross-section.

Barrios — Villages.

Basilica — The early Greek name for a royal palace; a large oblong building with double columns and a semicircular apse at one end, frequently used by Christian emperors of Rome for religious purposes.

Bas-relief — Carving or sculpture raised above a background plane.

Bastion — A solid masonry projection.

Bastiones — See *baluartes*.

Batalan — An open gallery at the rear of the house that is used for keeping water jars (*banga*), or used as a place for bathing.

Batangan — A bowlike wooden frame that anchors the *katig* (outrigger) to the main structure of the houseboat.

Battlement — The top part of a castle wall often used to detail a parapet; a parapet with indentations or embrasures, with raised portions (merlons) in between, also known as crenellations.

Bauhaus — The style of the Bauhaus School, founded in Germany by Walter Gropius in 1919, emphasizing simplicity, functionalism, and craftsmanship; the leading intellectual and creative center in the development of modernism in the 1920s and 1930s. Emphasis was placed on factory-produced designs that were simple, functional, and industrial. The egalitarian philosophy espoused by the school embraced clean designs in basic materials, and this philosophy permeated all types of design, from furniture to textiles to applied art.

Bay Sinug — (from *bay*, "house," and *Sug*, "Jolo" or "Sulu"; also *bay sug*) The traditional Tausug house. The Tausug use either heavy timber or rough-hewn wood cut from small trees and plain bamboo. Building the house first entails erecting nine posts, each representing a part of the human body.

Bayanihan — (*Tagalog*) Cooperative or community labor usually done in building a house or transporting it from one place to another. It involves sharing a task, the absence of compensation or payment for participating laborers, and a festive atmosphere manifested in the eating and merrymaking after the accomplishment of the task.

Beaux Arts — A classical-inspired style taught and promoted by the Ecole des Beaux Arts in Paris during the nineteenth century, where many architects were trained. The school and the style were very influential in nineteenth- and early twentieth-century North America.

Binayon — (*Kalinga*; also *finanyon, finaryon*) Octagonal house found in Upper Kalinga, in settlements along the Chico River. It has a low, thatched, hipped roof; the octagonal form is not clearly evident in the wooden and bamboo walls. The house is about six meters long and 5.2 meters wide, with the floor of its living quarters 1.2 meters above ground.

Binuron — (*Isneg*) The Isneg who live close to the only navigable river (Apayao) in the Cordillera region are boatmen and boatbuilders. Thus, Isneg house design appears to have been influenced by boat design. Their roofs seem to be an inverted hull, and the floor joists, visible on the outside, suggest the profile of a boat.

Borak — (*Maguindanao*; also *burrak*) A traditional design motif representing a mythical winged creature which is half-human and half-horse. See *okir*.

Bracket — A small, supporting piece of wood or stone, often formed of scrolls or other decorative shapes, such as an inverted "L," set under a projecting element, like the eaves of a house or a cornice.

Brick — A molded, rectangular block of clay baked under the sun or in a kiln until hard and used as a building and paving material. Most bricks used for buildings in the Ilocos region are of a warm, red color. Early in history, bricks were handmade and costly to distribute, and so only the most wealthy could afford to build their houses with them.

Brise-soleil — Sun breakers.

Bubong — 1. (*Kalinga*) Cogon over the ridge of a roof. 2. (*Ifugao*) Top of pyramidal roof; grass cover at the roof ridge.

Buhos — (*Tagalog*, "to pour") Poured concrete; also known as reinforced concrete. A building technique introduced during the early American period. Cement, sand, gravel, and water are poured into forms where steel bars have been inserted.

Bulwagan — (*Tagalog*) 1. Hall; ceremonial hall for large gatherings; a large entrance or lobby to a building. 2. The main room of a bahay kubo, either square or rectangular in shape, where floor mats are spread for sleeping, sitting, or eating.

Bungalow — Common house form of the early twentieth century distinguished by its horizontal appearance, wide eaves, large porches, and multilight doors and windows.

Buttresses — A solid mass of masonry or brick projecting from or built against a building wall to provide additional strength.

Byzantine — A style dating from the fifth century characterized by masonry construction around a central plan, with domes on pendentives, typically depicting the figure of Christ; foliage patterns on stone capitals; and interiors decorated with mosaics and frescoes.

Caida — The most immediate room from the stairs; an all-purpose room for entertaining, sewing, dining, or dancing in the bahay na bato.

Cal y Canto — (*Spanish*) Cut stone and lime mortar.

Calados — (*Spanish*) Openwork or "pierced screen work" found above the wall partitions, reaching up to the ceiling, thus enhancing crossventilation inside the bahay na bato.

Camino — (*Spanish*) Road.

Campanario — (from *Spanish, campanas*) A wall with openings for bells.

Campanile — A bell tower, usually not attached to the church; also, lofty towers that form parts of buildings.

Canted — Angled at the sides, as in a bay window.

Cantilever — A horizontal projection from a building, such as a step, balcony, beam, or canopy, that is without external bracing and appears to be self-supporting.

Cap — A stone piece on top of a pier to protect it from weathering.

Capiz — (*L. Placuna placenta*) Edible bivalve protected by two flat, circular shells growing in the muddy, sandy bottoms of shallow salt bays or junctions where slow streams meet the sea. At low tide, shell gatherers harvest, clean, grade, and sell these shells in huge baskets to window-makers, who then transform them into lattice panels for windows. Capiz windows have a translucent quality, filtering harsh external light into soft and comforting luminescence.

Cartouche — In architecture, usually a sculptured ornament in the form of an unrolled scroll, which often appears on cornices. The cartouche is frequently used as a field for inscriptions and as an ornamental block in the cornices of house interiors.

Casa — Spanish for "house" or "home."

Casamatas — Spanish word for "stone landings" on top of fort walls where artillery weapons are propped up.

Casement Window — A window that swings outward on its side hinges.

Cast Iron — Iron cast into molds and used as posts for building frames in the nineteenth and early twentieth century. Cast iron was also used to make decorative details on building facades.

Ceramic Tile — Any of a wide range of sturdy floor and wall tiles made from fired clay and set with grout. May be glazed or unglazed. Colors and finishes vary. May be used indoors or outdoors.

Chamfer — A diagonal surface made when the sharp edge (or arris) of a stone block is cut away, usually at an angle of forty-five degrees to the other two surfaces; a bevelled edge. If the diagonal plane on two chamfered blocks are placed together, creating a groove between them, it is called a hollow chamfer; an object with the edges of the front face angled back to give a sense of depth, e.g., on a door stile.

Choir — The space reserved for the clergy in a church, usually at the east of the transept, but, in some instances, extending into the nave.

City Beautiful Movement — Inspired by the urban planning of the 1893 Chicago World Fair, this is a movement dedicated to promoting classically planned cities that combine urban activity with green spaces.

Clapboard — Thin wooden planks applied horizontally, one overlapping the next, used as weatherproof siding on buildings or the timber-framed wall of a house.

Classical or Classical Revival — The style or design using the principles of Greek or Roman architecture, with their prescribed sense of proportion and decorative details; the Italian Renaissance or neoclassical movements in England and the United States in the nineteenth century that employed the traditions of Greek and Roman antiquity.

Classicism — A tradition of Greek and Roman antiquity distinguished by the qualities of simplicity, harmony, and balance.

Clerestory — The upper storey of the nave, transepts, and choir of a church, containing windows, and rising above the aisle roofs, designed to bring light into the church and relieve the weight on the walls and arches.

Cloister — A court, usually with covered walks or ambulatories along its sides.

Cocina — (*Spanish*) Kitchen in the bahay na bato.

Coconut — (*L. Cocos mucifera*) A tall palm tree reaching some twenty-five meters high, with leaves radiating from its apex like umbrella

spokes. Mature leaves are long, narrow, and extend from a flexible midrib in a uniform series, hence, it is pinnate (from Latin *penna*, meaning "wings") like the nipa and rattan palms. The coconut tree thrives in tropical climates and moist air. Its leaves may be used for roofing and wall sidings; its trunk produces lumber for posts and other woodwork.

Coffered — Used to describe a surface, such as a ceiling, with deeply recessed panels (analogous to the inside of an egg-tray); (*Spanish*) *artesonado*.

Cogon — (*L. Imperata cylindrica (L.) Beauv.*) a wild grass growing throughout the year to heights from thirty to eighty centimeters. Its sturdy underground stems and roots are difficult to destroy or uproot; thus, land where it has taken hold is difficult to convert to agricultural purposes. Its thin, flat leaves lengthen to fifty centimeters when dry and bundled. These leaves make excellent material for roof thatching. [Hart 1959; Perez et al. 1989].

Colonnade — Series of columns set equidistant at regular intervals.

Colonnette — A small, slim column, usually arranged in groups.

Column — A structural or decorative vertical element, usually circular, supporting or framing the upper parts of a building.

Comedor — (*Spanish*) Dining room in the bahay na bato.

Composite Order — A Roman order, its capital combines the Corinthian acanthus leaf with volutes from the Ionic Order.

Concrete — A mixture of cement, sand, gravel, and water in specific proportions that hardens into a stone-like substance.

Convento — (*Spanish*) A parish house or rectory. It may refer to a wing of a mission building or the set of rooms in which the missionaries lived.

Corraline — Fossilized coral used as building blocks.

Corbel — A projecting wall member or bracket of stone, wood, brick, or other building material, projecting from the face of a wall and generally used to support a cornice or arch, with two such structures, meeting at the topmost course, creating an arch. The word comes from the Latin word for raven, *corvus*, because of its similarity to the shape of a raven's beak. Corbels are often carved with decoration, especially in churches.

Corinthian or Corinthian Order — The last and most elaborate of the three orders of Greek architecture. Similar to the Ionic, but with the

capital decorated in the shape of a bell with acanthus leaves.

Cornice — A horizontal moulding projecting along the top of a building or wall. Any projecting ornamental moulding that finishes or crowns the top of a building, wall, arch, etc.

Cortinas — Spanish word for "walls," often pertaining to those of a typical fort built in the Spanish colonial tradition.

Cota — (*Bisaya*, also *kútà*) In earlier times, a fort of masonry or wood. By the nineteenth century, this word had evolved to refer to a thick wall of masonry. In its basic sense, a low wall to sustain a thinner upper wall; in another sense, a wall enclosing a space, such as a cemetery.

Crenellated — Having repeated square indentations like those in a battlement.

Cresting — Decoration applied along roof ridges generally consisting of ornamental metal.

Cross gable — A gable set parallel to the roof ridge.

Crossing — The space in the middle of the transept, at the junction of the nave and apse.

Cruciform — Cross-shaped; most often used to describe churches, with the nave forming the body of the cross, the altar and choir at the top (usually to the east), and the transept forming the arms of the cross.

Crypt — A vaulted underground room beneath a church which may be used either as a burial place or storage.

Cuadras — (*Spanish*) Stable located under the bahay na bato where horses for carriages were kept.

Cuarto — (*Spanish*) Bedroom or sleeping quarters of the bahay na bato.

Cupola — A domed structure on the roof.

Dait-dait — (*Mamanua*) A simple windscreen or lean-to made from the leaves of wild banana, coconut fronds, or grass and usually lashed together with rattan.

Dangkal — (*Tagalog*) The distance from the tip of the thumb to the tip of the middle finger when the hand is spread out.

Dapang — (*Badjao*) An outriggered houseboat of varying size and length, generally used for fishing or short trips.

Dap-ay — 1. (*Bontoc*) A circular open space paved with flat stones, which forms part of a Bontoc communal center. 2. (*Kankanay*; also *dap-pay*) Wards or sections into which large

compact villages are divided. **3.** (*Kankanay, Sagada Igorot*) Male clubhouse or dormitory for unmarried males; the Kankanay *ato*. It is usually slightly elevated, with a flat stone platform about ten feet across as its most prominent feature. Surrounding this paved platform are upright stones set in the ground at angles, which render them convenient as backrests.

Dapug — (*Isneg*) Hearth. A square space surrounded by four small beams and consisting of layers of leaves covered with sand or clay. In the center of the square are three stones so arranged as to be able to support cooking pots or utensils.

Datag — **1.** (*Isneg;* also *xassaran*) a. The main section of an Isneg dwelling. It is a sunken central space surrounded by a narrow, slightly raised platform (*tamuyon*) and, at the fourth end, by the slightly raised floor of the annex (*tarakip*). b. A kind of reed mat tied together with strips of rattan laid over laths of wood or palma brava to form a floor. It consists of several sections, independent of one another and remains free to be lifted at will or rolled separately for cleaning. **2.** (*Tausug*) A flat piece of land sloping toward the direction of Mecca and, thus, suitable as a house site. **3.** a. (*Palawanon*) The main floor of a house, raised higher than the floor of the house's rear. b. (*Tau't Batu, S. Palawan*) A split bamboo platform constructed with a roof and elevated from the ground by wooden or bamboo stilts.

Details — These may be split into two categories—structural and architectural: a. Structural details are best illustrated by sectional, isometric, or exploded views, accompanied with complete notes. Larger scale sections and details of joints are often required. b. Architectural details include stairways, doorways, doors and windows, mantels, paneling, mouldings, and hardware.

Dingding — (also, *dindin*) **1.** (*Tagalog*) Wall or partition. **2.** (*Isneg, Sagada Igorot*) Wall-boards. **3.** (*Yakan*) Walls made of sawali. See *sawali*.

Djenging — (*Badjao;* also *jenging*) Outriggered houseboat with a structure walled in on all sides by wooden boards nailed permanently to the house framework. It has window openings and doors and galvanized iron roofing.

Dome — Roof formed by a series of rounded arches or vaults on a round or many-sided base.

Doric Column — A Greek-style column with only a simple decoration around the top, usually a smooth or slightly rounded band of wood, stone, or plaster.

Doric Order — The oldest architectural style of ancient Greece; characterized by simplicity of form—fluted, heavy columns and simple capitals.

Drawbridge — A movable bridge; originally moved horizontally like a gangway.

Dulang — A low wooden table.

Eaves — The lower, overhanging section of a pitched roof.

Elevation — One of the external faces of a building; also, an architect's drawing of a facade set out to scale.

Encomienda — (*Spanish,* from *encomendar,* "to commend," "entrust," "commit") The right to collect tribute from people from a piece of land, with the corresponding responsibility of providing protection and Christian education. The encomienda was administered by an encomendero.

Engaged Column — A round column attached to the wall.

Entablature — The top part of a column or pediment comprising a number of elements, i.e., architrave, cornice, modillion, capital, etc.

Entasis — The very slight convex (curving out) curve used on columns to correct the optical illusion of concavity (curving in) which would result if the sides were straight.

Ermita — (*Spanish,* usually referring to an hermitage or shrine) A small chapel.

Escalera — (*Spanish*) Staircase of the bahay na bato.

Espadaña — A wall which seems to be an upward continuation of the façade but which actually projects above the roofline. It has the visual effect of adding height to the building. It is roughly triangular in shape but with graceful curved or scalloped edges. Openings for bells make the espadaña a type of *campanario*.

Façade — The face or front of a building; any important face of a building, usually the principal front with the main entrance.

Farola — Lighthouse.

Fascia — A flat, horizontal wooden member used as facing at the ends of a roof.

Fayu — (*Bontoc*) A large, open-board dwelling about twelve by fifteen square feet, with side walls three-and-a-half feet high, and a steep, heavy, thatched roof. The side walls—often made of two boards extending the full length of the structure—are the same height as the ends, although generally longer. Rear walls are built of stones held together with mud.

Fenestration — The design and placement of windows in a building.

Festoon — A sculpted swag or garland in a catenary curve; a carved or painted ornament in the form of a garland of fruits and flowers tied with ribbons and suspended at both ends in a loop. Also called a swag.

Finial — A sculptured ornament, often in the shape of a leaf or flower, at the top of a gable, pinnacle, or similar structure.

Flute (or **fluting**) — Vertical channeling, roughly semicircular in cross section, used principally on columns and pilasters.

Flying Buttress — A freestanding buttress linked to a church wall by an arch or part of an arch that serves to transmit the outward thrust of the wall to the buttress, thus relieving the strain on the walls.

Foliated — Carved with leaves.

Font — A basin for holding baptismal water in a church.

Footings — Bottom part of wall.

Foso — (*Spanish*) Moat which surrounds the whole fortification as a form of defense.

Foyer — The entrance hall of a home.

Frame — The skeleton of a building made of wood, cast iron, steel, or concrete that supports the walls and roof.

Fresco — Mural painting applied on wet plaster.

Fretwork — Ornamental woodwork cut into a pattern and often elaborate.

Frieze — A band or decorative motif running along the upper part of the wall, sometimes carved.

Frontal — (*Spanish*) A decorative panel to cover the lower part of an altar, made of carved wood, worked metal, or embroidered cloth.

Fuerza or **Fortaleza** — (*Spanish*) Fortification.

Gabaldon Schoolhouse — A type of architecture for Philippine schools implemented during the American period, beginning in the first decade of the twentieth century. Named after assemblyman Isauro Gabaldon who authored the bill mandating their construction, it essentially lifted the building off the ground following the principle of the nipa hut.

Gable — The triangular section of the end wall of a gable roof.

Gable Roof — A roof that has one slope on opposite sides of the ridge, with a gable at either end.

Gallery — A long room, often on an upper floor, for recreation, entertainment, or display of artwork.

Garitas — (*Spanish*) Little turrets in forts where sentinels keep watch.

Gilding — The art of ornamenting furniture, accessories, and architectural details with gold leaf or gold dust.

Gothic — An architectural style popular in western Europe during the High Middle Ages, lasting from the twelfth to the sixteenth century, characterized by pointed arches and lofty, "spiny" silhouettes.

Gothic Architecture — A style of architecture that was prevalent in western Europe from about 1200 until 1550. Some of the characteristic features of this school of architecture are pointed arches (lancets), tall, slender pillars, flying buttresses, and large windows, often with ornate tracery.

Grada — (*Spanish*, "step") A type of pedestal shaped like one or two steps for flowers and other ornaments; a pair of these flanked the tabernacle on the altar.

Gradillas — (*Spanish*, diminutive of "step") A pair of stepped pedestals flanking the tabernacle, with the same function as the *grada* but with the difference in the silhouette: the gradillas resemble a small stairway with several steps.

Greek Revival Style — Mid-nineteenth century revival of forms and ornaments of the architecture of ancient Greece.

Gunu Bong — (*T'boli*) Large or long house, occupied by an extended family of some eight to sixteen members. From the outside, the gunu bong looks like a roof on stilts, since the roof eaves extend about a meter over the side walls, which, in turn, are just over a meter high. Its roof is not very steep. The bamboo stilts for the piles which support it rise some two meters above the ground, and tree stumps may also be used as posts or supports for the floor.

Hadji — (*Tausug*) In the Islamic calendar, a lucky month to commence housebuilding. Building during this month will give the owners a good chance of going to Mecca and acquiring religious and social prestige.

Hagabi — (*Ifugao*) A carved wooden long bench, usually made from a single tree. At the opposite ends of the bench are animal heads, either of carabaos, goats, or pigs. Several days of feasting precede the installation of a hagabi. The bench itself is a status symbol, present in most homes of wealthy Ifugaos.

Half-timbering — A method of construction featuring walls built of timber framework with the spaces filled in by plaster or brickwork. Often, some of the exposed planks are laid at an angle to create a pattern. In modern homes, half-timbering is usually not authentic and used only as decoration in small areas.

Haligi — (*Tagalog*; also *adigi, arigue, halige, haligue*) Wooden house posts.

Halipan — (*Ifugao*) Wooden disks attached to main posts just below the floor beams to prevent rats, mice, and other vermin from entering a house or granary; rat guards.

Hall — The principal room or building in complex.

Hipped Roof — A roof which slopes back equally from all sides of a building.

Horno — (*Tagalog*) A wood-fired, cone-shaped brick oven.

Impost — The uppermost part of a column or pillar supporting an arch.

Idjang — (*Ivatan*) Ancient fortifications found in Batanes island.

Infill — Refers to the construction of a building to fill a void between two existing structures or a vacant space in the downtown core.

International Style — A modern architectural style that eschews decoration and is based on designing buildings in simple cubist forms with no reference to local styles or materials. Characterized by modern building materials such as concrete, steel, and plate glass, the International Style is used to describe an architectural design that is simple, functional, and unornamented following the theoretical teachings of Bauhaus and the leading figures of Modernism of the 1920s and 1930s.

Ionic — Greek style of architecture characterized by ornamental spiral scrolls on the capitals.

Italianate — Built in a style derived from Italy.

Jabu-jabu — (*Maguindanao*; also *dabu-dabu, tabo*) Drums suspended within an Islamic masjid or mosque. The jabu-jabu were beaten to call believers to prayer.

Kamalig – **1.** (*Bicol, Ilocano, Tagalog*) A barn, granary, or storehouse, separate from the main house or bahay kubo, often constructed on stilts using the same materials as the house, and where unhulled rice and similar articles are stored. **2.** (*Agusanon Manobo*) A wooden shed used by the community's *baylan* or priest/priestess and built near his or her home. It contains the paraphernalia needed for religious rites. **3.** (*Sagada Igorot*) Boxlike bedroom in the *inagamang*; about three feet high, used to store items which are not often used.

Kapilya — A term for "church" which is most commonly associated with the religion Iglesia ni Cristo (INC).

Katig — An outrigger of a boat.

Keystone — The central, wedge-shaped piece that locks an arch in place.

Khatib — The Muslim elder.

Klabu — (*T'boli*) A richly decorated and colored cloth canopy which hangs over the *desyung* or place of honor in the T'boli *gunu bong* and serves as a ceiling. Its quality is a gauge of the family's wealth and social standing.

Komedya — A musical comedy.

Kubo — Derived from the Spanish word "cubo" meaning cube.

Kusina — (*Tagalog, from Spanish cocina*) Kitchen or kitchen area.

Kuta — (*Islamic*) Palisade or fortifications. In a general sense, a kuta could be any position or place fortified to defend the lives and property of its occupants. Islamic communities were historically reputed to have the best kuta, since they were able to repel both Spanish and American intruders. This was, of course, before the advent of modern heavy artillery, against which thick walls of stone and wood were no match.

Kuwarto — (*Tagalog, from Spanish cuarto*) Room or bedroom.

Lamin — (*Maranao*) A tower-like extension or room constructed atop the center of the roof of a Maranao *torogan*. It serves as the exclusive quarters of the datu's unmarried daughter or daughters (*liyamin*) and their ladies-in-waiting or *manga ragas*.

Lancet Arch — A pointed arch whose width or span is narrow compared to its height.

Langgal – **1.** (*Tausug, Yakan*; also *ranggar*) Small mosque. For the Yakan, the langgal is built like an ordinary dwelling erected on piles. However, its side walls do not extend up to the roof. The entrance to the house of prayer is through the porch, which is a step lower than the main room and covered with a roof that is correspondingly lower than the main roof. **2.** (*Maranao*) Small mosque to accommodate a few worshippers for daily prayers, usually built in rural areas.

Latrina — (*Spanish*) Toilet of the bahay na bato.

Lattice — An open grillwork of interlacing wood strips used as screening.

Lavanderia — Laundry.

Lintel — A horizontal structural member spanning an opening (e.g., window or door), usually made of wood, stone, or steel (such as a beam). Carries the weight and provides support to the wall above the opening.

Ilustrado — The "enlightened" or educated class of Philippine society during the Spanish Colonial Period.

Loggia — A gallery open on one or more sides, sometimes pillared. It may also be a separate structure, usually in a garden.

Louvers — Vents or horizontal slats covering an opening, which admit air but no light.

Lozenge — A diamond-shaped pattern characteristic of Romanesque decoration that is often carved on pillars, arches, and doorways.

Lumah — 1. (*Badjao*) Stilt house; a permanent dwelling located in the waters of the sea near the shoreline and elevated from the water by a number of major and minor posts, poles, and stilts. Stairs or notched poles with three rungs or notches above the water lead to porch-like landings floored with irregularly spaced boards and to a one-room, two-door structure.

Madrasa — Islamic school where subjects such as Tawhid (oneness of God), Arabic language and text, and the five pillars of Islam are taught. A madrasa is usually financed by cooperative efforts of Yakan villages.

Maestros de Obras — (*Spanish*) Master builders.

Marble — A metamorphic rock formed by the alteration of limestone or dolomite, often irregularly colored by impurities, and used especially in architecture and sculpture.

Masjid — literally "a place for prostration"; mosque; a larger and more permanent type of mosque that has a stone foundation near a body of water. Originally a three-tiered bamboo or wooden structure, the masjid evolved into the familiar pointed or onion dome sheltering a carpeted square or rectangular hall and having small towers or minarets. The mosque complex may also incorporate structures for a variety of religious and community functions, which may include a library, school, conference halls, and other rooms, located around a courtyard behind the main prayer hall.

Maytuab — (*Ivatan*) A type of Ivatan house that has walls made of stone and lime mortar with a cogon hip roof.

Media Agua — (*Spanish*) Protective shade over a window used in many Philippine ancestral houses.

Mihrab — (*Maguindanao, Maranao*) A niche enclosed by a small dome; a prayer niche, said to be the most important part of the mosque or *masjid* since it is situated toward the direction of the Ka'aba (black stone) in Mecca.

Mimbar — (*Maguindanao, Maranao*) Stepped or wooden pulpit inside a mosque, often decorated with traditional okir designs, Arabic ornamental decoration or Koranic inscriptions, where the Muslim elder stands to deliver the sermon.

Minaret — A slender, lofty tower with balconies attached to a Muslim mosque.

Mixed-use Building — Describes a structure that serves more than one purpose, such as a first floor retail storefront with residential units on the second and succeeding upper floors.

Modern Architecture or **Modernism** — One of the most important architectural movements of the twentieth century. Simple, geometric building forms are characterized by steel or concrete frames and glass walls.

Moderne — Historical and stylistic term for the advanced design efforts of the 1920s and 1930s. A French word, it refers to developments in France that were moving toward a truly modern style, but it implies a fashion-oriented emphasis lacking any serious theoretical basis. The term has become somewhat interchangeable with the English "modernistic," which has similar suggestions of a modern style viewed as an alternative to other more traditional styles.

Modillion — A horizontal bracket or scroll that appears at the building or porch cornice.

Module — The measurement that architects use to determine the proportions of a structure, for example, the diameter of a column.

Morphology — The study of the shape and layout of an area as defined by natural and man-made features, e.g., valleys, rivers, roads, boundaries.

Mortar — A mixture to bind stone, composed of washed sand, crushed lime, and water.

Mosaic — A picture or decorative design made by setting small colored pieces of stone or tile onto a surface.

Moulding — A continuous, narrow surface (projecting or recessed, plain or ornamented) designed to break up, accent, or decorate a surface.

Mudéjar — Moorish architecture (eighth through fifteenth centuries) marked by lavish decorative elements, ornate geometric designs, arches, and tiles. Mudejar is also the name given to the Moors who remained in Spain under Christian rule.

Mullion — A vertical post or other upright element that divides a window or other opening into two or more panes.

Municipio — (*Spanish*) Municipal hall, formerly called tribunal.

Muog — (also *moog*) See *kuta*.

Naga — (*Maranao, Samal, Tausug*, other Islamic groups; also *niaga*) Stylized dragon or snake motif common in Islamic carvings, cloth, and wall designs.

Narthex — Vestibule at the "foot" or entrance of the church, corresponding to the lobby of a building; a porch or vestibule of a church, generally colonnaded or arcaded, preceding the nave.

Nave — The middle aisle of a church; in broader terms, the longitudinal part of a church, the part of a church between the chief entrance and the choir (quire), demarcated from the aisles by piers or columns; the central portion of a church, flanked by the aisles.

Neoclassic — A style reviving the use of classic Greek and Roman architectural forms; the style became popular in the Philippines in the latter half of the nineteenth century and the first half of the twentieth century.

Neoclassical Style — Early twentieth century style which combines features of ancient, Renaissance, and Colonial architecture; characterized by imposing buildings with large columned porches.

Niche or **Nicho** — A recess in a wall (interior or exterior), especially for a statue. Usually curved at the back.

Nipa — (*L. Nipa fruticans Wurmb.*) East Indian palm; a thatch made of its leaves; a palm whose stems generally grow underground in swamps and muddy banks. Leaves grow directly from the stem, seven meters or more in length, without spreading in all directions like the coconut palm. Its leaves may be used as a durable roof thatching material.

Obelisk — A tall, tapering column or structure, square or rectangular in section, with a pyramid-shaped top. It is often used as a commemorative monument; a tall, four-sided shaft of stone, usually tapered and monolithic, that rises to a pointed pyramidal top.

Octagonal — Having eight sides and eight angles.

Oculus — A round or eyelike window.

Ogee arch — An arch formed by two S-shaped curves meeting at a point. In other words, a pointed arch with double curved sides, the upper arcs convex, and the lower concave.

Okil or **Okir** — a. (*Maguindanao, Maranao*) Carvings or carved ornamentation on Islamic structures, such as mosques or houses. These carvings were usually centered on several traditional design motifs, such as the *pako* or fern; the *manuk-manuk* or *sarimanok*, a mythical, varicolored bird usually represented with a fish in its beak; the *naga* or stylized, S-shaped serpent; the bird or vine; and the *borak*, or mythical, half-horse, half-human, winged creature. b. (*Maranao* for "ornamental design," either in scroll or geometric forms; related terms are *Maguindanao* ukil, *Tausug* ukkil, and *Tagalog* ukit, all meaning "carving") This term is commonly used to refer to the carved art of the Maranao, Maguindanao, and Tausug, noted for its scroll and leaf designs.

Olog — (*Bontoc Igorot*) A public dormitory for girls of marriageable age; often a small, rectangular structure made of rough, rounded stones with thatch roofing. Inside is a large, crude bed elevated about a foot off the ground, upon which the girls sleep.

Order — A term applied to the three styles of Greek architecture, the Doric, Corinthian, and Ionic, referring to the style of columns and their entablatures; it also refers to the Composite and Tuscan, developed from the three original orders.

Oro, plata, mata — (*Aklanon*, other lowland Christian groups; from *Spanish*, literally, "gold, silver, death") Houses, particularly in lowland Christian areas, had to have stairs whose number of steps was not a multiple of three. Counting from the first step to the last while saying the words in sequence, the final step had to end with either *oro* (gold) or *plata* (silver). It was exceedingly bad luck if they ended with *mata* (death). Thus, builders learned to consider good luck into the number of steps in a staircase.

Osario — (*Spanish*) Ossuary, a place for depositing the bones of the dead.

Pagoda — A temple or sacred building, typically in Buddhist tradition, usually pyramidal, forming a tower with upward curving roofs over the individual stories.

Pako Rabong — (*Maranao, Samal*; also *piako*) A fern-leaf motif, usually stylized, common in Islamic okir carvings.

Pakyaw — (*Tagalog*, also *pakyao, pacquiao, pakyawan*) Contracting construction labor and materials according to an agreed-upon bulk rate, instead of paying workers on a daily wage basis. It is generally regarded as a less expensive arrangement than paying piecemeal for labor and materials.

Paletada — (*Spanish*) A protective layer of mortar that safeguards the walls from moisture and erosion brought by rain and humid air.

Paliguan — (*Tagalog*) See *banyo*.

Palisade — A defensive screen or fence made of timber.

Palma Brava — Fan palm.

Panel — A portion of a surface, often of a wall lining or door, usually rectangular, and can be recessed or raised.

Panolong — (*Maranao*) The projecting floorbeam-ends of a Maranao *torogan*. The wing-like panolong flares outward like a boat prow from the façade of the house and is intricately carved with traditional *okir* designs of fern, snake, or bird motifs.

Panpe — (*Ivatan*) A large, sturdy roof net made of thick ropes and thrown over the roof of the *rakuh* to prevent the roof thatching from being destroyed by strong winds or rain. The panpe is lashed, in turn, to large stones or pegs buried or half-buried in the ground for added security.

Pantile — A roofing tile with an S-shaped profile, laid such that the down curve of one tile overlaps the up curve of the next one.

Papag — Built-in bed.

Parapet — A low protective wall or railing along the edge of a raised platform, roof, or bridge.

Parquet Flooring — Flooring of thin hardwood laid in patterns on a wood subfloor. Inlaid parquet flooring consists of a veneer of decorative hardwoods glued in patterns to squares of softwood backing, then laid on a subfloor.

Pasadizo — (*Spanish*) Corridor, hallway.

Paseo — Passage or walkway; or "to promenade."

Patio — Paved recreation area, usually at the rear of a home.

Pavilion — A projecting section of a building forming an angle on the facade or terminating the wings.

Pedestal — In classical architecture, the base supporting a column or colonnade.

Pediment — The crowning element of pavilions, doorways, or other architectural features, usually triangular in shape, and sometimes filled with carving or sculpture. A pediment may also have a segmental, elliptical, or serpentine design, or broken in the center to receive an ornament.

Pendant — A suspended or hanging ornament, often tear-shaped.

Pendentive — A curved support shaped like an inverted triangle, used to support a dome.

Penthouse — A separately roofed structure at the top of a tall block of apartments or condominiums, or simply the top-floor unit in a residential high-rise.

Pergola — A covered walk in a garden, usually formed by a double row of posts or pillars, with joists above, and covered by climbing plants.

Persianas — (*Spanish*) Blinds.

Piedra China — (*Spanish*) Heavy slabs of granite left by Chinese junk ships, which had been used as ballasts when the ships were not fully loaded.

Pier — Any unattached mass of construction, such as the solid between two windows or a support with no base or cap for an arcade.

Pilaster — A flat, rectangular, vertical member projecting from a wall of which it forms a part; usually has a base and capital and is often fluted. It is designed to be a flat representation of a classical column in shallow relief.

Pillar — Usually a weight-carrying member, such as a pier or a column; sometimes an isolated, freestanding structure used for commemorative purposes.

Pinnacle — A tower, primarily ornamental, that also functions, in Gothic architecture, as an additional weight to a buttress or a pier.

Pitch — Roof slope.

Planter — A container for holding plants.

Plateras — (*Spanish*) Glass-paneled cabinets.

Plateresque — Early Spanish Renaissance architecture; fine detail resembling ornate silverwork.

Plaza — Public square at the center of the town; site of the traditional evening *paseo* or "promenade."

Plinth — The projecting base of a wall.

Población — (*Spanish*, literally, "population") In Philippine context, the main part of town where business and other affairs are conducted.

Pop — Popular, art historical, and critical term used for work that developed in the 1950s and 1960s that drew its inspiration from commercial art expression, including packaging, the art of the comic strip, the vocabulary of film animation, and advertising art. The influence of several major artists during the 1960s, with their realistic images of film stars, enlarged comic strip blocks, and versions of soup and beer cans, became a school of art. Pop-influenced design was seen in the inflated furniture of the 1960s and 1970s and the Memphis designs of the 1980s. With its

eccentric forms and semicomic references, postmodernism also reflects the pop aesthetic. The style opened avenues of expression that had been previously regarded as too frivolous to have any role in architecture and design.

Porch — A covered platform usually with a separate roof at an entrance to a building.

Portal — An entrance, doorway, or gateway.

Portcullis — A grating dropped vertically from grooves to block passages or gates in castles made of wood, metal, or a combination of the two.

Porte Cochere — A carriage porch large enough to allow sheltered arrival.

Portico — A structure usually attached to a building, such as a porch, consisting of a roof supported by piers or columns. A covered or roofed colonnade used at a building's entrance.

Post and Lintel — A method of construction in which vertical beams (posts) are used to support a horizontal beam (lintel).

Postigo — (*Spanish*) Door for pedestrians punctured into the *puerta mayor* (door for carriages).

Postmodernism — The term that has come to describe the stylistic developments that depart from the norms of modernism. Robert Venturi, in his 1996 book, *Complexity and Contradiction in Architecture*, questions the validity of the emphasis of modernists on logic, simplicity, and order, suggesting that ambiguity and contradiction may also have a valid place. Design directions introducing color, ornament, references to historical styles, and elements that sometimes appear eccentric or disturbing have come into increasing use. The Memphis group displays postmodern characteristics in furniture and smaller objects. Debate continues as to whether the postmodernist direction is destined to become the main line of future development or no more than a fashionable trend, soon to be forgotten.

Poured Concrete — Also known as reinforced concrete. A building technique introduced during the early American period; cement, sand, gravel, and water are poured into forms where steel bars have been inserted.

Precast Concrete — Concrete components cast in a factory or on site before being placed in position.

Prefabrication — Manufacturing whole buildings or components cast in a factory or on site before being placed in position.

Prestressed Concrete — A development of ordinary reinforced concrete. The reinforcing steel is replaced by wire cables in ducts.

Principalia — The elite class of Philippine society during the Spanish Colonial Period that included landowners, traders, and professionals.

Puerta — (*Spanish*) Door.

Puente — (*Spanish*) Stone bridge.

Pulpit — A raised and enclosed platform in a church from which a preacher delivers a sermon.

Purlin — Horizontal longitudinal timber in a roof structure.

Pyramidal — Shaped like a pyramid; used especially to describe the roof over the crossing of a church.

Quadrangle — Inner courtyard.

Quibla — (*Maguindanao*) The wall that faces Mecca within the Islamic *masjid* or mosque. The *mihrab* or prayer niche is located along this wall.

Rakuh — (*Ivatan*) Houses built by inhabitants of the Batanes islands. Out of necessity (Batanes being extremely vulnerable to strong typhoons and weather disturbances), the rakuh, or big house, is a sturdy structure with thick lime-and-stone walls and a thick thatched roof lashed tightly to rafters and beams by layers of clipped reeds and rattan.

Ranggar — A small, semipermanent chapel constructed for the convenience of worshippers living far away from the mosque.

Rattan — (*L. Calamus maximus Blanco*) A palm which may grow to more than 150 meters. By extending its leaves and leaf-end whips studded with spines and hooks, it holds on to other plants. Its internode segments grow a meter long, and they are both flexible and sturdy, making them ideal for lashing flooring and thatching materials together. Thicker rattan may be used for furniture.

Refectory — A communal dining hall.

Rehabilitation — Improvements made to a neglected structure to bring it up to standards and make it attractive to prospective owners or tenants.

Reinforced Concrete or **Ferroconcrete** — Concrete that is poured over steel rods or steel mesh to augment its strength.

Relief — Mouldings and ornamentation projecting from the surface of a wall.

Renaissance — Styles existing in Italy in the fifteenth and sixteenth centuries; adaptations of ancient Roman elements to contemporary uses, with attention to the principles of Vitruvius and to existing ruins. Symmetry, simplicity, and exact mathematical relationships are emphasized.

Reredos — An ornamental screen behind and above an altar; can be painted, sculpted, or both.

Restoration — Undertaking improvements to a structure based on historical research or physical evidence, with the use of traditional materials, meant to return the building to its original integrity.

Retablo — An architectural screen or wall above and behind an altar, facing the congregation, usually containing paintings, sculptures, carving, or other decorations. It features any number of niches where images of saints are displayed for veneration.

Revelin — A massive structure constructed on one side of the fort entrance.

Ribbed Vaulting — Stone or brick vaulting typically used for roofing consisting of a thin, light layer of stone supported by a framework of arched ribs.

Rococo — A style of décor popular in Europe and America about the middle of the eighteenth century (it reached the Philippines in the second half of the eighteenth century), characterized by asymmetrical composition and the use of elements inspired by rocks and shells known as rocaille.

Romanesque Architecture — A style of architecture that flourished in Western Europe between 1050 and 1200. This style derived its name from the fact that it drew much of its influence from Roman architecture. In England, it is also called the Norman style. Some of the characteristic features of this school of architecture are rounded arches; squat, massive pillars; small windows; and simple, carved decoration.

Rose Window — A large, circular window with tracery and stained glass; often the central feature of Gothic church facades.

Rosettes — French for "little roses." A floral decorative device, usually a circle with petals developing out from a central point. The outer contour may be round, elliptical, or square. The rosette has been a popular motif since the Gothic period.

Rotunda — A round hall or room surmounted by a dome.

Rowhouse — A residential building, usually built as rental apartments. The floor plan is commonly repeated from unit to unit, with each unit sharing a wall with the adjacent one. The building has a single, continuous wall along the street.

Runo — (*Miscanthus sinensis Anders*) A coarse, wild grass which takes hold in soil that has been wasted by fire, except in higher elevations.

It grows in bunches to a height of one to three meters. Its stems, which resemble slim bamboo, may be used for fencing, wall sidings, and flooring.

Rustication — Masonry cut in massive blocks separated by deep joints used to give a rich, bold texture to an outside wall; common in Romanesque-inspired architecture; effect sometimes simulated in stucco and other building materials.

Sabungan — A cockpit; any building where cockfights are held, usually a coliseum, arena, or sports center with a central area ringed by seats or benches for spectators. The sabungan is a town landmark, and cockfights are usually held on holidays and weekends. The roof varies according to the floor plan and may be hipped or gabled over a square cockpit or conical over a circular one. Walls or sidings are usually absent, a concession both to the size and the excitement of the crowds. The more modern cockpits are walled and air-conditioned.

Sacristy — A room usually attached to the north side of the chancel where vestments and sacred vessels used in the altar are placed. It is synonymous with the vestry.

Sagang — A barrier placed at the top of the stairs to prevent children from falling.

Sahig — (*Tagalog*) Floor; the slatted floor of a *bahay kubo*.

Sala — (*Spanish*) Located at the front side of the traditional *bahay kubo*, the sala is a multipurpose room for any family activity, except cooking, bathing, and toilet functions.

Salagúnting — (*Bisaya*) Spelled in sources as salaguntines. Rafters of a roof; also known as quilos.

Salakot — Native wide-brimmed hat.

Sala-sala — Bamboo latticework.

Sanctuary — The immediate area around the main altar.

Santos — (*Spanish*) In the Philippines, the term refers to images of Christian saints and heavenly personalities.

Sarimanok — An indigenous bird motif often used in Maranao and other Islamic art, such as woodcarving and brassware. The motif has the appearance of a bird or rooster holding a fish in its claws or beak.

Sarsuwela — (*Tagalog*; from *Spanish zarzuela*) A musical comedy.

Sawali — (*Tagalog*) Flattened, split bamboo woven together into herringbone patterns and used for wall sidings or ceilings.

Screen — A partition of stone or wood that separates, without completely cutting off, one part of a church from another part.

Scroll — An ornament carved in the form of a scroll of paper.

Shaft — The main vertical part of a column between the base and the capital.

Shingle — A standard-sized unit, usually made of wood, used for covering walls or roofs, applied (laid) in an overlapping fashion.

Sibi — A native term for "portico."

Siding — The exterior wall covering or sheathing of a structure.

Silid — (*Tagalog*; from *Spanish celda*) Room, usually a bedroom, marked off from the *bulwagan* or *sala*, the main room of the house, by a wall of sawali.

Sill — The lower horizontal part of a window frame.

Silong — (*Tagalog*; other lowland Christian groups) The space underneath a house; usually open-sided. Stakes or fences of woven bamboo may sometimes cover its sides and enclose it. Often, farm and fishing tools, pestles, chickens, pigs, or other livestock are kept here. During the day, the animals are allowed to wander freely, but at night, they are herded into the silong where their commotion will warn the owners of the house of intruders or thieves.

Sinadumparan — (*Ivatan*) A type of Ivatan house that has walls made of stone and lime mortar. The narrower walls at the opposite end are extended upward, forming a triangle with which the cogon roof is leveled. It has a low basement, which is used as storage area or as shelter for domesticated animals during typhoons.

Simbahan — (*Tagalog*) A church; private places where relatives and dependents meet for special rituals during the Pre-Hispanic period.

Skylight — A window set into a roof or ceiling to provide extra lighting. Sizes, shapes, and placement vary widely.

Soffit — The exposed undersurface of any overhead component.

Spire — An elongated, pointed structure that rises from a tower, turret, or roof.

Splayed — An oblique angle or bevel given to the sides of an opening in a wall so that the opening is wider on one side of the wall than on the other.

Stained Glass — Glass colored by mixing pigments inherently in the glass by fusing colored metallic oxides onto the glass, or by painting and baking transparent colors on the glass surface.

Streetscape — Refers to the pedestrian view of the downtown area. The streetscape includes the harmonious mix of buildings, sidewalks, signs, public furnishings, and the distance from which the buildings are set back from the curb edge.

Stucco — Final cement color coat plastered in the exterior of an adobe-style building and often spread in a decorative pattern.

Studs — Smaller upright beams in a house to which drywall panels or laths for plaster are attached.

Style — Refers to the design elements that define the architecture of a building and the period in which it was built.

Swag — A decorative carving representing a suspended cloth or curtain.

Tabernacle — A boxlike shrine where the Blessed Sacrament is kept.

Tabique Pampango — A Filipino version of wattle-and-daub construction popular in Europe. Instead of using pliable branches of plants with a mixture of mud and straw applied on both sides of the wall and allowed to be sun-dried, the local builders used pliable bamboo with a mixture of mortar composed of sand, lime, and water.

Tabla — (*Spanish*) A board of wood used for floors and walls.

Tadjuk Pasung — (*Tausug*; also *tajuk*) Roof gable decoration; intricately carved wood design on either or both ends of a sungan roof. The tadjuk pasung may be a stylized bird or dragon accompanied by leaf-like designs (*pako rabong*). See *naga, okir, sarimanok*.

Terra-cotta — Fired but unglazed clay used mainly for floor and roof tiles; can be fired in molds to produce a wide range of shapes; usually red in color.

Terrace — A level promenade in front of a building; usually made of stone and accented with plants, statuary, etc.

Terrazzo — A sturdy flooring finish of marble chips mixed with cement mortar. After drying, the surface is ground and polished.

Thatch — A roof covering of straw, reeds, or even living grass. In modern homes, most "thatching" is only decorative, simulated with shingles.

Tie-beam — The main horizontal beam in a roof, connecting the bases of the rafters, usually just above a wall.

Tile Roof — Made of clay tiles (*Spanish tejas*) shaped over log molds (not over Indian women's thighs as legend has it). The tiles are then fired in a kiln which makes them hard and, most importantly, weatherproof.

Torogan — (*Maranao*) Large, lavishly ornamented ancestral houses of the upper classes of the Maranao, usually built for sultans or datus. The torogan was a symbol of rank and power. Its floor beams are supported by many thick posts, the trunks of large trees or large round balusters that stand on large stones. It has a high, steep roof; its floor panels and the wall sidings of the windows are decorated with traditional carvings known as *okir*. Its windows are horizontal openings about two meters in length and over fifteen centimeters wide between the *panolong* or sculpted floor-and side-beam ends.

Tracery — Carved stonework of interlaced and branching ribs, particularly the lace-like stonework in the upper part of a Gothic window.

Transept — The part of a cruciform church with an axis that crosses the main axis at right angles; the transverse portion or "arms" of a cruciform church; *Spanish crucero*.

Transom — A panel or crosspiece, which could be fixed or movable, that is placed over a door or window to provide additional natural light and ventilation for the interior of the building. Some transoms open to cross-ventilate a home, while others are only decorative.

Trefoil — Literally means "three leaves," thus relating to any decorative element with the appearance of a clover leaf.

Trelliswork — An open pattern of interwoven strips usually of wood but, sometimes, of metal; also called latticework.

Tribuna — (*Spanish*) A balcony overlooking the nave of a church, especially over the sanctuary; it is connected to the convento. Dignitaries and members of the convento household could join the services below without mingling with the crowd; also, those with private devotions could face the altar without having to go down.

Tribunal — (*Spanish*) The seat of the local civil administration in a town; later called the *municipio*.

Truss — A number of wood planks framed together to bridge a space, such as a roof truss.

Tsalet — (from *French* chalet) A typical dwelling in the early twentieth century American Period with a distinctive L- or T-shaped stairway leading to a front or surrounding porch.

Tukod — (also *tukud, tuod, pangtuod*) **1.** (*Kankanay*) Pillar, post, or secondary post; newel post. **2.** (*Ifugao*) Main posts of a house. **3.** (*Maranao*) Corner post.

Turret — A small tower, usually starting at some distance from the ground, attached to a building, such as a castle or fortress.

Tuscan Order — A Roman order resembling the Doric but without a fluted shaft.

Tympanum — The ornamental, triangular, recessed space or panel enclosed by the cornices of a triangular pediment. Also, a similar space between an arch and the lintel of a portal or window.

Urban Sprawl — A development that allows structures with deep setbacks and large parking lots in front at the gateway of communities.

Vault — A masonry roof or ceiling constructed on the arch principle. A barrel or tunnel vault, semicylindrical in cross section, is in effect a deep arch or an uninterrupted series of arches, one behind the other, over an oblong space.

Ventana — (*Spanish*) Window.

Ventanilla — An opening between the windowsill and the floor of the bahay na bato, with sliding wooden shutters and wooden balustrades or iron grilles.

Veranda — An open gallery or balcony with a roof supported by light supports.

Vestibule — Small entrance hall of a building.

Vestry — A room in or attached to a church where the clergy put on their vestments and where these robes and other sacred objects are stored; synonymous with a sacristy.

Villa — In Roman architecture, the land-owner's residence or farmstead on his country estate; in Renaissance architecture, a country house; in nineteenth-century England, a detached house usually on the outskirts of town; in modern architecture, a small house.

Visita — (*Spanish*) Mission station established in key settlements of a parish and visited by the priest or his assistant on certain occasions, such as feast days, to administer the sacraments.

Volada — (*Spanish*) Cantilevered gallery extending from the exterior of a building, usually with sliding windows.

Volute — A spiral scroll.

Voussoir — The shaped bricks or stones over a window, forming a head or arch.

Vuchid — (*Ivatan*) A type of grass used for the Ivatan thatch roof.

Wainscoting — Decorative paneling covering the lower three to four feet of an interior wall. Usually of wood in a plain design; it may be painted or just varnished.

Whitewash — A mixture of lime and water, often with whiting, size, or glue added, used to whiten walls, fences, or other structures.

Wudu — (*Maranao*) Areas near a mosque where ablutions may be performed.

Zaguán — (*Spanish*) Hallway at the ground level of a building, just behind the main entrance. The ground floor of the bahay na bato contained the grand staircase and was reserved for storage or leased to shop owners in business areas.

Bibliography

Abel, Chris. *Architecture and Identity (Second Edition).* Oxford and Boston: Architectural Press, 2000.

Agana, Anastacio. "Construction of the UST Main Building." *Unitas* L, no. 4 (December 1977).

Agoncillo, Teodoro. *History of the Filipino People.* Quezon City: GAROTECH Publishing. 1990.

Aguado, Rex. "Scraping the Sky." *Manila Chronicle* (December 7-13, 1991).

Ahlborn, Richard. "The Spanish Churches of Central Luzon: The Provinces Near Manila." *Philippine Studies* VIII (January 8, 1960): 283-300.

———. "Spanish-Philippine Churches: An Interpretation." *Exchange News Quarterly* (October–December 1958).

———. "The Spanish Churches of Central Luzon (I)." *Philippine Studies* VII (October 1960): 802-13.

Alcazaren, Paulo. "The American Influence on the Urbanism and Architecture of Manila (1898–1952)." Unpublished masteral thesis, National University of Singapore, 2000.

———. "(Re)structuring Philippine Architecture." *Sanghaya 2002: Philippine Arts and Culture Yearbook.* Manila: National Commission for Culture and the Arts, 2003.

Alcudia, Paterno. "Can We Develop a Native Architecture?" *Philippine Institute of Architects Journal.* Manila: Philippine Institute of Architects, 1966.

Alejandro, Reynaldo and Vicente Santos. *Tahanan: A House Reborn.* Malabon City: Duende Publishing, 2003.

"A Look at Philippine Mosques." *Salam* III, no. 1 (1976): 12–14.

AlSayyad, Nezar, ed. *Forms of Dominance: On the Architecture and Urbanism of the Colonial Enterprise.* Aldershot, England: Avebury, 1992.

Anderson, Benedict. *Imagined Communities: Reflections on the Origins and Spread of Nationalism.* London: Verso, 1991.

Anderson, Warwick. "Excremental Colonialism: Public Health and the Poetics of Pollution" *Critical Inquiry* 21 (1995): 640-69.

Arellano, Otilio. "Philippine Architecture." *Philippine Panorama* (September 1960).

Aschroft, Bill, Gareth Griffiths, and Helen Tiffin, eds. *Key Concepts in Postcolonial Studies.* London and New York: Routledge, 1988.

———. The Postcolonial Studies Reader. London and New York: Routledge, 1995.

"A sensation anticipated." *Manila Times* (June 23, 1903): 1.

Atayde, Juan De. "Los Teatros de Manila." *La Ilustracion Filipina* (August 21– September 7, 1892).

"Ayala Land Set Complete Makati's New Village." http://www.ayala.com.ph/news/view.asp?news_id=32.

Bacani, Cesar and Wilhelmina Paras. "God's Builder in Manila: A Developer Works to Deliver on a $1.6 billion Gamble." *Asiaweek* (May 24, 1996).

Ballentine, Charles. *As It is in the Philippines*. New York: Lewis, Scribner, and Co., 1902.

Bañas, Raymundo. *A Brief Sketch of Philippine Catholic Churches*. Manila: Self-published, 1937.

Barile, Lorna E. "The Hotels of Old Manila." *Observer* (March 6, 1983).

Barringer, Tim and Tom Flynn. *Colonialism and the Object: Empire, Material Culture, and the Museum*. London and New York: Routledge, 1998.

Baterina, Margot. "The Coconut Tahanan." *Philippine Panorama* (November 29, 1981).

Bayer, Patricia. *Art Deco Architecture: Design, Decoration, and Detail from the Twenties and Thirties*. London: Thames and Hudson, 1992.

——. *Art Deco Interiors: Decoration and Design Classics of the 1920s and the 1930s*. London: Thames and Hudson, 1990.

Bello, Moises. "Some Notes on House Styles in a Kankanai Village." *Asian Studies* III, no. 1 (1965): 41–45.

Bennagen, Ponciano L. "The Agta." *Esso Silangan* XIV, no. 3 (1969): 4–7.

Bergaño, Diego. *Vocabulario de la Lengua Pampangan en Romance*. American Philosophical Society. Library. Manila: Imp. de Ramirez y Giraudier, 1860.

Bethune, Ade De. "Philippine Adventure." *Philippine Studies* II (1955): 234–40.

Betsky, Aaron. *Violated Perfection: Architecture and the Fragmentation of the Modern*. New York: Rizzoli, 1990.

Beyer, Henry Otley. "The Non-Christian Peoples of the Philippines." *Census of the Philippine Islands*, volume II. Manila: Bureau of Printing, 1918.

——. *The Origin and History of the Philippine Rice Terraces*. Proceedings of the Eighth Pacific Science Congress. Quezon City: University of Philippines, 1955.

Beyer, William G. "Mountain Folk Arts." *Aspects of Philippine Culture*, 1948.

Bhabha, Homi K. "Signs Taken for Wonders: Questions of Ambivalence and Authority under a Tree Outside Delhi, May 1817." *The Location of Culture*. London: Routledge, 1994.

——, ed. *Nation and Narration*. London: Routledge, 1990.

Blair, Emma Helen and James Alexander Robertson, eds. *The Philippine Islands, 1493–1898*. 55 volumes. Cleveland, Ohio: The A. H. Clark Company, 1903–1909.

Blust, Robert. "Lexical Reconstruction and Semantic Reconstruction: The Case of Austronesian 'House' Words." *Diachronica* IV (1/2) (1987): 79–106.

Bocobo Jr, Antonio E. "The Legacy of a Great Builder." *Pasugo* (May–June 1986), 27–34.

Bourdieu, Pierre. "Structures, Habitus, Power: Basis for a Theory of Symbolic Power." *Culture/Power/History*, edited by Nicholas B. Dirks et al. Princeton, NJ: Princeton University Press, 1994.

———. *Distinction: A Social Critique of the Judgement of Taste.* Cambridge, MA: Harvard University Press, 1984.

Bourne, Edgar K. "Exhibit B: Report of the Chief of the Bureau of Architecture and Construction of Public Buildings." *Sixth Annual Report of the Philippine Commission 1905* (In Four Parts) Part 4, 617–22. Washington: Government Printing Office, 1906.

Boyer, Christine. *CyberCities: Visual Perception in the Age of Electronic Communication.* New York: Princeton Architectural Press, 1996.

Bragdon, Claude. *The Frozen Fountain: Being Essays on Architecture and the Art of Design in Space.* New York: Alfred A. Knopf, 1932.

Brody, David. "Fantasy Realized: The Philippines, Orientalism, and Imperialism in Turn-of-the-Century American Visual Culture." Unpublished doctoral dissertation, American and New England Studies Program, Boston University, 1997.

———. "Building Empire: Architecture and American Imperialism in the Philippines." *Journal of Asian American Studies* 4, no. 2 (June 2001): 123–45.

Brolin, Brent. *Architectural Ornament: Banishment and Return.* New York and London: W. W. Norton and Co., 2000.

Buenaventura, Cristina Laconico. "The Theaters of Manila." *Philippine Studies* XXVII (1979): 5–37.

Bureau of Education. *Bulletin Number 32–1910.* Courses in Mechanical and Free-Hand Drawing for Use in Trade and Intermediate Schools. Manila: Bureau of Printing, 1910.

Bureau of Printing. *A Brief Description of the Bureau of Printing Plant.* Manila: Bureau of Printing, 1915.

Bureau of Public Instruction. *Annual Report of the Superintendent of Education.* Manila: Bureau of Printing, 1904.

Bureau of Public Works. *Bureau of Public Works Philippine Carnival Catalogue.* Bureau of Printing: Manila, 1911.

———. *The Bureau of Public Works Bulletin* (1910–1927).

———. *The Bureau of Public Works Bulletin.* (1957).

———. *The Bureau of Public Works Bulletin* (April–June 1958).

———. *Quarterly Bulletin of the Bureau of Public Works* (April 1912; April and October 1913; January, April, and July 1914; July and October 1916; and January 1917).

Burnham, Daniel Hudson. *Report on Proposed Improvements at Manila.* Washington: Government Printing Office, 1906.

Cabalfin, Edson Roy G. "Art Deco Filipino: Power, Politics, and Ideology in Philippine Art Deco Architectures (1928-1941)." Unpublished master's thesis, University of Cincinnati, Design, Architecture, Art, and Planning: Architecture, 2003.

Calairo, Emmanuel Franco. *Sulyap sa Lumipas: Mga Tahanang Ancestral sa Kabite.* Dasmariñas Cavite Studies Center: De La Salle University, 1999.

Cameron, H. F. "Provincial Centers in the Philippine Islands." *Bureau of Public Works Quarterly Bulletin* (April 1914): 3-12.

Candelaria, Max. "A History of Philippine Architecture." *Architectscope* (October 1972).

Caoili, Manuel A. *The Origins of Metropolitan Manila: A Political and Social Analysis.* Quezon City: New Day Publishers, 1988.

Capital City Planning Commission. *The Master Plan for the New Capital City.* Manila: Bureau of Printing, 1949.

Carpenter, Frank G. *Through the Philippines.* New York: Double Day Publications, 1925.

Caruncho, Eric. *Designing Filipino: The Architecture of Francisco Mañosa.* Manila: Tukod Foundation, 2003.

Casal, Gabriel S. *T'boli Art in its Socio-Cultural Context.* Makati, Metro Manila: Ayala Museum, 1978.

Castañeda, Dominador. *Art in the Philippines.* Quezon City: University of the Philippines Press, 1964.

Cawed, Carmencita. *The Culture of the Bontoc Igorots.* Manila: MCS Enterprises, 1972.

Celik, Zeynep. *Displaying the Orient: Architecture of Islam in Nineteenth Century World Fairs.* Berkeley and Los Angeles: University of California Press, 1992.

Chirino, Pedro. *Relación de las Islas Filipinas, The Philippines in 1600.* 1604. Manila [Historical Conservation Society; Bookmark, exclusive distributor], 1969.

Chrisostomo, Isabelo T. "Felix Y. Manalo and the Iglesia ni Cristo." *Pasugo* (May–June 1986): 5-21.

Churchill, Bernardita R., ed. *Selected Papers of the Annual Conferences of the Manila Studies Association, 1989-1993.* Manila: Manila Studies Association, Philippine National Historical Society, National Commission for Culture and the Arts, 1994.

Cody, Jeffrey W. *Exporting American Architecture 1870-2000.* London and New York: Routledge, 2003.

Cole, Fay Cooper. "The Wild Tribes of Davao District, Mindanao." *Field Museum of Natural History Anthropological Series* 12, no. 2, (1913): 49-203.

Colquhoun, Alan. "The Concept of Regionalism." *Postcolonial Space(s),* edited by Gulsum Badyar Nalbantoglu and Wong Chong Thai. New York: Princeton Architectural Press, 1997.

Concepcion, Leonardo. "Architecture in the Philippines." *Pamana* (1972).

Conklin, Harold C. *Ifugao Bibliography—(SI) South East Asian Studies* (1968).

Condit, Carl W. *The Chicago School of Architecture: A History of Commercial and Public Building in the Chicago Area, 1875-1925.* Chicago: University of Chicago Press, 1964.

Conrads, Ulrich, ed. *Programs and Manifestoes of 20th Century Architecture.* Massachusetts: MIT Press, 1971.

Cordero-Fernando, Gilda, ed. *Turn of the Century.* Quezon City: GCF Books, 1978.

Coseteng, Alicia M. L. *Spanish Churches in the Philippines.* Manila: Mercury Press, 1972.

Craig, Lois A. *The Federal Presence: Architecture, Politics, and Symbols in United States Government Buildings.* Cambridge: MIT Press, 1978.

Crang, Mike, Phil Crang, and Jon May, eds. *Virtual Geographies: Bodies, Space, and Relations.* London and New York: Routledge, 1999.

Cruz, Jose A. "Progress of Development of the Port of Manila." *The Bureau of Public Works Bulletin* (July–September 1956).

Cullinane, Michael. "The Changing Nature of the Cebu Urban Elite in the 19th Century." *Philippine Social History: Global Trade and Local Transformation.* Quezon City: Ateneo de Manila University Press, 1986.

Curtis, William. "Towards an Authentic Regionalism." *Mimar* 19. Singapore: Concept Media Ltd., 1986.

——. *Modern Architecture Since 1900* (Third edition). London and New York: Phaidon Press, 1996.

Dacanay Jr., Julian. *Selected Writings I: Ethnic Houses and Philippine Artistic Expression.* Pasig, Metro Manila: One Man Show Studio, 1988.

——. "The Burnham-Anderson Blueprints." *Filipino Heritage* 9. Manila: Lahing Pilipino Publishing, 1978.

Dakudao, Michelangelo. "The Imperial Consulting Architect: William E. Parsons (1872–1939)." *Bulletin of the American Historical Collection* (January 1994).

Dampier, William. *Travel Accounts of the Islands (1513-1787).* Manila: Filipiniana Book Guild, 1971.

Davidson, Lilian. "The Philippine Panorama." *The Rotarian* (October 1932).

Davis, Mike. *City of Quartz: Excavating the Future in Los Angeles.* New York: Verso, 1990.

Day-Romulo, Beth. "Leandro Locsin: Manila's Master Builder." *Reader's Digest* (December 1977).

De la Costa, Horacio. *Jesuits in the Philippines, 1581–1768.* Cambridge, Massachusetts: Harvard University Press, 1967.

De La Gironiere, Paul P. *Twenty Years in the Philippines.* New York: Harper and Brothers, 1854.

De la Torre, Visitacion. *Landmarks of Manila, 1571–1930*. Makati: Filipinas Foundation, 1981.

——. "The Metropolitan Theater: Waiting for a Curtain Call." *Pamana* 29, no. 52 (1977).

De Leon Jr., Felipe M. "The Architecture of the Philippines: A Survey." *Philippine Art and Literature, Vol. III, The Filipino Nation*. Manila: Grolier International Philippines, 1982.

——. "The Unity of Spatial Concepts in Philippine Architecture and Other Arts." *National Symposium on Filipino Architecture and Design*. Quezon City: Sentro ng Arkitekturang Filipino, 1995.

De los Reyes, Gilberto M. "An Old House that History has Touched." *Michael Goldenberg Memorial Book*. Manila: The Heirs of Michael Goldenberg, 1963.

"Demolition of City Walls," *Manila Times* (June 25, 1903): 1.

De San Antonio, Juan Francisco. *The Philippine Chronicles of Fray San Antonio 1686–1744: A Translation from the Spanish*. Manila: Casalinda and Historical Conservation Society, 1977

De San Buenaventura, Pedro. *Vocabulario de Lengua Tagala*. Villa de Pila, 1613.

De Viana, Lorelei. *Three Centuries of Binondo Architecture, 1594-1898: A Socio-Historical Perspective*. Manila: University of Santo Tomas Press, 2001.

Delgado, Jose. *Historia General Sacro-profana, Politica y Natural de las Islas de Poniente llamadas Filipinas*. Manila: Imprenta del Eco de Filipinas de Don Juan Atayde, 1892.

Design Magazine (May 1956).

Diaz-Trechuelo, Lourdes. *Arquitectura Española en Filipinas (1565–1800)*. Sevilla: Escuela de Estudios Hispano-Americanos de Sevilla, 1959.

Doane, Ralph Harrington. "The Story of American Architecture in the Philippines." *Architectural Review* 8, no. 2 (February 1919); 8, no. 5 (May 1919).

Doeppers, Daniel. "The Development of Philippine Cities Before 1900." *The Journal of Asian Studies* 31, no. 4 (August 1972): 769-92.

——. *Manila 1900-1941: Social Change in a Late Colonial Metropolis*. Quezon City: Ateneo de Manila University Press, 1984.

Dovey, Kim. *Framing Places: Mediating Power in Built Form*. London and New York: Routledge, 1999.

Dozier, Edward P. *The Kalinga of Northern Luzon*. New York: Holt, Rinehart, and Winston, 1967.

Duncan, Alastair, ed. *Encyclopedia of Art Deco*. New York: E. P. Dutton and Co., 1988.

During, Simon. "Postmodernism or Postcolonialism Today." *Postcolonial Studies Reader*, edited by Bill Aschroft, Gareth Griffith, and Helen Tiffin. London and New York: Routledge, 1995.

El Archipielago. Washington DC: Government Printing Press, 1900.

Elliot, Charles B. *The Philippines to the End of the Military Regime.* Indianapolis: Bobbs-Merill, 1917.

Ellis, Henry T. *Hongkong to Manila and the Lakes of Luzon in the Philippine Isles in the Year 1856.* London: Smith, Elder, and Company, 1859.

"Everything San Francisco." http://www.brittany.com.ph/victorianne.asp.

Far East Economic Review (January 2, 1976): 39.

The Far Eastern Review. "Details and Description of Burnham for the Reconstruction of Manila." (March 1907): 322–27.

——. "New Army and Navy Club in Manila." (January 1909): 269–73.

——. "New Insane Wards at San Lazaro Hospital, Manila, of Reinforced Concrete." (April 1907): 355–56.

——. "New Manila Club." (February 1908): 276–77.

——. "New Young Men's Christian Association." (February 1908): 278–79.

——. "Reinforced Concrete in the Cathedral Church of St. Mary and St. John at Manila." (November 1906): 175–80.

——. "The Manila Hotel." (August 1911): 103.

Feliciano, Edgardo M. *Condominiums and Townhouses in the Philippines: A Fact-Book and Directory.* Makati: EM Feliciano Publishing, 1991.

Fernandez, Honrado. "Philippines." *Transforming Traditions: Architecture in ASEAN Countries.* Singapore: ASEAN Committee on Culture and Information, 2001.

Fernandez, Pablo. *History of the Church in the Philippines 1521–1898.* Manila: National Bookstore, 1979.

Filipiniana Book Guild. *The Colonization and Conquest of the Philippines by Spain: Some Contemporary Source Documents, 1559-1577.* Manila: Filipiniana Book Guild, 1965.

"FLI to build ₱780-M Township in Laguna." *Philippine Star* (March 20, 2004).

Forbes, William Cameron. *The Philippine Islands.* Boston: Houghton Mifflin, 1928.

"Fort William McKinley, Manila." *Far Eastern Review* 2, no. 5 (October 1905): 126–28.

Foucault, Michel. "Of Other Spaces." *Diacritics* 16 (Spring 1986): 22–27.

——. *Politics, Philosophy, Culture: Interviews and Other Writings, 1977–1984,* translated by Alan Sheridan and others; edited with an introduction by Lawrence D. Kritzman. New York: Routledge, 1990, c1988.

Fox, Robert B. "Tabon Caves." *Filipino Heritage—The Making of a Nation I,* edited by Alfredo R. Roces.

——. "Looking at the Prehispanic Community." *Filipino Heritage—The Making of a Nation II,* edited by Alfredo R. Roces.

———. *The Tabon Caves*. Manila: National Museum, 1970.

Frampton, Kenneth. "Prospects for Critical Regionalism." *Theorizing a New Agenda for Architecture: An Anthology of Architecture Theory from 1965-1995*, edited by Kate Nesbitt. New York: Princeton Architectural Press, 1996.

———. "Towards a Critical Regionalism: Six Points for an Architecture of Resistance." *The Anti-Aesthetic: Essays on Postmodern Culture*, edited by Hal Foster. New York: The New Press, 1983.

Friedmann, John. "The World City Hypothesis." *Development and Change* 17, no. 1 (1986): 69-84.

Fuentes, Feljun B. "The Iglesia ni Cristo Central Office." *Pasugo* (May-June 1986): 88-90.

Fuller, Richard Buckminster. *Critical Path*. New York: St. Martin's Press, 1981.

Galende, Pedro and Regalado Trota Jose. *San Agustin Art and History, 1571-2000*. Manila: San Agustin Museum, 2000.

Galende, Pedro. *Angels in Stone: The Architecture of Augustinian Churches in the Philippines*. Manila: GA Formoso Publishing, 1987.

———. *San Agustin: The Noble Shrine*. Manila: GA Formoso Publishing, 1989.

Garcia, Felino Jr. "The Danger of Excrement: Feces, Filth, and the Body in the American Colonial Regime in the Philippines." *Theory, Practice, and Application of Health Social Science in the Philippines*. Iloilo: Philippine Health Social Science Association. 2001.

Gatbonton, Esperanza. *Bastion San Diego*. Manila: Intramuros Administration, 1985.

———. *Intramuros: A Historical Guide*. Manila: Intramuros Administration, 1980.

——— and Jaime Laya. *Intramuros of Memory*. Manila: Intramuros Administration, 1983.

Gatbonton, Juan. *Philippine Churches*. Manila: National Media Production Center, 1980.

Gates, John M. *Schoolbooks and Krags: The United States Army in the Philippines, 1898-1902*. Westport, CT: Greenwood Press, 1973.

Gatmaitan, Rhoderick D. "SMC Head Office Complex—Taking a Closer Look." *Kaunlaran* (July 1984).

General Headquarters, USAFFE. Press Release of MacArthur, Douglas (December 27, 1941).

Gianzo, F. "Puente Grande." *La Ilustracion Filipina* (March 15, 1892): 9-10.

Giddens, Anthony. *The Consequences of Modernity*. Stanford: Stanford University Press, 1990.

"Glimpses: Church's Construction Programs Goes On." *Pasugo* (September-October 1988): 46.

Golay, Frank. *Face of Empire: United States-Philippine Relations 1898-1941*. Diliman, Quezon City: Ateneo de Manila University Press; Madison: University of Wisconsin, 2000.

Gonzales, Julio. *The Batanes Islands.* Manila: University of Santo Tomas Press, 1969.

Goodno, James. "Burnham's Manila: A Century Later, the Master Planner's City Beautiful Ideas Still Have Meaning." *Planning* 70, no. 11 (December 2004): 30–34.

Gowing, Peter G. *Muslim Filipinos: Heritage and Horizon.* Quezon City: New Day Publishers, 1979.

Gray, Russell D. and Fiona M. Jordan. "Language Trees Support the Express-Train Sequence of Austronesian Expansion." *Nature* 405 (June 29, 2000): 1052–55.

Guijo, Javier Galvan. "Spanish Colonial Architecture in the Philippines." *Manila 1571–1898: The Western Orient.* Madrid: Universidad de Alcalá, Instituto Español de Arquitectura, A. E. C. I, Ministerio de Asuntos Exteriores; Ministerio de Fomento: Centro de Estudios y Experimentación de Obras Públicas; Centro de Estudios Históricos de Obras Públicas y Urbanismo, 1998.

Hannaford, Ebenezer. *History and Description of Our Philippine Wonderland, and Photographic Panorama of Hawaii, Cuba, Porto Rico, Samoa, Guam, and Wake Island.* Springfield, OA: The Crowell and Kirkpatrick, 1899.

Hannerz, Ulf. *Transnational Connections: Culture, People, Places.* London: Routledge, 1996.

Hargrove, Thomas R. *The Mysteries of Taal.* Manila: Bookmark, 1991.

———. "Submerged Spanish-Era Towns in Lake Taal, Philippines: An Underwater and Archival Investigation of a Legend." *International Journal of Nautical Archeology and Underwater Exploration* XV, no. 4 (1986): 323–37.

Hart, Donn V. *The Cebuano Filipino Dwelling in Caticugan: Its Construction and Cultural Aspects.* New Haven: Yale University South East Asian Studies, 1959.

Hartendorp, A. V. H. "The Legislative Building." *Philippine Education Magazine* (October 1926).

———. "Philippine Regional Architecture and Juan Arellano's Design Based on Ethnic Forms." *Philippine Magazine* 31, no. 6 (June 1934).

———. "The Metropolitan Theater." *Philippine Education Magazine* (January 1932).

Harvey, David. *The Condition of Postmodernity.* New York: Blackwell, 1989.

Heiser, Victor G. *An American Doctor's Odyssey: Adventures in Forty-five Countries.* New York: W. W. Norton and Co., 1936.

Heistand, H. O. S. and A. E. W. Salt. *An Introduction to the History of Manila: Notes on the Historical Origin of the Names of the Districts, Barrios, Streets, Monuments, etc., of Manila, with some Account of the Fortifications of the Walled City.* Manila: s.n., 1912.

Herbella, Perez Manuel. *Manual de Construcciones y de Fortification de Compañia en Filipinas.* Madrid: Imprenta del Memorial de Ingenieros, 1882.

Hernando, Eugenio. "Sanitacion En Filipinas." *Journal of the Philippine Islands Medical Association* 12 (1927): 455–573.

Hila, Corazon. *Arkitektura: An Essay in Philippine Ethnic Architecture.* Manila: Cultural Center of the Philippines. 1992.

———, Rodrigo Perez and Julian Dacanay. *Balai Vernacular: Images of the Filipino's Private Space.* Manila: Sentrong Pangkultura ng Pilipinas, Museo ng Kalinangang Pilipino, 1992.

Hillier, Bevis. *The World of Art Deco.* New York: Dutton, 1971.

Hines, Thomas S. "American Modernism in the Philippines: The Forgotten Architecture of William E. Parsons." *Journal of the Society of Architectural Historians* XXIII, no. 4 (December 1973): 324–25.

———. "The Imperial Façade: Daniel H. Burnham and the American Architectural Planning in the Philippines." *Pacific Historical Review* XLI, no. 1 (February 1972).

———. *Burnham of Chicago: Architect and Planner.* New York: Oxford University Press, 1974.

Hornedo, Florentino H. "The Traditional Ivatan House." *St. Louis University Research Journal* IV, nos. 3–4 (September–December 1983): 285–312.

———. "The Tumauini Church: Praise of Sublime Labor in Clay." *Filipino Times* (February 23–March 1, 1987): 1, 5, and 7; and (March 2–8, 1987): 1 and 6.

Hutchinson, John and Anthony Smith, eds. *Nationalism.* New York: Oxford University Press, 1994.

Hutteter, Karl L. *An Archaeological Picture of a Pre-Spanish Cebuano Community.* Cebu City: San Carlos Publications, 1973.

Ilustre, Federico and Felino Leon. "New Design Concepts in Government Buildings." *Philippine Architecture and Building Journal* (1955).

Insular Purchasing Agent to Bureau of Insular Affairs' Chief, July 2, 1902.

"Investigation of Architect Bourne." *The Manila Times* (July 17, 1903): 1.

Ira, Luning. *Streets of Manila.* Quezon City: GCF Books, 1977.

"Jai-Alai Sports Center in Manila." *Architectural Record* 97, no. 2 (February 1945).

Jainal, Tuwan Iklali, Gerard Rixhon, and David Rupert. "Housebuilding among the Tausug." *Sulu Studies I.* Jolo: Notre Dame of Jolo College, 1972.

Javellana, Rene. "The Jesuit House of 1730." *Philippine Studies* XXXI (1982).

———. *Wood and Stone for God's Greater Glory: Jesuit Art and Architecture in the Philippines.* Quezon City: Ateneo de Manila University Press, 1991.

———. "Angels and Gargoyles of Loboc Church." *Philippine Studies* XXXIII (1984).

———, Fernando Zialcita Nakpil, and Elizabeth Reyes. *Filipino Style.* London: Thames and Hudson, 1997.

Jenks, Albert E. *The Bontoc Igorot.* Manila: Bureau of Printing, 1904.

Joaquin, Nick. "A Stage for Greatness." *Philippines Free Press* (September 13, 1969).

Jocano, Felipe Landa. *Philippine Prehistory.* Quezon City: Philippine Center for Advanced Studies, 1983.

Jones, Antoinette M. Barrett. *Early Tenth Century Java from the Inscriptions: A Study of Economic Social and Administrative Conditions in the First Quarter of the Century*. Dordrecht-Holland: Foris Publication, 1984.

Jordana y Morena, Don Ramon. *Bosquejo Geografico e Historico Natural del Archipiélago Filipino*. Madrid, 1885.

Jorde, Elviro P. *Catalogo de los Religiosos Perteniente a la Provincia del Smo. Nombre de Jesus de Filipinas Desde su Fundacion Hasta Nuestros Dias*. Manila: 1901.

Jose, Regalado Trota. "Bamboo or Brick: The Travails of Building Churches in Spanish Colonial Philippines." *Proceedings of the VII General Assembly of ICOMOS*. Washington DC, 1987.

———. "Felix Roxas and the Gothicizing of Earthquake Baroque." *1030 Hidalgo II* (1986): 7-26.

———. "Rococo Church Art in the Philippines." Published as "How to Recognize Rococo Art." *Art Collector* (September–October 1984): 16-22.

———. "Styles in Philippine Retablos: Some Examples from Cavite." *Sculpture in the Philippines: From Anito to Assemblage*. Manila: Metropolitan Museum, 1991.

———. *Simbahan: Church Art in Colonial Philippines, 1565–1898*. Makati: Ayala Museum, 1991.

Journal of the Philippine Commission. Manila: Bureau of Printing, 1901–1917.

Jumsai, Sumet. *Naga: Cultural Origins in Siam and the West Pacific*. Singapore: Oxford University Press, 1988.

Karnow, Stanley. *In Our Image: America's Empire in the Philippines*. New York: Ballantine Press, 1989.

Keesing, Felix M. *The Ethnohistory of Northern Luzon*. California: Stanford University Press, 1962.

Keleman, Pal. *Art of the America: Ancient and Hispanic, with a Comparative Chapter on the Philippines*. New York: Thomas Y. Crowell Company, 1969.

King, Anthony D., ed. *Culture, Globalisation, and the World-System*. Basingstoke: Macmillan, 1991.

———. "Rethinking Colonialism." *Forms of Dominance*, edited by Nezar AlSayyad. Aldershot, England: Avebury, 1992.

———. "Colonial Urban Development." *Culture, Social Power, and Environment*. London: Routledge; Henley and Boston: Kegan Paul, 1976.

———. *Global Cities: Post-Imperialism and the Internationalization of London*. London and New York: Routledge, 1990.

———. *Urbanism, Colonialism, and the World-Economy: Cultural and Spatial Foundations of the World Urban System*. London and New York: Routledge, 1990.

———, ed. *Culture, Globalization, and the World-System: Contemporary Conditions for the Representation of Identity*. Minneapolis: University of Minnesota, 1997.

Klassen, Winand. *Architecture in the Philippines: Filipino Building in the Cross-Cultural Context.* Cebu City: University of San Carlos Press, 1986.

Kostoff, Spiro. *A History of Architecture: Settings and Rituals.* New York: Oxford University Press, 1995.

Kroeber, Alfred Louis. "Peoples of the Philippines." *Handbook Series no. 8* (2nd revised edition). New York: American Museum of Natural History, 1928.

Kultermann, Udo. *Architecture in the 20th Century.* New York: Van Nostrand Reinhold, 1983.

Kusno, Abidin. *Behind the Postcolonial: Architecture, Urban Space, and Political Cultures in Indonesia.* New York and London: Routledge, 2000.

Lachica, Eddie. "Burnham Plan of Manila." *Bulletin of the American Historical Collection* 5, no. 2 (1977).

La Ilustracion Catolica. Madrid, 1881.

Lambrecht, Francis M. "Ifugao Villages and Houses." *Publications of Catholic Anthropological Conference* I, no. 3 (1929): 14-117.

Lampugnani, Vittorio Magnano, eds. *Encyclopedia of 20th Century Architecture.* New York: Henry A. Brahms, 1980.

Laugier, Abbe. *Essai sur l'architecture (Essay on Architecture).* Paris: Chez Duchesne, 1753.

Le Roy, James A. *The Americans in the Philippines: A History of the Conquest and First Years of Occupation.* Boston and New York: Houghton Mifflin, 1914.

Leach, Neil, ed. *Rethinking Architecture: A Reader in Cultural Theory.* London: Routledge, 1997.

Lefebvre, Henri. *The Production of Space*, translated by Donald Nicholson-Smith. Oxford, UK and Cambridge, MA: Blackwell Publishers, 1991.

Legarda, Benito F. "Angels in Clay: The Typical Cagayan Church Style." *Filipinas Journal of Science and Culture II.* Makati: Filipinas Foundation, 1981.

——. "Colonial Churches of Ilocos." *Philippine Studies* VIII (January 1960): 121-58.

Lico, Gerard. "Building the Imperial Imagination: The Politics of American Colonial Architecture and Urbanism in Manila." Unpublished doctoral dissertation, University of the Philippines, 2006.

——. *Edifice Complex: Power, Myth, and Marcos State Architecture.* Manila: Ateneo de Manila University Press, 2003.

——. "The Rockwell Center: Design, Aesthetics, and Ideology." *Bluprint* 1 (1999a): 73-78.

——. "Fort Bonifacio: Siting/Sighting a Global City Towards a Transnationalized Architecture and Culture." *Bluprint* 2 (1999b): 108-13.

——. "(Re)structuring Philippine Architecture." *Sanghaya 2002: Philippine Arts and Culture Yearbook.* Manila: National Commission for Culture and the Arts, 2003.

———— and Edson Cabalfin, eds. *Arkitekturang Filipino: Spaces and Places in History* [CD-ROM]. Manila: National Commission for Culture and Arts, 2003.

Locsin, Leandro. "Need for a Filipino 'Style in Architecture.'" *Philippine Architecture, Engineering and Construction Record* 13, no. 4 (1966).

Loomba, Ania. *Colonialism-Postcolonialism*. London and New York: Routledge, 1998.

Loos, Adolf. "Ornament and Crime." *Programs and Manifestoes on 20th Century Architecture*, edited by Ulrich Conrads. Cambridge, MA: MIT Press, 1971.

Lopez, Renato. "History of Santa Barbara in Pangasinan during the Spanish Time." *Ilocos Review* XVI (1984): 75-133.

Los Dominicos en el Extre,o Oriente, Provincia Santissimo del Rosario de Filipinas. Barcelona: Industria Graficas de Barcelona Seix Y Barral, Herma, S.A., 1961.

Maceda, Marcelino N. "Brief Report on Some Mangyans in Northern Oriental Mindoro." *Unitas* XL (1967): 102-55.

Madale, Nagasura T. *The Muslim Filipinos: A Book of Readings*. Quezon City: Alemar's Phoenix Publishing House, 1981.

Mahan, Alfred T. *The Influence of Sea Power upon History*, 1660-1783. Boston: Brown Little, 1918.

Maher, R. F. "Archaeological Investigations in Central Ifugao." *Asian Perspectives* 16, no. 1 (1973): 39-70.

Majul, Cesar Adib. "Mosques in the Philippines." *Filipino Heritage: The Making of a Nation III*, edited by Alfredo R. Roces. Manila: Lahing Pilipino Publications, 1978, 779-84.

————. *Muslims in the Philippines*. Quezon City: Asian Center and University of the Philippines Press, 1973.

Malcolm, George A. *The Charter of the City of Manila and the Compilation of Revised Ordinances of the City of Manila*. Manila: Bureau of Printing, 1927.

Mallari, I. V. "Architect and Architecture in the Philippines." *Philippine Education Magazine* (August–October 1930).

————. "Rising Manila." *Philippine Education Magazine* (January–February, October, December 1941).

————. "The New Post Office." *Philippine Education Magazine* (April 1931).

Manahan, Geronimo. *Philippine Architecture in the 20th Century*. Manila: Cultural Center of the Philippines, 1994.

Mandelbaum, Howard and Eric Myers. *Screen Deco: A Celebration of High Style in Hollywood*. New York: St. Martin's Press, 1985.

"Manila Wall in the Way." *New York Times* (May 31, 1903): 29.

Mañosa, Manuel. "Manila's Obsolete Sewer." *American Chamber of Commerce Journal* (October 1947).

Manuel, E. Arsenio. *Dictionary of Philippine Biography I-III*. Quezon City: Filipiniana Publications, 1955; 1970; 1986.

Manuel, Maria Teresa, ed. *TAO: Humanism at Work in Filipino Society.* Hong Kong: National Media Production Center, 1979.

Manuud, Antonio G. "The Manila Cathedral, 1571–1958: A Symposium." *Philippine Studies* VII (1959): 98–110.

Mapua, Tomas. "The Executive Building." *Bureau of Public Works Quarterly Bulletin* 8, no. 1 (April 1919): 3–8.

Marche, Alfred. *Lucon et Palaouan: Six années de Voyages Aux Philippines.* Paris: Librairie Hachette Et Cie, 1887.

Marco, Dorta, Enrique. *Arte en America y Filipinas ara Hispaniae: Historia Universal del Arte Hispanico.* Madrid, Spain: Editorial Plus-Ultra, 1973.

Marcolena, Rodante D. "The Central Temple: Fulfilling a Prophecy." *Pasugo* (May–June 1986): 50–57.

Marcos, Ferdinand E. *Five Years of the New Society.* Manila: Marcos Foundation, 1978.

———. *Letter of Instruction* 73 (May 8, 1973).

Marcos, Imelda R. "The City of Man Is Founded on the City of God." *The Ideas of Imelda Romualdez Marcos*, edited by Ileana Maramag. Manila: National Media Production Center, 1978.

———. *Paths to Development.* Manila: National Media Production Center, 1981.

Masterson, William. *War Damage Claims.* Quezon City: Ateneo de Manila University Press, 1945.

McDill, John R. "The Philippine General Hospital." *The Manila Times* (March 19, 1911): 32–33.

McGregor, J. "Reconstruction of the Insular Ice Plant." *Bureau of Public Works Quarterly Bulletin* 3, no. 3 (October 1914): 22–25.

McLaughlin, Allan. "The Suppression of a Cholera Epidemic in Manila." *Philippine Journal of Science* 4B (1909): 43–56.

McLeish, Kenneth. "Help for Philippine Tribe in Trouble." *National Geographic Magazine* (August 1972).

Mendoza-Guanzon, Maria Paz. *The Development and Progress of the Filipino Women.* Manila: Bureau of Printing, 1928.

Merino, Luis OSA. *Arquitectura y Urbanismo en el Siglo XIX, Estudios Sobre el Manila II.* Manila: Centro Cultural de España and the Intramuros Administration, 1987.

———. *Estudious Sobre el Municipio de Manila.*

Merino, Luis. "Las Casas Consistoriales del Cabildo de Administrativos." *Estudios Sobre el Municipio de Manila I.* Manila: The Intramuros Administration, 1983.

———. *Arquitectura y Urbanismo en el Siglo XIX.* Manila: The Intramuros Administration II, 1987.

Metcalf, Thomas R. *An Imperial Vision: Indian Architecture and Britain's Raj.* California: University of California Press, 1989.

Miller, George Amos. *Interesting Manila*. Manila: E. C. McCullough, 1912.

———. *Interesting Manila: Historical Narratives Concerning the Pearl of the Orient*. Manila: E. C. McCullough, 1919.

Missioneros Catolicos en Extremo Oriente. Manila: Cacho Hermanos, 1937.

Mitchell, Timothy. *Colonizing Egypt*. New York: Cambridge University Press, 1988.

Mojares, Resil B. *Casa Gorordo in Cebu. Urban Residence in a Philippine Province, 1860-1920*. Cebu: Ramon Aboitiz Foundation, 1983.

Moore, Charles. *Daniel H. Burnham, Architect, Planner of Cities*, 2 volumes. Boston and New York: Houghton Mufflin, 1921.

Morga, Dr. Antonio de. *Sucesos de las Islas Filipinas*. Mexico, 1609, translated and edited by J.S. Cummins. The Hakluyt Society, Cambridge University Press, 1971.

Muijzenberg, Otto van den and Ton van Naerssen. "Metro Manila: Designers or Directors of Urban Development?" *Directors of Urban Change in Asia*, edited by Peter Nas. London: Routledge, 2005, 142–63.

Municipal Board of Manila. *[Annual] Report of the Municipal Board of the City of Manila*. Manila: Bureau of Printing, 1900–1914.

Musgrove, John, ed. *Sir Banister Fletcher's A History of Architecture* (19th edition). London and Boston: Butterworth Group, 1987.

Nakpil, Angel E. "An Evolution of Filipino Architects." *Woman and the Home* 1 (October 1953).

Nakpil, Angel E. "Philippine Architecture Today." *Comment* 16 (1962).

Nakpil, Juan F. "In Defense of the Rizal Monument." *Philippines Free Press* (October 13, 1962): 34–52.

———. *Juan Nakpil and Sons: Architects and Engineers 30th Anniversary*. Manila, 1960.

Nalbantoglu, Gülsüm Baydar and Wong Chong Thai, eds. *Postcolonial Space(s)*. New York: Princeton Architectural Press, 1997.

Nance, John. "The Gentle Tasaday: A Stone-Age People." *Philippine Rainforests*. New York and London: Hardcourt Brace Javanovich, 1977.

National Geographic Society. *A Revelation of the Filipinos: Illustrated by 130 Pictures Showing the Types of People, Their Manner of Life and Industries, Their Country and Resources*. Washington, DC.: National Geographic Society, 1905.

Neely, Tennyson. *A Wonderful Reproduction of Living Scenes in Natural Color Photos of America's New Possessions*. Chicago: International View Company, 1901.

Nells-Lim, J. "Metro Manila in the 1980s." *Manila Magazine* 2, no. 6. Manila: Communicasia, 1981.

Nino, Andres G. *San Agustin of Manila*. Manila: The Augustinian Monastery, 1975.

Norton, Morilla Maria. *Studies in Philippine Architecture*. Manila, 1911.

Nutall, Zelia. "Royal Ordinances for the Laying Out of Towns (July 3, 1573)." *Hispanic American Historical Review* 5, no. 2 (May 1922).

O'Sullivan, John L. "The Great Nation of Futurity." *The United States Democratic Review* 6, Issue 23, 426–30.

Ocampo, Galo. "Cultural Patterns in Philippine Architecture." *Science Review* 6, no. 9 (1965).

Ocampo, Pablo. *Floor Plan and Elevations of the San Ignacio, Drawn for the War Damage Claims.* Quezon City: Ateneo De Manila University Administration, 1945.

Ocampo, Romeo B. "Planning and Development of Prewar Manila: Historical Glimpses of Philippine City Planning." *The Philippine Journal of Public Administration* 36, no. 4 (October 1992).

Official Handbook. Description of the Philippines. Part I. Compiled by the Bureau of Insular Affairs, War Department, Washington, DC. Manila: Bureau of Printing, 1903.

Oliver, Paul, ed. *Encyclopedia of Vernacular Architecture of the World.* Cambridge, UK and New York: Cambridge University Press, 1999.

Ortiz-Armengol, Pedro. *Intramuros de Manila de 1571 Hasta su Destruccion en 1945.* Madrid: Ediciones de Cultura Hispanica, 1958.

Palazon, Juan. *Majayjay: How a Town Came into Being.* Manila: Historical Conservation Society, 1964.

Pareja, Lena S. "Philippine Cinema: The First 15 years (1897–1912)." *Kultura* III, no. 2 (1990): 14–23.

Parsons, William E. "Burnham as Pioneer in City Planning." *Architectural Record*, no. 38 (July 1915).

Peralta, Jesus T. *Pre-Spanish Manila: A Reconstruction of the Prehistory of Manila.* Manila: National Historical Commission, 1974.

—— and Lucila A. Salazar. *Pre-Spanish Manila: A Reconstruction of the Prehistory of Manila.* Manila: National Historical Institute, 1974; 2nd printing, 1993.

Perez III, Rodrigo D. "Architects of a Generation." Parts I to IV. *Sunday Times Magazine* (July 22, 1956; July 29, 1956; August 5, 1956; August 12, 1956).

——. "Arkitektura: An Essay on Philippine Architecture." *Tuklas Sining: Essays on Philippine Arts*, edited by Nicanor G. Tiongson. Manila: Sentrong Pangkultura ng Pilipinas, 1991.

——. "Architecture in the Philippines." *The Art of the Philippines 1521–1957.* Manila: Art Association of the Philippines, 1958.

——. *Arkitektura: An Essay on the American Colonial and Contemporary Traditions in Philippine Architecture.* Manila: Cultural Center of the Philippines, 1991.

——, Rosario S. Encarnacion, and Julian Dacanay. *Folk Architecture.* Quezon City: GCF Books, 1989.

Peterson, Jon A. *The Birth of City Planning in the United States, 1840–1917.* Baltimore: Johns Hopkins University Press, 2003.

Phelan, John Leddy. *The Hispanization of the Philippines: Spanish Aims and Filipino Responses, 1565–1700.* Madison: University of Wisconsin Press, 1959.

Philippine General Hospital Medical Center. *The Hospital: 75 Years of the University of the Philippines-Philippine General Hospital Medical Center (1910–1985).* Manila: Philippine General Hospital, 1986.

Philippine Health Service. *Plans and Instructions Relative to the Construction of the Sanitary Model House.* Manila : Bureau of Printing, 1917.

Pinches, Michael. "Modernization and the Quest for Modernity: Architectural Form, Squatter Settlements, and the New Society in Manila." *Cultural Identity and Urban Change in Southeast Asia: Interpretive Essays,* edited by Marc Askew and William Logan. Geelong: Deakin University Press, 1994.

Polites, Nicholas. *The Architecture of Leandro V. Locsin.* New York: Weatherhill, 1977.

Presidential Decree No. 1277. "Providing for the Preservation of the Walls of Intramuros and the Restoration of its Original Moat and Esplanade." January 4, 1977.

Presidential Decree No. 37. "Creating the Nayong Pilipino Foundation." November 6, 1972.

Presidential Decree No. 772. "Penalizing Squatting and other Similar Acts." August 20, 1975.

Presidential Proclamation No. 1578. "Declaring as a Game Preserve and Wildlife Sanctuary a Certain Parcel of Land of the Public Domain Embraced and Situated in the Island of Calauit, Municipality of New Busuanga, Island of Busuanga, Province of Palawan." August 31, 1976.

Preziosi, Donald. *The Art of Art History: A Critical Anthology.* New York: Oxford University Press, 1998.

Quezon, Manuel L. *President Quezon: His Biographical Sketch, Messages, and Speeches: A Record of the Progress and Achievements of the Philippine People,* edited by Eulogio B. Rodriguez. Manila: Bureau of Printing, 1940.

Quirino, Carlos. *Maps and Views of Old Maynila.* Manila: Mahamilad, 1971.

—— and Mauro Garcia, eds. "The Manners, Customs, and Beliefs of the Philippine Inhabitants of Long Ago. A Late 16th Century Manila." Manuscript, transcribed, translated, and annotated by the National Institute of Science and Technology, Manila. *The Philippine Journal of Science* LVXXXVIII, no. 4 (December 1958).

Rafael, Vicente. *White Love and Other Events in Filipino History.* Durham: Duke University Press, 2000.

Rapoport, Amos. *House Form and Culture.* Englewood Cliffs, NJ and New York: Prentice-Hall, 1969.

Razul, Jainal D. *Muslim-Christian Land: Ours to Share.* Quezon City: Alemars-Phoenix Publication House, 1979.

Rebori., A. N. "The Work of William Parsons in the Philippine Islands Part I." *Architectural Record* 41 (April 1917).

——. "The Work of William Parsons in the Philippine Islands Part II." *Architectural Record* 42 (May 1917).

Reed, Robert. "From Suprabarangay to Colonial Capital: Reflections on the Hispanic Foundations of Manila." *Forms of Dominance: On the Architecture and Urbanism of the Colonial Enterprise*, edited by Nezar AlSayyad. England: Avebury Publishing, 1992.

——. "Hispanic Urbanism in the Philippines: A Study of the Impact of Church and State." *Journal of East Asiatic Studies* 11 (March 1967).

——. "City of Pines: The Origins of Baguio as a Colonial Hill Station and Regional Capital." *Research Monograph* 13. Berkeley: Center for South and Southeast Asia Studies, University of California, 1976.

——. "Colonial Manila: The Context of Hispanic Urbanism and Process of Morphogenesis." *University of California Publications in Geography* no. 22. Berkeley and Los Angeles: University of California Press, 1978.

Reibling, W. C. and F. D. Reyes. *The Efficiency of Portland Cement Raw Materials from Naga, Cebu*. Manila: Bureau of Printing, 1914.

Report of the Philippine Commission for the Fiscal Year Ended June 30, 1902. Washington: Government Printing Office, 1902.

Report of the Philippine Commission for the Fiscal Year Ended June 30, 1903. Washington: Government Printing Office, 1903.

Report of the Philippine Commission for the Fiscal Year Ended June 30, 1906. Washington: Government Printing Office, 1906.

Report of the Philippine Commission for the Fiscal Year Ended June 30, 1912. Washington: Government Printing Office, 1912.

Report of the Philippine Commission for the Fiscal Year Ended June 30, 1908. Washington: Government Printing Office, 1908.

Report of the Philippine War Damage Commission. Washington: U.S. Government Printing Office, 1947.

Reports of General MacArthur, 2 volumes, Gordon W. Prange, ed., Volume II, Part II. Washington, DC: Center of Military History, 1944.

Reports of the Civil Government of the Philippine Islands. Washington: Government Printing Office, 1900–1903.

Rizal Centennial Bulletin. Issues 1–11. Manila: Jose Rizal National Centennial Commission, 1955–1961.

Robertson, Roland. *Globalization: Social Theory and Global Culture*. Newbury Park, CA: Sage, 1992.

Robles, Eliodoro. *The Philippines in the 19th Century*. Quezon City: Malaya Books, 1969.

Roces, Alfredo R., ed. *Filipino Heritage—The Making of a Nation*. 10 volumes. Manila: Lahing Pilipino Publishing Foundation, 1978.

Rodriguez, Isacio R. *The Augustinian Monastery of Intramuros*, translated by Pedro Galende. Makati: Colegio de San Agustin, 1976.

Roxas, Felix M. "Our City." *Merchants Association Review* 1 (August 1911): 11.

Rudofsky, Bernard. *Architecture without Architects: An Introduction to Nonpedigreed Architecture.* New York: Museum of Modern Art; distributed by Doubleday, Garden City, NY, 1964.

Ruiz, Julio. "A Brief Historical Sketch of the 'Antipolo System' of Privy." *Monthly Bulletin of the Philippine Health Service* V, no. 2 (February 1925).

Rusling, James. "Interview with President William McKinley." *The Christian Advocate* (January 22, 1903): 17. Reprinted in *The Philippines Reader,* edited by Daniel Schirmer and Stephen Rosskamm Shalom. Boston: South End Press, 1987, 22–23.

Saber, Mamitua and Abdullah T. Madale. *The Maranao.* Manila: Solidaridad Publishing House, 1975.

Said, Edward. *Culture and Imperialism.* Vintage Books: London, 1994.

———. *Orientalism.* London: Routledge and Kegan Paul, 1978.

Salazar, Tessa R. "Recreational Complex Out to Preserve Nature." *Philippine Daily Inquirer* (September 4, 2003).

Salcedo, Juan de. "Relation of the Discovery of the Island of Luzon, One of the Western Islands 1570." *The Philippine Islands: 1493–1898,* edited by Emma Helen Blair and James Alexander Robertson. 55 volumes. Cleveland, Ohio: The A. H. Clark Company, 1903-1909.

Sassen, Saskia. *Cities in a Global Economy.* Thousand Oaks, California: Pine Forge Press, 1994.

———. *The Global City: New York, London, Tokyo.* Princeton, New Jersey: Princeton University Press, 1991.

Scharpf, Frederick. "San Diego en los Montes de Labra de Vigan." *Ilocos Review* XV (1983).

Schuyler, Montgomery. "Our Acquired Architecture." *Architectural Record* 9, no. 3 (January 1900).

Scott, William Henry. *On the Cordillera: A Look at the Peoples and Cultures of the Mountain Province.* Manila: MCS Enterprises, 1966.

———. "Cordillera Architecture of Northern Luzon." *Folklore Studies* 21, no. 1 (1962).

———. *Barangay: Sixteenth-Century Philippine Culture and Society.* Quezon City: Ateneo de Manila University Press, 1994.

Secretary of Interior. *Report of the Secretary of Interior to the Philippine Commission for the Year Ending August 31, 1902.* Manila: Bureau of Printing, 1902.

Shillony, Ben-Ami. *Politics and Culture in Wartime Japan.* New York: Oxford University Press, 1981.

Silao, Federico B. "Burnham's Plan for Manila." *Philippine Planning Journal* 1, no. 1. Quezon City: Institute of Planning, University of the Philippines (October 18, 1969).

Sison, Arsenia B. "The Iglesia ni Cristo Engineering and Construction Department." *Pasugo* (May–June 1986): 30–31.

Smith, Robert R. "Triumph in the Philippines." *United States Army in World War II: The War in the Pacific.* Washington, DC: Center of Military History, 1963.

Smith, Winfield Scoot III, ed. *Art of the Philippines 1521–1957.* Manila: The Art Association of the Philippines, 1958.

Soja, Edward W. *Third Space Journey to Los Angeles and Other Real-and-Imagined Places.* Cambridge, MA: Blackwell Publishers, 1996.

Synder, W. R. "Meralco History." *American Chamber of Commerce of the Philippines Journal* 31, no. 9 (September 1955): 384–87.

Taft, William H. and Theodore Roosevelt. *The Philippines.* New York: Outlook, 1902.

"The Decline of Filipino Architecture." *Content* 16 (1962): 166–71.

"The New Customs in House Building." *The Manila Times* (July, 11 1903): 1.

"The New Manila Hotel." *The Manila Times* (August 29, 1910): 1.

The Official Journal of the Japanese Military Administration. 2nd edition, volumes 1–13. Manila: Manila Sinbun-Sya, 1942–43.

The Philippines Herald (January 9, 1935).

Tiangco, Mamerto. *Philippine Health Service Sanitary Almanac for 1919 and Calendars for 1920 and 1921.* Manila: Bureau of Printing, 1918.

Tiongson, Nicanor, ed. *Cultural Center of the Philippines (CCP) Encyclopedia of Philippine Arts,* [CD-ROM]. Manila: Cultural Center of the Philippines, 1994.

Turalba, Maria Cristina. *Philippine Heritage Architecture Before 1521 to the 1970s.* Pasig City: Anvil Publishing, 2005.

Tzonis, Alexander and Liane Lefaivre. "The Grid and Pathway: An Introduction to the Work of Dimitris and Susan Antonakakis in the Context of Greek Architectural Culture." *Atelier 66: The Architecture of Dimitris and Susan Antonakakis.* New York: Rizzoli, 1983.

——. "Tropical Critical Regionalism: Introductory Comments." *Tropical Architecture: Critical Regionalism in the Age of Globalization,* edited by Alexander Tzonis, Liane Lefaivre, and Bruno Stagno. Great Britain: Wiley Academy, 2001.

Tzonis, Alexander and Liane Lefaivre. "Why Critical Regionalism Today?" *Theorizing a New Agenda for Architecture: An Anthology of Architectural Theory 1965–1995,* edited by Kate Nesbitt. New York: Princeton Architectural Press, 1996.

United States Bureau of Insular Affairs. *Annual Reports, War Department for the Fiscal Year ended June 30, 1913.* Washington: Government Printing Office, 1913.

Vale, Lawrence J. *Architecture, Power, and National Identity.* New Haven and London: Yale University Press, 1992.

Van Hise, Joseph B. "American Contributions to Philippine Science and Technology: 1898–1916." Unpublished doctoral dissertation, University of Wisconsin, 1957.

Veloso-Yap, Veronica T. "Tribute to Artist: The National Arts Center." *Pamana* 21. Manila: Cultural Center of the Philippines, 1976.

Venturi, Robert. *Complexity and Contradiction in Architecture*. New York: Museum of Modern Art, 1966.

Villalon, Augusto. *Lugar: Essays on Philippine Heritage and Architecture*. Manila: Bookmark, 2002.

Villaroel, Fidel. "The UST Main Building: A Witness to History." *Unitas* L, no. 4 (December 1977).

Vlekke, Bernard Hubertus. *Nusantara: A History of Indonesia*. Revised edition. Chicago: Quadrangle Books, 1960.

Warren, James Francis. *Sulu Zon 1768–1898*. Singapore: University of Singapore Press, 1981.

Waterson, Roxana. *The Living House, An Anthropology of Architecture in South East Asia*. Singapore: Oxford University Press, 1990.

White, Trumbull. *Our New Possessions*. Chicago: John E. Hoham, 1898.

Wilcox, Marrion, ed. *Harper's History of the War in the Philippines*. New York: Harper and Bros. Publication, 1900.

Williams, A. D. and A. Silvester. "History of Public Works in the Islands." *Annual Report of the Bureau of Public Works* (September 1933).

"Will Fill Moats and Build Parks." *Cable News American* (January 15, 1903): 1.

Wilson, Lawrence, L. *Ilongo Life and Legends*. Manila: Bookman, 1967.

Wright, Gwendolyn. *The Politics of Design in French Colonial Urbanism*. Chicago and London: The University of Chicago Press, 1991.

———. "Building Global Modernisms." *Grey Room 07* (Spring 2002).

Yap, David Leonides. "Transformation of Space in Philippine Traditional Houses: Studies in Morphology of Space from the Prehistoric to American Period." *National Symposium on Filipino Architecture and Design*. Quezon City: University of the Philippines, Sentro ng Arkitekturang Filipino, 1995.

Yu, Francis. "Philippine Architecture from the 1950s to the 1960s." Unpublished doctoral dissertation, University of Tokyo, 1991.

Zaragosa, Jose Ramon Ma. *Philippine Historical Illustrations*. Manila: Total Book World, 1991.

Zarate, Ernesto R. *Oro, Plata, Mata!: Filipino Building Beliefs*. Manila: National Commission for Culture and the Arts, 2000.

Zelinsky, Wilbur. *Nation into State: The Shifting Symbolic Foundations of American Nationalism*. Chapel Hill: University of North Carolina Press, 1988.

Zialcita, Fernando N. and Martin I. Tinio Jr. *Philippine Ancestral Houses 1810–1930*. Quezon City: GCF Books, 1980.

Zobel de Ayala, Fernando. *Philippine Religious Imagery*. Quezon City: Ateneo de Manila, 1963.

Zukin, Sharon. *The Cultures of Cities*. Cambridge, Massachusettes: Blackwell Publishers Inc., 1995.

Index of Names and Subjects

T

U

V

W

Y

Z

Index of Photographs

Index of Illustrations

The Author

Dr. Gerard Lico is an architect and art historian. He teaches at the College of Architecture, University of the Philippines (UP) at Diliman and practices architecture as the Campus Architect of the same institution. He is the author of *Edifice Complex: Power, Myth, and Marcos State Architecture* (2003) and a series of interactive cd-roms, "Arkitekturang Filipino: Spaces and Places in History" (2003), "Through the Lens of an American Soldier" (2004), and "Building Modernity: A Century of Philippine Architecture and Allied Arts" (2008). For his research work in architectural history and cultural studies, he was conferred the UP Gawad Chanselor para sa Pinakamahusay na Mananaliksik (Arts and Humanities) in the years 2002, 2004, and 2005, installing him to its Hall of Fame. He was one of the recipients of the Ten Outstanding Young Men (TOYM) award in 2004. He is currently the Vice Head of the National Committee on Architecture and Allied Arts of the National Commission for Culture and the Arts, Research Program Director of the UP College of Architecture, and Curator of the Museum of Filipino Architecture in UP.